Women Graphic Designers

Women Graphic Designers

Rebalancing the Canon

Edited by
Elizabeth Resnick

BLOOMSBURY VISUAL ARTS
LONDON · NEW YORK · OXFORD · NEW DELHI · SYDNEY

BLOOMSBURY VISUAL ARTS
Bloomsbury Publishing Plc
50 Bedford Square, London, WC1B 3DP, UK
1385 Broadway, New York, NY 10018, USA
29 Earlsfort Terrace, Dublin 2, Ireland

BLOOMSBURY, BLOOMSBURY VISUAL ARTS and the Diana logo are trademarks of Bloomsbury Publishing Plc

First published in Great Britain 2025
Selection and editorial matter © Elizabeth Resnick, 2025
Individual chapters copyright © their authors, 2025

Elizabeth Resnick has asserted her right under the Copyright, Designs and Patents Act, 1988, to be identified as Editor of this work.

For legal purposes the Acknowledgments on p. xxxiv constitute an extension of this copyright page.

Cover design: Elizabeth Resnick Design
Cover image: Elizabeth Resnick Design

All rights reserved. No part of this publication may be: i) reproduced or transmitted in any form, electronic or mechanical, including photocopying, recording or by means of any information storage or retrieval system without prior permission in writing from the publishers; or ii) used or reproduced in any way for the training, development or operation of artificial intelligence (AI) technologies, including generative AI technologies. The rights holders expressly reserve this publication from the text and data mining exception as per Article 4(3) of the Digital Single Market Directive (EU) 2019/790.

Bloomsbury Publishing Plc does not have any control over, or responsibility for, any third-party websites referred to or in this book. All internet addresses given in this book were correct at the time of going to press. The author and publisher regret any inconvenience caused if addresses have changed or sites have ceased to exist, but can accept no responsibility for any such changes.

A catalogue record for this book is available from the British Library.

A catalogue record for this book is available from the Library of Congress.

ISBN: HB: 978-1-3503-4923-0
PB: 978-1-3503-4921-6
ePDF: 978-1-3503-4926-1
eBook: 978-1-3503-4925-4

Typeset by Integra Software Services Pvt. Ltd.
Printed and bound in India

For product safety related questions contact productsafety@bloomsbury.com

To find out more about our authors and books visit www.bloomsbury.com and sign up for our newsletters.

This book is dedicated to the memory of
Dorothea Hofmann (1929–2023)

Artist, designer, educator, design historian, and research collaborator
Author of *Die Geburt eines Stils: Der Einfluss des Basler Ausbildungsmodells auf die Schweizer Grafik,* Triest Verlag 2016 [*The Birth of a Style: The Influence of the Basel Educational Model on Swiss Graphic Design,* Triest Verlag 2024]

CONTENTS

List of Illustrations **x**
Preface **xxvi**
Acknowledgments **xxxiv**

SECTION 1
New Millennium Pioneers
(1875–1920) 1

1.0 Introduction **3**
Elizabeth Resnick

1.1 Uemura Shōen: The Pine that Stands Alone Yet Which Is One of Many **9**
Ian Lynam

1.2 Jane Atché: The Smoking Woman **17**
Vanina Pinter

1.3 Varvara Stepanova: Life under Construction **29**
Dr. Olga Severina

1.4 Fré Cohen: A Dutch Jewish Socially Conscious Feminist Artist **43**
Alice Roegholt

1.5 Ans van Zeijst: A Dynamic Designer within Religious and Secular Contexts **57**
Ginger van den Akker

1.6 Maria Keil: The Polyphonic Work of a Pioneering Portuguese Designer **71**
Dr. Maria Helena Souto

1.7 Sufism and Science in Saloua Raouda Choucair's Design Work **83**
Dr. Yasmine Nachabe Taan

1.8 Dorrit Dekk: Making a Name for Herself in Graphic Design **95**
Ruth Sykes

1.9 Roswitha Bitterlich: Between Two or More Worlds **109**
Dr. Paula Ramos and Dr. Raquel Castedo

SECTION 2
Modernist Trailblazers
(1925–1939) 121

2.0 Introduction **123**
Elizabeth Resnick

2.1 Anita Klinz: The Art of Book Design **133**
Laura Ottina

2.2 Jacqueline S. Casey: Design and Science **143**
Elizabeth Resnick

2.3 Lora Lamm: Between Swiss and Italian Graphic Design **157**
Dr. Carlo Vinti

2.4 Claudia Morgagni: Woman, Graphic Designer, Teacher **171**
Dr. Cinzia Ferrara and Dr. Francesco E. Guida

2.5 Nelly Rudin: A Concrete Graphic Designer **183**
Sandra Bischler-Hartmann

2.6 Dorothea Hofmann: Patiently Persevering **193**
Margo Halverson

2.7 Karmele Leizaola: The First Woman Graphic Designer in Venezuela
Faride Mereb **205**

2.8 Gülümser Aral Üretmen: A Pioneering Turkish Female Graphic Designer **215**
Ömer Durmaz and Dr. Murat Ertürk

2.9 Tomoko Miho: The Personification of European Modernism **227**
Elizabeth Resnick

2.10 Anneliese Ernst: Graphics for Use **243**
Rose Epple

2.11 Dolly Sahiar: Layers of Artistry in Editorial Design **255**
Rukminee Guha Thakurta

2.12 Odiléa Toscano: Elegance and Wit for Printed Graphics and Public Architectural Spaces **267**
Dr. Sara Miriam Goldchmit, Dr. Maria Cecilia Loschiavo Dos Santos, and Luciene Ribeiro dos Santos

2.13 Thérèse Moll: An Enigma Gone Too Soon **277**
Elizabeth Resnick

2.14 Eiko Emori: Designer, Artist, and Trailblazer **289**
Stephan Rosger

2.15 Dorothy E. Hayes: Shaping the Narrative of Black Creatives in Design **303**
Tasheka Arceneaux Sutton

2.16 Agni Katzouraki: The "Light" of Greek Aesthetics in Graphic Design **313**
Dr. Marina Emmanouil

2.17 Bonnie MacLean: Pioneering Psychedelic Poster Artist **325**
Elizabeth Resnick

SECTION 3
Postmodern Innovators (1940–1970) **337**

3.0 Introduction **339**
Elizabeth Resnick

3.1 Eulindra Lim: The Rise of Women in Singapore Design **347**
Justin Zhuang

3.2 Elizabeth Fitz-Simon: Professionalizing Graphic Design in Ireland **359**
Dr. Linda King

3.3 Anna Monika Jost: A Nomadic Practitioner **373**
Dr. Chiara Barbieri and Dr. Davide Fornari

3.4 Anna Eymont, Myriam Kin-Yee, and Alison Hulett: EKH, the Quiet Australians **387**
Dr. Jane Connory

3.5 Making a Difference: The Graphic Design Work of Trish de Villiers **399**
Dr. Deirdre Pretorius

- **3.6** Mahnoosh Moshiri: Designs as a Poet, Writes as an Illustrator, and Lives as an Artist **411**
 Parisa Tashakori

- **3.7** Arlette Haddad: An Arabic Type Design Hermit **425**
 Dr. Bahia Shehab

- **3.8** Farideh Shahbazi: Illustrator, Graphic Designer, and Publisher of Children's Books **435**
 Mehrdokht Darabi

- **3.9** Polly Bertram: From New Wave to AGI **447**
 Dr. Chiara Barbieri and Dr. Davide Fornari

- **3.10** Sylvia Harris: The Enduring Influence of a Resolutely Black and Worldly Citizen Designer **459**
 Anne H. Berry

- **3.11** Kyungja Keum: Golden Days **473**
 Dr. Yoonkyung Myung

- **3.12** Winnie Wai-kan Kwan: The Nurturer of Museum Design, Public Engagement, and Life Balance **485**
 Dr. Wendy S. Wong

- **3.13** Elisabetta Ognibene: A Militant Feminist Designer **499**
 Dr. Monica Pastore

- **3.14** Mara de Oliveira: A Woman Designer from Northern Uruguay **511**
 Luis Blau

- **3.15** Marjaana Virta: Designer for Text and Textile **525**
 Dr. Arja Karhumaa

- **3.16** Sujata Keshavan: Indian Graphic Design Pioneer **535**
 Tanishka Kachru

Notes on Contributors **546**
Index **554**

ILLUSTRATIONS

1.1.1　Uemura Shōen, photographic portrait. *Source*: Portraits of Modern Japanese Historical Figures, National Diet Library **9**

1.1.2　*Left:* Uemura Shōen, *Flame* painting, 1918. Tokyo National Museum, Tokyo, Japan. *Right:* Uemura Shōen, *Firefly* painting, 1913. Portrait of a woman airing her kimono. Yamanate Museum of Art, Tokyo, Japan **12**

1.1.3　*Left:* Uemura Shōen, Board of Tourist Industry poster, Japanese Government Railways, featuring the 1936 *Classical Dance* painting. Kyodo Printing Company, Ltd. (n.d.). *Right:* Uemura Shōen, *Classical Dance* (also titled *Noh Dance Prelude*) painting, 1936. Tokyo National University of Fine Arts and Music, Tokyo, Japan **13**

1.1.4　*Left:* Uemura Shōen, *Young Woman Miyuki* painting, 1914. Adachi Museum of Art, Yasugi, Japan. *Right:* Uemura Shōen, *Mother and Child* painting, 1934. National Museum of Modern Art, Tokyo, Japan **14**

1.2.1　Jane Atché, *Self-portrait with a green hat*, 1909. Oil on canvas. Musée du Pays Rabastinois, France **17**

1.2.2　Jane Atché, poster for JOB Cigarette paper, 1896. Color lithograph on paper. Musée du Pays Rabastinois, France **18**

1.2.3　*Left:* Jane Atché, *La Célestine* poster, circa 1898. Lithograph on paper. *Right:* Jane Atché, *Le Gui et le Houx* (decorative panel), 1899. Color lithograph. Bibliothèque Nationale de France **24**

1.2.4　Jane Atché, cover illustration, *Belle capricieuse: valse par Gabriel Allier*, 1904. Bibliothèque Nationale de France **26**

1.3.1　Varvara Stepanova, photo by Alexander Rodchenko, 1931. © Varvara Stepanova and Alexander Rodchenko Family archives **29**

1.3.2　Varvara Stepanova, collages for the book *Gly-Gly*. Author: Alexei Kruchenykh, 1918. © Varvara Stepanova and Alexander Rodchenko Family archives **32**

1.3.3　Varvara Stepanova, sportswear designs, *LEF* magazine, 1923. © Varvara Stepanova and Alexander Rodchenko Family archives **35**

1.3.4 Varvara Stepanova, textile patterns 1920–24. © Varvara Stepanova and Alexander Rodchenko Family archives **37**

1.3.5 Varvara Stepanova, cover for *Kino-Fot* magazine, 1922; book cover for *Mountain Roads*, TransPrint Publishing, 1925; cover for *New LEF* magazine, 1928. © Varvara Stepanova and Alexander Rodchenko Family archives **39**

1.4.1 Fré Cohen, photographic portrait, circa 1920s. Image courtesy of the Museum Het Schip **43**

1.4.2 Fré Cohen, cover for *Hoogty, Tag der Freude*, 1926, Progress, German Edition. Image courtesy of the Museum Het Schip **47**

1.4.3 Fré Cohen, *September 14 Rotterdam* poster for the NVV and SDAP, The Concern is for Your Child's Future. SDAP (Social Democratic Workers Party) Meeting Rotterdam, Amsterdam 1930, Dutch Confederation of Trade Unions. Image courtesy of the Museum Het Schip **48**

1.4.4 Fré Cohen, Calendar, Printing Office Amsterdam, 1929. Image courtesy of the Museum Het Schip **50**

1.4.5 Fré Cohen, Antisemitica bookplate, 1936. Image courtesy of the Museum Het Schip **52**

1.5.1 Ans van Zeijst, Sister Theofoor in her self-designed habit, photo by Ad Kon, circa 1965. Archive Ans van Zeijst, collection Beeld en Geluid, Catholic Documentation Centre, Radboud University Nijmegen, the Netherlands **57**

1.5.2 Ans van Zeijst, poster for the *Agrarische Afdeeling (Agricultural Department) Jaarbeurs*, 1941. Archive Ans van Zeijst, collection Beeld en Geluid, Catholic Documentation Centre, Radboud University Nijmegen, the Netherlands **60**

1.5.3 Ans van Zeijst, poster for Philips, 1941, signed "Ans van Zeyst." Archive Ans van Zeijst, collection Beeld en Geluid, Catholic Documentation Centre, Radboud University Nijmegen, the Netherlands **61**

1.5.4 Ans van Zeijst, photo of people looking at the *koppenserie* on an advertising kiosk in Amsterdam, circa 1949. Archive Ans van Zeijst, collection Beeld en Geluid, Catholic Documentation Centre, Radboud University Nijmegen, the Netherlands **63**

1.5.5 Ans van Zeijst, *Samen denken samen praten over het religieuze leven* (*Thinking Together Talking Together about Religious Life*) poster, 1964. Archive Ans van Zeijst, collection Beeld en Geluid, Catholic Documentation Centre, Radboud University Nijmegen, the Netherlands **65**

1.6.1 Maria Keil in her atelier located on Faial Street in Lisbon, Portugal, in the 1950s. Collection of Francisco Pires Keil do Amaral **71**

1.6.2 Maria Keil, an advertisement for Pompadour girdles, printed in several editions of *Panorama* magazine in 1941. Photo: Museu da Presidência da República-MPR/imagens de Luz **74**

1.6.3 *Left:* Maria Keil, commemorative stamp study for International Women's

Year, 1975. FPC/Museu das Comunicaões. Reproduction authorized by CTT. *Right: Stories from My Street*, written by Maria Cecília Correia with illustrations by Maria Keil. 1st ed. Lisbon, Portugália (D.L. 1953). Photo: Museu da Presidência da República–MPR/imagens de Luz **76**

1.6.4 Maria Keil, study for tile mural *The Sea*, 1956–58, in Avenida Infante Santo, Lisbon, Portugal. Museu Nacional do Azulejo Collection–MNAz. Photo: MNAz/DGPC **77**

1.6.5 Maria Keil, *Stars of the Paris Opera* program, presented at the Tivoli Theatre in November 1957. Museu Nacional do Teatro Collection – MNT (Inv. no. 148108). Photo: MNT/imagens de Luz/DGPC **78**

1.7.1 Saloua Raouda Choucair photographic portrait, 1995. Photo: Sueraya Shaheen. Courtesy of the Saloua Raouda Choucair Foundation **83**

1.7.2 Saloua Raouda Choucair, two book cover designs and layouts. *Left:* Thuraya Malhas, *Ab'ad al-Ma'arri*. Beirut: Sumayya Printing Press, 1962. *Right:* Thuraya Malhas, *Malhamat al-insan*. Harissa: Dar Shamali printing press, 1961. Courtesy of the Saloua Raouda Choucair Foundation **85**

1.7.3 Saloua Raouda Choucair, book cover design, and layout for Thuraya Malhas, *Qurban*. Beirut: Sader Rihani Printing Press, 1952. Courtesy of the Saloua Raouda Choucair Foundation **86**

1.7.4 Saloua Raouda Choucair, poster announcing the opening of her geometric abstract painting exhibition at the École des Lettres (Saint Joseph University) in Beirut, Lebanon. Courtesy of the Saloua Raouda Choucair Foundation **89**

1.7.5 Saloua Raouda Choucair, women's coat made of hand-woven goat wool on a traditional loom with natural dye color threads by Abu Jouhayna and the artisans in Kfarqatra, Shouf region, Lebanon, 1973. Courtesy of the Saloua Raouda Choucair Foundation **90**

1.8.1 Dorrit Dekk, 1951 newspaper cutting of Dorrit in front of her Festival of Britain work. Image courtesy of Dorrit Dekk Archive, University of Brighton Design Archives **95**

1.8.2 Dorrit Dekk, *Staggered Holidays* poster created for the Centre of Information (COI) circa 1946–48. The National Archives UK **97**

1.8.3 Dorrit Dekk, self-promotional letter on her letterhead depicting Dorrit the artist, the saleswoman, and on holiday, circa 1954. Image courtesy of Dorrit Dekk Archive, University of Brighton Design Archives **100**

1.8.4 Dorrit Dekk, *We Londoners* poster for London Transport, 1961. Image courtesy of London Transport Museum Archive **101**

1.8.5 Dorrit Dekk, one of a series of five illustrations drawn for Tender Co. T-shirt range, 2010. Image courtesy of William Kroll **104**

1.9.1 Roswitha Bitterlich, photographic portrait, January 1, 1935. Photo: Max Hayek. Image courtesy of Österreichische Nationalbibliothek **109**

1.9.2 Roswitha Bitterlich, illustration for the book *Schwarz-Weiss-Kunst* (*Black and White Art*), Innsbruck, Leipzig: Felician Rauch, 1936. Image courtesy of @ Roswitha Bitterlich **112**

1.9.3 Roswitha Bitterlich, illustration for the cover of the book *Eulenspiegel*, Stuttgart: Cotta, 1941. Image courtesy of @ Roswitha Bitterlich **113**

1.9.4 Roswitha Bitterlich, illustration for the tale *Thumbelina* for the Brazilian edition of the book *Andersen's Fairy Tales*, Livraria do Globo, 1958–61. Image courtesy of @ Roswitha Bitterlich **116**

1.9.5 Roswitha Bitterlich, full-page illustration and drop caps for the Brazilian edition of the book *Grimm's Fairy Tales*, Livraria do Globo, 1970. Image courtesy of @ Roswitha Bitterlich **117**

2.1.1 Anita Klinz at work in the office of the Mondadori artistic department, n.d. Courtesy of Arnoldo and Alberto Mondadori Foundation, Anita Klinz Archive **133**

2.1.2 Anita Klinz, four book jackets from the sixteen-volume series *I Maestri dell'Architettura Contemporanea* (*Masters of Contemporary Architecture*), Il Saggiatore, 1960–64. Courtesy of Arnoldo and Alberto Mondadori Foundation, Il Saggiatore Historical Library **135**

2.1.3 Anita Klinz, cover of *Genghis-Khan*, Mondadori, 1962. Courtesy of Arnoldo and Alberto Mondadori Foundation, Mondadori Historical Library **136**

2.1.4 Anita Klinz and Pater Gogel, four covers from the *Enciclopedia dei Ragazzi*, Mondadori, 1966. Courtesy of Arnoldo and Alberto Mondadori Foundation, Mondadori Historical Library **138**

2.1.5 Anita Klinz, cover of *L'Impero Americano* (*The American Empire*), Il Saggiatore, 1969. Courtesy of Arnoldo and Alberto Mondadori Foundation, Il Saggiatore Historical Library **139**

2.2.1 Jacqueline S. Casey photographed on the MIT campus, Cambridge 1985. Photo: Marie Cosindas. Image courtesy of Marie Cosindas **143**

2.2.2 Jacqueline S. Casey, poster for *Faculty-Student Exchange Program*, 1972, MIT Faculty-Student Exchange Program. Jacqueline S. Casey Collection. Courtesy of Massachusetts College of Art and Design Archives **148**

2.2.3 Jacqueline S. Casey, poster for the MIT art exhibition *Body Language: Figurative Aspects of*

Recent Art, 1981, for the MIT Committee on the Visual Arts, Hayden Gallery. Jacqueline S. Casey Collection. Courtesy of Massachusetts College of Art and Design Archives **149**

2.2.4　Jacqueline S. Casey, poster *RUSSIA/USA Peace* 1985, commissioned by the Shoshin Society to commemorate the 40th anniversary of the bombing of Hiroshima. Jacqueline S. Casey Collection. Courtesy of Massachusetts College of Art and Design Archives **150**

2.2.5　Jacqueline S. Casey, exhibition poster for *Intimate Architecture: Contemporary Clothing Design*, 1982, for the MIT Committee on the Visual Arts, Hayden Gallery. Jacqueline S. Casey Collection. Courtesy of Massachusetts College of Art and Design Archives **151**

2.3.1　Lora Lamm photographed at the Salto bookshop in Milan, Italy, circa 1960. Image courtesy of AIAP CDPG **157**

2.3.2　Lora Lamm, *Arredate la vostra casa d'estate* poster for La Rinascente, 1956. © Zurich University of the Arts/Museum of Design Zurich **159**

2.3.3　Lora Lamm, lR *Occasioni per le vacanze* poster for La Rinascente, 1959. © Zurich University of the Arts/Museum of Design Zurich/poster collection **161**

2.3.4　*Left:* Lora Lamm, *Pirelli tires for bicycles* poster, 1960. *Right:* Lora Lamm, *Pirelli for scooter* poster, 1960. Images courtesy of AIAP CDPG **163**

2.3.5　Lora Lamm, *Cynar aperitivo* poster, 1974. © Zurich University of the Arts/Museum of Design Zurich/poster collection **166**

2.4.1　Claudia Morgagni, portrait. Photo: Davide Cerati, ITSOS, 1979. Image courtesy of AIAP CDPG **171**

2.4.2　*Left:* Claudia Morgagni, Santagostino advertisement, 1955–56. *Right:* Claudia Morgagni, Esso Extra Motor Oil poster, 1956. Images courtesy of AIAP CDPG **175**

2.4.3　*Left:* Claudia Morgagni, *Lanerossi* house organ cover, January 1960. *Right*: *Lanerossi* house organ cover, February–March 1960. Images courtesy of AIAP CDPG **176**

2.4.4　*Left:* Claudia Morgagni, *Ceramiques Sanitaire* poster, 1963. *Right:* Claudia Morgagni, Pellizzari cover, 1967. Images courtesy of AIAP CDPG **177**

2.4.5　Claudia Morgagni, CIBA Pharmaceuticals cover, 1972. Image courtesy of AIAP CDPG **178**

2.5.1　Nelly Rudin photographed in her Graphic Design Studio in Zurich in 1958. Photo: Klaus Zaugg. © Eredi Zaugg—Regione Lombardia/Museo di Fotografia

 Contemporanea, Milano-Cinisello Balsamo. Image provided by Zürcher Hochschule der Künste Archive **183**
2.5.2 Nelly Rudin, poster for *SAFFA* (*Swiss Exhibition for Women's Work*) held in Zurich, Switzerland, 1958. © Nelly Rudin Stiftung c/o Prolitteris, Zürich **184**
2.5.3 Nelly Rudin, advertisement for the packaging company L+C (lithography + cardboard packaging), 1954/55. Photo: Serge Libiszewski. © Nelly Rudin Stiftung c/o Prolitteris, Zürich **186**
2.5.4 *Top:* Nelly Rudin, advertising card for Synopen, an allergy medication, J.R. Geigy AG, Basel, CH, designed for Studio Müller-Brockmann, 1953–54. *Bottom:* Nelly Rudin, advertising card for Insidon, a mood-enhancer medication, J.R. Geigy AG, Basel, CH, circa 1962. © Nelly Rudin Stiftung c/o Prolitteris, Zürich **187**
2.5.5 Nelly Rudin, poster for her second solo exhibition in 1969 at the Kleine Galerie in Zurich, Switzerland. Image provided by Museum für Gestaltung Zürich.© Nelly Rudin Stiftung c/o Prolitteris, Zürich **189**
2.6.1 Dorothea Hofmann, photographic portrait, 2002. Photo: Melchior Imboden. Image courtesy of Melchior Imboden, Switzerland **193**
2.6.2 Dorothea Hofmann, class project for a poster competition, *Swiss youth music community*, 1953 (*Schweizerische Jugendmusikgemeinde*, 1953). Image courtesy of Matthias Hofmann **196**
2.6.3 Dorothea Hofmann, *Beginning of Film Art* poster for the Trade Museum, Basel, 1963. Image courtesy of Matthias Hofmann **196**
2.6.4 *Top:* Dorothea Hofmann, charcoal drawing of the Indian temple, Mandu, 1964. *Bottom:* Dorothea Hofmann, charcoal drawing of the Indian temple, Surkhej, 1964. Image courtesy of Matthias Hofmann **199**
2.6.5 *Left:* Dorothea Hofmann, *Stone III*, 1991. *Right:* Dorothea Hofmann, *Stone 6*, 1991. Images courtesy of Matthias Hofmann **201**
2.7.1 Karmele Leizaola photographed at Tipografía Vargas, circa 1950. Image courtesy of Faride Mereb **205**
2.7.2 Karmele Leizaola, spread for *Élite* magazine, circa mid-1950s. Photo: Carlos Alfredo Marín. From the National Library of Venezuela archive. Image courtesy of Faride Mereb **207**
2.7.3 Karmele Leizaola, cover for *A.D.* (*Acción Democrática*), Julio 26, 1958, No. 12. Photo: Carlos Alfredo Marín. From the National Library of Venezuela archive. Image courtesy of Faride Mereb **208**

2.7.4 Karmele Leizaola, double-page spread for *Imagen* magazine, circa 1967. Photo by Gabriela Navarro. Karmele Leizaola personal archive. Image courtesy of Faride Mereb **209**

2.7.5 Karmele Leizaola, spread for *Venezuela* magazine, circa 1990s. Photo: Carlos Alfredo Marín. From the National Library of Venezuela archive. Image courtesy of Faride Mereb **211**

2.8.1 Gülümser Aral Üretmen, photographic portrait, circa 1950s. Courtesy of the Ömer Durmaz Archive **215**

2.8.2 Gülümser Aral Üretmen, two poster designs for Denizyolları, circa 1950s. Courtesy of the Ömer Durmaz Archive **219**

2.8.3 Gülümser Aral Üretmen, 1953–54 price list cover for Denizyolları. Courtesy of the Ömer Durmaz Archive **221**

2.8.4 Gülümser Aral Üretmen, poster design that won an award in the Garanti Bank Poster Competition, 1952. Courtesy of the Ömer Durmaz Archive **223**

2.9.1 Tomoko J. Miho, formal graduation portrait, 1956. Photo: Toyo Miyatake Studio. Image courtesy of the RIT Cary Graphic Design Archive, Tomoko Miho collection **227**

2.9.2 Herman Miller price list and 7 product brochures with black cardboard slipcase, 1962. Image courtesy of Herman Miller Archives **231**

2.9.3 Herman Miller Design product specification catalog binder and spreads, 1964. Images courtesy of Herman Miller Archives **233**

2.9.4 Tomoko Miho, three folding envelopes for product inserts for Jack Lenor Larsen, n.d. Photo: Elizabeth Resnick. Images courtesy of the RIT Cary Graphic Design Archive, Tomoko Miho collection **235**

2.9.5 Tomoko Miho, logo and poster to introduce a new name and identity for Omniplan Architects, Dallas, Texas, 1970. Photo: Elizabeth Resnick. Images courtesy of the RIT Cary Graphic Design Archive, Tomoko Miho collection **236**

2.10.1 Anneliese Ernst, photographic portrait, circa 1980. © Photo by Hans-Eberhard Ernst **243**

2.10.2 Anneliese Ernst, TV title graphic for a film about the Angara River, 1983. © Anneliese Ernst **246**

2.10.3 Anneliese Ernst, film poster for *The Last Empress* by director Chen Jialin, 1989. © Anneliese Ernst **247**

2.10.4 Anneliese Ernst, poster competition entry for Protestant Church Day, 1989. © Anneliese Ernst **250**

2.10.5 Anneliese Ernst, draft for the Lower Oder Valley National Park logo, 1993. © Anneliese Ernst **251**

2.11.1 Dolly Sahiar photographed by her colleague, Behroze J. Bilimoria, at *Marg*. Image courtesy of Behroze J. Bilimoria **255**

2.11.2 *Top:* Dolly Sahiar, vertically cropped, colored, translucent paper section break in a *Marg* issue on contemporary Indian architecture. From "Reflections on the House, the Stupa, the Temple, the Mosque, the Mausoleum, and the Town Plan from the Earliest Times till Today (Being Notes on the Social and Spatial Imagination in Indian Architecture)," by Mulk Raj Anand, *Marg*, Vol. 17, Issue 1, December 1963, pg. 41. *Bottom:* Playful artwork placement within columns, below text, and in the margins in an issue of *Marg* on Rabindranath Tagore. From "Paintings of Rabindranath Tagore," by Mulk Raj Anand, *Marg*, Vol. 14, Issue 2, March 1961, pgs. 6–7. Courtesy of the Knowledge Management Centre, National Institute of Design, Ahmedabad, India **258**

2.11.3 *Top:* Dolly Sahiar, spread of images in *Marg's Contemporary World Sculpture* issue in which brown handmade paper holding text is bound into the issue. *Bottom:* Dolly Sahiar, spread with a rust-colored handmade paper insert. From "Preliminary: The Contemporaries," by Mulk Raj Anand, *Marg*, Vol. 21, Issue 2, March 1968, pgs. 18–21. Courtesy of the Knowledge Management Centre, National Institute of Design, Ahmedabad, India **260**

2.11.4 Dolly Sahiar designed this elaborate gatefold for an issue of *Marg* titled *Treasures of Everyday Art—Raja Dinkar Kelkar Museum*, Vol. 31, Issue 3, June 1978. Courtesy of the Knowledge Management Centre, National Institute of Design, Ahmedabad, India **261**

2.11.5 Dolly Sahiar, gatefold illustrating an elaborately painted banner on cloth in *Homage to Kalamkari*, published by *Marg* Publications in 1979. From "Painted Banners on Cloth: Vividha-tirtha-pata of Ahmedabad," by Shridhar Andhare, *Marg*, Vol. 31, Issue 4, April 1979, pg. 41. Courtesy of the Knowledge Management Centre, National Institute of Design, Ahmedabad, India **262**

2.12.1 Odiléa Toscano photographed inside the Romi-Isetta, circa mid-1950s FAU USP. Photo: João Xavier. Collection of Odiléa Toscano **267**

2.12.2 Odiléa Toscano, book cover for the collection *Jovens do Mundo Todo* (1960–61). Photo: Sara Goldchmit. Collection of Odiléa Toscano **269**

2.12.3 Odiléa Toscano, illustration for the *Bondinho* magazine, circa 1970. Photo: Sara Goldchmit. Collection of Odiléa Toscano **271**

2.12.4 *Top:* Odiléa Toscano, mural in Largo 13 de Maio station, 1986. *Bottom:* Odiléa Toscano, Mural in Paraíso station, 1991. Collection of Odiléa Toscano **272**

2.13.1 Thérèse Moll, photographed in Basel, Switzerland, circa 1953. Photo: Karl Gerstner. Courtesy of the Karl Gerstner Archive **277**

2.13.2 Thérèse Moll, black and white exercises for a course taught by Armin Hofmann, Allgemeine Gewerbeschule, Basel, Switzerland, 1950–51. Images courtesy of Armin and Dorothea Hofmann **278**

2.13.3 Thérèse Moll, package design for Broxi, a detergent made by BP Petroleum, Atelier Karl Gerstner, Basel, Switzerland, 1954–57. Image courtesy of Armin and Dorothea Hofmann **280**

2.13.4 Thérèse Moll, Prospectus front cover for Micoren, a respiratory and circulatory stimulant, J.R. Geigy A. G., Basel, Switzerland 1958. Image courtesy of Armin and Dorothea Hofmann **282**

2.13.5 Thérèse Moll, front cover for "Aesthetics of Surfaces," summer session pamphlet, MIT Office of Publications, Massachusetts Institute of Technology, Cambridge, Massachusetts, 1959. Image courtesy of Armin and Dorothea Hofmann **283**

2.14.1 Eiko Emori, photographic portrait circa 1974. Photograph by Keiichi Okura, Tokyo, Japan. Image courtesy of Eiko Emori **289**

2.14.2 Eiko Emori, Arthur Ransome Series, Vol. 7, "Didn't Mean to Go to Sea," November 1967, published by Iwanami Shoten. Image courtesy of Eiko Emori **292**

2.14.3 Eiko Emori, cover, *Perspecta: The Yale Architectural Journal*, Vol. 8, New Haven: School of Art and Architecture of Yale University, Image courtesy of Eiko Emori **294**

2.14.4 Eiko Emori, cover, *Donald Judd: A Catalogue of the Exhibition at the National Gallery of Canada*, May 24–July 6, 1975. Image courtesy of Eiko Emori **296**

2.14.5 Eiko Emori, cover, and pg. 33, *Inuktitut* magazine, Issue #72, 1990, published by Inuit Tapirisat of Canada. Image courtesy of Eiko Emori **299**

2.15.1 Dorothy E. Hayes, photographic portrait. Image courtesy of Dorothy's Door/Carol Lauretta George **303**

2.15.2 *Left:* Dorothy E. Hayes, *Color is a State of Mind*, "Black and White: A Portfolio of 40 Statements on a Single Theme," a special *Print* magazine issue, July/August 1969. *Right:* Dorothy E. Hayes logotype, circa 1970. Images courtesy of Dorothy's Door/Carol Lauretta George **306**

2.15.3 Dorothy E. Hayes, "Type Talks" postcard for the Advertising Typographers Association of America, January/February 1965. Image courtesy of Dorothy's Door/Carol Lauretta George **307**

2.15.4　Dorothy E. Hayes, logotype for Charles J. Dorkins, a film producer, n.d. Image courtesy of Dorothy's Door/Carol Lauretta George **309**

2.15.5　Dorothy E. Hayes, "Francesca," a typographic design that plays with repetition and creates pattern, texture, and symmetry, n.d. Image courtesy of Dorothy's Door/Carol Lauretta George **310**

2.16.1　Agni Katzouraki, photographic portrait, August, 2023. Image courtesy of Agni Katzouraki **313**

2.16.2　*Left:* Agni Katzouraki, poster for Mobil Oil, circa 1960s. *Right:* Agni Katzouraki, package design for El Greco Toys, 1968. Images courtesy of Agni Katzouraki **315**

2.16.3　Agni Katzouraki, poster for a dance performance by Martha Graham, 1962. Image courtesy of Agni Katzouraki **318**

2.16.4　Agni Katzouraki, design for an advertisement for Stratigiou swimming costumes, 1967. Photo: N. Mavrogenis. Image courtesy of Agni Katzouraki **320**

2.17.1　Bonnie MacLean signing posters for the Hall & Oates concert at the opening of the Philadelphia Fillmore in 2015. Her son, David Graham, is standing behind her. Photo: © Michael Morsch. Image courtesy of Michael Morsch **325**

2.17.2　Bill Graham standing in front of the Fillmore announcement board for the Blues Project, Mothers and Canned Heat Blues Band, February 17–19, 1967, painted by Bonnie MacLean. Photo: © Jim Marshall Photography LLC **328**

2.17.3　Bonnie MacLean, concert poster for The Yardbirds, The Doors, James Cotton Blues Band, Richie Havens, July 25–30, 1967 (BG75). © Bill Graham Archives LLC **330**

2.17.4　Bonnie MacLean, concert poster for Eric Burdon and The Animals, Mother Earth, Hour Glass, October 19–21, 1967 (BG89). © Bill Graham Archives LLC **331**

3.1.1　Eulindra Lim, photograph, circa 1972. Photographer unknown **347**

3.1.2　Eulindra Lim, page from a brochure with the Fidgi Perfume counter showcard (above) and the logo for the Sixth Asian Advertising Congress (below). Image courtesy of Singapore Graphic Archives **350**

3.1.3　Cover for *A Concise Guide to Hand-Made Oriental Carpets* featuring the logo for Oriental Carpets. Eulindra Lim likely designed both the logo and the cover. Image courtesy of Singapore Graphic Archives **351**

3.1.4　*Left*: A luggage tag for Hotel Bali Beach circa 1970s, likely designed by Eulindra Lim. Image courtesy of Singapore Graphic Archives. *Right*: PUB logo designed by Eulindra Lim, 1977. Image courtesy of PUB, Singapore's National Water Agency **352**

3.1.5　Eulindra Lim, brochure for The Ming Court Hotel, circa 1970.

Image courtesy of Singapore Graphic Archives **354**

3.2.1 Elizabeth Fitz-Simon, photographed in 1977. Image courtesy of Elizabeth Fitz-Simon **359**

3.2.2 Elizabeth Fitz-Simon, *Drink Metric* poster for the *Think Metric* campaign, 1967. Credit: the Construction Industry Training Board. Image courtesy of Elizabeth Fitz-Simon **362**

3.2.3 Elizabeth Fitz-Simon, *Eirebus* bus, and identity, photographed outside Kilkenny Design Workshops, 1973. Credit: Eirebus. Image courtesy of Elizabeth Fitz-Simon **365**

3.2.4 Elizabeth Fitz-Simon, cover of *Ireland Today*, May 1977. Credit: The National Film Studios of Ireland (photograph) and reproduced with permission of the Irish Department of Foreign Affairs. Image courtesy of Elizabeth Fitz-Simon **367**

3.2.5 Elizabeth Fitz-Simon, *ROSC '77* poster, 1977. Credit: collage by Patrick Scott. Image courtesy of Elizabeth Fitz-Simon **368**

3.3.1 Anna Monika Jost photographed in her Paris home, 2023. Photo by Rudi Meyer. © Rudi Meyer **373**

3.3.2 Anna Monika Jost, poster for the *Olivetti Innovates* exhibition held in Hong Kong, City Hall, October 19–25, 1966. Courtesy of Associazione Archivio Storico Olivetti, Ivrea **376**

3.3.3 Anna Monika Jost, poster designed for the advertising agency Reiwald, *Con Fiat verso gli anni 70* (*With Fiat Towards the 1970s*) for a Swiss Fiat dealership based in Ticino, 1970. Courtesy of Anna Monika Jost **378**

3.3.4 *AIDS. It's Time for Schools to Act* poster designed by Anna Monika Jost and Jean Francis Chériez for the UNESCO campaign on World AIDS Day, December 1, 1993. © Zurich University of the Arts/Museum of Design Zurich/poster collection **381**

3.3.5 Anna Monika Jost, cover and frontispiece of the monographic issue no. 9–10 of the scientific journal *Technè*, dedicated to color and perception, for C2RMF, the Centre for Research and Restoration of Museums of France, 1999. Photo by Niccolò Quaresima. Courtesy of Anna Monika Jost **382**

3.4.1 EKH Partners, group portrait, 1993. *Left to right:* Myriam Kin-Yee, Alison Hulett, and Anna Eymont. Courtesy of Myriam Kin-Yee on behalf of EKH **387**

3.4.2 EKH, logo designed for Optus, the second-largest telecommunications company in Australia, 1993. Courtesy of Myriam Kin-Yee on behalf of EKH **390**

3.4.3 EKH, poster for the Australian National Maritime Museum commemorating two centuries of maritime contact between the United States and Australia, 1991.

	Courtesy of Myriam Kin-Yee on behalf of EKH **393**		Image courtesy of Mahnoosh Moshiri **411**
3.4.4	EKH, *Sex Discrimination Book*, 1990, *Insurance and the Sex Discrimination Act 1984*, book cover for the Human Rights Commission. Courtesy of Myriam Kin-Yee on behalf of EKH **395**	3.6.2	Mahnoosh Moshiri, illustration for a *Tamasha* magazine cover on Artour Maimane, 1974. Image courtesy of Mahnoosh Moshiri **414**
3.5.1	Trish de Villiers, photographed in Cape Town, South Africa, circa 1985. Photographer unknown. Image courtesy of Trish de Villiers **399**	3.6.3	Mahnoosh Moshiri, poster design for Shakespeare's play, *Hamlet*, 1977. Image courtesy of Mahnoosh Moshiri **415**
3.5.2	Trish de Villiers, CAP, poster design for COSATU, Cape Town, South Africa, 1988. Image courtesy of Trish de Villiers, ASAI, and UWC RIM Mayibuye Archives **401**	3.6.4	Mahnoosh Moshiri, two pages from the 1980 illustrated love story, *Khosrow and Shirin*. Images courtesy of Mahnoosh Moshiri **417**
3.5.3	*Left:* Trish de Villiers, *The Madwoman of Chaillot*, theater poster design for UCT Little Theatre, Cape Town, South Africa, 1985. *Right:* Trish de Villiers, *The Great South African Circus*, theater poster design for CAP Theatre Group, Cape Town, South Africa, 1985. Images courtesy of Trish de Villiers, ASAI, and UWC RIM Mayibuye Archives **406**	3.6.5	Mahnoosh Moshiri, portrait of Qamar-ol-Moluk Vaziri from *Daughters of Cyrus* project, 2022. Image courtesy of Mahnoosh Moshiri **420**
		3.7.1	Arlette Haddad photographed in London. Image courtesy of Arlette Haddad **425**
		3.7.2	*Left:* Arlette Haddad, Arabic Borders, Letraset instant lettering, London, 1981. *Right:* Decorative Kufic No. 2, Letraset instant lettering, London, 1982. Images courtesy of Arlette Haddad **427**
3.5.4	Trish de Villiers, *Your Own Thing*, theater poster design for UCT Little Theatre, Cape Town, South Africa, 1984. Image courtesy of Trish de Villiers, ASAI, and UWC RIM Mayibuye Archives **407**	3.7.3	*Left:* Arlette Haddad, Antarat, Letraset instant lettering, London, 1984. *Right:* Arlette Haddad, Marco Polo, Letraset instant lettering, London, 1984. Images courtesy of Arlette Haddad **428**
3.6.1	Mahnoosh Moshiri photographed in 2020. Photo by Alireza Fani.	3.7.4	*Left:* Arlette Haddad, Daniel Chrome, Letraset instant lettering, London, 1986. *Right:* Kufic

Display, Letraset instant lettering, London, 1986. Images courtesy of Arlette Haddad **430**

3.8.1 Farideh Shahbazi photographed in her office in Tehran, Iran, 2023. Photo: Mehrdokht Darabi. Image courtesy of Mehrdokht Darabi **435**

3.8.2 Farideh Shahbazi, *Persian Motifs* books: Vol. 1, 1996 and Vol. 2, 2015. Image courtesy of Farideh Shahbazi **436**

3.8.3 Farideh Shahbazi designed city-themed notebooks stacked (*left*) and one notebook spread (*right*). Cities: Tehran, Shiraz, Tabriz, Isfahan, Yazd, and Gilan. Photo: Mehrdokht Darabi. Images courtesy of Mehrdokht Darabi **437**

3.8.4 Farideh Shahbazi, two *Soroush* magazine covers. *Left:* July 1991; *Right:* October 1992. Images courtesy of Farideh Shahbazi **440**

3.8.5 Farideh Shahbazi, logo design for various companies. Image courtesy of Farideh Shahbazi **443**

3.9.1 Polly Bertram, photographic portrait. In the background is a poster designed by Polly Bertram for the exhibition *Auslandateliers Stipendien Ankäufe Stadt Zürich* (*Acquisitions of the City of Zurich from the foreign artist's grant program*), held in Zurich, Helmhaus, April 5–28, 1991. Photo by Jul Keyser. © Jul Keyser **447**

3.9.2 Polly Bertram and Daniel Volkart (with photographs by Cristina Zilioli), poster for the Swiss premiere of the play *Die Oper vom großen Hohngelächter* (from *The Beggar's Opera* by John Gay), by Dario Fo, Theater am Neumarkt, Zurich, on April 27, 1984. © Zürcher Hochschule der Künste/Museum für Gestaltung Zürich/Plakatsammlung **449**

3.9.3 Polly Bertram and Daniel Volkart, exhibition poster for *Wissenschaftliches Zeichnen* (*Scientific Drawings*), Museum für Gestaltung Zürich, August 29–October 14, 1990. © Zürcher Hochschule der Künste/Museum für Gestaltung Zürich/Plakatsammlung **451**

3.9.4 Polly Bertram and Daniel Volkart, exhibition poster for *Schweizerwelt: Plakate aus der Sammlung* (*Swiss World: Posters from the Collection*), Museum für Gestaltung Zürich, July 10–August 25, 1991. © Zürcher Hochschule der Künste/Museum für Gestaltung Zürich/Plakatsammlung **452**

3.9.5 *Emigre* magazine, no. 14 (1990), cover and double pages featuring a twenty-four-page visual essay by Richard Feurer, Peter Bäder, Polly Bertram & Daniel Volkart, Roland Fischbacher, Margit Kastl-Lustenberger, and Daniel Zehntner. Photo by Niccolò Quaresima. Courtesy of Polly Bertram **454**

3.10.1 Sylvia Harris, photographic portrait. Photo: George Larkins. Image Courtesy of George Larkins **459**

3.10.2 Sylvia Harris, 2000 US Census materials. Image courtesy of Gary Singer **462**

3.10.3 Sylvia Harris presenting work. Image courtesy of Gary Singer **465**

3.10.4 Sylvia Harris, "Who Owns Cultural Imagery?" The Property Issue, *AIGA Journal of Graphic Design*, Vol. 14, No. 1, 1996, edited by Sylvia Harris and Steven Heller. Image courtesy of Michele Y. Washington **466**

3.10.5 Sylvia Harris, *Voting by Design* poster 2003. Client: University of Minnesota Design Institute. Image courtesy of Gary Singer **467**

3.11.1 Kyungja Keum photographed working at her desk. Image courtesy of Kyungja Keum **473**

3.11.2 Kyungja Keum, cover, and table of contents, *Monthly Job Placement*, Vol. 7, No. 12, December 1979. Image courtesy of Kyungja Keum **475**

3.11.3 Kyungja Keum, spreads from the article "Pass or Fail: The Glory and Defeat in Interviews! From the Basics of Interviews to Model Answers—Part 2," *Monthly Job Placement*, Vol. 7, No. 12, December 1979. Image courtesy of Kyungja Keum **477**

3.11.4 Kyungja Keum, *Hometopia* cover and a spread from the article, "Barbecue Lunch in Summer," Vol. 2, No. 6, June 1989. Image courtesy of Kyungja Keum **479**

3.11.5 Kyungja Keum, spread from the article, "Oh! It's Raining," *Hometopia*, Vol. 2, No. 6, June 1989. Image courtesy of Kyungja Keum **481**

3.12.1 Winnie Wai-kan Kwan, 2014. Photo: Kam Lan Chow. Image courtesy of Winnie Wai-kan Kwan and The Hong Kong Museum of Art **485**

3.12.2 Winnie Wai-kan Kwan, poster design for *Cheung Yee: Sculptures, Prints, Drawings*, The Hong Kong Museum of Art, Hong Kong, 1978. Image courtesy of Winnie Wai-kan Kwan and The Hong Kong Museum of Art **488**

3.12.3 Winnie Wai-kan Kwan, poster design for the exhibition catalog, *Hong Kong Design Exhibition 1984*, The Hong Kong Museum of Art, the Urban Council, and the Hong Kong Designers Association, Hong Kong, 1984. Image courtesy of Winnie Wai-kan Kwan and The Hong Kong Museum of Art **489**

3.12.4 Winnie Wai-kan Kwan, catalog design for *The Art of Xie Zhiliu and Chen Peiqiu*, The Hong Kong Museum of Art, Hong Kong, 1998. Image courtesy of Winnie Wai-kan Kwan and The Hong Kong Museum of Art **490**

3.12.5 Winnie Wai-kan Kwan, exhibition design for Tsz Shan Monastery Buddhist Art Museum, Li Ka Shing Foundation, Hong Kong, 2019. Image courtesy of Winnie Wai-kan Kwan and The Hong Kong Museum of Art **495**

3.13.1 Elisabetta Ognibene, self-portrait, Modena 2023. © Elisabetta

Ognibene. Image courtesy of Elisabetta Ognibene **499**

3.13.2 Elisabetta Ognibene, poster *Stardust Memories: Immagini, parole, musiche dei divi di ogni tempo*, The Graphic Design Office of the Municipality of Modena, 1981. © Elisabetta Ognibene. Image courtesy of Elisabetta Ognibene **504**

3.13.3 Elisabetta Ognibene, *Olivetti SMAU exhibition stand*, Olivetti Image Office, Milano, 1985. © Elisabetta Ognibene. Image courtesy of Elisabetta Ognibene **505**

3.13.4 Elisabetta Ognibene/Kennedy's Studios, flyer *Rap&Show!*, FGCI, Modena, 1983. © Elisabetta Ognibene/Kennedy's Studios. Image courtesy of Elisabetta Ognibene **506**

3.13.5 Elisabetta Ognibene/Avenida, corporate identity for Libera, 1994–2015. © Elisabetta Ognibene/Avenida. Image courtesy of Elisabetta Ognibene **508**

3.14.1 Mara de Oliveira, photographed in her home studio, 2022. Photo: Myriam Esteves (MEI). Image courtesy of Myriam Esteves **511**

3.14.2 Mara de Oliveira, complete set of *Materia Sensible* magazines designed for the Foto Club Uruguayo. Photo: Myriam Esteves (MEI). Image courtesy of Mara de Oliveira **514**

3.14.3 Mara de Oliveira, *Culturas*, *El Observador*'s weekly supplement designed with Lucio Ornstein. Photo: Myriam Esteves (MEI). Image courtesy of Mara de Oliveira **515**

3.14.4 *Left:* Mara de Oliveira reviewing a copy of the Collection of Uruguayan Classics. *Right:* title page whose cover is purely typographical with hierarchical color on a white background. Photo: Myriam Esteves (MEI). Image courtesy of Mara de Oliveira **516**

3.14.5 Mara de Oliveira, *Cultura en Plantas* magazine, designed with the support of her colleagues from the newspaper, collaborating on the writing, photography, illustration, and part of the distribution. Photo: Myriam Esteves (MEI). Image courtesy of Mara de Oliveira **517**

3.15.1 Marjaana Virta, photographed in 1993 with fabric from her textile line "Mediatext" for Marimekko. Photo: Markku Niskanen/Journalistinen kuva arkisto (Press Photo Archive). Image courtesy of Markku Niskanen **525**

3.15.2 Marjaana Virta, two book covers for Finnish author Leena Krohn: *Matemaattisia olioita ja jaettuja unia* (WSOY 1992), and *Kynä ja kone* (WSOY 1996). Photo: Maarit Bau Mustonen. Image courtesy of Marjaana Virta **527**

3.15.3 Marjaana Virta, two layout spreads for *Imagologies* by Esa Saarinen and Mark C. Taylor, Routledge 1994. Photo: Maarit Bau Mustonen. Image courtesy of Marjaana Virta **530**

3.15.4 Marjaana Virta, two layout spreads for *Filosofia* by Esa Saarinen (WSOY 1994). Photo: Maarit Bau Mustonen. Image courtesy of Marjaana Virta **531**

3.16.1 Sujata Keshavan, portrait, 2023. Image courtesy of Sujata Keshavan **535**

3.16.2 Sujata Keshavan, poster for the Center for Contemporary Art, Ray+Keshavan, 1990. Image courtesy of Sujata Keshavan **540**

3.16.3 Sujata Keshavan, identity for J&K Bank (Jammu and Kashmir Bank), Ray+Keshavan, 2006. Image courtesy of Sujata Keshavan **541**

3.16.4 Sujata Keshavan, identity for Kotak Mahindra Finance Bank, Ray+Keshavan, 2010. Image courtesy of Sujata Keshavan **542**

3.16.5 Sujata Keshavan, identity for Vistara Airlines, Ray+Keshavan, 2014. Image courtesy of Sujata Keshavan **544**

PREFACE

Elizabeth Resnick

Women Graphic Designers is an anthology of illustrated stories exploring the resilient and determined lives of forty-two women graphic designers—from Europe, Asia, North America, South America, South Africa, and Australia—who worked professionally during the twentieth century.

Why is it important to tell these stories? Women's contributions to graphic design, like in many fields, have often been overlooked or forgotten. Telling their stories ensures their impact is acknowledged and preserved for future generations. It also helps to build a more comprehensive and accurate historical record of the graphic design profession. It contributes to breaking down barriers and reshaping the narrative around who can be successful in the field of graphic design. Stories have a universal appeal that transcends cultural and linguistic boundaries. Stories can evoke emotions and create a sense of empathy, fostering a deeper understanding of the historical challenges women faced as they navigated through impediments such as reinforced stereotypes and preconceived notions about gender roles. Simply put, stories have the power to inspire and motivate. When individuals hear about the challenges and triumphs of others, it can fuel their own aspirations and motivate them to overcome obstacles.

Women Graphic Designers recounts compelling stories that illuminate human perseverance, tenacity, and creativity. Told by a cohort of dedicated international design scholars,[1] each story weaves the disparate threads from rigorous research, unpublished and published first- and second-person encounters, and interviews, when available, with the subjects.[2] Each story unfolds through a chronological order of biographical and autobiographical events, revealing the invisible and making it visible—a pathway for fostering understanding and empathy between people from diverse cultural backgrounds.

The Plight of Women in the Twentieth Century

Women graphic designers—born in the late nineteenth and early twentieth centuries—have been routinely overlooked or overshadowed in a design history of predominantly "heroic male modernist practitioners." They are absent from design history surveys primarily because their work was frequently marginalized, credited to their male colleagues, or not recorded or archived. The workforce has traditionally been organized around patriarchal[3] structures, with men typically occupying higher-paying and more influential positions. Women were undervalued assets, paid less than their male counterparts, or relegated to lower-paying jobs simply because of their gender.

In the early twentieth century, women faced considerable barriers—they could not own property and had no right to vote or hold a government position. Design education and training were barred to many women as the expectations of traditional duty—raising children, cooking, and cleaning the house—were considered a woman's burden. The first wave of feminism[4] in Western societies gradually softened these ingrained attitudes; however, it still took remarkably determined women to succeed within the relentlessly patriarchal structure of society. The advent of the Second World War created employment opportunities for female designers to showcase their capabilities and prove what they could do while the men were at war. Still, the societal expectation was that women would give up their wartime employment and return to their "traditional" homemaking and child-rearing roles when the men returned.[5] There were even accusations that women who worked outside the home were taking the jobs away from men with families to support. Despite these challenges, the war had a lasting impact on the perception of women in the workforce.

The postwar decades from the mid-1940s to 1970 were driven by intensive and rapid economic modernization, resulting in more professional opportunities for women and expanded professional training. It was a time of increased consumer demand for goods and services. Growing awareness of women's influence on family purchases motivated many companies to employ female designers to boost their sales. Sadly, these decisions were motivated by commercial goals rather than equal employment advocacy. But with significant developments in design education, print technology, and the emergence of professional organizations, the stage was set for a new era in graphic design, one based on merit and talent rather than gender.

Yet, the struggle of being female in a male-dominated industry meant that many women went above and beyond their male counterparts' expectations to keep their positions, often sacrificing their happiness and family obligations. Some women left their jobs to marry, while others took their husbands' surname, making tracking their earlier achievements more challenging. Unless a woman's work is visible or documented, she does not exist.

In 1991, US designer/design educator and historian Martha Scotford published her seminal article "Is There a Canon of Graphic Design History?"[6] Much of her early research

focused on locating the invisible women graphic designers once she discovered they were essentially missing from published literature. Her method to discuss the "missing" was to show how few had work published in graphic design history books. Scotford chose five books considered the best historical surveys of that time and applied a statistical analysis to question inclusion criteria. "When I researched my 1991 article by counting images, I claimed that the authors of the five books involved had unintentionally created a canon."[7]

Gendering the Canon

What is a canon? One of the best definitions I found is by a Leiden University student: "Canons are an ambiguous standard by which other works are measured. Canons also have the authority to influence beauty standards, legitimize institutions, and greatly impact artistic education."[8] Perhaps canons are simply the amplification of the communities that produce them. "In graphics, the word 'canon' refers to the heavy hitters—such as Bass, Cassandre, Bill, Brody, and Carson—who turn up in nearly every history of graphic design, however slim," suggests John L. Walters, editor and publisher of *EYE* magazine (UK).[9] "In the 1990s, an identifiable canon of graphic design history emerged," writes UK design educator and historian Teal Triggs. "The 'heroic' designer monograph appeared, providing a list of 'Who's Who' … with the contribution of women and ethnic role models notably absent."[10]

While defining a canon as a list of productions created by authors or designers based on supreme criteria and assessments, Martha Scotford emphasizes that "a canon creates heroes, superstars, and iconographies … (and) for students new to the study of graphic design, a canon creates the impression that they need go no further; the best is known, the rest is not worth knowing."[11]

The fact that canons even exist is concerning as it implies that a "group of gatekeepers" has agreed on specific pathways of narrating past achievements.[12] The first historians interested in graphic design were professionals seeking greater recognition and a desire to elevate the profession, distinguishing it from the tandem fields of fine arts, architecture, industrial design, and fashion design. Graphic design history is a history of graphic design practice. Through various deliverables such as textbooks, conferences, exhibitions, and lectures, design historians and design educators have narrated the industry's development by identifying pivotal figures, canonical works, and dominant styles, usually based on the achievements of white male graphic designers.[13] This is primarily due to the historiography methods used by male authors,[14] who were disproportionately biased toward male graphic designers. "Books about design, as any cursory visit to a bookshop will reveal, almost invariably deal with 'star' designers (usually male), historical design movements (which show a male bias in their conventional, patriarchal approach), or professional male-determined organizations and activities."[15]

Determination and Perseverance for Gender Visibility

In 1994, Martha Scotford published "Messy History vs. Neat History: Toward an Expanded View of Women in Graphic Design" in *Visible Language* (Journal of Visual Communication Research).[16] In her introduction, she states:

> For the contributions of women in graphic design to be discovered and understood, their different experiences and roles within the patriarchal and capitalist framework they share with men, and their choices and experiences within a female framework, must be acknowledged and explored. Neat history is conventional history: a focus on the mainstream activities and work of individual, usually male, designers. Messy history seeks to discover, study, and include the variety of alternative approaches and activities that are often part of women designers' professional lives.

Since the 1990s, a disproportionate influx of female students enrolled in design courses worldwide. They are now the largest student body demographic in graphic design programs. This increase could be due to the changing societal attitudes toward gender roles and the breaking down of traditional stereotypes. Yet, despite this fact, many design educators continue to use mainstream, biased graphic design resources in their curriculums, leading students to believe that most successful graphic designers are male.[17] This lack of depth, perseverance, and inclusion in education and research impedes the profession's subsequent development.

Even with the substantial developments toward gender equality that have taken place in the twenty-first century, the evidence still suggests that little progress has been made to ensure the graphic design profession is an equitable industry. US designer/design educator and historian Aggie Toppins writes, "Design heroes are mythical—we imagined them, and we can unimagine them. As a field, we should stop perpetuating the idea that designers are singular change agents who act on culture from outside of it. Rather, we should make visible the complex social worlds in which designers practice."[18]

Through its illustrated narratives, *Women Graphic Designers* seeks to shape a framework of historical design practice through a feminist perspective—to challenge and transform traditional design practices that perpetuate gender-related biases, preconceived notions that reinforce stereotypes or assumptions about gender roles that ignore the diverse experiences of different genders, backgrounds, and cultural identities.[19] There is currently a considerable need to recognize and document the role of multicultural women at this time when there are increasingly insistent calls to decolonize design[20] by eliminating gender disparity, promoting gender equality, and embracing cultural diversity through intercultural narratives.

"Educators have a responsibility to expand and reshape the canon to include work that honors diverse experiences and audiences," advocates US designer/design educator Kaleena Sales. "If we continue to indoctrinate new generations of designers into the industry by making them believe there's something inherently wrong with the way they see the world, we risk crushing their confidence and making them lose interest in an industry that desperately needs their voice."[21]

Storytelling is a crucial tool—there are so many compelling stories waiting to be told—to give all students and young designers the role models they deserve. Reading the stories of women with similar backgrounds, experiences, or identities succeeding in the design profession can encourage and inspire underrepresented groups to pursue careers in the field. Astronaut and the first US woman in space, Sally Ride (1951–2012), said it best: "Young girls need to see role models in whatever careers they may choose, just so they can picture themselves doing those jobs someday. You can't be what you can't see."

Structure of the Book

Women Graphic Designers is divided into three sections:

> **Section 1: New Millennium Pioneers (1875–1920)** features illustrated essays on nine women designers who all acquired artistic training, often through private instruction or courses open to women in art academies in the early decades of the twentieth century.
>
> **Section 2: Modernist Trailblazers (1925–1939)** features illustrated essays on seventeen women designers who were born in the years between the First and Second World Wars and who were formally educated after the Second World War.
>
> **Section 3: Postmodern Innovators (1940–1970)** features illustrated essays on sixteen women designers born during and after the Second World War who came of age during the postmodern era.

Contextualizing section introductions provide readers with a broader understanding of the historical time periods during which these women were active, discussing the prevailing attitudes toward women in the workforce and the challenges they faced. Concise biographies of each subject highlight the diverse cultural experiences, perspectives, and contributions these women brought to the developing profession.

Key Features

- *Women Graphic Designers* brings together forty-two original and previously published illustrated essays on a hidden history of women in graphic design—from

Europe, Asia, North America, South America, South Africa, and Australia—emphasizing the broader sociocultural factors that influenced their roles and contributions that were intricately tied to the unique cultural milieus in which they operated.
- *Women Graphic Designers* includes 200 black-and-white and color images to enhance the visual storytelling aspect, making design history more engaging and accessible to a broader audience. Images showcase each woman's creativity and the impact of their designs.
- *Women Graphic Designers* seeks to redress the gender imbalance in the canon of graphic design history by providing role models who reflect diverse experiences, perspectives, and approaches to design to inspire a new generation of designers.
- *Women Graphic Designers* assists the reader in comprehending the significance of women's success and achievements in different parts of the world within the larger framework of the evolving graphic design profession in the twentieth century. Whereas many new books on women in design have taken a broad approach by including women practitioners in architecture, fashion design, graphic design, and interior and product design, *Women Graphic Designers* is laser-focused on women who excelled in the graphic arts, illustration, and design.

NOTES

1. "Expanding the 'canon' fully to embrace the accomplishments of female graphic designers is currently being addressed by an international cohort of professional female and male graphic designers and design educators. They have shifted their professional practice and scholarship towards researching, writing essays, and curating exhibitions on marginalized, overlooked, and underappreciated female designers. They aim to question and challenge the widely accepted pantheon of established, primarily white male figures and, by doing so, promote female role models as a grounding and a mechanism for achieving equal industry status for women graphic designers." Elizabeth Resnick, "Rebalancing the Design Canon," *EYE* Magazine 102, Summer 2021. Available at: https://www.eyemagazine.com/opinion/article/rebalancing-the-design-canon/

2. All of the essays have been edited in American English for consistency, as the editor is American. Differences in spelling and vocabulary between British English and American English are common and a result of historical and cultural factors. A good example would be "colour" in British English and "color" in American English. Both "dialects" of English often feature different terms to describe the same thing: "mobile phone" in British English and "cell phone" in American English. A good read on the history of these differences can be found at http://www.bbc.com/culture/story/20150715-why-isnt-american-a-language (accessed November 29, 2023).

3. Patriarchy is a social system where men hold the primary power, and women are often marginalized or oppressed. This perspective is commonly applied to various aspects of society, including politics,

economics, culture, and interpersonal relationships.

4. For the purposes of this book, "feminism" is a social, political, and cultural movement that advocates for women's rights and equality of the sexes. It seeks to address and rectify the historical and ongoing inequalities between men and women in various aspects of life, such as gender-based discrimination, sexism, and the unequal distribution of power between men and women. "In my understanding, feminism acknowledges the past inequality of women, and doesn't want it to continue into the future." Quote from the "Reputations" interview with US designer and design educator Sheila Levrant de Bretteville by Ellen Lupton published in *EYE* Magazine 8, Vol. 2, 1993, pg. 13.

5. Pound, Cath, (2023), "The American Designers Who Were Ignored," available at: https://www.bbc.com/culture/article/20230317-the-american-designers-who-were-ignored/

6. Scotford, Martha, "Is There a Canon of Graphic Design History?" *AIGA Design Journal*, vol. 9, no. 2, 1991, reprinted in De Bondt, Sara, de Smet, Catherine, eds. (2012) *Graphic Design: History in the Writing* (1983–2011). London: Occasional Papers.

7. Scotford, Martha, "Googling the Design Canon," *EYE* Magazine 68, Summer 2008. Available at: https://www.eyemagazine.com/feature/article/googling-the-design-canon/

8. Harjani, Celine George, "Meanderings on art history canons defined by museums expanded by exhibitions," August 8, 2020. Available at: https://medium.com/@celinegh/meanderings-on-art-history-canon-s-defined-by-museums-expanded-by-exhibitions-56f024f6b591/

9. Walters, John L., "Beyond the Canon," *EYE* Magazine 68, Summer 2008. Available at: https://www.eyemagazine.com/feature/article/beyond-the-canon/

10. Triggs, Teal, "Designing Graphic Design History," *Journal of Design History* 22 (4) 2009, pg. 328.

11. Scotford, "Is There a Canon of Graphic Design History?"

12. "It is the responsibility of the gatekeepers—who write, who teach, who collect, who curate, who sell, who promote, who advocate—to open the gates for the dismantling of past and present conditions in order to make women's work, contributions and visibility a permanent condition." Quote from the article "Dear Gatekeepers" by Foreign Legion, published in *Icon* 190, April 2019 issue. Foreign Legion is a globally active curatorial initiative by Vera Sacchetti and Matylda Krzykowski.

13. Toppins, Aggie, "We Need Graphic Design Histories that Look Beyond the Profession," *AIGA Eye on Design*, June 10, 2021. Available at: https://eyeondesign.aiga.org/we-need-graphic-design-histories-that-look-beyond-the-profession/

14. Josef Müller-Brockmann, *A History of Visual Communication* (1971); Philip B. Meggs, *A History of Graphic Design* (1983); Roger Remington and Barbara Hodik, *Nine Pioneers of Graphic Design* (1989); Richard Hollis, *Graphic Design: A Concise History* (1994). Generations of graphic design students were schooled using these books and continue to be today. Interestingly, Josef Müller-Brockmann (1914–1996), Philip B. Meggs (1942–2002), Roger Remington (1936), and Richard Hollis (1934) worked as professional graphic designers and design educators.

15. Quote from UK design educator and historian Nigel Whiteley (1953–2010) essay, "Feminist Perspectives," in *Design for Society*, London: Reaktion Books Ltd., 1993, pg. 136.

16. Scotford, Martha, "Messy History vs. Neat History: Toward an Expanded View of Women in Graphic Design," *Visible Language*, 28, 1994, pgs. 367–87.

17. "In some history of design surveys, instructors rely on well-known designers to structure the material, an approach in the 'great artists' mode. They foreground a design history 'canon' and emphasize 'key objects' using an art-historical model that moves from one 'great movement' to the next ... [which] reinforces an established and increasingly contested canon." Quote by Sarah A. Lichtman from her essay "Reconsidering the History of Design Survey," *Journal of Design History* 22 (4) 2009, pg. 345.
18. Toppins, Aggie, "Can We Teach Graphic Design History without the Cult of Hero Worship?" *AIGA Eye on Design*, May 29, 2020. Available at: https://eyeondesign.aiga.org/can-we-teach-graphic-design-history-without-the-cult-of-hero-worship/
19. "A plurality of evolving definitions, critiques, and objectives has been a hallmark of feminism since its inception," states US designer and design educator Alison Place in her book *Feminist Designer: On the Personal and the Political in Design*. Cambridge, MA: The MIT Press, 2023, pg. 2.
20. "... decolonizing design requires that we break down our basic assumptions of what design is and what it has been, and then rebuild anew with a more inclusive understanding of its theories and practices," affirms Elizabeth (Dori) Tunstall in her book *Decolonizing Design: A Cultural Justice Guidebook*. Cambridge, MA: The MIT Press, 2023.
21. Sales, Kaleena, "Beyond the Universal: Positionality & Promise in an HBCU Classroom," in *The Black Experience in Design: Identity, Expression, & Reflection*. New York: SVA/Allworth Press, 2022, pg. 174.

ACKNOWLEDGMENTS

This collection of illustrated essays would not be possible without the dedicated and brilliant research work of a cohort of international design scholars invested in redressing gender inequities in the graphic design canon. I am in your debt:

Ginger van den Akker, Dr. Chiara Barbieri, Anne H. Berry, Sandra Bischler-Hartmann, Luis Blau, Dr. Raquel Castedo, Dr. Jane Connory, Mehrdokht Darabi, Luciene Ribeiro dos Santos, Dr. Maria Cecilia Loschiavo dos Santos, Ömer Durmaz, Dr. Marina Emmanouil, Rose Epple, Dr. Murat Ertürk, Dr. Cinzia Ferrara, Dr. Davide Fornari, Dr. Sara Miriam Goldchmit, Dr. Francesco E. Guida, Margo Halverson, Tanishka Kachru, Dr. Arja Karhumaa, Dr. Linda King, Ian Lynam, Faride Mereb, Dr. Yoonkyung Myung, Laura Ottina, Dr. Monica Pastore, Vanina Pinter, Dr. Deirdre Pretorius, Dr. Paula Ramos, Alice Roegholt, Stephan Rosger, Dr. Olga Severina, Dr. Bahia Shehab, Dr. Maria Helena Souto, Tasheka Arceneaux Sutton, Ruth Sykes, Dr. Yasmine Nachabe Taan, Parisa Tashakori, Rukminee Guha Thakurta, Dr. Carlo Vinti, Dr. Wendy S. Wong, and Justin Zhuang.

I would like to acknowledge and express my appreciation to John L. Walters, publisher and editor of *EYE* magazine (UK), for his encouragement, superb editing, and subsequent publishing of my research and writing on twentieth-century women graphic designers.

I am indebted to my editor, Louise Baird-Smith, for giving me this unique opportunity to create *Women Graphic Designers*. I wish to thank her former editorial assistant, Hattie Morrison, for keeping me on track and for all the small things she helped me with during the course of developing the manuscript, and current editorial assistant, Joseph Skingsley, for his assistance in moving the project through production.

Thank you to Alice E. Drueding for your friendship, encouragement, and help during the book's process.

I am thankful to my husband, Victor Cockburn, and my adult children, Alex and Elana, who all endured my distraction and frequent spells of anxiety with encouragement and grace.

This book is dedicated to the many pioneering women designers who forged the way forward with infinite passion, grace, and determination. We are all in your debt.

SECTION ONE

New Millennium Pioneers (1875–1920)

The struggle against patriarchy and male domination has always taken place in every corner of the globe. Because virtually all countries are structured by patriarchal mentalities, the global standard for being human is male, and women in nearly every culture and country are "othered"— a common condition that is both unique to each locality and context yet deeply familiar to every human who identifies as a woman.
—Alison Place, *Feminist Designer: On the Personal and the Political in Design*, 2023

1.0

Introduction

Elizabeth Resnick

Women born in the late nineteenth and early twentieth centuries lived very restricted lives. They were denied the legal, social, or political rights that are now taken for granted in most civilized countries: they could not vote, had limited control over their personal property after marriage, were rarely granted legal custody of their children in cases of divorce, and were routinely barred from institutions of higher education in some countries. Their role in society differed significantly from that of men, as they were expected to remain subservient to their fathers and husbands.

Women were often not allowed to be outspoken or given the same opportunities; their occupational choices were minimal. Middle- and upper-class women—whether wives, daughters, or sisters—were left at home all day to care for their children and run the household that domestic servants increasingly would carry out. If they did undertake paid work, it was only for respectable activities like serving as a governess, a music teacher, or a nurse. Lower-class women worked as laborers in factories and mills or as poorly paid domestic servants for wealthier households. Many women also did home-based work such as seamstresses finishing garments and shoes for factories, laundry, or preparing food to sell in the market or streets.

With the advent of the First World War (1914–18) in North America and Western Europe, many women were recruited or volunteered for jobs vacated by men who had gone to fight in the war. New jobs were also created as part of the war effort, for example, in munitions factories, allowing for a rapid rise in production. Although there was

initial resistance to hiring women for what was seen as "men's work," the high demand for weapons resulted in the munitions factories becoming the largest single employer of women during 1918. Women also worked as railway guards, ticket collectors, bus and tram conductors, postal workers, police, firefighters, bank clerks, and farm and factory workers. Others provided support on the front lines as nurses, doctors, ambulance drivers, translators, and, in rare cases, on the battlefield.[1]

The First World War resulted in a social revolution, opening up opportunities for women to pursue vocations and directions that had been previously barred. "Female graphic designers were strongly represented and much more visible both in the applied arts at the turn of the century and in the booming market of illustrated magazines, journals, advertising, and popular culture during the 1920s. During their lives, they were held in high esteem by their clients and the trade press, yet few of them entered the canon of design history."[2] For these women whose artistic talents could not be denied, they needed to maintain a delicate balance of propriety and feminine appeal by not "threatening" men or the family unit.

The nine women designers featured in this section all acquired artistic training, often through private instruction or courses open to women in art academies in the early decades of the twentieth century. Several of the women leveraged the advantages gained from their social class and family background to fulfill their ambitions. Six of nine women married, but only four became mothers. Rarely did the careers of these talented women follow a linear path, as there was immense social pressure on them to live traditional lives and remain at home.

1.0.1 Uemura Shōen

Uemura Shōen (1875–1949) was born in Kyoto, Japan, and became the most prominent and commercially successful female artist, arts educator, and illustrator in pre-war Japan. She did this despite unbelievable odds—Uemura was not born of the aristocracy, she was a single mother, and her subject matter was other women in a time before suffrage. She was celebrated for her bijin-ga, or paintings of beautiful women, in the nihonga style, although she also produced paintings on historical themes and traditional subjects.

1.0.2 Jane Atché

Jane Atché (1882–1937) was born in Toulouse, France, and worked as an illustrator, painter, and poster artist in the Art Nouveau style. Her visual form sometimes resembled the famed Czech artist Alphonse Mucha, and according to biographies of her life, Mucha was a mentor. She excelled in art, and at the age of twenty-four, Atché debuted her poster for

JOB cigarette papers at the Cirque de Reims to great success. She was the only woman among the numerous French poster artists for many years.

1.0.3 Varvara Fyodorovna Stepanova

Varvara Fyodorovna Stepanova (1894–1958) was born in Kaunas, Lithuania, and was a multitalented artist—painter, graphic, book, and theatrical set designer—and the wife of fellow artist Aleksandr Rodchenko, a prominent figure in the Russian avant-garde. Their creative collaboration began as students at the Kazan Art School, where Stepanova studied from 1910 to 1913. In the mid-1920s, she began working with various magazines, producing photomontages and collages. Like many avant-garde artists, she resisted the powerful dominance of Socialist Realism and was subjected to attack by the Stalinist cultural establishment in the late 1920s. As a result, she immersed herself in book printing and worked as a movie-set designer before she was ultimately isolated and marginalized.

1.0.4 Fré Cohen

Fré Cohen (1903–1943) was born in Amsterdam, the Netherlands, where her parents were diamond workers. From 1929, she was employed by the municipality of Amsterdam, supervising all the printing for the city, including posters and covers of publications and invitations. In the 1930s, she worked for Jewish organizations and created designs for publications to support Jewish refugees from Germany. She also provided graphic work for the labor and women's movement. During that time, she was one of the few female artists who could make a good living from her work. She was asked to give a series of lectures on graphic design in England and to show her work. The German invasion of the Netherlands in 1940 ended her career early. She went into hiding in 1942 but was arrested on June 9, 1943. To avoid being sent to a concentration camp, she committed suicide and died on June 12, 1943.

1.0.5 Ans van Zeijst

Ans van Zeijst (1906–1988) was born in Utrecht, the Netherlands, and worked as an artist and designer. She designed silver cutlery and crockery, prints such as posters, book covers, and several Catholic magazines. After being ordained in Rome in 1934, she began her life as a lay sister, taking the name Sister Theofoor (or Théophore). She was sent to the Vita et Pax Foundation in Cockfosters, London, where she took over the management of an art school and practiced graphic design. Later, she successfully ran her Utrecht communications and advertising agency thanks to the support from Catholic patrons.

1.0.6 Maria Keil

Maria Keil (1914–2012) was born in Silves, Portugal, and studied painting at the Lisbon School of Fine Arts. She quickly migrated to other visual art forms: graphics and advertising design, illustration, furniture, scenography, costume design, tapestry, and tile design. She married architect Francesco Keil Amaral, and in working together, she created several urban installations in Lisbon that are a contemporary heritage of the capital's tile legacy. Maria Keil has constantly rejected the passé arts system, anticipating the dissolution of genres, crossing languages, forms, and techniques that intersect the multiple artistic universes she developed.

1.0.7 Saloua Raouda Choucair

Saloua Raouda Choucair (1916–2017) was born in Beirut, Lebanon, and was considered a pioneer of abstract art in the Middle East. Influenced by her Lebanese heritage, she introduced geometric abstract art with a modernist approach rather than Western traditions and forms. She combined her knowledge in science, Islamic geometry, engineering, and poetry while exploring an extensive range of materials in producing her furniture, products, jewelry, weaving, and fabric designs made over five decades. Despite the many challenges during her career, she believed that art and design were universal. Her approach to eliminating the boundaries between art, architecture, and design will continue to inspire present and future generations of designers.

1.0.8 Dorrit Dekk

Dorrit Dekk (1917–2014) was born Dorothy Karoline Fuhrmann, a Czech-born British graphic designer, printmaker, and painter. She studied art in Vienna before moving to London in 1938 during the rise of Nazism and came to be regarded as among Britain's most successful commercial artists of the postwar period. She was known as the travel queen for her work with Air France, P & O shipping line, London Transport, and British Rail. She retired from her graphic design practice in 1982 but continued working as a painter and printmaker until her death.

1.0.9 Roswitha Bitterlich

Roswitha Bitterlich (1920–2015) was born in Bregenz, Austria, and was considered a child prodigy, having published her first book in 1933 when she was just thirteen years old. She emigrated to Brazil with her second husband, Hubert Wingen, and her young daughter

in 1955, settling in Porto Alegre, where she lived and worked modestly and silently until she died in 2015. Among her works are the magnificent illustrations for Hans Christian Andersen's Tales and the Grimms' Fairy Tales, published by the former Editora Globo at the end of the 1950s and early 1960s.

NOTES

1. The First World War marked the first time American women formally served in the armed forces. Over 20,000 women served in the U.S. Army Nurse Corps, and those who went overseas were often stationed close to the front lines, experiencing artillery barrages and gas attacks. See: https://www.theworldwar.org/learn/women#:~:text=With%20millions%20of%20men%20away,rare%20cases%2C%20on%20the%20battlefield.

2. "From 1890 onwards, a continuously large group of women was active in the field of graphic design. Many were better known during their lifetimes than they are today, and a considerable number were recognized among their peers as well as experts in the field … it is astonishing that almost none of them are mentioned in the standard works on design history." From Gerda Breuer and Julia Meer (eds.), *Women in Graphic Design 1890–2012*, Berlin: Jovis, 2012, pg. 390.

1.1

Uemura Shōen: The Pine that Stands Alone Yet Which Is One of Many

Ian Lynam

Uemura Shōen 上村松園 (1875–1949) was one of the leading artists in Japan in the Meiji (1868–1912), Taishō (1912–1926), and early Shōwa (1926–1989) periods who broke conventions regarding the roles of women in Japan and set precedents for emerging female artists in Japan as the country Westernized following the Meiji Restoration of 1868 and Japan reopening to the West after the 265 years of isolationist policy known as *Sakoku* (literally translated as "chained country").

Uemura Shōen was born Uemura Tsune 上村津禰 on April 23, 1875, in Kyoto, Japan, to a merchant family that ran a popular tea shop called Chikiriya in the center of downtown. She was the second of two daughters and was preceded by her sister Koma (1871–1951). Her father, Uemura Taihei (unknown–1875), passed away two months before she was born, so she was raised in an all-female household. Her mother, Uemura Naka

Figure 1.1.1 Uemura Shōen, photographic portrait. *Source*: Portraits of Modern Japanese Historical Figures, National Diet Library.

(unknown–1934), encouraged her study of art despite criticism from other family members. (Sewing lessons were considered more appropriate than studying art for a young woman then.) Despite insistence from other family members, Naka remained steadfast in her decision to rear Shōen as a single mother—working in the tea retailing business by day and sewing kimonos at night.

Shōen showed an early skill at rendering the human figure as a child and enrolled in the Kyoto Prefectural School of Painting in 1887 at the age of thirteen with her mother's permission. The school, established seven years earlier in 1880, was the earliest professional arts institution in Japan that taught both *nihonga* (Japanese-style painting) and *yōga* (Western-style painting). The institution had been created in an attempt to break the traditional master/disciple roles of art education in Japan and to offer students a more unified and modern approach to the study of the arts. At the Kyoto Prefectural School, Shōen studied under *nihonga* landscape painter Suzuki Shōnen 鈴木松年.[1] Shōnen was one of the foremost painters active in Kyoto and who dedicated himself to keeping traditional forms of Japanese painting alive during Japan's rapid Westernization in the latter half of the nineteenth century.

Suzuki resigned from the school in 1888. Shōen left the Kyoto Prefectural School of Painting—choosing tradition over modernity in regard to educational methodology and pedagogical approach—and followed Suzuki, becoming his private student. Shortly thereafter, Shōnen bestowed upon Shōen the kanji of her artist name, "Shōen," which means "pine farm" or "pine garden." In early modern Japan, artists adopted different pseudonyms or *gō* at different stages of their career, usually to signify their lineage of artistic education. Shōen's artist name is derived from Shōnen's, which means "aged pine." Doubtlessly, this hierarchical connection brought Shōen added attention, having been initiated into the well-respected lineage of the Suzuki school.

The atavistic upstart Shōen exhibited her painting *Women of the Four Seasons* at the Third Industrial Exposition held in Tokyo in 1890, winning an award. The painting was purchased by Queen Victoria's son, Prince Arthur of Wales and Duke of Connaught, on one of the prince's trips to Japan,[2] making Shōen a celebrity in the Japanese art world at the tender age of fifteen. This initial success also paved the way for Shōen to be invited to contribute a painting to be exhibited at the Chicago World Exposition in 1893, one of fourteen works by female painters from all over Japan.

Shōen left Shōnen's tutelage in 1893 to study under Kōno Bairei for two years to expand her artistic repertoire. She then studied under former student Takeuchi Seihō in 1895 after Bairei's death, when she established herself as a professional painter. From Shōnen, she learned dramatic and often rough linework; from Bairei, a more enhanced use of color; and from Takeuchi, an insistence upon naturalism. Shōen was incredibly dedicated to her studies, noting, "Our teacher emphasized the importance of sketching, and we often went on long sketching trips carrying our lunches. I didn't want to be left behind by the men, so I even went on overnight sketching trips with them."[3] Furthermore, Shōen rejected the

ornate hairstyles required of women of the time, adopting a simple bun that symbolized a refutation of traditional womanhood of the Kyūshu area. "She did not choose a painting career over traditional womanhood based on the modernistic conviction of individual freedom as one of women's rights … Shōen became a painter because she was driven by her love of painting."[4] Her love for art was bolstered by a profound dedication that lasted her entire lifetime despite numerous hardships along the way.

Shōen emerged from her studies with the successive trio as one of the earliest female painters of the Meiji era who came from a non-elite family and who chose to specialize in figurative painting and artwork. Uemura's paintings combined technical mastery with a romanticized reverence for her medium: *bijinga*, paintings of idealized beautiful women. Bijinga were one of the primary themes of the woodblock prints and paintings known as *ukiyo-e* that emerged in Japan during the seventeenth to nineteenth centuries and gained immense popularity among the Japanese merchants and middle-class citizens of that era. During the conception of bijinga in the Tokugawa, or Edo period, women were viewed as lower-class citizens, and this notion was often projected onto the female subjects depicted in the genre. Shōen was one of the leading and groundbreaking women working in this style in the mid-Meiji era. Her painting and illustrated works often idealized and presented women from all walks of life in poses of dignity—from everyday females of assorted ages to courtesans and geisha. Shōen wrote, "Even when depicting a geisha, I want to represent a woman with a will of her own and a sense of pride rather than simply beautiful and enchanting."[5] Despite the waning popularity of bijinga as a subgenre of ukiyo-e painting in the late Taishō era due to increased Westernization, Shōen stuck to her preferred subject matter, a testament to her tenacity and desire to defy convention.

Shōen gave birth to a son, Uemura Shintaro (1902–2001) (artist name: Uemura Shōkō[6]) out of wedlock, the result of an extramarital relationship with her former teacher Shōnen. The perception of unmarried mothers in greater Kyoto society at that time led to social ostracization. Yet, Shōen's decision to pursue the life of an artist, at a time when it was rare for non-aristocratic women to do so, allowed her to raise her son in what would otherwise be an untenable cultural situation. Despite many parents refusing to send their children to study under Shōen because she was a single mother, enough liberal-minded parents were aware of her reputation as an unparalleled artist in the Kyoto area for her to have a healthy roster of private students. Due to her sheer talent and determination, many members of Kyoto society "overlooked" Shōen's status as a single mother, in essence "absolving" her and supporting her lifework.

Shōen and her mother closed their tea shop in 1903 and made their living solely on the income provided by Shōen's painting commissions and sales and her private teaching of many female students that increased over time. Shōen published a book of her paintings that she designed in 1909, called *Shōen bijingafu* (Collection of bijinga paintings by Shōen), which met with unwavering success. The arts magazine *Chūō Bijutsu* recognized in 1916

Figure 1.1.2 *Left:* Uemura Shōen, *Flame* painting, 1918. Tokyo National Museum, Tokyo, Japan. *Right:* Uemura Shōen, *Firefly* painting, 1913. Portrait of a woman airing her kimono. Yamanate Museum of Art, Tokyo, Japan.

that she was the wealthiest female painter in Japan, having built a sizable private home in the traditional style containing her studio two years prior.

Shōen was invited to participate in the state-sponsored Bunten[7] exhibition and was bid to demonstrate her painting prowess in front of the empress at the 1916 exhibition, followed by two more invitations in 1917 and 1918. These successes, combined with participating in major group exhibitions in Tokyo and Kyoto, established Shōen further as one of the leading painters of that time, coupled with financial independence equal to or surpassing male painters. Yet, being the sole provider for her mother and son meant that Shōen had to eschew the traditional role of being a mother, leaving her mother and aunt to raise her son—Shōen was literally and figuratively forced into being a painter and illustrator first, foremost, and in the singular.

Section 1 New Millennium Pioneers (1875–1920)

Figure 1.1.3 *Left:* Uemura Shōen, Board of Tourist Industry poster, Japanese Government Railways, featuring the 1936 *Classical Dance* painting. Kyodo Printing Company, Ltd. (n.d.). *Right:* Uemura Shōen, *Classical Dance* (also titled *Noh Dance Prelude*) painting, 1936. Tokyo National University of Fine Arts and Music, Tokyo, Japan.

Primarily remembered as a painter, Shōen designed the covers of periodicals as well, integrating more bold and graphic illustration work depicting her preferred idealized female subjects with a masterful approach to lettering. Her choice to depict women who were fulfilled in their traditional roles as wives and mothers stood in direct opposition to her circumstances. In her own words, "My paintings are not simply faithful portrayals of beautiful women in reality. Rather, I try to express my own ideal of feminine beauty and womanhood while paying attention to realistic representation."[8] Shōen provided cover designs for most of the leading arts periodicals in Japan during her lifetime, including *Chūo Bijutsu*, *Atelier*, *Sansai*, and *Mizue*.

In 1919, the Bunten exhibition was reorganized as the Teikoku Bijutsu Tenrankai, or Teiten for short. Shōen was appointed the very first female jury member in 1926, sealing her position as one of the artistic elites in Japanese society. Shōen was invited to join the Imperial Art Academy in 1941, becoming the first female painter in Japan to receive the honor. Four years later, in 1944, she was appointed as a court painter for the Imperial Household Agency.

Amidst the Second World War, Shōen created pieces that promoted nationalism, such as *Late Autumn* (1943), which portrays a beautiful woman contributing to the war effort. Despite her elderly age, she accepted an invitation from the Japanese government for propaganda purposes and traveled to the war zone in China to sketch daily life there. Shōen's works from this period, such as *Twilight* (1941) and *Clear Day* (1941), alongside *Late Autumn*, depict working women fulfilling their daily tasks with a strong sense of vitality. As with her pieces from the 1930s, she skillfully employed negative space, realistic details, neat lines, and a subdued color palette.

As the war situation worsened, Shōen moved to her vacation house in the Nara area in February 1945, which she became fond of due to the region's idyllic nature and where she would reside for the rest of her life. Shōen received the Order of Culture Award, the highest honor bestowed upon any Japanese artist, in 1948, making her the first woman to receive it. She died on August 27, 1949, of lung cancer in Nara.

Uemura Shōen stands as a female artist, illustrator, and—perhaps happenstance—graphic designer whose legacy deviates from accepted notions of feminism as a facet of Modernism and modernity. Yet her work empowered women through graceful and resolute traditional

Figure 1.1.4 *Left:* Uemura Shōen, *Young Woman Miyuki* painting, 1914. Adachi Museum of Art, Yasugi, Japan. *Right:* Uemura Shōen, *Mother and Child* painting, 1934. National Museum of Modern Art, Tokyo, Japan.

representations of women in a rapidly changing world. Shōen found little interest in the evolving Western fashions and trends for women that pervaded Japan in the latter half of her life—the bobbed haircuts, permanent wave hairstyles, and Western clothing that would largely supplant kimono and traditional Japanese fashion postwar.

Simultaneously, it was through the support of women, namely her mother Naka, that Shōen was encouraged to pursue the life of an artist. She wrote, "My mother, who gave birth to me, also gave birth to my art."[9]

© **Ian Lynam**

Note: Names within this essay are initially presented in the traditional Japanese order—surname first and forename second, yet as artists of the times depicted were often referred to by their forenames as identifiers of cultural significance, the author has followed the traditional mode of signification.

NOTES

1. Shōnen was the son of Suzuki Hyakunen (1825–1891), founder of the formidable Suzuki school of painting in the Edo Period (1603–1827).
2. A member of the British Royal Family, Prince Arthur, the First Duke of Connaught and Strathearn, was the third son and seventh of Queen Victoria and Prince Albert's nine children. He had an illustrious and extensive career in the British army, serving in various countries including South Africa, Canada, Ireland, Egypt, and India.
3. Shōen, Uemura (1972). *Seibisho*. Tokyo: Sansaisha, pg. 127.
4. Morioka, Michiko (1990). *Changing Images of Women: Taisho Period Paintings by Uemura Shōen (1875–1949), Ito Shoha (1877–1968), and Kajiwara Hisako (1896–1988)*. Seattle: University of Washington, pg. 84.
5. Shōen, Uemura (1972). *Seibisho*. Tokyo: Sansaisha, pg. 112.
6. Uemura Shōkō became a lauded nihonga painter who infused traditional rendering with modern approaches to perspective. His son Uemura Atsushi (1933–2024) is also a nihonga painter based in Nara.
7. In 1907, the Monbushō Bijutsu Tenrankai, abbreviated as the Bunten, became the first juried state art exhibition held under the supervision of the Japanese Ministry of Education, Science, Sports, and Culture, which was then called Mombushō. It took place at the Tokyo Metropolitan Art Museum or Tōkyō-to Bijutsukan and comprised three sections: Japanese-style painting, Western-style painting, and sculpture. For artists of that era, having one's works displayed in the Bunten was a pathway to financial success, as Bunten artists' works' prices were valued at triple the price of artists who did not participate.
8. Shōen, Uemura (1972). *Seibisho*. Tokyo: Sansaisha, pgs. 92–93.
9. Shōen, Uemura (1972). *Seibisho*. Tokyo: Sansaisha, pg. 147.

1.2

Jane Atché: The Smoking Woman

Vanina Pinter

Jane Atché was twenty-four years old when she designed her first poster, a poster considered by many to be by far her most remarkable work. One of the first female French poster artists has only one centerpiece in her repertoire. This is anything but innocuous and is, in fact, quite significant.

It can sometimes happen that certain graphic designers begin their career with a "masterpiece," like Cassandre (1901–1968), who, at only twenty-two, split the walls of Paris with his woodcutter (*Au Bûcheron*, 1923), or Max Bill (1908–1994), who encapsulated African art in a handful of lines (*Negerkunst*, Kunstgewerbemuseum, Zürich, 1931). For many artists, their first encounter with poster design is often fortuitous, and an inaugural moment can turn out to be decisive. Although Jane Atché continued to create commissioned artwork for a part of her life, she never equaled this first achievement.

We need to address a number of issues: how, in *the* decade of poster art, did Jane Atché become a poster designer? What is the formal particularity of her work? Why did she not

Figure 1.2.1 Jane Atché, *Self-portrait with a green hat*, 1909. Oil on canvas. Musée du Pays Rabastinois, France.

enjoy a career equal to that of her peers and contemporaries, Alphonse Mucha in particular? More than anything else, this text invites the reader to continue to be astonished and to salute the power of female artists to have created and left us such wonderful pieces to be savored and commented upon.

A Woman Smoking

In the midst of a major poster exhibition in Paris, Jane Atché's *Smoker*, the new muse of the JOB paper brand, managed to capture everyone's attention. This lithograph print depicts an elegant woman with a dreamy gaze and golden stained-glass hair, smoking. Her dress is adorned with embroidery. Two contrasting elements stand out within the composition: the black cape on one side, a stark, bare, monochrome block that occupies much of the

Figure 1.2.2 Jane Atché, poster for JOB Cigarette paper, 1896. Color lithograph on paper. Musée du Pays Rabastinois, France.

surface; on the other, a halo of smoke, all light and transparency. The circular trail of smoke snakes and curls around the letters JOB,[1] even hiding them in places. How singular it was for a young artist of twenty-four in 1896 to impose a monumental woman and a smoker, no less. Smoking was still frowned upon for women of good standing, but Jane Atché transformed it into an everyday, elegant gesture. A protective adornment that encouraged distance, keeping the viewer at arm's length. Her smoking woman captivates the viewer. Jane Atché's sole poster stood out in the Cirque de Reims exhibition on display from November 7 to 17, 1896, which featured 1,690 "artistic, modern, and retrospective" posters. Of the four hundred participants, only seven were women, of whom two were French. The exhibition included work by French masters of poster art, such as Toulouse-Lautrec (1864–1901), Eugène Grasset (1845–1917), and Alphonse Mucha (1860–1939). Jane Atché's poster was so successful that a second version, known as the *avant la lettre* version, was published, this time absent the brand name, with the rings of smoke now almost forming letters.

On the poster, the young woman stares intensely at the burning tip of her cigarette. The black cape emphasizes the verticality of the poster, creating even more distance between this woman and the spectator, leaving her to her dreams. This feeling of introspection is intensified by the combination of two pastel green colors (the dress and the background). It is often pointed out that there is a button on her sleeve. Jane Atché's figure shows very little bare skin, not even a wrist. She sits in a static, non-lascivious pose—a distinguished (the lining of her cape is the same golden color as her hair) and thoughtful young woman. The radical nature of the composition could be compared to the artist's self-portrait (oil on canvas, 1909) with its green tones, showing an elegantly dressed, slightly austere woman in a traditional style facing toward us. In 1896, Jane Atché used lithography for a stripped-down, suggestive, modern style.

The work done on the letters is an integral part of the composition. The J of JOB (at the top) is formally similar to the letter J in the artist's signature. One could argue that this represents the first time that a poster designed by a woman received such wide distribution and such fame in France. The poster was commented on in the press, but no trace remains of its effect or its critical success on Jane Atché herself (in terms of feelings and inner transformation). Neither muse, nor ambassador, nor divinity, "her" hieratic woman towers above.

Career and Education

Jane Atché was born in Toulouse, France, on August 16, 1872, to a father who was a captain in the infantry. She was passionate about drawing, and her parents had ties to two painters from Toulouse, Jean-Paul Laurens (1838–1921) and Jean-Joseph Benjamin-Constant (1845–1921). Both pursued institutional careers[2] in Paris. Convinced of the young woman's

talent, they undoubtedly played a decisive role in convincing Jane's parents to allow the young woman to "move up" to Paris. She first set foot in the city as she came of age at twenty-one, immediately enrolling in classes intended for young women at the Académie Julian, where Constant and Laurens taught. Young women were forbidden to attend the School of Fine Arts at the time. Before coming to Paris, Jane Atché had what could be described as a classical education.

Like many girls, a more artistic education was encouraged, intended to produce pleasant young women who were ideal "wife material," with this type of schooling taking place in the home in the form of private lessons. Jane Atché learned to play piano, draw, and paint. Her parents favored this artistic education over a more solid education in French, mathematics, and the sciences. A woman who painted in her spare time, embroidered quietly, and played music was pleasing to men, thanks to her reserved talents. These so-called ornamental arts paved the way to marriage, not the way to becoming an artist. Yet Jane Atché managed to make the leap. Taking classes in a studio meant becoming part of a community and potentially exhibiting. Fifteen years earlier, in 1876, painter Rodolphe Julian (1839–1907) opened a school specifically for young women.

We have information about these classes and the working conditions for female students, thanks to Ukrainian artist Marie Bashkirtseff (1858–1884). The school for girls was very profitable for Julian, with more and more young women enrolling—mainly foreigners in the beginning and occasionally, but not always, rich. Although these women could acquire an artistic education thanks to these private studios, they were not encouraged to the same extent as their male counterparts and were certainly not taken as seriously. On November 22, 1873, Marie Bashkirtseff wrote: "People irritate me when it comes to my studies. I am forced to say that I study very little because I am often told that I study too much."[3]

As she left no diary behind, there is scant information about Jane Atché and even less about her years of learning. But one could suppose that it was more acceptable for a French woman from a good family to attend painting classes in 1897, even though "in October 1877, it was not yet customary for a young girl from the French bourgeoisie to come and study at Julian's."[4]

The Influence of Japan and the City

Over the course of the three years between her arrival in Paris and the creation of her poster, Jane Atché learned a great deal from her painter masters, but also, and certainly just as much, from her life in the vibrant city. What posters did she see in the street? What museums, salons, and exhibitions caught her eye and contributed to her formal choices? Toulouse-Lautrec's posters, no doubt. *Les Ambassadeurs* (1892) is proof of this: seen in profile, facing left, Aristide Bruant is striking in his huge black cape. The layout of this poster, particularly in terms of typography, is very similar to that of Jane Atché's. Enamored

with Japanese prints, as were many of her contemporaries, Jane Atché played with lines, black circles, and blocks of color. Indeed, she left a collection of Japanese prints behind after her death.[5]

The Japanese-like element in this composition resides in the very grand style of the black cape. Bruant's black cape is a mass that conveys authority; for Jane Atché, this black cape contributes to monumentalizing the woman depicted, connecting her to the outside. The cape also has the effect of hiding her feminine curves. One could cite other Japanese-like elements: the use of a block of black color, the tight framing, a part of the composition which lies outside of the frame, a staggering of the different planes with no distant perspective effect, intensifying the sensation of verticality.

Jane Atché lived alone in the early 1890s, moving a number of times from rue Faubourg-Poissonnière to the Pigalle district, nearer to the cabarets, including the Chat Noir. It is easy to imagine that she witnessed many street scenes with *gigolettes* and experienced firsthand how posters transformed the urban landscape. One of her earliest drawings is of a *gigolette*, or "flapper," figures often featured on posters to attract passers-by. In this drawing from 1893, Jane Atché represents a young woman in profile, standing upright, smoking, and dressed sensibly, with only the serif typeface indicating that she is a rigoletto: a depiction that had nothing in common with the reality of these women. Jane Atché never painted dancers, actresses, or other "public" women in her compositions, unlike all her peers.

The Nude and the Poster

A distinctive feature of Jane Atché's posters is the absence of any eroticization of the female body, something that was considered the very symbol of modernity in the French poster. Here, it is important to review a well-studied fact: it was incredibly difficult for female artists to have access to nude bodies. They were only allowed to paint a naked body—particularly male—if it was covered up by a loincloth. Little by little, particularly in the private academies, the ban on painting nudes was lifted. Even so, internalized resistance took much longer to eliminate. Painting naked bodies is one of the cornerstones of artistic practice; it means being able to grasp the whole of the human machine and allows one to paint historical and mythological scenes. On a symbolic level, it means possessing the right to see everything, to explore everything—scrutinizing the circulation of lines and shadows of a body, of the other, losing oneself in the limits between exteriority and intimacy. When a painter poses a body, they manipulate it, bending and twisting it into restricting and sometimes convoluted postures in order to practice or for the needs of a particular composition.

Studio photographs taken by Mucha testify to his attempts to place the body in different postures. This liberty was obviously denied to the female artists of the time, as their

own bodies were hampered by a significant weight of fabrics, pleats, and embroideries. Spending time with a naked body was not something available to all, and even when it was possible, the guilt of lust, the sin of being an easy girl, weighed heavy. The prohibition of pleasure, whether sexual or visual, and its very control influenced the gazes and compositions of female artists. Every one of Jane Atché's female bodies is wrapped up warmly.

One exception is a poster where the artist indulged in a nude drawing. This poster for Gaz Benoit referenced an academic pose, a draped female nude holding a bright spotlight. One can sense that this feminine nude is a work that is more akin to the study of a painting than a commissioned work. Jane Atché set her draped figure within a classical composition, cleverly hiding the innovative technical element behind a massive balustrade (Jules Chéret completely ignored the petrol barrels to only show the seductive woman in a series of advertising posters for Saxoléine). Jane Atché chose a classical format for the depiction of the nude. Similar to her print *Lilia*, an interpretation of Carolus-Duran's painting from 1889,[6] Atché's poster featured a partially nude woman, face turned slightly to the left, red hair tied in a bun, and it is worth lingering on an interesting element, the capital letters set within the beam of light. This poster's typographic elements occupy almost as much space as the illustrations. A way of toning down the naked surface? Was this nude figure really Jane Atché's choice?

The Erotic Lines of Art Nouveau

Lithographic printing, perfected by Jules Chéret (1836–1932) in the 1860s, profoundly transformed the streets of Paris. His posters embraced and illuminated the city walls. The artist brought colors and bodies, particularly those of dancing women, into the lines of sight of passers-by. This work was very popular as it echoed a range of commissions (cabaret, theater …), but also because these women, these actresses, were fascinating. They were daring, and they brandished their bodies as a standard of freedom. The trajectory of these women was captivating and inventive, and they themselves provoked a shift in people's perception. It is not enough to simply observe the objectification of these women's bodies (in line with studies around the male gaze); it is also important to be aware of the paths of the women depicted on these posters in order to measure their courage and their audacity. The craze for poster art in France served up these women—apples to be looked at, to be consumed: their nudity (their apple-like breasts) aroused both gaze and desire (consumption). They were stripped bare in place of the product to be sold. This is how the *Chérettes*, Mucha's flower women, were displayed.

Without necessarily being aware of it, Jane Atché took no part in this parade of enticing flower women that spread throughout Europe during the decade of Art Nouveau (1885–1905). Philosopher Christine Buci-Glucksmann summarizes it: "By reconciling the tectonic and the floral, 'modernity becomes Modern Style,' with the three major themes

and motifs of feminine floral: the hieratic, perversion, and emancipation, all omnipresent in Klimt's work."[7] One finds these themes and motifs in Mucha's work, with its continuous, bewitching, and untameable line. This could bring to mind another artist born the same year as Jane Atché, who, despite passing away at the age of twenty-five in 1898 left behind a considerable and sulfurous body of work: Aubrey Beardsley. The female body associated with flora is a pictorial path to emancipation, occasionally touching on madness and morbidity. These motifs, this voluptuous line (a counter to photography, objective and omnipresent) could not be the work of female artists as they were not allowed the chance. They did try, but never really pressed the issue.

Another painter, a contemporary of Jane Atché, Clémentine-Hélène Dufau (1869–1937), also enrolled in classes at the Julian Academy and created two remarkable posters during the same period: one, *Le Bal des Increvables* (1896) for the Casino de Paris; the other, an advertisement for Marguerite Durand's feminist newspaper, *La Fronde* (1897). The representation of women was a central issue: the first shows a naked muse bewitching a gaggle of men, and the second is a group of determined women from different sociocultural backgrounds with serious ambitions. The images are clearly treated in very different ways: the first uses a lively and serpentine line, and the second prefers a more realistic observational drawing. Two designs, two drawings.

Women's bodies were omnipresent on posters from 1890 to 1900. If one observes the particular corpus of posters that advertise exhibitions of posters, the eroticized bodies of women almost became a metaphor for the poster. One could mention Mucha's poster for the Cassan printworks (1896) with a topless woman at its center, hair flowing out in waves, women falling at her feet, or even his poster for *Le salon des cent* (1896).

The modernity of the posters at the end of the nineteenth century was achieved by working with the female motif through an eroticization of lines, skin tones, and postures. How could a young woman have appropriated the transgressive line of Art Nouveau without appropriating the sensuality of pleasure, the pleasure of capturing the beauty of young bodies, pleasure for its own sake? The body, duties, and freedoms of female artists forbade them to brush up against Eros or Thanatos with the same aesthetic candor. Yet Jane Atché came as close as possible to mastering this sensual line. She spent three years working in the shadow of Alphonse Mucha.

Ruptures

Constant and Laurens, her teachers, observing the ease with which Jane Atché mastered drawing and printing techniques, encouraged Mucha to take her on as his student. He is named as her teacher in the 1897 catalog of the Salon of French Artists (the lithography section). Commissions continued to pour into the master's studio, and that same year, he moved into a much larger studio on rue Vale de Grâce, surrounding himself

with assistants. Like Rodin, Mucha dabbled with printing but needed help to accelerate the pace and intensity of his production. There is no doubt that Jane Atché contributed to the 134 lithographic prints in the book *Ilsea, Princess of Tripoli*, and *Pater*, published in 1899. The formal kinship that the two artists shared can be seen in Mucha's *Têtes Byzantines* and the decorative panels created by Jane Atché: *Le Gui et le Houx* (1898), *La Femme aux pavots* (1899), and *La Cigarette* and *l'Éventail* (1903).

Working in Mucha's studio, Jane Atché developed an art of composition somewhere between Art Nouveau and Pre-Raphelite art, where the central female figure is interwoven with the background, with symbolic and biological attention paid to flowers. Possessing a certain dexterity, alluding to techniques of enameling, stained-glass windows, marquetry, tapestries, and even wallpaper, Jane Atché's work was consistent with the basic principles of William Morris: a revalorization of craft that brought value to everyday life and a transformative effect on living conditions. Claudine Dhotel-Velliet suspects, based on a letter written by Jane Atché's sister, a love affair between master and student that could explain Atché's retreat and eventual isolation from the art scene.

Figure 1.2.3 *Left:* Jane Atché, *La Célestine* poster, circa 1898. Lithograph on paper. *Right:* Jane Atché, *Le Gui et le Houx* (decorative panel), 1899. Color lithograph. Bibliothèque Nationale de France.

Jane Atché ultimately left Mucha, this greatly admired master. How and when exactly is not known. Although her beautiful posters for *La Célestine* and *Chocolat Vincent* probably date from this period, her creative audacity seems to have been cut down in full flight toward the end of 1899.[8]

To add to her great difficulties of acculturation (her parents had no links at all to the art world), Jane Atché also bore the weight of her social origins, provincial and petit bourgeois. She had no developed social network and was not part of an art scene that could have helped maintain and encourage some sort of creative impetus (as was the case for Julie Manet in 1878). This social determinism is visible in her productions, where women are endowed with an irreproachable respectability. Her poster for Vichy liqueur, *La Célestine*, is remarkable in its austerity. Her female figure—almost religious—standing upright, holding a bottle, leaning on a gothic structure, providing a view of a building and a landscape. All of this evokes a form of classicism and a rural, medieval atmosphere. At the time, posters advertising alcohol were generally much more cheerful.

The medieval inspiration underpinning Atché's work seems to reference a representation of the devout woman. In her illustrations (notably for Désiles wines), she also continues a representation of regional folklore, which is particularly visible in her poster for Chocolat Vincent au miel de Provence, with a male figure that looks more like a woman with a mustache in profile. Jane Atché was born into a Catholic family and a relatively modest one at that. Her compositions are tightly framed, with even dancing bodies having relatively little free space in which to move. Where Camille Claudel (1864–1943) struggled with the body, her feelings, and her outbursts, Jane Atché perhaps opted for a quieter life.

Jane Atché married "watchmaker" Raymond Leroux in December 1905, nine months after the death of her younger sister, also an artist. This was followed by her father's passing in 1907 (they were perhaps the two greatest supporters of her artistic career?). Thus began a gradual retreat from public life and exhibitions, with less and less attention being paid to her work. She faded into the background, no doubt living a happier, more tolerable life. In July 1918, her husband, a second lieutenant at the time, "died for France" at the Marne near the end of the First World War. Jane remarried in April 1920, at the age of forty-seven, to Arsène Bonnaire (1862–1947), a widower and salesman. Jane and Arsène had known each other through mutual friends for over twenty years. They settled in Rabastens, the city where the artist had spent her childhood (now home to many of the artist's works). She visited Paris occasionally, having kept an apartment in the 17th arrondissement. Although she joined the Union of Women Painters and Sculptors in 1908, her painting continued to decline. From 1908 onwards, she no longer participated in official events or exhibitions, only showing her painting to family and close friends.

A shadow of authority hangs over her work, as can be seen in the cover she proposed for the German magazine *Jugend*: in the foreground, a young woman wearing a crown of morning glories, and in the background, the shadow of a majestic and sovereign father

figure. Who is this master? One might also mention her drawing *Fiat voluntas tua*[9] (*Thy will be done*, 1899). Visible in the background of her drawings, but also on a symbolic level, one can detect a submission to the will of another superior, divine (male) being.

Figure 1.2.4 Jane Atché, cover illustration, *Belle capricieuse: valse par Gabriel Allier*, 1904. Bibliothèque Nationale de France.

Lettering

The artist plays just as much with the autonomy of the line when working with a different type of body: that of letters. In her musical scores, Jane Atché engages the letters in lyrical flights of fancy. In *Le vertige Valse* by G.F. Breuksine (1904), the letter is placed in the foreground on the same level as the illustration. The letter invites itself into the image to form links. In *Missel d'amour valse* by Gabriel Frontin (1903), the letters' interlacing responds to the woman's solitude shown in profile. This formal rhetoric can be found on numerous scores: a woman's body arranged like letters along with a calligraphic title. The composition of *Belle Capricieuse* is particularly fanciful in its response to the falling marguerite petals. The letter, considered an organic structure, becomes an entirely separate space to be explored (in the manner of Hector Guimard and the Castel Béranger).

It seems that Jane Atché was never a model who posed for painters. It also seems that at a very young age, she wanted to impose the figure of a woman considered above reproach, whose body was neither the center nor the focus. The first woman she put on a poster had a sense of distinction, a certain affirmation, and something … of solitude perhaps, or of distress. By 1907, Jane had already suffered the loss of her mother, sister, and father. Her first husband died in 1918, and she was childless. Unknown, completely ignored by the art world, Jane died in Paris in 1937, apparently of "infectious flu." Her work raises a number of important questions: When and how does a promising art practice fade away when faced with an absence of support? Is graphic design even crueler for female creators due to its commercial rationality and its power games?

© **Vanina Pinter**

NOTES

1. Jean Bardou (1799–1852) founded a cigarette paper and cigarette company in 1849. In the beginning, the initials JB were separated by a star, then by a diamond, which created the name JOB.
2. They were notably teachers at the École des Beaux-Arts in Paris, then members of the Académie des Beaux-Arts.
3. Cosnier, Colette (1985). *Marie Bashkirtseff, un portrait sans retouches*. Paris: Pierre Horay, pg. 43 (passage translated).
4. Cosnier, *Marie Bashkirtseff*, pg. 149 (passage translated).
5. Jane Atché had no direct descendants. The first female art historian, Claudine Dhotel-Velliet, author of a biography of the artist, is a descendant of one of Jane's close friends.
6. Currently conserved at the Musée d'Orsay.
7. Buci-Glucksmann, Christine (2008). *Philosophie de l'ornement: D'Orient en Occident*. Paris: Galilée, pg. 32 (passage translated).
8. Dhotel-Velliet, Claudine (2009). *Jane Atché: 1872–1937*. Lille: Le Pont du Nord, pg. 55 (passage translated).
9. With which she obtained an "honorable mention" at the 1902 Salon.

1.3

Varvara Stepanova: Life under Construction

Dr. Olga Severina

As the new century came of age in nineteenth-century orthodox Russia, the old country was being shaken to its very core. Weakened by the world war and rampant political unrest, the entire fabric of its archaic society was rapidly disintegrating. The kingdom that stood for a thousand years was on the verge of collapse. It was the end of the world that was and the dawn of a new era—the age of a neoteric republic that brought forth a fundamentally new brand of citizens and a truly revolutionary way of life.

The advent of this "Great Transformation" is inherently linked to the formation of new artistry forged by the dramatic changes that engulfed the country during this period. To understand the origins of these novel arts, it is imperative to explore the historical context that became a backdrop for the audacious creative advancements of the early twentieth century.

On the eve of the Revolution and in the days that followed the emergence of a new republic, nearly every aspect of life in Russia underwent an irreversible transformation.

Figure 1.3.1 Varvara Stepanova, photo by Alexander Rodchenko, 1931. © Varvara Stepanova and Alexander Rodchenko Family archives.

Resenting the lifetimes of mistreatment and hardships, in a few short years, the discontented masses demolished canonical hierarchies, nationalized all means of production, and ended the czarist rule, placing power into the hands of the people.

Galvanized by the life that was being remade in front of their very eyes, the turbulent Russian art world was bursting with waves of experimental creative styles that became known as the Russian Avant-Garde. One of the masters of this pivotal twentieth-century movement was Varvara Stepanova, a multidisciplinary artist who was a painter and a stage set designer, a graphic artist and a poet, an illustrator, and a fashion designer.

The Early Years

Varvara Stepanova was born in Kovno (modern-day Kaunas, Lithuania) on November 4, 1894, into a family of a minor government official. Her father, Fyodor, worked for the postal office, and her mother, Alexandra, was a housewife. Varvara had two siblings—a brother, Dmitry, and a sister, Naina. The family moved from place to place before settling in the Russian city of Kazan. From a very early age, the future "Amazon of the Russian Avant-Garde" loved to draw and dreamed of becoming an artist. Following her passion, sixteen-year-old Varvara began her studies at the Kazan School of Art in 1910.[1]

As a young student, Varvara was drawn to the emerging creative trends sweeping pre-Revolutionary Russia. Together with Alexander Rodchenko[2] (1891–1956)—who would later become her husband and lifelong creative collaborator—Varvara attended a lecture presented by Vladimir Mayakovsky (1893–1930), Vasily Kamensky (1884–1961), and David Burliuk (1882–1967) when they visited Kazan in 1914 as part of their cross-country tour. The lecture introduced the audience to one of these new-age movements—a neoteric form of expression that became known as Russian Futurism.

Moving to Moscow

Inspired by the lecture, Varvara soon dropped out of school to move to Moscow, where she continued her education, attending workshops of great contemporary masters such as Konstantin Yuon (1875–1958), Mikhail Leblan (1875–1940), and Ilya Mashkov (1881–1944), while she earned a living as a bookkeeper, a librarian, and a secretary. In the first decades of the twentieth century, Moscow was truly a place to be for any devout modernist. Varvara joined a group of young, like-minded artists who were creating the art of the future. This guild of new-age artisans—people like Lyubov Popova (1889–1924), Vladimir Tatlin (1885–1953), Olga Rozanova (1886–1918), and Alexander Vesnin (1883–1959)—were casting aside the antiquated canons of conventional arts and inventing the new-world artisanship defined by novel, provocative concepts and daring transformations of the stylistic formulae. It was the golden age of creative anarchism that gave rise to

such groundbreaking innovative styles as Cubo-Futurism, Suprematism, Russian Futurism, Constructivism, Zaum, and Neo-primitivism that became the principal movements of the Russian Avant-Garde.

As the young avant-gardists were passionately theorizing and bringing to fruition the new-wave arts of the Modern, the world around their simple, often barren workshops was on the precipice of an abyss. The dismal omens of the looming downfall were the abdicated throne of a 300-year-old dynasty, a failed grain requisitioning program, and rampant mutiny among the troops. The ossified kingdom was cracking under political pressures, and in 1917, the crumbling country erupted into the Russian Revolution,[3] bringing misery, tumult, and havoc. The bulwarks of old life were now scattered heaps of rubble, yet from the ruins of the fallen empire, amid the chaos, anguish, and upheaval, a state like no other was achingly coming to life.

Despite the utter devastation and lack of the basic essentials that still plagued Russia in the wake of the Great Turmoil, it was an era of unprecedented enthusiasm. The nation was intoxicated with a flood of newfound liberties brought forth by the Revolution. Perhaps the most profound amidst a deluge of sociopolitical reforms carried out by the new regime was a mandate that guaranteed equal rights for women and men. The country was now a dominion of the gender-neutral working class. The proletariat, and not male-dominated elites, had the seat of power. A legendary rallying cry commonly heard on Bolshevik Russia's streets proclaimed: "Any scullery maid can now govern the state!"

These far-reaching freedoms, unheard of in the empire of old, gave the art world a powerful creative momentum that was in no small part fueled by the female visionaries who stood at the vanguard of novel creative artistry. Often called "Amazons of the Russian Avant-Garde"—Alexandra Exter (1882–1949), Natalia Goncharova (1881–1962), Lyubov Popova (1889–1924), Olga Rozanova (1886–1918), Nadezhda Udaltsova (1885–1961), and Varvara Stepanova, along with their male counterparts, became the "art engineers" of the new republic.

The Russian Futurists of both genders greeted the new state with exuberant fervor and widespread elation. The art studios of Moscow's avant-gardists exploded with ambitious new projects praising life being reconstructed anew. "We hail the Revolution as the only engine of life," professed Varvara Stepanova and Alexander Rodchenko during these early days of a newborn country.

This sense of jubilant euphoria that permeated the air of a young nation was in defiance of the many plights that continued to ravage the realm. Those days of hardships and joy were chronicled by Vladimir Mayakovsky—a Soviet Futurist, poet, artist, and arguably the most faithful paladin of the Revolution. In his "Open Letter to the Working Class," he wrote: "The fork-tongued flames of war and revolution—they burned our souls and torched our cities. Once lavish halls are all but bones and ashes. The cities that lay waste await the new and eager architects. I write to you, the heirs of the legacy of Russia, as you will soon (I know it!) become the masters of the world …"

Figure 1.3.2 Varvara Stepanova, collages for the book *Gly-Gly*. Author: Alexei Kruchenykh, 1918. © Varvara Stepanova and Alexander Rodchenko Family archives.

Moscow, although not yet a seat of the Soviet government, was undeniably a capital of all contemporary arts. The architects of the Russian Avant-Garde were redefining the very idea of what art is and what its place is in the modern world. Breaking free from any formerly sacred doctrines of traditional artistry, Varvara Stepanova and her fellow inventors declared any illustrative imagery depicting objects or elements of the natural world obsolete. True agents of the new arts, they turned their canvases into abstract plains of non-representational visualizations that featured rudimentary pictorial units—geometric shapes, random textures, and colored splatters. This minimalist visual language will later be known as non-objective art.

Zaum (Visual Poetry)

While exploring this emerging creative style, Stepanova became fascinated with "Zaum" or "Visual Poetry"—a non-contextual literary construct where transrational phonemes are assembled into an arbitrary framework of absurd, undecipherable lyrics. Varvara's painterly stanzas, written with broad strokes of brightly colored script, crystallized into "Graphic Colorgraphy"—an amalgamation of illustrative neologisms that professed coequality of

rhyming phonemes with abstract pictographic lexicon. Bereft of any traditional subject matter, which would undermine the symbolic unity of character and image, her abstruse compositions are akin to non-communicative verbalizations and scribblings of young children.

When creating her visual poetry, Varvara never locked herself into using any specific techniques or materials—lithography and engravings, stencils, and spray guns—nothing was off limits. Varvara was a master calligrapher who often used a paintbrush to create her literary visualizations, eager to let some non-existent oriental ancestry bring out her latent inner scribe.

One day, an engrosser, Varvara Stepanova easily switched gears to spend the next day as a typist, often using a typewriter to transfer her latest linguistic pseudo-phraseologies onto paper. A practical tool for ordinary artists, the typewriter became an instrument of illustrative rather than literary expression in many of Varvara's transrational poems. She was not simply transcribing her verses but rather searching for their inner placement within the plains of the untrodden pages. Unbound by any predefined restraint, Varvara situated letters high and low upon the sheets, assorting characters into abstruse morphemes shaped as geometric figures.

Varvara Stepanova's "Graphic Colorgraphy" is a cacophony of improvised media. Onto the pages, she would often glue an assorted patchwork of scraps found around the house—pieces of wallpaper and torn fabric scraps, newspaper cutouts, and mixed collages. In some cases, Stepanova engrossed her non-coherent verses onto newspaper sheets, making them the impromptu pages that encompassed her creative concept. Varvara talks about her abstract poetry in a diary titled "There is no Life when it is Without a Miracle." She writes: "By piercing with my ornate graphics a lifeless tedium of typeset letters' fusion I charge towards a new form of creativity."

Volumes of eclectic poesies like *Rtny homle*, *Zigra ar*, and *Globolkym*[4] that Varvara Stepanova wrote between 1917 and 1919 were a beauty to behold and a nightmare to publish. Regular book layouts simply could not absorb Varvara's vision of what an avant-garde folio should be like. Publishers demanded that she follow approved guidelines—work with standard sheet sizes, transcribe lines of text only in a horizontal direction, and use a single typeface. Unwilling to compromise, Varvara "self-published" her nonsensical lyrics by handwriting each individual sheet and binding them into 10-page folios. She'd make very few copies of these homemade manuscripts, which she kept for herself and distributed among friends.

Working in the Theater

As practitioners of the abstract were inventing creative styles like non-objective art and visual poetry, the country, too, was reinventing itself. Once an archaic, agrarian state, post-Revolutionary Russia slowly began moving towards industrialization. Many Russian

Avant-Gardists who once hailed the Revolution quickly fell under the spell of the industrial age of the early 1920s. Aflamed by sprouting technological developments that promised a pathway to the future, the artists began developing new forms of expression that promoted and stimulated social progress.

The result of these radical creative endeavors became known as Constructivism. In this new art movement, pieces were created not as aesthetically pleasing imagery but as utilitarian "art products" with a clearly defined purpose. The name "constructivism" came from the word "construct" and described artworks that were not created but engineered to be intrinsic components of a larger unit that was modern life.

Like many of her fellow Futurists who became the true adherents of industrialization during this time, Varvara Stepanova made a fateful decision to transition from illustrative artistry into the arts with a purpose. She describes this new creative movement: "Art that is turned into action, into a manifestation of objective reality, becomes a blueprint for manufacturing a life that never existed before."[5] Entirely dedicated to this novel form of creative expression, Varvara never again referred to herself as an artist—since then, she only called herself a constructivist.

A movement that redefined the very meaning of contemporary art, Constructivism demanded new types of exhibition halls. For Varvara, the theater stage became this novel and perhaps the most memorable showroom. As avant-garde experiments were taking over the art world of Bolshevik Russia, in the realm of performing arts, there was no playhouse more radical than Meyerhold Theater and no director more daring than its renowned director Vsevolod Meyerhold[6] (1874–1940). Equally brilliant and audacious, the two artists seemed destined to join forces, and, as fate would have it, they began collaborating in 1922 when Meyerhold hired Varvara as a stage engineer for an upcoming production, *The Death of Tarelkin*.[7]

Working with Meyerhold, Varvara practically rewrote the book on stage and theater design. She eliminated all traditional scenery, placing simple, white-painted props on stage against a plain brick wall. Some props resembled furniture, whereas others were nothing but boxes and screens. At the back of the stage was an ambiguous structure reminiscent of a hybrid between a meat grinder and a police booth. During scenes, a specially designed screen would come apart, the meat grinder's wheel rotated, and the chairs folded under the actors or sprung back into place pulled by elastic bands. Perhaps the most impressive stunt prop Varvara created for *The Death of Tarelkin* was the "meat grinder." In the play, the actors climbed up the wooden stairs attached to the fabrication to reach the mouth of the piece, then climbed into the opening, and finally, after flipping inside a huge rotating drum, ended up in a barred box that looked like a mocked prison cell.

A fully committed artisan, Varvara also created costume designs for the entire troupe, with each character's outfit having a distinct combination of geometric patterns and either a light or a dark color scheme. These simple but vivid outfits made performers look like animated geometric blocks that popped against the unembellished stage.

Figure 1.3.3 Varvara Stepanova, sportswear designs, *LEF* magazine, 1923. © Varvara Stepanova and Alexander Rodchenko Family archives.

The Death of Tarelkin was made into a folk farce, which should have contrasted with the stern aesthetics of Constructivism. Varvara's avant-garde vision, however, fused perfectly with the mastery of Meyerhold's absurd and grotesque theatrics. Many believe that it was primarily due to her groundbreaking designs that *The Death of Tarelkin* became such a sensation among the theatergoers of the young proletarian state.

Designing Clothing

This was the age of the great pursuits for the nascent republic that was forging itself into a new nation requiring a new brand of citizen—a bold, free-thinking cosmopolite unburdened by the old-fangled pettiness of bourgeois life. Russian avant-gardists, animated by these changing realities, began working on a fundamentally different type of apparel that would help bring about and shape the citizen of tomorrow. They believed that by putting on a different outfit, a person was "putting on" an alternate identity and thus becoming a changed human being—the one who would engineer the future.

Prozodezhda (industry garments) were comfortable and functional workers' coveralls intended for various fields and professions, which became arguably the most emblematic clothing concept that came out of this effort to define post-Revolutionary fashion. Every design element of prozodezhda, from heavy-duty, damage-resistant fabrics to trade-specific functional details, was carefully thought out and individually tailored to a particular line of work. Prozodezhda was meant to be more than just an attire; it was conceptualized as another tool to be utilized by the workers.

Drawn to this idea of molding the citizen of the future, in 1923, Varvara began creating clothing designs for different areas of modern life. In her apparel, which ranged from worker's uniforms and sportswear to everyday attire, Varvara sought to accentuate the mechanics of movements while adhering to the constructivist notions of frugal aesthetics and useful functionality. Stepanova outlined her approach to clothing design in her lecture at INHUK (Artistic Culture Institute that operated in Moscow in the 1920s):

> True contemporary apparel is defined by two basic designing principles: comfort and functionality. There is no such thing as an outfit in general; there is only attire engineered for a specific function. The life cycle of modern apparel begins with the initial specs, continues onto fabric design, and culminates in tailoring it into prozodezhda to make it best fit its intended use.

Varvara followed these principles with genuine ardor. The painter's coveralls she designed with Rodchenko were shaped like a comfortable boilersuit with different-sized pockets to hold pencils, erasers, and notepads. Her suit for drafter engineers had a similar multi-pocketed design crafted to allow industry-specific measuring instruments to fit into custom-made pockets. This ample use of pockets became Varvara's trademark and is found

Figure 1.3.4 Varvara Stepanova, textile patterns 1920–24. © Varvara Stepanova and Alexander Rodchenko Family archives.

in many of her clothing designs. To streamline her process, Varvara developed templates that could be adapted for a particular type of labor by adding appropriate functional elements. She viewed templates as stepping stones for bringing prozodezhda into the factories to be mass-produced for the citizens of tomorrow.

Building on the constructivist notions of simplicity and pragmatism, Varvara developed a novel concept in clothing design—function versus fashion. While drafting her

clothing patterns, she would abandon all traditional decorative lines and make the outfits' functional details like pockets, straps, and stitching the new ornamental pieces of her avant-garde apparel. She deconstructed this creative style in her designer's manifesto "The Outfit of Today is Prozodezhda," published in the constructivist magazine *Lef* in 1923: "Decorative aesthetics (in modern clothing design) are to be replaced by the production components that are the inherent elements of the outfits' manufacturing process. To be clear (the clothing designer) is not to add any purely ornamental pieces to the apparel but allow the stitchings used to make the outfit define the final shape of the garment."

Alongside prozodezhda, which outlined a visual matrix of the proletariat at work, Varvara was also developing unadorned and practical sports uniforms that set the trends for working-class athletes. Following the same avant-garde doctrines of functional aesthetics, Varvara's sportswear designs featured vivid and concise geometric patterns, contrasting color schemes, and simple shapes that accentuated the lines of a human body while offering comfort and freedom of movement. Embracing the idea of gender equality promoted by the Bolshevik state, Varvara designed her sportswear as gender-neutral outfits that foreshadowed the emergence of contemporary unisex fashions so ubiquitous in today's garment industry.

Varvara Stepanova's groundbreaking designs were an instant hit at the World's Fair in Paris in 1925. Still, war-torn post-Revolutionary Russia lacked the technologies to produce avant-garde apparel, and the designs never went past the development stage; worse yet, some of her sketches are forever lost. Nevertheless, Varvara's works that did survive are now considered the finest examples of constructivist apparel of the Soviet era.

Textile Designs

The early decades of the twentieth century were nothing short of the formative years for the young proletarian nation. Although civil war, hyperinflation, and a terrible famine still ailed parts of the heartland in the 1920s, comprehensive political reforms like the *New Economic Policy* and nationwide electrification efforts took the country on the road to recovery. Fueled by this economic growth, new industrial workshops were being opened all over Moscow—now the capital of Russia—and factories once owned by the upper class were starting to come back online.

Moscow's First Textile Factory was one of these plants that resumed operations in 1922, following a prolonged interruption caused by the Revolution and subsequent nationalization. Factory management chose to forgo unpopular, bourgeois textile patterns and placed newspaper ads, inviting avant-garde artists to become creators of the new-era fabrics. With her friend Lyubov Popova—another creative visionary of the avant-garde—Varvara answered the ad. In less than twelve months, they created several hundred textile designs for the new collection. About twenty of Varvara's design patterns were later put into production.

Figure 1.3.5 Varvara Stepanova, cover for *Kino-Fot* magazine, 1922; book cover for *Mountain Roads*, TransPrint Publishing, 1925; cover for *New LEF* magazine, 1928. © Varvara Stepanova and Alexander Rodchenko Family archives.

Varvara's textile designs were derivations of basic geometric shapes—circles, rectangles, and triangles—which she sketched out using just two simple tools: a compass and a ruler. She did not design but rather "engineered" her fabrics to align with constructivist methodology. The use of drafting instruments for making print patterns was, at the time, a groundbreaking innovation in the textile industry. The Constructivist community sang the highest praises to Varvara's and Lyubov's designs, calling them fierce "art engineers"—avant-gardists who believed that only applied arts solely intended to further the country's development were the arts worth pursuing.

In creating their textile designs, both avant-gardists saw a perfect opportunity to fully embrace the fundamental principle of Constructivism—rejection of "art made simply for the sake of making art" in favor of applied artistry, which had only one master, the people. An ardent "manufacturer," Varvara dreamt of having her work reproduced on an industrial scale. This dream was realized tenfold by the summer of 1924 when nearly all of Moscow wore clothes made from fabrics imprinted with her textile designs. After that summer, Constructivist apparel, de facto, became the genesis of all Soviet fashion.

Later Years

Constantly pursuing novel creative venues, in the second half of the 1920s, Varvara began working in the publishing industry that was rapidly growing in post-Revolutionary Russia. In 1928, she became a designer for the *Modern Architecture* magazine, where she continued to explore her innovative style of avant-garde artistry. She turned a prosaic publication

where architectural drawings were the only illustrations into a magazine known for its visionary layouts. She redefined traditional layout methodology by introducing into her designs articles with diagonal columns, varying-size fonts, contrasting graphical elements, and gripping socialist slogans.

Varvara's magazine designs were the last bursts of her rebellious creative genius as the age of the avant-garde was sharply coming to an end. Once praised by the regime for being "the first Soviet art," in the early 1930s, Constructivism was declared ideologically corrupt, leaving social realism as the only official form of artistry. Bound by government restrictions and self-censorship, Varvara abandoned all innovative forms of expression and, in the twilight of her career, worked solely in the style of social realism.

During the 1930s, Varvara and Rodchenko designed layouts for various publications, including twenty issues of the magazine *USSR at a Construction Site*, which celebrated Soviet industrialization efforts. It was these government-commissioned jobs that may have saved both Varvara and Rodchenko during The Great Purges. Fortunately, in the eyes of the state, they were indispensable as the true masters of proletarian art propaganda.

Varvara Stepanova died on May 20, 1958, leaving future generations a remarkable oeuvre of works, among which are some of the most iconic examples of constructivist applied arts in the twentieth century.

© **Dr. Olga Severina**

Note: The author wishes to thank Professor Alexander Lavrentiev for his support and for providing the images used in this article from the Varvara Stepanova and Alexander Rodchenko Family archives.

NOTES

1. Kazan School of Art is one of the oldest art schools in Russia. Founded in 1895, it is the alma mater for artists like Aleksander Rodchenko, Alexander Grigoriev (1891–1961), and Nicolai Fechin (1881–1955), the school's most famous instructor whose name it now bears.
2. Alexander Rodchenko was a Russian photographer, painter, graphic artist, inventor of the advertising poster, and master of the collage technique. One of the founders of Constructivism, and advertising design innovator, he revolutionized the art of photography and shaped the development of design and applied arts.
3. Brought on by sociopolitical instability in early twentieth-century Russia, the Russian Revolution was an armed rebellion led by the Bolshevik Party in October 1917. The uprising resulted in Bolsheviks seizing power and establishing a socialist state of Soviet Russia.
4. Visual poetry books written by Varvara Stepanova in 1918.

5. Lavrentiev, Alexander (1988). *Varvara Stepanova: A Constructivist Life*, London: Thames & Hudson.
6. Vsevolod Meyerhold was a Russian avant-garde theater director, actor, and scholar. Theorist and practitioner of the theatrical grotesque. One of the reformers of the twentieth-century theater.
7. *The Death of Tarelkin* is a three-act play written by Alexander Sukhovo-Kobylin in 1869. Tarelkin was a minor official who fakes his death to escape pesky creditors and prepares to blackmail his former boss. Things, however, do not go as planned, and now Tarelkin could lose his life for real.

1.4
Fré Cohen: A Dutch Jewish Socially Conscious Feminist Artist

Alice Roegholt

Fré Cohen was one of the most important graphic designers of the first half of the last century. Leading museums in the Netherlands, such as Amsterdam's Stedelijk Museum, have her work in their collections, as does the Museum of Modern Art (MoMA) in New York. Her deft, socially conscious work contributed to the emancipation of laborers and women. She also supported Jewish refugees fleeing to the Netherlands from Germany to escape Hitler's regime in the 1930s. Her work is tremendously versatile, ranging from book covers and ex-libris bookplates to paintings, drawings, lithographs, and woodcuts.

Figure 1.4.1 Fré Cohen, photographic portrait, circa 1920s. Image courtesy of the Museum Het Schip.

Antwerp

Fré Cohen was born on August 11, 1903 to Levie Cohen (1874–1942), a diamond cutter, and Esther Sarlie (1883–1943). Her official name was Frederika Sophia Cohen, but everyone called her Fré. She was later joined by a sister, Sophie (1906–1949), and a brother, Bernard Henri (1912–1945).[1] Fré Cohen spent her early years in Amsterdam-Oost, the city's eastern part, which hosted a sizeable Portuguese synagogue dating from 1675 and two large Ashkenazi synagogues. This part of Amsterdam had a substantial Jewish community. Fré's parents were diamond cutters, like many other Jews working in Amsterdam. There were close links between the diamond trades in Amsterdam and Antwerp, and diamond cutters who could not find work in Amsterdam would often try their luck in Antwerp, resulting in a large colony of Dutch diamond workers in the Belgian city. Fré's father also frequently traveled to Antwerp. In 1908, he took his whole family along with him, and Fré came to live in a Jewish neighborhood again. Many of the houses in that particular neighborhood were built in the Art Nouveau style, which would undoubtedly have made an impression on her. On October 10, 1913, shortly before the outbreak of the First World War, the family returned to Amsterdam—just in time, as Belgium, contrary to the neutral Netherlands, was to become the scene of heavy fighting. Levie Cohen was to return to Antwerp for business occasionally, but the rest of the family remained in Amsterdam.

Amsterdam School

Around the time when Fré returned to Amsterdam, the city was experiencing the emergence of a new style of art known as the *Amsterdamse School*—Amsterdam School. The city was expanding, and new town quarters were being built with buildings in a highly expressionist style somewhat reminiscent of the buildings designed by Antoni Gaudí (1852–1926) in Barcelona. The year 1918 saw the publication of the first edition of a new magazine focusing on architecture and decorative arts. This magazine, called *Wendingen* (Inversion/Upheaval), was the mouthpiece of the Amsterdam School, and its publications even included a few English and German issues besides the Dutch ones. The magazine's broad orientation included oriental architecture, particularly that of the former Dutch colony Indonesia, and the buildings of Frank Lloyd Wright (1857–1959), to which it devoted several issues. Besides architecture, the magazine also covered various ornamental arts, such as typography.

The term "Wendingenstijl" (Wendingen style) started to be used because the magazine paid close attention to its typography. At first, it used sturdy, strictly geometric letters in harmony with the brick architecture of the Amsterdam School, but the style soon became more elegant and expressionist. There was no single, uniform Amsterdam School typography: all the artists designed their own letters. Above all, the *Wendingen* magazine

symbolized the artists' search for a new design for modern times, and in this respect, it was very influential. Fré Cohen didn't do any work for the magazine; she was probably still too young then.

The Amsterdam School had a profound impact on Fré Cohen. In 1923, she started studying at the School of Graphic Design, and after that, she attended the School of Applied Arts in Amsterdam, which in those days focused primarily on the style of the Amsterdam School. Several of her teachers designed covers for the *Wendingen* magazine.

The Amsterdam School couldn't have escaped Fré Cohen's attention because she came to live in some of the buildings designed in this style herself. In 1924, she and her parents moved to a building in the then-new Betondorp quarter in the east of Amsterdam, and in 1933, she acquired her own studio in Amsterdam South, known as the famous Plan Zuid area built in the 1920s. It was to this neighborhood that, in 1933, Anne Frank (1929–1945) and her family moved from Germany, having become fearful of the future following Hitler's assumption of power.

The architect H.P. Berlage (1856–1934) proposed the urban development plan, and its buildings were designed by architects working in the style of the Amsterdam School, one of whom was the Jewish architect Michel de Klerk (1884–1923), the great pioneer of this style. Like Fré Cohen, he grew up in a family of diamond workers in the eastern part of Amsterdam.

The Family Cohen

Family was very important to Fré Cohen. Officially banned from living in her studio, she registered the homes of her uncles and aunts as her home addresses in Amsterdam's population register. This meant that she was officially registered at different addresses around Amsterdam during the 1930s while she lived in her studio, furnished with chairs and tables to give it a homely feel. It also contained a piano that she liked to play.

The story goes that her parents were unhappy about their elder daughter leaving home. But they were soon to move home themselves, to an address close to Fré's studio. Their new house belonged to the Algemene Woningbouw Vereniging, the General Housing Association closely affiliated with the diamond cutters' union. Her brother was also to leave the parental home when he married. And so did her sister, who was married in 1929 to a young German social democrat called Paul Waltemathe, whom she had met at one of the camps organized by the Socialist Party's Youth Organization. She and her husband moved to Germany, where they had two children, Freddie and Ernst. But in 1938, she returned to Amsterdam when the Nazi regime forced her to divorce her husband, and she no longer felt safe in Germany. She and her two sons moved in with her parents, and then all the members of the Cohen family once again lived close to one another, within a radius of a few hundred meters.

Fré Cohen herself never married, and little is known about her love life. She did have lots of friends and a busy social life. For instance, she was good friends with the Dutch socialist leader Koos Vorrink (1891–1955), for whom she designed many brochures. For his thirty-fifth birthday, she created a special manuscript written in calligraphy and bound in a Japanese way. Entitled "Romance," it recounted a medieval story about two royal children who were in love with one another—but are we to see a deeper meaning in this?

Another close friend was the poet and journalist Joseph Gompers (1899–1945), with whom she worked closely helping Jewish refugees. She created ex-libris bookplates for him and illustrated many of his articles. He wrote a poem commemorating Fré Cohen on May 1, 1944, during his time in the Bergen-Belsen concentration camp. The poem, entitled *De roode meidoorn bloeit* (*The red hawthorn flowers*), acutely expressed Fré Cohen's faith in a new, righteous world. Gompers wrote this poem especially for Fré's brother, who was interred in the same concentration camp. Joseph Gompers did not live to see the end of the war. He was transferred to Theresiënstadt and died shortly after his liberation in Tröbitz, where his train had been switched from the main track to a dead end. Fré's brother, who remained in Bergen-Belsen, was likewise to succumb to the hardships of the concentration camp. It is thanks to a fellow prisoner who did survive the war that we still have the poem.[2]

Social Democratic Workers' Party

Fré Cohen shared the ideals of the Amsterdam School, whose slogan was "Nothing is beautiful enough for the worker who has had to live without beauty for so long." Much of the graphic work was for organizations allied to the labor movement. No surprise here, considering Fré's "red" family background. She was a member of the Stem des Volks (Voice of the People) youth choir and regularly enjoyed nature camps organized by the Arbeiders Jeugd Centrale (AJC; Socialist Party's Youth Organization),[3] for which she designed brochure covers and invitation cards for many years. At the age of twenty, Fré Cohen started working for De NV Ontwikkeling, a publishing firm allied to the Nederlandse Sociaal Democratische Arbeiders Partij (SDAP; Social Democratic Workers' Party), just like the AJC.

After starting as an office clerk, she soon began designing book covers whose impressive covers caught the attention of newspapers that wrote about them. She also became involved in the Socialistische Kunstenaars Kring, a socialist movement aiming to bring art to the people.[4] In 1930, she participated in a major international exhibition of this organization in Amsterdam's Stedelijk Museum, which also featured works by artists from Germany and Russia, such as the architects Bruno Taut (1880–1938) and Walter Gropius (1883–1969). Fré Cohen submitted printed matter she had made for the labor movement, one of which was a poster for a peace demonstration.

Figure 1.4.2 Fré Cohen, cover for *Hoogty, Tag der Freude*, 1926, Progress, German Edition. Image courtesy of the Museum Het Schip.

She designed this poster specifically for a joint demonstration of the Social Democratic Workers' Party and the Dutch Trade Union Confederation. The image depicted a working-class couple with their baby and called on people to demonstrate against the Fleet Act on September 14, 1930. The man holds a red flag while the woman, wearing a red dress, holds the baby on her arm like a kind of Madonna. Below them is the text: 't Gaat om de toekomst van uw kind—kind tot geluk geschapen (Your child's future is at stake—child born for happiness). It was a lithograph that she had drawn on a flat stone that was then printed on paper in a press. The poster shows the colors red, black, and white and sturdy capitals contrasting with the flag's jaunty flutter, making it an excellent example of the Amsterdam School style that Fré Cohen used in her designs at that time. The ratios and combinations of outlines reflect the architectural style of the Amsterdam School.

Figure 1.4.3 Fré Cohen, *September 14 Rotterdam* poster for the NVV and SDAP, The Concern is for Your Child's Future. SDAP (Social Democratic Workers Party) Meeting Rotterdam, Amsterdam 1930, Dutch Confederation of Trade Unions. Image courtesy of the Museum Het Schip.

A Feminist Artist

Fré Cohen was a self-confident woman, a real feminist. Much of her work was for publications by women or women's organizations: covers of poetry books, novels, and magazines. Among the latter designs was the running header of *Ha'ischa*, a magazine published by the Jewish women's associations in the Netherlands. She also designed the covers of booklets published by the socialist women's library and provided several illustrations for the *De Proletarische Vrouw* (*The Proletarian Woman*) magazine.

Her design for the flag of the Sociaaldemocratische Vrouwenclubs (SDVC; Social Democratic Women's Clubs) caused quite a sensation because, in the 1930s, the Dutch government had banned politically charged flags at demonstrations. A few women who ignored this ban had to appear in court, and their defense council summoned Fré Cohen to appear as a witness to convince the district judge that her bright red flag adorned with flames was not politically charged. Fré Cohen tackled this tricky situation by explaining that her only aim in designing the flag had been to create a "purely decorative solution, inspired by common idealism." The judge commented on her having chosen the color red. "Yes, your honor, a nice bright color," she answered. The judge continued: "And then you drew some white flames on it and added some green, the color of hope." Fré Cohen: "I hadn't really given that any thought." To which the Public Prosecutor responded: "How would you have designed a flag for a chess club?" "Madam might have drawn a king on it," suggested the judge, who was willing to accept that purely artistic motives had inspired Fré Cohen.[5] The Public Prosecutor was not convinced and demanded a fine of five guilders or two days in prison. The judge did not accept this sentence, and in the written judgment that followed a week later, both women were discharged from prosecution.[6] In writing about this court case, the feminist magazine *De Proletarische Vrouw* reported that when the women's union's flag was unfolded before the judge, the members of the union who were present in court asked themselves whether they had actually fully appreciated Fré Cohen's design for their flag: "Not only its beauty" but "also its significance for the movement."[7]

Fré Cohen was one of the few graphic designers who could live off the proceeds of her work. Her nephew, Ernst Waltemathe (1935–1997), a member of the German Bundestag—on behalf of the SPD for many years after the Second World War—even referred to her as his "rich aunt." Fré Cohen's ability to make a career for herself in a male-dominated world was a remarkable achievement. But her efforts were not always appreciated—if things did not go entirely according to her plans, she often became impatient, earning her the nickname "Saartje Wip" ("Seesaw") among male colleagues.

Printing Office of the City of Amsterdam

In 1929, Fré Cohen joined the printing office of the City of Amsterdam, responsible for the graphic design of the city's printed matter.[8] This appointment she owed to her

Figure 1.4.4 Fré Cohen, Calendar, Printing Office Amsterdam, 1929. Image courtesy of the Museum Het Schip.

winning a contest for a calendar of 1929. Her design was entirely in the style of the Amsterdam School: sleek shapes, fairly dark colors, and a distinct sans-serif typeface. The director of Amsterdam's printing office expressed his enthusiasm about it in the Christmas edition of the *Drukkersweekblad* printers' magazine of 1928 by praising "Miss Fré Cohen" for her keen awareness of the need for her, as a designer, to understand the possibilities and limitations of printing: *Als de meest volleerde zetter spreekt ze van geheele en halve cicero's, drie en vier punten wit. (…) Als onze sierkunstenaars over het algemeen zoo handelen, zouden we veel meer dan tot dusverre kunnen spreken van kunst in het boekdrukkersvak* (Like the most accomplished typesetter she speaks of whole and half ciceros, three and four white spaces. (…) If our artists were generally to act like this, we would be able to speak of art in book printing to a much greater extent than we have hitherto done).[9]

Fré was to design almost all the printed matter of the City of Amsterdam, including the booklet of the municipal giro bank and various city coats of arms. Her appointment to this post attracted much attention: never before had a woman been in charge of Amsterdam's design department. A German magazine commented on the "modern principle of an independent female manager" finally making its appearance in the "ultraconservative" Netherlands, with particular reference to Fré Cohen, "whose decorative sensibility" had managed to convince Amsterdam's city fathers of the importance of the city's printed matter being properly and artistically designed. The magazine praised her for possibly being the only woman working as an aesthetic advisor in a city printing office.[10] Her work had an impact in England, too. Heading an article on Amsterdam design written by William Farringdon in the London-based magazine *Advertising Display* were the words, "Amsterdam makes even cheque books look lovely."[11] He referred to Fré Cohen as Amsterdam's printed matter expert, quoting a few examples of her designs, including the aforementioned cheque book, a marriage certificate, and some school diplomas. Farringdon concluded that England could learn much from Amsterdam's approach to designing printed matter.

In 1934, the Midland Master Printers Alliance in Birmingham—the largest printers' organization in the British Midlands—some of whose members had previously visited printers in Amsterdam and attended a lecture by Fré Cohen, invited her to exhibit her graphic work in England and deliver a speech about modern Dutch design. The lecture, which was titled "Modern Lay-out in Holland," was delivered in seven different towns. English newspapers announced the lectures and the journal of the British printers' organization published the entire text of her speech, followed by a few brief but very positive comments. In her lecture, Fré Cohen talked about the new views on typography that were taking shape in the Netherlands, the Amsterdam School, and the origins of the "Wendingen style." She found this new style very important, but she immediately added that this "decorative movement" would "of course" inspire a reaction. She ended her lecture by commenting that designers should be free to develop themselves: "We do not want to be bound by old traditions that curtail our creativity. We want to follow tradition

Figure 1.4.5 Fré Cohen, Antisemitica bookplate, 1936. Image courtesy of the Museum Het Schip.

when necessary, but otherwise, we want to be totally free." Fré Cohen believed beauty lies in the "harmony of essential elements." A final result has to be an efficient, practical product but also a product that expresses the beauty of its time.[12]

Jewish Refugees

At first, Fré Cohen's Jewish background didn't play an essential part in her work. Her family honored Jewish traditions, but religion wasn't a big issue. This changed when fascism emerged in Germany and started threatening Jewish lives, resulting in a major exodus of Jewish refugees to Amsterdam after 1933. Concerned about their fate, Fré Cohen began to help them by making designs for an emergency fund intended to support Jewish refugees financially. At the request of a few publishers, she designed covers for books written by authors who had fled Germany, such as Lion Feuchtwanger (1884–1958), Emil Ludwig (1881–1948), and Joseph Roth (1894–1939), whose works in question are known as "Exilliteratur."

She also designed the cover of *Phoenix*, the magazine of Amsterdam's Portuguese Jewish community. In 1935, she made drawings to illustrate a series of articles by her good friend Joseph Gompers (1899–1945) in the *Nieuw Israëlietisch Weekblad*.[13] The series, entitled *Zwerftochten door Klein-Jeruzalem* (*Wanderings in Little Jerusalem*), started with a climb up the Portuguese Synagogue. Joseph Gompers worried about Fré Cohen's white summer frock in the synagogue's rather dirty attic. They made it out onto the roof, from where they had a stunning view of life in the nearby Jewish neighborhoods.

A Versatile Artist

Fré Cohen was an extremely versatile artist. Besides the many graphic design projects she produced for publishers and printers, she created other work, too. She liked to experiment with different mediums, such as photography and photo collage. Also of interest was the method of creating pictorial statistics introduced by Otto Neurath (1882–1945), Gerd Arntz (1900–1988), and Peter Alma (1886–1969) in Vienna, which involved expressing statistical data in icons instead of numbers, with each pictogram representing a number.[14] Fré also enjoyed designing ex-libris bookplates using woodcuts. She would gouge images in softwood, which were then printed on paper. Her highly successful bookplates earned her an honorable mention at the Bookplate Association International annual exhibition in Los Angeles in 1932. The award was for her bookplate designed for the actress Marie Hamel (1897–1964), and it depicted an actress with two masks surrounded by flames and a radiant sun. The award attracted a lot of publicity for Fré Cohen.[15]

Another of her favorite pastimes was painting. Fré didn't have much time for it in her everyday life, but she spent almost all her time painting when she was away on holidays. She would then give her customers a bookmark showing a painting woman on the front and on the back a text telling them she would take a break from a year of hard work, hoping to later return to Amsterdam "full of new impressions and fresh ideas." She liked to spend her holidays at Ascona, an idyllic village on the shore of Lake Maggiore in Switzerland—a famous artists' haunt and a haven for utopians and idealists. The village also attracted many Jewish artists who had fled Germany. Fré illustrated an account of one of her trips to Ascona in a Dutch family magazine. She also wrote the article describing the idyllic village with its "typically Bohemian atmosphere" as a lovely tourist attraction. She wrote about the nature-loving vegetarians and principled nudists, saying that nothing was considered shocking or outlandish in Ascona: "Here, people who enjoy bathing in the lake and all the good things in life live side by side with Buddhist 'Yogi.'"[16]

Some of the watercolors and pastel drawings she made in Ascona were later displayed at exhibitions organized by an artists' association known as De Onafhankelijken ("The Independents") in Amsterdam's Stedelijk Museum.

The German Invasion

The German invasion of the Netherlands on May 10, 1940 caused many changes. Fré Cohen could no longer receive commissions from the Amsterdam city council. She could not continue to work under her own name—to make a living, she set up a small firm under the pseudonym of Freco, publishing children's books and postcards. She also started teaching at the W.A. van Leer Jewish School of Applied Arts, but she had to give that up as her name was on a list for deportation. A letter she wrote in March 1942 expresses her fear concerning the war's outcome. To a good friend, she wrote: "I have plenty of plans, sketches, and drawings ready for after the war if we live to see the end of it. You sometimes start to doubt it."[17] This was when the razzias started in Amsterdam, in which Jews were captured and sent to concentration camps in Germany. Various family members, including her father, fell victim to this early in the war, and Fré Cohen was forced to go into hiding.

This was a challenging time for someone as active and energetic as Fré. She stayed at several addresses but was eventually betrayed. On June 9, 1943 she was captured at a farm in Borne in the east of the Netherlands.[18] Acutely aware of what awaited her from her interaction with Jewish refugees, she decided to swallow the poison she always carried with her for, if this time should ever come, her final act of self-confidence. Her motto was "They will not get me alive"—a view shared by many Jews in the Netherlands after the German invasion, including some of her best friends. She died in a hospital in Hengelo on June 12, 1943, and was buried in the town's Jewish cemetery.

Renewed Attention

The past few years have seen a tremendous resurgence of interest in Fré Cohen. Quite often, new works of hers are discovered. In 2018, for example, the Amsterdam-based International Institute for Social History (IISG) received a donation of an extensive collection of works that included several original drawings by Fré Cohen that had somehow ended up in Australia.[19] Her works are also often admired in exhibitions focusing on female artists. She was well represented in New York's Museum of Modern Art exhibition *Engineer, Agitator, Constructor, The Artist Reinvented,* organized in late 2020/early 2021 to highlight radical innovations and social commitment in art after the First World War. And in 2022, the Amsterdam School Museum Het Schip organized a major solo exhibition of her life and work. Two recently published Dutch works focus on her: a novel by Edith Brouwer (1968)[20] and an extensive reference book by Museum Het Schip.[21] There is much interest in Fré Cohen at the moment—in Fré as a feminist, a Jewish woman, and a social democrat, but above all, an exceptionally talented artist who aimed to make beauty available to everyone with her art.

© **Alice Roegholt**

Note: First published online as "Dutch artist Fré Cohen grew up in Antwerp," this essay has been revised and retitled "Fré Cohen: A Dutch Jewish Socially Conscious Feminist Artist."

NOTES

1. Peter van Dam and aag, Philip van Praag (1993). *Fré Cohen 1903–1943: Leven en werk van een bewogen kunstenares.* Abcoude: Uniepers.
2. Dick Dooijes, Ber Drukker, and Dolf Stork (1977). *Rond Paasheuvel en Prinsenhof.* Stadsdrukkerij van Amsterdam, pg. 52.
3. AJC, *Onze Paasheuvel. Vrolijke lotgevallen en aangename herinneringen. Uitgave ten bate van het kampeerfonds der AJC*, Amsterdam, 1923.
4. Peter Manasse, "Fré Cohen en de Socialistische Kunstenaarskring," *Boekenpost*, Vol. 56, November/December 2001, pgs. 24–25.
5. "Rood staat frisch, zei de decoratrice" in *Leeuwarder Nieuwsblad*, January 20, 1934.
6. "Vlaggen bij demonstraties, ontslag van rechtsvervolging" in *Het Volk*, January 26, 1934.
7. *De Proletarische Vrouw* (963), January 31, 1934.
8. Peter van Dam, and Philip van Praag (1996). *Amsterdam gaf het voorbeeld: Gemeentelijke opdrachten aan grafische kunstenaars 1912–1939.* Abcoude: Uitgeverij Uniepers.
9. Hans Moolenbel, (2014). *Gedrukt voor de stad: De geschiedenis van de Stadsdrukkerij Amsterdam.* Amsterdam: Bas Lubberhuizen, pg. 137.
10. W.H. Wolff, "Werbetätige Frauen in Holland," *Mitteilungen des Verbandes der Werbetätigen Frauen Deutschlands*, 1931/32.
11. William Farringdon, "Amsterdam makes even cheque books look lovely," *Advertising Display*, December 1930, pgs. 358–359.
12. Fré Cohen, "Modern Lay-out in Holland," *Magazine of the Midland Master Printers Alliance*, December 1934, pgs. 12–16.
13. Joseph Gompers and Fré Cohen in *Nieuw Israëlietisch Weekblad*, 1935.
14. Benjamin Benus and Wim Jansen, "The Vienna Method in Amsterdam: Peter Alma's Office for Pictoral Statistics," *Design*, Vol. 32, No. 2, 2016, pgs. 19–36.
15. Johan Schwencke in *Den Gulden Winckel*, September 1932, pg. 173.
16. Fré Cohen, "Ascona, een kunstenaarsdorp aan de Lago Maggiore," *Wij, ons werk ons leven*, Vol. 49, January 10, 1936, pgs. 16–17.
17. Letter written by Fré Cohen to Johan Schwencke, 1942. Files of J. Schwencke. Museum van het Boek, The Hague.
18. Annette Evertzen, and Stevine Groenen, *Jodenjagers bij de Hengelose politie*, Hengelo, 2020, pg. 68.
19. Harriet Stroomberg, "Fré Cohen," *On the Waterfront*, 38, 2019, pgs. 7–9.
20. Edith Brouwer: De Letterkast, Amsterdam, 2021.
21. Museum Het Schip: Grafisch kunstenares Fré Cohen, vorm en idealen van de Amsterdamse School, Amsterdam, 2021.

1.5

Ans van Zeijst: A Dynamic Designer within Religious and Secular Contexts

Ginger van den Akker

Ans van Zeijst was a designer who displayed adaptability and versatility within the design field. She worked as an independent graphic designer, catering to both secular and Catholic clients. Later in life, she became a nun housed in a contemplative order while continuing her profession as a designer.

Anna Maria Elisabeth van Zeijst, also known as Ans or Annie, was born in Utrecht, the Netherlands, on December 28, 1906. She grew up in a Roman Catholic family passionate about silver design because her father, Johannes Abraham Bernardus van Zeijst (1880–1956), owned A.J. Cral, a well-known Utrecht jewelry store. Her mother, Aletta Hermina

Figure 1.5.1 Ans van Zeijst, Sister Theofoor in her self-designed habit, photo by Ad Kon, circa 1965. Archive Ans van Zeijst, collection Beeld en Geluid, Catholic Documentation Centre, Radboud University Nijmegen, the Netherlands.

Maria Gooselink (1870–1951), was a homemaker caring for Ans van Zeijst and her brothers. The oldest brother, Johannes Gerardus Maria van Zeijst (1903–1978), took over the family silver shop. The youngest brother, Henri Gerhard Antonius van Zeijst (1905–1988), devoted his life to religion: first, as a Benedictine monk in England, and later after converting to Buddhism, he moved to Sri Lanka.[1] After obtaining her M.U.L.O. degree in 1922,[2] she attended a girl's boarding school run by the religious order of the Ursulines sisters in Venlo, the Netherlands.[3] She was thus raised with the values of both religion and design. To pursue her career as an artist, she attended several academies in the Netherlands: the Rijksakademie van Beeldende Kunsten in Amsterdam, the Royal Academy of Art in The Hague, and the Academie Kunstoefening in Arnhem.[4] At the last institution, she was discovered by a director of the Gerritsen & Van Kempen silver factory around 1930.[5] She was among the first employees to design modern-looking cutlery and tableware at this company.[6] In a radio speech for the Dutch Christian Radio Association NCRV, director Albert Gerritsen (1874–1946) expressed his appreciation by bringing her work into context with the collaboration between the artists and technology that led to the creation of new forms tailored to the machine's capabilities.[7] Annelies Krekel-Aalberse, a former curator at the Stichting Het Van Kempen & Begeer Museum, emphasized Ans van Zeijst's novelty by declaring that "Her designs are clearly influenced by the Bauhaus ideas, something which cannot be said of the work of Gustav Beran (1912) […]."[8] Unlike her male colleagues, such as the Viennese designer Beran, she contributed her unique insights to the field of silverware. After a year, she left the factory to acquaint herself with the practice of silversmiths at the Staatliche Zeichenakademie in Hanau, Germany. After experiencing diverse educational programs, she declared that she still gravitated toward graphic design.[9] Beran, Ans van Zeijst's successor at the silver factory, stated that "she did not do what other girls did: she did not get married—but joined a convent."[10]

In 1934, after leaving Gerritsen & Van Kempen, she joined the order of the Benedictine Olivetan nuns at the convent Regina Pacis in Schotenhof, Belgium, as an oblate. She adopted the name Sister Théophore and continued to design for different purposes, including creating printed materials and furniture. While taking charge of the art school at her order's residence in Cockfosters, England, she developed into a versatile designer. She worked for an architect there before returning to Antwerp, Belgium, to obtain her "advertising art" degree at the Vakschool voor Kunstambachten on March 28, 1940.[11] Her work did not go unnoticed by the public. An article in the *Leidse Courant* from December 22, 1934, reviewed her work on the first baby book for Catholic families titled *Baby's dagboek (Baby's Diary)*. The author, J.F., referred to the books of Rie Cramer and "Willebeek, Le Maire" whom Dutch design historian Marjan Groot considered two of the most renowned Dutch female illustrators.[12] J.F. argued that although their books were of good quality, they did not address religious ceremonies due to their neutral nature. The text asserted that Ans van Zeijst introduced a new and modern approach to designing baby books that catered explicitly to Catholic families.[13]

An Independent Graphic Designer during Changing Times

When the Second World War broke out in 1939, Ans van Zeijst left the order to work as an independent graphic designer, establishing her advertising and communication design business in Utrecht in 1940. She accepted as many design projects as possible to make a living during the war years.[14] The discipline of graphic design in the Netherlands was a promising field for women early on. Throughout Dutch history, critics discussed women's contribution to graphic design, including an observation made by Johan Schwencke—founder of the Dutch Ex-libris Circle N.E.K.—about the contrasts between the powerful "manly" aesthetic and the "feminine" delicacy in 1927. However, such discussions on the roles of gender were infrequent. Accordingly, the field appeared to experience fewer problematic gender connotations than other disciplines, such as handcrafted bookbinding, where women had fewer opportunities. To compensate for the shortage of luxury in design and fewer job offers on the luxury book market—compared to countries like France and England—the Netherlands showcased the design talent of both men and women in the industrial graphic sector. Consequently, women designed advertisements and posters relatively early, creating work for various audiences and purposes beyond targeting homemakers.[15]

Ans van Zeijst's design practice was no exception—she accepted various requests, ranging from designing invitations and announcement cards for individuals to decorating the Tivoli concert hall, the cathedral, and the episcopal palace in Utrecht for the creation of the cardinal.[16] During an interview with Lenie Vierkens for the magazine *De vrouw en haar huis* (*The Woman and her House*) in 1951, she highlighted the types of graphic work Ans van Zeijst made, such as book covers, illustrations, panels, advertisements, and propaganda posters. Vierkens also noted that people in magazines and trade journals appreciated her work, as it led to numerous design projects.[17] Although most of her clients were Catholic individuals or organizations, Ans van Zeijst also received requests from large companies like the Nationale Omroep (National Broadcaster) and the Jaarbeurs. This trade fair venue, founded in 1916 in response to the crisis of the First World War, organized exhibitions to boost the Dutch trading market and commercial sector.[18] Ans van Zeijst was assigned multiple commissions, including designing cards and a poster for the *Agrarische Afdeeling (Agricultural Department) Jaarbeurs* conference in 1941. Many contemporary newspaper writers assessed this poster as an impactful advertising tool. The *Utrechtsch Nieuwsblad* concluded that this successful design met the criteria of being concise, as formulated by A.M. Cassandre, the famous advertising designer. With the application of the strong complementary colors of blue and yellow and the composition's simplicity and sobriety, the result fits the purpose.[19] The *Leidsch Dagblad* noted that the message was very clear, which made it effective in attracting people to visit.[20] The monthly journal *Revue*

Figure 1.5.2 Ans van Zeijst, poster for the *Agrarische Afdeeling (Agricultural Department) Jaarbeurs*, 1941. Archive Ans van Zeijst, collection Beeld en Geluid, Catholic Documentation Centre, Radboud University Nijmegen, the Netherlands.

Figure 1.5.3 Ans van Zeijst, poster for Philips, 1941, signed "Ans van Zeyst." Archive Ans van Zeijst, collection Beeld en Geluid, Catholic Documentation Centre, Radboud University Nijmegen, the Netherlands.

der Reclame agreed by proclaiming that she accurately depicted the scene "as an urbanite" because urbanites would have the "instant" association of grain with agriculture.[21] However, depicting a shovel instead of a sickle as a symbol of agricultural work was criticized as it could cause confusion when interpreting the show's subject. Despite this detail, the authors generally agreed that the quality of the poster was not affected.

Ans van Zeijst's work caught the attention of Philips, a multinational corporation founded in Eindhoven, the Netherlands, in 1891 that responded to the introduction of electricity on the mass market. Her personal archive at the Catholic Documentation Centre (KDC) indicates that she executed at least two jobs for Philips, as only two posters have been preserved. Philips likely sought to leverage her talent for their business ventures in multiple regions because she created work for the Dutch market as well as projects for South Africa, according to the interview in the weekly magazine *Philips Koerier* on November 4, 1967.[22] The focal point of Philips was distributing "cost-effective, reliable electric incandescent light bulbs."[23] An article in February 1950 in the *Announcer: monthly review of Philips Industries* on the advertising strategies of incandescent lamps in Austria emphasized the importance of propaganda by using impressive posters with the same slogan. Their slogan, "Philips doppelwendellampe hilft sparen" (Philips double-coil lamp helps saving), intended to address homemakers, was used in Ans van Zeijst's poster for Philips.[24] Her other poster, created in 1941, also advertised incandescent light bulbs. It was published in an earlier issue in August 1949, in context with the use of window displays. This Dutch shopping window display once again stressed the efficiency and inexpensive character of the product by displaying her poster.[25] The design of a light bulb, encircled by the signs of the zodiac and the globe, was, according to Vierkens, a successful formula.[26] Her inspiration reflected the personal interest of Sies W. Numann—former head of the propaganda department—in astronomy. She always kept this specific poster while remembering a time filled with enjoyment, and she never forgot Numann's help in arranging her study/work trip to Norway directly after the Second World War.[27]

The war years significantly impacted graphic design as visual communication, and it became essential in influencing and convincing the masses of certain beliefs.[28] During the reconstruction, the Netherlands aimed to restore the pre-war, segregated society rather than to advocate for renewal. Various media and network institutions encouraged the segregation of groups based on their socioeconomic, ideological, or religious positions.[29] An example of a trade union that employed propaganda to actively recruit new members for their Catholic association was the Katholieke Arbeidersbeweging (Catholic Labor Movement, K.A.B.). In 1949, they started a campaign for the first time together with other Catholic trade unions. Through this nationally organized action, they aimed to increase the overall number of members from 40,000 to 300,000. Their poster campaign, the *koppenserie* (*Series of Heads*), was designed by Ans van Zeijst. A set of six faces, five men and one woman, were displayed on public billboards and advertising kiosks in multiple cities.[30] The faces included a construction worker, a railroad man, a farm worker, a textile

Figure 1.5.4 Ans van Zeijst, photo of people looking at the *koppenserie* on an advertising kiosk in Amsterdam, circa 1949. Archive Ans van Zeijst, collection Beeld en Geluid, Catholic Documentation Centre, Radboud University Nijmegen, the Netherlands.

worker, a welder, and a laborer. They encouraged viewers to join the unions by responding to the construction worker's quote, "I am a member of the K.A.B.," with the slogans "me too" and "come as well!"[31] The only woman portrayed was engaged in the stereotypical female profession of textile craftsmanship—probably because the trade union's clothing and textile department focused primarily on recruiting women, unlike the other sections. The propaganda action was successful, with the goal of 300,000 members already accomplished by July 1, 1949. To celebrate this achievement, Ans van Zeijst designed the football-related poster called *goal!*, which the K.A.B. considered one of its best designs.[32] Over the years, she continued to design for the K.A.B. and other Catholic trade unions, such as Katholiek Thuisfront and Katholieke Actie, mainly working on propaganda campaigns in the aftermath of the Second World War.[33] Art Historian Tim Graas, who

researched Ans van Zeijst's design practice while working at the KDC, highlighted that her printed materials provide valuable insight into the multitude of organizations and implemented actions within the Catholic community.

Catholic Designer?

According to Graas, she could be considered *the* female designer of the postwar Catholic reconstruction of the Netherlands. Numerous job offers bolstered her reputation within the Catholic environment.[34] Notably, she undertook design projects concurrently for both religious and secular contexts. For instance, after her work on K.A.B.'s propaganda action, Dutch architect and furniture designer Gerrit Rietveld (1888–1964) asked her to design a map of the Netherlands for the *Holland Fair* in Philadelphia, United States, that opened on May 5, 1950. This exhibition, designed by Rietveld, was created to promote Dutch products and industry to the American public in hopes of increasing export possibilities. Ans van Zeijst created a 3.5 m × 4 m map featuring 260 small figurines representing Dutch products and attractions to lure potential tourists. Additionally, she designed decorated signs exhibiting remarkable Dutch artist products, such as Delft Blue, glass, textiles, and candles.[35] Despite the cultural differences between the United States and the Netherlands, Ans van Zeijst adapted to this challenge while showcasing her remarkable draftsmanship, as noted by Vierkens.

Ans van Zeijst traveled extensively throughout her life while maintaining a diverse and engaging body of work as she sought inspiration to keep up with the influx of new projects.[36] As fate would have it, one of these design projects drastically changed her life. In 1950, she was asked to design a folder to promote the Augustinian sisters' convent in Maarssen, the Netherlands. This strict, contemplative order devoted their lives to God by isolating themselves from the outside world. Following Saint Augustine's belief in prioritizing the community above oneself, the nuns gathered together to pray for the world.

After completing the folder in 1952, she entered the world she had depicted.[37] She declared that this action was surely no escape from reality.[38] In an interview in the *Leidsch Dagblad* published on November 23, 1968, she recounted her desire to join a convent. She compared it to the concept of marriage, stating that sometimes you find the right path without a rational explanation.[39] Despite becoming part of the closed order, she continued to work as a designer. She did stop accepting secular commissions and instead received an increasing number of commissions for religious purposes. These commissions included creating tapestries and chalices for churches and chapels and designing posters, calendars, and book covers for Catholic clients. She adopted the name Sister Theofoor, the Dutch version of Théophore, and stopped signing her works "Ans van Zeyst." The new signature "Mon.Aug." which was an abbreviation for "Monialen Augustinessen" (Augustinian nuns), reflected the shared beliefs of the order: sacrificing oneself as an individual

Figure 1.5.5 Ans van Zeijst, *Samen denken samen praten over het religieuze leven* (*Thinking Together Talking Together about Religious Life*) poster, 1964. Archive Ans van Zeijst, collection Beeld en Geluid, Catholic Documentation Centre, Radboud University Nijmegen, the Netherlands.

for the sake of the group. This signature eventually became a trademark, as other sisters helped work on the execution of the designs.[40] One of the posters featuring this signature is *Samen denken samen praten over het religieuze leven* (*Thinking Together Talking Together about Religious Life*). The poster was created in 1964 to promote the meeting days arranged for girls and novices at eight different monasteries. She was the regular designer for the committee that organized these introduction days until the 1960s.[41] At least 3,000 copies of this poster were printed at Drukkerij Kerkmeester in Utrecht, and smaller flyers with the same design were also distributed.[42]

Sister Theofoor and her sisters' design practice became the convent's primary source of income.[43] Upon relocating to the new convent God's Werkhof in Werkhoven, the Netherlands, in 1960, she established a studio for graphic design, vestments, and pottery. Her designs dominated its interior and chapel. Together with the prioress, they formed a duo that left a lasting impression on the monastic community, according to the other sisters.[44] Sister Theofoor had no regrets about leaving her secular life and even stated that her work benefited from improved concentration.[45] Following the call for openness during the Catholic Church's renewal between 1962 and 1965, her artistic style became more liberated and abstract. This shift was influenced by inspiration gained from the now accessible outside world. After the physical barriers were removed in 1963, the order allowed her to go on trips and visit exhibitions to keep up with the latest artistic developments.[46] During these years, her graphic work decreased, whereas projects for liturgic tableware and vestments increased. She felt that all the knowledge she had acquired over the years flourished in this phase of her life.[47]

The Reception of Her Work

Sister Theofoor remained active in the design world until the late 1970s, with an unwavering passion for her practice.[48] Although her work received some media attention over the years, she did not necessarily aim to generate publicity. While working as an independent graphic designer, she participated in multiple exhibitions, such as the *Pro Arte Christiana* exhibition for contemporary religious art at the Stedelijk Museum Amsterdam in 1941.[49] Despite being recognized by some connoisseurs in group exhibitions, she was not widely known. To understand the perception and opinions of both Ans van Zeijst and her contemporaries, multiple articles with interviews are essential for the reception of her work. None of these texts highlight that she was a woman in a male-dominated field. Her interview for *De vrouw en haar huis*, a leading magazine that provided information on Dutch women in design, helped grow their exposure and enabled her to stand out as an artist. According to Groot, the lack of information available about some female designers, aside from an article in this magazine and their inability to maintain a lasting professional career, was a common problem stemming from the gender dynamics in society and the economic instability of the times.[50]

Despite this, Ans van Zeijst was able to pursue a professional career without regard for gender. She was praised for being diverse and versatile, from creating an impactful propaganda campaign for the K.A.B. to designing posters for Philips worldwide. However, despite her silverware for Gerritsen & Van Kempen and her graphic work on the first Catholic baby book, she was often not regarded as "innovatory" and apparently not worth mentioning in art and design literature.[51] Her attribution to the design field deserves attention without considering issues like gender and lack of renewal.

Although ignored by experts in her field, Ans van Zeijst's work is represented in Dutch museum collections, including the Centraal Museum Utrecht, Museum Boijmans van Beuningen in Rotterdam, Museum Catharijneconvent in Utrecht, and the Vrijheidsmuseum in Groesbeek. After her passing on February 16, 1988, her atelier and extensive artistic archive were preserved in their original state out of honor and respect by the sisters.[52] This archive now serves as a valuable source for research—especially as it has been relatively accessible since 2005—yet only a few researchers have examined it.[53] In 2015, the KDC arranged for the first-ever solo exhibition with just a few pieces from the archive in limited space.[54] Therefore, it is finally time to visit the archive and museum collections to bring the work of Ans van Zeijst out of the dark and into the spotlight, the place where she belongs.

© **Ginger van den Akker**

NOTES

1. For information on her family and early life: "Stamboom—Web Site familie van Zeijst," *MyHeritage*. https://www.myheritage.nl/site-family-tree-178991191/web-site-familie-van-zeijst.
Ginkel-Meester, S. van, "Ans van Zeijst (Zuster Theofoor) (1906–1988): beeldend kunstenaar en ordezuster," in Eerden-Vonk, M.A. van der (ed.), *Utrechtse biografieën, Het Kromme Rijngebied: Levensbeschrijvingen van bekende en onbekende mensen uit het Kromme Rijngebied*, Utrecht: SPOU, 2002, pgs. 204–08.
2. M.U.L.O. is the short term for *Meer Uitgebreid Lager Onderwijs* (More Extensive Elementary Education). It was a form of secondary education in the Netherlands that provided more advanced education than primary school, but less advanced than a full secondary school education.
3. Rhoen, R.P.M., "Ans van Zeijst, Toos den Hartoog-Muijsert, Cor Stramrood-Aalten: Portretten van markante vrouwen op de zilverfabriek Gerritsen & Van Kempen," *Stichting De Zilver-Kamer*. https://www.zilverkamerzeist.nl/publicaties-gerritsen-begeer.html.
4. Vierkens, Lenie, "Ans van Zeyst en haar Grafisch werk," *De vrouw en haar huis* 45, 1951, pgs. 170–3, pg. 173.
5. Graas, Tim, *Catalogus bij de tentoonstelling "Ans van Zeijst/Zuster Theofoor 1906–1988. Vormgeefster van de katholieke naoorlogse wederopbouw,"* Katholiek Documentatie Centrum Nijmegen, 2015, pg. 3.
6. Graas, Tim, "Ans van Zeijst alias zuster Theofoor 1906–1988. Een bijna vergeten ontwerpster van modern zilver," *De Stavelij Jaarboek*, 2013, pgs. 122–30, pg. 123.
7. Voorthuysen, W.D., Annelies Krekel-Aalberse (2004). *Zeist, zilver, werken,* Zwolle: Uitgeverij

WBOOKS, pg. 66.

8. Krekel-Aalberse, Annelies, Joost Willink (1992). *Silver of a New Era: International Highlights of Precious Metalware from 1880 to 1940*. Rotterdam: Museum Boijmans van Beuningen, pg. 98.
9. Vierkens 1951 (note 4), pg. 173.
10. "Maar zij stopte bij Gerritsen & Van Kempen om in het klooster te gaan, zoals haar baas Gustav Beran in zijn herinneringen schreef: 'Zij deed niet wat andere meisjes deden; zij ging niet trouwen—maar in een klooster.'" Groot described Beran as "her boss": however, he was her successor in 1934. Groot, Marjan (2007). *Vrouwen in de vormgeving, 1880–1940*. Rotterdam: Uitgeverij 010, pgs. 376–8.
11. Vierkens 1951 (note 4), pg. 173.
12. Groot 2007 (note 10), pg. 307.
13. J.F., "Baby's dagboek," Ontworpen door Ans Théophore van Zeijst, oblaat van Schotenhof, Uitg. V. Goor & Zonen, Den Haag. *Leidsche Courant* (12/22/1934). https://leiden.courant.nu/issue/LC/1934-12-22/edition/0/page/14?query=ans%20van%20zeijst&sort=relevance. The author put a comma between "Willebeek" and "Le Maire" and an extra E was added to Mair. Because of the context, I interpret this as Henriëtte "Willebeek le Mair," the famous book illustrator. Perhaps this was either a way of writing at the time, or a typo. On page 92 of "Honderd jaar geleden werd Rie Cramer geboren" in *Literatuur zonder Leeftijd. Jaargang 1–2*, they also wrote Maire with an e at the end. https://www.dbnl.org/tekst/_lit004198601_01/_lit004198601_01_0047.php. According to the RKD, her signature was "H.W. Le Mair," which could explain the comma. https://rkd.nl/nl/explore/artists/84594.
14. Graas 2015 (note 5), pg. 4.
15. Groot 2007 (note 10), pg. 317, pgs. 321–2.
16. P.K., "Een medewerkster aan de 'Holland Fair': Een bezoek aan Ans van Zeijst, grafisch ontwerpster," *Beatrijs. Katholiek Weekblad voor de Vrouw*, 4/14/1950, pgs. 34–6, pg. 35.
17. Vierkens 1951 (note 4), pg. 172.
18. "Over Jaarbeurs," *Jaarbeurs*, 4/28/2023. https://www.jaarbeurs.nl/over-jaarbeurs.
19. "Nieuwe Jaarbeursplaat," *Utrechtsch Nieuwsblad*, 8/13/1941, pg. 6, Archive Erfgoedcentrum Nederlands Kloosterleven.
20. "Kunst en Letteren Nieuwe Uitgaven. Reclameplaat voor de Najaarbeurs," *Leidsch Dagblad*, 8/13/1941, pg. 2. https://leiden.courant.nu/issue/LD/1941-08-13/edition/0/page/2?query=ans%20van%20zeyst&sort=relevance.
21. "Agrarische Afdeeling Jaarbeurs," *Revue der Reclame*, Archive Erfgoedcentrum Nederlands Kloosterleven.
22. "Ex-Philipsemployée Ans van Zeijst, nu slotzuster: In het klooster kan ik me beter concentreren," *Philips Koerier*, 11/4/1967, pg. 9.
23. "Our history," *Philips*, 4/28/2023. https://www.philips.com/a-w/about/our-history.html?_ga=2.87360477.414804963.1680865305-1053476104.1680865305.
24. "Radio-Advertising in the Austrian Campaign for Incandescent Lamps: Experiment was a Brilliant Success," *Announcer: monthly review of the Philips Industries* 4, 2/1950, no. 2, pgs. 11–13, pgs. 11–12. Frans Wilbrink provided this text.
25. Hoeneveld, T.K., "Don't feel stepmotherly towards shop-windows!" *Announcer: monthly review of the Philips Industries* 3, 8/1949, no. 9, pgs. 16–19, pg. 17. Frans Wilbrink provided this text.
26. Vierkens 1951 (note 4), pg. 172.
27. Philips Koerier 1967 (note 22), pg. 9.
28. Müller, Jens, Julius Wiedemann (2017). *The History of Graphic Design: Vol. 1, 1890–1959*. Cologne, Germany: Taschen GmbH, pg. 192.
29. Cuilenburg, Jan van, ed. (1999). *Media in overvloed: Boeknummer bij Mens &*

Maatschappij 1999, Amsterdam: University of Amsterdam Press, pg. 10.
30. Beumer, Louis, "Acties en Suggesties," *Lering en Leiding* 17, 1949/1950, pgs. 82–5. The photo of the poster campaign was taken on a small square in the Indische Buurt in Amsterdam, a former working-class neighborhood: Email Tim Graas, March 24, 2023.
31. The Dutch sentences are "Ik ben lid van de K.A.B.," "ik óók," and "kom ook!"
32. "Verslag van de Nederlandse Katholieke Arbeidersbeweging betrekking hebbende op de omvang en werkzaamheden gedurende de jaren 1948–1954, deel 1," *Verslag K.A.B. 1948–1954*, pgs. 415–16, Archive Koninklijke Bibliotheek.
33. Graas, Tim, "Zeijst, Anna Maria Elisabeth van," in *Digitaal Vrouwenlexicon van Nederland*. https://resources.huygens.knaw.nl/vrouwenlexicon/lemmata/data/Zeijst 10/3/2017, *Stichting De Zilver-Kamer*, https://www.zilverkamerzeist.nl/publicaties-gerritsen-begeer.html.
34. Graas 2015 (note 5), pg. 4.
35. P.K. 1950 (note 16), pgs. 35–6.
36. Vierkens 1951 (note 4), pgs. 170–2.
37. Maassen, Gertrudis, and others, *Monialen Augustinessen te Werkhoven*, Amstelveen, 1985, pgs. 16–19, pg. 108.
38. Philips Koerier 1967 (note 22), pg. 9.
39. "Waarom gaat een jonge vrouw het klooster in?" *Leidsch Dagblad*, 11/23/1968, pg. 7. https://leiden.courant.nu/issue/LD/1968-11-23/edition/0/page/7?query=zuster%20theofoor&sort=relevance
40. Graas 2017 (note 33).
41. Graas 2015 (note 5), pg. 18.
42. Correspondence between Sister Theofoor and Drukkerij Kerkmeester, July 29, 1963, Archive Erfgoedcentrum Nederlands Kloosterleven.
43. Graas 2015 (note 5), pg. 5.
44. Staal, Casper, "Ans van Zeijst—Zuster Theofoor. Een Utrechts kunstenaarsarchief," *Nobel Magazine. Beeldende kunst in Utrecht vanaf 1900*, Vianen 3, 2006, no. 2, pgs. 3–6, pg. 4.
45. Philip Koerier 1967 (note 22), pg. 9.
46. Van Ginkel-Meester (note 1), pg. 207.
47. Graas 2015 (note 5), pgs. 5–6, pg. 8.
48. Graas 2017 (note 33).
49. *Tweede tentoonstelling van Hedendaagsche Religieuze Kunst en van Vijf Eeuwen Paramentiek georganiseerd door de Stichting Pro Arte Christiana*, Pro Arte Christiana Amsterdam, 1941, pg. 11.
50. Groot 2007 (note 10), pg. 37.
51. Graas 2013 (note 6), pg. 123.
52. Staal 2006 (note 44), pg. 5.
53. Email Tim Graas, April 22, 2023.
54. Graas 2015 (note 5), pg. 2.

1.6

Maria Keil: The Polyphonic Work of a Pioneering Portuguese Designer

Dr. Maria Helena Souto

There are professions that, *a priori*, are considered the provinces of men rather than women. Design is one of them. Supported by general design histories that reinforce a history of male "heroes," there is a refusal to acknowledge gender bias, its blindness to the contribution of individual women, and to recognize the importance of collaboration in the design process.

In the case of Portuguese design, we are dealing with late industrial development associated with technological backwardness in a country that experienced a long dictatorship (1926–1974). The regime's rigorous isolationist, colonial, and economically protectionist agendas resulted in the late development of Portuguese design.[1] Moreover, the first cycle of Portuguese Modernism historically converged with the 1926 military coup, which

Figure 1.6.1 Maria Keil in her atelier located on Faial Street in Lisbon, Portugal, in the 1950s. Collection of Francisco Pires Keil do Amaral.

led to the New State (Estado Novo) dictatorship established by the 1933 Constitution. During this period, creative women linked to the avant-garde movements were mainly associated with painting. Some of them, however, also worked as illustrators in graphic areas, in scenography,[2] and during the following decade, in advertising, where they were expected to provide a female consumer's perspective.

One of these women, Maria Keil, belonged to the second generation of Portuguese Modernism. Although she began her career as a painter, she quickly adapted to other art forms, contributing significantly to graphic design, primarily through illustration and advertising design. She also worked in scenography, costume design, tapestry, designing furniture and ceramic tiles.

Maria Keil was born on August 9, 1914, in Silves, in the Portuguese region of the Algarve, a land of cork producers. She was the youngest of four siblings, two boys and two girls, the children of Maria José Silva, a housewife, and Francisco da Silva Pires, a small cork industrialist. Following her parents' separation, she stayed with her father, who remarried a woman from the local, provincial, and prejudiced bourgeoisie.[3] Maria's childhood would be marked by her parents' separation and her stepmother's education, which was full of bourgeois rules.

Maria revealed a talent for drawing while attending the Industrial School. An attentive and artistic teacher, Samora Barros, influenced Maria and convinced her father to let her pursue a career in the arts. The bold decision to enroll in the fine arts painting course in Lisbon was made easier as Maria could stay in the family home of her stepmother's brother, a military man. In 1930, at the age of sixteen,[4] Maria moved to the capital, which proved to be a new and stimulating environment, along with the atmosphere of Fine Arts School, where lifelong friendships were made among students in painting, sculpture, and architecture. There, she met her future husband, the architect Francisco Keil do Amaral (1910–1975), whom she married in 1933.

If and when women were mentioned, it was often in conjunction with—and therefore "subsumed" under—a male partner or family member,[5] but this was not the case for Maria Keil. Although the collaboration with her husband (which quickly became a reference[6] in Portuguese modernist architecture) was vital for her career, Maria did not remain in his shadow. With Francisco, Maria found a husband who knew how to be a collaborative support, although their marriage was a union of social opposites: he belonged to a family of Lisbon's artistic and intellectual elite, and Maria was from the petite bourgeoisie of the province. Only her character and her husband's support explain her adjustment. In 1935 their only son, the future architect Francisco Pires Keil Amaral (nickname *Pitum*), was born.

The twenty-one-year-old young mother simultaneously experienced the critical gaze of Lisbon high society and the advantages of having a large staff to carry out domestic tasks and support to care for the baby. This privileged situation never dazzled her. Whenever possible, the couple escaped to the vernacular-inspired house that Francisco Keil

do Amaral designed and Maria furnished in the Sintra region to enjoy family life that included friends with the same cultural and political affinities.

Maria was a powerful advocate of collaborative and craft-based design, creating works that straddled or blurred the traditional divisions between art and craft, handicrafts, and industrial production, as well as amateur and professional.[7] Her polygraph body of work was not only innovative but also provocative, given she lived in a country where the conservative dictatorship expected women to be "the Angel in the House" as implied by "the 1933 Constitution [which] stated that the husband was the head of the family and that he had the authority, while the woman had to play the role of a mother devoting herself to her home."[8]

In 1937, she accompanied her husband to Paris after he won the competition for the Portuguese Pavilion for the *Exposition Internationale des Arts et Techniques dans la vie modern*—but also because she was part of the Estúdio Técnico de Publicidade (ETP) (Technical Advertising Studio), under the direction of the designer, José Rocha (1907–1982). In a 2005 interview, Maria Keil mentioned how experimental the learning process in this field was in the 1930s: "We learned from each other, especially among the Fred Kradolfer (1903–1968) and José Rocha groups, many of whom were my masters."[9] At that time, this group of designers was still under the influence of Art Deco models, with emphasis on the work of Cassandre (Adolphe Mouron, 1901–1968).

Indeed, in the same interview, Maria mentions how she "really liked and admired Cassandre's graphic work."[10] It is not by chance that her stay in Paris included a visit to the exhibition at *Pavillon de la Publicité*. Designed by the French architect René Herbst (1891–1982),[11] the display included significant names in graphic design and French advertising—Cassandre, Paul Colin (1892–1985), and Jean Carlu (1900–1997). The pavilion was the first of its kind, announcing the birth of marketing tools and the emergence of the mass consumer society.[12]

At the ETP, she was the first woman to work as a graphic designer in Portuguese advertising. She designed several advertisements, beginning in 1942, for Pompadour, the women's lingerie establishment. She was inspired by the mask concept associated with a "duplicated" female face in Cassandre's 1930 work for Dr. Charpy's beauty products. The female figure is represented as an entire body as required by the product but without loss of an aura of mystery in which the fluid line accentuates the slender length—arousing in the consumer the belief that wearing the girdles will transform her into a woman who is elegant and young. With a subtle irony, however, Maria stretches beyond the viewpoint of a woman as a consumer, questioning the status of women in the 1940s.

Although the ETP team had produced several works for the SPN, Secretariado de Propaganda Nacional (National Propaganda Secretariat),[13] Maria sought to distance herself from historic and folk themes (be they nationalistic or historical) through the use of forms, colors, and motifs, which some artists created (with varying degrees of quality) due to the

Figure 1.6.2 Maria Keil, an advertisement for Pompadour girdles, printed in several editions of *Panorama* magazine in 1941. Photo: Museu da Presidência da República-MPR/ imagens de Luz.

demands of the dictatorship. This attitude was underlined in 1939 and 1941 when she produced a series of vignettes for *Seara Nova* magazine. Maria created thematic separators for the various sections: *Facts and Documents* (no. 619, June 24, 1939, pg. 16), *Books and Periodicals* (no. 621, July 8, 1939, pg. 51), *Our Editions* (no. 707, March 1, 1941, pg. 174), *Music* (no. 708, March 8, 1941, pg. 200), *Theatre* (no. 709, March 15, 1941, pg. 219), and *Cinema* (no. 710, March 22, 1941, pg. 234). This work clearly displays the three-dimensionalization of the objects referring to each section, taking advantage of the black printing and the chiaroscuro effects to emphasize the distinct nature of the background planes.

Between 1939 and 1941, 1940 was marked in Portugal—neutral vis-à-vis a Europe almost completely torn apart at the start of the Second World War—by a significant

event. Several initiatives commemorating the eight centuries of Portuguese independence (1140) and the three centuries since the restoration of independence from Spain (1640) culminated in the great Portuguese Exhibition in Belém, Lisbon. Various graphic objects, such as Maria Keil's "Era of the Discoveries" stamp, were produced in connection with this double commemoration. This was directly linked to the exhibition and followed the graphics of the painter, graphic artist, set designer, and interior architect Eduardo Anahory (1917–1985), representing the Discoveries Monument (Padrão dos Descobrimentos). An initially temporary structure designed by Cottinelli Telmo (1897–1948), the chief architect of the exhibition, and with sculptural figures by Leopoldo de Almeida (1898–1975), it was later re-erected with permanent materials (concrete covered with rosal de Leiria limestone).

For the Centenary Celebrations and linked to António Ferro's (1895–1956) desire to enhance folk traditions, crafts, and folklore, the SPN created the Verde-Gaio Ballet Company, "the first Portuguese theatrical dance company, which produced more erudite versions of all the performing components represented in folklore (music, dance, and costume)"[14] and which had its first public performance in Lisbon in November 1940. Maria Keil was responsible for the set and costume design of the ballet *A Lenda das Amendoeiras* (*The Legend of the Almond Trees*), with a script by Fernanda de Castro (1900–1994), music by Jorge Croner de Vasconcelos (1910–1974), and choreography by the dancer Francis Graça (1902–1980). The Museu Nacional do Teatro (National Theatre Museum) has in its collection gouaches on paper by Maria for the costumes of the several characters. Maria embodied the evocative possibilities of recreating archetypal images of a Silves Moor from the kingdom of Al-Gharb on stage. She achieved this effect by employing local color in a symphony of greens, whites, and blues, evoking the enchanting light of the Algarve, Maria's birthplace. It is also interesting to recognize one of the artist's leitmotifs in the Dama bodice: the undulating lines bordering the center of the front and back of the bolero create a floral analogy recalling her recurrent studies on leaves, some reminiscent—as is the case here—of a Matissian motif.

In the same year, 1940, the writer Irene Lisboa (1892–1958) published the book *Começa uma Vida* (*A Life Begins*) under the male pseudonym João Falco. Maria was the main accomplice in the game created with the author, who revealed herself to be the girl behind the male pseudonym when placing the portrait of Irene Lisboa on the cover in a composition reminiscent of a stamp (as if the author sent this autobiographical memoir).

Maria Keil diverged into creating drawings with social themes that denounced widespread misery—that had repercussions on her creations—bringing them closer to the Neo-Realist aesthetic. One can discern this style development in her covers for the magazine *Ver e Crer* (*See and Believe*). In May 1945, coinciding with the end of the Second World War, the first issue of this monthly magazine was published, directed by José Ribeiro dos Santos and Mário Neves (1912–1993), with artistic direction by José Rocha and advertising by ETP. The artist produced the covers of no. 6 (Oct. 1945) and

Figure 1.6.3 *Left:* Maria Keil, commemorative stamp study for International Women's Year, 1975. FPC/Museu das Comunicações. Reproduction authorized by CTT. *Right: Stories from My Street*, written by Maria Cecília Correia with illustrations by Maria Keil. 1st ed. Lisbon, Portugália (D.L. 1953). Photo: Museu da Presidência da República-MPR/imagens de Luz.

no. 21 (Jan. 1947). On the first cover, which concurs with the beginning of the school year, there is a boy with his back to us, face outlined in profile, bag, and book open in his hands, next to a slate picture, drawn strongly and dynamically. The second cover greets the new year with a child holding a flag with the inscription 1947 and, on the other hand, an olive branch, a peace symbolically reinforced by the passage from the interior to the auspicious exterior. The image is crossed by an unusual rectangle in red—a color with subversive implications for the dictatorship—with the title and subtitle (each subject is worth a book) in white.

In 1953, she illustrated her first work for children, *Histórias da Minha Rua* (*Stories from My Street*) by Maria Cecília Correia (1919–1993). Here, she brought together a set of complex graphic exercises and an experimental search for a geometric abstraction of the represented forms, such as juxtaposing motifs in triangles that build a deliberate continuity between the image on the cover and the back: an infinite network made visually dynamic. Maria would return to this game of triangular motifs, influenced by Op Art, in the celebrated ceramic tile panel *O Mar* (*The Sea*, 1956–58, Avenida Infante Santo, Lisbon). Its suggestive vibrations thus consummate the abovementioned dissolution of genres in a crossing of languages that confer a particular modernity to her work.

Histórias da Minha Rua is a book that is seminal to understanding the work that Maria Keil illustrated later. It heralds a métier she would embrace for the rest of her career—illustration for children. Maria would construct a visual language full of meanings, where, most of the time, only the linearity of the written text itself could clarify the polysemy and subjectivities proposed by the richness of some of the images. Her graphic "formula" was to highlight the background for the first scene, transforming it into a "scenario" where the main scenes would unfold. Maria did this simply by opening, in the textures created, flat spaces reserved for inserting the characters. This formal structure would be adapted in other books for children, such as *A Noite de Natal* (*Christmas Eve*, 1959) by Sofia de Mello Breyner Andresen (1919–2004).

Also in 1953, when *Histórias da Minha Rua* was published, Maria Keil was arrested by the PIDE—dictatorship's political police—for meeting Maria Lamas[15] at the airport. She spent about a month in Caxias prison (near Lisbon) with other women who opposed the dictatorial regime. From then on, her position as an opponent of the dictatorship and advocate of feminist movements was expressed through her support for organizations like the National Council of Portuguese Women and the Democratic Women's Movement.

Maria anticipated what is today known as the dissolution of artistic genres—crossing languages, forms, and techniques in various forms that intersect the multiple creative worlds she developed in graphics, furniture, and interior design, as well as in her tile patterns and compositions. Moreover, as one of the leading creators in the modern reinvention of tile art tradition since 1954, she has a special place in the history of postwar Portuguese azulejos (ceramic tiles). She is part of a group of artists who, following varied paths, carried out tile work in public art commissions beginning in the 1950s.

Figure 1.6.4 Maria Keil, study for tile mural *The Sea*, 1956–58, in Avenida Infante Santo, Lisbon, Portugal. Museu Nacional do Azulejo Collection–MNAz. Photo: MNAz/DGPC.

Figure 1.6.5 Maria Keil, *Stars of the Paris Opera* program, presented at the Tivoli Theatre in November 1957. Museu Nacional do Teatro Collection – MNT (Inv. no. 148108). Photo: MNT/imagens de Luz/DGPC.

Working with her husband on the Lisbon metro project, Maria Keil created a body of tile work between 1958 and 1972, where all motifs have unique features and identities for each station. The project was also a means of educational and civic intervention, simultaneously playful and artistic, capable of projecting images that presented the visual memory of Lisbon or those visiting the city. For the Restauradores station (1958–59)—in this first cycle of tile wall coverings for the Lisbon metro—a blue and lilac chromaticism showcases a pattern dotted, here and there, with strong contrasts in black, blue, and yellow with traditional elements of eighteenth-century tiles, called albarradas, which appear perfectly integrated.

In 1963, with the lining of the Rossio station, Maria researched historical methods and references for tile wall coverings from the fifteenth century, when the tiles came from Sevillian potteries. The results of this process attained a reinforced relevance through the opening of the Intendente underground station in 1966, which is considered the most accomplished design made by Maria among the various tile patterns she created for nineteen Lisbon metro stations. For the stations that opened in 1972, Maria returned to the optical effects research, which, although close to the wall coverings designed previously, now takes on a more significant role.

In the late 1960s and early 1970s, in the context of the so-called Marcelist Spring[16] (and its failure), Maria Keil collaborated with Luís Filipe Abreu (1935) to produce school books for the first and second years of primary education. They created the illustrations and planned the graphic structure to ensure that the spaces for images and text were respected. The books became a vehicle for literacy, introducing a whole lexicon of imagination that the illustrations created in generations of Portuguese children and developing their knowledge of their mother tongue. Even though only two people, Maria Keil and Luís Filipe Abreu, produced the books, there were still technical, creative, and production challenges to solve. For example, their decision to use spot colors instead of a four-color process for the printing kept the price of the books accessible.[17]

By resolution of the United Nations General Assembly, 1975 was declared "International Women's Year." Portugal—which was experiencing a revolutionary period that began with the military coup of April 25, 1974, which ended the dictatorship—joined the commemoration through the Portuguese Women's Democratic Movement. Maria Keil was invited to design a series of four stamps to pay tribute to working women in different professions: the nurses in a hospital, harvesters in a wheat field, administrative staff in an office, and factory workers. The compositional strategy is repeated in the four drawings. In the foreground is a young female figure at work and, in the background, other women working in the same profession. The four compositions are also linked by the iconographic image of the dove bearing the female symbol, a rhythmically engraved leitmotif that reinforces the message.

In 1975, Francisco Keil do Amaral died. After a painful mourning period, in 1977, Maria wrote and illustrated the book *O Pau-de-Fileira*, where her thick-lined sketches, with loose

and superimposed features, showed her immense interest in the city: its rhythms, architecture, and the workers at their jobs. Among the various elements, stamped textures and the dynamics of a second color were used "with remarkable abstract moments produced by the scaffolding of construction sites,"[18] which we decipher as a tribute to her husband through their shared love of the city, the urban rhythm, and its change, particularly in the architectural landscape.

By the late 1970s, Maria Keil increased her collaboration with the writer Matilde Rosa Araújo (1921–2010), with whom she had worked since the 1960s. She illustrated a series of books for children, in which the writer's words and Maria's illustrations highlighted the shortcomings of childhood, an essential theme for post-1974 revolutionary ideals. These books display a characteristic moment in her work—her illustrations are a collage of distinct planes in a single composition with a centrality marked by movement. The detail of the more complex and expressive drawing varies, as does the dynamic use of a second spot color and textures (in the boots and the cat, for example).

In 1980, with the support of a grant from the Calouste Gulbenkian Foundation "to go see children's literature,"[19] Maria made a trip through several European countries that she considered the most important of her life: "I went to the Bologna children's book fair. I continued to Warsaw, then Prague. Then, I went to Paris to see all the publishers, and I realized that the children's book business was massive. I even went to Switzerland [and] I returned after three months."[20] Travel had always been present in her life. With her husband, Maria made several trips across Europe by car, and the couple's most extensive trip was to the United States of America shortly after the end of the Second World War.

Throughout her long life, Maria possessed a resiliency in unison with the ability to rebuild herself through tireless curiosity, which she maintained until the age of ninety-seven, when she died in Lisbon on June 10, 2012, independent and close to a family that had expanded to include great-grandchildren. Maria Keil's creativity, project capacity at the service of dynamic compositions, and constant desire for experimentation placed her in a seminal position in Portuguese Design. Her influence also reflected her status on contemporaries who revolutionized this discipline, without ever forgetting its educational and civic intervention.

© **Dr. Maria Helena Souto**

NOTES

1. Souto, Maria Helena (2016). "Portuguese Design," in Clive Edwards (ed.), *The Bloomsbury Encyclopedia of Design*. London, New York: Bloomsbury Publishing), Vol. 3, pg. 71.
2. In these two areas, Mily Possoz (1888–1968) and Alice Rey Colaço (1892–1978) were especially prominent, and whose works in the 1920s and 1930s reflected the influence of the Art Deco style.
3. Amaral, Pitum Keil do (2011). *Maria Keil: uma biografia acelerada para uso na casa da achada*. [S.l.]: Casa da Achada (pg. 1). https://noticias.centromariodionisio.org/wp-content/uploads/9f97912f
4. Ibid.

5. Buckley, Cheryl (1986). "Made in Patriarchy: Toward a Feminist Analysis of Women and Design," in *Design Issues*, Vol. 3, No. 2, pgs. 3–14.
6. See Tostões, Ana (2017). *Arquitectos Portugueses: Francisco Keil do Amaral*. Ed. Verso da História.
7. Souto, Maria Helena (2014). "Design Gráfico e Publicidade," in *Maria Keil—De Propósito, Obra Artística*. Lisboa: Museu da Presidência da República—Imprensa Nacional-Casa da Moeda, pg. 151.
8. Cova, Anne and Pinto, António Costa (1997). "O salazarismo e as mulheres: uma abordagem comparativa," in *Penélope: Fazer e Desfazer a História*. Lisbon: Edições Cosmos, pg. 73.
9. Fragoso, Ana Margarida de Bastos Ambrósio Pessoa (2009). *Formas e expressões da comunicação visual em Portugal: contributo para o estudo da cultura visual do século XX, através das publicações periódicas*. Tese de Doutoramento em Design apresentada à Faculdade de Arquitectura da Universidade Técnica de Lisboa, pg. 537.
10. Ibid., pg. 538.
11. René Herbst (1891–1982), co-founder of UAM (Union des Artistes Modernes). A defender of industrialization and pioneer of industrial design in France, his creations include the famous chair with a metallic structure, Chaise 101 or Sandow (1928–30).
12. On the impact of the Advertising Pavilion at the 1937 International Exhibition, see Chessel, Marie-Emmanuelle (1998). *La publicité: Naissance d'une profession 1900–1940*. Paris: CNRS Editions, 1998.
13. Created in 1933, the SPN (later, in 1944, SNI, National Secretariat of Information) was the highest propaganda organ of the dictatorial regime, created and directed for the first sixteen years by the journalist and writer António Ferro (1895–1956).
14. Sardo, Susana (2009). "Música Popular e diferenças regionais." *Multiculturalidade: Raízes e Estruturas*. Lisboa: Universidade Católica Portuguesa, vol. I (chap. VIII), pg. 444.
15. Maria Lamas (1893–1987) was one of the first Portuguese women to take up a journalistic career and committed herself personally and professionally to giving voice to the cause of women: their emancipation and social recognition. In 1953, she returned from Paris after participating in the World Peace Council in Bucharest and the World Congress of Women in Copenhagen. See Tavares, M. (2011). *Feminismos: percursos e desafios (1947–2007)*. Lisboa: Ed. Texto.
16. The *Marcelist Spring* designates the initial period of the government of Marcelo Caetano, who replaced Oliveira Salazar as President of the Council of Ministers in 1968, during which some social modernization took place. Still, the promised political opening did not happen, and on the contrary, the repression tightened from 1970 and maintained the colonial war (begun in 1961).
17. Silva, Susana Maria Sousa Lopes (2011). *A Ilustração Portuguesa para a Infância no Século XX e Movimentos Artísticos: Influências Mútuas, Convergências Estéticas*. Tese de Doutoramento apresentada ao Instituto de Educação da Universidade do Minho, pg. 147.
18. Cotrim, João Paulo (2014). "Ilustração," in *Maria Keil—De Propósito, Obra Artística*. Lisboa: Museu da Presidência da República—Imprensa Nacional—Casa da Moeda, pg. 188.
19. Cruz, Valdemar (re-ed. 2012). "Maria Keil: *O mundo é deslumbrante, mas não é bonito*." Semanário *Expresso*, 11 Junho 2012. https://expresso.pt/actualidade/maria-keil-o-mundo-e-deslumbrante-mas-nao-e-bonito=f732225
20. Ibid.

1.7

Sufism and Science in Saloua Raouda Choucair's Design Work

Dr. Yasmine Nachabe Taan

While teaching graphic design history courses at the Lebanese American University (LAU) in Beirut, I came across an article written by Saloua Raouda Choucair (1916–2017).[1] In this 1951 manifesto, Saloua Raouda Choucair raises a number of concerns about how Arab artistic production is being evaluated using Western nomenclature and thought that trying to understand Islamic art from a Western perspective would lead to a flawed interpretation of it.[2]

As Saloua reminds us, "Arabs are the most sensitively sophisticated of peoples in understanding art, and that is why they broached the subject at its abstract essence."[3] According to her, they were creative in abstract art and geometry and excelled in mathematics and its related fields, such as astronomy and medicine. For her, it is unnecessary to associate Arab Islamic art with other art forms for it to be complete. The Arabs used abstraction in

Figure 1.7.1 Saloua Raouda Choucair photographic portrait, 1995.
Photo: Sueraya Shaheen. Courtesy of the Saloua Raouda Choucair Foundation.

the representation of God to purify the spirit, and not as assumed by many Western art historians because the Quran forbade representing God.[4]

After the French mandate ended in Lebanon in 1943, a group of artists gathered under the auspices of the Arab Cultural Club to promote pan-Arabism through art. One of the active artist group's goals was to determine the character of Lebanon and other Arab countries as independent nations through a reinforcement of Arabness that is reflected in their art production. They aimed to develop new modern aesthetic standards and a unique visual language inspired by their Arab heritage. In 1952, in an effort to acquaint the Lebanese public with art and design, Saloua gave a talk on art education at a well-attended conference held at the American University of Beirut. She was later invited to give a radio talk on how to teach art in schools within Arab countries.[5]

In line with this project, Saloua asks: "Why does Islamic art eschew realism? Why isn't it inspired by the nude body?" Here, she defends the use of abstract geometry in Islamic art by arguing that Islamic art is not "merely decorative art, as the early Orientalists claimed."[6] She explains that after in-depth reading and research, she concluded that "the first Orientalists didn't understand Islamic art because they only appreciated it from an aesthetic point of view influenced by Greeks and Romans like Vitruvius or Florentine Renaissance era artists."[7]

This statement made me realize the importance of looking into the history of visual culture, including material visual culture and graphic design, from a postcolonial perspective as well as from a female designer's lens. It encouraged me to rethink my approach and content in the history of graphic design courses. It prompted me to introduce raw material about the local culture in the curriculum by adding, for example, design work produced by pioneer artists and designers such as Saloua Raouda Choucair.

A Different Kind of Feminism

In her early thirties, Saloua traveled to Paris to enroll in the École Nationale des Beaux-Arts. Her mother—without really understanding the purpose of this trip—encouraged her to do so. For Saloua, Anissa, her older sister, and their circle of female friends, to be a feminist was not about joining the sexual revolution as much as it was about being an independent thinker. Sex and the human body are not taboo topics. Her perspective was from a scientific lens where the human body is mainly about atoms and DNA, as seen in her sketches, prototypes, and sculptures. Sex and the body have a deeper meaning in Saloua's thinking and work; they are part of life.

Saloua Raouda Choucair was not a socialite. "My mother used to spend most of her time in her studio that was part of our house. She was not fond of social activities and entertainment. When a few friends and family members passed by, she would come out of her studio to briefly greet them and return to her work," recalls her daughter Hala

Schoukair (1957).[8] Her husband, Youssef, a journalist, had the mind of a philosopher, and he enjoyed spending time alone, never interfering with her work. "She was 37 (in 1953) when she married him, and three years later, she had me," Hala recounts.[9] Hala spent most of her childhood with her cousins who lived in the same Beirut neighborhood. Both Saloua and Anissa were raised to firmly believe in the establishment of al-Qawmiyah al-Arabia, which is the idea of building a modern Arab nation where active women adamantly defended the Palestinian cause and the fight against British imperialism.

There was no separation between Saloua's life and her creativity. Her studio was her museum. Her studio was her life, and every day was a new creative project—a piece of furniture, jewelry, a garment, a tapestry, a sculpture, or a painting. Her many sketchbooks are evidence of her continuously boosting creative mind. "I remember the endless hours during which I would sit next to her in her studio; she would give me a piece of clay but no instructions. She gave me the space to think and create. She designed most of the furniture in our house, and she designed my clothes, my toys, and later when I grew up, she designed my hair buckle, my skirts, my bags, and matching jewelry," Hala recalls.[10]

Figure 1.7.2 Saloua Raouda Choucair, two book cover designs and layouts. *Left:* Thuraya Malhas, *Ab'ad al-Ma'arri*. Beirut: Sumayya Printing Press, 1962. *Right:* Thuraya Malhas, *Malhamat al-insan*. Harissa: Dar Shamali printing press, 1961. Courtesy of the Saloua Raouda Choucair Foundation.

Figure 1.7.3 Saloua Raouda Choucair, book cover design, and layout for Thuraya Malhas, *Qurban*. Beirut: Sader Rihani Printing Press, 1952. Courtesy of the Saloua Raouda Choucair Foundation.

Sufism and Book Covers

Saloua sought to prove that engaging in Sufism and Islamic art is not, as many thought, merely decorative.[11] Sufism and Islamic art, for her, is far more complex than just geometric compositions of repeated patterns. She engaged in analyzing the complex geometric structures in the production of her compositions.[12] She justifies her use of abstract geometric form; for example, her effort to place a red tilted squarish form against a white background could be done to reveal "the eternal essence that is defined neither by time nor space."[13] Saloua designed many of Thuraya Malhas's book covers and layouts. Malhas's books primarily dealt with spiritual, mystical, and contemplative Sufi poetry and philosophy. In designing the book covers, Saloua developed a contemporary visual expression of Sufism using abstract compositions that visually express the kinetic infinite circular movement typical of Sufism. This is seen in the spiral yellow line against the gray background on the front cover of *Ab'ad al-Ma'arri* (*The al- Ma'arri Dimensions*)[14] or the olive-green,

yellow, and gray geometric composition with pointed black edges on the cover of Malhas's *Malhamat al-insan* (*The Human Epic*).

How best to represent Thuraya Malhas's Sufi poetry in *Qurban* than by a dynamic abstract black and red composition? Saloua developed this geometrical irregular black frame with thick lines and thin pointed edges to express a circular movement starting from the lower right side and ending at the same point on the front cover of *Qurban*. These irregular black lines are deconstructed and transformed into various playful shapes—circles, rectangles, and triangles—that merge into each other on the book's inside pages to retell the poem or to complete its meaning visually. Some pages are linked with a thread (a thin black line) to visually express the continuity of the text or the narrative from one page to another.[15] The abstract morphing compositions express or complete the meaning of Malhas's Sufi poem. Saloua uses an interplay of positive and negative forms to express voids, feelings, and emotions in an infinite metaphysical space. For *Qurban*'s title on the book's front cover, Saloua designed the Arabic letters in an unconventional way. She chose not to use the traditional calligraphic style commonly drawn by master calligraphers but instead used letters that she cut and cast in linoleum to print this cover manually.

Saloua Raouda Choucair and Other Arab Women

Chiseling and welding in her wood and metal workshop were unusual choices for young women in 1950s Beirut. Not so for Saloua Raouda Choucair, who saw no need or purpose for gender differences or separate activities for men and women. She was small, energetic, and wore comfortable clothes both inside and outside her workshop.[16] When I interviewed her older sister—who was a Lebanese feminist and women's rights activist since the 1930s—about the activities of women at the time, she constantly referred to Saloua, her ideas, her boyish attire, and her strong-willed personality. "Saloua was a tomboy," her sister, Anissa, said, "she was a feminist in the sense that she believed that women and men are equal."[17] Daughters of a landowner and pharmacist Salim Anis Raouda (1872–1917)[18] and Zalfa Amine Najjar (1891–1995), both women attended the Beirut College for Women (BCW) and the American University of Beirut in the 1930s.[19] The girls of their generation who were privileged to attend an educational institution did so to attain skills complimenting girls' future roles as mothers and wives; they took art and "décor" courses as a hobby to decorate their homes. Yet not all women in Beirut dealt with art as a hobby to decorate their homes.[20] For example, Marie Chiha Hadad (1889–1973) is considered a pioneer in Lebanese art circles during the first two decades of twentieth-century Lebanon. She headed the Association des Artistes du Liban during this period. Her salon was famous as a meeting place for Beirut's intellectuals and artists. Yet, unlike Saloua, her work focused on still-life compositions following the classical tradition of European master painters. Huguette Caland (1931–2019), the daughter of Bechara el-Khoury, Lebanon's

first post-independence president (1943–52), was another female artist who, like Saloua, chose art and design as a professional career. Saloua's other close friends were artists like Etel Adnan (1925–2021), a Lebanese poet whose career as an artist did not take off until she was in her eighties, and Helen El-Khal (1923–2009), a painter and art critic who valued her artwork. Saloua also befriended prominent women whose careers were outside the arts, like Thuraya Malhas (1925–2013), a poet and writer, and Saloua Nassar (1913–1967), who also attended the BCW and became the first Lebanese woman to earn a PhD in physics. Saloua and Nassar exchanged books, ideas, and thoughts on science and art during their studies at the BCW.

"Modernism in my work is not a European influence"

"Modernism in my work is not a European influence," Saloua insists, "but rather a universal influence, a global one; I am experiencing my era the way any other artist in the world would do, in my own way."[21] She did not share her predecessors' radical views on artistic production or follow the classical trajectory of becoming a master artist in the tradition of Mustapha Farrukh, Omar Unsi, Khalil Saleebi, Saliba Douaihy, or Rachid Wehbi, among many others of the pioneer Lebanese painters. Rather, she continued exploring novel methods by experimenting with new materials and approaches. For her, artistic production was not restricted to mixing colors and studying perspective to achieve the closest reproduction of reality on canvas. In her art and design work, she brought quantum physics and Sufi philosophy into conversation. "She was an avant-garde who was inspired by the principles of Islamic art, but without any visual references to what people were accustomed to seeing in that art," Hala told *The Wall Street Journal* in 2013.[22]

With her short, self-styled, geometric haircut and wearing chunky jewelry designed herself, Saloua is known as the first abstract artist in Lebanon. Her exhibition in 1947 at the Arab Cultural Club Gallery in Beirut is considered to have been the Arab world's first display of abstract art.[23] In 1948, Saloua curated Henry Seyrig's collection at the same gallery.[24] The show included valuable pieces by renowned international artists like Picasso, Matisse, Klee, Braque, and Calder, whose artworks were seen for the first time in Beirut.[25] In Paris during the same year, she joined the École Nationale Supérieure des Beaux-Arts, where she took silk-screen print courses and attended Fernand Léger's (1881–1955) workshops at his studio.[26] In 1950, she was one of the first Arab artists to participate in the Salon des Réalités Nouvelles in Paris. For the opening of her geometric abstract painting exhibition at the École des Lettres at the Saint Joseph University in Beirut, which was sponsored by the first lady, Mrs. Laure Bechara el-Khoury, Saloua designed the lettering for her name in Arabic and Latin, as well as the layout of the manually printed poster in a modernist style that reflects her work—using vertical and horizontal lines.

Figure 1.7.4 Saloua Raouda Choucair, poster announcing the opening of her geometric abstract painting exhibition at the École des Lettres (Saint Joseph University) in Beirut, Lebanon. Courtesy of the Saloua Raouda Choucair Foundation.

The Crossroad of Art and Design

Saloua may not have seen herself as a designer when, at age fourteen, she crafted custom-made rabbit-skin slippers for family members and friends—ahthiat Saloua (shoes by Saloua), as her cousin called them. The complex process of producing them—including cutting the pattern for different sizes—is evidence of her creative design thinking.[27] These slippers can be seen as Saloua's debut in her long journey of developing concepts for design products. Carla Chammas, an art connoisseur based in New York, described Saloua Raouda Choucair not only as an artist but as "a thinker, an inventor."[28]

The question of how best to respond and adapt her products to the needs of changing social, cultural, and economic conditions was often addressed in Saloua's work. She understood design as an evolution.[29] She would produce an object and then sketch new ideas to improve it. For her, design was a continuous development in experimenting

Figure 1.7.5 Saloua Raouda Choucair, women's coat made of hand-woven goat wool on a traditional loom with natural dye color threads by Abu Jouhayna and the artisans in Kfarqatra, Shouf region, Lebanon, 1973. Courtesy of the Saloua Raouda Choucair Foundation.

and exploring new materials and solutions. Local critics reacted positively to Saloua's artistic practices but have had little to say about her design thinking. Perhaps they were uncomfortable discussing her design work, fearing it would diminish her artistic work's value. Artistic production is generally perceived as higher in value than design production. The design profession is commonly seen as a "lower" rank than fine arts due to its "commercial" function. The corresponding duality between art and design and between "serious" and frivolous work is broken down in Saloua's studio. She believed in herself and the equal power of her art and design to mobilize and shift how people perceived art and design.

Saloua's work using diverse materials and processes to produce her carpets, furniture, and jewelry subverts conventional approaches to art and design.[30] It challenges the general understanding of art as focused in one direction. Saloua Raouda Choucair straddled two worlds; she was simultaneously a designer and artist inspired by abstract rather than figurative form.

Designing Lebanese Traditional Crafts

Determined, proud, and motivated, Saloua appears in a 1954 photograph receiving a grant to travel to the USA from the Point IV president. The Point IV project was an educational initiative established in 1952 as a collaboration between the Lebanese and the US governments to provide consultation and advice to support craftsmanship and develop local industries—while teaching home economics to small groups of women in communities in Beirut and rural areas in Lebanon.[31] At age thirty-six, Saloua joined this project and offered women in rural areas training in producing refined local crafts. She revived traditional crafts and used the local skilled craftsman to produce well-designed projects such as the goat wool weaving techniques commonly used for the production of Bedouin tents, carpets, and camel bags, and to produce a modern coat designed using natural color dyes in the vertical stripes that she wore on various occasions—her exhibition openings and other formal events.

Combining Aesthetics and Utilitarian Functions

Saloua remembers being repeatedly criticized for working in "too many different areas and using too many different materials."[32] But this did not stop her from further exploring uncommonly used materials in her work, such as clay, wood, plastic, Plexiglas, metal, stone, and others. She wanted her art to be practical—designing electric appliances, book covers, street furniture, jewelry, carpets, and other utilitarian objects—for example, a design could be art. The tension inherent in distinguishing design production from artistic production and fine arts from applied art exemplifies how difficult it was for the wider public to understand and make sense of Saloua Raouda Choucair's work. She is known as a painter

and a sculptor, but at the same time, she strove to combine fine craftsmanship and design in her art. She brought her artistic creativity into the production of design products, and in turn, her interest in design enriched her artistic production. By crossing and re-crossing the boundaries between art, craft, industry, and commodity, Saloua's work can be understood as artistic design production. In Saloua Raouda Choucair's work, the designer and the artist were one and the same.

© **Dr. Yasmine Nachabe Taan**

NOTES

1. Choucair, Saloua Raouda, "How the Arab Understood Visual Art" (1951). This text was originally part of Choucair's letter to Musa Sulaiman, published in *Al-Abhath* Vol. 4, No. 1, June 1951. Kirsten Scheid translates part of this letter in *ARTMargins,* Vol. 4, No. 1, 2015, pgs. 119–28.
2. The term Arab here refers to the Arab culture in general and not a geographically determined location.
3. Choucair, "How the Arab Understood Visual Art" (1951, 2015), pg. 120.
4. Choucair, S.R., "Hiwar maa al-fannanah: Raouda Salim Choucair" (Interview with Saloua Raouda Choucair), in *al-Hayat al-Tashkilyiah,* Vol. 13, Nos. 49–50, 1993, pgs. 74–85. Trans. Michelle Hartman in Nachabe Taan, Y. (2019), *Saloua Raouda Choucair: Modern Arab Design: An Exploration of Abstraction Across Materials and Functions.* Amsterdam: KHATT Books, pgs. 15–17, pg. 15.
5. Hala Schoukair. Personal interview. June 12, 2017.
6. "Interview with Saloua Raouda Choucair" (1993, 2019), pg. 15.
7. Ibid.
8. Hala Schoukair. Personal interview. April 20, 2023.
9. Ibid.
10. Ibid.
11. Sufi poetry is a spiritual, mystical, and contemplative poetry that dates back to twelfth-century Islam. Sufism has been a prominent spiritual tradition in Islam, contributing substantially toward the spiritual well-being of many people within and outside the Muslim world. According to Choucair, it is a philosophy that inspired a growing number of Western philosophers such as Kierkegaard, Jaspers, Heidegger, and Sartre. ("How the Arab Understood Visual Art," pg. 123.)
12. Ibid.
13. Choucair, "How the Arab Understood Visual Art" (1951–2015), pg. 128.
14. Abu al-Ala' al-Ma'arri (973–1057), also known under his Latin name Abulola Moarrensis, is an Arabic philosopher, poet, and writer.
15. Examples of the inside double-page spreads in *Qurban* (1952) can be seen on pg. 145, Nachabe Taan, Y. *Saloua Raouda Choucair,* 2019.
16. For more on Choucair's workshop, see Mehranguise Irani's description of Choucair's studio, in "Treasure House of Sculpture" in *Alumnae Bulletin—BUC,* Vol. XVII (3), 1974, pg. 9.
17. Anissa Najjar, Personal interview. September 21, 2013.
18. Salim Raouda was an expatriate in Australia trading herbs and writing manuscripts on their medicinal values. When he returned to Lebanon in 1910, he met and married Zalfa Amin Najjar. They had three children: Anis

Raouda (1911–1988) was a businessman and a member of the Beirut municipality; Anissa Raouda Najjar (1913–2016) was a social activist who was married to the late Fouad Najjar; and Saloua Raouda Choucair. As a conscript in the Ottoman army, Salim Raouda contracted typhoid in Damascus and died in 1917, leaving Saloua's mother to raise three children alone (Najjar, Fouad (junior)). Personal interview. May 13, 2023.

19. The American Junior College for Women, founded by the Presbyterian missionaries as a school for girls around the 1860s, became the Beirut College for Women, BCW (now referred to as the Lebanese American University, LAU). In 1924, the Beirut College for Women became the first institution in the Middle East to offer higher education for women. Fleischmann, E.L. "Under an American Roof: The Beginnings of the American Junior College for Women in Beirut," in *The Arab Studies Journal*, Vol. 17, No. 1, Spring 2009, pgs. 62–84.

20. For more on emerging and established female artists in Lebanon and the Arab world, see El-Khal, Helen, *The Woman Artist in Lebanon*, Beirut: Beirut University College, Institute for Women's Studies in the Arab World (1988), and Saloua Mikdadi Nashashibi, *Forces of Change: Artists of the Arab world*. Lafayette, CA.: International Council for Women in the Arts, 1994.

21. Interview with Saloua Raouda Choucair in *Taa' al-Ta'nith*, Tele Liban, late 1980s.

22. Grimes, W. "Saloua Raouda Choucair, Early Exponent of Abstract Arabian Art, Dies at 100," in *The New York Times*, February 17, 2017. Retrieved March 11, 2023.

23. Tarrab, Joseph, Schoukair, Hala, El-Khal, Helen (2002). *Saloua Raouda Choucair: Her Life and Art*. Beirut, Lebanon (privately printed).

24. Henri Seyrig was general director of antiquities of Syria and Lebanon since 1929 and director of the Institute of Archaeology in Beirut for over twenty years.

25. El-Khal, Helen (1987). *The Woman Artist in Lebanon*. Beirut, Lebanon: Institute for Women's Studies in the Arab World.

26. *Saloua Raouda Choucair: Her Life and Art*. Beirut, 2002.

27. Hala Schoukair. Personal interview. June 12, 2017.

28. Jones, Kevin. "Saloua Raouda Choucair: Memory, Corrected," *ArtAsiaPacific Journal*, May 2014.

29. For examples of Saloua's sketches that show the thinking process and evolution of Choucair's design, see Nachabe Taan, Y. (2019), *Saloua Raouda Choucair: Modern Arab Design*, pgs. 72, 75, 77, 82, and 122.

30. For more on Choucair's design approach and process, see Nachabe Taan, Y. (2019), *Saloua Raouda Choucair: Modern Arab Design*, pgs. 15–17.

31. Cleveland, C. et al. (1953) *The Point IV Report Document*. Beirut, Lebanon: Point IV Project.

32. "Interview with Saloua Raouda Choucair" (1993, 2019), pg. 15.

Original as her name, DORRIT DEKK has brought lively invention and considerable research to her design for a mural. Athletic prowess, ancient and modern, is the theme. Size 50 by 12 feet, the mural is included in the overland Travelling Exhibition, now touring Britain's Festival centres. (Below.)

1.8

Dorrit Dekk: Making a Name for Herself in Graphic Design

Ruth Sykes

London, England, shortly after the Second World War: Graphic designer Dorrit Karoline Fuhrmann Klatzow (1917–2014) is at work in a government design office. About to send her first poster design into production, her printer suggests she signs it first. Klatzow is momentarily confused. This employment, begun in 1946, is her first as a graphic designer, and it had not occurred to her to sign her work. She wondered, is her surname Klatzow a good one for a designer wanting to make a name for herself in the world of mid-century British design?[1]

Dorrit thought the name was "difficult and unpronounceable."[2] A colleague, designer Reginald Mount, suggested using her initials DKK instead. Adding an "E" produced an easy-to-pronounce yet unique name that still spoke to her European heritage—born as she was in Brno, Moravia. At this moment, Dorrit Dekk, the graphic designer, was born. Her trade name would serve Dorrit well during a career stretching over four decades.[3] Varied and versatile, her practice encompassed design and illustration for advertising,

Figure 1.8.1 Dorrit Dekk, 1951 newspaper cutting of Dorrit in front of her Festival of Britain work. Image courtesy of Dorrit Dekk Archive, University of Brighton Design Archives.

publishing, retail, interiors, and exhibitions.[4] Dorrit's work met the demands of some of the most high-profile clients in Britain and beyond, with national and international audiences. Her advertising client list included Air France, Schweppes, P&O, London Transport, and the Post Office. Publishing clients included fashion magazines *Tatler* and *Harper's Bazaar*, British newspapers, and book publishers. At the height of her career, Dorrit's work formed part of the visual fabric of everyday life in the UK. It was ubiquitous, seen by millions of people every day.

Yet, her life and work are rarely mentioned in mainstream graphic design histories. But Dorrit's career and her life story that shaped it should not be forgotten. Dorrit's resourceful, playful, and meticulously researched approach has a timeless relevance to graphic designers who seek inspiration through studying the history of their discipline.

Dorrit's life encompassed tragedy and triumph, glamour and graft.[5] Born on May 18, 1917, into a well-connected Czech textile manufacturing family of Jewish heritage (related to the wealthy Tugendhats who commissioned Mies Van Der Rohe to design their iconic villa), Dorrit later lived in Vienna with her mother and brother Robert, following her parent's divorce.[6,7] A high-flying design student at the Viennese Kunstgewerbeschule (Arts and Crafts School), Dorrit was selected to design the set and costumes for a production of *A Midsummer Night's Dream*.[8] But she was barred from entering the theatre to see the outcome of this work: this was Dorrit's first personal encounter with Nazi persecution.[9] Even though her parents, Valerie and Hans Fuhrmann,[10] strove to "assimilate" their family, even baptizing Dorrit as Protestant,[11] this would count for little, and Dorrit's art-school professor urged her to escape, arranging a place for her at the Reimann School of Art and Design in London.[12] Dorrit traveled alone to Britain on a student visa, with sponsorship from one of her mother's many British friends, and Valerie followed later.[13] Robert moved to England before the occupation as part of the Czech government in exile army. He returned to Czechoslovakia after its liberation and then emigrated to Canada in 1948.[14] Dorrit's father died in Auschwitz in 1944.[15]

During her career, Dorrit secured work in glamorous contexts. She worked at the heart of the British government; she created work for the world's most beautiful cruise ships, an airline client would whisk her away on much-needed breaks from work.[16] Her work was commissioned by national and international publications, and personal commissions came from film stars and landed gentry.[17] But the first years in London were hard. Dorrit and her mother struggled financially, sharing a room.[18] Dorrit worked as an au pair and carer after leaving the Reimann School.[19] In 1940, Dorrit married scientist Dr. Leonard Klatzow (1907–1942), who died in a plane crash on September 22, 1942 while testing infra-red technology he had helped develop.[20,21] Dorrit played an important wartime role herself, working as a radio intelligence officer in the Women's Royal Navy Service.[22] According to Dorrit, her marriage to Leonard allowed her entrance to the Navy: usually, British blood relatives were a joining requirement, but this was waived for Dekk because of Leonard's

Figure 1.8.2 Dorrit Dekk, *Staggered Holidays* poster created for the Centre of Information (COI) circa 1946–48. The National Archives UK.

significant contribution to the war effort.[23] Following Leonard's death, Dorrit remained unmarried until 1968, when she married Kurt Epstein (1920–1990).[24,25]

At the war's end, about to be demobbed from the Navy, Dorrit contacted a former Reimann tutor who secured her an interview with the UK government's Ministry of Information.[26] Despite a thin portfolio of mainly student projects, Dorrit was hired. She attributed this to her "knockout" appearance, turning up in her Royal Navy uniform.[27] Under the supervision of Reginald Mount (1906–1979) and working alongside fellow Reimann graduate Eileen Evans (1921–2006), Dekk learned a great deal about effective graphic design, producing posters worthy of inclusion in the industry publication *Designers in Britain*, and was granted membership to the Society of Industrial Artists.[28] So began her journey of making a name for herself in graphic design.

It was a journey without a guide. Lacking role models, women had to invent a career path into the male-gendered job role of a graphic designer.[29] If a woman "needed" to work, then a female-gendered role, such as nursing, teaching, or retail, was considered most appropriate. Here, a woman would not need to assume a supervisory position over men.[30] Graphic design, however, requires instruction of (often) male professionals and tradesmen, such as printers and typographers. According to Enid Marx (1902–1998), the first woman to be awarded the British design industry accolade "Royal Designer for Industry," women had to work harder to sell their skills.[31] Marx commented: "I do think you're more likely to get a job as a woman if you're well turned out and able to sell the stuff, whereas a man could just produce it, put it down, and they'd either take it or leave it. They wouldn't expect him to sell it quite so hard."[32]

Fortunately, Dorrit was "well turned out," and she knew how to "sell the stuff"—developing her personal brand "Dorrit Dekk" was key to that. Although Dorrit fully credits Reginald Mount with the idea for her professional name, she developed and capitalized on the persona. She used it to invent a professional identity that was strong enough to sustain her through the rocky launch of her freelance career in the late 1940s, which began with the failure to establish herself professionally in South Africa.[33] Back in London, the character of "Dorrit Dekk" helped her "fake it till she made it" to become "probably the most prolific female poster designer of the 1950s and 60s."[34] In the 1970s, her adherence to her professional identity kept her practice going despite the rise of slick photography in the graphic design of that era,[35] which was visually at odds with her signature style of carefree drawing. Dorrit kept her design practice until 1982, well past the usual retirement age for British women of her generation.[36]

The British graphic design field remained hostile to female designers throughout Dorrit's career span. *Getting Jobs in Graphic Design*, a career advice book published in 1988, starkly stated that being female can make it harder to succeed as a graphic designer, noting that "far fewer women seem to enter the industry through the studio junior route, and women are under-represented in the ranks of art director in advertising agencies."[37] Dorrit had to negotiate these sexist attitudes throughout her career. Her clients were mostly

men, and she strategically declined offers of meetings over dinner to discuss business.[38] Yet Dorrit knew that to take control of her own career and meeting with clients herself was a necessity. She stated that she "hardly ever worked for an advertising agency because they work on behalf of clients, through a middleman—art directors would deal with the client, not the designer—but if you're a freelance designer, you can deal with the clients directly, and that's how I wanted to operate."[39]

Dorrit was one of several designers of Jewish heritage who chose to modify their names. Abram Games (1914–1996) was born Abraham Gamse.[40] George Him (1900–1982) modified his name from Jerzy Himmelfarb.[41] Hans Schleger (1898–1976) shortened his surname from Schlesinger and signed his work Zéró.[42] Dorrit explained her name modification as merely a matter of pronunciation. Still, there was a political expectation for Jewish immigrants to "assimilate" into British society to reduce the risk of anti-Semitic disturbances.[43] In 1936, two years before Dorrit came to Britain, the British Union of fascists carried out violent attacks against Jewish people in London.[44] In August 1947, anti-Semitic riots were experienced in London, Manchester, and Liverpool, with windows smashed, personal assaults, and the burning of a synagogue. Ten other locations experienced unrest.[45]

Still, Dorrit's European identity was important to her, and she had no desire to pass as British.[46] Perhaps the high value on European, modernist design ideologies held within the British design industry influenced her decision to choose a professional name that sounded European. For visual communicators aware of the power of a well-chosen name in creating a marketable identity, a simplified name retaining a European ring to it might help create an association with the most current design ideas. Although Dorrit followed a common path in changing her name, she went a little further than most, inventing a completely new one. As Enid Marx suggested, a woman trying to sell her "stuff" had to work a little bit harder than men.

In 1948, Dorrit even dropped her first name, identified only by the genderless name "Dekk," in the captions for her work featured in *Designers in Britain*.[47] Dorrit's gender-obscuring caption is undermined, however, by the way her name is entered in the index of the book. It starts with the name DEKK, with no first name given, but this is immediately followed by the qualifier "Mrs. D. Klatzow." In future volumes of the *Designers in Britain* publication, Dekk's entry in both captions and index changes to "DEKK, Dorrit," and so the experimentation of genderless presentation appears to have ceased. Returning to a full name may have partly been due to the onward march of professionalization in the design industry.[48] Designers were keen to position themselves as members of a reputable profession, seeking the respectability of doctors, lawyers, and architects. A mysterious moniker would not help a graphic designer achieve this status. The aim was to reframe the perception of designers from a type of "artist" to being a "gentleman professional."[49] Unfortunately for women designers, an image of a "lady-professional" did not seem to feature in this plan for the reasons mentioned above. Nevertheless, to build

Figure 1.8.3 Dorrit Dekk, self-promotional letter on her letterhead depicting Dorrit the artist, the saleswoman, and on holiday, circa 1954. Image courtesy of Dorrit Dekk Archive, University of Brighton Design Archives.

Figure 1.8.4 Dorrit Dekk, *We Londoners* poster for London Transport, 1961. Image courtesy of London Transport Museum Archive.

trust in this new breed of professionals, clients needed to know precisely who a designer was. Dorrit negotiated this requirement in her own imaginative way by using the more playful version of her first name, "Dorrit" rather than the formal "Dorothea." Further, the name "Dorrit" had fictionally heroic connotations, from its similarity to the name of Charles Dickens's well-known character, Little Dorrit. In this way, she had cleverly developed a professional name that had several powerful benefits: it eased difficulties of pronunciation, warded against anti-Semitism, met professional standards, stayed authentic to her own background, and communicated the playfully imaginative, narrative spirit inherent in her work. The combination of oddness with ease of pronunciation made it eminently memorable.

Inventing this imaginative professional alter ego may have helped Dorrit overcome sexist ideas about women's roles. It gave her a quasi-fictional persona to inhabit to help her break societal rules. Dorrit had firsthand experience of the narrow ideas about women and design prevalent in the UK on arrival in London. At the Reimann School, she was advised to switch from her previous path of studying theater design to graphic design, as it was considered that a woman would not be able to establish a career in the former in Britain.[50] Design for advertising, however, was a newer field of professional creativity with less oppressive tradition. The British advertising industry was receptive to new sociological ideas imported from the United States that suggested an understanding of the female psyche was required to persuade women to purchase, so allowing women into the advertising industry had obvious benefits,[51] although the powerful women in advertising were more likely to be executives than creatives.[52] The role of the risk-taking, creative visual designer was still mostly seen as one most suited to men. Dorrit, therefore, found herself channelled into a field she hadn't previously imagined and in which there were very view creative female role models. "If you can't see it, you can't be it" is an oft-repeated phrase. Designing the persona "Dorrit Dekk" helped Dorrit visualize her future success as a graphic designer.

Inhabiting the persona of "Dorrit Dekk" may have helped Dorrit summon what Ruth Artmonsky has called the "chutzpah" required for a woman at this time to advance her career.[53] A telling example of Dorrit's bravado is found in the circumstances that led to her becoming one of the designers for the Festival of Britain in 1951, where "everyone who was anyone" in the design industry had a commission.[54] Dorrit got talking to a fellow member of the Society of Industrial Artists, Richard Levin, at a party. Discovering he needed a mural designer to work on the *Land Traveller Exhibition*, part of the Festival of Britain, Dorrit lied that she had experience in designing murals. Levin, "like a fool, didn't ask to see any [of her mural designs]," she recalled.[55] A harsh judgment of Levin: playing her Dorrit Dekk role, she would have created a persuasive impression of a designer capable of handling prestigious work in any format. The *Land Traveller Exhibition* toured the UK, sometimes Dorrit with it, getting her picture and design achievements featured in newspapers. Her memorable name was now receiving publicity beyond the design world.

Dorrit's original approach to self-publicity is illustrated by her invention and promotion of a fresh style of graphic portraiture she developed in the 1960s. On November 13, 1967, *The London Times* printed an article on Dorrit's innovation headlined "Personality in Art."[56] The headline referred to how Dorrit conjured up the personality of her sitters visually, but could equally have been referring to Dorrit herself and the key to her success as a designer: the creative, inventive, and playful personality she had successfully communicated to her clients and her audiences.

This new style Dorrit created was an intensely detailed collage of visual material taken from press cuttings, photographs, and other ephemera from the subject's public life, and was christened a "personality panel" by Dorrit. According to the *Times* article, this new visual language had recently won her commissions used for a cover of *Harper's Bazaar*, a large interior panel for the head office of the National Provincial Bank, and private commissions from highly influential people. Member of Parliament and newspaper owner Robert Maxwell used one for his family Christmas card in 1967. The Duke of Bedford and actress Moira Lister also had their portrait done in the new style. After the *Daily Mail* newspaper published a personality panel of the Israeli actress Dalia Penn, the positive response from readers was so great that Dorrit was commissioned by the *Mail* to produce one of British prime minister Harold Wilson, printed the following week.[57]

With trademark panache, Dorrit invented a way to create notoriety for her name by associating herself with powerful players in British culture and generating publicity about it. It was also a way to drum up income: the *Times* article was intended to drive readers to an exhibition of Dorrit's personality panels at a gallery on Sloane Street in November 1967.[58] According to the *Daily Mail* article, the portraits sold for between 70 and 100 guineas—broadly equivalent to 700–1,000 British pounds today.

Looking through the archive of Dorrit's work held in the University of Brighton archives, the crowded visual language of the personality portraits seems in surprising contrast to her airy, free-wheeling drawing style. But the visual language Dekk used throughout her graphic design career changed, chameleon-like, with the context surrounding her commissions, whether she was mastering the airbrush under Reginald Mount's instruction, illustrating[59] posters for Air France with cartoon-like flowing lines and primary colors,[60] or making charming collage-characters for WH Smiths' book tokens.[61] The adaptability that Dorrit showed in her own life, transforming herself from Dorrit Klatzow to Dorrit Dekk, is mirrored in her changing visual language.

Although Dorrit closed her graphic design studio in the 1980s, she continued to paint throughout her retirement, exhibiting in solo and group exhibitions.[62] In 2010, she produced a series of illustrations for cult menswear label Tender Co., giving exuberant visual form to creatures from Jorge Luis Borges's *Book of Imaginary Beings*.[63] The drawings were printed on T-shirts and sold internationally. The T-shirt swing tag pictured Dorrit at work on the illustrations. The illustration style is modern and timeless and shows that

Figure 1.8.5 Dorrit Dekk, one of a series of five illustrations drawn for Tender Co. T-shirt range, 2010. Image courtesy of William Kroll.

Dekk's approach to visual communication is still relevant today. The commission came about through a family connection: Tender Co. is owned by William Kroll, grandson of Alex and Maria Kroll, fellow European émigrés of a similar generation to Dorrit, and fellow ex-students of the Reimann School in London.[64,65,66]

Dorrit died at age ninety-seven on December 29, 2014, in London.[67] The creativity inherent in her professional name lives on curiously, however. Today, should you wish, you can sport a pair of spectacles from a designer range of eyewear entitled "Dorrit Dekk." Proving what a marketable name "Dorrit Dekk" is, the owners of this range have gone as far as trademarking the name "Dorrit Dekk" and creating a logo for it.[68] Unlike other instances of eyewear named after cultural visionaries, such as "Coltrane," "De Beauvoir" and "Wollstonecraft," few who encounter this range will know who Dorrit Dekk was. But, with its catchy alliteration and visual rhythms, they'll recognize a great name when they see one.

© **Ruth Sykes**

Section 1 New Millennium Pioneers (1875–1920) **104**

NOTES

1. Dorrit Epstein, "Dorrit Dekk Interview: Dorrit and World War Two." Interview by Linda Eells and Nicola Fleming, September 15, 2008. Available online: https://webarchive.nationalarchives.gov.uk/ukgwa/20111206063451/http://yourarchives.nationalarchives.gov.uk/index.php?title=Dorrit_Dekk_Interview:_Dorrit_and_World_War_Two/
2. L. Eels and N. Fleming, "Dorrit Dekk Interview: Dorrit and World War Two."
3. Ben Uri Museum and Gallery, *Dorrit Dekk*.
4. Ruth Artmonsky, *Designing Women: Women Working in Advertising and Publicity from the 1920s to the 1960s*. London: Artmonsky Arts, 2012.
5. Jana Buresova, "Dorrit Dekk." The British Czech and Slovak Association. Accessed online May 27, 2023: https://www.bcsa.co.uk/wp-content/uploads/2021/01/DorritDekk-Jana.pdf
6. Villa Tugendhat, "About the House." Accessed online May 27, 2023: https://www.tugendhat.eu/en/
7. Pavla Hind, "Dorrit Dekk." The British Czech and Slovak Association. Accessed online May 27, 2023: https://www.bcsa.co.uk/wp-content/uploads/2021/01/Dorri-Dekk-Pavla-blog.pdf
8. William Mager, "Festival of Britain 2011: Dorrit Dekk and the Land Traveller," YouTube, April 20, 2011, educational video, 4:06. https://www.youtube.com/watch?v=zZJMe9IUMp8/
9. William Mager, "Festival of Britain."
10. Valerie Fuhrmann, born 1893, date of death unknown. Hans Fuhrmann born 1885, died 1944. This information is held on the website Geni.com (https://www.geni.com/people/Valerie-Fuhrmann-Forman/6000000041536724781 and https://www.geni.com/people/Ing-Hans-Fuhrmann/6000000041537252145).
11. Jana Buresova, "Dorrit Dekk."
12. L. Eells and N. Fleming, "Interview with Dorrit Dekk."
13. Jana Buresova, "Dorrit Dekk."
14. Internet Encyclopedia of the History of Brno, "Robert Paul Fuhrmann." Accessed online August 23, 2023: https://encyklopedie.brna.cz/home-mmb/?acc=profil_osobnosti&load=16275/
15. Geni, "Ing. Hans Fuhrmann." Accessed online August 24, 2023: https://www.geni.com/people/Ing-Hans-Fuhrmann/6000000041537252145.
16. Ruth Artmonsky, *Designing Women*; Naomi Games, "Dorrit Dekk Obituary," *The Guardian*, January 7, 2015. Online: https://www.theguardian.com/artanddesign/2015/jan/07/dorrit-dekk.
17. "The Forsyte Girl's Saga … All In One Picture," *Daily Mail*, October 30, 1967.
18. Jana Buresova, *The Dynamics of Forced Female Migration from Czechoslovakia to London, 1938–1950*. Oxford: Peter Laing, 2019.
19. L. Eells and N. Fleming, "Interview with Dorrit Dekk."
20. Naomi Games, "Dorrit Dekk Obituary."
21. L. Eells and N. Fleming, "Dorrit Dekk Interview: Dorrit and World War Two."
22. Jana Buresova, "Dorrit Dekk."
23. Ibid.
24. Ben Uri Museum and Gallery, "Dorrit Dekk."
25. Kurt, born in Czechoslovakia in 1920, escaped to England, where he worked as a general manager for a food merchant. He died in London in 1990. Geni, "Kurt Vladislau Epstein." Accessed online August 23, 2023: https://www.geni.com/people/Kurt-January 23, 2009. Accessed online May 27, 2023: *The London Gazette*, "*The London Gazette*, June 21, 1949." Accessed online August 23, 2023: https://www.thegazette.co.uk/London/issue/38647/page/3063.
26. L. Eells and N. Fleming, "Dorrit Dekk Interview: Dorrit and INF 3," *The National*

27. *Archives*, January 23, 2009. Accessed online May 27, 2023: https://webarchive.nationalarchives.gov.uk/ukgwa/20121225165722/http://yourarchives.nationalarchives.gov.uk/index.php?title=Dorrit_Dekk_Interview%3A_Dorrit_and_INF_3.
27. Ibid.
28. The Society of Industrial Artists (1949). *Designers in Britain 1948*. London: Allan Wingate. It is interesting to note that Reginald Mount worked in partnership with designer Eileen Evans, producing many posters for the Ministry of Information's public awareness and propaganda campaigns.
29. E. Wilson, (1980). *Only Halfway to Paradise: Women in Postwar Britain 1945–1968*. London: Tavistock Publications.
30. Ibid.
31. Royal Society of Arts, "Past Royal Designers for Industry," November 2022. Available: https://www.thersa.org/about/royal-designers-for-industry/past-royal-designers-for-industry.
32. H. Salter, (1994). "Enid Marx RDI: An Interview," in J. Seddon and S. Worden (eds.), *Women Designing: Redefining Design in Britain between the Wars*. Brighton, UK: University of Brighton, pg. 92.
33. "Who Was Dekk," *Cape Times*, April 1949.
34. David Bownes. "Poster Girls—Dorrit Dekk: The Travel Queen." London Transport Museum. Accessed online May 28, 2023: https://www.ltmuseum.co.uk/blog/poster-girls-dorrit-dekk-travel-queen.
35. Dorrit Dekk [Dorothy Karoline Epstein] (1917–2014), Dorrit Dekk Archive, c. 1945–2014. University of Brighton Design Archives. GB 1837 DES/DDK.
36. Parliamentary and Health Service Ombudsman, "Women's State Pension Age: Our Findings on the Department for Work and Pensions." Accessed online May 28, 2023: https://www.ombudsman.org.uk/publications/womens-state-pension-age-our-findings-department-work-and-pensions-communication/background-relating-changes-state-pension-age-women.
37. T. Jones, (1988). *Getting Jobs in Graphic Design*. London: Cassell, London.
38. Naomi Games, "Dorrit Dekk Obituary."
39. L. Eells and N. Fleming, "Dorrit Dekk Interview: Dorrit and World War Two."
40. Ben Uri Gallery and Museum, "Abram Games." Accessed online May 29, 2023: https://benuri.org/artists/46-abram-games/biography/.
41. Ben Uri Gallery and Museum, "ATL>George Him." Accessed online May 29, 2023: https://benuri.org/artists/282-george-him/biography/.
42. Ben Uri Gallery and Museum, "ATL>Hans Schleger Zéró." Accessed online May 29, 2023: https://benuri.org/artists/502-hans-schleger-%28zero%29/overview/.
43. L. London, (2003). *Whitehall and the Jews*. Cambridge, UK: Cambridge University Press.
44. British Library, "Lou Kenton describes the Battle of Cable Street." Accessed online May 29, 2023: https://www.bl.uk/collection-items/lou-kenton-describes-the-battle-of-cable-street.
45. T. Kushner, (1996). "Anti-Semitism and Austerity: The August 1947 Riots in Britain," in P. Panikos, (ed.), *Racial Violence in Britain in the Nineteenth and Twentieth Centuries, 1840–1950*. UNKNO Publishing.
46. L. Eells and N. Fleming, "Dorrit Dekk Interview: Dorrit and World War Two."
47. The Society of Industrial Artists (1949). *Designers in Britain 1948*. London: Allan Wingate, pg. 148. M.S.I.A. stands for Member of the Society of Industrial Artists.
48. Leah Armstrong, "A New Image for a New Profession: Self-Image and Representation in the Professionalization of Design in Britain, 1945–1960," *Journal of Consumer Culture* Vol. 19, July 20, 2017, pgs. 104–24. https://journals.sagepub.com/doi/pdf/10.1177/1469540517708830.
49. Ibid., pg. 104.

50. Naomi Games, "Dorrit Dekk: Obituary."
51. Artmonsky, *Designing Women*.
52. Ibid.
53. Artmonsky, *Designing Women*, pg. 100.
54. Julian Hendy, *1951 Festival of Britain: A Brave New World*, 20:15 24/09/2011, BBC2, 60 mins. https://learningonscreen.ac.uk/ondemand/index.php/prog/0200D24D?bcast=134407737.
55. Hendy, 2011, 60 mins.
56. Suzy Menkes. "Personality in Art," *The London Times*, November 13, 1967.
57. *Daily Mail*, "It's a Hang-Up of Harold ... By Popular Request," October 30, 1967.
58. Dorrit Dekk: An exhibition of personality panels, November 14–18, 1967, GB 1837 DES/DDK/7, Dorrit Dekk Archive, University of Brighton Archives.
59. L. Eells and N. Fleming, "Dorrit Dekk Interview: Dorrit and INF 3."
60. Christian Maryška, "Dorrit Dekk—ein verspäteter Nachruf," Austrian Posters. Accessed online May 28, 2023: https://www.austrianposters.at/2015/04/11/dorrit-dekk-ein-verspaeteter-nachruf/.
61. Book Token Cards, GB 1837 DES/DDK/3, Dorrit Dekk Archive, University of Brighton Archives.
62. Ben Uri, *Dorrit Dekk Overview*.
63. William Kroll, email message to author, Tuesday, April 18, 2023.
64. Veronica Horwell, "Alex Kroll." Accessed online August 29, 2023: https://www.theguardian.com/media/2008/jul/02/pressandpublishing.
65. William Kroll, email message to author, Tuesday, August 28, 2023.
66. Geni, "Maria 'Mia' Kroll (Wolff)." Accessed online August 29, 2023: https://www.geni.com/people/Maria-Kroll/6000000080390727160.
67. Geni, "Dorrit 'DEKK' Epstein." Accessed online August 23, 2023: https://www.geni.com/people/Dorrit-DEKK-Epstein/6000000188918462846.
68. Quick Company. "4356480-dorrit-dekk." Accessed online May 27, 2023: https://www.quickcompany.in/trademarks/4356480-dorrit-dekk.

1.9
Roswitha Bitterlich: Between Two or More Worlds

Dr. Paula Ramos and Dr. Raquel Castedo

A child steps into the intellectual, shaken battlefield of the present, from the ground up. A charming, softly-gazing girl, whose soul encompasses a realm of imagination that stretches from the whimsical ideas of a puppeteer to the horrors that Francisco de Goya, in his chilling depictions of war and degeneration, has never laid bare. All the horrors that have shaken the souls of men until today; the monstrosities that seem to dominate the world, pass before this girl like flashes of lightning. Roswitha—the prodigy girl—can, through her artistic ability, represent these images in a way that can only be compared to masters of the past and present. [...][1]

This is how the Austrian writer Karl Emmerich Hirt (1866–1963) begins his presentation of Roswitha Bitterlich (1920–2015) in the preface of the book *Schwarz-Weiss-Kunst* (*Black and White Art*), published in 1936. Committed to the Catholic ideology, Hirt associates the young artist's talent with a divine gift: "[...] Her technique and skill are only a message from the Creator. Her inspiration is a miracle. When and in whom can an inspiration of such magnitude and strength be found, as in this child?"

Figure 1.9.1 Roswitha Bitterlich, photographic portrait, January 1, 1935. Photo: Max Hayek. Image courtesy of Österreichische Nationalbibliothek.

At sixteen years old, Roswitha had already published at least eight illustrated books, many of which were populated by representations of gnomes, fairies, and beings from the imaginary world of Tyrol, western Austria, where she lived with her family.[2] She was a true phenomenon, hailed by the press as "Das Wunderkind" and compared to another "child prodigy" of that country: Wolfgang Amadeus Mozart (1756–1791).

One year earlier, in 1935, she had held an exhibition in Vienna at the Glaspalast, inaugurated by Chancellor Kurt Schuschnigg (1897–1977), also of Tyrolean ancestry.[3] As Karin Nusko informs us, the public's enthusiasm was so great that there were continuous queues at the ticket offices.[4] One of the visitors was the composer Erich [Eric] Zeisl (1905–1959),[5] who, swept away by the images, wrote four musical pieces: "The paintings, that is, rather the ideas behind the paintings, provided such a stimulus that immediately after coming home from the exhibition, I started out to set these ideas in music and completed the work … in four days."[6] To the set of pieces based on the paintings *Der Wahnsinnige* (*The Madman*), *Arme Seelen* (*Poor Souls*), *Der Leichenschmaus* (*The Funeral Feast*), and *Die Vertreibung der Heiligen* (*Expulsion of the Saints*), Zeisl called it *Kleine Sinfonie* (*Little Symphony*).[7] In 2013, Yarlung Records released the first recording of this work, performed by the UCLA Philharmonia. On the CD cover was the striking *Der Wahnsinnige*: a young, ragged man dancing with a smile while playing an imaginary violin made with the rope that would hang him.[8]

Like many pieces from the 1935 exhibition, this image brought a sharp view of the world in a tone quite different from her earlier drawings. The Italian critic Giuseppe De Logu (1898–1971), in an article for the magazine *Emporium*, in 1936, was already drawing attention to this point:

> […] The work is openly divided into two moments. Naïve, childish drawing for tales, fables, narratives, animated by a spirit of observation with invention, a joyful sense of caricature; in a second moment, wit and caricature turn into bitter irony, and the drama plunges into tragedy. How can little Roswitha, gentle and provincial, see the world in such desolation and feel life already tainted with such bitterness?[9]

As we will see, this duality may have its roots in the influence and interests of her father and mother, ubiquitous characters in her upbringing and trajectory. Similarly, this duality foreshadows the diametrically opposed moments she experienced: one in the Old World and another in the New World. Roswitha Bitterlich, who had published almost two dozen books and exhibited her works in several European cities before turning twenty, crossed the Atlantic in 1955 to settle in Porto Alegre, the capital of the southernmost state of Brazil. The celebrated artist would spend her next sixty years in seclusion, devotion, and resignation there, eventually passing away in obscurity in 2015.

"Das Wunderkind" (The Child Prodigy)

Roswitha Bitterlich was born on April 24, 1920, in Bregenz, Austria, the daughter of Hans Maria Bitterlich (1889–1961) and Gabriele Göhlert (1896–1978). Shortly after her birth, the family moved to Šluknov, what is now the Czech Republic, where her father worked as a manager in a textile factory.[10] It was there that the girl's two brothers, Hansjörg (1923–1998) and Wolfram (1924–1971),[11] were born. Despite its brevity, the period in Šluknov was particularly significant. Apart from providing Roswitha's early childhood with peace and tranquility, there was something extraordinary: a rose garden surrounding the house. According to Mechthild Maria Brink (1946), the artist's eldest daughter, during spring and summer, these flowers were picked in the morning and arranged into bouquets, which adorned and perfumed the house. "For my mother, the scent of childhood was the scent of roses," Mechthild recalls.[12]

In 1928, the family moved to Innsbruck, the capital of Tyrol, initiating a prolonged period of economic hardship. They settled on the third floor of Kaiser-Franz-Joseph-Straße 5, where they could glimpse the Inn Valley with its snow-covered mountain range for much of the year. Mechthild spent her childhood in the rented property, remembering afternoons in her grandfather's office beside the wooden desk. "He would paint on one side and I on the other. There were colored pencils, ink, watercolors, and many colors … If he made ceramics, I could make them too. Actually, I could do anything. That is unforgettable to me!" she reminisces.

Hans Maria Bitterlich graduated with a degree in Law to satisfy his father, who disapproved of his true passion: visual arts. Being self-taught and fascinated by astrology, mineralogy, music, and literature, he produced a myriad of drawings, paintings, and prints, most of which had a modern style with a caricatural bias. He also created sculptures in ceramics, bronze, and wood. Despite participating in exhibitions and investing time and effort into this craft, he never made a living from his art. However, when he recognized his daughter's genuine vocation, he didn't hesitate to encourage her. Gabriele did the same. For Mechthild, her grandparents' role was decisive: "Without them, my mother's drawings would have remained in drawers. She was a little hermit who didn't enjoy contact with the public. In fact, the exhibitions were organized by my grandpa and grandma."

Roswitha had her first exhibition in Innsbruck in the spring of 1932, receiving acclaim for her precocity and talent. Two years later, another exhibition caused great commotion due to her dark and gloomy paintings, the same ones that would impress Erich Zeisl in 1935. Between these two sets, something unsettling emerged: how could the girl known for images and poems about "little dwarves" produce something so sorrowful?

In Germanic mythology, *Zwerge* or dwarves are elemental beings that live in forests, mountains, and underground. As guardians of nature, they are associated with craftsmanship, mining, and forging. Between 1932 and the early 1940s, Roswitha published a significant collection of books about these beings under the title *Mit Roswitha ins Märchenland*

(*With Roswitha into the Fairyland*).¹³ The little dwarves also circulated in the form of calendars, postcards, and collectible figures, the last being distributed in cereal packages by the company Peter Kölln.¹⁴ This editorial and commercial strategy provided a regular income for the family. They turned her into a true media phenomenon: her name appeared in newspapers and magazines from Tyrol, Salzburg, Germany, and the Netherlands. Her portraits in these publications showed her wearing the famous attire associated with Tyrolean peasant women: a white shirt with puffy sleeves under a fitted bodice, an apron covering a long skirt down to the ankles, and braided hair framing her face. Whether she wanted it or not, Roswitha's public image praised her connection to the land, obedience, and tradition. And these aspects, during a time of rising nationalism, were widely exploited.

In 1936, she released one of her most important works: *Schwarz-Weiss-Kunst*.¹⁵ It is not an illustrated publication or driven by a narrative; its focus is on the artist's poetics and, as

Figure 1.9.2 Roswitha Bitterlich, illustration for the book *Schwarz-Weiss-Kunst* (*Black and White Art*), Innsbruck, Leipzig: Felician Rauch, 1936. Image courtesy of @ Roswitha Bitterlich.

the title suggests, on the possibilities of black and white. With prefaces and comments by Carl Drießlein and Karl Emmerich Hirt, the book showcases seventy-four images dated between 1925 and 1935. They are accompanied by German, English, and French texts, demonstrating the desire for internationalization. The comments discuss the represented themes, the difficulty of each approach, and, of course, the artist's age when creating them. For example, the book's opening image is a silhouette that she drew and cut out at the age of five. Following that, there are visually structured narratives on two or three levels, in dialogue with comic books; interpretations based on the reading and synthesis of illustrated books; sketches of moving figures, suggesting observational drawing; short and quick strokes, like storyboards used in animated films.

As Clarissa Faccini de Lima pointed out, in addition to displaying her technical and formal research, *Schwarz-Weiss-Kunst* reveals the axes that would accompany Roswitha throughout her life.[16] Elements of German folklore are present, but also imagery from

Figure 1.9.3 Roswitha Bitterlich, illustration for the cover of the book *Eulenspiegel*, Stuttgart: Cotta, 1941. Image courtesy of @ Roswitha Bitterlich.

China, demonstrating her sympathy for the world's mythology; caricature-like and somber representations of individuals and groups, attesting to her acute examination of the human condition; allegories and scenes with religious and mystical roots, to which she would dedicate herself from the 1950s onward. Therefore, we are faced with a small Roswithian vocabulary.

In that same year, 1936, reinforcing his daughter's recognition, Hans Maria Bitterlich published a catalog listing 359 works.[17] This material would serve as the basis for the exhibitions she held in Prague (1936), Amsterdam, Rotterdam, and Copenhagen (1937), Zurich, London, and The Hague (1938), and Munich and Stuttgart (1939). Despite enjoying her youth, she continued to be referred to as *Das Wunderkind* (*The Child Prodigy*).

With the Mirror and the Owl

Convinced of her artistic vocation and wanting to embark on a new stage of her journey, Roswitha traveled to Rome in the summer of 1938 after completing her education at Gymnasium Ursulinen. There, she dedicated herself to learning the processes of fresco and sgraffito. Before winter, she was in Stuttgart, determined to master graphic techniques. There, she produced magnificent engravings centered on the medieval character Eulenspiegel. Released as a homonymous book in 1941, they were accompanied by poems by Hans Leip (1893–1983), composed based on the observation of the images.[18]

The territory of Till Eulenspiegel, somewhere between a folkloric and picaresque or historical rogue, was the Duchy of Brunswick-Lüneburg in northern Germany. His surname combines two words: "Eulen," owl, and "Spiegel," mirror. If the owl is associated with wisdom, the mirror preaches the importance of self-criticism. In popular tradition, the anti-hero would traverse various localities, exposing the sins and vanities of his contemporaries through mischievous acts.[19]

Roswitha's interpretation deviates from this approach. Although the protagonist interacts with other figures, he is on an intimate and personal journey of enchantment and disillusionment with life. Along his path, he encounters kings, beggars, magicians, and charlatans, oscillating between brief delight and the inevitable despair that arises from these experiences and lucidity. After all, his world is in collapse, governed by greed, illusion, arrogance, hunger, addiction, and war.

In terms of iconography and formal aspects, the eleven metal engravings, executed in etching, display multiple references. The representations of demons, knights wielding death, monkeys playing dice, desperate mothers, and abandoned children echo the apocalyptic imagery of Hieronymus Bosch (1450–1516) and Pieter Brueghel (1525/30–1569).[20] The compositions and technical treatments allude to the early masters of metal engraving: from Martin Schongauer (1448–1491) to Albrecht Dürer (1471–1528) and even Francisco de Goya (1746–1826). A seminal work, *Eulenspiegel* bears witness to Roswitha's awareness of the memories and traditions she was evoking while, like the wanderer it references, signifying an important transition in her life and work.[21]

Among Crosses

From Stuttgart, Roswitha traveled to Berlin. In mid-1943, she met the German writer Michael Brink (1914–1947), pseudonym of Emil Piepke. Brink was a journalist committed to Catholicism and linked to resistance groups against the Nazi regime.[22] They became engaged in early 1944. In May, he was arrested, sent to the Ravensbrück concentration camp, and later to Sachsenhausen, escaping in April 1945 during one of the many "death marches."

Crossing Germany on foot, he arrived in Innsbruck on July 16, where Roswitha, unsure of his whereabouts, had been since the previous year. They married on November 1, "All Saints' Day," and Gabriele Bitterlich's birthday. Mechthild, their daughter, was born a year later, on December 9, 1946, but she did not get to know her father. In January, he was hospitalized for the treatment of tuberculosis contracted during his imprisonment. He passed away in Agra, Switzerland, on August 9, 1947.

At twenty-seven years old, widowed, and with a baby daughter in her arms, Roswitha returned to her parent's home. There was an understandable interruption of her creative activity—shaken by her husband's premature death and the cold reception of an Innsbruck exhibition held a year earlier, where she failed to sell a single artwork for the first time. "That was a kind of verdict: You, no more," comments Mechthild. Roswitha took on sporadic projects and even held an exhibition in New York in 1951 at Galerie St. Etienne, specializing in German and Austrian expressionist artists.[23] She presented oil paintings, watercolors, and graphic works she had created in the past six years, which were met with indifference by the public and critics. The world, after the Second World War, had changed significantly, and so had art. Feeling displaced, emotionally fragile, and with few prospects, she dedicated herself to religious art.[24]

In the early 1950s, Roswitha intensified her correspondence with the German Hubert Wingen (1911–1968). He lived in Porto Alegre, in southern Brazil, a region marked by various migration cycles of Germans, Italians, Swiss, and Poles, among others. According to Mechthild, Wingen discovered Roswitha through magazines: "He was enchanted by her. We don't know how, but Hubert found her address, and the two started communicating. And suddenly, my mother went to Brazil. And she went to get married without ever having seen him before."

On January 25, 1955, accompanied by Hans Maria Bitterlich, Roswitha, and young Mechthild, then eight years old, left Innsbruck bound for the port of Genoa, Italy. They boarded the ship Augustus two days later, heading for South America. Their luggage consisted of seven large wooden trunks filled with clothes, shoes, books, and work materials.

What Do Roses Smell Like?

The arrival on the new continent was impactful. Before reaching Brazil, mother and daughter passed through Buenos Aires, Argentina, which left a mark on Mechthild's eyes:

Figure 1.9.4 Roswitha Bitterlich, illustration for the tale *Thumbelina* for the Brazilian edition of the book *Andersen's Fairy Tales*, Livraria do Globo, 1958–61. Image courtesy of @ Roswitha Bitterlich.

"We had left colorful Innsbruck and arrived in a gray city with a dark river. It was a huge shock." In Porto Alegre, where they changed addresses multiple times and faced persistent financial hardships, Roswitha and Hubert had three children: André (1957), Bernardo (1958), and Anselmo (1963). Her husband worked in facade painting, carpentry, and woodworking.[25] Linguistically reserved, shy, and unfamiliar with the artistic and cultural environment, Roswitha remained withdrawn.

In 1958, through her husband, she contacted the German designer Ernst Zeuner (1895–1967), head of the legendary Drawing Department of the former Editora Globo in Porto Alegre, one of Brazil's most important publishing houses.[26] Zeuner invited her to illustrate two of the five volumes of *Andersen's Tales*, which were being prepared for a luxury edition.[27] Roswitha shared the work with renowned illustrator Nelson Boeira Faedrich (1912–1994), taking on the volumes *The Snow Queen* and *The Little Mermaid*.

Figure 1.9.5 Roswitha Bitterlich, full-page illustration and drop caps for the Brazilian edition of the book *Grimm's Fairy Tales*, Livraria do Globo, 1970. Image courtesy of @ Roswitha Bitterlich.

She created about eighty illustrations and dozens of vignettes, executed meticulously in pen and watercolor.

With the earnings obtained from her work, Roswitha returned to Austria that same year. Pregnant with Bernando and taking Mechthild and André with her, she intended to fulfill an order from Family Swarovski. However, the torment of producing something under those conditions was immense, and the project did not materialize. She remained at her parent's house, distraught, until 1959, when she received compensation for the death of Michael Brink. Back in Porto Alegre, in early 1960, she built a small house with Hubert where the family took up residence. In 1963, she undertook her last major editorial project: the illustrations for *Grimm's Fairy Tales*, published in two volumes by Globo in 1970.[28]

The images were developed through woodcut printmaking between 1964 and 1966. There are sixteen color illustrations and sixteen black and white ones, individually reproduced on odd pages. Roswitha also created 112 drop caps for each of the tales, displaying a rare ability for synthesis and imagination by condensing characters and settings within the limited space of a drop cap.

At least ten woodcut prints for *Grimm's Fairy Tales* and nine other pen-and-ink works for *Andersen's Fairy Tales* were displayed in the only solo exhibition Roswitha presented in

Brazil. The exhibition took place in April 1967 at the Museum of Art of Rio Grande do Sul in Porto Alegre, by invitation of the then-director, sculptor Xico Stockinger (1919–2009), who was also Austrian. Almost an anthology, it showcased sixty-five works dated between 1937 and 1966. Of these, sixty-two were somehow related to the world of books and illustration, including the extraordinary prints for *Eulenspiegel*. Perhaps this helps explain its low impact, like her last exhibition in Innsbruck.[29] It is possible to imagine that visitors who were blind to the artist's excellence had heard and repeated the embarrassing and discriminatory idea that illustration is an image in service of a text and, therefore, not art. There was a gap between the audience and the artwork, just as there was a gap within the artist and herself. On the cover of the catalog, in India ink, there was a silent and evocative image of a kneeling woman, covering her face, surrounded in tormented cooling mists. In front of her, a massive candlestick with an extinguished candle; behind her, fragments of toys and a distant house, a distant home.

In 2009, her work regained visibility when she was honored at the XVII International Exhibition of Press Drawing. Six years later, on December 10, 2015, she passed away at the age of ninety-five, six months before seeing her work prominently featured in the project *Printed Modernity*, presented in Porto Alegre as a book and exhibition.[30]

Roswitha Bitterlich's favorite scent was roses, which reminded her of a happy childhood in Šluknov. Symbolically, the poem that accompanied her in mind and heart spoke about this. Written by the German author Ina Seidel (1885–1974), it contains the following stanza: "I bought a rose for the money. / Roses are better than bread. / I put it next to my pillow, it blooms and smells dead."[31]

© **Dr. Paula Ramos and Dr. Raquel Castedo**

NOTES

1. Karl Emmerich Hirt, "Vorwort" (Foreword) to *Schwarz-Weiss-Kunst*, by Roswitha Bitterlich, Innsbruck, Leipzig: Felician Rauch, 1936.

2. Among the books with this theme, published in the 1930s, are the series *Mit Roswitha ins Märchenland (With Roswitha into the Fairyland)*, edited from 1932 onwards; *250 der schönsten Sagen aus Nordtirol (250 of the Most Beautiful Legends from North Tyrol)*. Innsbruck: Wagner, 1933, and *Die schönsten Sagen aus Südtirol (The Most Beautiful Legends from South Tyrol)*, Innsbruck: Wagner, 1937, both with texts by Karl Paulin; and *Frühling, Sommer, Herbst und Winter im Zwergenland (Spring, Summer, Autumn and Winter in Dwarf Country)*, Rosenheim: Berchtenbreiter, 1935.

3. Schuschnigg governed Austria between 1934 and 1938 and was the last Austrian head of state before the "Anschluss," the annexation of Austria by Germany in March 1938. Associated with the conservative Christian Social Party (PSC), he was inspired by fascism and anti-communism. He advocated for Austrian autonomy, opposed the "Anschluss," and ultimately was arrested by the Nazis.

4. Karin Nusko, "Roswitha Bitterlich," in *BiografiA. Lexikon österreichischer Frauen: Band 1, A–H*, ed. Ilse Korotin, Wien, Köln, Weimar: Böhlau, 2016, pgs. 323–5.
5. Erich Zeisl was born in Vienna, into an upper-middle-class Jewish family. In 1938, with the "Anschluss," he went to France, and in 1939, he moved to the United States, settling in Hollywood, where he worked for the film industry and began using the name "Eric Zeisl." Source: Michael Beckerman, "Eric Zeisl," The Orel Foundation, http://orelfoundation.org/composers/article/eric_zeisl.
6. In: Christoph Schlüren, "Eric Zeisl: Little Symphony (after Pictures of Roswitha Bitterlich)," 2018, Musik Production Hoeflich, https://repertoire-explorer.musikmph.de/en/product/zeisl-eric/.
7. According to Christoph Schlüren (2018), the premiere took place on May 30, 1937, and was broadcast by Radio Brünn (Brno). On December 3, 1939, the piece was performed by the Music Hall Symphony Orchestra in New York, with a broadcast on NBC Radio. The *Kleine Sinfonie nach Bildern der Roswitha Bitterlich* was published by Universal Edition, Vienna, in 1953.
8. "Eric Zeisl," https://www.yarlungrecords.com/product/eric-zeisl-ucla-philharmonia/.
9. Giuseppe de Logu, "Roswitha Bitterlich," *Emporium*, Vol. LXXXIII, 1936, no. 494, pgs. 102–03, Emporium Parole e Figure, https://emporium.sns.it/fototeca/scheda.php?id=50063#
10. Karin Nusko, "Gabriele Bitterlich," in *BiografiA. Lexikon österreichischer Frauen: Band 1, A–H*, ed. Ilse Korotin, Wien, Köln, Weimar: Böhlau, 2016, pgs. 321–2.
11. Hansjörg Bitterlich (1923–1998) pursued a religious vocation, whereas Wolfram Bitterlich (1924–1971) was a nuclear physicist.
12. Mechthild Maria Brink [de Telleria, her married name], in interviews with Paula Ramos on June 9, 2017, and March 20, 2023. All the information provided by the interviewee comes from these meetings held at Mechthild's house in Porto Alegre.
13. The books were published by Berchtenbreiter Publishing House, located in Rosenheim, Germany, which also published *Sie fiedeln und blasen voller Lust: 10 lustige Kinderlieder* (1930s), featuring texts by Maria Berg and compositions by Leonore Pfund.
14. The company Peter Kölln, located in Elmshorn, Germany, has been active for at least two centuries. They sold the homonymous albums *Mit Roswitha ins Märchenland*, completed with adhesive stickers inserted into the packages of oat flakes.
15. Roswitha Bitterlich, *Schwarz-Weiss-Kunst*, Innsbruck, Leipzig: Felician Rauch, 1936.
16. Clarissa Faccini de Lima, *Com Roswitha Bitterlich no mundo dos contos*, Monograph, Universidade Federal do Rio Grande do Sul, UFRGS, 2017.
17. *Katalog Roswitha Bitterlich*, Innsbruck: Selbstverlag Hans Maria Bitterlich, 1936.
18. Roswitha Bitterlich, *Eulenspiegel*, Stuttgart: Cotta, 1941.
19. A German chapbook from 1510 is the oldest printed reference to the character. A second edition (1515) from Strasbourg depicts the hero holding an owl and a mirror in each hand. These elements appear on a tombstone in Mölln, Schleswig-Holstein, where Eulenspiegel is honored with a water fountain and is said to have died from the plague in 1350. On this tombstone, the figure resembles the "Fool," the "Arcanum Zero" of the Tarot, whose iconography is reminiscent of a wanderer.
20. Interestingly, Roswitha descends from the Van Aken family, the same family as Jeroen van Aken, the real name of Bosch.
21. The matrices for *Eulenspiegel* were destroyed during the bombings in Stuttgart in 1942.
22. In 1942, Brink released *Don Quichotte: Bild und Wirklichkeit*, comparing the fight against windmills to the resistance against Nazism. In 1946, he published *Revolutio*

humana, a theological confrontation about the crimes in Germany under Hitler.

23. Susanne Blumesberger, "Roswitha Bitterlich," in *Handbuch der osterreichischen Kinder- und Jugendbuchautorinnen:* Band 1, A–L, Wien, Köln, Weimar: Böhlau, 2014, pgs. 136–8.

24. Roswitha had already illustrated books with a Catholic bias, such as *Licht im Schnee: Ein Weihnachtsgang* (*Light in the Snow: A Christmas Walk*), Vienna: Tyrolia, 1935, *Hallelui ja! Hallelui nein!* (*Hallelujah! Hallelui no!*), Rosenheim: Berchtenbreiter, 1935, *Stille Nacht, Heilige Nacht* (*Silent Night, Holy Night*), Zurich: Globi, 1949, and *Wie die Welt erschaffen wurde* (*How the World was Created*), Zurich: Globi, 1949. However, her most significant production in this field lies in the paintings and frescoes for churches and monasteries in Brazil and Austria, many of which are associated with Opus Sanctorum Angelorum, an organization founded by her mother in 1949. Extremely devout, Gabriele Bitterlich claimed to have visions from her "guardian angel" since childhood, an experience that became more frequent in the 1940s when she allegedly received revelations from this entity. Authorized by the Bishopric of Innsbruck in 1951, the organization expanded rapidly in the following years, establishing a presence in Germany, Switzerland, Portugal, and Brazil, where the founder is called "Mutter Gabriele" (Mother Gabriele). Both Gabriele's visions and the organization are controversial, with many members of the Catholic Church considering it a sect. In 1965, Opus Sanctorum Angelorum acquired the medieval castle of St. Petersberg near Silz, Tyrol, as its headquarters. For this space, Roswitha created her most crucial set of frescoes. In Brazil, her notable work includes collaborations with the Monastery of Belém in Guaratinguetá (São Paulo) and the Monastery of Santa Cruz in Anápolis (Goiás).

25. According to Mechthild, despite their different fields of activity, Roswitha and Hubert shared a love for reading, a daily and nightly habit for them.

26. Born in Zwickau, Carl Ernst Zeuner graduated from the Hochschule für Graphische Künste und Buchgewerbe in Leipzig. In 1922, he arrived in Porto Alegre and was hired by Livraria do Globo, which would become the second-largest publisher in the country between the 1930s and 1950s. With extensive graphic knowledge, Zeuner coordinated the work of some of the most important artists in the region who served as illustrators and designers, such as João Fahrion (1898–1970), Edgar Koetz (1914–1969), and Nelson Boeira Faedrich (1912–1994). Roswitha was the first woman to gain prominence as an illustrator in Globo's publications. For more information on this topic, check: Paula Ramos, *A modernidade impressa: Artistas ilustradores da Livraria do Globo*, Porto Alegre, Porto Alegre: UFRGS Publishing House, 2016.

27. Each volume had an average of 300 pages, featuring thirty black-and-white illustrations and ten color illustrations, in addition to vignettes. Printed on high-quality paper, the books had cardboard covers and were accompanied by a significant advertising strategy.

28. The commission from the publisher took place in 1963. Between 1964 and 1966, the artist created the illustrations. However, the publication itself was not circulated until 1970.

29. One single piece was sold as a result of the exhibition, purchased, unbeknownst to the artist, by her own daughter, Mechthild.

30. Paula Ramos, *A modernidade impressa: Artistas ilustradores da Livraria do Globo*, Porto Alegre, Porto Alegre: UFRGS Publishing House, 2016. Exhibition at MARGS, curated by Paula Ramos, between June 25 and August 21, 2016.

31. Free translation from: "Ich kaufe mir eine Rose ums Geld- / Rosen sind besser als Brot. / Ich habe sie neben mein Kissen gestellt, / sie blüht und duftet sich tot."

SECTION TWO
Modernist Trailblazers (1925–1939)

Design has always been a man's world. A white cis-men's world, to be precise. Thankfully, there have always been gifted and inspiring exceptions who have overcome the obstacles to make important contributions to design.
—Paola Antonelli and Alice Rawsthorn, "Hidden Heroines of Design," Design Emergency podcast, March 8, 2023.

2.0

Introduction

Elizabeth Resnick

The exceptional women included in this section were born in the years between the First and Second World Wars. The incomprehensible carnage of the First World War, where millions of soldiers and civilians died, led to the notion that the world had to be fundamentally rethought. The belief that new approaches to art and design could heal the human condition gave rise to Modernism, a global movement in society and culture that sought a new alignment with the experience and values of modern industrial life. Modernism was a break from the inherited notions of the past, fostering experimentation with new forms of expression in literature, visual art, architecture, dance, and music during the early decades of the twentieth century.[1]

In the 1950s, very few women worked in the nascent design industry, and almost none were at the top of the profession. By the 1960s, when design was coming of age, women employed in the design profession were still the exception, not the rule, with very few female role models in leadership positions. During this period, societal norms and expectations often limited women's opportunities for advancement, and there were systemic barriers to their entry into certain professions. Design was primarily considered a male-dominated profession, and women were often relegated to more supportive roles or positions that were perceived as traditionally feminine. UK design historian, curator, and writer Libby Sellers concedes that "The gender-biased historiography of design meant that many of the so-called 'feminine' disciplines were downgraded or completely disregarded by historians and academics eager to emphasize Modernism's love affair with machine manufacturing, industry, and architecture."[2]

Burdensome obstacles for female designers were numerous, as Turkish graphic designer Gülümser Aral Üretmen (1929–2022) comments:

> At that time, graphic design was looked down on due to the lack of specialization. Graphic design was perceived as a more masculine discipline. Women were more inclined to specialties such as interior design, fashion, crafts, painting, and opera. As the number of advertising agencies increased, female graphic design graduates slowly gained job opportunities but were always one step behind; male designers were preferred first. In addition, although women designers participated in the postage stamp, banking, and tourism poster competitions organized by the state and the Izmir Fair, male designers were mostly preferred.[3]

Swiss graphic designer Lora Lamm, who worked in Milan in the 1950s, didn't see her gender as an issue. "I was considered, first of all, a feminine being—young and blond-haired—which I thought was acceptable. Italian colleagues saw me first as a woman and then as a woman doing well professionally. That did not bother me at all; I felt proud and accepted."[4]

East German graphic designer Anneliese Ernst (1932), whose husband Hans-Eberhard Ernst (1933) was also a graphic designer working in their home, laments,

> My husband and I both worked at the same table—but individually on our own commissions. My mornings were usually hectic: getting our son ready for school, doing the shopping, housework, cooking, and all the rest. Often, I would not get down to my work before mid-afternoon. By then, my husband would have already had hours by himself and was very happy to share his ideas on my projects.[5]

"In the 1970s, everyone was talking about gender identity," recalls US graphic designer Tomoko Miho (1931–2012). "It came as a surprise to me. I can't recall a situation where the fact I was a woman was a problem, even when I became a design director in the Nelson office or later when John Massey asked me to set up the CARD office in New York. I'm sure it happens … we were all just working together, trying to respect each other."[6]

The seventeen designers featured in this section were primarily educated or formally trained after the Second World War. They began their careers in the 1950s and 1960s, often as the only female designer supervised by male colleagues. The patriarchal nature of the design profession, which favored Modernism, encouraged women designers to work in areas where the feminine perspective could be marketed to a broader consumer audience. Their compelling stories portray how they each challenged traditional gender roles with innovative approaches, creativity, and dedication, paving the way for future design practitioners. Almost all the women were in personal relationships or married, yet only seven chose motherhood.

2.1 Anita Klinz

Anita Klinz (1925–2013) was born in Croatia and became one of the few women who played a significant role in graphic design in mid-century Italy. She arrived in Milan, a refugee at the end of the Second World War, and began her career in advertising. In 1951, she was hired by Mondadori, a major publishing house, to create their in-house design studio, becoming its first art director. Over the next two decades, she designed hundreds of book covers and series for Mondadori and its subsidiary Il Saggiatore, individually and in collaboration with various designers and illustrators. Her work has received international prizes in Germany and Britain.

2.2 Jacqueline S. Casey

Jacqueline S. Casey (1927–1992) was born in Quincy, Massachusetts. She became a graphic designer and was best known for the posters she designed at the Massachusetts Institute of Technology (MIT) in Cambridge, Massachusetts. She was hired as a staff designer in the MIT Office of Publications in 1955, working with her MassArt classmate Muriel Cooper. The office was renamed Design Services in 1972, and she became its director. Many of her posters were created to publicize exhibitions organized by the MIT Committee on the Visual Arts. Influenced by European typography and design, her strong elemental imagery, often with manipulated letterforms, was the basis for the "MIT Style."

2.3 Lora Lamm

Lora Lamm (1928–2025) was born in Arosa, Switzerland. She is a well-known Swiss graphic designer whose career in graphic design spanned over sixty years. Considered a significant figure in graphic design in Italy, she is perhaps the best known of the women designers among the talented graphic artists who worked in Milan after the war—between 1953 and 1963—designing packaging, posters, and invitations for La Rinascente, Pirelli, and Elizabeth Arden. She returned to Switzerland in 1963 to work in Frank Thiessing's studio in Zurich, designing for clients in fields as diverse as pharmaceuticals, textiles, aerospace, and food.

2.4 Claudia Morgagni

Claudia Morgagni (1928–2002) was born in Milan, Italy, and worked as a graphic designer, artist, and teacher. In the 1950s, she began collaborating with advertising agencies and Santagostino. She opened her professional studio in 1957, quickly acquiring

a critical client base that included Decca, Esso, Orzoro, Kneipp, Lanerossi, Montedison, Ruffino, and IBM. She was active until the 1980s. The Claudia Morgagni Fund, preserved by the Documentation Center on Graphic Project thanks to the donation of her son Paolo, has kept the project archive since 2015, with studies, sketches, documents, and photographs.

2.5 Nelly Rudin

Nelly Rudin (1928–2013) was born in Basel, Switzerland, and trained as a designer at the Allgemeine Gewerbeschule Basel from 1947 to 1950. She joined the advertising department of the pharmaceutical company J.R. Geigy AG in Basel in 1951, where she designed advertising and packaging committed to a strict modernist style. After an encounter with Max Bill (1908–1994), who became an important mentor, she moved to Zurich in 1954, where she worked for three years in the graphic design studio of Josef Müller-Brockmann (1914–1990). In 1957, Rudin set up her graphic design studio. In 1964, she decided to work entirely as a freelance artist and devote herself to the Concrete Art movement.

2.6 Dorothea Hofmann

Dorothea Hofmann (1929–2023) was born in Lucerne, Switzerland. She trained as a graphic artist at the Allgemeine Gewerbeschule Basel from 1950 to 1954. In the ensuing decades, Dorothea developed educational syllabi, publications, and exhibitions in close collaboration with her husband, Armin Hofmann (1920–2020). As an artist/designer, she has taught at various art and design schools and has presented her work at exhibitions in Switzerland and abroad. She is the author of *Die Geburt eines Stils* (*The Birth of a Style*), the story of Swiss graphic design from a new perspective published in 2016 by Triest Verlag, Switzerland. The English translation was published in 2024.

2.7 Karmele Leizaola

Karmele Leizaola (1929–2021) was born in the Basque country but fled with her family due to the consequences of the Spanish Civil War and Second World War. She was the first documented woman to work as a graphic designer in Venezuela and is considered a pioneer of information design. Boosted by the oil boom, she began her career at Tipografía Vargas, laying out magazines like *Momento* and *Élite* and newspapers like *El Nacional* and *Domingo Hoy*. She won the National Journalism Award in Venezuela in 1982. Her work has been influential for many generations of editorial designers.

2.8 Gülümser Aral Üretmen

Gülümser Aral Üretmen (1929–2022) was born in Bursa, Turkey, and was one of the few successful female graphic designers in Turkey's male-dominated advertising/promotion world of the 1950s. Her talent for drawing was discovered at an early age, and due to her academic education and early professional achievement, she was hired at Denizcilik Bankası (Maritime Bank) in 1953, becoming the institution's first permanent graphic designer. She also designed posters, calendars, brochures, postage stamps, and logos for companies such as Garanti Bank, *Dünya* Newspaper, Turkish Airlines, Şişecam, Paşabahçe, Sugar Factory, and Ministry of Tourism, among others.

2.9 Tomoko Miho

Tomoko Miho (1931–2012) was born in Los Angeles, California. She spent her early life at the Gila River War Relocation Center in Arizona during World War II. She attended the ArtCenter School in Los Angeles, earning a degree in industrial design. She and her husband, James Miho (1933–2022), traveled through Europe and were introduced to Swiss typography and design. Between 1960 and 1980, Tomoko Miho worked for George Nelson Associates and, later, the Center for Advanced Research in Design with John Massey (1931). In the 1980s, she founded her studio, Tomoko Miho & Co. Her clients included MoMA, the Smithsonian Institution, the National Air and Space Museum, and the Isamu Noguchi Foundation.

2.10 Anneliese Ernst

Anneliese Ernst (1932) was born in Altlandsberg, Germany, and studied at the School for Print, Graphics and Advertising Schöneweide/East-Berlin from 1950 to 1955. Throughout her career in the former German Democratic Republic (GDR), she worked freelance as a graphic designer and illustrator, creating posters for films, cultural events, and TV graphics. Anneliese Ernst lives in Berlin with her husband, Hans-Eberhard Ernst.

2.11 Dolly Sahiar

Dolly Sahiar (1933–2004) was born in Bombay, India, and belonged to the Parsi community. She studied commercial art at Sir J.J. School of Art, and in 1955, she worked as a designer for the influential art quarterly *Marg*. The magazine was edited by Dr. Mulk Raj Anand (1905–2004), an eminent figure who, along with others, shaped post-Independence India's cultural landscape. Dolly Sahiar also designed other publications on Indian art

and culture over the decades. However, her pioneering work in editorial design remains unknown in India.

2.12 Odiléa Helena Setti Toscano

Odiléa Helena Setti Toscano (1934–2015) was born in São Bernardo do Campo, Brazil, and worked as an architect, professor, and graphic artist. She joined the School of Architecture and Urbanism of the University of São Paulo in 1953 in a group of five girls and twenty-five boys. In 1958, she married João Walter Toscano (1933–2011), a notable architect of this generation, and collaborated with him in his architectural and urban projects, especially in developing landscape architecture projects. She was also a professor at FAU USP between the mid-1970s and the late 1990s. She produced drawings, serigraphs, book covers, and illustrations for the editorial market and projects of panels and murals for private and public architectural spaces. Her most visible works are the murals she created for several subway stations in São Paulo.

2.13 Thérèse Moll

Thérèse Moll (1934–1961) was born in Basel, Switzerland, and studied graphic design at the Allgemeine Gewerbeschule Basel from 1949 to 1954. After graduation, Moll became an assistant at Studio Boggeri in Milan, Italy, one of Europe's great design offices. She returned to Basel in 1955, working in Karl Gerstner's studio and then at J.R. Geigy Pharmaceuticals. She briefly worked at the MIT publications office in 1959, and was credited her with introducing the staff designers to working with the grid in European typography and design. Upon returning to Switzerland, Moll accepted a staff position at Le Porte-Échappement Universel, a Swiss watch components company, in 1960. She accomplished her most sophisticated and technically proficient design work while on staff.

2.14 Eiko Emori

Eiko Emori (1935) was born and grew up in postwar Japan. She was significantly influenced by her parent's vast collection of books. As early as age six, she knew she wanted to be a book designer. Before immigrating to Canada in 1963, Emori pursued a remarkable and genuinely global education, studying design abroad at the Central School of Arts and

Crafts. She was the first female Japanese student of her generation to attend the school. She continued her education at Yale University, earning her MFA degree. She interned at I.M. Pei's architectural studio in New York City but later settled in Ottawa in 1967 to work for the National Gallery of Canada's publications unit, creating acclaimed exhibit catalogs and posters for its exhibitions. She is now retired and has a very active glass-making practice.

2.15 Dorothy Hayes

Dorothy Hayes (1935–2015) was born in Mobile, Alabama, and decided that she wanted to be a graphic designer when she was still in high school. She moved to New York in 1958 and graduated in graphic design from Cooper Union in 1967. As a Black graphic designer and educator, she is most well-known for being the co-chair of the committee and the co-curator of the Black Artists in Graphic Communication exhibition. This exhibition took place in 1970 and profiled the work of 49 Black artists, illustrators, and designers.

2.16 Agni Katzouraki

Agni Katzouraki (1936) was born in Athens, Greece, and studied graphic design at the Slade School of Fine Art in London in the early 1950s. In 1962, Katzouraki co-founded the K+K advertising agency in Athens with Freddy Carabott (1924–2011) and Michalis Katzourakis (1933), her husband. With an eye on European and American graphic design, she has changed the landscape of 1960s Greek graphic design and advertising with her modern, minimalistic, fresh, humorous, and inherently Greek design propositions.

2.17 Bonnie MacLean

Bonnie MacLean (1939–2020) was born in Philadelphia, Pennsylvania. After graduating from Pennsylvania State University and working at the Pratt Institute for one year, she moved to San Francisco in 1963. Bill Graham (1931–1991) hired her as a secretary. They fell in love and began living together. In 1966, Graham and MacLean started organizing successful rock concerts at the Fillmore Auditorium. Taking over the design of the posters from Wes Wilson (1937–2020), she created thirty-two posters before leaving Graham in 1971 and moving back to the Philadelphia area with her new partner, artist Jacques Fabert (1925–2013), and her young son David Graham (1968). MacLean developed a career as a painter of nudes, still lifes, and landscapes.

NOTES

1. Accessed at: https://www.britannica.com/art/Modernism-art
2. Seller, Libby (2017). *Women Design*. London: Quarto Publishing, pg. 12.
3. Durmaz, Ömer, Ertürk, Murat (2025). "Gülümser Aral Üretmen: A Pioneering Turkish Female Graphic Designer." This volume.
4. Kwun, Aileen, Smith, Bryn (2016). *Twenty Over Eighty: Conversations on a Lifetime in Architecture and Design*. New York: Princeton Architectural Press.
5. Epple, Rose (2025). "Anneliese Ernst: Graphics for Use." This volume.
6. Bouabana, Samira, et al., eds. (2013). *Hall of Femmes: Tomoko Miho*. Stockholm: Hall of Femmes and Oyster Press, pgs. 53–7, 17.

2.1

Anita Klinz: The Art of Book Design

Laura Ottina

Italian modernist design's golden age emerged in the 1950s and continued into the 1970s. After years of fascist dictatorship and war, Italy experienced democratic stability, rapid industrialization, and economic growth. In an effort to build a progressive image for this renewed society, leaders in the cultural and manufacturing industries embraced a modernist aesthetic by establishing mutually beneficial collaborations with innovative artists, architects, and designers. One of the few women to play an essential role in this productive yet extremely patriarchal environment was Anita Klinz, the first art director of a major Italian publishing house.

Like many of her generation, dramatic political events strongly affected her early life. Anna Maria Leucodia Klinz was born on October 15, 1923, in the seaside resort of Abbazia, located in Istria, a tranquil peninsula Italy had gained from Austria–Hungary in 1920, became part of Yugoslavia in 1947 and now belongs to Croatia.

Figure 2.1.1 Anita Klinz at work in the office of the Mondadori artistic department, n.d. Courtesy of Arnoldo and Alberto Mondadori Foundation, Anita Klinz Archive.

Anna, known as Anita, was the second child in an affluent and influential family. Her father, Giuseppe, was a doctor, and her maternal uncle, Antonio Vio, was a lawyer and former mayor of Fiume (now Rijeka, Croatia). The authoritarian and pessimistic personality of her homemaker mother, Carmen, was a powerful influence on Anita throughout her life. Anita's older sister was named after her mother, and the two girls were affectionately nicknamed Nucci and Carmucci.[1]

When Anita was two years old, the Klinz family moved to Prague, the capital of Czechoslovakia, and remained there during the German invasion and the duration of the war. Anita attended German-speaking schools, including the Faculty of Economics, and studied graphics at a Czech-speaking school for two years.[2] Every summer, she returned to Abbazia for the summer holidays. In 1945, after the Soviet occupation and bombing of their family home, the Klinzes tried to leave the country. Anita's father was arrested for his Italian nationality and held in a prison camp. She escaped with her mother and sister and, after a perilous journey on foot and hitchhiking, arrived in Milan, Italy, where they had relatives.[3] When the family finally reunited and decided to move again soon after, she remained alone in the city and eventually obtained refugee status.[4]

Milan remained the country's major economic and commercial center even though Allied bombings heavily damaged the city. Its bustling cultural sector offered many career opportunities. Anita initially supported herself with odd jobs as a nanny, translator, and bank clerk. In 1947, she found work as a layout artist and illustrator for *La Vispa Teresa*, a new periodical addressed to young girls. She remained in this position for two years and obtained freelance commissions to create ads, promotional material, and illustrations for Singer, the sewing machine company, and other clients.[5] Her true ambition, though, was to work as a book designer. She sent employment requests to Arnoldo Mondadori (1889–1971), the major Milanese publisher, until 1951, when she was finally interviewed and hired.[6]

Mondadori was, and still is, one of the largest Italian publishing houses, with a vast production ranging from fine literary editions to popular crime novels, children's books, and periodicals. Anita's first assignment was to lay out the ads on the pages of *Epoca*, a recently launched weekly photojournalism magazine. Its art director was Bruno Munari (1907–1998), one of Italian design's most influential creative minds, who Anita later remembered as a "Master of life and creative imagination."[7] She worked for about a year at *Epoca* before being transferred to the publisher's book division.

In 1953, Klinz was put in charge of the interior decoration of the first Mondadori flagship store, which opened in one of Milan's main shopping avenues. By this time, she had gained the trust and admiration of the company's president, Arnoldo Mondadori, and that of his son and vice president, Alberto. The latter became a personal friend who ushered Anita into his intellectual and progressive circle and, according to her, played a crucial role in her artistic development.[8] In 1958, Alberto Mondadori (1914–1976) founded Il Saggiatore, a small imprint that aspired to introduce important books of

Figure 2.1.2 Anita Klinz, four book jackets from the sixteen-volume series *I Maestri dell'Architettura Contemporanea* (*Masters of Contemporary Architecture*), Il Saggiatore, 1960–64. Courtesy of Arnoldo and Alberto Mondadori Foundation, Il Saggiatore Historical Library.

essays, fiction, and poetry by international authors to Italian readers. The new company was established as a subsidiary of Mondadori, and soon, Anita was positioned to design its books and editorial collections.

Working on book series enabled her to explore a systematic approach to design, which suited her organized and methodical mindset. Her graphic solutions, considered among the most original of her time,[9] range from rigorous typographic and geometric minimalism to more playful and varied compositions of cutout photographs and type. Typical of her attention to the physical presence of books, often the design extends onto the spine and the back cover. Her work on individual book covers was equally as strong, and she excelled at designing art books, a subject she was both passionate and knowledgeable about.[10]

In the early 1960s, Anita and Alberto Mondadori established the artistic department of the Mondadori book division, the first of its kind in Italian publishing, and she became its art director. The job was creative and managerial: all the design and production aspects of

books (including the choice of paper and binding), promotional materials, and fair booths were under her control and responsibility.[11] Anita helped to put together a team of fifteen illustrators and graphic designers[12] who were in charge of producing several hundred volumes each year. She hand-picked her collaborators based on their specific talents and decided who would be assigned to each project.

As an art director, Anita was passionate, authoritative, and demanding. Driven by a tenacious desire to achieve the highest quality and beauty in every volume, she was fiercely determined to hold her ground and exploit her decisional role. Based on the testimony of her collaborators, this sometimes led to pointed comments and heated discussions.[13] On the other hand, the team trusted and respected her professional perfectionism and refined taste, and she always praised and expressed gratitude to them for their joint achievements.

Well aware of the exceptional nature of her position, Anita protected herself by putting up a facade and generally kept her colleagues at a distance. Although she always participated in the company's parties and events, she kept mostly to herself. This solitude

Figure 2.1.3 Anita Klinz, cover of *Genghis-Khan*, Mondadori, 1962. Courtesy of Arnoldo and Alberto Mondadori Foundation, Mondadori Historical Library.

Section 2 Modernist Trailblazers (1925–1939)

extended to her private life; Anita had several sentimental relationships over the years but never married, and she lived alone in an apartment in a residential area of the city.[14]

Looking at the photos taken in the office dating back to those days, we can catch a glimpse of her presence and energy, an impeccably elegant and attractive woman with a serious, focused expression and penetrating gaze. Under her watchful guidance, the artistic department produced book covers and jackets that were invariably beautiful, rigorous, and imaginative. Like other prominent Italian designers at that time, Anita favored Swiss-style clarity, simplicity, and abstraction. She always seemed to know how to adapt her communication approach to each book's target and subject matter.

Although she generally chose purely typographic, geometrically abstract, or photographic covers for Il Saggiatore, Anita often turned to illustration for Mondadori's narrative collections and their paperback series. It was thanks to her decision that two of the period's greatest illustrators—Ferenc Pinter (1931–2008) and Karel Thole (1914–2000)[15]—were hired at the company, where they enjoyed decades-long careers. Their masterful and unique illustrations became the central ingredient of the popularly beloved and iconic covers for the crime series *Gialli Mondadori* and the science fiction series *Urania*. In 1962, Anita redesigned the latter, enclosing Thole's surrealistic scenes into a red circle that stood out from the white background as a spaceship porthole.[16]

When working with photographic material, Anita always avoided obvious solutions in favor of symbolic and allusive ones. For example, the "Il Tornasole" cover series (1963–68) featured photo portraits of the authors but relegated their faces to the back cover, only showing a semi-abstract detail on the front.

The young Swiss designer Peter Gogel (1934–2020), a graduate of the prestigious Basel School of Design, joined the office as a layout artist in 1961. Soon, Anita recognized his talent, and he was promoted to designing covers, eventually becoming her closest collaborator and a trusted personal friend. As Gogel recalled, "The projects usually started from an idea of Ms. Klinz, which we discussed together in order to find the best way to achieve it, or she found a photo that, in her opinion, was right for the cover, and I had to work on the typography and composition. So the concept always came from her, but then we developed everything together."[17]

From 1964 to 1966, Peter and Anita collaborated on an extensive project, supervising the 12 volumes of the new edition of the *Enciclopedia dei Ragazzi* (*Children's Encyclopedia*). Under their guidance, the artistic office produced most of the 10,000 photos, infographics, and illustrations utilized in the encyclopedia.[18]

In 1967, Alberto Mondadori abruptly quit his father's publishing house due to their irreconcilable views on the company's direction. He established Il Saggiatore as an independent publisher, and Anita, who strongly believed in the project, was among those who chose to join him in this new adventure.[19] Under Alberto's proprietorship, Il Saggiatore quickly grew and became more ambitious, with prestigious office spaces, a large staff of employees, and an output of over 100 titles per year.[20]

Figure 2.1.4 Anita Klinz and Pater Gogel, four covers from the *Enciclopedia dei Ragazzi*, Mondadori, 1966. Courtesy of Arnoldo and Alberto Mondadori Foundation, Mondadori Historical Library.

Anita was once again nominated art director and put in charge of all the graphic output, including the catalogs, monthly bulletin, and fair booths. She enlisted the help of a few collaborators, including Peter Gogel, who, in the meantime, had left Mondadori and moved to the United States. In 1969, the two won a gold medal at the Leipzig Book Fair for their minimalist design of a boxed set of Winston Churchill's writings, which featured an enlarged photo of barbed wire running through all four covers.[21] In the same year, Anita's career took a challenging turn when Alberto Mondadori, burdened by debt, was forced to reduce Il Saggiatore's output and workforce. She was made redundant, a massive blow as she had to abandon a project she was deeply invested in. She also lost the rare privilege of operating within a managerial position that offered her a significant margin of freedom and independence. Sadly, she was never again given that opportunity.

Around the time of her dismissal, which coincided with a period of hospitalization for a serious health issue, Anita found a personal haven of solitude and freedom on the tiny island of Giannutri off the Tuscan coast. Sparsely populated, without cars and asphalt roads,

Figure 2.1.5 Anita Klinz, cover of *L'Impero Americano* (*The American Empire*), Il Saggiatore, 1969. Courtesy of Arnoldo and Alberto Mondadori Foundation, Il Saggiatore Historical Library.

Giannutri is a wild, natural paradise with crystalline waters and rugged coastlines. She fell in love with its quiet, simple lifestyle. Anita bought a tiny home and a small motor boat; for the rest of her life, she spent as much time there as she could.[22]

After finding herself unemployed, Anita returned to work as a freelance art director in the periodicals department at Mondadori. From 1970 to 1974, she worked for *Duepiù*, the first Italian magazine focused on family issues and sexuality. She established a fruitful collaboration with its female director[23] and created a bold and modern look for its pages. One of her most important tasks was to decide how to visualize the sometimes controversial subjects of the articles, either assigning them to illustrators or overseeing the photoshoots.[24] Mondadori then offered her an in-house position as art director of the women's magazine *Grazia*. Unfortunately, she was forced to resign in 1976 after being sidelined by the magazine's new director.[25] In the same period, Anita suffered a nasty fall on the rocks of her beloved Giannutri and had to undergo various surgeries on her knee over the following years.[26]

Her next big commission arrived in 1967 when Alberto Mondadori's brother Giorgio Mondadori (1917–2009)[27] hired her to design the layout of two local newspapers. Anita found this challenge exciting, even though it forced her to learn to work with the new phototypesetting technology. Employing her usual precision and commitment to quality, she thoroughly studied all the technical and editorial facets of newspaper design and tested hundreds of different layout grids. Her projects were approved, but she could not participate in the final execution stage due to her ongoing health issues.[28]

Being sidelined until the mid-1980s, Giorgio Mondadori hired her again to design a new women's magazine called *F*. After months of preparatory work, this project was shelved.[29] Anita Klinz led a private and secluded existence for the rest of her life, only staying in touch with a few trusted friends like Peter Gogel.[30] She lived to be ninety years old and died in Milan on March 8, 2013. When her health was stable, she spent most of her time in Giannutri, documenting its nature and landscapes in hundreds of sketches and thousands of photographs.[31]

In her old age, Klinz ignored researchers' requests to interview her about her work and career.[32] Her fiercely independent, solitary personality is one of the reasons she has remained on the margins of graphic design history until recently. Despite her accomplishments and pioneering roles as a female designer and the first art director of an Italian publisher, she is barely mentioned in histories and surveys of publishing and graphic design.

In the years following her death, her work is being rediscovered and celebrated thanks to the research of designers and historians like Leonardo Sonnoli (1962) and Anty Pansera (1948) and the ongoing wave of interest toward underrepresented women in graphic design.[33] At the end of 2022, the Italian graphic designer Luca Pitoni (1982) published *Ostinata Bellezza, Anita Klinz, la prima art director italiana*, a richly illustrated monograph published by the Arnoldo and Alberto Mondadori Foundation.[34] This book is a true labor of love resulting from three years of independent research sparked by Pitoni who stumbled upon one of Klinz's book designs at a flea market. His text explores her professional and personal life, using testimonies and excerpts from Anita's manuscript diaries. *Ostinata Bellezza, Anita Klinz, la prima art director italiana* was an invaluable resource in writing this essay, uncovering many little-known facts. I acquired a much deeper understanding of her timeline, personality, and struggles. This publication will introduce Anita Klinz and her timeless creations to many others, helping her gain her rightful place in the history of Italian design.

© **Laura Ottina**

Note: The AIAP archive website hosts a selection of covers from the Anita Klinz Collection. https://aiap.it/2000-2020/cdpg%EF%B9%96IDsubarea=169&IDsez=332.html

NOTES

1. Pitoni, Luca (2022). *Ostinata Bellezza. Anita Klinz, la prima art director italiana*. Milan: Fondazione Arnoldo e Alberto Mondadori, pg. 30.
2. Pitoni, *Ostinata Bellezza*, pg. 33.
3. Pansera, Anty (2017). "Anita Klinz," in *Angelica e Bradamante: Le Donne del Design*. Padova: Il Poligrafo, pg. 78.
4. Having lost their property and belongings in the war, Anita's parents went to live in Tuscany while her sister moved with her husband to Sicily. Pitoni, *Ostinata Bellezza*, pg. 34.
5. Pitoni, *Ostinata Bellezza*, 34. Throughout her career, Anita continued to work as a freelancer designing logos, ads, and textiles. Pansera, "Anita Klinz," pg. 88.
6. Pansera, "Anita Klinz," pg. 79.
7. Ibid., pg. 79.
8. Pitoni, *Ostinata Bellezza*, pg. 44.
9. Mazzoni, Niccolò, Sonnoli, Leonardo (2013). "Su Anita Klinz," in *AWDA Aiap Women in Design Award*. Milano: AIAP, pgs. 45–6.
10. Pitoni, *Ostinata Bellezza*, pg. 192.
11. Pitoni, *Ostinata Bellezza*, pg. 67.
12. The artistic department team was predominantly male; besides Anita, there was only one woman, Giuliana Superbi. Pitoni, *Ostinata Bellezza*, pg. 70.
13. Pansera, "Anita Klinz," pg. 82, Pitoni, *Ostinata Bellezza*, pgs. 54–5.
14. Pitoni, *Ostinata Bellezza*, pg. 42.
15. Like Anita, both artists were not Milanese natives but had recently arrived from abroad, Pinter from Hungary and Thole from Holland.
16. Pansera, "Anita Klinz," pg. 83.
17. From an interview with Peter Gogel quoted in Niccolò Mazzoni, "Il Saggiatore: 1958–1969. Identità visiva e culturale di una casa editrice," master's thesis, 2009–10, Faculty of Design and Art, IUAV University, Venice.
18. Pitoni, *Ostinata Bellezza*, pg. 67.
19. Mazzoni, Sonnoli, "Su Anita Klinz," pg. 46.
20. Alberto Mondadori's idealistic and grandiose personality, and his tumultuous relationship with his pragmatic father, were recently investigated by his grandson Sebastiano Mondadori in the volume *Verità di famiglia—Riscrivendo la storia di Alberto Mondadori*. Milano: La nave di Teseo, 2022.
21. Pansera, "Anita Klinz," pg. 84, in *Angelica e Bradamante*.
22. Pitoni, *Ostinata Bellezza*, pgs. 90–1.
23. Pitoni, *Ostinata Bellezza*, pg. 99.
24. Pitoni, *Ostinata Bellezza*, pg. 100.
25. Pitoni, *Ostinata Bellezza*, pg. 102.
26. Pitoni, *Ostinata Bellezza*, pg. 51.
27. Giorgio was the president of Mondadori from 1968 to 1976, when his sisters pushed him out. In 1977 he founded his publishing company, Giorgio Mondadori e Associati, specializing in periodicals.
28. Pitoni, *Ostinata Bellezza*, pgs. 110–11.
29. Pitoni, *Ostinata Bellezza*, pgs. 111–14.
30. Pansera, "Anita Klinz," pg. 88.
31. Pansera, "Anita Klinz," pg. 88, Pitoni, *Ostinata Bellezza*, pg. 41.
32. Sonnoli, Leonardo, "Signora delle copertine," *Il Sole 24 Ore*, March 17, 2013.
33. In 2012, Klinz was given a career award in the first edition of the AIAP Women in Design Award.
34. The volume includes two essays by Mario Piazza and Leonardo Sonnoli.

2.2

Jacqueline S. Casey: Design and Science

Elizabeth Resnick

In the years between the First and Second World Wars in American society, a woman's role was to marry and care for her home and children, while her husband's responsibility was to earn money to support the family. When the US entered the war after the bombing of Pearl Harbor in December 1941, traditional roles for women changed forever as women began working outside the home while the men were away at war. Women who held jobs before the war could now fill positions at a higher salary than previously available. Although some women returned to traditional roles after the war ended, others continued to work outside the home well into the 1950s. One young woman who directly benefited from women defying professional gender norms was graphic designer Jacqueline S. Casey (1927–1992).

Jacqueline P. Shepard was born on April 20, 1927 in Quincy, Massachusetts, the only child of Helen Kingston and Roy Shepard, a young working-class couple who struggled to make ends meet. A few years later, when Jacqueline was just a child, Helen Shepard married George Barkas, and Jacqueline adopted her stepfather's name. However, when

Figure 2.2.1 Jacqueline S. Casey photographed on the MIT campus, Cambridge 1985.
Photo: Marie Cosindas. Image courtesy of Marie Cosindas.

she turned twenty-one, she changed her name back to Jacqueline Shepard. By several accounts, Jacqueline was a committed school student, shy but blessed with a sense of humor.[1] She attended Boston Girls' High School, where students were required to choose a major. Although she was determined to become an artist, her parents insisted her major be in bookkeeping and administration services, and she persevered despite being forced to specialize in a subject she did not like.[2] She was elected senior class president and graduated at the top of her class on June 6, 1945, just months before the formal ending of the Second World War.

Studying Art in Boston

In September 1945, Jacqueline prevailed over her parents' objections by enrolling at Massachusetts School of Art—a state-funded college in Boston renamed Massachusetts College of Art and Design. Now free to explore artistic practice, Jacqueline thrived. Following a formative studio foundation year, she majored in Fashion Design and Illustration, intending to work professionally after graduation. "I loved fashion and clothes. I followed all that stuff," she confessed in an interview in 1973. To help pay for art supplies and expenses, she worked as a bookkeeper and cashier at Art School Associates, the college's art supply and bookstore, becoming friends with fellow student Candy Cooper, better known as the pioneering designer Muriel R. Cooper (1925–94). Cooper described their time together:

> Jackie and I both went to Mass College of Art in the late 1940s. We were cashiers in the school store, both eventually becoming bookkeepers—first Jackie and then me. We learned more in the store than we did in school. When the store would close in the afternoon, the students who worked there—about a dozen of us—had the studio to ourselves and our little bin of paints and papers and materials.[3]

Jacqueline graduated with a Fashion Design and Illustration certificate in 1949 and a bachelor of fine arts degree a year later. In the 1950s, both fashion design and fashion illustration were considered narrow specializations, and there were few existing full-time opportunities. Jacqueline supported herself with various jobs while accepting freelance assignments in fashion illustration, despite becoming increasingly disillusioned with the fashion world: "I tried working as an illustrator, but I didn't like the whole fashion thing. The values weren't interesting enough for me. I was the production manager of Boston's version of *Women's Wear Daily*. I worked there for two-and-a-half years, but there was no one there that knew more than I did, so I never learned anything. I also worked as an interior decorator for six months."[4] Frustrated by working in situations where she was neither challenged nor mentored, she sought a change: "I broke the negative cycle by traveling through Europe for three months. I returned with the decision to focus my life on something related to the arts, knowing well enough that the arts in themselves offered little hope for economic security."[5]

The Office of Publications, Massachusetts Institute of Technology

In 1951, John I. Mattill (1921–2019), an administrator at Massachusetts Institute of Technology's News Office, established the Office of Publications to centralize and manage the expanding volume of communications across the Institute. The Office provided writing and editing services in addition to giving these materials visual form. "Effective writing is not enough," said Mattill in a published interview in 1956. "Visual presentation does many jobs that words cannot. Typography can add a perspective of atmosphere, environment, and attitude, which no publication can treat with indifference. So, design becomes an essential partner in virtually all our undertakings—and in fact becomes a controlling element in those which must, to find attention, catch a fast-moving eye."[6]

In early 1953, Mattill hired Muriel Cooper—the first office staffer responsible for graphic design. Cooper had been recommended by Mattill's MIT colleague György Kepes (1906–2001), who had taught visual design in the Department of Architecture since 1945. "Kepes likely knew Cooper from Boston design circles, and at the very least, the two would have met while she was freelancing at Boston's Institute for Contemporary Art in 1951, the same year Kepes worked with the museum as a designer."[7] As the Office's workload grew, Mattill hired Jacqueline Shepard, Muriel Cooper's former classmate and friend, upon her recommendation in 1955. In a published interview many years later, Jacqueline recalled:

> I had always known Muriel and admired her. She offered me a job, a temporary job, to come and help her during the busy season, which in the old days meant 30 to 40 special summer programs, each one a design project. Although I never studied graphic design, I wanted to know how to do something. So, I accepted her offer. I just stayed on and on and on.[8]

Both women worked four full days in the Office, sometimes collaborating on a single project, but more often, they would alternate on incoming projects. Mattill gave them both a free hand to work within a contemporary design style for all MIT's books, folders, and catalogs: "Our search for new knowledge implies the highest creativity, and we seek to stimulate our student's imagination. So, our college publications, too, must show creativity and imagination."[9] In describing the general working atmosphere in the Office, Mattill suggested that both designers enjoyed working within the MIT scientific environment because it was receptive to good ideas. Once the project concepts were defined, each designer was free to translate the idea into print using "good design judgment and good taste." But by early 1957, Muriel, ever the restless spirit, was ready for new challenges.[10] She applied for a Fulbright fellowship to travel and study in Italy and left the Office in September 1957. She returned to Boston in March 1958 because of an illness in her family and freelanced before becoming the first design and media director of MIT Press in 1967.[11]

In Muriel's absence, Jacqueline recommended Ralph Coburn (1923–2018) join the Office after she visited an exhibition of his geometric abstract paintings on display in a Boston gallery. Coburn had studied architecture as an undergraduate at MIT in the early 1940s before leaving to pursue his passion for painting. He was an established minimalist, a driving force behind the founding of the Institute of Contemporary Art in Boston, and a close friend and collaborator with American abstract artist Ellsworth Kelly (1923–2015). Although he was not trained as a graphic designer, Ralph Coburn accepted the position because it provided him with financial security and a creative work environment. On July 16, 1958, Jacqueline Shepard became Jacqueline S. Casey when she married William "Bill" Casey (1924–1975), a gregarious, prickly, in-your-face personality. Bill Casey worked from an office in their art-filled Brookline home as a psychiatric case worker affiliated with a local social work organization. He would proudly describe their roles in the following terms: "I make people better, and Jackie makes things pretty."

Development of the MIT Style

In the late 1950s, John Mattill initiated an innovative visiting program for designers from Europe. His reasoning was pragmatic: he wanted to introduce Europe's progressive design influences into the MIT culture. The idea was that invited designers would come for five months, from January to May, to tackle the crush of design work needed to advertise the MIT Summer Session courses. In the process, the MIT design staff would learn by working alongside them. The first invited designer was George Adams (1904–1983) in 1958. He was an Austrian who had studied at the Bauhaus, where he was known as Georg Teltscher. The second invited designer, in 1959, was a young Swiss designer with impeccable design credentials, Thérèse Moll (1934–61).[12] Thérèse "was the critical visitor," said Jacqueline.

> She introduced the Office to European typography. She had been well-trained in the design of modular systems. This use of proportions in designing publications series became a useful tool for developing MIT's image. Although much has been modified by time, technology, and the work of other designers in the Office, the basics that Thérèse brought with her are still operating today.[13]

Thérèse Moll had studied with Armin Hofmann (1920–2020) and Emil Ruder (1914–70) at Allgemeine Gewerbeschule (AGS), now known as the Schule für Gestaltung Basel/Basel School of Design, from 1949 to 1954. Upon graduation, she worked as an assistant at Studio Boggeri in Milan for six months before joining Karl Gerstner's (1930–2017) Basel atelier from 1954 to 1956. Thérèse was a staff designer at Geigy Pharmaceuticals from 1957 to 1958, where she designed some of her best work before leaving for MIT in early 1959.[14]

Undoubtedly, Jacqueline Casey and Ralph Coburn were creative and talented individuals, but they needed more educational training in the fundamentals of typographic design. Although Jacqueline could apply the principles of the "Swiss" style acquired from carefully studying international design publications, it was Thérèse who brought the concept of the modular typographic grid. "I was influenced by the Swiss," said Jacqueline. "I certainly grew up in art during the time of hard-edge painting and abstraction. When I finally understood about typography, it came together very nicely."[15]

Grid of Invention

In a short essay, "Jacqueline Casey/Modern Typography" written for the *MIT/Casey* exhibition she organized in 1989,[16] designer and curator Ellen Lupton (1963) wrote: "The grid and other restricting parameters, such as a fixed set of typefaces, constitute a system within which the designer works, rather as one might speak through the rules of a language. Whereas some designers see the grid as impersonal and mechanical, Jacqueline Casey has used it in her work as a means for invention."[17]

"It is important to have a process in which logic determines where things are placed," Jacqueline explained. "I use a grid because I won't build a page without first laying a foundation. The grid is the architecture of type and image."[18] To this rational design methodology—typified by the use of a grid, sans-serif typefaces, and abstracted imagery—Jacqueline Casey added her playful sense of visual metaphor and wordplay in the posters and other materials she created to publicize MIT events and exhibitions during the 1960s, 1970s, and 1980s. She used the Swiss-designed typefaces Helvetica and Univers almost exclusively to create visually and verbally compelling typographic compositions. Jacqueline exemplified what came to be labeled the "MIT Style," which relied on bold geometric forms, contrasting planes of color, and high-contrast dense type compositions designed to stand out on already cluttered university bulletin boards.

In many of her posters, a typographic image forms the core of a message, often prominently placed in a visual hierarchy through its size, placement, and color. The 1972 poster for the MIT Faculty-Student Exchange Program is an excellent example of how space and order are vital to the design. There are two ways to view this playful visual gestalt: a meticulously cropped white "x" with three different colored triangles (red, blue, and black) that define the negative space, or three colored triangles organized as such on a white field to shape a white "x." Either way, the "x" represents the word "exchange" while the position of the colored triangles draws the viewer's eye to the center of the composition, affixing meaning.

In Jacqueline Casey's 1982 poster for the exhibition *Body Language*, the letters that spell out the title are placed on a black background and highlighted by a light source, making them appear three-dimensional. These monumental letterforms possess both scale

Figure 2.2.2 Jacqueline S. Casey, poster for *Faculty-Student Exchange Program*, 1972, MIT Faculty-Student Exchange Program. Jacqueline S. Casey Collection. Courtesy of Massachusetts College of Art and Design Archives.

and physicality, insinuating possible life-size figures. The overall effect produces a dynamic visual pattern that seduces the viewer while enhancing the message.[19]

Invited by the Shoshin Society (also known as the Hiroshima Appeals peace campaign) to commemorate the fortieth anniversary of Hiroshima's bombing, *RUSSIA/USA Peace 1985* is one of the few posters Jacqueline Casey created outside of the MIT community. The predominantly black poster has a clear gloss varnished image of planet Earth in the upper right-hand corner. She employs wordplay—the "USA" nestled within the word "RUSSIA"—and uses color (red and white) to separate the two superpowers. The lettering is placed at the base of the poster with the letters "R" and "A" extending off the trim edges, visually pleading for a continuing peaceful coexistence.

Figure 2.2.3 Jacqueline S. Casey, poster for the MIT art exhibition *Body Language: Figurative Aspects of Recent Art*, 1981, for the MIT Committee on the Visual Arts, Hayden Gallery. Jacqueline S. Casey Collection. Courtesy of Massachusetts College of Art and Design Archives.

Figure 2.2.4 Jacqueline S. Casey, poster *RUSSIA/USA Peace* 1985, commissioned by the Shoshin Society to commemorate the 40th anniversary of the bombing of Hiroshima. Jacqueline S. Casey Collection. Courtesy of Massachusetts College of Art and Design Archives.

"MIT Is a Source of Design Inspiration"

The increasing workload necessitated hiring a third full-time designer; Dietmar Winkler, born in 1938 and educated in Germany, joined the Office of Publications in 1965. He was a decade younger than Jacqueline Casey and Ralph Coburn and served an essential role by producing sophisticated European designs for MIT clients. He shared his knowledge of designing with typography, print-production methodology, and offset-printing techniques.

Figure 2.2.5 Jacqueline S. Casey, exhibition poster for *Intimate Architecture: Contemporary Clothing Design*, 1982, for the MIT Committee on the Visual Arts, Hayden Gallery. Jacqueline S. Casey Collection. Courtesy of Massachusetts College of Art and Design Archives.

My design training and job experience—practicing typography in the real world rather than relying on theoretical interpretations from books or Swiss design examples—may have put me ahead for a moment, but both Jackie and Ralph caught up quite quickly. Ralph, with his background in architectural design, was quite comfortable experimenting with more complex typographic systems. Jackie, on the other hand, inferred her typographic structures from the organism within the most critical component, letterform or image. When it came to complex text environments like books and pamphlets, she used straightforward geometric systems like Müller-Brockmann's grid.[20]

The MIT community was considered progressive in many aspects, yet the pay scales would have reflected women received less money than their male counterparts in similar positions. Jacqueline Casey's salary was meager even when she assumed the role of Director of Design Services in 1972. She was well aware of prevalent institutional inequality, yet her bond with MIT only intensified in 1975 after her husband Bill died of cancer. Deeply saddened by his death, MIT filled the void: "I can just walk around and immerse myself in knowledge. It is a cultural sanctuary. When you come right down to it, everything that happens at MIT is a source of design inspiration. It's where all the material for my designs comes from."

Celia Metcalf (1954), a graphic designer who worked directly with Casey from 1984 to 1989, described Jacqueline Casey as a "humorous, imaginative, intelligent woman and a tenacious leader. She was passionate about design excellence and at times, would stay in her office for days. She craved privacy during her creative spurts, and all her energy went into one project at a time. Her greatest strength as a designer was in cultivating a publications office where art and design were integral to the educational process. The poster became an important means of communication at MIT."[21] Interviewed by F.H.K. Henrion (1914–1990) for his book *Top Graphic Design*, Jacqueline shared, "My objective was to design a product with an accurate visual and verbal message that could be understood by the audience. I measure my success as a designer when the work is displayed in offices and dormitories on and off the campus when the event is a memory."[22] She also understood that she could build public recognition for her work outside the MIT community by entering annual design competitions, submitting her work for publication in magazines and books, and participating in public exhibitions.

Muriel and Jackie

Jacqueline Casey's career path was closely linked to her friendship with former MassArt classmate Muriel Cooper. As close friends, their lives were intertwined both professionally and personally; they lived in the same neighborhood in Brookline. When Muriel transitioned from designer to teacher and researcher, forming the MIT Visual Language Workshop in 1974, Jacqueline strove to understand the significance of emerging design

technologies and how they could fit into her work. She was diagnosed with cancer in 1982 and struggled to keep pace with the workload in the Design Services office. Her staff became very protective of her and covered her health-related absences for as long as possible. But by February 1989, she was forced to retire. Knowing that her friend would be devastated by losing her position, Muriel arranged for Jacqueline to join the MIT Media Lab as a visiting design scholar. She was given her own office space with a computer.

While in residence at the Media Lab, Jacqueline worked on several projects and was available to interact with Muriel Cooper's graduate students. "It was just so wonderful to have her there for all of us," Michelle Fineblum (1958) shared in an interview. "She was always reaching out to us, always checking in. She was a great presence and always happy to advise us."[23] By August 1989, Jacqueline Casey was experimenting on her Mac II with Studio 8 software. One of the projects that she completed was the 1990/91 catalog cover for Massachusetts College of Art (now Massachusetts College of Art and Design). She described making the catalog cover image as a liberating experience. Without her familiar tools, she found inspiration within the capabilities of the various Studio 8 programs, working her way through menus while creating a new collection of complex and arresting images.

In the late 1980s, Muriel Cooper was an influential member serving on MassArt's Board of Trustees. She was successful in nominating Casey for an honorary doctorate of fine arts. The award ceremony took place at the college on January 23, 1990, adjacent to an exhibition of her poster work installed in the President's Gallery. On April 25, 1992, an exhibit, *MIT/Casey, Jacqueline S. Casey, A retrospective: MIT's graphic design in evolution*, organized by the MIT Museum, opened in the Compton Gallery.[24] *Posters: Jacqueline S. Casey: Thirty Years of Design at MIT*, a catalog edited by her colleague, Dietmar R. Winkler, was published in conjunction with the exhibition. She was able to attend the opening reception, but a few weeks later, on May 18, 1992, Jacqueline Casey died at age sixty-five. In eulogizing her dear friend, Muriel Cooper wrote: "The spirit of MIT nurtured her work and, in turn, her work nurtured the humanity of MIT."[25]

A Colleague Remembers

Dietmar Winkler worked as a staff designer with Jacqueline S. Casey and Ralph Coburn in the MIT Office of Publications from 1965 to 1970.

> I don't ever remember any open office competition or jealousies for specific clients or projects. There was enough work for all three designers, and we grew organically into specific directions, each having clients that preferred working with either one or the other. Jackie specialized in poster design for music and art events; Ralph and I worked on all other projects. We did everything together; we worked, learned, and goofed off together. We were a team.

All designers would initially meet with clients so that each of us could take up any project without double-guessing the intended function or purpose. If it turned out to be a project of a new client, the first available designer would begin the design process. After meeting with clients, each designer would retreat to the office cubicle to design. Colleagues would walk in and out. The doors were rarely closed, and we could see each other at work. Surprisingly, there was never an organized or spontaneous moment of criticism; any critique of each other's work was taboo. For Jackie, a negative critique … would have been devastating. Jackie had so much respect for MIT and its image that she would have interpreted any criticism as if letting the institution down.

Jackie's office was so meticulous that I wondered: "Where is the design work done?" Usually, Jackie had a single mock-up or design prototype on the opposite wall from her desk. She would get up, walk up to it, make a change, step back, sit down and stare at it, just to perform the same process again and again. That dispels the idea that she used mathematics and geometry to construct her work. While she used Müller-Brockmann's book on grid systems, her poster work was an optical exploration, much like painters and photographers develop a keen awareness of proportions inherent in the construction of individual images. An important thing she learned from modular typography was that the proportions in the folding of the printed poster for mailing purposes had to be included at the concept stage.

Whenever I think of the Office, I am reminded of the banter, the amazing humor, Jackie's ear-piercing laughter, the intelligent conversations, being indulged by clients, sometimes for many hours, by lectures on their research or introductions to whole new worlds, and learning something new and crucial every day.[26]

© **Elizabeth Resnick**

Note: First published in *EYE* Magazine 101, Summer 2021, "Jacqueline Casey: Design and Science" has been revised with the addition of footnotes. Thank you to Dietmar Winkler, who provided detailed information on Casey's personal and professional life; and Kevin Keane, Celia Metcalf, David Small, and Michelle Fineblum for their contributions to this article.

NOTES

1. Meeting with Kevin Keane, Jacqueline Casey's first cousin, on Thursday, January 15, 2015, in Boston. Keane, born in 1957, enjoyed a close bond with Jacqueline despite their thirty-year age difference. She was also his godmother. "My mother Phyllis had an elder sister, Helen Kingston (Jackie's mother), who married Roy Shepard. Everyone in that generation in my family grew up poor. They struggled to pay the rent and feed themselves." It is unclear as to whether Roy Shepard died or if there was a divorce. Helen remarried, and "for a brief period in her life, from age eight or ten to her early twenties, Jackie changed her name to be consistent with the family—

either voluntarily or because she was told to. When she was out and independent, she went back to Shepard." Keane also mentioned in our meeting that Jacqueline "had a great sense of humor."
2. "My parents tried to thwart my wish to be an artist as much as possible. When I was in high school and the time came to specialize in my junior year, I wanted to continue in art but was told that I had to take bookkeeping. I took a commercial business program. Even this did me some good. Designers should be familiar with economics, too." Dietmar R. Winkler, ed. (1992) *Posters: Jacqueline Casey, 30 Years of Design at MIT: Jacqueline Casey*, Cambridge, MA: MIT Museum, pg.10.
3. Ellen Lupton, "Conversation with Muriel Cooper, May 7, 1994," unpublished interview.
4. Jean A. Coyne, "MIT Design Services Office," *Communication Arts*, 15, no. 4, 1973, pg. 44.
5. Winkler, *Posters*, pg. 10.
6. *Direct Advertising*, Vol. XLI, no. 3, 1956.
7. "Kepes, a former colleague of Bauhaus master László Moholy-Nagy in Berlin, London, and then Chicago, had been teaching visual design in MIT's Department of Architecture. Kepes recommended Muriel Cooper for the job, a young Boston designer who graduated from the Massachusetts School of Art in 1951." Robert Wiesenberger and Elizabeth Resnick, "Basel to Boston: An Itinerary for Modernist Typography in America," *Design Issues*, Vol. 34, no. 3, Summer 2018, pg. 30.
8. Coyne, "MIT Design Services Office," pg. 44.
9. Mary Ann Ademino, "College Publications," *Communication Arts*, 9, no. 4, 1967, pg. 43.
10. "I left because I was bored with the projects and with the work. I felt I knew enough about it, and it was time to move on." Janet Fairbairn, *The Gendered Self in Graphic Design: Interviews with 15 Women*, MFA thesis, Yale University of Art, 1991: np.
11. "Muriel Cooper was a powerhouse, a feminist, who confronted the male bastions of the corporate and institutional structure in very provocative ways. She was a superb corporate politician and manipulator. She managed to overpower a sleepy editorial system at the MIT Press." Dietmar R. Winkler, "Random Notes and Thoughts in Relationship to the MIT Museum: Jacqueline Casey Book Project," June 10, 2015, pg. 16.
12. Other visiting designers included Denis Postle, John Lees, Walter Plata, and Paul Talman. Winkler, *Posters*, pg. 9.
13. Winkler, *Posters*, pg. 17.
14. Elizabeth Resnick, "The Enigma of Thérèse Moll," *Eye* Magazine, 98, Spring 2019, pgs. 74–81.
15. Janet Fairbairn, *The Gendered Self in Graphic Design*, np.
16. *MIT/Casey* was an exhibition organized by the Herb Lubalin Study Center of Design and Typography, The Cooper Union, April 4–May 5, 1989.
17. Ellen Lupton, ed., "Jacqueline Casey/Modern Typography," *MIT/Casey*, New York: Herb Lubalin Study Center of Design and Typography, 1989, pg. 1.
18. Lupton, *MIT/Casey*, pg. 1.
19. "In many ways, black is very pristine. It is the ultimate contrast in its relationship to white." Winkler, *Posters*, pg. 52.
20. Winkler, "Random Notes and Thoughts," pg. 6.
21. Interview with Celia Metcalf, September 5, 2019.
22. F.H.K. Henrion (1983) "Jacqueline Casey," in *TopGraphic Design*. Zurich: ABC Verlag, pg. 24.
23. Interview with Michelle Fineblum, July 6, 2019.
24. *MIT/Casey* was first presented at The Cooper Union for the Advancement of Science and Art, April 4–May 5, 1989.
25. "Designer Jacqueline Casey Dies at 65," *MIT News*, May 20, 1992.
26. All quotes from "A Colleague Remembers" are taken from Winkler, "Random Notes and Thoughts …"

2.3

Lora Lamm: Between Swiss and Italian Graphic Design

Dr. Carlo Vinti

Lora Lamm (1928), born and trained in Switzerland, was the sole female presence in the literature on Italian graphic design for a long time.[1] Lora's critical and historical fortune is peculiar. Although much of her professional career took place in Zurich, she is remembered almost exclusively for the ten years she spent in Milan, from 1953 to 1963. In 2013, an important exhibition dedicated to her by the MAX Museum in Chiasso inaugurated a major rediscovery and recognition of her graphic design work.[2]

The years of Lora's stay in Milan coincided with the period between the first Italian industrial takeover and the alleged "economic miracle" in Italy. Milan enjoyed a moment of great economic and cultural vitality and was about to become the core of a vibrant and internationally renowned design scene. The city, with its geographical position open towards Europe, became a center of attraction for designers from other parts of Italy and neighboring countries such as Switzerland. Many among them were women, who faced challenges in finding space, except for the opportunities provided by a few companies like the department store La Rinascente, geared toward a female clientele.

Figure 2.3.1 Lora Lamm photographed at the Salto bookshop in Milan, Italy, circa 1960. Image courtesy of AIAP CDPG.

The arrival of Swiss designers in Italy,[3] along the Zurich–Milan axis, has often been seen in terms of a successful marriage between a kind of functional and calculated Swiss prose and a spontaneous Italian poetic vein. Nevertheless, as we will see, the great success enjoyed by the graphic design work produced by Lora Lamm between 1953 and 1963 is only partially attributable to her ability to blend the rigorous training she received in her native country and the stimuli she found in a vital and effervescent context in the city of Milan.

Early Life, Education, and the Move to Milan

Lora Lamm was born in Arosa, Switzerland, on January 11, 1928, in the Prättigau region of Canton Graubünden, where her mother, Dorothea Roffler (n.d.), was born. She grew up with her sister Eliana (1931) and her two brothers, Ernest (1926) and Erwin (1932), in a typical Swiss mountain setting, to which she would frequently return during vacation periods for the pleasure of rediscovering natural landscapes and a familiar atmosphere. Her father, Ernst Lamm (1891–1966), was originally from Prussia and worked in Arosa as a craftsman and "master painter," and for a time, he also ran a guesthouse. The family could afford to provide a good education for their children and indulged Lora's desire to pursue artistic training professionally. After completing schools first in Arosa and then—during the Second World War—in French-speaking Switzerland,[4] in 1946, Lora passed the entrance exam to the Kunstgewerbeschule in Zurich, where both a former teacher and a family friend had suggested that she might study.

The director of the renowned Zurich school at the time was Johannes Itten (1988–1967), the legendary instructor of the preliminary course at the Weimar Bauhaus. No wonder, then, that the educational process in Zurich started with a *vorkurs*, which—as Lora herself has recalled—was aimed at "purifying" the students of previously acquired preconceptions.[5] After these two foundational semesters, she chose the graphic design and illustration curriculum for the next four years of study. During that time, her teachers included Ernst Keller (1891–1968), one of the most influential figures in the education of Swiss designers after the Second World War,[6] and Ernst Gubler (1895–1958), who taught the figurative drawing course. Some of the work that Lora produced for the class is held at the Museum für Gestaltung Zürich, attesting to her early attempts to find a personal style of representation, something that was strongly encouraged by Gubler.[7]

In 1951, Lora completed her studies and began working as an intern at the Triplex advertising agency in Zurich.[8] It was there that she met the copywriter Frank Thiessing[9] (1917–2009), who became a very important figure in Lora's professional as well as personal life (from that moment on, they stayed in regular contact and eventually married in 2003).[10] As a friend of Max Huber (1919–1992), Frank had a connection with Studio Boggeri, and he suggested Lora move to Milan, where she arrived in August 1953.

Figure 2.3.2 Lora Lamm, *Arredate la vostra casa d'estate* poster for La Rinascente, 1956. © Zurich University of the Arts/Museum of Design Zurich.

Lora has always fondly recalled this initial period in Italy when she lived in a student house and overcame her initial language difficulties with a spirit of initiative and independence.

Her first professional experience was at the Studio Boggeri. Founded in 1933 by Antonio Boggeri (1900–1989),[11] who was known for employing not only prominent Italian graphic artists but also foreign and, in particular, Swiss designers such as Xanti Schawinsky (1904–1979) and Max Huber. Lora was tasked to temporarily replace Aldo Calabresi (1930–2004), also of Switzerland. During that time, Boggeri worked extensively with the chemical and pharmaceutical industry, for which Lora designed routine work that didn't especially interest her. Within two months, she started looking for new opportunities.

Lora designed wrapping paper and packaging for the San Babila shoe manufacturer before landing in the Motta confectionery industry. Unfortunately, she was not allowed to work in the advertising department alongside the other graphic designers, all of whom were men. The presence of a young, blond foreign woman in that particular context was deemed inappropriate and a potential threat to work productivity. Instead, Lora found herself working in the office of director Angelo Motta (1890–1957), where she was

required to wear a black apron. This experience, like the previous ones, did not prove to be particularly fulfilling in terms of creativity.

The turning point came only in 1954 when Lora had the opportunity to join the advertising division of La Rinascente department store. She was introduced by Max Huber, who had been collaborating with the company since 1950, but it was the departure of the in-house graphic designer Roberto Maderna for military service that created an opening for Lora to fill. Initially intended as a temporary arrangement within the advertising department, her stint at La Rinascente swiftly transformed into a permanent post.

Contributing to La Rinascente's Visual Identity

When Lora Lamm arrived at the department store La Rinascente—as part of its postwar recovery effort—it had already involved prominent figures in Milan's design culture, such as the architect Carlo Pagani (1913–1999) and the graphic designer Albe Steiner (1913–1974). Max Huber, in particular, had defined some key elements of the company's visual identity, such as the famous *lR* monogram.

Lora's entrance at La Rinascente and her rapid affirmation as a designer occurred as the company experienced a major expansion across Italy. Its top management—represented by Romualdo (Aldo) Borletti (1911–1967) and Cesare Brustio (1936–1968)—clearly aimed at creating a consistent visual identity that would convey a spirit of modernity. In addition, they were actively targeting a female clientele, and this resulted in a range of opportunities that women working in design, illustration, photography, and fashion could not easily find in other professional settings.[12]

Lora was initially entrusted with the task of designing the page layout of the corporate magazine *Cronache–La Rinascente Upim*, while she tried to find her place in a structured office with established practices and a good number of collaborators and in-house designers. One of her early illustrations vividly captured this work environment,[13] situated on the seventh floor of La Rinascente's new building in Milan, which overlooked Piazza del Duomo and had been reconstructed after the bombings that devastated the previous structure. Within the drawing, one can identify several individuals who played significant roles in the department store's grand revival following the Second World War. Notably, two Swiss women established a fruitful professional collaboration and formed strong bonds of friendship with Lora: Anja Storck (n.d.), a fellow graphic artist, and Amneris Liesering (1924–2012), who started as a journalist and copywriter before joining La Rinascente in 1954. Originally from the Ticino canton, Amneris relocated to Milan in 1946 to accompany her husband, Mario Latis. She served as art director and played a crucial role in shaping the department store's image. Besides curating many of La Rinascente's cultural initiatives, she also supervised various advertising creations, skillfully harmonizing them with the ever-changing dynamics of fashion.[14]

Figure 2.3.3 Lora Lamm, lR *Occasioni per le vacanze* poster for La Rinascente, 1959. © Zurich University of the Arts/Museum of Design Zurich/poster collection.

As early as 1956, Gianni Bordoli, head of the advertising department, could claim that the department store's internal graphic work was "in the hands of Lora Lamm."[15] In 1960, an article in the magazine *Gebrauchsgraphik* dedicated to La Rinascente's advertising style stated that Lora had succeeded in breaking, or at least tempering, the austere and abstract modernist line previously introduced by Max Huber and other designers such as Albe Steiner. The article recognized Lora as the primary force behind a pivotal shift towards more gentle and distinctly feminine graphic solutions. Nevertheless, just as it seems difficult to force Max Huber's work—rich in expressive dynamism and spectacular graphic inventions—into the category of austerity, Lora's versatile graphic abilities cannot be easily restricted to the "feminine" quality of her illustration style.

At La Rinascente, Lora soon demonstrated the skills of a well-rounded designer and team leader, capable of mastering different techniques and coordinating the work of other designers, illustrators, and photographers. Lora displayed a remarkable ability to adapt a diverse range of design solutions to many different formats, motifs, and themes. Although she occasionally favored hand-drawn lettering, Lora generally opted for a wide array of typefaces ranging from geometric sans serif to grotesque, from Bodoni to other serif types, and even typographic compositions inspired by nineteenth-century wooden typefaces. For images, in addition to the now highly valued tempera paintings by her own hand, she used techniques ranging from photogram to collage, or she turned to her closest collaborators at La Rinascente such as the Swiss photographer Serge Libiszewski (1930–2019)—also trained at the Kunstgewerbeschule in Zurich—and the fashion illustrator Brunetta Mateldi Moretti (1904–1989). Above all, Lora's inventions seem to arise directly from the specific subject matter she was promoting: homewares, furniture, sports, travel, stationery, camping, toys, and even special exhibitions featuring Japanese or Mexican culture. Her great technical versatility and her ability to adopt very different registers matched perfectly with the need to build an image for La Rinascente that would be recognizable but also "multifaceted and iridescent."[16]

La Rinascente, thanks to its ability to combine an exemplary organizational structure with a thorough design policy, has frequently been associated with the celebrated Olivetti approach to corporate image. However, as with Olivetti, the visual consistency of its communication efforts was due not to codified procedures and written guidelines as to the existence of effective in-house oversight, to which Lora herself soon made a fundamental contribution.

As the de facto supervisor of the advertising department's graphic production, Lora played a role that included training younger designers, who, through a kind of apprenticeship, had the "opportunity to study the problems of commercial art, packaging, window display, and exhibition design," compensating to some extent for the lack of specialized schools in Italy.[17] But working for La Rinascente store in those years entailed yet another teaching mission: educating the consumers. Following the lead of similar initiatives in Scandinavian countries and the United States, the Italian department store set out to democratize good design and adopted an "advertising and marketing policy of good taste."[18]

In keeping with this policy, La Rinascente carried out significant cultural activities in which Lora was directly involved. On the one hand, there were regular initiatives to promote industrial design. The department store's management played a crucial role in the establishment of the *Compasso d'Oro* Prize in 1954, which remains the most prestigious award for Italian design today. On the other hand, La Rinascente organized renowned exhibitions dedicated to the culture and products of countries such as Spain, Japan, Great Britain, the United States, and Mexico. Lora was responsible for the graphic identity of many of these displays, which transformed the retail space into something more akin to a gallery or museum.[19]

Beginning in 1958, Lora's professional relationship with La Rinascente underwent a significant change. She personally requested and was granted the position of consultant designer, similar to the role previously held by Huber. This shift, besides proving to be financially advantageous, represented a decisive turning point in her career, as she was now permitted to sign her own creations and work with other clients as a freelancer.

The years between 1958 and 1963 were a period of intense activity. She recalled: "I was working for Rinascente by day and working for other clients by night; on holidays, I went back to the Alps."[20] Besides regularly staying late at the La Rinascente offices, she dedicated her nights, and even Saturdays and Sundays, to working at home. Lora lived with her

Figure 2.3.4 *Left:* Lora Lamm, *Pirelli tires for bicycles* poster, 1960. *Right:* Lora Lamm, *Pirelli for scooter* poster, 1960. Images courtesy of AIAP CDPG.

landlady in the Brera area of Milan, where she was allowed access to the living room for drawing.[21] It was under these conditions that she produced works for Elizabeth Arden and Niggi, as well as many of the projects commissioned by Pirelli. Watercolors made for Pirelli, such as those depicting a woman on a scooter and a young girl with a hot water bottle, are among Lora's most iconic and frequently reproduced works. In Italy, the in-house design work created in offices like the *Direzione Propaganda* at Pirelli, as well as the *Servizio Centrale Pubblicità* at La Rinascente, preceded the corporate identity programs developed by consultant designers beginning in the mid-1960s. Precisely because it was based on the daily practice of teamwork rather than on written rules and manuals, the image of enterprises such as La Rinascente or Pirelli could tolerate the coexistence of different stylistic registers and even leave room for the personal voice of individual designers like Lora.

Speaking about teamwork at La Rinascente, Lora said: "We used to gather together to discuss and brainstorm ideas with Gianni Bordoli, Amneris Latis, and other designers. Decisions were always made collectively." On the other hand, she acknowledged the importance of imbuing each of her works with her unique style. When choosing a proof from the array of experiments she had conducted for a project, she recalled: "I would place it next to me in front of the mirror and ask myself, "If it were a dress, would I wear it?"[22]

Lora Lamm's Third Way

Those who, like Gillo Dorfles (1910–2018), wrote about Lora Lamm during the years when she was active in Milan often emphasized the fusion of the solid technical and typographical training she received in Zürich and her personal imaginative powers, "further enriched no doubt by her familiarity with Italian graphic design."[23]

The vision of Nordic austerity and Swiss mathematical order being balanced by Italian exuberance and preference for experimenting freely is a neat and convenient representation of what transpired, but, looking a little more closely at the developments of graphic design in Italy and Switzerland, the picture becomes more complex and nuanced.

First, it is advisable to question the idea that the two graphic traditions are diametrically opposed. This idea is founded on two reciprocal prejudices. On the one hand, there is an image of Swiss graphic design based exclusively on the mature developments of a national school that had a profound impact on the history of graphic design in the latter half of the twentieth century. On the other hand, there is a notion of Italian design as consistently lagging behind others on the international scene and managing to compensate for its deficiencies through inspiration and inventiveness.

As pointed out by the graphic design historian Richard Hollis (1934) in the book *Swiss Graphic Design*, the hegemony of *Neue Grafik* gradually emerged in the varied landscape of Swiss graphic art, becoming evident only in the second half of the 1950s.[24] It was during this period that several features typically associated with Swiss graphic design, such as

the use of modular grid and rigid restrictions on fonts, became consolidated and highly recognizable. The training that Lora Lamm received at the Zürich Kunstgewerbeschule from teachers such as Ernst Keller was inspired by modernist principles, even if it did emphasize drawing and manual illustration, being still quite distant from the orthodoxy of the international style.

The relationship between Swiss and Italian graphic art was marked early on by strong mutual interest. The Italians greatly admired the professionalism and the level of specialization of Swiss graphic designers. Conversely, Milan exerted a strong attraction on designers coming from Zurich due to the vibrant and burgeoning school of graphic design in the city, which was also rooted on Modernism, being acquainted since the 1930s with the new typography movement.[25] In a playful remark during one of her interviews, Lora Lamm commented on the subject, saying, "Strangely enough, we Swiss were coming to Milan as prophets, but I felt that [Milanese designers] were all already very good."[26]

It is wholly plausible, as Dorfles had already suggested at the time, that not only Lora Lamm's light, minimalist, and subtly humorous illustrative style but also certain features of her acute typo-photographic sensitivity reflected Italian influences. Lora cited among her references a rather eclectic panorama of designers: Erberto Carboni (1899–1984), Piero Fornasetti (1913–1988), Bruno Munari (1907–1998), Giovanni Pintori (1912–1999), Giulio Confalonieri (1926–2008), and Ilio Negri (1926–1974). However, working for a department store like La Rinascente also meant that Lora's gaze was constantly directed toward international production, especially what was happening in the United States. The company sought regular contact with similar businesses abroad, and magazines such as *McCall's*, *The New Yorker*, *Fortune*, *Vogue*, and *Harper's Bazaar* clearly served as some of Lora's sources of inspiration.

In 1965, Bruno Alfieri (1927–2008), the editor of the magazine *Pagina*, defined the production of Italian graphic designers as a "third way" between "the Northern rationalist trends," which he identified in "Swiss academicism," and the more conceptual, surreal, and humorous approach of English-speaking countries.[27] Perhaps Lora's work can best be understood not by placing it at a point exactly mid-way between Zurich and Milan but by adopting this metaphor of a different, third way and seeing it as one of the many paths that it was possible to take at that crossroads of graphic cultures represented by Milan in the 1950s.

Lora Lamm's highly original and diversified production cannot be confined to national stereotypes. It was in Milan that she developed her very personal style, which resulted from a wide array of influences. But as she has repeatedly stated in interviews, one of her motivations for leaving Italy, apart from the rapidly changing climate at La Rinascente, was precisely her desire to avoid being trapped within a specific style. Post-Milan, she initially planned to spend some time working in the United States, but she had to abandon this intention due to difficulties obtaining permission to work there. In 1963, she returned to

Figure 2.3.5 Lora Lamm, *Cynar aperitivo* poster, 1974. © Zurich University of the Arts/Museum of Design Zurich/poster collection.

Zurich and went to work at the advertising agency founded by her friend and mentor Frank Thiessing, although for a time, she continued to work as a freelancer for some Italian clients. She soon became a partner at Thiessing SRA, which also had an office in Lugano and handled many international accounts.

Lora's work from 1964 through the 1990s—preserved at the Museum für Gestaltung Zürich along with the rest of her production—deserves greater recognition and critical attention. Although some of those works exhibit what we might call an "anonymous" style, reminiscent of the typical results achieved through team collaboration within a full-service advertising agency, others continue her graphic-illustrative approach; still, others cleverly leverage the realistic impact of color photography or concentrate on purely typographic compositions.

In 2015, Lora Lamm was awarded the Swiss Grand Prix of Design by the Swiss Federal Office of Culture, and her professional trajectory continues to inspire new generations of designers. She passed away on March 23, 2024 at 97. Lora will continue to be admired as an example of a female figure who, with dogged determination, made her mark in a world dominated by men.

© **Dr. Carlo Vinti**

Note: First published as "Lora Lamm's Third Way to the Corporate Image," in Lora Lamm, Nicoletta Ossanna Cavadini, eds. (2013). *Lora Lamm: Graphic Design in Milan 1953–1963*. Cinisello Balsamo: Silvana. This essay has been substantially revised and retitled "Lora Lamm: Between Swiss and Italian Graphic Design."

NOTES

1. Typical is Heinz Waibl's *Alle radici della comunicazione visiva in Italia* (Centro di Cultura grafica di Como, 1988), essentially a collection of designers' profiles. Recent contributions on women designers in Italy include Raimonda Riccini, ed. (2017). *Angelica e Bradamante le Donne del Design*, Proceedings of the 3rd AIS/Design Conference, Padua: il Poligrafo; Francesco Guida, "Women in Italian Graphic Design History," in Fedja Vukić and Iva Kostešić, eds. *Lessons to Learn? Past Design Experiences and Contemporary Design Practices. Proceedings of the ICDHS 12th International Conference on Design History and Design Studies.* Zagreb: UPI2M BOOKS, 2020, pgs. 601–610.

2. Lora Lamm, Nicoletta Ossanna Cavadini, eds. (2013). *Lora Lamm: Graphic Design in Milan 1953–1963*, exhibition catalog, Silvana Editoriale. The small book series "Oilà," on women designers, has just launched a volume devoted to Lora Lamm; the text is by the illustrator Olimpia Zagnoli (*Come sale e pepe nella zuppa*, Electa, 2023).

3. On the Italy–Switzerland relationship see, among others: Davide Fornari, (2014). "Swiss Style, Made in Italy: Graphic design on the border," in *Mapping Graphic Design History in Switzerland*, Zurich: Triest Verlag, and Hans Höger (2007). *Poster Collection. Zurich Hbf—Milano Centrale Incontri grafici 1945–1970.* Baden, Switzerland: Lars Müller.

4. She attended two different boarding schools in Vevey in Canton Vaud and Fribourg, the capital of the eponymous region in western Switzerland.
5. Interview by Centro di Documentazione del Progetto Grafico Aiap, Zurich, May 19, 2011. Now available on YouTube: https://www.youtube.com/watch?v=I7ln7BvHCH8 (accessed July 24, 2023).
6. On Keller see: Peter Vetter, Katharina Leuenberger, and Meike Eckstein (2017). *No Style: Ernst Keller (1891–1968)*. Zurich: Triest Verlag.
7. See interview by Nicoletta Osanna Cavadini to Lora Lamm, in *Lora Lamm: Graphic Design in Milan 1953–1963*, pg. 144.
8. It was actually an apprenticeship at the Romain Sager atelier, which at the time was connected to the Triplex agency.
9. He edited a monograph on Ernst Erni (*Elements of Future Painting*, 1948) and was a copywriter at the Graphis agency in Zurich.
10. See Chiara Medioli's text first published in *Pulp* no. 5: https://pulp.fedrigoni.com/it/articles/un-fuoco-sacro/) and in *EYE Magazine* 93 vol. 24, 2017 as "A Breath of Fresh Air," https://www.eyemagazine.com/feature/article/a-breath-of-fresh-air (accessed July 24, 2023).
11. On Boggeri see: Paolo Fossati and Roberto Sambonet (1974). *Lo Studio Boggeri 1933–1973*. Milan: Atre Grafiche Amilcare Pizzi; and Bruno Monguzzi, ed. (1981). *Lo Studio Boggeri 1933–1981*. Milan: Electa.
12. On the relationship between La Rinascente and women see the curatorial narrative *La Rinascente è donna!*, in the online archives of the department store: https://archives.rinascente.it/it/paths/la-rinascente-e-donna (accessed July 24, 2023). Among the women who collaborated with La Rinascente were: Rosita Missoni, Aoi Huber, Carla Gorgerino, Pegge Hopper, Ornella Noorda, Rosanna Monzini, Paola Lanzani, Piercarla Toscani Lanzani, Marirosa Toscani Ballo, Adriana Botti Monti.
13. On La Rinascente as a center for creative production, see: Sandrina Bandera and Maria Canella (2017). *IR 100: Rinascente Stories of Innovation*. Milan: Skira; and Nicoletta Osanna Cavadini, and Mario Piazza (2017). *La Rinascente 100 anni di creatività d'impresa attraverso la grafica*. Milan: Skira.
14. R. Hrbak, "Der Werbesstil eines italienischen Warenhaus," *Gebrauchsgraphik*, April 1960, pgs. 10–17. Amneris Liesering's archive is preserved at CASVA (Centro di Alti Studi sulle Arti Visive): https://casva.milanocastello.it/it/content/amneris-latis.
15. Giovanni Bordoli, "La Rinascente," *Graphis* magazine, Vol. 63, January/February 1956, pg. 49. Three works attributed to the collaboration between Max Huber and Lora Lamm appear in the article.
16. Carlo Munari, "Lo Stile Rinascente," *Linea Grafica*, April/May 1965, pgs. 73–84.
17. G. Bordoli, "La Rinascente," pg. 49.
18. Ibid.
19. See: https://archives.rinascente.it/it/paths/grandi-manifestazioni-lr (accessed on July 24, 2023).
20. C. Medioli, "A Breath of Fresh Air," *EYE Magazine* 93, vol. 24, 2017: https://www.eyemagazine.com/feature/article/a-breath-of-fresh-air (accessed July 24, 2023).
21. See: O. Zagnoli, *Come sale e pepe nella zuppa*, Electa, 2023.
22. Interview by Centro di Documentazione del Progetto Grafico Aiap, previously cited (note 5).
23. Gillo Dorfles, "Lora Lamm," *Graphis*, vol. 90, July–August 1960, pgs. 330–335.
24. Laurence King Publishing, 2006.
25. See, among others: Carlo Vinti "The New Typography in Fascist Italy: Between Internationalism and the Search for a National Style," in Matthieu Cortat, and

Davide Fornari, eds. (2020). *Archigrahiae: Rationalist Lettering and Architecture in Fascist Rome*. Lausanne: ECAL/University of Art and Design, pgs. 49–77.
26. Interview with Lora Lamm by Valeria Malito, Zurich, May 20, 2011, in *Lora Lamm: Milano 1953–1963*, master thesis, IUAV University of Venice, aa. 2011–12, pg. 67.
27. B. Alfieri, *Pagina*, no. 6, January 1965.

2.4

Claudia Morgagni: Woman, Graphic Designer, Teacher

Dr. Cinzia Ferrara and Dr. Francesco E. Guida

Historical research on visual communication design, both at the Italian and international levels, has revealed a landscape primarily populated by significant male figures who have contributed to the development and evolution of the design discipline. However, when examined more closely, this landscape reveals the absence of many equally important female figures, often overlooked and understudied. If we look at the so-called golden age of Italian graphic design, very few female figures have emerged from the 1950s to the early 1970s. Those are regarded more as exceptions than as the result of contextualized and intentional historical research.

Claudia Morgagni's (1928–2002) figure is emblematic and unique: an audacious, modern, determined woman who defied established norms. She intertwined her professional life with that of an artist, educator, mother, and woman in constant pursuit of new linguistic expressions, never content with those embraced and appreciated by clients. In her projects, she gradually reduced iconographic elements, whether photographs or illustrations, shifting her focus toward a more dry, abstract, rigorous, and concise language. She expressed

Figure 2.4.1 Claudia Morgagni, portrait.
Photo: Davide Cerati, ITSOS, 1979.
Image courtesy of AIAP CDPG.

herself through perfectly defined geometric forms in contours and colors. As they moved within the "broken up" composition space, these forms overlapped and combined, building dynamic geometric relationships and giving rise to configurations of extreme formal elegance and conceptual synthesis.

> It is not easy to suppose for what reasons the number of women who dedicate themselves to advertising and graphic design is so modest and rare. Also, among the poster artists, there are no female signatures […]: instead, we find them among the ever more numerous fashion illustrators, and this would demonstrate that they tend to deal with those activities that best match their character […]. So, we must say that Claudia Morgagni […] constitutes an exception and is so unique to the point of embodying "graphic design"' with rare linearity, even among men […].[1]

These words, with which Dino Villani (1898–1989)—president of the Italian Advertising Federation (FIP)—introduces the work of Claudia Morgagni in the mid-1960s, also reveals a clue to the culture of the time in his somewhat paternalistic tone in evaluating a colleague's work. However, there is something more to it as well. Villani generalizes excessively: There were women who were dedicated to graphic design, advertising, and other fields of design. Indeed, they were in small numbers but not so definitively confined to areas that better suited their character. However, Villani himself admits that Claudia Morgagni stood out.

At the time, women were active in graphic and advertising design. Besides the well-known Lora Lamm (1928–2025) or Anita Klinz (1925–2013),[2] it is possible to cite, among others, Simonetta Ferrante (1930), Alda Sassi (1929), and Umberta Barni (1927). However, many other women were employed in agencies and professional firms, thus assuming secondary roles. Claudia Morgagni chose, with a few others, to own her autonomy.

According to Proctor,[3] it was only during the 1960s that Italian women artists "began to enter art training and the profession in numbers comparable to those of other European countries." Graphic design was included in the broader field of arts, as AIAP (Italian Association of Advertising Artists) testified in the name itself. The association was established in 1955 after the departure of ATAP (Association of Advertising Technicians and Artists), elucidating the separation of the technical aspects from artistic expression.

The seventy "secessionists" who founded AIAP in 1955 included four women: Umberta Barni and Brunetta Mateldi (1905–1989) from Milan, Alda Sassi from Turin, and Annaviva Traverso (1915–2003) from Savona[4]—just a few of the many women designers active in the field, mainly based in Milan and reported on in yearbooks and annuals. Amongst these names, it is possible to identify some modern-era pioneers whose careers and memories have been heavily influenced by context and the stereotyping of female

figures. Although not well known, Claudia Morgagni is interesting in this regard for her professional autonomy and life experience.[5]

Life and Education: Art as a Path for Independence

Claudia Morgagni was born in Milan on July 21, 1928, to Ferrino Morgagni and Alberta "Berta" Camerani, both originally from Filetto, a small town near Ravenna, Italy.[6] The couple had four daughters: Claudia, Liliana, Annamaria, and Gabriella. Claudia had a special relationship with her step-grandfather, Matteo, a defrocked priest, a shoe modeler for Quintè on Corso Venezia, and a violinist in the La Scala orchestra. He taught her the game of chess and instilled a passion for cinema and classical music. Claudia grew up in a stimulating family environment, surrounded by diverse influences and decent financial resources.

Claudia graduated from the Casati Suore Orsoline Institute, a secondary school specializing in commerce, in October 1943. Her school certificate prominently displays a grade of "nine" in drawing and calligraphy. She continued her studies at the art high school of the Brera Academy in Milan, graduating in 1949. After graduation, she immediately enrolled in the four-year painting course, continuing her academic journey at the Academy.

In the summer session of 1953, Claudia Morgagni obtained her painting degree with the highest marks in art history. In the 1950s, female students outnumbered the male students in the painting classrooms of Brera despite being discredited by their male counterparts and accused of having little artistic vocation. It was a common belief that women could only aspire to a "marginal" art profession without the risk of competing with their male colleagues. Despite this view, journalist Enzo di Guida highlighted a critical characteristic of Brera's female students: independence.[7] This particular aspect will recur throughout Claudia's life, accompanying her in personal and professional choices.

After graduating from Brera, she enrolled in courses in ceramics (in Faenza), mosaic (in Ravenna), and graphic design in Paris. She intended to indulge her artistic interests and began building the path of professional autonomy.

Since her first years of study at the Academy, Claudia Morgagni has participated in numerous collective exhibitions of figurative arts. Her debut was during the summer of 1951 when she took part in the National Painting Exhibition "Premio Città di Monza" at Villa Reale with two paintings. Then, she exhibited in Gorizia, Graz, Vienna, Messina, Mantua, and Milan. The following year, from May 8 to 20, 1954, a personal exhibition of portraits by Claudia was presented at the Galleria del Voltone in Bologna. The exhibition failed, resulting in no artworks being sold. The documents in her archive indicate that she resumed participating in painting exhibitions in 1973 with the National Art Exhibition "Via il governo Andreotti," organized by the Promoting Committee of Artists'

Mobilization against the clerical–fascist block. This participation and another one the following year, on the occasion of the exhibition organized in the Sala della Balla of the Sforza Castle in Milan by the National Association of Italian Partisans (ANPI), clearly shows her political alignment.

In addition to pursuing her artistic research on paintings and participating in collective exhibitions—the last one in 1997—Claudia Morgagni continually experimented. Her archive includes sketches and drawings of various types: jewelry designs, photographic proofs, and drafts for etchings. She created etchings commissioned by Arturo Jeker, an influential Milanese entrepreneur, who gave them as Christmas gifts to friends.

Art was a fundamental part of her life, evolving in styles and techniques but always accompanying her, not necessarily aiming at public recognition and often devoting experimentation to the professional sphere. The Brera Academy's studies also helped her to have access to the cultural and artistic circles of the time, and where Claudia met aspiring sculptor Mario Robaudi (1933–2010) in 1956. Mario Cesare Romano Robaudi, his full name, was the author, among others, of the monuments to the Bersaglieri in Corso Europa and to the Resistance at Idroscalo, both in Milan. He left Florence to study at the Brera Academy, moving to Milan in October 1953 to attend sculpture classes with Giacomo Manzù (1908–1991) and Marino Marini (1901–1980). The two young artists married on August 3, 1957, at the San Vincenzo in Prato church in Milan. Simone, their first child, was born on January 10, 1958, followed by Francesca on March 1, 1959, and their third child, Paolo, on May 23, 1967.[8]

Mario Robaudi traveled extensively for study and work, spending several months away from Claudia and the children. In 1960, he was awarded the "Devoto" scholarship from the Falck Foundation for the Maison d'Italie in Paris. In 1965, he was entrusted with restoring the Holy Sepulchre in Jerusalem on a Vatican commission and resided there until 1969. Claudia joined him in 1966, leaving her teaching position at Brera to assist him with his restoration work for about six months. However, on February 2, 1972, the couple entered a consensual separation and later obtained a divorce decree on October 31, 1973. The law on divorce in Italy had only been enacted in 1970, making the dissolution of marriages possible in the legal system.

Upon returning to Italy in 1969, Mario did not join his wife and children, leaving Claudia alone to care for their three children with the help of babysitters. She faced considerable challenges balancing her role as a mother and a graphic designer. Claudia experienced financial difficulties, particularly in the late 1970s, due to delays in receiving alimony payments from her ex-husband as stipulated by the divorce decree. However, she continued to work tenaciously until her health made that impossible.

Claudia had always experienced health problems. From age eight, she was treated for scoliosis, a condition she suffered throughout her life. In 1984, she began pulmonary ventilation treatments with oxygen and respiratory exercises thrice a week at the San Raffaele Resnati clinic in Milan. Over the years, the problem continued, forcing her to engage in oxygen therapy at home, where she suddenly died on January 7, 2002.

Figure 2.4.2 *Left:* Claudia Morgagni, Santagostino advertisement, 1955–56. *Right:* Claudia Morgagni, Esso Extra Motor Oil poster, 1956. Images courtesy of AIAP CDPG.

Professional Practice and Teaching

During her studies at the Brera Academy, Claudia Morgagni began her collaboration with Santagostino (1953–56), a long-standing Milanese company of socks and cotton yarn founded in 1876. She was responsible for designing brochures, advertisements, and packaging made of cardboard or plastic.

On April 28, 1955, while working for Santagostino, she was awarded the Diploma of Honor for the First National Competition for Window Display Sketches and Models, titled *Vetrine in Vetrina* (*Showcases in the Window*). The prize was 50,000 lire (equivalent to approximately 780 euros), sponsored by SNIA Viscosa. She submitted a collage for an advertisement entitled *Calza che non molla* (*Never-giving-up stockings*). The subject featured two lions fighting over a sock, created with a "crepe nylon" sample glued over an ink illustration. The competition was organized by the magazine *Vetrina*, a monthly publication for textile traders. The jury was chaired by lawyer Dino Alfieri, president of the Italian Fashion Center, and composed of Dino Villani; Carlo Benedetti, president of the National Association of Window Dressers and Decorators (ANVED); Marzio Simonetto, director of the magazine; the painter and illustrator Brunetta Mateldi (who was at the time an AIAP member); and the journalist Vera Rossi. Well-known designers like Ivo Sedazzari and Enzo Mari were also awarded.[9]

During this time, she also experimented with colorful textures, likely for potential packaging materials for Santagostino products. In some of the advertisements promoting Santagostino's affiliated knitwear manufacturers, she applied a more synthetic visual language to express the concept of the campaign "Friendship is the spirit of life" (1954–56). This visual synthesis will characterize most of her future graphic design.

Claudia invested in graphic design and advertising for economic autonomy and other personal reasons. As reported in a letter sent to Dino Sassoli, the founder of ItamCo advertising agency, in 1977, she wrote: "When I realized that painting was in deep crisis and could not be useful to society with its various -isms, around 1953, I turned to advertising, believing in it because it seemed to me the most appropriate means."[10]

Sassoli was her second employer. After her experience at Santagostino, she worked at ItamCo, from March 1, 1956, to October 16, 1957. The agency, founded in 1948, "was particularly receptive to the language of US advertising and acquired an international standing in the 1960s."[11] Some of its well-known clients included Barilla and Esso, for which she created mainly advertisements and some brochures. She designed her most successful poster for one of the company's flagship products, Extra Motor Oil. The

Figure 2.4.3 *Left*: Claudia Morgagni, *Lanerossi* house organ cover, January 1960. *Right*: *Lanerossi* house organ cover, February–March 1960. Images courtesy of AIAP CDPG.

artwork depicts a can held in the hand of a woman with short, light-colored hair, her gaze directed towards the viewer above the can. The photograph of the female figure is treated with halftone screening and a cyan color tone. However, working for an agency, artistic freedom in decision-making was limited by the need to follow established company guidelines and could not satisfy Claudia's ambitions. When her contract with ItamCo expired, she opened her studio, Studio Morgagni, basing it in her home at Via San Martino 8, shared first with her husband, Mario, and then with their children Simone and Francesca.

An influential art critic, Vittorio Fagone (1933–2018), wrote in 1961: "Since 1957, she has been running her advertising studio. Claudia Morgagni owes her good reputation among young Italian advertising graphic designers today to her rigorous cultural education, vibrant taste, and rich experience gained during these years of intense activity. Indeed, Morgagni's numerous creations stand out for their measured control of expressive means and effective characterization."[12]

Claudia developed a respectable portfolio with clients like Lanerossi, Manifattura Marzotto, Caffè Franck, Tupperware, Pellizzari, and Montecatini and adequate remunerations, on average, with those of men, confirming the quality of her professional work and out-of-the-ordinary personality. Villani added that Morgagni had "an important and impressive curriculum, for a woman who works without an organization behind; who is

Figure 2.4.4 *Left:* Claudia Morgagni, *Ceramiques Sanitaire* poster, 1963. *Right:* Claudia Morgagni, Pellizzari cover, 1967. Images courtesy of AIAP CDPG.

resistant to conduct her business independently, to preserve her independence and rely on her individuality […]. She would have no worries in a studio or an agency but should give up her beliefs. Instead, she intends to assert them not so much for pride and prestige reasons but because she is convinced to obtain better results for clients interpreting their needs with a much personal mark."

Her ability for visual synthesis can be seen in a competition's winning poster for the French Syndicate of Ceramic Sanitaryware Manufacturers (1963), in which the sharp contrast between black and white highlights the typical sinuous lines of sanitaryware. She submitted the poster for the first Biennale Internationale de l'Affiche of Warsaw (the Poster Biennale) in 1966, and two years later, it was added to the permanent collection. She also participated in the second Biennale in 1968 and the third Biennale in 1970, each with three posters.

She confirmed her critical style in her work for Pellizzari (1967–68), an industrial machinery manufacturer. Her geometric compositions are articulated on a thin color register (red, blue, and black) in all printed matter. With Pellizzari, Claudia could work

Figure 2.4.5 Claudia Morgagni, CIBA Pharmaceuticals cover, 1972. Image courtesy of AIAP CDPG.

in different dimensions; for example, in the "dynamic" exhibit at the Verona Fair (1968), in which a long movable wall with detailed photographs of machinery is in the background of the equipment samples. Both plans, the two-dimensional (of printed matter) and the three-dimensional (of the exhibit), are interpreted rationally and through a few elements. Synthetically.

Her professional activity continued between 1969 and 1972 with collaborations with Decca, designing a significant production of 7-inch singles covers for 45s for artists such as Minnie Minoprio, Ann Peebles, and Julio Iglesias and international hits such as "Look What You Done for Me" by Al Green or "Sea Side Shuffle" by Terry Dactyl and the Dinosaurs. Other clients were Ciba, IBM, and Montedison, for which she designed Duco's corporate identity, a brand of paints and varnishes. Montedison was one of the longest-lasting clients: she worked for this chemical company from the early 1960s until 1975 on several occasions. She would manage clients who sometimes lasted only a few years.

At the end of the sixties, Claudia redirected her energy toward teaching. She obtained her teaching qualification in drawing for all middle schools in 1951 through a competition announced by ministerial decree. In her last year of studies at the Brera Academy, the academic year 1952–53, Claudia began teaching the History of Costume at the Marangoni Artistic Clothing Institute. After graduation, she taught Figure Drawing at the Professional Schools for Adults, which was managed by the Provincial Consortium for Technical Education in Milan from 1953 to 1956.

Officially included in 1955 as a teacher in the professional registry for drawing, she taught at the State Middle School "Duca degli Abruzzi" for four years from 1958 until 1962. Claudia then became a teacher of Advertising at the evening school of the Brera Artisans, annexed to the Academy, until 1966. She then resumed her teaching career in 1969 at the Odoardo Tabacchi State Middle School and as a graphic design teacher at the courses for graphic designers at the Società Umanitaria, collaborating with Albe Steiner (1913–1974) and Pino Tovaglia (1923–1977) for two years. Beginning in 1972, she was appointed as a permanent teacher for the subject of drawing in high schools and training institutes. After a pause between 1972 and 1973 due to health reasons, she continued to teach until 1987 in various Milanese schools.

In 1977, she ceased her professional activity and focused solely on teaching. While she was still studying, the decision to pursue a career in teaching was both an ideological choice and a certainty to have access to a pension and healthcare benefits, not sufficiently guaranteed through professional practice. For Claudia, teaching was a way to fulfill professional practice, as confirmed in Villani's article.

Her growing "ideological" state dictated this commitment, as Franco Grignani (1908–1999) wrote in a letter of recommendation for the prize to women's engagement in advertising promoted by ACPI (the Italian Association of Advertising Consultants).[13] On December 10, 1975, in the Grechetto Hall of Palazzo Sormani, the jury unanimously awarded Claudia Morgagni the silver plaque to recognize her design career.

Beyond Professional Stereotypes

Claudia Morgagni's worklife is a stellar example of professional autonomy. She was one of the few female practitioners who, following the Second World War, started their businesses, taking on responsibilities, covering different roles, and interacting with clients and suppliers. Many of these women worked and lived in a city like Milan during unprecedented social changes and economic growth. They undertook independent careers in a male-dominated context where certain occupations and social roles were designated female.[14] As reported by her son Paolo in some interviews, Claudia was sometimes marginalized in some professional circles as she was more dedicated to advertising. Despite having demonstrated the quality of her work with significant economic results, it is assumed that her ability to manage her practice independently was considered abnormal.

She was able to handle different kinds of clients in diverse fields, such as heavy industry or chemistry, not just in those of fashion or textiles. Moreover, in her rich production—from advertising to exhibit—she adopted a visual language often far from illustration and drawing, evolving it over time and with interlocutors. Her work was repeatedly reported in magazines, catalogs, and yearbooks, highlighting her confidence in promoting it.

By combining teaching with practice, as a social commitment and for practical reasons, she once again broke a stereotype that assigned women to be relegated to specific roles. The multiplicity of roles is then an essential factor of evaluation. For a woman at the time, carving out her own independent professional business was almost heroic. Especially if the profession had to be accompanied by conventional social and cultural roles: being a wife, being a mother, taking care of the family home, and looking after the offspring. At that time, as it is today, the graphic design profession can offer the practitioner flexibility in time management. However, independence is only relative if it is possible to achieve economic stability.

It is by no means an exaggeration to define Claudia Morgagni as a pioneer of the graphic design field and a role model, at least for Italy. For this reason, the 2019 edition of the AIAP Women in Design Award (AWDA)[15] dedicated the Lifetime Achievement Award to Claudia Morgagni.

© **Dr. Cinzia Ferrara and Dr. Francesco E. Guida**

NOTES

1. Villani, Dino. "Claudia Morgagni: sintetismo spinto sull'orlo dell'esasperazione," *Parliamoci*, n.d., pgs. 22–3. Translation by the authors.
2. Anita Klinz is considered the first Italian female art director. Pitoni, Luca (2022). *Ostinata Bellezza. Anita Klinz, la prima art director italiana*. Milan: Fondazione Arnoldo e Alberto Mondadori.
3. Proctor, Nancy, "Training and Professionalism, 18th and 20th Centuries: Italy," in Delia Gaze, ed. (1997) *Dictionary of Women Artists: Volume 1*. London: Fitzroy Dearborn Publishers, pgs. 106–08
4. Guida, Francesco E. (2020). *Beyond Professional Stereotypes: Women Pioneers in the Golden Age of Italian Graphic Design*. PAD (Pages on Arts and Design), 13 (19), 14–39.
5. The following events have been reconstructed thanks to the materials from the Claudia Morgagni Fund (FCM) preserved at the Graphic Design Research Center of AIAP (from now on referred to as AIAP CDPG), the Italian Association of Visual Communication Design. The archive was donated in 2015. See Guida, Francesco E. (2016). *Claudia Morgagni, Commitment as a Professional Model*. Milan: AIAP Edizioni, and Abbiati, Paola (2023). *Claudia Morgagni: Indomita essenza. Progettista dimenticata degli anni d'oro della grafica italiana*. Master thesis, Università Iuav di Venezia, supervisor Prof. Fiorella Bulegato, co-supervisor Prof. Francesco E. Guida.
6. The biographical notes are taken from the identification documents of Claudia Morgagni and Alberta Camerani, preserved at the AIAP CDPG, and from interviews with Paolo Robaudi conducted by Paola Abbiati during the preparation of her thesis.
7. As reported in the article "Dieci in condotta per le ragazze di Brera" published in the weekly magazine *Settimo Giorno*.
8. It is mainly thanks to Paolo's efforts that Claudia's Archive was donated to AIAP CDPG, and his testimonies and memories were important in reconstructing her personal, artistic, and professional life.
9. The complete list of the awarded designers is in *Vetrina*, VIII (47), April 25, 1955. The *Vetrine in Vetrina* competition awarding is reported in *Vetrina*, VIII (53), October 25, 1955.
10. Translation by the authors. Letter by Claudia Morgagni to Dino Sassoli, October 10, 1977.
11. Fasce, Ferdinando, Bini, Elisabetta. "Irresistible Empire or Innocents Abroad? American Advertising Agencies in Post-War Italy, 1950s–1970s," *Journal of Historical Research in Marketing*, 7 (1), 2015, pgs. 7–30, https://doi.org/10.1108/JHRM-08-2013-0050. To know more about the relationships between Italian and American advertising businesses, see De Iulio, Simona, Vinti, Carlo. "The Americanization of Italian Advertising during the 1950s and the 1960s: Mediations, Conflicts, and Appropriations," *Journal of Historical Research in Marketing*, 1 (2), 2009, pgs. 270–94, https://doi.org/10.1108/17557500910974613.
12. Fagone, Vittorio. "Questo mese il grafico Claudia Morgagni," *Legatoria* (2), November–December 1961, pgs. 18–20. Translation by the authors.
13. The letter by Franco Grignani is dated November 1975.
14. See in Buckley, Cheryl. "Made in Patriarchy: Toward a Feminist Analysis of Women and Design," *Design Issues*, 3 (2), 1986, pgs. 3–14.
15. AWDA, AIAP Women in Design Award, www.aiap-awda.it.

2.5

Nelly Rudin: A Concrete Graphic Designer

Sandra Bischler-Hartmann

When asked, in 1958, whether a photography student at the Zurich School of Arts and Crafts could do a photo reportage on her, thirty-year-old Swiss graphic designer Nelly Rudin had been running her own studio in Zurich for two years. The budding photographer took Nelly's picture inside her studio and outside, meeting with clients and photographers.[1]

Although the photographs seem staged, the images provide a rare glimpse into the daily business and work environment of a Swiss graphic designer in the late 1950s—Nelly Rudin, at work in her studio, which was sparsely but functionally furnished with home-made shelves made of boards and bricks. The designer is sitting at a large drawing desk in front of a Buddha figure and a Concrete painting, surrounded by designs for print material and a cardboard model of one of her exhibition designs. She is looking at contact sheets with a magnifying glass, making image selections for a brochure design, talking on the

Figure 2.5.1 Nelly Rudin photographed in her Graphic Design Studio in Zurich in 1958. Photo: Klaus Zaugg. © Eredi Zaugg—Regione Lombardia/Museo di Fotografia Contemporanea, Milano-Cinisello Balsamo. Image provided by Zürcher Hochschule der Künste Archive.

Figure 2.5.2 Nelly Rudin, poster for *SAFFA* (*Swiss Exhibition for Women's Work*) held in Zurich, Switzerland, 1958. © Nelly Rudin Stiftung c/o Prolitteris, Zürich.

phone, and working manually at her drawing desk using a t-square, cutter, and tape—the daily routine of a graphic designer before the digital age. Photographs from outside the studio show Nelly Rudin standing next to a photographer, giving instructions for a shot.

It should come as no surprise that a woman working as a self-employed graphic designer in her own studio during the late-1950s Switzerland was notable. Generally, working women were in the minority, especially in male-dominated professions such as graphic design, with a high rate of self-employment; they were the exception.[2] At the time the photo reportage on Nelly Rudin was produced, she had just landed a big coup professionally: She had won the nationwide poster competition for *SAFFA*, the *Swiss Exhibition for Women's Work* (*Schweizerische Ausstellung für Frauenarbeit*). Her design prevailed, competing with 140 other designs submitted by 96 female designers.

The *SAFFA* exhibit was held for the second time in Zurich in 1958 under the motto "Women of Switzerland—Their Life, their Work."[3] Its thematic pavilions showed different aspects of Swiss women's everyday life, dealing with topics such as the home, education, nutrition, clothing, women in public service, and women's contribution to the economy. In addition to designing the poster, Nelly Rudin was also responsible for the exhibition design of the "Women and Money" pavilion, which informed visitors about insurance coverage, taxes, and financial security in terms of gender. Nelly arranged the information texts and accompanying large-format photographs on modular exhibition panels, which were set up in curved shapes to structure the exhibition space.[4]

In the *SAFFA* poster's foreground, Nelly Rudin had placed a black-and-white photographic portrait of a short-haired young woman looking directly into the camera. Diagonally to the left, she placed the photograph of a stone-age Venus figure and connected the two photos by spiral forms in green and white, which enhanced the spatial effect already created by the photos' size difference. According to Nelly Rudin, the design symbolized Swiss women's 'Path of Development'[5] from the Stone Age to the present day. This strong image layer was contrasted by reduced, grid-based sans-serif typography that provided the most necessary information about the exhibition.[6] When Nelly's *SAFFA* poster was hung on billboards and facades throughout Switzerland, in Swiss Federal Railways trains, and at airports for several months beginning in the spring of 1958, the motif caused a great stir because it was quite progressive in style and content. Nelly Rudin was publicly criticized for using photography on a poster—not the traditional means of 1950s Swiss poster design, which was hand-drawn illustration. Critics even complained that the young woman in the photo was not a "treat" for the eye—meaning she did not correspond to the "pretty" women's image that the public was used to seeing in everyday advertising. In contrast, the poster's supporters praised the choice of the photo model, especially because it avoided the typical cover-girl cliché, deeming the choice particularly fitting to the *SAFFA* exhibition.[7] In fact, the photo used by Nelly Rudin was authentic: it portrayed Monica Brügger (1932), a young Swiss architect and thus a pioneer in a male domain, just like graphic designer Nelly Rudin. Eventually, the *SAFFA* poster became a memorable visual landmark and was an important career step for Nelly, who had embarked on her professional path about ten years prior.

Nelly Rudin was born in Basel, Switzerland, on July 11, 1928. Her father, Robert Rudin, was a merchant, and her mother, Hulda Rudin, was engaged in artistic activity, inspiring that talent in her daughter. Nelly and her older brother spent their youth living in Basel's Bachletten neighborhood, and after finishing high school, she enrolled in the Basel School of Design's one-year pre-course for arts and crafts professions at the age of sixteen in 1945. The pre-course was a preparatory program for artistically talented young people to clarify their aptitude for an artistic profession while teaching them basic drawing and design skills. Only the most talented students from the pre-course were accepted

into the school's four-year graphic design program—she was one of those lucky few who started the program in 1947.[8]

The school was one of the most renowned Swiss institutions for graphic design and typography education. Nelly Rudin completed the graphic design program in 1951, earning the federal certificate of proficiency. The program only admitted from five to ten students per year housed in one classroom, enabling them to learn from each other. Nelly's classmates included soon-to-be successful Swiss graphic designers such as Thérèse Moll (1934–1961), Dorothea Hofmann (1929–2023), Heidi Soland-Schatzmann (1929–2008), and Gérard Ifert (1929–2020). Armin Hofmann (1920–2020) and Donald Brun (1909–1999) were Nelly's graphic design teachers, famous Swiss graphic designers with contrasting approaches. Although Hofmann's methodology was based on formal reduction and artistic integrity, Brun's teaching focused on advertising factors and the use of figurative illustration. In addition to these practical courses, the Basel graphic design

Figure 2.5.3 Nelly Rudin, advertisement for the packaging company L+C (lithography + cardboard packaging), 1954/55. Photo: Serge Libiszewski. © Nelly Rudin Stiftung c/o Prolitteris, Zürich.

program curriculum included intensive training in naturalistic and free drawing taught by local artists and introductory courses in typography and photography.[9]

Nelly Rudin's graphic work reveals that she was a proponent of the "Swiss Style,"[10] which, around 1960, gained an international reputation—and was later called the "International Style." The essential design principles of this style were formal reduction and functionality. Nelly Rudin's *SAFFA* poster is an instructive example of this style, whose designers preferred abstracted or geometrically constructed forms and photography, grid-based typography, and sans-serif typefaces. Nelly's first employer after graduation was the Basel-based chemical company J.R. Geigy's in-house advertising studio, an important patron for Swiss Style graphic design.[11] Beginning in 1950, Nelly Rudin was one of the first Basel School of Design alumni to gain practical experience at J.R. Geigy—starting to work there before graduating from the graphic design program and remaining there

Figure 2.5.4 *Top:* Nelly Rudin, advertising card for Synopen, an allergy medication, J.R. Geigy AG, Basel, CH, designed for Studio Müller-Brockmann, 1953–54. *Bottom:* Nelly Rudin, advertising card for Insidon, a mood-enhancer medication, J.R. Geigy AG, Basel, CH, circa 1962. © Nelly Rudin Stiftung c/o Prolitteris, Zürich.

for three years. In 1953, she moved from Basel to Zurich and began working for Studio Müller-Brockmann, also committed to Swiss Style. There, she designed corporate work for "L+C," a packaging company—a series of advertisements and giveaways that were consistent in appearance but not repetitive. Nelly was fascinated by the shape of the punched-out packages when flat and chose their silhouette as her advertisements' repeating basic element.

She managed to visualize the company's advertising promise—to produce suitable and practical packaging for every type of goods—in a recognizable yet fresh and different way with each ad, combining the package silhouette with photographs or graphic translations of the possible package contents. The design with the light bulb was shown in the traveling exhibition *Swiss Graphic Designers*, which toured the USA in 1957. Nelly Rudin was the only female graphic designer participating in this exhibition. In the foreword of the exhibition catalog, the US graphic designer Noel Martin (1922–2009) wrote about the "geometric" Swiss graphic design shown: "We hope that this exhibition as it travels across the country will reveal to designers and their clients what can be accomplished by an open-minded attitude and a desire to present the facts honestly without gimmicks, unfunny humor, redundancy, and coupons."[12]

After freelancing in design studios, Nelly Rudin opened her studio in 1957 in Zurich city center. In addition to her work for *SAFFA*, she realized other exhibition designs, designed logos and advertising campaigns, and consolidated her position among the Swiss "Graphic Designers of the New Generation"[13] when she was included in a trade magazine article in 1959. She continued to design regularly for clients in the pharmaceutical industry, such as ads for Insidon, an antidepressant drug manufactured by J.R. Geigy. Unlike typical advertising for consumer products, advertising for medications required conceptual ideas for visualization due to the products' often invisible effects and unappealing looks. Nelly's bursting bubble motif symbolized the drug's liberating, anxiety-relieving effect.

In 1961, Nelly Rudin won another competition for the corporate design of Schwabenbräu, a German brewery. Designing the company's advertisements, beer mats, car lettering, etc., she found a purely typographic solution, which was very unusual in beverage advertising then, and demonstrated her courage for non-conformity once again.[14]

She also received commissions in one of her favorite areas of design, "packaging problems."[15] In an essay on package design published in 1961, Nelly wrote about her design principles and explained the methodical approach to graphic design she advocated to seek a "harmony of purpose, shape and graphic design."[16] According to her, the graphic designer must first determine what function a design must fulfill: a purely informative or an advertising function. The design means had to be selected according to this function.[17] Although Nelly propagated an openness to all styles in principle, she saw the most promising approach in a reduced and subtle use of design elements and typography, which also needed to be aesthetically pleasing.[18]

Figure 2.5.5 Nelly Rudin, poster for her second solo exhibition in 1969 at the Kleine Galerie in Zurich, Switzerland. Image provided by Museum für Gestaltung Zürich. © Nelly Rudin Stiftung c/o Prolitteris, Zürich.

Nelly Rudin was a contributing author for *New Graphic Design*, a Swiss trade magazine that was an important mouthpiece for Swiss Style graphic design and typography. During its publication between 1958 and 1968, she was the only female graphic designer who wrote for the magazine, amongst its now famous editors/graphic designers such as, for example, her former employer Josef Müller-Brockmann (1914–1996) and Hans

Chapter 2.5 Nelly Rudin: A Concrete Graphic Designer

Neuburg (1904–1983). Despite these close ties, Nelly Rudin succeeded in creating an independent graphic oeuvre. Her work avoided formalism and always captivated with an idea—a conceptual strength that she implemented convincingly in formal terms. Her former teacher, Armin Hofmann, wrote retrospectively that Nelly Rudin had an "original gift for analytical thinking and designing."[19]

Nelly Rudin's reduced visual language is also closely linked to the Concrete Art movement, which emerged in the 1930s and was refined in Switzerland in the following decades by artists such as Max Bill (1908–1994), Richard Paul Lohse (1902–1988), Verena Loewensberg (1912–1986), and Camille Graeser (1892–1980). The rational formal language of the Zürich Concretists aimed at the autonomy of art, which was supposed to shape reality instead of imitating it. The artistic means themselves—line, surface, form, color, light, materials, and space—were in the foreground.[20] Since moving to Zürich in the early 1950s, Nelly Rudin had been friends with this group of artists who often worked in both art and graphic design fields. Nelly's close friend Max Bill was an advisor when she began working as a Concrete painter in the 1960s. Nelly's poster for her second solo exhibition in 1969 at the Kleine Galerie in Zürich features one of those early paintings.

Proceeding systematically and guided by geometric principles, she explored surface, form, and color, subtly balancing plane volumes and color intensities. In the following decades, Nelly Rudin transformed her painted compositions into three-dimensional space, creating painted aluminum frames, acrylic glass objects, and walk-in installations. She gave up graphic design altogether in the mid-1960s and, from then on, devoted herself exclusively to art. She was married to the doctor Dieter Loewensberg (1914–1995), the brother of Concrete artist Verena Loewensberg, and was the stepmother of two children from her husband's first marriage. Nelly Rudin's artistic oeuvre was honored in 2011 with an extensive retrospective at the Museum Haus Konstruktiv in Zurich. Two years later, in 2013, she died on December 4 in Zurich, at the age of eighty-five.

© **Sandra Bischler-Hartmann**

NOTES

1. The complete photo series is available online at www.emuseum.ch/people/14712/nelly-rudin (accessed March 7, 2025).
2. For example, only twelve of 186 members of the VSG, the Swiss Graphic Designers' Association, were female in 1960. See Vogt, Adolf Max, ed. (1960). *Schweizer Grafiker Handbuch*. Zurich: Verlag Käser Presse.
3. The first SAFFA exhibition was held in Berne in 1928 and was intended to highlight the Swiss women's social and economic importance to a national and international audience. See Tanner, Jakob (2015). *Geschichte der Schweiz im 20. Jahrhundert*. Munich: C. H. Beck, pg. 205.
4. Rudin's exhibition design was reviewed in a magazine article in 1958. See Sachs, Lisbeth, "Zur Ausstellungsgestaltung der Saffa," *Das Werk: Architektur und Kunst*, Vol. 45, No. 10 (1958), pg. 363.

5. Rudin gave this title to her design during the poster competition. See Wehrli-Knobel, Betty, "Baubeginn der Saffa 1958," *Schweizer Frauenblatt: Organ für Traueninteressen und Frauenaufgaben*, Vol. 36, No. 42 (17.10.1957), pg. 1.
6. The *SAFFA* logo on Rudin's poster was designed by Swiss graphic designer Heidi Soland-Schatzmann.
7. As for these discussions, see readers' letters and journalists' comments published in *Schweizer Frauenblatt: Organ für Traueninteressen und Frauenaufgaben*, Vol. 37, No. 10 (07.03.1958), pg. 3.
8. In 1947, the graphic design program was still part of the arts and crafts department of the vocational trade school, the Allgemeine Gewerbeschule Basel, which later became known as the Basel School of Design.
9. Besides Armin Hofmann and Donald Brun, Rudin's teachers were, among others: Emil Ruder (Typography), Theo Ballmer (Photography), Theo Eble, Julia Eble, and Walter Bodmer (Drawing).
10. The main characteristics of "Swiss Style" graphic design and typography—which originated in Switzerland and peaked during the late 1950s and 1960s, becoming an international success—are "clarity and order," according to design historian Richard Hollis. See Hollis, Richard (2006). *Swiss Graphic Design: The Origins and Growth of an International Style, 1920–1965*. London: Laurence King Publishing, pg. 7.
11. As for J.R. Geigy's role as a patron for Swiss Style graphic design, see Janser, Andres, Junod, Barbara, eds. (2009). *Corporate Diversity: Swiss Graphic Design and Advertising by Geigy 1940–1970*. Zurich: Lars Müller Publishers.
12. Martin, Noel, "Preface," in *Swiss Graphic Designers. Flückiger, Gerstner, Hofmann, Honegger, Lohse, Müller-Brockmann, Neuburg, Odermatt, Ruder, Rudin, Schmid, Vivarelli*, edited by The Contemporary Arts Center, Cincinnati Art Museum, Cincinnati, 1957, no page numbering.
13. Ifert, Gérard, "Graphic Designers of the New Generation," *Neue Grafik / New Graphic Design / Graphisme Actuel*, No. 2, July 1959, pgs. 21–37. Nelly Rudin's work appears on pg. 33. Eighteen issues of *New Graphic Design* magazine were published from 1958 to 1965 by an editorial collective of graphic designers, Josef Müller-Brockmann, Richard Paul Lohse, Carlo Vivarelli, and Hans Neuburg. The magazine exclusively featured "Swiss Style" designers and their works, accompanied by texts in German, French, and English, and was highly influential in promoting this approach internationally.
14. This work was presented in detail in the *New Graphic Design* magazine. See Neuburg, Hans, "From Beer Mat to Façade," *Neue Grafik / New Graphic Design / Graphisme Actuel*, No. 10, June 1961, pgs. 37–42.
15. In 1960, Nelly Rudin wrote that her preferred fields of work were "statistics, facades, packaging problems, and consistently designed advertising." See Rudin, Nelly, "Portfolio," in Vogt, Adolf Max, ed. (1960). *Schweizer Grafiker. Handbuch*. Zurich: Verlag Käser Presse, pg. 205.
16. Rudin, Nelly, "Package Design," *Neue Grafik / New Graphic Design / Graphisme Actuel*, No. 6, June 1960, pg. 46.
17. See ibid., pg. 35.
18. See ibid., pgs. 36, 41.
19. Hofmann, Armin, "Nelly Rudin" (republished article from 1988), in Grossmann, Elisabeth, ed. (2000). *Nelly Rudin. Edge Zones: Inside is Outside—Paintings and Objects*. Zurich: Offizin Verlag, pg. 12.
20. See Strauss, Dorothea, "Breathing and Glowing. On the Art of Nelly Rudin," in Strauss, Dorothea, ed. (2011). *Nelly Rudin—Open Space*. Heidelberg: Kehrer Verlag, pgs. 7–8.

2.6

Dorothea Hofmann: Patiently Persevering

Margo Halverson

Dorothea Hofmann's first letter to me, typewritten, arrived in an A6 envelope also addressed by typewriter, began: "It was a wonderful surprise to hear from you. It felt as if we had never stopped being in touch with each other. And it is a wonderful occasion to renew our communication. Elizabeth Resnick's idea to ask you to be the interviewer for the piece … is perfect."

I bought a new typewriter ribbon for my own non-electric machine but never felt confident enough to use it until my last interview letter to her, as Dorothea's white-out appeared only rarely. Her five letters arrived beautiful, thoughtful, and with considered photocopies with typewritten captions illustrating what she was telling me about. This attention to detail is how I remember Dorothea now, almost 30 years after our brief times together.

She taught drawing at the Maine Summer Institute of Graphic Design in Portland, Maine, of which I was director. She came for a week each in the summers of 1994, 1995,

Figure 2.6.1 Dorothea Hofmann, photographic portrait, 2002.
Photo: Melchior Imboden. Image courtesy of Melchior Imboden, Switzerland.

and 1997, with her son Matthias Hofmann (1970) accompanying her. Dorothea worked with us first in the studio[1] before we headed into the Maine coastal landscapes with drawing boards, good drawing paper, graphite, charcoal, kneaded erasers, sun hats, and lunch. She taught us how to look and translate—she inspired graphic designers in various stages of their professional careers to slow down and see.

Around picnic table evening dinners, Dorothea shared stories in response to questions that were way outside of drawing technique. She was a mentor, giving and supportive, sharing her path, and in doing so, she encouraged reflection on personal routes taken as she comfortably questioned next moves.

I first met her in 1990 with her husband, Armin Hofmann (1920–2020),[2] while I was attending the Yale School of Art Brissago (Switzerland) summer graphic design program, where she taught a drawing workshop. Her kindness, with a direct and supportive style, stayed with me and most definitely influenced my own long teaching career. When I invited her (by fax) to teach in the early 1990s in the Maine College of Art summer program, she said yes on three occasions. And I agree with her statement: "It felt as if we had never stopped being in touch with each other." Because that's the way she is: open, giving, and continually connected to what is in front of her.

Dorothea responded to my written questions methodically. She articulated specifics of her path that combined her professional work, her education, teaching, and drawing practice. She suggested the influence of raising a family on her focus on drawing, her relationship with Armin and her work to support his career, the importance of travel, and what she received back from teaching. "I realized that I was a mother, wife, and collaborator at once, and a big effort was needed to master this challenge." Dorothea is an influential force in her work, her teaching, her kindness, and her beautiful giving to all these things.

Dorothea Hofmann

Dorothea C.E. Schmid was born in Lucerne, Switzerland, in 1929. Her father, Gustav F.J. Schmid (1888–1950), was a specialist in internal diseases and a practitioner in the city of Lucerne. In 1939, he became the director of the Lucerne District Hospital, a position that was an enormous challenge, pressing him to work toward his limit. "He cared for his patients, and he cared for his family. As a father, he was demanding but fair."

Dorothea's mother, Helena J.R. Hess (1896–1977), grew up in a hotel with twelve siblings. Her father, Eugen Hess-Waser, was both Dorothea's grandfather and godfather.[3] Everyone in the family was engaged in managing this business and the other hotels her grandfather built. "My mother was a wonderful person and managed our family with the help of housekeepers as if we were a small hotel."

Dorothea's older sister Johanna M. Ch. Müller-Schmid (1928–2022) and her younger brother, Franz B.M. Markus Schmid (1931),[4] experienced a happy childhood. Dorothea writes: "The middle position was special. My sister was very lively and a little inquisitive. She always answered first when someone asked a question. I kept quiet. My brother drew

attention because he was a male and the family's eldest son. I, in the middle position, was left alone and kept quiet. On rare occasions, when someone took notice of me, the stereotypical sentence was said: … look at her, she looks just like her father!! But I did not want to look like my father! I was a girl and did not want to look like a man! This situation of my quietness only changed when I went to school and found my middle position to be of the same value as the others."

Margo Halverson
Dorothea Hofmann

What were your early influences?

I loved drawing in my early childhood. When I was in high school, I expressed my wish to attend an art school.[5] My father said: "You can go to any school and learn whatever you want, but first, I needed to meet his conditions: (a) to learn a profession and (b) to speak four languages." After high school, I did a three-year professional education at a commercial college and took German, French, and Italian. Because I needed English as well, I took the opportunity to work as a nanny for a family in Cambridge.[6]

When I returned home from Cambridge in 1948, I presented to my father: (a) the profession and (b) the four languages. I expressed my wish to attend an art school. He suggested that I write to the two art schools, Zurich and Basel, to get information. I did not consider staying in Lucerne. The examination to enter art education in Basel was one week earlier than in Zurich. My father said, "Go to Basel, take the examination, and see what happens." Which I did. And I got accepted.

In the spring of 1949, I began my art education in the Vorkurs.[7] To enter any specific direction—like interior design, textile design, graphic design, or any other profession—I had to take an exam. I decided to take the examination to enter the four-year program in graphic design. It was challenging. I saw Armin Hofmann for the first time during this examination. I remember what assignment we had to do in his day: A capital T in an advertisement for Tea combined with text. Out of about thirty examinees, only six students were accepted per year. And I was one of them, I was accepted.

In the early 1950s in Basel, the four-year professional class in graphic design (Graphik-Fachklasse) students, six per year, were taught together in one studio, a hard

Figure 2.6.2 Dorothea Hofmann, class project for a poster competition, *Swiss youth music community*, 1953 (*Schweizerische Jugendmusikgemeinde*, 1953). Image courtesy of Matthias Hofmann.

Figure 2.6.3 Dorothea Hofmann, *Beginning of Film Art* poster for the Trade Museum, Basel, 1963. Image courtesy of Matthias Hofmann.

task for the teacher. But for students, it was an interesting situation—the first-year students could see what the students in the upper years were doing, and vice versa. Armin Hofmann's way of teaching was not based on a particular entering class but rather on the design someone was working on.

The first assignment in his class was to design a Roman-Capital alphabet. The simplicity of round and straight forms, the serifs, and the elliptical and round movement, I discovered analogies in these basic elements from drawing to graphic design. Everything was based on very simple lines—vertical, horizontal, diagonal, and round, which served to create objects, figures, letters, and readable texts.

MH You and Armin were married in 1953 while you were still a student. What was your experience during that time?

DH As a student in this program for graphic design, everything seemed perfect. But it all became different. I was only six weeks into the class when my father passed suddenly of a heart attack.[8] My mother suggested that I continue my education in Lucerne instead of Basel. In my dilemma, I asked my teacher, Mr. Hofmann, for his advice. He suggested that I try to stay in Basel and offered that he could give me little lettering jobs to earn money to support myself. There was no love between us at that time. Besides the lettering jobs for Armin Hofmann, he also recommended me to architecture firms to do plan inscriptions.

After one year, our relationship was no longer limited to calligraphy jobs. When love came, we both realized we had to keep it secret. But unfortunately, in my third year, we were seen together. Armin decided to inform Mr. Berchtold von Grünigen, the director, to avoid any gossip. In response, von Grünigen made very clear conditions: (a) Armin Hofmann would lose his job as a teacher! Or (b) Miss Schmid would leave the school, or (c) get married. We were married on January 24, 1953, only two months after the von Grünigen conditions.[9]

MH What did you do after graduating?

DH In the first ten years after I completed my design education in Basel, I did graphic design work, besides work in collaboration with the architects. I was also busy administering work—especially from the fall of 1955 to the fall of 1956 when we were in Philadelphia. It was Armin's first teaching appointment in the USA, and my English knowledge was important.[10] After our return from the United States, I received many very interesting assignments and concentrated on these projects.

MH Did you and Armin ever collaborate on projects or teaching?

DH Armin and I did not work together.[11] I immediately began my project for the *SAFFA 1958* exhibition in Zurich. It was the pavilion "Women in Art Professions." In 1958, I did different projects for the architects Herman & Hans Peter Baur—originally starting with calligraphy on plans—on large projects like those for a church in Birsfelden: mosaic work on the floor and designs on the wall.[12]

Besides his teaching, Armin designed several exhibition posters: *Switzerland in Roman Time*, *Léger/Calder*, *Karl Geiser*, and others. His year in Philadelphia concluded with the offer of a Yale professorship and an invitation to present his teaching philosophy at the International Design Conference in Aspen.[13] This is how we worked: each of us knew what the other one did, and we respected each other.[14]

MH Can you describe what it was in the India experience that inspired drawing to become such an integral focus of your creative work?

DH The government of India established the National Institute of Design in Ahmedabad in 1961. Armin was invited in 1964 to build up the Visual Communication Department in the Educational Program. He taught graphic design, and I taught letterform design. On our free days, we visited historical architecture around Ahmedabad. In contrast to Armin, who documented the places we visited by taking photographs, I—who was never interested in photography—documented these sites by drawing them at the location. The vibrant Indian culture and architecture inspired me, and drawing became a shift for expressing myself and for memorizing.

I had viewed my education as a tool and wanted to see what I could do with it, and seeing how Armin's work was developing inspired me to do something of my own. This reason, and the six months spent in India in 1965, were the initial principal reasons for concentrating on my drawing. My first exhibition of drawings took place at the Felix Handschin Gallery in Basel in 1966. Included were many of my Indian drawings, together with the work of Meret Oppenheim and K.R.H. Sonderborg. I had a very positive review which encouraged me to continue to draw.

"But at some point, Dorothea's own talent and creativity powerfully demanded attention," writes friend and colleague Inge Druckrey (1940). "She must have realized that she had to stake out some ground for her own creative work, especially the drawings."

DH My drawing was for both art and commercial, and I worked the same way for both. I see the letterform as the strongest reduction in the balance of black and white, whereas drawing offers the widest field of gray variations from white to black. When we returned from India, I was thirty-six, and Armin and I had to decide about having children. Conrad Arnold was born in 1968, followed by Matthias Philipp in 1970. The birth of the two children made it more difficult to work for clients. But drawing I could do whenever I had a spare moment.

Drawing was not for solitude or meditation. It was rather ... don't give up ... surviving ... observing. "Her drawings don't look like they are from a very patient person," writes her friend and colleague Katharine Wolff. "They're very expressive, like a madness to get to the essence of the thing—in every positive way. Exactly energetic. And then no, it's not that, and you take it away, and then you put it in. It's a dynamic process. Maybe that's just a difference between her work and how she taught: patience in teaching and energy in her own process."

Figure 2.6.4 *Top:* Dorothea Hofmann, charcoal drawing of the Indian temple, Mandu, 1964. *Bottom:* Dorothea Hofmann, charcoal drawing of the Indian temple, Surkhej, 1964. Image courtesy of Matthias Hofmann.

DH In 1974 we started the Summer Program in Graphic Design in Brissago[15]—for the next twenty-four years! I realized that I was a mother, wife, and collaborator at once, and a big effort was needed to master this challenge, as it was also necessary for me to continue doing administrative work for Armin and myself. For the next lifespan, there was a combination of two occupations: 1967 to 1987, children and family,[16] and until 2000, part-time teaching drawing and letterform drawing.

In 2000, I started working on my book *Die Geburt eines Stils* (*The Birth of a Style*), which was published in 2016.[17] The book investigates the history and teaching philosophy of the Basel School of Design based on more than fifty years of living together with Armin Hofmann and being responsible for all his administrative work. This writing work—often considered unimportant—proved to be of great help as a documentation of the fifty years of Armin's teaching, which was carried into the world by his former students and thus became internationally known.

"Dorothea's book, *Birth of a Style*, is a very impressive achievement," Katharine Wolff writes. "Her research uncovered new information about art education in Switzerland long before the Bauhaus and included new information about an important period in the history of design to which she was an eye-witness. Most importantly, in this book, she sets the record straight about the faculty and the design program in Basel. Her book took fifteen years. Dorothea perseveres."

MH I love your phrase that "for the next lifespan, there was a combination of two occupations dominant: children/family, and teaching." Where did you find your creative support? You did so much for others, and this time was also fruitful in your administrative work for Armin, which later became your work for your book. Things build, don't they, in ways we can't predict? I'd like to hear about your focus and attitudes at this time.

DH In 1978—the children were eleven and eight years old—Inge Druckrey visited Basel to ask Armin if there was someone to replace her at Yale while she was on a sabbatical from her teaching. I spontaneously said: Inge, I would love to do this, but I have these children … Her reply … you must do it … look for someone to look after the children. This changed my life. I started to teach letterform design and drawing in 1978, and then almost every year (for several weeks) for twenty years at different universities in the USA and Mexico.[18] And from 1979 through 2002, I had about ten exhibitions of my drawings.

Inge Druckrey shared:

> Her large-scale drawings are beautiful. They remind me of fast, gestural writing. There is no question that Dorothe's drawings very much impressed Armin and caused him to bring more drawing sensitivity into his own work and teaching. The following story is an example of this: I had arranged an exhibit of Dorothe's drawings in the exhibition space of the Yale Art and Architecture building in New Haven. At the same time, Armin was teaching his yearly course for graphic design students at Yale. One day he asked me to accompany him to see Dorothe's exhibit. We quietly walked around and enjoyed the work, and then Armin suddenly said: "Here I feel good." (*Hier ist mir wohl.*) Without any question, Dorothe was a very important part of Armin's life and work.

DH I found my creative support in teaching in the work my students did at the end of my classes. And I found personal inspiration watching Armin's work develop, as well as my drawings being exhibited and in exhibitions together with Armin's posters. I do not feel that I gave more to others than what I received back, from my students, from Armin, and from my children.

Figure 2.6.5 *Left:* Dorothea Hofmann, *Stone III*, 1991. *Right:* Dorothea Hofmann, *Stone 6*, 1991. Images courtesy of Matthias Hofmann.

Following a brief illness, Dorothea passed away on July 26, 2023, several weeks after I had received her few short edits, typewritten, by mail.

© **Margo Halverson**

NOTES

1. Dorothea's sessions start out with demonstrations of the tools: for instance, vine charcoal shaved to a fine point for precise use, the proper paper, the right board. Dorothea would go from student to student and sit to evaluate and discuss what they were doing, occasionally making smaller notations on their page to show how to achieve what they were trying to do. Email interview with Philip Burton, April 13, 2023.

2. Armin Hofmann was a Swiss graphic designer and educator. He began his career in 1947 as a teacher at the Allgemeine Gewerbeschule Basel School of Art and Crafts at the age of twenty-six. Hofmann followed Emil Ruder as head of the graphic design department at the Schule für Gestaltung Basel (Basel School of Design) and was instrumental in developing the graphic design style known as the Swiss Style. His teaching methods were unorthodox

and broad-based, setting new standards that became widely known in design education institutions worldwide. In 1965 he wrote the *Graphic Design Manual*, a popular and influential textbook in the field.

3. Dorothea explains why her third name is Eugenia. "My grandfather's first wife died after she had given birth to six children. He married again and had another six children with my grandmother, Christine Waser."

4. A second younger brother, Andreas Schmid, died shortly after he was born in 1933.

5. "My first focused encounter with art was through my British great grandmother, who's paintings and drawings were hanging on the walls of our house. My father, her grandson, was a physician, not an artist, but he was interested in art history."

6. "In 1947, the hospital, where my father worked, invited a physician couple from Groningen, Holland, for recuperation. My parents became friends with the Huizinga family. Their daughter, Toa, had just finished working at the Richards family home in Cambridge, and they suggested that I replace Toa. Paul and Anne Richards were both teachers at the university with three children. I worked as household help and as a nanny. The Richards realized that a household occupation was not my preference and suggested that I take evening classes at the art school, which I did."

7. The Vorkurs is the foundation program organized to teach the basics of design. "In the Vorkurs from 1949 to 1950, I had eleven different teachers from various backgrounds: artists, architects, sculptors."

8. "My mother, sister, brother and I received a three-month payment from his salary, but we also had to leave our house within three months, and with no further income. My sister and my brother were also in their professional education."

9. "I was not allowed to attend any lessons from the moment that von Grünigen was informed about my relationship with Armin—until I was married."

10. "When we arrived in Philadelphia, the dean Emanual Benson realized that when Armin arrived for his one-year professorship, he hardly spoke any English, and asked him, how he would teach. Armin replied: 'No problem, Dorothe just comes with me.' It worked perfectly."

11. "When I met Armin and Dorothe, I did not get the impression that they worked as a team, only in the sense of artist and support staff. She accepted her role as Armin's helper, and she filled that role with such energy and responsibility that many considered Dorothe as the motor behind Armin's career. It was she who sent posters to exhibitions or responded to requests from publications, and it was she who answered all mail sent to Armin." Email interview with Inge Druckrey, March 23, 2023. "Dorothea did all of the administration work so Armin could do his thing—she also saw that as her work." Zoom conversation with Katharine Wolff, April 17, 2023.

12. "From 1954–70, I collaborated with Hermann and Hans Peter Baur, Architects, Basel on the following projects: Stain glass windows, crypt of church Birsfelden, Switzerland; Relief, Co-op building, Basel; Tapestry, reliefs, church Doettingen, Switzerland; Color designs College of Disentis, Switzerland, Private house, Biel-Benken, Switzerland, Church Brislach, Switzerland."

13. "Walter Herdeg, editor and publisher of *Graphis* magazine, invited Armin to do an article on this work. 'A Contribution to the Education of the Commercial Artist' published in *Graphis* 80 was a great success, inspiring students from all over the world to come and study in Basel."

14. "After my diploma I continued with jobs for architects. Armin's main work in his studio was poster design for different clients and teaching. We never worked together on the same project. But I realized that Armin did not have the time nor the desire to do any of the required correspondence work. I started to do all of this important work in

15. The majority were American students, but we also had students from South America, China, Germany, and Scandinavia.

16. "The parenting turned out to be clearly Dorothe's responsibility. Because the apartment in Basel was too small to raise a child, Dorothe spent a large part of the year in their summer home in Brissago. It was probably here that she began to work more seriously on her drawings. But the beautiful large-scale drawings were done at the house of her parents in Luzern, which she had purchased from her sister and brother. From his time, Dorothe told me a little story. The bedroom of one of the children was always a total mess. One day Dorothe entered the room and looked with exasperation at the disaster. Clothes were strewn around the room, and the bed was a rumpled heap of pillows and sheets, and then Dorothe began to look at it as an artist and began to enjoy the beauty of the play of light and shadows on the crumpled sheets." Email interview with Inge Druckrey, March 23, 2023.

17. "My motivation to write *The Birth of a Style* is not so difficult. I was often asked when teaching in the USA, where I received my knowledge, or better: What was the background of my teachers in Basel, where I learned how to do letterform design, drawing, composition, and so on? Everybody expected that it was the Bauhaus. Neither Armin nor my drawing teachers Walter Bodmer, Theo Eble, Gustav Stuttler, and others, came from the Bauhaus. That's why I started to investigate the history of the Basel School." *Editors note*: *The Birth of a Style* was originally written in German when it was published in 2016. Later, the book text was translated into English by Katharine Wolff and published in 2024 by Triest Verlag.

18. "Dorothea was a very good teacher. During my time as a student in Basel, she would off and on teach Armin's class. During my time as a faculty member at Yale, Dorothea taught a drawing class for graduate design students over a long weekend in Norfolk, Connecticut. Dorothea never critiqued, only encouraged. The high point of the weekend was a final review. As she would have done for a show of her own, the selected drawings were carefully mounted. In her view, these drawings represent important stages in the learning process of students and need to be taken seriously." Email interview with Inge Druckrey, March 23, 2023.

2.7

Karmele Leizaola: The First Woman Graphic Designer in Venezuela

Faride Mereb

Karmele Leizaola (1929–2021) is considered the first Venezuelan woman graphic designer. She pioneered the design of magazines, newspapers, and infographics that emphasized photography, composition, and typography, setting the standard for a new phase of editorial design that influenced future generations of editorial designers.

Uncovering Karmele's accomplishments resulted from many years of searching dozens of boxes of neglected and uncataloged archives in Venezuela's National Library. As each year passed, the library's conditions worsened: the book-shelved rooms were without lightbulbs, there was no running water in the bathrooms, the elevator was always out of service, and the air conditioning didn't work in 90° weather. Many newspapers[1] were designed by Karmele Leizaola,[2] and yet there was little or no documentation of her work.

Figure 2.7.1 Karmele Leizaola photographed at Tipografía Vargas, circa 1950. Image courtesy of Faride Mereb.

Reconstructing a coherent timeline of her life was challenging as most archival processing relied on testimonial sources[3] and printed publications, which were generally uncredited. In Venezuela, designers are only sometimes credited for their work, even less so when they are female. But I discovered that processing archival material is an act of translation, an honor, and an obligation.

Karmele Leizaola was born on May 11, 1929, in San Sebastián, Gipuzkoa, Bay of Biscay, in the Basque country, Spain. She was the daughter of Ricardo Leizaola and María Azpiazu. She had eight siblings: Iñaki (who died of meningitis in San Sebastián), Xavier, Maite, Itziar, Joseba, Jon, Paul, and Ana Belén. In 1936, Karmele's parents fled their birth country due to the Spanish Civil War. Both were members of the Republican faction against Francisco Franco, and the nationalistic party had led a coup against the Spanish Republic. First, her father left Spain, leaving behind his wife and eight children, promising to meet them again. Then María fled to France with her children; they remained in the Pyrénées-Atlantiques region until 1944. Karmele completed her primary education there, learning to speak French fluently.

After a short stay in the United States, Ricardo Leizaola moved to Venezuela in 1940.[4] When he arrived in Caracas, he joined the newspaper *La Esfera* as a photojournalist, inspired by the thought of working with his Leica camera. There, he covered boxing events for the sports section. But when the Spanish Embassy in Caracas contacted his managers, his opposition to Franco's regime was discovered, and he was fired.

On July 20, 1945, Spain granted passports to the Leizaola family, and on that same day, they boarded a ship in the port of Barcelona bound for Venezuela. On August 6, the ship's crew sighted land. Once they landed, they received news of the atomic bombs dropped on Japan, ending the Second World War. Four days later, on August 10, the Leizaola family disembarked in Puerto Cabello, Carabobo. Soon after, the family moved to Caracas and settled temporarily in the Hotel Bidasoa, in the heart of the capital. Not long after, Karmele continued her studies at the Colegio San José de Tarbes with her two older sisters.

Karmele's father, formerly a printer in Spain, joined Tipografía Vargas,[5] a press owned by Juan de Guruceaga (1897–1974), in 1947. As the manager of Tipografía Vargas, Ricardo Leizaola was able to replace their obsolete printing system with a new one: rotogravure,[6] which he imported from the USA. Although the equipment wasn't new, this substantial technological improvement would influence Venezuelan design.[7] Karmele attended her father's workshops in downtown Caracas, between Santa Capilla and Principal. Getting to know the equipment and diving into graphic arts and journalism sparked lifelong passions for her.

Karmele's design work began in magazines like *Élite*. She first appeared in the credits in 1954 as a layout designer.[8] In 1957, she began working as a layout artist at *Momento* magazine, and she continued to do so until 1960. In her work at that time, we see

Figure 2.7.2 Karmele Leizaola, spread for *Élite* magazine, circa mid-1950s. Photo: Carlos Alfredo Marín. From the National Library of Venezuela archive. Image courtesy of Faride Mereb.

silhouetted images, extensive use of grids for photographic placement, white space as a compositional element, and full-bleed images that cross the inner margin to produce expansive compositions.

Political conflict and social uprisings always surrounded her, building her character and later influencing her work as a designer and activist through design. She was the first woman designer in Venezuela to do this style of work amid the hybridity of European and Latin American influence. She translated Spanish and French orally, on-site, helping other immigrants with technical specs while working at the Tipografía Vargas. In 1958, she designed *AD, Órgano Central del Partido Acción Democrática*, the main journal of the Democratic Action Party—participating in the final years of resistance against the dictatorship of Marcos Pérez Jiménez[9]—for the Acción Democrática party.[10] Many of the covers feature aerial photos of crowds and political slogans, which would influence her future work.

Karmele met architect Luis las Heras in 1959[11] at the Basque Center in Caracas. A few months later, they were married. By December 1960, their son Txomin was born, followed by Mikel in January 1962, Eneko in April 1963, and Estibaliz in August 1964.[12] During the period of her multiple pregnancies, Karmele never stopped working.

In 1966, a credit for Karmele appeared for the first time in *Bohemia* magazine, a weekly publication owned by businessman Armando de Armas founded in 1962, and in 1967,

Figure 2.7.3 Karmele Leizaola, cover for *A.D.* (*Acción Democrática*), Julio 26, 1958, No. 12. Photo: Carlos Alfredo Marín. From the National Library of Venezuela archive. Image courtesy of Faride Mereb.

Karmele was credited as the layout designer for the first issue of *Imagen*, a magazine sponsored by the National Institute of Culture and Fine Arts. She was responsible for designing the logotype and the layout for the first nine consecutive issues. Karmele sat on the editorial committee with editors and poets Esdras Parras (1924–2004), Guillermo Sucre (1933–2021), and other personalities of the country's cultural sphere. This magazine's aesthetic included illustrated elements, photographs, silhouettes, and flat colors in geometric elements, such as lines in the gutters, and mainly featured literature and interviews with artists.

In 1968, Karmele returned to San Sebastián, the Basque country,[13] for two years. Amid rising political tensions and for a brief period, she was employed at Gráficas Valverde. In this small printing company, she worked on commercial projects that did not align with

Figure 2.7.4 Karmele Leizaola, double-page spread for *Imagen* magazine, circa 1967. Photo by Gabriela Navarro. Karmele Leizaola personal archive. Image courtesy of Faride Mereb.

her professional interests. By 1970, she returned to Caracas for the second time with all her children and divorced Luis las Heras. During this year, Karmele worked with Sofía Ímber, a prominent journalist and director of the Caracas Museum of Contemporary Art, on *Variedades* Magazine, a publication sponsored by the Bloque De Armas. After the divorce, her children were already in their teens. She continued her arduous work schedule but became more devoted to her family, hosting dinners at home and dining out on Fridays after work. Another noticeable change in her attitude was when her grandchildren were born. Karmele poured herself into homemaking and cooking, wanting to do more for the family.[14]

Later in her career, she adapted her experimental aesthetic to the more demanding conditions of newspaper work. Karmele was the first woman to join the editorial department at *El Nacional*, which included editing and design of a publication in Venezuela, a

field dominated by men. She was always immersed in work; newspaper hours included late nights and weekends most of the time. She didn't have much social life but always prioritized family; she often resorted to phone calls to keep in touch with everyone.[15] She worked on several weekly journals and supplements: *Cuerpo E*, *Cuerpo C*, *Economía*, *Mujer*, and *Feriado*, at different points in her career between 1979 and 1992. Newspapers are designed around content, and that content can change at a moment's notice. It wasn't easy to make visually compelling work on such a tight schedule, but the news didn't stop, so she handcrafted complex, high-quality compositions despite the fast pace of her work.

Karmele's layouts often included silhouetted portraits and plenty of white space for titles to breathe. Many of these passed over headers and text columns, thus linking one news item visually to another. Many images covered four of six or seven columns, promoting photographs as an essential element for the reader, not a secondary one. Blank spaces were often seen as the main element of the page. This was a turning point in the journal's graphic discourse. One notable page people recalled was a cover of *El Nacional's Cuerpo C* on Marcel Marceau's (1923–2007) visit to Caracas in the 1980s. She silhouetted a photo sequence, creating a sense of space and movement. White horizontal lines anchored the figures, and right- or left-aligned text in narrow columns in small point sizes generated tension around the different body positions. The rhythm was very evocative of the photographic work of Bárbara Brändli (1932–2011) in *Duraciones visuales* (*Visual Durations*).[16]

Karmele's father's photography had an immense influence on her. The same movement and angles from his sports section photographs for *Diario La Esfera* found their way into the setting, pacing, and composition within her grids. At the beginning of the twentieth century, photomontage was peaking as a technique with postwar advertising graphics, avant-garde art, and the legacy left of the Bauhaus before the Nazi occupation. Hannah Höch (1889–1978) and Lucia Moholy's (1894–1989) work is worth mentioning in this context. Karmele expanded the boundaries of traditional photography, creating images that incorporated more than a single shot: hands moved the reader from one news item to another, and large portraits overlapped with full-body silhouettes. She silhouetted photos carefully and produced intricate type lockups for titles. Her compositions were defined by white space and a meaningful sense of layout, which was always derived from photography; she was one with the printed page.

From 1986 to 1999, Karmele was credited in *Venezuela* magazine, published by the Ministry of Foreign Affairs. This magazine was created by her friend Simón Alberto Consalvi (1927–2013) and distributed in embassies worldwide to promote the best of Venezuelan culture. She worked with designers such as Aitor Azúa, Estibaliz Las Heras (her daughter), and Eric Mendéz. Also, in 1992, Karmele joined the supplement *Domingo Hoy* as an art director and worked on this publication until 1997, according to family and friends.

Karmele Leizaola was possibly the only female designer in Venezuela working in the 1940s and 1950s[17] whose work is documented. When Karmele began in the trade, the

Figure 2.7.5 Karmele Leizaola, spread for *Venezuela* magazine, circa 1990s. Photo: Carlos Alfredo Marín. From the National Library of Venezuela archive. Image courtesy of Faride Mereb.

term "graphic design" wasn't used, and women were only just granted the right to vote in Venezuela.[18] Some scholars maintain there is a big difference between a "layout maker" and a designer. Still, we must ask, "who is formulating these distinctions, and what purposes such formulations may serve."[19] After all, when not talking about women's accomplishments, scholars are often less exact, referring to printers as the first graphic designers[20] or to pictograms as the starting point of the alphabet. Nearly a century after Karmele's birth, women are still not credited or fairly compensated for their work and the opportunity to develop professionally. Over 60% of designers are currently women, although few occupy leadership roles. The wage gap widens not only with gender but also with language, race, and ethnicity.[21]

In the last stages of her career, around 2003, she worked as a consultant for *El Nacional* and *VenAmCham Business* magazine. As the years passed, Leizaola developed the early stages of Alzheimer's disease. She moved to Buenos Aires to live with her daughter Estibaliz in 2014. Two years later, she moved to Madrid to live with her son Eneko. She loved Venezuela so profoundly that even in her last years in Madrid, while her memory failed and

she couldn't recognize the people who visited, she would ask when she could return to Caracas. In 2021, Karmele, age ninety-two, died due to Covid-19 two days after being discharged from the hospital. She had been a lifelong smoker.

© **Faride Mereb**

NOTES

1. For example, *El Nacional*, a newspaper founded in 1943, was one of the most important publications in the country. In 2018 it ceased distribution. Economic measures enacted by Nicolas Maduro's regime made it impossible to buy paper or other printing supplies. When the newspaper launched a web portal, the government blocked their IP address. The editor of the Art and Culture section, journalist and researcher Nelson Rivera, was openly against the government and left the country. As a form of resistance, the newspaper was circulated as a PDF sent by email to a select group of people, who were then in charge of forwarding it to everyone else, and a website accessed by a different VPN from inside the country. Eventually, the offices of the paper were seized by the military.

2. I first encountered her work online due to a short video on Vimeo. I remember seeing a woman with a cigarette talking about typography and how the only way to design was to recognize and learn from our mistakes. I was immediately intrigued, but couldn't find any more information online. The video was posted a decade ago and published by Seminario de Diseño de la información, concept by Carmen Riera, 2011, an initiative of Cadena Capriles (that publishes and edits the newspapers: *Últimas Noticias*, *El Mundo*, *Líder en Deportes*, and *Urbe*), in Caracas, Venezuela. https://vimeo.com/user4169361. In 2019, Venezuela endured the most prolonged blackout in its history. Since the blackout, a lot of information has gone missing. For example, years of records from protests, videos, journalist research, and over two decades of photo documentation were lost from Cadena Capriles. This archive also housed Karmele's work and her short documentary's original footage and photos.

3. Carmen Riera, Elina Pérez Urbaneja, her colleagues, Mikel Las Heras, Estibaliz Las Heras, her children, and Jone Leizaola, her niece.

4. In 1938, around 80,000 Basque exiles in France awaited authorization to migrate to Venezuela, and most of them were members of the Republican faction. As a result of the war, Venezuela began to receive a significant influx of Basque and Spanish immigrants.

5. Tipografía Vargas would become a haven for young Basque immigrants entering the job market and a remarkable school for developing and modernizing Venezuelan graphic arts.

6. Rotogravure is a printing system or process using a rotary press with a cylinder etched with many small recesses, typically running at high speed and used for long print runs of magazines and stamps. Rotogravure is notable for achieving dark, robust blacks.

7. With these presses, they printed the famous magazine *CAL* (*Crítera Arte y Literatura*), designed by Nedo M.F. (1926–2001) and published 1962–67.

8. Her credit appeared alongside Plinio Apuleyo Mendoza, a Colombian writer, politician, and diplomat. The magazine sold 50,616 copies weekly, considered an unprecedented figure for print media in

Venezuela. Karmele began working at *Élite* in September 1950 but was not included in the credits.

9. General Marcos Pérez Jiménez was appointed constitutional president of Venezuela in 1957. These years brought economic development and modernized infrastructure, but many opposition groups lived in hiding or exile, and censorship of the press by the dictatorship's police intensified.

10. In 1959 Rómulo Betancourt (of the Democratic Action Party) took office, restoring faith in the country's democratic institutions. He confronted military uprisings linked to Pérez Jiménez and leftist guerrilla movements throughout his term.

11. He later became the coordinator of Amnesty International in Venezuela. https://escritorasunidas.blogspot.com/2017/04/amnistia-internacional-venezuela.html?m=1.

12. Txomin and Mikel are journalists, Eneko is a famous cartoonist, and Estibaliz is a renowned graphic designer for the Argentinian newspaper *El Clarín*.

13. On July 29, 1967, an earthquake measuring 6.7 on the Richter scale shook Caracas and the central coast resulting in 236 deaths. The Leizaola family decided to return to their hometown of San Sebastián, Spain.

14. Her niece Jone remembered visiting Karmele's home in Chacaíto, where she had the most beautiful home decor, gift taste, and books. She recalled one time when she received a chocolate cockroach as a birthday present, a treasured story among the family.

15. Karmele was known for going to bed really late and also waking up late. She drank cup after cup of coffee and smoked a cigarette whenever possible. She had people help her with household duties and cooking throughout the years, and these women became part of the family. (Paraphrased comments from her son Mikel.)

16. "Bárbara Brändli made the images for Visual Durations following the lines of the Bauhausian tradition of representation and also evoking the movements of her early classical ballet studies in Geneva and Paris, where she lived before settling in Venezuela, and before deciding to devote herself to photography. Summoning what she has done and seen and inspired by the choreographies and thoughts of Sonia Sanoja, the dancers' bodies, and the balanced distribution of John Lange's design, the book becomes a waltz of characters. The dancers serve as text, image, letter, and idea, and the work is glanced at and leafed through at a rhythm that turns it into continuous writing, a score, and a dance." From Angela Bonadies, *Notes on the Photobook Visual Durations*, February 19, 2019. https://elarchivo.org/notas-sobre-el-libro-duraciones-visuales/.

17. Soledad Mendoza, born in Colombia, has also been brought to my attention while working on this research. Other examples of women designers in fashion and interior design from the beginning of the century are Isabel Castillo (1931) and Carmen Elena de las Casas (1900–1976). https://simbold.com/isabel-castillo-muebles-azpurua/, https://simbold.com/carmen-elena-de-las-casas-diseno-interior-art-deco/.

18. There is an anecdote about her being the only woman in the office and Gabriel García Márquez commenting on her appearance and her legs to the point it became a nickname. (An anecdote that most people find endearing but, in reality, is utterly offensive.)

19. Linda Nochlin about men questioning women, "*Why have there been no great women artists?*" From Nochlin, Linda (1971). "Why Are There No Great Women Artists?" in Vivian Gornick and Barbara Moran (eds.), *Woman in Sexist Society: Studies in Power and Powerlessness*. New York: Basic Books.

20. Referencing David Jury's *Graphic Design before Graphic Designers: The Printer as Designer and Craftsman: 1700–1914*. London: Thames & Hudson, 2012.

21. This is according to AIGA's 2019 census.

2.8

Gülümser Aral Üretmen: A Pioneering Turkish Female Graphic Designer

Ömer Durmaz and Dr. Murat Ertürk

In the design profession, the roots of women's invisibility can be traced back to the past. Women have also been ignored in historiography—this neglect is not specific to graphic design in developing countries like Turkey. The book *Where Are the Women Architects?*, published in 2016, argues that this undervaluation also applies to architecture and the Western world. The book's author, Despina Stratigakos (1963), emphasizes existing eclecticism in historiography, and she claims that history is not a simple meritocracy; it is a narrative of the past written by people with private agendas and revised according to their perspectives—but not written in its entirety.[1]

Women graphic designers have been present since the emergence of contemporary graphic design in the 1970s. They gained attention in the 1980s, played a role in design platforms, and achieved international success in the 1990s. By the 2000s, they were influential in the industry and universities. Today, the number of female students in graphic

Figure 2.8.1 Gülümser Aral Üretmen, photographic portrait, circa 1950s.
Courtesy of the Ömer Durmaz Archive.

design departments is usually higher, and the distribution of academic staff also follows a similar pattern. Even though the developments are positive, it cannot be said that women have been recognized for their achievements in recent history.

When examining studies related to the history of graphic design from the Ottoman Empire or the Republic of Turkey—which includes a wide historical interval—we find that women were rarely documented until the 1970s, raising some questions regarding scientific skepticism. Why are pioneering women artists working in the fine arts acknowledged before 1970 but not women designers? Were there no women designers, illustrators, or commercial artists pre-1970? Is their absence a theoretical framework issue due to period-related differences in the definition of the profession and changes in perspective? If they were ignored, would it be due to a lack of quantity and qualification, or were they considered incompetent? If there were competent women designers and they were not mentioned in the historical canon, to what extent can we talk about the validity of the accepted historiography? Could their omission be seen as marginalization or a research problem due to a lack of information/documentation? Has previous research been able to answer these questions?

Comprehensive research and much-needed discussion can foster a more objective, democratic, and feminist perspective on the history of design—changing the existing history with its findings. Gülümser Aral Üretmen was one of the few female graphic designers who succeeded in the male-dominated design world of the 1950s. Examining her career is a step toward comprehending women's place in the history of graphic design.

The Importance of Prehistorical Research

Despite the short history of Turkish graphic design—with its inadequate experience and accumulation—it has developed into a comprehensive, established, and institutionalized discipline. However, once significant publications are examined, it is clear that although women designers have been present for the last fifty years, the subject of women has only recently been mentioned or recognized as existing. Considering the recent deepening of related research in Turkey, there are mitigating circumstances for this deficiency.

After the term was coined and graphic design emerged as a discipline in the 1920s, it took many years for those trained as designers to be heard, as the profession was primarily codified after the Second World War. The printers were the first practitioners to arrange text and images—the pioneering graphic designers in historical research were the press and publishing industry laborers.[2] This perspective is undoubtedly valid for the Turkish geography of the Ottoman Empire too. However, as the related research has only recently begun, there are many unknowns regarding the transition from craftsmen such as printers, compositors, and printing plate makers to artists such as painters, illustrators, and commercial artists, and then from these artists to designers. Although some progress has been made

in considering graphic design history as a fully fledged academic discipline, the effort is still a work in progress.[3] Among the essential shortcomings of this incomplete history is the invisibility of the pioneering women, which suggests the need for a multifaceted, unbiased, and feminist perspective in historiography. If historical research is supported and encouraged, the history of women's presence in the design field could be dated back to the early 1900s. This effort would not only honor the mission and vision of the women in the past, it would also deepen the roots of the discipline of graphic design in the country, expand its impact on society, and bring a holistic historiography focused on the continuity of the profession.

The Life and Professional Career of Gülümser Aral Üretmen

Gülümser Aral Üretmen was born in Bursa, Turkey, on August 23, 1929, as the second daughter of Lütfi Aral (?–1972), a finance inspector, and Melek Aral (1900–1981). She spent her childhood in Bursa[4] with her older sister Ülker Algan (1922–2004). Due to Lütfi Aral's job, the family moved to Istanbul but continued visiting Bursa whenever they could, especially during the holidays. Gülümser's talent for drawing was discovered at an early age. While still a high school student, she worked as a commercial artist at Bâb-ı Âli,[5] the center of the country's printing and publishing world. At that time, artists worked at the Bâb-ı Âli to meet the visual needs of newspapers, magazines, publishing houses, and printing houses. Lettering, drawing, and illustration were the responsibility of these talented people. These artists, whom we can call the pioneers of graphic design, shaped our visual memory and became the hidden actors in the transition from craftsmanship to design.[6] They formed an essential professional group by carving out a different place for themselves in a short time among the intertwined institutions and structures. Gülümser Aral Üretmen, one of these artists, made fashion illustrations for the magazine *Ev-İş* published by Türkiye Publishing House between 1944 and 1953. She worked with Kemalettin Tuğcu (1902–1996), the most widely read children's literature writer then, in the Türkiye Publishing House. Gülümser described that period in the following words:

> With the tendency of having done a lot of fashion drawings in high school, I drew clothes models for Bâb-ı Âli and *Ev-İş* magazines on the advice of a relative. In 1944, I started drawing covers, pillows, and children's and women's clothes in the fashion and home industry for a fee. It was the years of World War II; fashion magazines were not enough. My only help was the cinema! I drew the clothes in the films I saw and then dressed the paper dolls I made in clothes I designed myself. This job took up a lot of my time, in addition to my schoolwork. These drawings were also bought and sewn by girls' art schools. I still have my fashion drawings.[7]

Gülümser wanted to pursue an education as a commercial painter, which she had started in high school. She took the exams at the Poster Workshop of the State Academy of Fine Arts (now known as the Department of Graphic Design, Faculty of Fine Arts, Mimar Sinan Fine Arts University). In 1949, she enrolled in the academy as a student. She also continued to work for Bâb-ı Âli during her college years:

> After graduating from Istanbul Girls High School in 1949, I took the exams at the State Academy of Fine Arts and chose the Graphic Department [It was called the Poster Workshop at that time] because of its wide range of fields of study. In 1948, the academy suffered a significant fire and unfortunately lost its library and most of its necessary educational materials. One year later, after this unfortunate period, I received preparatory education from Sabri Berkel, Emin Barın, and Zeki Faik İzer. I continued my further studies at Zeki Faik İzer's Poster Workshop. We continued to work with our friends on our own 70×100 cm drawing tables and easels in front of the stove that heated our workshop. After three years of education, I felt this was insufficient time for my development. Pursuing graduate education in Paris through the Suna Kan Fund was offered to my father with the referral of Mr. Zeki Faik. However, my parents were reluctant to send me to Paris as a young woman because I did not speak any foreign languages then.[8]

Melike Abasıyanık (1931–2021), Semih Balcıoğlu (1928–2006), Ayhan Işık (1929–1979), Mengü Ertel (1931–2000), Kuzgun Acar (1928–1976), Ayhan Akalp (1929), and other names we know well today were her classmates at the academy. These young people struggled against shortcomings during the Second World War years:

> There were some friends who were accepted into the academy but couldn't attend classes all the time. They lived by drawing for cinemas or magazines in Bâb-ı Âli. For an academic career, it was a matter of devoting the necessary time first and then making a serious effort by constantly developing good drawing and composition skills. Our professors were benevolent but could be very disciplined and strict when necessary. This attitude played a significant role in making us realize how serious our work was. Therefore, the time we spent on our studies was of great importance. Our teacher, Zeki Faik İzer, would give us the topics, give us extra time, evaluate the sketches individually, and then discuss and approve the successful/unsuccessful aspects of the works together. He concentrated more on composition and ideas. Poster and graphic design techniques were left to our own talent. Naturally, we had none of today's technical facilities and conveniences. *Gebrauchsgraphik*, the German graphic design magazine, was our only window to the world. When I was given a poster subject, I would concentrate on the central theme and complete my work with color and composition experiments and determinations. I took great care to ensure that my poster was, first and foremost,

my own design. İhap Hulusi (Görey), an essential name in poster design, was known then, but his works were not much of a subject at the academy.⁹

Gülümser graduated from the academy on June 11, 1951, and her professors admired her dedication to her studies. After graduation, she worked with Albert Gabriel (1883–1972), Celal Esat Arseven (1875–1971), Zeki Faik İzer (1905–1988), Halil Dikmen (1906–1964), and Mualla Eyüboğlu (1919–2009) until 1952: "With the continued support and invitation of Zeki Faik İzer, I prepared Ottoman Janissary and Mehter costumes from Topkapı Palace miniatures for the Institute of Islamic Art and Costume History. I gave them to the Military Museum to celebrate the liberation of Istanbul."¹⁰

Due to her nearly ten years of experience, academic education, and professional achievement, she was hired as an artist at Denizcilik (Maritime) Bank in 1953. She became the institution's first permanent graphic designer. In the bank's archives, the following information is written about her position: "Starting Date: 12.1.1953, Salary: 550 Turkish Liras. She was appointed externally as an artist at Public Relations Affairs." At that time, instead of being called a graphic designer, one could be called an artist,

Figure 2.8.2 Gülümser Aral Üretmen, poster designs for Denizyolları, circa 1950s. Courtesy of the Ömer Durmaz Archive.

an advertising artist, a printing house artist, or a poster artist. Gülümser defined herself as a graphic artist. From 1954, she worked as an advertising propaganda artist in the Publications Office of the bank's Public Relations Department. When she left the bank in 1960, her ending salary was 925 Turkish Liras. Gülümser Aral Üretmen was the only graphic designer in the bank. The team included an interior architect, a photographer, and Mazhar Nazım Resmor (1901–1977), a famous artist and designer of the period.

Looking at the graphic products produced before 1953 by Denizyolları (Maritime Lines)—affiliated with Denizcilik Bank—we see different signatures and illustration styles. The advertising and promotional activities of the institution are dominated by an understanding that is far from the visual integrity of the company. With Gülümser's style, it can be observed that the institution achieved a consistent visual language in its advertising, promotion, and communication activities. It can also be said that with her maritime illustrations, she contributed to shaping the perception of marine transport. She describes this period: "It was at the Denizcilik Bank that I developed in my real graphic and illustration works, in other words, my mastery period. I designed posters and brochures on the themes given by Abidin Daver and General Manager Ulvi Yenal to revitalize tourism. The themes given by the bank were very diverse and spread over a wide area."[11]

Ayhan Akalp, one of Gülümser's Poster Workshop classmates, who became famous for the spike logo he designed for Ziraat Bank, describes those days:

> As for Ms. Gülümser, she was a well-behaved friend, and we grew up together. After graduation, she applied for a job at the Denizcilik Bank. At the same time, a printing house recommended me to the bank, and by coincidence, we met there. Abidin Daver, a columnist at the time, was working as an honorary officer at the bank with a passion for maritime affairs. He preferred Gülümser over us, and Gülümser started working at the bank.[12]

Abidin Daver (1886–1954), a journalist and politician—known as a "civil admiral" due to his maritime contributions—wanted to innovate the advertising and promotion activities of the Denizyolları. In his column in *Cumhuriyet* newspaper, he discussed the advertisement and mentioned Gülümser, whom he had just hired. He wrote that after İhap Hulusi (1898–1986) proved himself as the first poster artist in the country and brought great innovation to this art, a poster workshop was opened at the Academy of Fine Arts, where his late friend Kenan Temizan (1895–1953) was a professor. He trained successful young male and female poster artists, one of whom was Mrs. Gülümser, who designed the posters for Garanti Bank.[13]

Gülümser's most productive years were in the 1950s and 1960s before her children were born. In addition to Denizcilik Bank and Denizyolları, Gülümser Aral Üretmen also designed posters, calendars, brochures, postage stamps, and logos for companies such as Garanti Bank, *Dünya* Newspaper, Turkish Airlines, Şişecam, Paşabahçe, Sugar Factory, Ministry of Tourism, Şehir Hatları, Yalova Thermal, Ports, and Port Restaurant.

Figure 2.8.3 Gülümser Aral Üretmen, 1953–54 price list cover for Denizyolları. Courtesy of the Ömer Durmaz Archive.

In 1960, Gülümser left her job at Denizcilik Bank to move abroad due to her husband's job. In Greece, the first foreign country she lived in, Gülümser continued to work as a freelancer, mainly for Turkish Airlines. However, due to her husband's assignments abroad, his busy work schedule, and her children's education, Gülümser could not continue in her profession, primarily focusing on her family during her life abroad. Gülümser described those days:

> I met my husband, Faruk Üretmen (1925–2013), whom I married on December 25, 1953, at the Denizcilik Bank. When Turkish Airlines was founded in 1957, he was appointed as the first foreign officer for Turkish Airlines in Athens upon the suggestion of Ulvi Yenal, the General Manager of the Denizcilik Bank. Our life abroad continued with my two daughters in countries such as Greece, Germany, Lebanon, and England. In the process, I think I completed my graduate educa-

tion, which I could not do in Paris when I had just graduated from the academy, by visiting the museums and exhibitions of the cities we were in, observing their cultural richness, and educating my daughters in art and design. Arzu (October 27, 1959), my elder daughter, worked as a fashion designer in the private sector for thirty years after graduating from Barnet College in London. My younger daughter Eren (February 14, 1968) graduated from the Department of Graphic Design, Faculty of Fine Arts, Marmara University, and completed her graduate education in illustration in London. In recent years, she has been working mainly on mask design. Although I took a break from my profession occasionally due to some health problems I experienced, I was never spiritually disconnected, and I continued my drawings as long as I had the energy. Byzantine history and art, ancient Egyptian history and art, hieroglyphs, Istanbul Yenikapı excavations, and Istanbul's museums and exhibitions, which are of particular interest to me, have always been at the top of the topics that especially excite me. Today, the fact that our country has made great progress in graphic design as well as in every field with its communication with the world makes us very happy. Our greatest chance is that our country has the infrastructure that will always feed artists with its historical and local richness. May all the luck be with way be open to all those who have set their heart on this profession.[14]

Since the 1970s, Gülümser participated in exhibitions with her works based on Turkish motifs and miniatures. In 1976, she illustrated Kemal Bilbaşar's (1910–1983) book *Kurbağa Çiftliği* (*The Frog Farm*). Gülümser returned to Turkey in the 1980s after living abroad for twenty years. Due to the onset of her health problems and her husband's continued business life abroad, she became increasingly responsible for raising her children. She was unable to continue her professional career. Gülümser passed away on July 19, 2022.

The Result of Success

In the 1940s, when market conditions were insufficient to accommodate academically trained designers, many Poster Workshop students struggled to continue their education or careers. The obstacles for women designers were numerous; they had to overcome prejudice and prove themselves tenaciously. Their small number was also an obstacle to women's solidarity. Gülümser, on the other hand, succeeded at a time when it was accepted that men made the decisions and there were limited job opportunities. Gülümser Aral Üretmen's views on this subject are remarkable as they are a testimony of her time:

> At that time, graphic design was looked down on due to the lack of specialization. Graphic design was perceived as a more masculine discipline. Women were more inclined to specialties such as interior design, fashion, crafts, painting, and opera. As the number of advertising agencies increased, female graphic design

Figure 2.8.4 Gülümser Aral Üretmen, poster design that won an award in the Garanti Bank Poster Competition, 1952. Courtesy of the Ömer Durmaz Archive

graduates slowly gained job opportunities but were always one step behind; male designers were preferred first. In addition, although women designers participated in the postage stamp, banking, and tourism poster competitions organized by the state and the Izmir Fair, male designers were mostly preferred. In the bright days of the Republic, women were offered the same opportunities, but there was also abstention due to the circumstances. It was up to the women to be a little more entrepreneurial, with a little support, of course.[15]

With the Garanti Bank poster award she won in 1952, Gülümser was the first female graphic designer to succeed in a competition.[16] The second woman to receive an award after Gülümser Aral Üretmen was Ruzin Gerçin (1929–2011), with her success in the Yapı ve Kredi Bank poster competition in 1956. Indeed, it is difficult to say that Gerçin is also mentioned in design history. For Gülümser, who worked as a designer in the 1950s, it could be said that she was the first educated female graphic designer to succeed. Until our article "Women Designers Have a Name: Gülümser Aral Üretmen"[17] was published in *Manifold* in 2016, the life and work of Gülümser, who passed away at the age of ninety-three, had not been comprehensively mentioned in any design or art history article.

It is interesting that graphic designer Mengü Ertel (1931–2000), one of the first authors to take a collective look at the history of graphic design in Turkey, did not mention the name of Gülümser Aral Üretmen, with whom he was friends during his academy years. Although Sabiha Bozcalı (1904–1998) was also a close friend of İhap Hulusi Görey, he did not mention Bozcalı. It is noteworthy that after Üretmen was awarded the poster prize, Orhan Omay, who was placed in a postage stamp competition in 1953 and attracted attention but could not follow it up and preferred to work as a public officer, is mentioned in history, whereas Gülümser Aral Üretmen is not.

The reasons for the neglect of women in historiography are varied and complex. A review of publications on the history of graphic design in Turkey reveals that women designers who played a role in the discipline's development or were pioneers in the field are mentioned only after the 1970s, and only some are named. Although the names of women artists before 1970 are known in fields such as caricature, painting, and sculpture, to talk about women in graphic design and illustration, it is necessary to look at recent history—when their witnesses are still alive. So, is it impossible to talk about women in graphic design before 1970? As in the case of Gülümser Aral Üretmen, could there not be other female designers whose names are unknown, although they should be included in history? Research is, of course, an ongoing process. New data may come to light with further research in the coming years, but it is clear that a feminist perspective on historiography is needed to answer these questions.

© **Ömer Durmaz and Dr. Murat Ertürk**

Note: First published online for *Manifold* in 2016 as "Kadın Tasarımcının Adı Var: Gülümser Aral Üretmen," this essay has been revised and retitled.

NOTES

1. Stratigakos, Despina (2016). *Where Are the Women Architects?* Princeton, NJ: Princeton University Press, pg. 65.
2. Jury, David (2012). *Graphic Design before Graphic Designers: The Printer as Designer and Craftsman 1700–1914.* London: Thames & Hudson.
3. Poynor, Rick (November 1, 2011). "Out of the Studio: Graphic Design History and Visual Studies." *Design Observer.* https://designobserver.com/feature/out-of-the-studio-graphic-design-history-and-visual-studies/24048 (accessed May 30, 2023).
4. Bursa is a city in the northwest of Turkey.
5. As the administrative center of the Ottoman Empire in the nineteenth century, Bâb-ı Âli was also the center of the Turkish press from the end of the nineteenth century until the end of the twentieth century. In the historical peninsula, the part from Sultan Mahmut's Tomb on Divanyolu to Sirkeci is also called Bâb-ı Âli. From the 1870s onwards, bookshops began to locate on this street. At the end of the nineteenth century, these bookshops increased their importance and number, making the street the most crucial center of the Turkish press and publishing industry. From the end of the nineteenth century until the end of the twentiethh century, Bâb-ı Âli became the heart of the press with bookshops, printing houses, printing plate makers, finishing operators, newspaper offices, and stationeries.
6. Durmaz, Ömer, İşli, Emin Nedret (February 2, 2016). *Ben Türkiye'nin İlk Kadın İllüstratörüydüm.* SALT Blog. https://blog.saltonline.org/post/138545501329/ben-turkiyenin-ilk-kadin-illustratoruydum (accessed May 30, 2023).
7. G.A. Üretmen, personal communication, April 21, 2016.
8. Ibid.
9. Ibid.
10. Ibid.
11. Ibid.
12. A. Akalp, personal communication, November 25–28, 2015.
13. Daver, Abidin (November 19, 1953). Hem Nalına Hem Mıhına/Reklamlâra Dair. *Cumhuriyet.*
14. G.A. Üretmen, personal communication, April 21, 2016.
15. Ibid.
16. Ibid.
17. Durmaz, Ömer (August 26, 2016). "Kadın Tasarımcının Adı Var: Gülümser Aral Üretmen," *Manifold.* https://manifold.press/kadin-tasarimcinin-adi-var-gulumser-aral-uretmen (accessed July 20, 2023).

2.9

Tomoko Miho: The Personification of European Modernism

Elizabeth Resnick

Tomoko Miho was arguably one of the most underappreciated graphic designers of the twentieth century. Her modest and reserved demeanor belied a fierce inner determination to produce distinctively content-driven work that employed her meticulous skill and exquisite clarity of vision. Miho's design methodology was a complex confluence of European Modernism, Japanese sensibility, and American business acumen that she applied to corporate communications, architectural signage, and environmental graphics. Her story is a legacy to the next generation of designers.

Tomoko Miho (née Kawakami) was born on September 2, 1931 in Los Angeles, California. She was the youngest of three children of Japanese-American parents Yoshitomo (John) Kawakami (1906–?) and Fumiko (Mary) Kuromi Kawakami (1907–1988). She had

Figure 2.9.1 Tomoko J. Miho, formal graduation portrait, 1956. Photo: Toyo Miyatake Studio. Image courtesy of the RIT Cary Graphic Design Archive, Tomoko Miho collection.

two older brothers: Mikio Kawakami (1926–1999) and Kazuo Kawakami (1928–2018). The Kawakami family were florists. "My parents had a flower shop on Los Feliz Boulevard in Los Angeles, with fields of flowers in the back," Tomoko told an interviewer. "My mother's sister and her husband ran Flower View Garden, her brother had a shop in Glendale, and my brothers and I helped our parents out on weekends … It was a wonderful way to grow up, seeing flowers all the time and watching my parents arrange them in the shop."[1]

Tomoko Kawakami was only ten years old when, on December 7, 1941, Imperial Japan staged a devasting surprise attack on Pearl Harbor, Hawaii, destroying much of the US Pacific Fleet and killing 2,400 Americans. A few days later, Germany and Italy declared war on the United States, plunging the country into the Second World War. On February 19, 1942, US President Franklin D. Roosevelt (1882–1945) issued Executive Order 9066, which mandated the incarceration of 110,000 Japanese Americans—including men, women, children, the elderly, and the infirm—for the duration of the war. They were given one week to settle their affairs and report to assembly centers with only what they could carry. Families lost thousands of dollars from having to sell off properties quickly. They lost their businesses, their personal property was stolen or vandalized, and their lives were shattered.

In spring 1942, the Kawakami family was dispatched to the Gila River War Relocation Center—one of ten internment camps located throughout the American West—along with Japanese Americans from Fresno, Sacramento, and Los Angeles, California. The living quarters across all camps resembled military-style barracks, creating incredibly cramped and unsanitary living spaces for families. At its peak, there were 13,348 people housed in the Gila River War Relocation Center.[2] In November 1945, interned Japanese Americans were released to face the test of starting over—building their businesses and livelihoods from scratch. Shamed and humiliated, they chose not to talk about their sorrow and resentment for fear of arousing an anti-Japanese backlash. Years later, Tomoko reflected on this challenging time: "In order to recover, we had to excel. The experience forced many Japanese-Americans to seek new horizons."[3]

After the war, the Kawakami family moved to Minnesota, and Tomoko attended West High School in Minneapolis. She later recalled: "When I was attending high school, the art teacher arranged for me to get a summer scholarship at the Minneapolis School of Art. She liked the work I did in her class and encouraged me. So that is how I started."[4]

Eventually, her parents separated. Her older brother Mikio worked as an architect in New York City, and her middle brother Kazuo became an accountant. In 1951, at nineteen, Tomoko and her friend Betty traveled to New York City. They visited the usual tourist sites like Rockefeller Center, the Empire State Building, and museums such as the Museum of Modern Art and the Morgan Library. She would later reminisce to an interviewer: "I'd read about impressionism and knew the names of a few European artists like Pablo Picasso (1881–1974) and Henri Matisse (1869–1954), and that was about it. Just seeing the paintings—that I only knew from books—on the walls of the museum was overwhelming. The scale of art, and the space."[5]

California Horizons

Invigorated and inspired, Tomoko continued taking classes at the Minneapolis School of Art, including courses in advertising and graphic design. She worked part-time at the Bureau of Engraving in Minneapolis to earn money for college and had the opportunity to learn the rudiments of print technology. One of her teachers suggested she look into ArtCenter School in Los Angeles, California (now the ArtCenter College of Design in Pasadena, California) to continue her art education full-time. She applied and was accepted with a full scholarship.[6]

Tomoko was fortunate to have her parents' support and Los Angeles-based relatives she could live with while she attended her classes. "ArtCenter College of Design really expanded my horizons, and I think it was there that I knew I wanted to be a graphic designer," she shared in an interview. Compared to Minneapolis, Los Angeles was a pulsating city with its frenzied traffic and clogged freeways. "I may have seen graphic design as a way to make sense out of all that, as a way of imposing a structure on my chaotic environment. Then, too, being with talented students and teachers couldn't help but make me think that I could be part of the graphic design world." She noted that her decision was influenced by "Mary Sheridan, one of the ArtCenter teachers, who always encouraged me. She was doing a lot of package design, which I loved, and sometimes let me help out in her office. I ended up switching to industrial design because packaging was in that department."[7]

Meeting James Miho

In 1952, during her first year at ArtCenter, she met fellow Japanese-American James Noboru Miho (1929–2022). Miho was born the second of three sons to a wealthy Japanese-American vineyard owner in Gridley, located in northern California. His grandfather and father had made successive fortunes in rice and grapes. "I'm glad we were wealthy when I was a kid because that's when you learn. My father was free to try new things, like flying an airplane to spray the orchards or buying a Caterpillar to make life easier for the workers. He loved to buy new cars, and we even had our own gas station. But when the war came—bang—that was it. We lost everything."[8] Like the Kawakami family, his family was also sent to a relocation camp; the Miho family was interned in Tule Lake on the California–Oregon border.

After graduating from high school, and at his father's request, Miho studied business at Pasadena City College for 3.5 years. An elective course in graphic design inspired him to transfer to ArtCenter but, after just one semester, he was drafted into the US Army at the start of the Korean War in 1950. He endured seven grueling months as an infantry officer before he received a life-changing two-week leave in Japan. He visited Tokyo and Kyoto and all the places his parents and grandparents had talked about during his childhood. Miho vowed: "I was so inspired by that trip that I decided—if I lived through nine more months of combat—I would become an architect or a designer." After his

release from military service, he sampled the offerings of several art schools before returning to ArtCenter in 1951 under the GI Bill to study advertising.[9]

It is often said that opposites attract; Tomoko Kawakami was naturally reserved and quietly observant, while James Miho possessed a vivacious and charismatic personality. It is also acknowledged that people tend to gravitate to those who have similar interests and backgrounds. In their case, they were both "Nisei"—Japanese for "second-generation"— children of Japanese immigrants born and educated in the United States. They shared the experience of being imprisoned in a relocation camp at a young and impressionable age. Still, Tomoko and James emerged from this circumstance to find joy and purpose in their studies at ArtCenter. They shared a passion for Modernist art and design, and an implacable resolve to earn their living as professional designers.

James Miho graduated in 1955, and with the help of Edward A. Adams (1898–1981), ArtCenter's founder, he secured his first job at an advertising agency in Philadelphia, N.W. Ayer & Son. He was to work directly with the firm's vice president and art director Charles Coiner (1898–1989)—who brought fine art into advertising—collaborating on Container Corporation of America's influential "Great Ideas of Western Man" advertising campaign. It was Miho who introduced the work of Pop artists such as Andy Warhol (1928–1987) and Larry Rivers (1923–2002) to the series, pairing contemporary images with timeless quotes.

A year later, in 1956, Tomoko graduated in industrial design. She recalled that time: "I'd thought of moving to New York because my brother was there. But I was going out with James Miho at the time." Instead, Tomoko moved to Philadelphia. "I found a job as a graphic designer, and we got married. But soon after, he was transferred to Detroit, and we moved there. I was always able to find a job on my own, which was fortunate because we moved around a lot."[10]

Once she resettled in Detroit in early 1957, Tomoko was hired as a package designer for Harley Earl Associates. She was primarily responsible for designing packaging for frozen foods, pharmaceuticals, and paper products. Famously known as General Motors' design czar, Harley Earl's (1893–1969) main job was as its design director. He transformed GM's design and styling into a marketing tool, and in the process, positioned the company as one of the world's largest automakers. Harley Earl Associates was his independent design firm established in 1945, and it boasted a client roster resembling a "who's who" of American industry. As Earl wasn't around too often, his son was responsible for running the agency.[11,12] Tomoko stayed for three years.

The Trip of a Lifetime

In March 1960, the Mihos took a work sabbatical and, along with their friends from ArtCenter, Bob and Vicky McClain, embarked on a six-month trip to Europe. They traveled in two silver Porsches each couple had purchased before the trip and picked up in Stuttgart, Germany. In the *Hall of Femmes* interview, Tomoko explained:

We'd heard that there was a lot of interesting design work being done in Europe, so we decided to go there. We put together a list of people and studios to visit, along with the museums and historical sites. Vicky was born in Italy, so we also spent some time with her family in Italy. Then we continued through Italy, Monaco, Spain, Portugal, France, and Belgium, and all the way up to Scandinavia. We visited many artists, like the sculptor Hans Erni and designers Herbert Leupin and Josef Müller-Brockmann in Switzerland, and Tomas Gonda at the Hochschüle für Gestaltung in Ulm, Germany. One of our classmates at ArtCenter was Björn Petersen who was quite well known as an art director (in Sweden). We visited Konstfack, the school. And we went to Helsinki in Finland, where we met Armi Ratia, the founder of Marimekko. We spent quite a bit of time with her and kept in touch for many years.[13]

"The Swiss design became very influential during the period when we were there. It was really an exciting time in graphic design," Tomoko noted. "Traveling in Europe opened my eyes to design work that was both freer and more structured than what we learned at ArtCenter. Though I wouldn't say that it had an immediate influence on my work because I'd become fairly confident in my own abilities as a designer. It was more about expanding my horizons."[14]

Figure 2.9.2 Herman Miller price list and 7 product brochures with black cardboard slipcase, 1962. Image courtesy of Herman Miller Archives.

She attributes her confidence to the cultural influence of "shakkei," a Japanese garden philosophy. Shakkei translates to "borrowed scenery" or "borrowed landscapes," a technique incorporating background landscape into the composition of a garden. The purpose is to integrate the background and the foreground into one, granting a small environmental space a sense of depth and dimension.

George Nelson Associates

The Mihos returned from their trip in September 1960. They rented an apartment at the Colonnade, a newly built high-rise apartment complex designed by Mies Van Der Rohe (1886–1969) in Newark, NJ, a short distance from Manhattan. Tomoko's nephew, Kenneth Horii (1951), remembers his visits: "As a young boy, I loved riding in Jim's Porsche sports car and appreciated their clean white Modernist apartment and architect-designed furniture. Tomoko was always very generous, talking with me and showing me their art collection. She had a dignified, quiet, sensitive demeanor consistent with her graphic sensibilities, and she exuded a calm strength of confidence and intelligence."

Once settled there, Tomoko looked for work. She later wrote: "I was eager to work, and George Tscherny recommended that I show my portfolio to Irving Harper (at George Nelson Associates). I met with him at the 50th Street office, and he hired me as a graphic designer. It was a memorable learning experience to work with Irving, who was an architect crossing over different disciplines to participate in the design of important projects like the Herman Miller furniture, the Howard Miller clocks, Bubble lamps, exhibitions, and graphics."[15]

> It was probably the best place I could have worked at that stage of my career. It was the best design firm in the 1960s, and it was an office with multi-disciplined designers. George Nelson himself was a great influence of that time, an architect, industrial designer, and also a writer about design. He wrote about a new idea for storage systems in his book *Tomorrow's House,* and the Herman Miller furniture company became interested and made him the company's director of design.[16]

Tomoko's view of design expanded and flourished under the mentorship of Irving Harper (1916–2015), George Nelson's (1908–1996) design director. Don Ervin (1925–2010) led the graphic design department, and it was under his direction that Tomoko designed price lists, product brochures, and collateral for Nelson's main account, Herman Miller. In 1962, she was a member of a collaborative team of ten—staff graphic designers and talented freelance photographers—that produced the innovative 1964 Herman Miller Design loose leaf catalog and specifying tool. The subdivided three-ring binder—containing several hundred pages—combined product photographs, text, dimensional

Figure 2.9.3 Herman Miller Design product specification catalog binder and spreads, 1964. Images courtesy of Herman Miller Archives.

illustrations, and textile and veneer samples in a modular system mirrored the company's modular furniture products. It would set the standard for future contemporary catalog design with its modernist sense of clarity, precision, and function.[17,18]

With Don Ervin's departure in 1963, Tomoko was selected to lead the graphic design program. Her colleague, Ronald Beckman, recounted her challenge of managing large projects in an interview: "She had to compromise a great deal when she worked with a team of people. But when she worked for herself, she was just very, very sure of herself and very commanding. She could work with a group, but she preferred to work alone."[19]

On the Move Again

In 1965, James Miho resigned from N. W. Ayer & Son and Tomoko left her position at the Nelson office to resettle in Los Angeles, citing family reasons. Tomoko and James worked as design partners and considered it a good experience. But after a while, they both realized that California offered a very different lifestyle and began to plan a return to New York. Fate intervened when James received a call from Needham Harper & Steers in Chicago inviting him to accept the position of art director on the Champion Papers account. He would be responsible for designing a wide range of materials for Champion, including product promotions and the annual themed book series *Imagination*, showcasing their paper products. During his five-year tenure at Needham Harper & Steers, he would be promoted to vice president and creative director.[20]

In 1967, Tomoko was hired by John Massey (1931), director of design and corporate communications for the Container Corporation of America (CCA). In an interview with UK designer Adrian Shaughnessy, John Massey recalled: "I met her through her husband, Jimmy Miho. Jimmy was Senior Art Director at N. W. Ayer, Container Corporation of America's advertising agency. He and I worked together for many years on various CCA programs. When the Mihos' moved to Chicago, I asked Tomoko if she would like to join the team at the Center for Advanced Research in Design (CARD), a subsidiary of CCA, which I founded. She accepted and became a major contributor to the broad range of design programs we created for organizations throughout the country."[21] A portion of CARD profits was used for design research and civic programs—a good example being the Cultural Communication Projects that produced the notable Chicago and New York City poster series in the late 1960s.

Tomoko designed the 1967 *Great Architecture in Chicago* poster—reproduced in numerous publications and held in collections of major museums—displaying her mastery of understatement influenced by the Swiss typographic style. "When you visit Chicago, you immediately get that sense of the architecture which is both solid and ethereal, with the light reflecting off the high-rise glass buildings," she told an interviewer. "Chicago has a great history of architecture, and that's what I tried to express in the poster."[22] Her concept was based on an architectural element invented in Chicago: the curtain wall—an outer covering of a building in which the exterior walls are non-structural and can be made of lightweight materials, such as glass. She found the building image in photographer Rodney Galarneau's portfolio. She converted the photo image into line, silk-screen printed it in black ink, and added sans-serif typography in white ink on silver metallic paper to maximize the visual effect.

In 1968, CCA commissioned a series of posters celebrating various aspects of New York City. These posters were placed around the city as part of an overall metropolitan beautification project. Tomoko designed four posters: *65 Bridges of New York*, *Wall Street*, *Broadway*, and *Empire City/Empire State*. For *65 Bridges of New York*, she based the concept

Figure 2.9.4 Tomoko Miho, three folding envelopes for product inserts for Jack Lenor Larsen, n.d. Photo: Elizabeth Resnick. Images courtesy of the RIT Cary Graphic Design Archive, Tomoko Miho collection.

Chapter 2.9 Tomoko Miho: The Personification of European Modernism

Figure 2.9.5 Tomoko Miho, logo and poster to introduce a new name and identity for Omniplan Architects, Dallas, Texas, 1970. Photo: Elizabeth Resnick. Images courtesy of the RIT Cary Graphic Design Archive, Tomoko Miho collection.

on an image of the Verrazano-Narrows Bridge by photographer Harvey Lloyd (1926). She tightly cropped the composition to emphasize the curve of the bridge's suspension cables, saturated it with red ink, and placed the white lower-case sans-serif type vertically to evoke a sensation of height.

Back to New York City

James Miho resigned from Needham Harper & Steers in 1970, relocating to Manhattan, to establish Miho, Inc. While the agency retained the bulk of the Champion Papers account, Miho was able to keep the Champion Papers *Imagination*-themed series. To accommodate Tomoko's move to New York City, John Massey established an office for his East Coast clients. He recounts: "I set up a branch of the Center in New York because we had a number of clients there."[23] Four years later, with the closure of this office, Tomoko became a partner in her husband's firm. "We were two independent designers. There was a project

that we did work on together (National Air and Space Museum), but mostly he had his own projects, and I had mine," she recalled. "His main client was Champion Papers which later became Champion International. I was also designing for Champion, all of their packaging, papers, and some of the signs. We shared ideas together."[24]

They lived and worked in a one-bedroom rental apartment at 1045 Fifth Avenue, across from Central Park West. "I always felt that they were a perfectly balanced couple, in that she was an introvert and he an extrovert, and that was also reflected in their work," their friend George Tscherny shared.[25] "In the 1970s, everyone was talking about gender identity," Tomoko later wrote. "It came as a surprise to me. I can't recall a situation where the fact I was a woman was a problem, even when I became a design director in the Nelson office or later when John Massey asked me to set up the CARD office in New York … we were all just working together, trying to respect each other."

"As a freelancer, designer and client have to work as a team," Tomoko told an interviewer. "My ideal client would be someone who respects my ideas, so even if we don't agree, we have a basis for discussion." She cites her relationship with Omniplan Architects—starting in 1970—as a good example. "My first assignment was to rename the company, which was called Harrell & Hamilton Architects. After the new name was accepted, I worked on developing a graphic expression for the structure of their organization, which included architects, engineers, and interior designers. If you look at the logotype—a center core in four interlocking squares—you see a graphic summary of the kind of work the company does. It was versatile, which meant that it could be scaled down for packaging, brochures, or a paperweight, or up for outdoor sculpture."[26]

National Air and Space Museum

Miho, Inc. was commissioned to design five posters for the Smithsonian's National Air and Space Museum, Washington, DC, in 1975. The posters were to be part of an exhibition celebrating the museum's official opening on July 1, 1976, during America's Bicentennial. Two of the most reproduced posters were *Friend? Or Foe?* (1976) and *Pioneers of Flight* (1976).

Friend? Or Foe? reflects on a time during the Second World War when the US government trained civilians to spot and identify silhouettes of warplanes flying overhead. This striking image, printed on metallic-coated paper, depicts fifty-four plane silhouettes at the top, the US Army Air Force symbol boldly placed in the center foreground, with captions identifying the planes lined up at the bottom, establishing a ground-level horizon. *Pioneers of Flight* features eighty miniature portraits of famous pilots and significant aeronautics individuals arranged in ascending diagonally stepped rows, and each accentuated with a different colored overlay. The poster title and the columns of pertinent information—name,

birth, death date, and accomplishment—are placed on an ascending diagonal to suggest flight. Tomoko stated that she "loved to impart information" in a "simple statement to make it relevant and clean." Both posters exemplify the influence of "shakkei"—the experience of space that imparts a sense of depth, width, and breadth to a small environment.

Tomoko Miho Co.

James Miho traveled extensively while working on the Champion Papers *Imagination* project books. On one such trip to Rome in the late 1970s, he met a woman with a young daughter and fell in love. He told an interviewer, "Judy introduced me to the human element. She showed me that there was more to life than design."[28] Tomoko was devastated. George Tscherny (1924–2023) later recalled: "We had a party at our house which they attended. As the party broke up, Jim departed by himself, carrying a little suitcase. When Tomoko was ready to leave, I walked her to the door. She turned briefly and kissed me on the cheek. One has to know Tomoko to recognize the impact of that emotion. Only later did I learn that Jim was leaving by himself to get a divorce."[29]

She established Tomoko Miho Co. in 1982. At the same time, her Fifth Avenue apartment building went "co-op"—a type of homeownership common to apartment buildings in big cities such as New York. She bought into the co-op, securing her home base for the rest of her life. Lucia DeRespinis, her former Nelson colleague and friend, remembered: "She had this beautiful first-floor apartment on Fifth Avenue. Everything was very exact. It was lovely. She was working like mad. She was so dedicated to her work. She totally gave herself to her work."[30]

Now, on her own, both personally and financially, Tomoko needed to expand her client base. Within her neighborhood, she secured a commission to design exterior building signage for 546 Fifth Avenue and 565 Fifth Avenue. She reconnected with her former client, Herman Miller, and was commissioned to design lighting installations for Herman Miller showrooms in New York City and Los Angeles, California. Tomoko also won commissions on a variety of large-scale interior signage projects, notably the signage system for Japan Airlines, Building 14, JFK International Airport signage (1993–94), working with former Nelson colleague Don Ervin, and for New York's Pennsylvania Station (1996–99) in partnership with Lance Wyman (1937), another former Nelson colleague. Tomoko noted: "I enjoy architectural signage because of the sense of scale, the variety of materials, and the fact that the work often involves collaborating with people in other fields."[31]

In 1983, Tomoko was introduced to sculptor Isamu Noguchi (1904–1988)[32] through a mutual friend, Japanese-American architect Shoji Sadao (1927–2019). Noguchi had decided to convert the factory building and garden he used as a studio into a museum

complex. He was working with Sadao, a longtime colleague and collaborator, to design the entry-level pavilion that would house indoor–outdoor galleries on the first floor and floating galleries above. The Isamu Noguchi Garden Museum opened in 1985 on a part-time basis. In collaboration with Noguchi and Sadao, Tomoko helped design and produce *The Isamu Noguchi Garden Museum* catalog published in 1987, promotional collateral, and museum installation graphics.

After Noguchi died in 1988, Sadao became the executive director of the Isamu Noguchi Foundation, working on numerous posthumous exhibition and publication projects to secure Noguchi's legacy. Sadao proved to be a crucial client and personal friend. Self-effacing in nature like Tomoko, Sadao was born in Los Angeles, and like the Kawakami family, his family was also interned in the Gila River War Relocation Center. Sadao commissioned Tomoko to design museum exhibition installations, promotional materials, and several book publications.

One such publication, *Buckminster Fuller and Isamu Noguchi: Best of Friends* (2011), was Sadao's intimate biography of the friendship between Fuller and Noguchi, having worked in close collaboration with both men.[33] The book was an expanded personal history of the 2006 exhibition of the same name, in which Tomoko designed the installation and all the promotional material. Another installation and book she undertook was *Zen No Zen Aspects of Noguchi's Sculptural Vision* (2002), which explored Zen Buddhism's influence on Noguchi's work.

Throughout the 1980s–2000s, Tomoko socialized with friends, traveled extensively for business and pleasure, and experienced a few meaningful relationships—most notably with Ross Littell (1925–2000), an American textile and furniture designer known for his practical, innovative, and minimalist style. During her long career, Tomoko acquired a formidable reputation among her peers, receiving many awards and accolades. In 1974, she was elected to join the Alliance Graphique Internationale (AGI), and in 1993, she received the American Institute of Graphic Arts (AIGA) Gold Medal. A superb essay by Véronique Vienne titled "Tomoko Miho: A Fearless Dedication to Content," published in the *AIGA Annual* no. 15 in 1994, offers a satisfying synopsis: "Her contribution to graphic design is far greater than the sum of her talents. Her posters, books, catalogs, logos, showrooms, and architectural signage share a common denominator—an internal breadth that comes from the exacting relationship between space and substance, between imagery and information, between concept and details."[34]

Tomoko Miho died in New York City on February 10, 2012, at age eighty, from complications due to stomach cancer.[35] The posthumous *Hall of Femmes: Tomoko Miho* (2013) by Samira Bouabana and Angela Tillman Sperandio, edited by Maina Arvas, highlights her achievements and includes a comprehensive interview that provided many of the quotes used in this essay. The collection of her work and personal documents now

resides in the Graphic Design Archive of the Cary Graphic Arts Collection at Rochester Institute of Technology (RIT).

© **Elizabeth Resnick**

Note: First published as "The Quiet Confidence of Tomoko Miho" in *EYE* Magazine 105, Autumn 2023, this essay has been revised with the addition of footnotes.

NOTES

1. Bouabana, Samira, et al., eds. (2013). *Hall of Femmes: Tomoko Miho.* Stockholm: Hall of Femmes and Oyster Press, pages 53–57, 17.
2. http://www.javadc.org/gila_river_relocation_center.htm (accessed October 31, 2023). https://en.wikipedia.org/w/index.php?title=Gila_River_War_Relocation_Center&oldid=1105239546 (accessed October 31, 2023). The Kawakami family was housed in Butte 33 at Gila River.
3. Delphine Hirasuna, from the preface to her book *The Art of Gaman: Arts and Crafts from the Japanese American Internment Camps 1942–1946.* Berkeley, CA: Ten Speed Press, 2005. "America's concentration camps were never mentioned in textbooks nor brought up in mixed (Japanese and non-Japanese) company. Japanese Americans chose not to talk about it because it stirred a sense of shame and humiliation, the sorrow and resentment of justice denied, and fear of arousing an anti-Japanese backlash."
4. Bouabana et al., *Hall of Femmes*, pg. 18.
5. Ibid., pg. 20.
6. Ibid., pgs. 20–22.
7. Ibid., pgs. 25–26.
8. Frolick, Stuart I., "Miho: Design Odyssey," *Graphis*, Vol. 314, 1988, pgs. 66–75.
9. Ibid.
10. Bouabana et al., *Hall of Femmes*, pg. 30.
11. In 1957, Tomoko Miho was interviewed for a short "lifestyle" piece in *The Detroit News*, titled "Petticoat Lane" by Beverly Keller, Friday, June 14, 1957 (pg. 38): "Tomoko Miho will be in Pittsburgh Monday. Anyone watching the tiny woman pack her belongings would think she smoked too much. The catch is that Mrs. Miho doesn't smoke at all, despite the several cartons of cigarettes she's taking on the trip. One of the few young women in the graphic and industrial in design field, Mrs. Miho has created several new look treatments in foil wraps for cigarettes. She'll present them to Eastern clients for her company, Harley Earl Inc., industrial designers. The new bride (she's been married for six months) has designed wrappings for frozen foods, pharmaceuticals, and paper products."
12. Bouabana et al., *Hall of Femmes*, pg. 30.
13. Ibid., pg. 32.
14. Ibid., pgs. 33–34.
15. Ibid., pg. 34.
16. Ibid., pg. 35.
17. Auscherman, Amy, et al., eds. (2019). *Herman Miller: A Way of Living.* London: Phaidon Press, pgs. 240–243. The office staff who worked on the design were Tomoko Miho, Ronald Beckman, Roger Zimmerman, Ray Wilkes, and Joe Manowski. The participating photographers were Lester Bookbinder, Charles Eames, David Attie, Lionel Freedman, and Hiro.
18. Nelson, G. and von Vegesack, A. and Eisenbrand, J., and Vitra Design Museum and Abercrombie, Stanley, Darling, Michael

19. Interview with Ronald Beckman, May 10, 2021.
20. "Imagination," *Communications Arts* Magazine, January/February 1976, pg. 68.
21. Shaughnessy, Adrian (2013) *Creative Class Hero: Tomoko Miho is One of the Design World's Best-kept Secrets*. https://www.hermanmiller.com/stories/why-magazine/creative-class-hero/ (accessed October 31, 2023).
22. Bouabana et al., *Hall of Femmes*, pg. 42.
23. Interview with John Massey, June 14, 2021.
24. Bouabana et al., *Hall of Femmes*, pg. 47.
25. Email exchange with George Tscherny, May 6, 2021.
26. Bouabana et al., *Hall of Femmes*, pgs. 59–60.
27. *Friend? Or Foe?* (1976), *Pioneers of Flight* (1976), *Space Art from the USSR* (1976), *24-Hour View of Earth* (1976), and *Kill Devil's Hill, NC* (1976).
28. Frolick, *Miho: Design Odyssey*, pg. 69.
29. Email exchange with George Tscherny, May 6, 2021.
30. "Tomoko was greatly affected by her time in the camp. She resented it. I think it may have been what turned her into a neatnik. She would vacuum after they had friends in the apartment, and her excessive cleanliness drove her husband crazy." Interview with Lucia DeRespinis, June 3, 2021.
31. Bouabana et al., *Hall of Femmes*, pg. 65.
32. Isamu Noguchi is one of the greatest twentieth-century sculptors who created innovative parks, plazas, and stage sets. The full breadth of his work can be seen at The Isamu Noguchi Garden Museum, Long Island City, New York.
33. https://www.noguchi.org/isamu-noguchi/digital-features/shoji-sadao/ (accessed October 31, 2023).
34. Vienne, Véronique (1993). "1993 AIGA Medalist: Tomoko Miho," *AIGA Annual* no. 15. New York: Watson-Guptill, 1994.
35. Letter to Lucia DeRespinis from James Miho, dated May 26, 2012: "Actually her problem since school days was ulcers. Today, it can be cured as it is a virus within a virus that causes ulcers. Probably, she reacted too late as ulcers turn into stomach cancer, which is deadly as it spreads."

2.10

Anneliese Ernst: Graphics for Use

Rose Epple

"How on earth did you find me?" asks Frau Ernst in our first telephone call. To tell the truth, it was not easy. Where would I—a twenty-first-century female graphic designer from West Germany—start looking for a twentieth-century East German equivalent? The prolific GDR graphic design scene largely disappeared from view in reunited Germany. However, I discovered that much of this heritage had been preserved thanks to a few institutions and spirited individuals like Dr. Sylke Wunderlich (1958), an art historian and author of the most comprehensive East German poster design survey to date.[1] With many personal ties to the GDR design community, she founded and runs the *Foundation Poster East*.[2] It is to her that I come with my quest, and we spend an enjoyable morning rummaging through her incredible archive.

Even though the overall percentage of working women in East Germany was significantly higher than in the West,[3] female graphic designers are still the minority in her archive. "Women tended to work more as illustrators," Dr. Wunderlich tells me as she

Figure 2.10.1 Anneliese Ernst, photographic portrait, circa 1980.
© Photo by Hans-Eberhard Ernst.

shares examples of artistic posters by Roswitha Grüttner (1939) and Jutta Mirtschin (1949). However, I am looking for a female graphic designer with a more conceptual approach. When we come upon the works of Anneliese Ernst, I feel an instant connection: Her work is striking, intelligent, inventive in its means, and stylistically diverse. I asked for her telephone number.

Two weeks later, I am sitting with Herr and Frau Ernst in front of a steaming pot of tea and a homemade cherry cake while Frau Ernst recounts how she became a practitioner of "graphics for use,"[4] as graphic design was called in the GDR (German Democratic Republic). Born in 1932 in Altlandsberg near Berlin, Anneliese Maaß came of age during the impoverished postwar years. After the war destroyed their home, her family found refuge with relatives in the countryside north of Berlin. Newly widowed, Anneliese's mother had to fend for three children alone. Anneliese was the oldest, and there was not enough money for all the siblings to finish high school. Despite her good grades, Anneliese had to leave school without any qualifications to learn a profession.

Due to her exceptional drawing skills, a teacher suggests that Anneliese become a graphic artist. She looks up "graphic" in *Meyer's Hand Lexicon* and learns that graphic is "painting and drawing as such," which suits her. Only one school accepts students without a high-school qualification: the *Technical school for graphics, printing, and advertising* in Berlin Schöneweide.[5] Anneliese applied and was accepted. In 1950, she moved to Berlin to study with a modest scholarship that just about kept her from starving, and every weekend she traveled back home to support her mother.

Anneliese was one of only a handful of female students at the school, located in the Soviet Occupied Sector of Berlin. Its curriculum followed the model of trade schools with a focus on practical skills: Students were taught drawing, printing techniques, bookbinding and repair, typesetting, and hand lettering. This education proves formative regarding her attitude toward graphic design, which Anneliese Ernst defines as "a craft by artistic means," as well as on a personal level. In Schöneweide, she meets fellow student and husband-to-be Hans-Eberhard Ernst (1933), with whom she graduated in 1955.

At their degree show, Anneliese and Hans-Eberhard are offered employment by a representative of the DEWAG,[6] the state-run advertising agency. It was owned by the ruling Socialist Unity Party SED and traditionally took its annual pick of outstanding graduates. But on learning that two of their chosen students are romantically linked, the offer to the young woman is retracted, as "relationships within the production unit are undesirable." In solidarity, Hans-Eberhard Ernst turned down the offer, and the young couple began their freelance careers.

"I did not want to make art; I wanted to make graphics for people to use, and if art came out of it, so much the better. I always worked on commission," Anneliese Ernst describes her attitude. Her first job is to produce technical drawings for a private graphic studio, which she found very boring. When they discovered a child was on the way, Anneliese and Hans-Eberhard married in 1958. In the years that followed, Anneliese Ernst

stayed home to care for their son. She was not entitled to free childcare as a freelance graphic designer because "freelance practice in the GDR was not really desired; we did not produce in a socialist way."

Most graphic work in East Germany was handled by the DEWAG or in-house designers for the larger publicly owned enterprises known as VEBs.[7] Smaller VEBs and private companies relied on the roughly 1,600 freelance graphic designers organized within the graphic section of the Association of Visual Artists.[8] Membership in the association is a precondition for working freelance. Mandatory membership was a way for the regime to keep an eye on the cultural sector and secure the quality and number of practitioners in relation to the amount of work available. When their son started school and Anneliese was free to work again, she had to reapply to the Association of Visual Artists and was readmitted in 1968.

Anneliese Ernst was now open to taking commissions from a broader range of sectors. One of her new clients was VEB Berlin Cosmetics, for which she designed adverts and the first-ever giant neon signage in East Berlin. Her portfolio also included a series of leaflets for centrifuges. The all-male admissions panel of the Association of Visual Artists was surprised to learn that Anneliese Ernst was not only responsible for the abstract graphics on their covers but also for the technical drawings and modernist typography inside. "Women usually didn't apply for work like that," Frau Ernst recalls, "most women wanted to do children's books. But not me—I found all topics and industries interesting."

During this time, the Ernsts bought a house located on the outskirts of East Berlin and set up their studio in a newly built annex. "My husband and I both worked at the same table—but individually on our own commissions." Once they established some rules, this arrangement worked successfully for decades. Frau Ernst recounts, "My mornings were usually hectic: getting our son ready for school, doing the shopping, housework, cooking, and all the rest. Often, I would not get down to my work before mid-afternoon. By then, my husband would have already had hours by himself and was very happy to share his ideas on my projects. Until one day, I could not take it anymore and started to cry. We then made a contract to only ever comment on the other's work when explicitly asked to do so."

In 1973, Anneliese Ernst began working for GDR Television—a job she loved.[9] The TV studios were conveniently located near their home. She would hop on her bicycle every Monday and deliver her work personally. Usually, she would present several episcopes or "epis," 30 × 40 cm cardboard graphics that act as title graphics or break fillers. Briefs were diverse, and visual reference materials were rarely available. But Anneliese Ernst has imagination and was resourceful with the means at hand: marbled bookbinding papers rescued from a closed-down stationery shop gave texture to cutout dinosaurs and Chinese pavilions. Colored paper dots made with a hole punch were painstakingly arranged to recreate the portrait of an actress. She drew type by hand with pen and ink

Figure 2.10.2 Anneliese Ernst, TV title graphic for a film about the Angara River, 1983. © Anneliese Ernst.

or cut out letters from photographs with nail scissors. To depict the Russian river Angara, Anneliese picked a fern leaf from her garden and applied color with a roller. Printed on paper, it resembled a forest mirrored in the water.

All freelance graphic jobs in the GDR were paid according to a national fee table, fixed in 1951 and never altered. Women and men received equal pay. The best-paying jobs were the political posters, commissions the Ernsts categorically ruled out: "We did not want to do them, and they were not offered to us anyway, as we were not in the ruling party. As non-party-members, we were not 'worthy' to do a poster for, say, Mayday." Fortunately, enough other work created camaraderie within the 700-men-strong graphic design community in Berlin. "There was no animosity between us," Frau Ernst describes the mood within their community. Every four years, the Association of Visual Artists staged an "accountability" exhibition in the galleries under the iconic East-Berlin TV Tower. With only a tiny budget, the resourceful graphic designers organized meet-ups, talks, and discussions. They opened the exhibition with a fabulous buffet featuring hand-baked letters that spelled out the show's title: *VISUELL 73*.

Figure 2.10.3 Anneliese Ernst, film poster for *The Last Empress* by director Chen Jialin, 1989.
© Anneliese Ernst.

At the exhibition, the Ernsts' TV work attracted the attention of the film distribution company VEB Progress. "Until then, our TV work was quite unknown, as not many people watched state television. They preferred to—secretly—watch West German TV." Anneliese Ernst and her husband became regular designers for the coveted film poster commissions. The film posters were needed for home-grown productions, and foreign films were routinely outfitted with new posters for the East German cinemas.

Since the sixties, East German film posters had been closer in spirit to the design work from Poland or Czechoslovakia than from West Germany. In the title of his compendium on the GDR film poster, designer Detlef Helmbold (1960) called them "More Art Than Advertisement."[10] "We were deliberately subjective. We aimed to show our own interpretation of a film," Herr Ernst described the prevailing attitude at the time. Designers treated their audience not as potential consumers but as partners in an ongoing cultural conversation. East German film posters might be scrutinized for hidden political messages by party officials, but crucially their graphic quality was usually judged by a committee consisting mainly of graphic designers.[11]

Over the next fifteen years, Anneliese Ernst designed dozens of posters for the VEB Progress. "At Progress, they had a little cinema, the size of a living room with six deep armchairs. That is where we were shown the films." Frau Ernst recalled, "when the dubbing had not been done yet, the dialogue would be read out in German for us."

Anneliese Ernst's poster solutions are concise. "A film is made up of so many images, and my job is to sum it up in one single image that gets straight to the point." She relied less on a recognizable graphic style and more on a good idea as the starting point. From there, she chose her medium—photo collage, drawing, painting, paper cutouts, or typographic solutions. She strived for an economy of means: a few black marks, some scattered scraps of red paper, and a translucent brushstroke are enough to evoke the feverish wedding ceremony of the doomed Chinese empress.[12] Herr Ernst sums up their different creative temperaments: "I am the raconteur; she writes the headline."

This quality earned her a memorable invitation to enter a poster competition for the West German Protestant Church Day as a GDR citizen during the Cold War in 1989.[13] Of the four German designers invited, two were from the East and two from the West. Anneliese was not a church member, but she agreed to participate under the condition that she could relate to the Church Day's motto. But first, she had to inform the Association of Visual Artists of her intent to enter an international competition. Her participation is tolerated despite the mounting tensions between the ruling party and the Protestant church, which supports the opposition movement in the GDR.

'Our Time in God's Hands' is announced as the motto of the Church Day. Anneliese Ernst immediately remembered a photo she had seen taken by Sigmund Jähn (1937–2019), the first German cosmonaut in space. The image, which was photographed from his spaceship, pictured the sun rising over the Earth: "You see the Earth's atmosphere as a line

of light, and you realize just how frighteningly thin it is." This image of the Earth's horizon forming the horizontal beam of a cross became the basis for her poster.

Earlier that year, Anneliese Ernst had put up a tape measure in her kitchen like many parents of young GDR soldiers serving their obligatory military service. She cut off one centimeter each day, counting the days until her son returned home from a maneuver—a dangerous place to be in these politically volatile times. A photo of this yellow tape measure forms the vertical beam of the cross, and the title runs down vertically along the tape measure. Her poster image is powerful, and the East German church loved it.

But by then, news of the competition had reached the GDR Ministry of Culture and caused unease. In a complete U-turn, Anneliese Ernst is instructed to withdraw from the competition under some pretext while being careful "not to make it look political." What to do? She deliberated with her church partners, who decided to defy the authorities and submit the poster clandestinely. Anneliese's poster was smuggled into West Berlin by a well-known East German legal counsel.[14] To Anneliese, the whole project feels "like a thriller."

None of the competition entries was chosen. But the East German Protestants are now determined to get their favorite poster out into the world and print it covertly at their own expense. In return, they invite Anneliese to join the 300-strong delegation of GDR citizens attending the Church Day in West Berlin. Fortunately, Anneliese had a passport because the journey from East to West Berlin not only passed the ideological border between two political blocks but also the heavily guarded physical border between two separate countries. In the convention center, the West German president welcomed the group. Anneliese's poster adorned the East German church stall, and the whole print run of posters sold out that weekend.

Anneliese Ernst gives me a mischievous smile. "They tried, but in the end, they just couldn't control everything. Sometimes you could find ways to get around them, and that was immensely gratifying." She was not the only person who felt like that. Later that year, the peaceful revolution of the East German people forced the fall of the wall and the collapse of the SED regime. Germany was reunited on October 3, 1990.

The new political situation meant new personal freedom for all GDR citizens, but for the Ernsts, it also meant a sudden collapse of their professional network. "All our clients were suddenly gone: TV, film, publishers—all either 'wound up,' that is liquidated through West German trusts, or staffed with a whole new set of people. Nobody knew us anymore."

The D-Mark was introduced in 1990, and the lifetime savings of GDR citizens devalued overnight. Real estate that the communist regime had confiscated was being restituted. As a result, many of their colleagues lost their homes or studios. To make matters worse for the Ernsts, the breakdown of the former GDR economy coincided with the shift from manual to digital tools within the graphic design discipline.

Figure 2.10.4 Anneliese Ernst, poster competition entry for Protestant Church Day, 1989. © Anneliese Ernst.

Shocked, the Ernsts have to adapt for better or for worse. Deliberating after a few sleepless nights, they decided, in 1991, to invest their remaining money to purchase an Apple Macintosh computer. Well before the computer age reached West German graphic design studios they taught themselves to use the computer for their work. Anneliese remembers how she had to "find out the hard way that your files are gone if you do not save them."

By 1993, their perseverance paid off, and new commissions started to trickle in. Anneliese Ernst entered a competition to design a logo for the Schorfheide, one of ten newly designated nature reserves in the former East. Anneliese's logo won out of 750 entries. She entered another logo design competition for the Spreewald National Park, and won again. "When a logo for the Lower Oder Valley National Park was needed, they probably thought, 'that woman is going to win anyway; we should just commission her straight away.'" She designed another thoughtfully scaled-down symbol, but by then, two young men from the West were in charge at the national park. They did not recognize the quality of her design and forced her to change it for the worse. She recalls this lack of respect for her design expertise as typical for clients' new West German attitude toward graphic designers.

It certainly sounds familiar to me, and I tell the Ernsts that, in that respect, they were fortunate to have practiced in a time and place where graphic designers were considered

Figure 2.10.5 Anneliese Ernst, draft for the Lower Oder Valley National Park logo, 1993. © Anneliese Ernst.

to be cultural practitioners, not merely service providers. Anneliese Ernst nods, "I enjoyed my working life very much—all of it." In 1997, she retired.

The Ernsts believe that women in the GDR were more emancipated than those in the West and enjoyed equality in the workplace. I asked Frau Ernst why so few female graphic designers from the GDR were well known. "Maybe they did not have the elbows to compete for poster commissions," she speculates, "it was always about posters; they brought you recognition." Alas, some things were the same on both sides of the iron curtain: In the introduction to their seminal book *Women in Graphic Design*,[15] the authors point out a bias—in design history—of focusing on the designer as an "auteur," with poster design being the most visible outlet for graphic design authorship. Tellingly, the few graphic design publications available in the GDR primarily focused on this genre.[16] Women like Anneliese, who successfully applied their design sense to a broader range of fields, were quickly written out of history. It is a loss for the individuals and the discipline due to this sole aspect in public perception.

Anneliese Ernst did not use her elbows but her talent, intelligence, and wit to create an impressive body of work that spanned four decades. I am inspired and grateful to Anneliese and Hans-Eberhard Ernst for sharing their memories and insights. I wish more women graphic designers like Anneliese Ernst could be discovered in the future.

© **Rose Epple**

NOTES

1. Wunderlich, Sylke, ed. (2007). *Überklebt. Plakate aus der DDR*, exhibition catalog, Schwerin.
2. Stiftung Plakat Ost. East German posters art after 1945, https://www.stiftung-plakat-ost.de.
3. In 1989, 91 percent of women living in the GDR were working compared to 41 percent of women living in West Germany. Source: Bundesministerium für Familie, Senioren, Frauen und Jugend, 2015: https://www.bmfsfj.de/resource/blob/93168/8018cef97 4d4ecaa075ab3f46051a479/25-jahre-deutsche-einheit-gleichstellung-und-geschlechtergerechtigkeit-in-ostdeutschland-und-westdeutschland-data.pdf.
4. "Gebrauchsgraphik" in German.
5. Fachschule für Grafik, Druck und Werbung.
6. DEWAG is the acronym for "Deutsche Werbe-und Anzeigengesellschaft."
7. VEB is the acronym for "Volkseigener Betrieb." In 1989, VEBs employed 79.9 percent of the East German workforce. Source: Wikipedia: https://en.wikipedia.org/wiki/Volkseigener_Betrieb.
8. VBKD (Verband Bildender Künstler Deutschlands), later VBK-DDR.
9. Deutscher Fernsehfunk, DFF.
10. Helmbold, Detlef (2018). *Mehr Kunst als Werbung: Das DDR-Filmplakat 1945–1990*. Berlin: Bertz + Fischer Verlag.
11. Ibid., pg. 139.
12. "Die letzte Kaiserin," Biopic | VR China 1986 | 104 (Video 90) Minuten, Dir.: Chen Jialin.

13. 23. Deutscher Evangelischer Kirchentag, Berlin (West), 7.–11. Juni 1989, Motto: "Unsere Zeit in Gottes Händen" (pgs. 31, 16).
14. Manfred Stolpe/CDU, later Ministerpräsident of Brandenburg 1990–2002.
15. Breuer, Gerda, Meer, Julia, eds. (2012). *Women in Graphic Design: 1890–2012*, Berlin: JOVIS Verlag.
16. See also *Anschläge von "Drüben." DDR-Plakate 1949–1990*, Edition Folkwang, Steidl Verlag, 2015.

2.11

Dolly Sahiar: Layers of Artistry in Editorial Design

Rukminee Guha Thakurta

In the early years after Independence,[1] a generation of Indian artists first encountered modern art through the art review quarterly *Marg*. Founded in 1946 by the Modern Architectural Research Group and spearheaded by Mulk Raj Anand (1905–2004), *Marg* was unlike international journals of the time—it featured the subcontinent's traditional art alongside modern expressions, constantly juxtaposing past and present. Set up in Bombay on the threshold of India's independence from British rule, *Marg*—which means "path" in Sanskrit—was also an acronym for the Modern Architectural Research Group. The publication anticipated the need to construct the region's art history. Anand's vision helped it to transcend a narrow East–West discourse, shake off academic constraints, and introduce broader, humanist perspectives. Although *Marg* disseminated information about past artistic traditions, it was anti-revivalist in spirit. Indeed, the journal aimed to help foster "new shoots of creative activity."[2] It included contributions by leading architects, photographers, curators, and art historians, but also gave space to enthusiasts and new scholars. *Marg* was dedicated to the arts of India, but it was placed within an international

Figure 2.11.1 Dolly Sahiar photographed by her colleague, Behroze J. Bilimoria, at *Marg*. Image courtesy of Behroze J. Bilimoria.

framework.[3] In Anand's view, *Marg*—over the decades of its publishing—had become an encyclopedia of Indian arts and culture.[4]

In 1955, Dolly Sahiar (1933–2004), a young graduate in commercial art from Bombay's Sir J.J. School of Art, met with Mulk Raj Anand, the distinguished writer, critic, and founder-editor of the art review quarterly *Marg*, at his home at 25 Cuffe Parade. The occasion was a job interview for the position of designer at *Marg*, which was, at the time, India's leading English-language journal on art. Soon, after another trepidatious meeting with the eminent industrialist J.R.D. Tata (1904–1993)—whose company published *Marg* during that time—Dolly was hired to design the magazine.

Dolly Sahiar, daughter of Sehra and Homi Sahiar, was born in Bombay's Parsi community in August 1933. She designed *Marg* for several decades until the early 1980s. Dolly's innovations in the design and production of *Marg*, her lively art for its pages and the photographs she made for it during her extensive travels to sites with Mulk Raj Anand constitute pioneering work in editorial design in India.

In his essay for the book *Mulk Raj Anand: Shaping the Indian Modern*, the artist Gulammohammed Sheikh (1937) acknowledges that he learned the "art of looking" through *Marg* and that the publication seemed to address people like him—the artists of India. He writes: "Following an impulse informed and deepened through years of scholarship, Mulk and photographer-designer and constant companion Dolly Sahiar found on their adventurous journeys wondrous images of the life and art which they shared with their readers. The triple spreads of the Bamiyan grottos in stark black and white left me with such an incredible sense of wonder that I dreamt of it like the invisible cities of Italo Calvino."[5]

The triple spreads that Sheikh mentions and several other stylistic elements were among the signature methods that Dolly Sahiar developed as *Marg*'s designer. After she joined *Marg*, Dolly continued her education in Indian art by visiting Anand's vast library in the home he shared with his wife, Shirin Vajifdar, who was a well-known classical dancer. Judging by the volumes that she designed across decades, Dolly developed an empathetic approach to materials. Issues of *Marg* from the 1950s provide evidence of the financial, technical, and material limitations within which they were produced; Dolly worked around these constraints with a thorough understanding and clever use of production techniques to animate the magazine's pages. *Marg* was printed at the Tata Press in Bombay on a limited budget. The early issues were published in a single color: black, plus a special color. The designer opened each magazine issue with a bold illustration in the special color that was taken across the top of a spread containing single columns of introductory text by Anand below. Subsequently, she would use that special color for simple line drawings or halftone artworks that she would layer under and around the body text. At times, she would use the margins of pages to place this art, adding vitality to pages of ordinary black text on regular paper.

In the early years, Dolly found another way of adding color to the magazine by having four-color images separately printed using letterpress blocks at the Commercial Art Engravers press, which still exists today in Mumbai's Prabhadevi. The color plates would be tipped onto the page manually, and the paper on which these images were pasted would often be heavily textured and colored as they were handmade. According to Behroze Bilimoria—a design and production assistant at *Marg* in the 1970s—Dolly would order handmade paper, made at units supported by Khadi and Village Industries Commission, and other colored papers from Perfect Papers, a paper manufacturer based in Byculla, Mumbai, and have these bound into the magazine.

Over a phone conversation, the art historian Annapurna Garimella referred to handmade paper as "the material of the moment." Early publications at the Lalit Kala Akademi, India's National Academy of Fine Arts, used handmade paper for their artist portfolios—large folders with printed works for sale. Behroze Bilimoria recalled the Maharashtra Tourism portfolios that she created with Dolly, which consisted of photographs pasted on handmade paper. In those years, it was also quite common to find stationery made of handmade paper. Another designer of those years, Dilip Chowdhury, extended the use of heavily textured papers into much later years with his abstract typographic covers for *Seminar* magazine. Chowdhury was also the designer of the journal *Design*, launched in 1957 by Patwant Singh (1925–2009). *Design* published critical writing on culture, architecture, and design, and Dolly Sahiar helped with the design of its initial issues. In his essay on *Design*'s role in Indian Modernism, the photographer and curator Ram Rahman (1955) quotes Patwant Singh on Dolly Sahiar's involvement with the journal:

> The layouts and typography of *Design* during the first year owed much to Dolly Sahiar, *Marg*'s brilliant art director. (She was helping as a friend.) In fact, Mulk Raj Anand's magazine would not have created the visual impact it did—through the imaginative use of types, the unconventional make-up of its pages, and the frequent use of textured paper inserts—but for her.[6]

By the 1960s, Dolly had begun to combine even more paper varieties into the magazine by introducing industrially produced, colored, translucent papers. In the December 1963 issue of *Marg* titled "Architecture and You," she cut these papers into vertical half-pages and bound them in the magazine as section breaks or overlays on regular pages. She often used this device to layer text onto images printed on regular paper. These and her use of lavishly illustrated gatefolds, cascading down vertically or opening up into horizontal galleries, were often repeated design elements that she drew from her bag of tricks for the reader.

Color printing crept into the pages of *Marg*'s issues in the 1960s by piggybacking on advertisement color forms that were bunched together at the beginning or the end of the magazine. Especially during this period, Dolly Sahiar made many hand-drawn images

Figure 2.11.2 *Top:* Dolly Sahiar, vertically cropped, colored, translucent paper section break in a *Marg* issue on contemporary Indian architecture. From "Reflections on the House, the Stupa, the Temple, the Mosque, the Mausoleum, and the Town Plan from the Earliest Times till Today (Being Notes on the Social and Spatial Imagination in Indian Architecture)," by Mulk Raj Anand, *Marg*, Vol. 17, Issue 1, December 1963, pg. 41. *Bottom:* Playful artwork placement within columns, below text, and in the margins in an issue of *Marg* on Rabindranath Tagore. From "Paintings of Rabindranath Tagore," by Mulk Raj Anand, *Marg*, Vol. 14, Issue 2, March 1961, pgs. 6–7. Courtesy of the Knowledge Management Centre, National Institute of Design, Ahmedabad, India.

to illuminate text pages. For example, in the June 1961 issue titled "Space, Time and Clay," she created illustrations using colors and textures that mimicked the feeling and texture of clay. These, possibly drawn with crayons or a dry brush, were used as full-page illustrations and layers over black-and-white photographs. Dolly used text and image layers confidently, narrowly averting readability issues at times. For this issue, she also made line drawings of the featured clay objects to create a striking numbered catalog on a gatefold.

Her playful spirit as a designer extended to her use of dangerously thin, translucent paper that could have easily disintegrated after a print impression or, conversely, thick, unbending, handmade paper, giving her publications a particular texture, even as unopened books. This design sensibility—that was uniquely Dolly Sahiar—distinguished *Marg* from other mainstream illustrated magazines of the 1950s and 1960s, such as the *Illustrated Weekly of India*, *The Times of India Annual*, and *Lalit Kala Contemporary*.

Apart from her work at *Marg*, Dolly also designed books by Anand and other writers and several books for Abhinav Publications, which regularly published Anand's work. Among them were *Ellora Concept and Style* by Carmel Berkson (1992), *Bharhut Sculptures* by R.C. Sharma, and *Kathak: Indian Classical Dance Art* by Sunil Kothari (1933–2020). In the acknowledgments in his book, Kothari writes of Dolly: "… she is justly celebrated for her impeccable sense of layout and design. But for her devotion and untiring efforts to illustrate the book, the present volume would not have been so rich visually."

For *Pahari Paintings of the Nala–Damayanti theme in the collection of Dr. Karan Singh* published by the National Museum, Dolly Sahiar decided to bind the book—very unconventionally and interestingly—by having the spine on top. Perhaps she had imagined how their collectors and patrons may have viewed portable albums of Pahari paintings. Dolly mostly used a simple two-column grid and uncomplicated type hierarchies in Times New Roman for her books, which made for uncluttered, logical, and legible pages. This allowed her to have fun elsewhere—using white spaces and margins, layering information and materials, and creating joyful drawings by hand. She was a master of contrasts, using gatefolds, printing techniques, and color, all to startling and buoyant effect.

By the 1980s, Dolly had achieved recognition for what she brought to the table with her myriad talents as an editorial designer—she had begun to be credited equally and alongside the book editor. In Carmen Kagal's book *Shilpakar*, a Crafts Council of Western India publication from 1982, her name appears prominently under Kagal's—in the same type and size—instead of in the colophon as is the practice for the designer's credit today. In her classic, earthy, and thoughtful style, *Shilpakar*'s cover is bound with a fabric that is actually designed by a "shilpakar" or artisan. The editorial is printed on a heavy, textured handmade paper, and essays in the book open with details of embroidery on fabric printed on rough, brown paper, which provides a contrast against the regular paper used in the book. Dolly made inspired use of the various styles of embroidery that are documented in the book by creating page borders with them or by zooming into their textures and

Figure 2.11.3 *Top:* Dolly Sahiar, spread of images in *Marg's Contemporary World Sculpture* issue in which brown handmade paper holding text is bound into the issue. *Bottom:* Dolly Sahiar, spread with a rust-colored handmade paper insert. From "Preliminary: The Contemporaries," by Mulk Raj Anand, *Marg*, Vol. 21, Issue 2, March 1968, pgs. 18–21. Courtesy of the Knowledge Management Centre, National Institute of Design, Ahmedabad, India.

using negative spaces for placing type. By this time, *Marg* had acquired advertisers among builders, airlines, engineering companies, and others that were to play a crucial part in the literal building of India's modernity. Dolly Sahiar designed their advertisements herself and as a result they appeared well integrated with each issue; she would choose arresting, stand-alone art and craft objects according to a theme to create them.

Described by all who knew her as simple, friendly, and easy-going, Dolly Sahiar was a loyal person and close to her family, which consisted of her parents and brother, Dinshaw Sahiar. She was a devout Parsi and an aesthete who was utterly devoted to her craft. Behroze Bilimoria recalled her as always elegantly turned out in handloom saris and silver jewelry. Chance, as Dolly herself wrote in *Mulk Raj Anand: Shaping the Indian Modern*, led her to Anand, and this association opened up her world. Before she met Anand, Dolly had pursued Indian classical music, which was quite an unusual choice for someone from the Westernized Parsi community. She had hoped to build a career as a singer and had been an enthusiastic concert-goer, spending nights at "mehfils"[7] listening to the foremost musicians of her time. After she joined *Marg*, she transferred her energies to soaking up volumes of work on Indian art and heritage. She confessed that she was a visual learner, and although she often ignored the written word, she could identify image plates without having to look at their captions. Anand's home attracted artists, scholars, poets, and filmmakers—key personalities in India's Modern art movement. Through such soirées at his home and his lectures elsewhere, Dolly continued on her journey as an autodidact.

Figure 2.11.4 Dolly Sahiar designed this elaborate gatefold for an issue of *Marg* titled *Treasures of Everyday Art—Raja Dinkar Kelkar Museum*, Vol. 31, Issue 3, June 1978. Courtesy of the Knowledge Management Centre, National Institute of Design, Ahmedabad, India.

Figure 2.11.5 Dolly Sahiar, gatefold illustrating an elaborately painted banner on cloth in *Homage to Kalamkari*, published by *Marg* Publications in 1979. From "Painted Banners on Cloth: Vividha-tirtha-pata of Ahmedabad," by Shridhar Andhare, *Marg*, Vol. 31, Issue 4, April 1979, pg. 41. Courtesy of the Knowledge Management Centre, National Institute of Design, Ahmedabad, India.

Anand conducted his research not only by personally meeting artists and craftspeople but also through extensive travels to sites around the subcontinent. Dolly Sahiar joined him on these excursions and vividly recalled her first sighting of the Kandariya Mahadeva temple in 1957 at Khajuraho: "… the first rays of the sun enveloped the front sides of the temple walls. My initial emotion on reaching the Kandariya Mahadeva temple was awe. I could not take my eyes off this miraculous achievement, my legs were glued to the ground, and I could not move. Dr. Anand was impatient and wanted me to look around, and since I had a borrowed camera, he asked me if I could take some pictures."[8] Her images of Khajuraho turned out to be stellar, and thus began her lifelong engagement with photography.

Dolly Sahiar traveled extensively with Anand—to well-known and unknown sites and museums along the Silk Route via Afghanistan, Iran, Turkey, Europe, and onward to the UK—making sketches and photographs wherever she went. She photographed India's first prime minister, Jawaharlal Nehru's (1889–1964) thang-ka collection in his home, where she also met his daughter, Indira Gandhi, India's future prime minister. In Afghanistan, she met and photographed Khan Abdul Ghaffar Khan (1890–1988), the famed "Frontier Gandhi." There, she traveled through rugged mountainous terrain to photograph the Bamiyan Buddhas. Wherever they went, Anand and Dolly were hosted by friends and diplomats, and through these journeys, while Anand made notes, Dolly photographed and sketched.

Dolly Sahiar was versatile with her stroke, adapting her drawing style to her subject and circumstances. Quick, impressionistic sketches from her travels reveal a dynamic style that could depict space, structures, and people with fluent ease—continuous lines, messy hatching and filling, and rough textures of details on monuments. However, her drawings for *Marg* and other books she designed show her mastery of line—from the controlled dry-brush stroke on textured paper to depict ceramics to precise and supple line drawings of motifs, patterns, and cutouts to create borders. The regional idiom was strong in her work, colored by a post-Independence ethos of simplicity and inventiveness, but, perhaps most importantly, her work was suffused with joy. *Marg* was a labor of love for her as for Anand. Behroze Bilimoria recounts how the pair would leave on Thursday evenings for their workstation in Khandala, a hill station beyond Bombay, and return on Tuesday mornings with designs manually cut and pasted onto grid pages ready for press.

Dolly Sahiar worked on *Marg* until 1981—both she and Anand left *Marg* after a change of management, but they continued to work together on books. When I asked Saryu Doshi, who succeeded Mulk Raj Anand as the editor of *Marg*, if she could think of other publications from which Dolly Sahiar might have drawn inspiration, she suggested that nothing like *Marg* existed in India then and that Mulk Raj Anand and Dolly Sahiar had certainly created a unique publication together.

Dolly Sahiar died from a stroke on May 16, 2004, while on her way back to Bombay (Mumbai was known as Bombay until 1996) on board a flight from the USA to Frankfurt. She was seventy-one. Anand, devastated by her death, died very soon after, on September 28, 2004, at the age of ninety-nine. In an obituary in *The Tribune* (2004), Humra Quraishi wrote:

> When I had asked her what had attracted her to Mulk so much that she never got married and continued to be his constant companion (Mulk has been married to Shirin, classical dancer of yesteryear), she quipped, "You know the first time I met him, I mistook him to be a servant; he was wearing red shorts with holes in them. I began illustrating his books, and he became my best friend."[9]

Although Dolly's answer sounds nebulous, her life's trajectory indicates that she was free-spirited and followed her heart and her interests uncompromisingly. It is easy to discern a joyous simplicity and rootedness in Dolly Sahiar's work. As easy as it is to find the quirky and warm person that she has been ubiquitously described as by all who knew her. She evidently derived great aesthetic pleasure from her work, which was the true expression of her selfhood, and she set a lofty standard for editorial design in India.

© **Rukminee Guha Thakurta**

NOTES

1. India gained freedom from the British Empire on August 15, 1947. This day indicates the end of British rule and the partition of British India into the two countries of India and Pakistan.
2. Quoted by Devika Singh, "Some Contemporary Artists," *Marg*, Vol. 4, No. 3 (1950), pg. 34.
3. Singh, Devika. *Modern Asian Studies* 47 (1). Cambridge, UK: Cambridge University Press 2012, pgs. 167–203.
4. Garimella, Annapurna, ed. (2005). *Mulk Raj Anand: Shaping the Indian Modern*. Mumbai: Marg Publications, insert on pg. 53.
5. Sheikh, Gulammohammed. "Mulk and Marg," *Mulk Raj Anand: Shaping the Indian Modern*, pg. 55.
6. Rahman, Ram. "Reflections on the Journal of Indian Modernism," *Marg: Designing a Brave New Era*, Vol. 72, No. 4, June 2021, pg. 71.
7. A mehfil is simply a gathering or a soirée.

8. Sahiar, Dolly. "My Journey with Mulk," *Mulk Raj Anand: Shaping the Indian Modern*, edited by Annapurna Garimella, *Marg* Vol. 56, No. 4, 2005, pg. 110.

9. Quraishi, Humra. "Mulk Raj Anand's Companion is No More," *The Tribune*, Online Edition, Chandigarh, June 6, 2004.

2.12

Odiléa Toscano: Elegance and Wit for Printed Graphics and Public Architectural Spaces

Dr. Sara Miriam Goldchmit, Dr. Maria Cecilia Loschiavo Dos Santos, and Luciene Ribeiro dos Santos

O diléa Toscano (1934–2015) was a Brazilian architect and graphic artist who designed book covers and illustrations for the publishing industry and environmental graphics for public architectural spaces. This essay profiles the biography and professional, academic, artistic, and teaching career of this woman architect who made a significant contribution to the field of visual design, still little recognized.[1] Odiléa's natural elegance and wit are unmistakable characteristics of her work and a vivid example of the fruitful interaction between her personal life circumstances and her creative practice.

Figure 2.12.1 Odiléa Toscano photographed inside the Romi-Isetta, circa mid-1950s FAU USP. Photo: João Xavier. Collection of Odiléa Toscano.

Odiléa Setti was born in São Bernardo do Campo on December 1, 1934, a descendant of an Italian family on her father's side and Syrian on her mother's side. During her childhood and adolescence her parents, Orlando and Hilda Setti, encouraged her to appreciate music, arts, and culture. Two grand pianos were in the house where Odiléa and her sister Kilza played together. Odiléa was also influenced by her father, who studied textile design in Milan. He transmitted the practice of observational drawing along with industrial design knowledge and experience. When she was still a child, she saw how a watercolor pattern made on graph paper could be transformed into a pillow. She shares:

> [...] I spent my early childhood in close contact with industries, weavings, and other small factories, which I visited and frequented through my father's hands. I soon learned to respect and recognize the dignity of these sober constructions, whose architectural design was based on elementary principles and which nevertheless contained activities that had a magical flavor for me. In the weaving mill, the colorless threads were dipped in the most varied dyes and combined in infinite ways and were transformed into soft, shiny silk full of colors and designs.[2]

While living in São Bernardo, her contact with art was limited to her father's encouragement, the practice of drawing, the reading of encyclopedias to learn about art history, and frequent visits to the opera and concerts in the capital. At seventeen, Odiléa's first significant encounter with artistic reality was when she attended the 1st São Paulo International Art Biennial in 1951.

She entered the Faculty of Architecture and Urbanism at the University of São Paulo in 1953 in a class with five women and twenty-five men. Her formative years at the FAU USP were linked to the effervescent discussion on modern architecture. She was a student of Vilanova Artigas,[3] Rino Levi, Abelardo de Souza, Carlos Lemos, and Renina Katz. In 1958, Odiléa graduated and married João Walter Toscano (1933–2011), a notable architect of that generation. She became his collaborator, an active participant in his architectural and urbanistic projects, with a special emphasis on landscaping design. Odiléa and João had four children during the 1960s and early 1970s: Guilherme, Ana Paula, Mariana, and Eduardo.[4]

The exhibitions of her work at the university gave her the visibility to produce her first professional works while still a student. In 1957, Lourival Gomes Machado (1917–1967) invited her to make illustrations for the literary supplement of the newspaper O *Estado de S. Paulo*, where she had the opportunity to publish a drawing for the first time, in a section for which she became a frequent illustrator, together with renowned Brazilian artists. With a delicate but precise trait, the characters are depicted in everyday situations: in front of the stove, looking through the window, chatting on the sofa, sewing … She highlighted the domestic environment. The objects of the house appeared as traces of an imaginary scene: the record player, the cabinet, and the kettle. Feelings are communicated: loneliness,

Figure 2.12.2 Odiléa Toscano, book cover for the collection *Jovens do Mundo Todo* (1960–61). Photo: Sara Goldchmit. Collection of Odiléa Toscano.

anticipation, sadness, and joy. She explored her surrounding materiality and subjectivity to produce compelling images.

"In general, the situation of the woman in the middle-class family in São Paulo is summed up in an unattractive and unglamorous life," according to her colleague Julio Katinsky (1932). "The irony is therefore configured in a caricature that is not merely episodic but critical of a situation of existence, through the exquisite care of details, without distinguishing the traditional hierarchy in the aspects of daily experience. The caricature is not aggressive but filtered through a certain tenderness in the lines."[5]

Between the end of the 1950s and the beginning of the 1960s, Odiléa was introduced by Renina Katz (1925) to the brothers Caio Graco and Yolanda Prado, owners of the publishing house Brasiliense. Then, she began working on the *Jovens do Mundo Todo* (*Youth of the World*) collection, designing forty book covers between 1960 and 1966. These covers deserved international attention and were given an award at the 1st São Paulo International Book Biennial. Her acceptance into the São Paulo selective cultural circles at the beginning of her career afforded her many new work opportunities.

This extensive book collection was her most important project for printed media at a time when the publishing industry was blooming. For each book, Odiléa conducted visual research into the customs, geography, architecture, characters, and objects of the place and time in which the story is set. The resulting illustration, therefore, carries information that situates the reader in the novel even before opening the book. She managed to create specific color combinations for each book, contributing to the atmosphere of the narrative.

The qualification of surfaces by using patterns is also a typical resource of her style. Black and white nankeen hatchings give rhythm and specificity to the figures, allowing the observer to study their nuances more closely. The colored grids of paper cutouts add grace and identify materials such as fabrics, floor coverings, and other components of the scene depicted. The detailed drawing of textures or paper clipping—as well as sewing, cooking, and other domestic tasks—required skilled hands and patience. The craftsmanship defined her working process. Her everyday skills were mixed with professional ones in this always manual, time-consuming, and meticulous work, which was undoubtedly a source of great satisfaction for her.

In 1963, Odiléa and João Toscano traveled to Paris for a one-year internship, receiving a scholarship from the French government for the *Cours de Fabrication du Livre* at the Lycée Estienne. In 1965, João Toscano received another grant to document Portuguese architecture, and the couple set off for Europe again, this time for six months. Thanks to the Calouste Gulbenkian Foundation, Odiléa also attended the Cooperative of Engravers of Lisbon studio—a creative period of experimentation and development of a personal language—opportunities for international exchange while accompanying her husband.

Throughout the 1970s, Odiléa continued to produce illustrations for various print media, such as the magazine *Bondinho* (*Cableway* in a literal translation). For *Bondinho*, Odiléa created illustrations full of humor and irreverence, with creative freedom rarely allowed in other works. In this series of illustrations, one can notice the improvement of graphic processes that took place at the end of the 1960s and during the 1970s, such as the spread of the photocomposition process and the new materials for the preparation of layouts, such as letterpress, transparent colored films, markers, and so on. The clipping and collage of colored paper—resources that had always been part of her repertoire—began to gain greater color possibilities, new textures, and transparencies. Odiléa's drawings for *Bondinho* speak of the contemporary city, polyphonic, echoing images from television, cinema, and advertising.

Figure 2.12.3 Odiléa Toscano, illustration for the *Bondinho* magazine, circa 1970. Photo: Sara Goldchmit. Collection of Odiléa Toscano.

In her academic research for her master's and doctorate degrees, Odiléa explored the theme of the representation of urban spaces. She was interested in the question of the passage of time, the transformation of places, and the sensitive perception recorded through drawing. "Among the many aspects that the city offers, which has always interested me closely, is the one that reveals the transformations configured by passages that resemble ruptures, the coexistence of large masses of buildings with small spaces that still keep the scale of queued houses, coexistences that translate, not infrequently, the phenomenon of oppression. I record these spaces while I traverse them […], and in every change of direction, I think that I conquer a new visual."[6]

The 1981 dissertation titled "The City: Images" includes a series of drawings of city spaces with testimonials about the creative process—images of São Paulo, taken from memory, mix elements from the actual landscape, and from imagination in a free exercise of poetic subjectivity. In the PhD thesis "The Contemporary City, Piranesi's Vision," completed in 1988, the city issue is discussed again, this time employing as its example

Figure 2.12.4 *Top:* Odiléa Toscano, mural in Largo 13 de Maio station, 1986. *Bottom:* Odiléa Toscano, Mural in Paraíso station, 1991. Collection of Odiléa Toscano.

the work of Giovanni Battista Piranesi (1720–1778). The research was conducted through an in-depth study of the artist's biography and of his artistic production, as well as some graphics work readings.

Throughout the 1980s and early 1990s, Odiléa produced her most visible large-scale work in the city of São Paulo: the panels and murals for the subway stations of São Paulo (Paraíso, Santana, Jabaquara, and São Bento). For those large public spaces, she designed colorful environmental graphics integrated into the architectural surfaces after studying its users' spatial dynamics and flux. An essential shift in her creative process occurred for these large and public projects. Her role as a visual planner was separated from the execution, which professional painters accomplished under her supervision:

> With the possibility—and even the necessity—to work with larger plans, the execution has become the responsibility of specialized companies whose resources allow greater precision and speed. I always follow the enlargement of the strokes and geometric constructions and check the fidelity of the colors, often collaborating with the painters and mixing the paints to obtain values as close as possible to those indicated in the project.[7]

The station Paraíso, located at the Paulista Avenue line in the city's central area, received six murals designed by Odiléa, situated at the entrances and the main access to the platforms. As well as adding gracefulness to the underground route, the murals help users find their way around. The murals convey elements of nature, which are almost diluted in a formal abstraction, especially when seen with a glance. The color palette conceived for the set presents tonal values of low saturation, harmoniously integrated into the grey of the concrete. There is a suggestion of transparent layers, achieved through a complex simulation of the color zones to be filled in the figure, followed by the preparation of a wide range of tones.

> […] I still find limitations in my projects if I want to stick only to the ready-made colors available on the market. For this reason, I use mixtures that allow me to work on the drawing with transparency and with a greater number of tonal variations. For example, in some of the underground murals, we prepared up to fifteen different values using three or four basic colors. I also used silver, which receives the light in diverse ways, giving different readings to each observer's point of view.[8]

Another outstanding contribution to the city was the station Largo 13 de Maio, designed by João Toscano circa 1985. Odiléa conceived a color scheme that was incorporated into the built environment with materials technology, especially the color treatments on the facade. She also designed a mural on the wall behind the rails, made up of a series of colored arches on a white background, with variations in width and mirroring along the way. The arches echo the sequence of steel building pillars, therefore portraying an

extension of the architecture. The repetition of the arches echoed the rhythm of the moving train.

In addition to her extensive artistic and professional career, Odiléa Toscano was a committed design educator. From 1960 to 1963, she taught at the Drawing Teacher Training Course of the Armando Álvares Penteado Foundation (FAAP). From 1968 to 1970, she taught in the Technical Communication Design Course at the Institute of Art and Decoration. In 1972, she joined the teaching staff of the Design Department of the Santos School of Architecture (FAUS/UniSantos), where she remained until 1985. Odiléa was also a lecturer at the Department of Journalism and Publishing at the School of Communication and Arts of the University of São Paulo (ECA-USP) from 1973 to 1975. In 1974, she joined the Department of Design of the School of Architecture and Urbanism of the University of São Paulo (FAU USP), where she taught visual communication until 2000, when she retired from teaching.

Studying Odiléa Toscano's career enables us to recover a little-known chapter in Brazilian and Latin American design history when the profession and formal design education were being established. Her activities as a teacher are noteworthy and contextualized in the country's early design education through design training at FAU USP for architects and urban planners. She was a trailblazer in her highly productive professional life, as she struggled with the difficult task of balancing personal life, marriage, and children's upbringing with the tenacity to express herself through the work she produced, especially challenging in a predominantly masculine professional domain.

Whether in an illustration for a newspaper, a book cover, or a panel for the São Paulo Metro, her elegant drawing was multiplied through graphic language and industrial reproduction. It gained scale and visibility in public spaces of great flux, becoming a remarkable example of achievement in projects that combine visual design and the built environment. Design was restricted to elitist circles for many years as a sign of cultural prestige. Odiléa was committed to democratizing design, bringing it into the public spaces of the megalopolis, and expanding access to these creations. With her unique aesthetic ability to combine elegance and wit, Odiléa's process and style have influenced generations of professionals.

Odiléa Toscano was eighty years old when she passed away on April 7, 2015. Her work remains vibrant and waiting to be explored for a better understanding of the relationship between design, society, and the built environment.

© Dr. Sara Miriam Goldchmit, Dr. Maria Cecilia Loschiavo dos Santos, Luciene Ribeiro dos Santos

Note: First published in 2015 as "Odiléa Toscano: Visual Design, Public Spaces, and Education" in PosFAUUSP 22 (38), this essay has been revised and retitled "Odiléa Toscano: Elegance and Wit for Printed Graphics and Public Architectural Spaces."

NOTES

1. This study was conducted through a literature review, image collection, and interviews. The documentation of the original drawings and images of the projects was conducted through immersion in the collections of the artist's studio, as well as consultations in public collections, bookstores, and private collections. In addition, as specific bibliographical references on her work were scarce, the in-person interviews with the designer and some of her closest colleagues were a vital primary source of information to assist in understanding her creative process, references, biographical facts, and achievements.
2. Toscano, Odiléa Setti (1981). *A Cidade: Imagens.* Thesis (master's degree in architecture and urbanism), School of Architecture and Urbanism, University of São Paulo, pgs. 13–14.
3. Vilanova Artigas (1915–1985) identified in Odiléa's work her ability to contribute to the artistic content in Brazilian industrial production: "I closely follow the expression of Odiléa, as well as that of other graphic designers who have graduated from our School of Architecture, which is so different today in terms of its teaching structure, and which is driven by the need to train professionals capable of interpreting industrial development and transforming it into a tool for artistic expression. I am not talking about Odiléa's piercing humor or graphic richness, which I see as coming from a critical position in the face of the reality she observes and explores so vigorously. That is a matter for others. What excites me the most is feeling the presence of graphic artists at this level, who are running to change the appearance and even a little of the structure of Brazilian industrial production, to express new artistic, intelligent content. The artists of Odiléa's generation represent a cohort of intellectuals whose vision of the problems of our time transcends the limits of autodidacticism. The books, the illustrations, the posters, and all the visual media, begin to reveal the presence of their personal talent and ability to nourish themselves in Brazilian culture, in its popular and scientific aspects. What we need is to recognize them, to create the means for them to accomplish their enormous task in the development of this country." (Artigas, Vilanova. Folder of the Graphic Arts Exhibition. São Paulo: Galeria Ambiente, 1963).
4. Odiléa's and João's four children were inspired by their parent's professional careers and personal interests. Guilherme graduated in architecture and urbanism, Mariana graduated in graphic design, and Ana Paula and Eduardo studied biology.
5. Katinsky, Júlio Roberto. São Paulo: Galeria Ambiente, 1963, s.p., our translation.
6. Toscano, 1981, pg. 6, our translation.
7. Toscano, 1991, pg. 110, our translation.
8. Toscano, Odiléa Setti. "Propostas cromáticas na arquitetura," *Projeto*, 1991, no. 139, pgs.109–110.

2.13

Thérèse Moll: An Enigma Gone Too Soon

Elizabeth Resnick

A young woman caught in an unguarded moment, deep in thought, yet frozen in time. She is wearing a long dark coat that defines her small figure against the background of the elevated dock hovering over the water below. The photograph is circa 1953. The young woman would be about nineteen years old. She is an enigma. Still.

Thérèse Moll, the young woman in the photograph, was born in Basel, Switzerland, on November 17, 1934, and grew up in the Laupenring neighborhood. Little is known about her early life, other than her father worked as a building site foreman for a local construction company. In 1949, at the age of fifteen, she was enrolled in the Vorkurs (foundation course) at the Basler Allgemeine Gewerbeschule (School of Arts and Crafts in Basel). The following year, she took the entrance examination for the four-year Fachklasse für Grafik (professional program for graphic design) with her Vorkurs classmate Dorothea Hofmann née Schmid (1929–2023) and thirty other students. Competition for places was fierce, as only six or seven students were accepted onto the course each year. The students were

Figure 2.13.1 Thérèse Moll, photographed in Basel, Switzerland, circa 1953.
Photo: Karl Gerstner. Courtesy of the Karl Gerstner Archive.

judged on the quality of their work and their Vorkurs portfolio. In 1950, seven young students (four women and three men) were accepted into the program, Thérèse Moll and Dorothea Hofmann included.[1]

Instead of entering the Fachklasse für Grafik, Thérèse began an apprenticeship in the Basel studio of Rolph Grossmann. At that time, there were two options to train as a Swiss graphic designer: a four-year program in the Fachklasse für Grafik or a four-year apprenticeship in a design studio combined with one and a half days a week attending courses at school. As Emil Ruder and Armin Hofmann taught the Fachklasse für Grafik and the apprenticeship students, Thérèse attended Hofmann's class all four years. In 1952, she left Rolph Grossmann's studio to become a full-time student.[2]

Figure 2.13.2 Thérèse Moll, black and white exercises for a course taught by Armin Hofmann, Allgemeine Gewerbeschule, Basel, Switzerland, 1950–51. Images courtesy of Armin and Dorothea Hofmann.

By 1947, the Basler Allgemeine Gewerbeschule (AGS; now known as the Schule für Gestaltung Basel/Basel School of Design) was under the directorship of Berchtold von Grünigen (1899–1976) and the tutelage of graphic designers Armin Hofmann (1920–2020) and Donald Brun (1909–1999) and typographer Emil Ruder (1914–1970). Drawing classes were taught by Theo Eble (1899–1974), Gustav Stettler (1913–2005), Walter Bodmer (1903–1973), and Hans Weidmann (1918–1997), among others. The faculty numbered twenty teachers. When Armin Hofmann joined the faculty at age twenty-seven, Ruder—who had been teaching typography there since 1942—was promoted to head the Department of Apprentices in Applied Art. Hofmann and Ruder made a formidable pair and collaborated on many professional projects. They also developed an educational model linked to their own professional education and to the elementary design principles of the Vorkurs that had been in place at AGS since 1908. Through a combination of their travels, lectures, and publications, this pedagogical teaching model was widely disseminated and received international recognition.[3]

By all accounts, Thérèse Moll was an exemplary student. As evidenced by her work, she was technically inclined, detail-oriented, and dedicated. She clearly thrived in the school's studio-based environment—all students worked together in one room for the entirety of their four years of design training. Her AGS instructors were not her only source of inspiration as her classmate Dorothea Hofmann recalls: "Armin Hofmann—whom I married in my third year of graphic design education in 1953—was our teacher. Karl Gerstner (1930–2017) took evening classes at the same time in Armin's graphic design course, and he sat next to Thérèse. Both Armin and I and Thérèse and Karl were close friends." At some point, Thérèse and Karl became a couple.[4]

In 1955–56, Armin Hofmann accepted a guest instructor position at the Philadelphia Museum School of Art and was a visiting lecturer at Yale University in New Haven. While in Philadelphia in 1956, Hofmann was invited to show a selection of students' work—which included Thérèse Moll's black-and-white exercises—in a small exhibition held at the offices of N. W. Ayer Advertising. He also had these same exercises in his lecture on teaching and design education at the Sixth Aspen International Design Conference in the summer of that year.[5]

As a result of Hofmann's professional activities in the United States, Walter Herdeg (1908–1995), publisher of the trilingual Swiss design magazine *Graphis*, invited him to write an article on design education. The article "A Contribution to the Education of a Commercial Artist" was published in *Graphis* no. 80 in 1958 and included four of Thérèse Moll's black-and-white exercises. The following year, Jean Koefoed, an editor at Reinhold Publishing New York, sent a letter to Armin Hofmann dated March 31, 1959:

> It is with great interest I have read your excellent article about the education of the commercial artist in *Graphis* magazine. As you undoubtedly know this whole subject is frightfully needed in the country. Nobody seems to have formulated any

theory as to how to teach design. Now it has occurred to me that if it were possible to expand this article into a basic textbook on design, we would be able to fulfill a great need in this country. Would you be interested in doing such a book?

This invitation was just too good to pass up, and Hofmann devoted several years to developing this book project. In 1965, the Swiss book publisher Verlag Arthur Niggli released *Methodik der Form und Bildgestaltung, Aufbau, Synthese, Anwendung*. In collaboration with Reinhold Publishing, the English version of *Graphic Design Manual: Principles and Practice* quickly became one of the most widely disseminated statements on Swiss graphic design principles. The text was illustrated with the work of his students and included Thérèse Moll's black-and-white exercises.

Upon completing her coursework and receiving her Swiss Federal Diploma in March 1954, Thérèse accepted an assistant's placement, a kind of short-term internship, at Studio Boggeri in Milan—one of Europe's great design offices. Antonio Boggeri (1900–1989), who worked primarily with industrial clients in pre- and post-war Italy, founded Studio

Figure 2.13.3 Thérèse Moll, package design for Broxi, a detergent made by BP Petroleum, Atelier Karl Gerstner, Basel, Switzerland, 1954–57. Image courtesy of Armin and Dorothea Hofmann.

Boggeri in 1933. It was the first Italian design studio to provide complete communication services for large industrial companies such as Olivetti, encouraging Boggeri to actively recruit the brightest and most innovative Italian, German, and Swiss graphic designers to work with his clients. Thérèse was only there for a short period of perhaps nine months, and little of her work survives from that time.[67] She returned to Basel in early 1955 to join Karl Gerstner[8] in his atelier, primarily working on industrial projects and Geigy projects under the supervision of Max Schmid (1921–2000).

Karl Gerstner had taken the AGS foundation course in 1944. He continued to take design and drawing courses off and on—from 1945 to 1949—while he fulfilled his compulsory apprenticeship with Fritz Bühler (1909–1963),[9] a graphic artist known for his ability to combine sensitive design with a strong sense of advertising. Armin Hofmann and Max Schmid also worked in Bühler's studio, where they developed their lifelong friendship. In 1947, Hofmann left for a teaching post at AGS, and Schmid left in 1948 to join the Geigy "propaganda" department, which René Rudin had founded in 1941. Schmid brought Gerstner into the Geigy fold as a freelancer before Gerstner formally opened his design atelier in 1953.[10]

J.R. Geigy A. G. was a Basel-based pharmaceutical and chemical company. During the late 1940s through the 1960s, their propaganda department worked with talented graphic artists to produce a high-quality graphic design that reflected its image. Collectively, they developed a formal modernist visual language but did so without conforming to any specific aesthetic style. The work became the embodiment of "informative" advertising and often reflected the scientific basis within each product's origins. Max Schmid was incredibly influential at Geigy, not only because of his design expertise but also in part due to his engagement with new talent:

> In the art director Max Schmid, Geigy was blessed with a brilliant designer who recognized young talent and employed it. The link between Geigy and Basel's Allgemeine Gewerbeschule was crucial. In Armin Hofmann and Emil Ruder, the school had two of the most brilliant designer teachers of their generation. Lessons learned in their classes were put to use at Geigy in masterly compressions of hidden anatomy, simplified graphics of complex processes, precise and elegant typography.[11,12]

Schmid engaged more than thirty talented AGS graduates to work at Geigy, helping to form what became known as the "Geigy style" distinguished by the generous use of white space, equal weight of stylized graphics or drawings, and photography, color contrasts, use of a grid, and the practically exclusive use of sans-serif typefaces, Berthold Akzidenz Grotesk in the 1950s and then Univers and Helvetica in the 1960s.

In 1957, after two years of working in Gerstner's studio,[13] Thérèse Moll accepted a staff position in the Geigy propaganda department, working with art director Gottfried Honegger (1917–2016), who replaced Schmid when he moved to head the Geigy office

Figure 2.13.4 Thérèse Moll, Prospectus front cover for Micoren, a respiratory and circulatory stimulant, J.R. Geigy A. G., Basel, Switzerland 1958. Image courtesy of Armin and Dorothea Hofmann.

in Ardsley, New York. She stayed at Geigy for one year before opening her studio in 1958, working with various industrial and scientific clients in Basel.

In 1958, she received an invitation from John I. Mattill (1921–2019), director of the Office of Publications at Massachusetts Institute of Technology (MIT), to work as a visiting designer assisting staff designers Jacqueline S. Casey (1927–1992) and Ralph Coburn (1923–2018). It was Mattill's idea to invite international designers to help out staffers in the office from January to May, the busiest time in the office, when between thirty and fifty MIT Summer Session course announcements had to be written, designed, and printed.[14]

There has been speculation about how Thérèse Moll came to be invited to work as a visiting designer at MIT. In early 1958, Karl Gerstner embarked on a lecture tour of the

USA with his wife, Ingrid, and his colleague Markus Kutter (1925–2005). The tour was arranged by Allon Schoener (1926–2021) and Noel Martin (1922–2009), organizers of the 1957 *Swiss Graphic Designers* exhibition that premiered at the ICA Boston and then traveled to venues around the USA.[15] Schoener and Martin also organized an extensive tour for Gerstner to visit schools and universities, where he had the opportunity to speak about his work and the new Swiss design movement. One of those universities was MIT. Gerstner must have recommended Thérèse Moll be invited as the visiting designer at MIT for 1959.[16] In accepting this invitation, she followed the example set by both Emil Ruder and Armin Hofmann, who encouraged their students "to travel the world, and to lecture and publish as advocates for rational design."[17,18]

Figure 2.13.5 Thérèse Moll, front cover for "Aesthetics of Surfaces," summer session pamphlet, MIT Office of Publications, Massachusetts Institute of Technology, Cambridge, Massachusetts, 1959. Image courtesy of Armin and Dorothea Hofmann.

As a contemporary graphic and typographic stylist, Thérèse brought a fresh and innovative approach to the design of the MIT Summer Session announcements. The 1959 summer session course materials she produced are disciplined yet dynamic—they follow a clear internal system. Akzidenz Grotesk, known as "Standard" in the USA, was probably unavailable given the bare-bones budget for typesetting at the office. Instead, Thérèse used Futura Extra Bold, showing that the importance of Swiss typography and design was less about a particular typeface than a design methodology.

In his book *Swiss Graphic Design: The Origins and Growth of an International Style 1920–1965* (2006), Richard Hollis (1934) states: "Swiss graphic design is a concept inseparable from the grid. In typography, the use of the grid grew from the nature of letterpress printing ... type metal, cast on a rectangular base, was composed in horizontal lines arranged in vertical columns and locked in a rectangular framework. Unlike the infinite scale possible on digital systems 50 years later, type and spacing material were produced in fixed sizes: typography was a modular system."

Thérèse Moll is credited for introducing her American design colleagues, Jacqueline S. Casey, Ralph Coburn, and freelancer Muriel Cooper (1925–1994), to modular typographic systems and "ragged right" configuration for running text blocks was not widely practiced in the USA at that time. In *Posters: Jacqueline S. Casey: Thirty Years of Design at MIT*, Jacqueline Casey acknowledged that Thérèse was the catalyst for what later became known as the "MIT style." She wrote:

> Thérèse Moll, a young Swiss designer, was the critical visitor. She introduced the office to European typography. She had been well-trained in the design of modular systems. This use of proportions in designing publications series became a useful tool for developing MIT's image. Although much has been modified by time, technology, and the work of other designers in the office, the basics that Thérèse brought with her are still operating today.[19, 20]

Upon her return from the USA, Thérèse accepted a staff position at Le Porte Echappement Universal, a Swiss watch company founded in 1931 and located in La Chaux de Fonds, the French-speaking part of Switzerland. The design work Thérèse accomplished while on staff was her most sophisticated and technically proficient.

On September 27, 1961, Thérèse Moll sadly took her own life.[21] She was just shy of twenty-seven years old. In the three years I have searched for information on this gifted and courageous young designer, I learned that everyone who knew Thérèse Moll thought, "she left us way too soon and that she had such a promising career ahead of her." Her early death shook the core of the professional design community. One can only wonder what she might have achieved and those she might have inspired had she lived a longer life.[22]

© **Elizabeth Resnick**

Notes: First published in *EYE* Magazine 98, Spring 2019, "The Enigma of Thérèse Moll" was revised with footnotes and retitled "Thérèse Moll: An Enigma Gone Too Soon."

NOTES

1. Letters from Dorothea Hofmann to Elizabeth Resnick, dated February 5, 2015, February 25, 2018, and September 20, 2021. "All four years in one room was a big advantage. First-year students could see what fourth-year students did. It was a special challenge for the teacher—either Armin Hofmann or Donald Brun—to teach advanced students and newcomers at the same time. It was very inspiring."

2. Letter from Dorothea Hofmann to Elizabeth Resnick dated September 20, 2021. Dorothea Hofmann remembered sitting beside her friend Thérèse Moll for all four years in Armin Hofmann's graphic design class.

3. Letters from Dorothea Hofmann to Elizabeth Resnick, dated April 2, 2015 and January 6, 2019.

4. Letter from Dorothea Hofmann to Elizabeth Resnick, May 31, 2015. According to Dorothea Hofmann, Gerstner sat next to Moll in the class. He had already finished his design education but still attended classes in the evening. Shortly afterward, they became a couple. "Karl and Thérèse met when he came to a lettering evening class 5–7 p.m. taught by Armin Hofmann, and Karl sat next to her (that was in 1950/1951)."

5. Letter from Dorothea Hofmann to Elizabeth Resnick, March 4, 2016.

6. Email from Bruno Monguzzi to Elizabeth Resnick, dated March 11, 2015. "In 1981, when I was working on the exhibition *Lo Studio Boggeri 1933–1981* for the Milan Triennale, and on the book for Electra with the same title, I remember asking Antonio Boggeri about Thérèse Moll. The few brilliant works I had seen published in *Schweizer Grafiker* (1960) and in *Neue Grafik* (issues 2/1959; 4/1959; and 10/1961) had made a great impression on me. The question was: How come there were no works by her in the various boxes I had viewed to make a selection? He answered that Thérèse was in the office just for a very short period."

7. Letter from Dorothea Hofmann to Elizabeth Resnick, dated March 4, 2015. "I have very little of her school work. But her mother gave me a portfolio with many samples of her professional work after Thérèse's death. I kept this work all these years."

8. Email from Bruno Monguzzi to Elizabeth Resnick, dated Monday, May 11, 2015: "I spoke with Lora Lamm, who was in Milan at the time. Lora was also at Studio Boggeri for a very short time. She remembers spending a day in Bergamo with Aldo and Elisabetta Calabresi, Thérèse Moll and Karl Gerstner. Lora remembers that Thérèse was very beautiful and very happy and apparently Thérèse was in love with Karl Gerstner."

9. Hollis, Richard, "Karl Gerstner: Principles, Not Recipes," in *Writings about Graphic Design*, Occasional Papers, 2012, pgs. 193–194.

10. "I never had much close contact with Bühler. First of all, he had little time for his apprentices. Secondly, I wasn't interested in advertising and wouldn't be for quite some time. Still, I felt I was in the right place because he always succeeded in recruiting interesting people for his studio. One of these was Max Schmid, who became my teaching master." *Karl Gerstner: Review of 5 x 10 Years of Graphic Design,* Hatje Cantz, 2001, pg. 13.

11. "The Geigy style was due to the consistent quality of design and a common view of what constituted Good Design and who could do it. The number of celebrated Swiss designers who worked for the firm in the 1960s is astonishing. As well as Schmid, they included Karl Gerstner, Armin Hofmann, Gottfried Honegger, Stephan Geissbühler, George Giusti, the photographer René Groebli, Jörg Hamburger, Andres His, Gérard Ifert, Warja Honegger-Lavater, Fridolin Müller, Thérèse Moll, Enzo Roesli, Nelly Rudin, Albe Steiner and Fred Troller. Their work for Geigy underlines the claim that 'Swiss' graphic design established itself first in Basel." Quote from the "The Chemistry that Created a Winning Swiss Formula" exhibition review by Richard Hollis, *EYE* 72, Vol. 18, Summer 2009, pg. 85.

12. Janser, Andres, and Junod Barbara, eds. (2009). *Corporate Diversity: Swiss Graphic Design and Advertising by Geigy, 1940–1970.* Zürich: Museum für Gestaltung, Baden, Switzerland: Lars Müller Publishers, pgs.10, 15.

13. Email from Jonas Deuter to Elizabeth Resnick, dated September 6, 2021. "The break-up of Gerstner and Moll finally became clear to me in conversation with Dorothea and Matthias Hofmann: Both K.G. and T.M. came from working-class backgrounds; but while Thérèse Moll remained down-to-earth, Karl Gerstner had an unquenchable striving to be someone else."

14. Winkler, Dietmar R., ed. (1992). *Posters: Jacqueline S. Casey: Thirty Years of Design at MIT*, Cambridge, MA: MIT Museum, pg. 9.

15. Letter from Dorothea Hofmann to Elizabeth Resnick, dated August 11, 2015. "Armin and I met Allon Schoener at Aspen, Colorado, where Armin spoke about his design education (methodology) at the design conference of 1956. Among other examples, Armin showed posters of Karl Gerstner. Allon Schoener and Noel Martin, both from Cincinnati Art Museum, were interested in making an exhibition about 'Swiss Design.' Allon came to Basel in 1957, organizing together with Armin and me the details for this exhibition and—amongst other visits to various designers—visiting Karl Gerstner. Gerstner had already left Geigy and was in the process of building up his own design studio."

16. Email from Louise Paradis to Elizabeth Resnick, January 13, 2016. "I talked with Dietmar Winkler and John Mattill. From their conversation, it seems that Karl Gerstner recommended Thérèse Moll." This was also confirmed in a letter from Dorothea Hofmann to Elizabeth Resnick, August 11, 2015. When Allon and Noel met with Karl Gerstner in Basel regarding the *Swiss Graphic Designers* exhibition, Gerstner expressed an interest in embarking on a lecture tour of the USA. "Allon and Noel organized an extensive tour to schools and universities all over the United States, where Karl contacted many people and spoke about his work and the new Swiss design movement. I am sure he was also at MIT. This was—in my opinion—how he was able to have Thérèse receive an invitation to MIT. He must have recommended her."

17. Conradi, Jan (2010). *Unimark International: The Design of Business and the Business of Design*. Baden, Switzerland: Lars Müller Publishers, pg. 11.

18. Letter from Dorothea Hofmann to Elizabeth Resnick, dated September 22, 2021. According to Dorothea Hofmann, Thérèse Moll spoke German, French, and enough English for her to work at the MIT Office of Publications.

19. Winkler, Dietmar R., ed. (1992). *Posters: Jacqueline S. Casey: Thirty Years of Design at MIT*, Cambridge, MA: MIT Museum, pg. 17.

20. Email from Dietmar Winkler to Elizabeth Resnick, dated February 15, 2015:

"Thérèse introduced the office to modular typography and 'Ragged Right' for running text blocks, which, in the US was very unusual. However, if you look at Gerstner's studio, for which Thérèse also worked, they were masters in modular type arrangements."

21. Email from Rosmarie Tissi to Elizabeth dated Monday, January 5, 2015: "… she died after an unhappy love affair (I think with a director of this firm). I remember how much I was moved about her sad end."

22. Email from Rosmarie Tissi to Elizabeth Resnick, dated Monday, January 5, 2015; Letter from Gérard Ifert to Elizabeth Resnick, dated March 25, 2015; letter from Friedrich Schrag to Elizabeth Resnick, dated November 20, 2015; and letters from Dorothea Hofmann to Elizabeth Resnick, dated May 31, 2015, and September 7, 2017.

2.14

Eiko Emori: Designer, Artist, and Trailblazer

Stephan Rosger

For a country that values cultural diversity, gender equality, and inclusion as Canada supposedly does, you'd think that its design history would reflect those values. If you're not familiar with our design history, it tells the story of how a dozen or so white men used modernist graphic design to pull us out of the shadow of British rule, thus creating a new "golden era" filled with "optimism, growth, and modernity." It is a narrative that hasn't changed for decades. But then again, why would it? The origin story that shapes Canadian graphic design is the same one that shapes the psyche and identities of many Canadians, including the design leaders, institutions, and organizations that steer the profession. If anything, Canadian design has doubled down on this narrative with films like *Design Canada* and archives like Canada Modern, both of which contain little to no critical perspective of our design history within the context of race, sex, or class. You'd think that with the Women's March of 2017, the global reckoning of inequality after George Floyd in 2020, and the discovery of thousands of indigenous children in unmarked graves since 2021, Canadian design would re-evaluate the exclusionary narratives that

Figure 2.14.1 Eiko Emori, photographic portrait circa 1974. Photograph by Keiichi Okura, Tokyo, Japan.
Image courtesy of Eiko Emori.

reinforce today's outdated hierarchies within the profession, and approach history differently for the sake of a more inclusive present and future. It hasn't.

What kind of achievement guarantees someone a spot in the historical canon of Canadian graphic design anyway? Graduating from an Ivy League school like Yale? Studying under the most influential graphic designers of the twentieth century? Running a multi-award-winning design studio? Redefining an entire genre of publishing? Being a master in book design and typography, with an ability to typeset in multiple languages and scripts, including Hebrew, Japanese, and Syllabics? Revitalizing indigenous languages across Canada through the computerization of Canada's first professionally designed syllabic typeface? How about being a longtime advocate of human rights, equality, and designer's rights?

Japanese Canadian typographer, graphic designer, and artist Eiko Emori accomplished all of this and much more. Still, compared to her white male counterparts, she has received very little recognition for the depth and range of her accomplishments over the past fifty years. If that wasn't enough, many of her accomplishments were during the mid-century, a time when there was considerable prejudice and inequality toward women and visible minorities. She was also a working mother during a time when most women were resigned to a life of homemaking and domestic servitude. With raising her daughter and managing a bustling design studio, she did both. Recognition for her enormous contribution to Canadian and Japanese design is long overdue.

Eiko Emori (江森瑛子) was born in Dairen, Japan, on March 19, 1938.[1] Her father was a trader for Mitsubishi Trading Company[2] and her mother honorably fulfilled the role of homemaker, raising both Eiko and her younger sister as their father worked abroad. In 1940, the Emori family moved from Dairen to the ancient coastal city of Kamakura, where they lived in an old summer house that belonged to her grandparents. With the ongoing Second Sino-Japanese War and Japan's entry into the Second World War in 1941, not only did Kamakura feel safer than Tokyo (where her parents had lived previously), but it was also a better place to raise children: "We were very lucky to even have a house," Eiko says. Despite her country being engulfed in war, Eiko found refuge in her parents' book collection, and it was this book collection that sparked her interest in design: "All I ever wanted to do from that time on, since I was a small girl, was design books—That's what started it all."

Eiko had several favorite books growing up, including an exceptionally good series of Bible stories. She also loved the work of venerated illustrator Shigeru Hatsuyama (初山滋) (1897–1973). The wide variety of illustrations Eiko encountered throughout her parent's book collection would also spark another passion of hers: drawing. To Eiko's benefit, her friend's father from school gave drawing lessons, and at eleven, she became his student. She describes his teaching style: "He taught us a little bit of drawing, a little bit of thinking, and …" Eiko pauses mid-thought: "Come to think of it, he taught us how to see." The name of her teacher was the celebrated artist Takuji Nakamura (中村琢二) (1897–1988).[3]

In 1955, the family moved to London. It was an optimistic time; She had access to some of Britain's best art and design schools, but unlike her peers attending university in Japan, Eiko also had to overcome language and cultural barriers. Regardless, she applied to the graphic design program at the Central School of Arts and Crafts (Central St. Martins).[4] Without knowing any English, she went in for an interview and showed them her small portfolio of drawings. Noting that "the entrance exam was not as rigorous as Japan,"[5] Eiko soon received a letter of acceptance, likely making her the first Japanese female to attend (and later graduate from) Central's graphic design program.[6] Jesse Collins, a highly influential educator and mentor to many students at the school, was head of the design department. But it was his eventual successor, future founding partner of Pentagram design studio Colin Forbes (1928–2022), who would usher in and orientate the young and impressionable Japanese student to her new life at Central, leaving a lasting impression of kindness on her in the process.

During her time at Central between 1955 and 1958, Eiko trained under many well-known British designers such as Jesse Collins, Colin Forbes, "Graphic Design's Moral Compass" Kenneth Garland (1929–2021), British infographics pioneer Peter Wildbur (1927), renowned British calligrapher M.C. Oliver (1886–1958), and many others. Although she was a design student, Eiko had always been an artist at heart, so in the summer of 1956, she decided to take drawing classes at The Académie Grand Chaumière in Paris. She dedicated her other summers to learning the French language at a school in Tours, France.

Many early pioneers of British graphic design would come to Central as visiting professors, including Hans Schleger (1898–1976). An old school pioneer of modernist design, Schleger lived and worked in the United States before moving to England from Germany in 1932 to escape Naziism. He had a prolific career in England but was also known for his genuine affection and generosity.[7] Having witnessed Eiko's work firsthand during a visit to Central, Schleger wrote her a letter of recommendation upon graduating. Years later, she applied to Yale and received a scholarship. Although Schleger's letter helped with the application, the scholarship was obviously a direct result of Eiko's talent, something Schleger detected very early on.

After graduating from Central School in 1958, Eiko moved to Tokyo and almost immediately began freelancing for multiple clients, including Asahi Shimbun and Iwanami Shoten publishers. She also worked for Hakuhodo, a full-service advertising agency. She would cross paths with many great designers while working in Tokyo, including Yusaku Kamekura (亀倉雄策) (1915–1997), who was a leading figure in the Japanese graphic design world. In 1960, she landed a job in art directing and designing a new magazine called *Asahi Sonopress* (later *Asahi Sonorama*) for Asahi Shimbun Publications. The magazine's name came from the thin, cheap, flexible counterparts of vinyl records called Sonosheets (aka flexi discs) that were included in each issue. "The publishers thought that soon people would not bother to read newspapers at all, but instead, the newspaper would talk to them."[8]

In 1961, while working at both Asahi Shimbun and Hakuhodo, Eiko started working for Iwanami Shoten, one of the foremost publishing houses in Japan.[9] Eiko's parents were old friends with Iwanami's managing director, Isamu Kobayashi (小林勇). Kobayashi knew that Eiko enjoyed reading Iwanami's books ever since she was a little girl, so one evening, after dinner and drinks with the family, Kobayashi wrote a promissory note to Eiko (who was then thirteen), saying that when she grew up, he would give her a job at the company. Ten years later, Kobayashi kept his promise, and at age twenty-three, Eiko was tasked with redesigning Iwanami's extensive portfolio of international children's literature, including works by British author Arthur Ransome and Hugh Lofting's *Doctor Dolittle* series. Eiko's modernization of the books included replacing the traditional mincho style typefaces with gothic typefaces, making them easier to read for children. Emori wasn't the first in Japan to shift away from traditional typography, but the changes she made for Iwanami's large portfolio of children's books definitely set a precedent within Japanese children's publish-

Figure 2.14.2 Eiko Emori, Arthur Ransome Series, Vol. 7, "Didn't Mean to Go to Sea," November 1967, published by Iwanami Shoten. Image courtesy of Eiko Emori.

ing; a remarkable achievement considering Emori's Western training was steeped in the pliability of Latin-based type forms.

After three non-stop years of successful freelancing, Emori was offered a scholarship to Yale's graphic design program. It was perfect timing: "I was much too busy and needed something more in terms of studies. I also wanted to see what the US was like, so going back to school seemed like a good idea."

In 1961, Emori made the long 11,000-kilometer journey from Tokyo to New Haven, Connecticut. As a foreign student, Eiko stayed at International House, which allowed students with a wide variety of backgrounds to meet and share their experiences and cultures while going to Yale. Some of the students at International House were refugees, including her future husband of ten years, Gyula Péch, who was taking his Masters of Forest and Ecology. Prior to Yale, he had been studying in Sopron until the Hungarian Revolution forced him out of his country.

With Alvin Eisenman (1921–2013) as department head, Emori trained under names such as Norman Ives (1923–1978), Paul Rand (1914–1996), Herbert Matter (1907–1984), Bradbury Thompson (1911–1995), John Hill (1934), and more. On top of studio classes, students were also required to take lecture classes outside of the design department. One of these courses included Josef Albers's famed color theory course. Albers had retired in 1958 (three years prior), but it was still being taught by his longtime assistant, Sy Sillman (1924–1992). Undergraduate and graduate design students were mixed together in the studios, so every student knew every other student.[10] Eiko's classmates included British photographer Tony Ray-Jones (1941–1972), Colombian graphic designer and illustrator David Consuegra (1939–2004), type designer Ron Arnholm (1939), curator and art historian Linda Konheim Kramer (1939), Oscar-winning director Michael Cimino (1939–2016), and Eisenman's eventual successor as director of Yale's graphic design program, Sheila Levrant de Bretteville (1940).[11]

In 1962, Eiko landed a summer job at the renowned architectural firm I. M. Pei & Associates (now Pei Cobb Freed & Partners) in New York City, where she worked with a small design team of designers to create signage, marketing, and other materials for Place Ville Marie, a forty-seven-story cruciform office tower that was being built in Montréal, Canada.

In her final year at Yale (1963), Eiko was selected to design the upcoming (eighth) issue of *Perspecta*, the oldest student-edited architectural journal of its kind in the United States. Slowly, the project morphed into her graduating thesis project, and following its publication, she received two awards: One from the Type Directors Club (TDC) and another from The International Center for the Typographic Arts (Typomundus 20).[12] Looking through the TDC 11 Awards catalog, you'll see Eiko's thesis holding its own among other winning entries by Herb Lubalin (1918–1981), and Milton Glaser (1929–2020) / Push Pin Studios.

Figure 2.14.3 Eiko Emori, cover, *Perspecta: The Yale Architectural Journal*, Vol. 8, New Haven: School of Art and Architecture of Yale University, Image courtesy of Eiko Emori.

Emori may have also been the first-ever Japanese woman to have graduated from Yale's graphic design program. In Sasha Newman's book *Yale Collects Yale* (1993), there's an extensive list of every student who graduated from the art and graphic design programs between 1951 and 1992, and aside from Emori, who received her MFA in Graphic Design in 1963, there only appears to be two other female names of Japanese descent. The first was Georgia A. Matsumoto, who received her MFA in Painting in 1969. The second is Lisa Ouchi-Yamamoto, who received her MFA in Graphic Design in 1986. The significance of Eiko's achievement as a Japanese woman cannot be understated here.[13]

Almost immediately after graduating in 1963, Eiko and Gyula got married and moved to Toronto, Canada, where Gyula attended the University of Guelph while Eiko worked for Stewart & Morrison in Toronto doing package design, publishing design, and logo design. In 1965, Eiko gave birth to her daughter, Emilia. Later the same year, they moved to Victoria,

B.C., until finally settling in Ottawa in 1967. Gyula worked for the government while Eiko continued on a freelance basis from her home, where she could watch her daughter. To drum up freelance work, she left her card with various government offices and institutions around the nation's capital, including the National Gallery of Canada (NGC).

In 1968, after a decade of trailblazing her way around the world through industry and institutions dominated by men, Eiko was hired by the NGC. This was significant because female graphic designers in general had been a rare sight within major Canadian institutions at that time, never mind female Japanese designers. As journalist Lorraine Hunter notes in her profile of Eiko for the *Ottawa Journal* (1968): "Although [the field of graphic design] is expanding all the time, Miss Emori has not come across many women other than her former classmates."[14] It's also important to note that only two decades earlier, Japanese Canadians were stripped of their homes and businesses and sent to internment camps throughout the country. The last Canadian internment camp closed in 1949 when Eiko was eleven years old and living in relative freedom in Kamakura, Japan.[15]

Over the course of almost twenty years, Eiko would design over fifty exhibition catalogs. Of those fifty plus catalogs, two have received significant attention from both design and art critics alike: *Dan Flavin, fluorescent light, etc.* (1969), and *Donald Judd* (1975).

In 1969, the NGC hosted a groundbreaking exhibition featuring American minimalist artist Dan Flavin (1933–1996), who is renowned for his fluorescent light installations. The exhibit, assembled by curator Brydon Smith and shown at both the NGC and Vancouver Art Gallery, was the first major retrospective of the artist's work. The unique catalog that Eiko designed was a hit. Flavin says in one letter to Smith: "Please reiterate to Mrs. Emori that I sense that I like the developing block-like bulk of the small catalog. Let's continue to set graphic precedents."[16]

After the Flavin catalog, Eiko continued to set graphic precedents with a variety of beautifully designed catalogs, including the triumphant *Donald Judd* in 1975, the very first catalog raisonné produced by the National Gallery. Independent scholar Ian Ferguson—perhaps the only other person to have written about Eiko's life and work—eloquently describes the Judd catalog in his homage to Eiko titled *Eiko Emori, Pioneering Graphic Designer* (2014):

> The heft of the Judd catalogue gives it a sculptural quality. The light cadmium-red of the cover was carefully chosen, evoking the artist's 1963–1964 solo exhibition at New York City's Green Gallery, the first to display his three-dimensional "specific objects." The catalogue's page layout also includes generous white space around text and illustrations, reflecting the way Judd liked his works displayed in galleries [...] When it was published, *Donald Judd* won a design award and attracted praise from leading curators in Britain and the U.S.A.[17,18]

Other NGC catalogs that deserve a closer look include *Boucherville, Montreal, Toronto, London 1973* (1973),[19] *Michael Snow: Cover to Cover* (1975), and *Hard-Edge Collection* (1975).

Figure 2.14.4 Eiko Emori, cover, *Donald Judd: A Catalogue of the Exhibition at the National Gallery of Canada*, May 24–July 6, 1975. Image courtesy of Eiko Emori.

Throughout the 1970s, Eiko continued to work for the NGC, but she also worked extensively in many departments and agencies of the Canadian government, such as the Department of Indian Affairs and Northern Development, Bank of Canada, Canada Council for the Arts, Office of the Comptroller General, and many more. This work regularly involved designing complex annuals, semi-annuals, and multi-volume reports, all typeset in both English and French as per Canadian law. For many designers, this kind of work was daunting, but Eiko could take the most intimidating and complex project and turn it into a masterpiece of typographic precision and clarity. If there was a government publication in Ottawa that required heavy lifting, Eiko was the person you would call.

Eiko was also a staunch advocate for the rights of Canadian graphic designers and fought hard to improve them by organizing her local design community. By the mid-1970s, Ottawa's design scene had grown significantly, but the closest chapter of the GDC (Graphic

Designers of Canada) was in Toronto, over 400 kilometers away. So, in 1976, Eiko and another Ottawa designer, George Rolfe, started talking about forming a local chapter in Ottawa. Members of Ottawa's design community met at her home to discuss various issues, and in October 1978, the group's application to form a chapter was accepted unanimously.[20] "I just wanted to get the group together and create a labor union type of thing," she says. Eiko was named a GDC Fellow in 1983.

Some of Eiko's most important design work came in 1978 when she was approached by the Education and Cultural Support Branch of Indian and Northern Affairs Canada to design a series of educational textbooks called *Teaching an Algonkian Language as a Second Language*. The purpose of the textbooks was to teach Algonquian languages (specifically Cree) to Indigenous teachers, teacher-aides, and language instructors.[21] Once trained, they could then go back to their classrooms and teach children in their own language instead of the language of their colonizers. But by the late 1970s, many Algonquian languages and the Canadian syllabics used for reading and writing had been systematically destroyed and replaced with English: "Not many Indigenous people knew how to speak their own language; some indigenous groups used the Roman alphabet while others used syllabics." Because of this, the textbook needed to be printed using both the Roman alphabet and syllabics. It's a straightforward concept, but they couldn't just order Cree type. Compared to the innumerable Roman typefaces that had been expertly designed by typographers, only a few syllabic typefaces existed at the time, and they were crude at best. If there was anyone who could design one, it was Eiko, but the project presented some enormous challenges. Not only was it about designing a syllabic typeface that was readable and accessible, but it was also about revitalizing Indigenous identity across Canada. Therefore, learning everything she could about Indigenous culture was crucial. So, with the help of a grant from The Canada Council, Eiko traveled to Alberta, Manitoba, and Ontario, where she met with local chiefs, linguists, and Indigenous language speakers. She also immersed herself in their culture by attending as many ceremonies and pow-wows as possible. Before long, she also inherited a nickname: "I got to be known as the 'syllabic lady,'" Eiko says.

While on the road, Eiko's assistant, Deborah Burgess, ran the studio in Ottawa: "When Eiko would take off for weeks on end, I would look after the business. I would also look after her daughter Emilia and the housekeeper. That's why Emilia and I remained so close for so many years, I was like a second mom," Burgess says.[22] Also assisting on the project, Burgess recalls:

> There was about a year and a half of solid research, double checking, and approvals before we could even get to the stage of actually going into the finalization of drafting each individual letter by hand […] She enjoyed meeting the elders and presenting her work to them because it was a socially righteous thing that she was working on. She provided a huge service to the Indigenous communities in Canada by going through this process.

In 1984, the Progressive Conservatives won the federal election, effectively ending the project. "They said 'Indian education by the Indians' and let all of the teachers go," says Eiko. "But I kept on going, meeting with educators and all of the Indigenous people I could." She also met with a committee from IBM and other computer manufacturers to discuss Unicode.[23]

"When I introduced the syllabic writing, they were very surprised and delighted to learn that there were uniquely Canadian characters." It was an exciting discovery, but it also meant that there was a lot of work to be done if this uniquely Canadian writing system were to be accessible to everyone. By the late 1980s, with type design software utilizing Adobe PostScript, Eiko worked to computerize the syllabics she had designed. Soon after, a new syllabic font was born. She named it "Emilia" (after her daughter), and with two different weights to choose from (Regular and Medium), Emilia was the very first professionally designed Canadian syllabic font for use on a computer. Reflecting on the entire experience, Eiko says: "I feel if there was one achievement I made in the whole syllabic project, is that I put Canadian Syllabics on the map."

Throughout the 1990s, Eiko used Emilia in a number of projects, including the Inuktitut translation of an NGC exhibit catalog titled *Pudlo, Thirty Years of Drawing* (*Putlu, 30-nik arraagunik titiqtugaqattalirninga*), and for an Inuit cultural magazine published by the Inuit Tapirisat called *Inuktitut*.[24] John Bennett, who was the editor of *Inuktitut*, recalls working with Eiko on the magazine's redesign: "If you look at the magazine pre-1989, it has a government feel to it; What she did was completely different. From a design point of view, the magazine is quite a challenge because it publishes in English, in French, in Inuktitut syllabics, and there's also Inuktitut in Roman letters."[25] John fondly remembers the positive feedback they received from the magazine's Inuit readership: "The Inuit who I worked with said Emilia was the best Inuktitut font that they had ever seen because it was very easy to read, and it looked so nice." Looking back on Eiko's contribution, he says: "She really believed in the service of people and that the magazine should be the best it could possibly be. That required a lot of effort on her part."

Starting in 1992, Eiko moved back and forth from Ottawa to Tokyo to take care of her mother. During this time, she tried to freelance in Tokyo again, but the economic conditions were unfavorable. It was a challenging time, but it also gave her an opportunity to learn more about glass-making. A member of the Royal Canadian Academy of Arts since 1976, she was first attracted to glass-making years earlier when admiring the colorful work of French artist Émile Gallé (1846–1904), whose factory produced remarkable examples of Art Nouveau. In Tokyo, glass-making was concentrated in an area known as Katsushika-ku, and it was there that she found some pâte-de-verre classes being offered at the Sanko glass factory. A process that Eiko describes as "very cumbersome and time consuming," pâte-de-verre is a glass-making method where powdered glass is placed into a high-temperature plaster mold and heated for up to a week while it fuses all together.

Figure 2.14.5 Eiko Emori, cover, and pg. 33, *Inuktitut* magazine, Issue #72, 1990, published by Inuit Tapirisat of Canada. Image courtesy of Eiko Emori.

It's incredibly labor-intensive, but she fell in love with the process and carried on with her new interest upon her return to Canada. She sees glass-making as an extension of her art training and is happiest when a piece emerges more beautiful than expected.

Eiko was born during a time of great upheaval, but under the guidance of artist Takuji Nakamura, she would learn "how to see" and capture the stillness and beauty of the world through drawing. Then, under the tutelage of modernist design masters, she spent a lifetime creating order out of chaos. Now, with her pâte-de-verre practice, there's an almost complete letting go of order that I find very beautiful and poetic. Having grown up at her grandparents' summer house in Kamakura—with its "garden by the sea"—Eiko often points to a favorite thirteenth-century poet of hers named Minamoto no Sanetomo (源実朝) (1192–1219) as inspiration for her delicate, nature-inspired glasswork: "I love reading and re-reading his powerful poems of the sea. This rhythmic, dancing, joyous movement of waves resonates not only in me but is translated into the glass pieces I create." Her favorite poem by Sanetomo is this seventeen-syllable poem of the classic style:

大海の磯もとどろに寄する波破れて砕けて裂けて散るかも

"Even the rocky shores of the biggest seas may be broken, torn, and scattered by the waves coming in."

Eiko now focuses exclusively on creating award-winning glass pieces at her studio in Ottawa.[26]

© **Stephan Rosger**

NOTES

1. The modern Chinese name, Dalian comes from a Chinese reading of the Japanese colonial name Dairen, which itself was a loose transliteration of the Russian name Dalniy. Source: "Russian Dalian," Wikipedia.
2. Mitsubishi Trading Company was the arm of Japan's most important conglomerates producing ships, aircraft, and machinery. Source: "Mitsubishi Corporation," Wikipedia.
3. Takuji Nakamura (1897–1988) was also in the 1936 Berlin Olympics as a participant in one of the many artist competitions. A member of the Issuikai (一水会) art group, he won various awards for his painting such as the Japanese Art Academy Prize. Source: olympedia.org.
4. In 1955, Central's graphic design program was called The School of Book Production and Graphic Design. Central School of Arts and Crafts is now called Central St. Martins.
5. Eiko wrote about her experience at Central for a special "Design Education" issue of *Design* magazine, which featured essays from Japanese graduates who attended various design schools throughout Europe. See: "London County Council Central School of Arts and Craft," *Design* (デザイン), No. 19, April 1961, Eiko Emori, Bijutsu Shuppan, pgs. 18–19.
6. This is based on looking for names of Japanese descent in the 1951–62 student registrar (Central St. Martins Collections and Archives). Because one cannot determine a person's country of origin by name alone, further verification is required. Eiko did not recall seeing or meeting any other Japanese students during her time at Central.
7. Paul Rand writes about Schleger's affection and generosity in a tribute to him for *Graphis* in 1977. See: Rand, Paul, Him, George, "Hans Schleger (Zéró)," *Graphis*, Vol. 32, No. 188, pgs. 518, 566, 1977–78.
8. Hunter, Lorraine, 'Graphic Designer Meets Challenge of Making Things Look Better, Read Easier,' *The Ottawa Journal*, Saturday, August 3, 1968, pg. 19.
9. Coincidentally, Iwanami Shoten is also where Shigeru Hatsuyama, one of her favorite childhood illustrators, had worked before her.
10. Kelly, Rob Roy, "The Early Years of Graphic Design at Yale University," *Design Issues*, Vol. 17, No. 3, Summer 2001, pg. 10.
11. Paul Rand was outraged that de Bretteville was chosen to replace Eisenman as director: "… a member of the faculty since the late 1950s, [Rand] resigned on principle, and encouraged his long-time colleague Armin Hofmann to do the same." Lupton, Ellen, "Reputations: Sheila Levrant de Bretteville," *EYE* Magazine 8, Autumn 1993.
12. Typomundus was an exhibition "showcasing the greatest typography of the twentieth century," and was held in Toronto. See *Typomundus 20: A Project of The International Center for the Typographic Arts*. New York: Reinhold Publishing Corporation, 1966.
13. Because one cannot determine a person's country of origin by name alone, further verification is required. Eiko did not recall seeing or meeting any other Japanese

students during her time at Yale. Also see: *Bulletin of Yale University, School of Art and Architecture*, Series 57, 58, 59, No. 1, 1961, 1962, 1963, Archives at Yale.
14. Hunter, "Graphic Designer Meets Challenge of Making Things Look Better, Read Easier," 19.
15. Five of those camps were located in Ontario, including one in the small town of Petawawa, just a two-hour commute from Ottawa where Eiko lives.
16. Ferguson, Ian C., "Contemporary American Art at the National Gallery of Canada (1967–79): The Surprising Legacy of Brydon E. Smith," Carleton University, 2014, pg. 56.
17. Ferguson, Ian C., "Eiko Emori, Pioneering Graphic Designer," *NGC Magazine*, 2014.
18. Judd's catalogue raisonné had one caveat: Because the NGC is federally operated, budget overruns for the ambitious catalog design rang alarm bells in government: "Canadian Parliament didn't like it," Eiko says. In 1975, a paper-bound copy of Donald Judd cost $15 Canadian, whereas a cloth-bound copy would set you back $20. The catalog is now highly coveted by collectors and can fetch tens of thousands of dollars.
19. "Boucherville, Montreal, Toronto, London 1973" was featured in Design Canada's 1974 issue of "The Look of Books" for its merits in layout, photography, and format.
20. *Graphic Design Journal*, Issue 5, pg. 30, Graphic Designers of Canada, 2002.
21. The Algonquian languages are a subfamily of Indigenous American languages that include most languages in the Algic language family. It's divided into three families according to geography: Plains, Central, and Eastern Algonquian. From these, there are around thirty subfamilies. Although some have survived colonialism, many are on the brink of extinction. Plains languages include Blackfoot and Cheyenne; Central languages include Cree and Ojibwe; whereas Eastern languages include Mi'kmaq. Source: "Algonquian languages," Wikipedia.
22. Deborah Burgess. Interview conducted by Emily Lu, July 20, 2021.
23. Unicode is an information technology standard for the consistent encoding, representation, and handling of text expressed in most of the world's writing systems. Source: "Unicode," Wikipedia.
24. Inuit Tapirisat is a national representational organization protecting and advancing the rights and interests of Inuit in Canada.
25. John Bennett. Interview conducted by Emily Lu, August 18, 2021.
26. Pattie Walker Memorial Award in Architectural Glass (2021).

2.15

Dorothy E. Hayes: Shaping the Narrative of Black Creatives in Design

Tasheka Arceneaux Sutton

The graphics industry is always searching for fresh talent. It is a field where talent is the prime prerequisite. I'm among the few blacks in this field.—Dorothy Hayes.[1]

The 1960s was a transformative decade in many aspects of American society, including graphic design. Although the field was evolving and expanding, it was not immune to the social and racial tensions that characterized the era. Black graphic designers faced unique challenges during this period as they sought to make their mark in a predominantly white industry.

This time marked a challenging period for Black Americans as they fought vigorously for basic human rights during the civil rights movement while simultaneously working to dismantle the oppressive system of Jim Crow. In this context, industries like advertising held substantial contracts with major corporations and did not favor having Black designers on staff. Moreover, for most Black creatives, breaking into or gaining a foothold in

Figure 2.15.1 Dorothy E. Hayes, photographic portrait. Image courtesy of Dorothy's Door/Carol Lauretta George.

an industry predominantly dominated by white men seemed almost impossible. Graphic design work during this era often focused on serving the needs of the Black community, as exemplified by the impactful creations of Emory Douglas for the Black Panther Party.

Many young Black creatives at the time went to school to major in graphic design, but many also majored in education just in case they had difficulty making it or landing a design job. They often gave up and moved to teaching after "long, fruitless periods of seeking design work that suits them."[2] "The gap between the black designer's first creative position is considerable."[3] Black art directors working in ad agencies usually could not meet the clients in person, earning $2,000–$5,000 less than their white colleagues. Most ad agencies that employed forty art directors employed only one to three Blacks.[4]

Dorothy Hayes, who graduated from college in 1967, faced these formidable challenges when Black individuals were still denied many rights. For women in general, and especially for a Black woman, navigating and gaining acceptance in the graphic design industry was an uphill battle. However, Hayes demonstrated remarkable resilience and determination in her quest for success in graphic design while demanding recognition and respect as a Black woman. She also made it her mission to mentor young Black designers and serve as an advocate and activist, dedicated to amplifying the voices and contributions of other Black creatives in the industry.

Dorothy E. Hayes

Dorothy E. Hayes was born in Mobile, Alabama, on December 1, 1935. Her father, Earl Hayes, served as a porter for The Louisville & Nashville Railroad. In 1940, the call of military duty beckoned Earl Hayes away from his family. Her mother, Annie Laurie Hayes, primarily dedicated her days to homemaking. Tragically, the untimely passing of Annie Hayes occurred at age forty, when Dorothy was a mere eleven years old. Dorothy found herself amidst a bustling household, surrounded by her five brothers, Earl, Eugene Sr., Rudolph, Walter, and Carmen, and two sisters, Rosemary and Lauvenia, positioning her as the fifth child in the birth order.

Among her sisters, Rosemary George took on the role of Director at Cedar Grove Day Care Center, and Lauvenia Dotch pursued a career as a Probation Officer within the Juvenile Court system. In the extended family circle, Dorothy's maternal uncle, John Garrich, held the esteemed position of professor at Alabama State University in Montgomery, Alabama.

Dorothy endured the profound sorrow of losing immediate family members throughout her lifetime. Regrettably, most of her siblings, barring her sister Lauvenia, departed this world ahead of her. In a particularly poignant year, 2007, two brothers and one sister succumbed to their fates, leaving a void in her heart.

In addition to her academic pursuits, Dorothy created floats and decorated cars for the annual Mobile Turkey Day Classic. Continuing her educational voyage, she gradu-

ated in 1958 from Alabama State College, majoring in fine arts and secondary education. She proudly joined the ranks of Delta Sigma Theta Sorority Inc., the second-oldest Black women's sorority, where she was also awarded a graduate scholarship from 1960 to 1962.

Dorothy's professional ambitions led her to New York, where she embarked on her graphic design journey. Initially, she pursued an associate degree at the Pratt Institute School of Visual Arts in 1962. Later, she secured a four-year scholarship at the Cooper Union School of Art, earning her graphic design degree in 1967. During this time, her interest in showcasing the creative work of Black artists, who were the architects behind print and TV commercials, ignited.

Furthering her education, Dorothy attended the New York Institute of Advertising and achieved a certificate and doctorate equivalency. Hayes candidly recounts the challenges she and her fellow Black students faced during their college years: "I don't think that I have ever experienced more discouragement and suppression of Black artists in art. Instructors treat the Black students as though we were some out-and-out freak and a tremendous threat to the instructor, when all the student is trying to do is develop talent."[5]

When Dorothy Hayes moved to New York City, she found no Blacks she could relate to professionally. Those she tried to connect with wouldn't talk to her, or they would brush her off. This experience prompted her to become a role model for future Blacks and create experiences to spotlight their work and achievements. She said in an interview in 1968:

> When I came to New York ten years ago, I couldn't find any Blacks in the commercial art field. Finally, after I found a job on my own, I did start to encounter Black people. But in trying to develop my talent, I discovered they wouldn't give it if I went to them for some direction. Nobody wanted to take the time to show or tell me anything. I vowed then that if I made it, I would never turn my back on any Black person who came to me for advice and information and wanted to learn.[6]

Dorothy's first job was at Robert N. McLeod, Inc. She was determined to be ultra-professional and win respect as a woman and a designer. In 1971, she told a journalist, "You can't get around being a woman. They'll see it the moment you walk in the door, and they'll have to go through their man thing with you, the idea that you're theirs, that you'll do whatever they say, like an office wife. It's beautiful, though: if you present yourself as a professional, they respect you. They know you've paid your dues just like they had to."[7]

Dorothy held various positions at Crowell-Collier Publishing Company as an art productions assistant. Crowell-Collier Publishing Company published periodicals and educational and technical manuals, was incorporated in 1920, and changed its name to Crowell, Collier, and Macmillan, Inc. in 1965. The company published *American Magazine*, *The Country Home*, *Woman's Home Companion*, and *National Weekly*.[8] As an art production assistant, Hayes most likely worked closely with an art director or graphic designer to provide technical and operational support and handle prepress work for the publications.

She also worked as a designer at Murray Leff and Company Advertising Agency, and as a design consultant at Wallack and Harris, Inc. Her job titles include Graphic Design Art Director, Art and Production Supervisor, Layout and Mechanical Artist for various firms, advertising agencies, publishers, and art and production companies in New York City.

Establishing Dorothy's Door

In 1967, Dorothy founded Dorothy's Door, a graphic design studio in New York City. She described her studio "… as a living and working environment and provides accessible and convenient space for study, research, and experimentation with plastic sculptures and serves such clients as CBS Radio, AT&T, and Dell Publishing."[9] Dorothy worked with other graphic artists in the studio to develop a three-dimensional book. Ashland Oil Co. of Kentucky commissioned her to create a "Traveling Exhibition System" for corporate meetings. Other commissions included the Museum of Modern Art Bookstore, Division of Health and Natural Sciences, New York City Tech, City College (CUNY), and the Los Angeles County Museum.

Figure 2.15.2 *Left:* Dorothy E. Hayes, *Color is a State of Mind*, "Black and White: A Portfolio of 40 Statements on a Single Theme," a special *Print* magazine issue, July/August 1969. *Right:* Dorothy E. Hayes logotype, circa 1970. Images courtesy of Dorothy's Door/Carol Lauretta George.

Her design work could be more conducive to a particular style. One notable consistent element is her use of black and white, which probably coincides with modest budgets. Dorothy used simplicity and negative space in the *8 + 8* exhibition catalog. The cover design for the Advertising Association of America and "Francesca" typographic design plays with repetition and creates pattern, texture, and symmetry. Her poster entry "Color is a State of Mind" for *Print* magazine's "Black and White: A Portfolio of 40 Statements on a Single Theme" is the most memorable and one of the few examples of her work. The black-and-white poster uses flat colors and simple geometric shapes. It states, "Color is a State of Mind," with a rainbow inside the head of an abstract figure. It alludes to the negative stereotypes associated with the color black and can be interpreted as her subtle protest against the negativity associated with blackness.

Teaching Career

In 1970, Dorothy Hayes began teaching at the New York City Technical College of the City University of New York. By 1982, she achieved a full professorship teaching art in the Department of Art and Advertising in Design. As an educator, Dorothy provided her students with the opportunity for hands-on experiences with her favorite medium,

Figure 2.15.3 Dorothy E. Hayes, "Type Talks" postcard for the Advertising Typographers Association of America, January/February 1965. Image courtesy of Dorothy's Door/Carol Lauretta George.

plastics, in her studio and school, assembling the work for exhibitions and promotions. "They thus receive some financial help while they learn and develop an appreciation of the unusual properties of a new and innovative material and art form," Hayes said regarding the financial benefits of her students while learning art.[10]

Dorothy comments on how her students have benefited from doing work in plastics: "These opportunities to assist projects help in addition to learning more about art. Often in their assignments and because of their familiarity with my work. This is highly exciting because I just know that these young artists, who share my romance with plastics, will propel the use of this marvelous sculptural medium as an art form, and they will project it far into the 21st Century and beyond."[11]

She taught at four different institutions for four years as an invitational lecturer. In 1969, at the High School of Art & Design. In 1970, she taught at Rhode Island School of Design, in 1971 at Kansas City Art Institute, and in 1972 at the School of Visual Arts.[12]

Black Artists in Graphic Communication

Dorothy Hayes's most well-known work was the co-chair of the committee and the co-curator of the Black Artists in Graphic Communication Exhibition. The exhibition concept was conceived after the 1968 article written by Dorothy Jackson, "The Black Experience in Graphic Design," was published in *Print* magazine. The article addressed the lack of accessibility, diversity, and equity in graphic design and highlighted several Black graphic designers, including Dorothy Hayes, Bill Howell (1942–1975), Alex Walker, and Dorothy Akubuiro.

In 1969, Dorothy Hayes and Joyce Hopkins met with Eli Cantor (1913–2006), chairman of The Composing Room and director of Gallery 303—a gallery for young graphic designers seeking exposure to the industry. After the meeting, Cantor agreed to the exhibit proposed by Dorothy and Joyce. A Call for Entries was initially mailed to 125 names, requesting five samples from each artist.

The first of its kind, this exhibition took place in 1970 and profiled the work of forty-nine Black artists, illustrators, and designers that featured advertising identity, illustration, print, TV commercials, and packaging. Dorothy remarked: "People spend a lot of time discussing what needs to be done and what they would like to do well; we didn't … we just did it! As a result, this show, *Black Artist in Graphic Communication*, was born." She wanted to message the ad industry that Black talent was successful and existed but was "unused, misused or underused"[13] and unappreciated. The exhibition traveled across the country for almost two years and caught the attention of significant design publications like *Communication Art* (USA) and *Idea* (Japan).

Dorothy stated, "Time and time again, I've been asked by the advertising and publishing industries and corporations, 'Where are the marvelous talented, Black Artists we're always

Figure 2.15.4 Dorothy E. Hayes, logotype for Charles J. Dorkins, a film producer, n.d. Image courtesy of Dorothy's Door/Carol Lauretta George.

hearing about but can never find?' This indicates that for young Black Artists, there has always been a lack of identification with the field of Graphic Communications, an identification that could inspire them to develop their talents." For Dorothy Hayes, the exhibition "represents my background, my present, and my hope for the future."[14]

"Unlike the sports hero, stage star, or musical performer, there is no overt evidence in graphic work that an artist is black," stated Eli Cantor on the exhibition's significance. "People viewing this exhibit will be surprised to see how much major work today turns out to have been done by black artists."[15] The exhibition traveled throughout the United States and Canada and was highly publicized. Hayes was honored by the City of Mobile while the exhibit, sponsored by the State of Alabama, was on view and events during the installation in Mobile's Fine Arts Museum of the South in 1971.

Figure 2.15.5 Dorothy E. Hayes, "Francesca," a typographic design that plays with repetition and creates pattern, texture, and symmetry, n.d. Image courtesy of Dorothy's Door/Carol Lauretta George.

A Romance with Plastics

Her romance with plastics began when she discovered the medium's unique properties while working on a student assignment at Cooper Union—that plastic could refract and reflect light, changing color sequences within a three-dimensional structure. Inspired by this discovery in 1963, she began designing with plastics. She developed a theory of geometry and physics, which led to the creation of panels consisting of clear Plexiglas casing and free-form sculpture of transparent plastic rods and cast balls encapsulated within the case. Further developmental techniques using this theory enabled Dorothy to create translucent, luminous sculpture pieces—allowing the play of multi-colored light patterns produced either from a motorized unit or natural light.

Proving that plastics can be an expressive and functional medium, Dorothy created a series of transparent modular sculptures utilizing contemporary materials and maximum potential based on an awareness of total environmental design from 1973 to 1974. Her

philosophy was that "… an art form should foster communication in traditional environments and remove the isolation factor from an artist's creative activity to establish a common bond between the artist and the viewer."

Dorothy Hayes died on July 31, 2015, at seventy-nine, in the Mobile Infirmary. There is much more to discover about Dorothy Hayes and her contributions to graphic design. Still, we know she cared deeply about Black artists and designers' recognition, respect, and exposure.

© Tasheka Arceneaux Sutton

NOTES

1. Quote from *The Montgomery Advertiser-Journal*, Montgomery, Alabama, September 28, 1969.
2. William Casey's quote from the essay, "The Black Experience in Design" by Dorothy Jackson, *Print* magazine, 1968.
3. Quote from *Print* magazine, from the essay "The Black Experience in Design" by Dorothy Jackson, 1968.
4. Ibid.
5. A quote by Hayes from a 1968 *Print* Magazine article, "Black Experience in Graphic Design."
6. Ibid.
7. Ibid.
8. The New York Public Library Archives & Manuscripts. Crowell-Collier Publishing Company records, 1931–55.
9. Kirkham, Pat (2000). *Women Designers in the USA 1900–2000: Diversity and Difference.* Bard Graduate Center/Yale University Press, pg. 136.
10. Quote taken from a speech by Dorothy Hayes on April 15, 1988, at New York City Technical College when she was honored as the 1988 Scholar on Campus. Many pieces of her art were displayed in the development of her speech, "Synthesizing Experience and Art: My Romance with Plastics."
11. Ibid.
12. Teaching credits taken from Dorothy Hayes's CV.
13. Quote from Dorothy Hayes from the article "Graphic Exhibit to Feature Works of Black Artists."
14. The Gallery 303 Exhibition, "Black Artist in Graphic Communication." *Idea: International Advertising Art*, 104. 1971. Tokyo, Japan.
15. PI A LA MODE by L.H.J. printed December 27, 1969.

2.16

Agni Katzouraki: The "Light" of Greek Aesthetics in Graphic Design

Dr. Marina Emmanouil

In post-Second World War Greece, the desire for upward social mobility shaped a new era of social optimism and economic prosperity, within which Greek advertising and graphic design emerged.[1] Professional advertising and publishing also allowed women to take on unusual leading roles in traditionally male-dominated sectors. The few examples of professional women in leading positions, although the exception rather than the rule, show that graphic design, especially advertising, had become a terrain where women could acquire a new status.[2] Successful and influential women also functioned as models for other working women.

Who is Agni Katzouraki? Why is it worth presenting her story as a case among other less-represented female graphic designers worldwide? How does her story relate to the emergence of corporate identity in the 1960s? This work is undoubtedly a personal account of a Greek female graphic designer who left a well-hidden thesaurus yet to be discovered.

Figure 2.16.1 Agni Katzouraki, photographic portrait, August, 2023. Image courtesy of Agni Katzouraki.

The Early Years

Agni Katzouraki (née Megareos) was born in Athens, Greece on March 22, 1936.[3] The first couple of years of her life were spent in the neighborhood of Kypriadou, an area close to the center of Athens where many influential personalities in Greek culture and art resided, namely, the architect-painter Dimitris Pikionis (1887–1968), who became her godfather. Agni's young parents were Eleni (Elly) Tsouka (1918–2004), who, according to Agni, had a talent for painting,[4] and George Megarefs (1912–1993), an engineer who seems to have been a decisive force in her professional trajectory.

In 1939, a few months before the declaration of the Second World War, the family moved to Berlin, Germany, for her father to commence his doctorate studies in engineering[5] while her mother enrolled at the Fine Arts school. However, as the signs of war threatened their safety—Agni recalled her family rushing to the basement of their building to be safe from the bombing—the family moved back to Athens in the summer of 1940. On October 28, 1940, when the Italian army invaded Greece from Albania, starting the Greco-Italian War, Greece officially entered the Second World War. Greek military successes forced Nazi Germany to intervene and invade Greece on April 6, 1941. Under those challenging times, the family moved to London (UK) around 1946 for her father to accept a scholarship for postgraduate studies from the British Council in Athens.[6]

Shortly after arriving in London, ten-year-old Agni was sent to a boarding school where she experienced an entirely different education and lifestyle than in Greece. Her parents worked for the BBC to support the family, while her father also freelanced as an engineer. Agni noted, "My mother was talented, but she never painted again; there was no time for it. My father was a very clever and cultured man, who had high standards for himself, but 'missed a whole generation' before reaching his ambitions" due to the war situation.[7] Although she admitted to having a lot of acquaintances and some friends in her school, she never really kept those up over the years. The time in the UK was not among her best years.[8] The memories of her life in Greece, with the whole family together and the crazy play in the gardens with friends, kept alive the wish to return.[9]

Due to family interests and connections with people in the Greek art scene, Agni was exposed to art from an early age. Although she enjoyed painting throughout her life, the career path she had in mind when graduating from high school was unexpected, a rather negative surprise for her father. After graduating from school, she wanted to become a secretary following, as she revealed, the general tendency among the girls of her age who "had no aspiration to get to a university." It was her father who enrolled Agni at the Slade School of Fine Arts. As Agni remembered, "Our father wanted us to play our own role in society, to study anything we wanted that would inspire us in our lives, something that we can express ourselves, and do something with it."

From 1953 to 1956, Agni studied at the Slade School, where she took up painting and attended theory classes, such as art history, perspective, and color theory. As she recalled, "these were the basic courses that were offered traditionally at art schools at the time" and remembered Lucian M. Freud (1922–2011), a visiting professor, and the sculptor Lynn R. Chadwick (1914–2003) as essential figures that stood out during her education at Slade. Agni noted that it was among the best of the London art schools offering a classical art education at that time.

In 1953, during one of her summer visits to Athens, Agni met her husband-to-be, Michalis Katzourakis (1933), after finishing her studies. Greece in 1956 was a country recovering from a bloody civil war (1943–49) and the destruction of the Second World War. Agni and Michalis lived with his parents in their home (where they still live today) and worked as freelance graphic designers. She remembered those early years as challenging ones, in which they designed Christmas cards and sold them, among other things, to get by. In the late 1950s, the couple was thinking of moving back to London, and Agni had already attended—for a short time—some classes at the Central School of Art to get practice in graphic design applications. The couple was considering a move back to London when, in the late 1950s, they received an invitation from Freddie Carabott (1924–2011)[10]

Figure 2.16.2 *Left:* Agni Katzouraki, poster for Mobil Oil, circa 1960s. *Right:* Agni Katzouraki, package design for El Greco Toys, 1968. Images courtesy of Agni Katzouraki.

to work in his "graphic arts" studio. Soon, Carabott's art studio expanded and, with Michalis Katzourakis as a partner, became the K+K Athens Publicity Centre (1962).[11] Slowly, they gained more prestigious commissions, including those from the Greek National Tourism Organisation (GNTO).[12]

In 1962, Agni joined K+K, designing a range of graphic work, such as posters, tourism pamphlets, brochures, leaflets, book covers, corporate logos, advertising, and illustration for cultural and commercial promotion of products, companies, and organizations. Among her distinctions are the Rizzoli award (Milan) for three consecutive years (1964, 1965, 1966) for the "Mobil Oil" advert, the "El Al" airline, and "Katrantzos Women's Fashions," respectively. During that time, she gave birth to two daughters, Loukia (1960) and Ellie (1968); she is now a grandmother of five grandchildren.

As a team, they received exposure in the international press for their work.[13] Freddie, Michalis, and Agni were perhaps the most renowned Greek graphic designers internationally in the late 1950s and 1960s, decorated with world design awards and distinctions and referenced in Graphic Arts and Design almanacs, such as the *Who's Who in Graphic Arts*.[14] Among the most celebrated work of this triad of "modern" graphic designers in Greece were their posters of the early 1960s. These posters employed a minimal composition consisting of a photograph (either plain or highly contrasted) of an antiquity (detail of a temple, sculpture, etc.) against a bold color background and the title "Greece" in either an upper- or lower-case (usually) sans-serif typeface.

In contemporary Greek press, the work of K+K is presented as "little known" to the younger generation. Apart from the retrospective of their work at the *Design Routes* in 2008, only a few publications and academic works present their design contribution.[15] Retrospectively, Fani Lampadariou, who had a leading position at GNTO in the 1950s and joined K+K as Director, argued:

> I am not surprised that the Katzourakises and Carabott have not earned the
> recognition they deserved from the Greek advertising community. Not only
> do the younger generations know very little about them, since unhappily they
> retired so early, but the very cultural gap would make them [the younger generation] unable to discern and appreciate the various aspects of any style other than
> the [current] modern Greek.[16]

Agni's work, specifically, remains in the shadows. Moreover, it is difficult to discern Agni's contribution as her work is sometimes confused with, credited to, or jointly signed by her husband.[17] And yet, as she explained, this silent role was consciously taken up to keep a healthy balance among colleagues and avoid unproductive competition in the team. Dimitris Arvanitis, a graphic designer and editor of *Design Routes*—a retrospective of the work of K+K—said that Agni was among his "discoveries." He confessed:

What I hadn't realized was her talent and separate existence in design. Now that the files and the signatures on the work are being classified, what has been revealed to me is her extraordinary illustrative maturity. Logos, illustrations, books, full of freshness and brilliance, are the maestro's legacy to young graphic artists, who must, and I am sure will, soon discover them.[18]

The Aesthetics of Color, Playfulness, and Social and Technological Limitations

Color is a critical component in design composition and, more broadly, in the design process. It comprises the visual vocabulary to communicate experiences and aid cognitive mapping. As in any culture over the years, color in postwar Greece held certain symbolic values defined by a devasting civil war that erupted shortly after the Second World War and consisted of a communist-dominated uprising against the established government of the Kingdom of Greece until 1949. On color, F. Carabott, in our 2004 interview, noted that the introduction of certain colors in the graphic design of K+K was seen as revolutionary at the time: "[We] introduced the colors black and red. […] Black [was connected to] bereavement, [thus] bad. Red [signified] Turkey, communism, 'bad' things […] these are nonsense talk, but they existed as elements and were taboo in Greek society."[19]

Indeed, as Agni herself admitted, what made their work "modern" in the late 1950s and 1960s was "the use of vivid, bright colors. Formerly, there were the 'exquisite' colors, olive-greens, browns, blues … and secondly, we chose one single element to highlight […] We had to make an image that would attract your attention among a thousand other things that existed around. To be simple and clear."[20]

The work created at K+K synchronized with work made in the big design centers. Freddie recalled: "We were certainly influenced by England, which interestingly wielded the scepters in graphic design, in smart posters and witty advertising. […] [We were also influenced] from France, and of course, from America, and the countries of the Eastern Bloc, [that is] Poland, and Czechoslovakia, which interestingly led [in graphic design] when under the Russian influence. These were the things that struck us … Among the places that influenced us, I forgot to mention, naturally, Switzerland, which wielded the scepters of clear, 'neat' design."[21] "The Swiss typographic influence, such as high-contrast photography, minimalist layout on a grid, and unmodulated color, is perhaps primarily visible in their work for the Greek Tourism Organization during 1960–1962."[22]

Agni's first work at K+K was for Martha Graham's (1894–1991) dance performance in Athens in November 1962, where the use of black-and-white, high contrast, and stylized imagery of the dancers was prominent and placed in a rigid composition with large text for the dance company. The rigidity of the letters accentuated the movement of the dancers.

Figure 2.16.3 Agni Katzouraki, poster for a dance performance by Martha Graham, 1962. Image courtesy of Agni Katzouraki.

Beyond the use of high-contrast photography, the modern look of her work was achieved by its intriguing and revolutionary color scheme. "It was a combination of photography and much more daring colors. Red, for instance, was a taboo color due to its association with Communism."[23] For the leaflets Agni produced, pure, bright, saturated colors and unusual color combinations such as magenta with orange/red or red/green were used. In our 2008 interview, Freddie Carabott made a bold statement about his friend and colleague: "Agni was the 'light' of Greek aesthetics in graphic design" with her powerful, vibrant colors.[24] This statement resonates as long overdue praise for Agni that needed to be heard and acknowledged. This was only known to her in our last interview when I told her. She was moved by it and embraced this statement with surprise: "I didn't know that Freddie said that … I like what he said."

Although the triad, Freddie Carabott and the Katzourakises, were considered the prime advocates of the International Typographic Style in Greece, they at times bent the strict rules of this design hegemony, and modifications were often subject to technical, technological, or economic limits, for a range of locally and culturally determined reasons. Professional photography was not a commonplace medium at the time due to its

complicated and time-consuming process.²⁵ As Agni explained, "At that time, it was difficult to do such a thing … to find a model, etc. […] Photography capturing everyday life was later. […]. I remember that when I started a work, my ideas were bound to the execution and printing limitations. All these play an important role. You couldn't do complicated things."²⁶ Often, it was Agni or her children who posed as models for advertising purposes, and, as she remembered, they all had a good time doing it. "Back then, there was the freedom to do these things …"

Working and Bringing Up a Family

When Agni described the years at the studio (and later at K+K), she noted: "We were not an advertising agency; we were a studio. The environment was not what we would imagine today. It was friendly and free, nothing like today's agency with work 'accounts,' then when we became an advertising agency, we were put into a mold, with account executives, secretaries, organizational charts."²⁷ "The atmosphere at the studio was very nice. We had an amazing time together. We laughed a lot."²⁸

> Things were simple back then. Everything was done with a lot of sincerity, the way we did things and related to each other. We were very good friends … Freddie, Panaghis Kanavos, Dimitris Tsopelas, and Michalis … the partners … We also worked with Lena Schina and Irini Vourloumi, creative artists, Elli Kanavou, photographer, and later with Fani Lampadariou as director and Iakovos Kampanelis as a creative writer. We had fun. We gave this tone. We didn't let anything else ruin this atmosphere. I cared about doing my work as best as I could, nothing else. In the office it was very nice not competitive. We were all friends but maybe not typical to other offices at the time. We signed the works as a team, as K+K.

Agni's commercial work included advertisements for women's products, such as swimming costumes, bridal dresses, fabrics, underwear, etc. About this work, she recalled: "I liked the women's issues, and we ended up doing a lot of work to update the image of women as well."²⁹ "In general, I liked to do this job because it had some practical application of the applied parameter, and to do it as best as I could to improve myself as much as possible."

> I happened to do the promotion for bridal dresses, for underwear, for fabrics, for swimming suits, and because I was a woman, they came out like that. In this swimming suit advert, I was the model, and I removed my face from the composition because back then, it was a great shame to do that. Back then, we didn't have models to work with. We could either draw them or … use our own kids and colleagues' kids as models … The kids had great fun! This generation is different. Our generation worked on a different code.

Figure 2.16.4 Agni Katzouraki, design for an advertisement for Stratigiou swimming costumes, 1967. Photo: N. Mavrogenis. Image courtesy of Agni Katzouraki.

Her reflection on her role as a working mother was not a very positive one, as she shared, "I can't say I was the perfect mother because I was working at the same time. I tried to make it happen by doing them "half and half," trying to keep a balance, half on the job and half on the home front. We went to work in the morning and had a lunch break in the afternoon, and then came back to work. I always had this anxiety about what was happening at home while at work … this ruined the mood a little. The babysitting was necessary, but I was not very happy with that arrangement. I had to leave my daughters with someone when I worked or when I had to go on a professional trip, such as the EXPO '70 in Japan. We came back through the US to visit my parents and sister there. Back then, my heart was tearing apart when I had to leave. Note that the communication facilities were not as easy as today. It was a difficult situation, there was always the anxiety of separation in the everyday setting too."

The Aesthetics of Humility

Retrospectively, looking at Agni's work, one can see experimentation with visual techniques and representations, from printmaking techniques and hand-drawn lines and strokes of shapes and colors to the more formalized, rigid compositions and treatment of visual elements on a grid. She reflected on this development: "In the beginning, I did more free-hand drawing, and later this became a little more controlled. But I didn't know if I was experimenting … It was something that comes out when you work on it … I don't think someone starts working having a predetermined solution cognitively. It happens, it comes out naturally, otherwise, it is kind of forced."

Agni recalled, "I was satisfied with what I was doing. I didn't want to achieve anything more in the team. I was happy simply to be there and work. From a little girl, I didn't like competition. I was satisfied with what I was. I must say, however, that I was a person with insecurities. I always doubted myself. I didn't want to promote myself among the team. Indeed, I was happy when I received an award, but I never thought I have achieved something important and after a while I forgot about it. It felt nice at the time."

Epilogue

Even though K+K won several international design awards in the 1960s—a few years later, Carabott and Katzourakis became members of AGI—and were a model for certain new graphic designers in Greece[30]—its founders changed direction in the early 1970s due to the growing division of labor in the field. They noted, "After 1970, things started to become complicated. We had account executives, they [clients] created their own design departments, and it was becoming circular … we did not have the freshness of the

beginning [the direct contact with the owner of the company]. [After that] we turned to interior design in cruise ships."[31]

Agni Katzouraki's design methodology represented an alternative to the more conventional design solutions of that time—through her radiant color palette, playful approach, and modest and focused approach to her work outside of competitive mindsets. Now in her late eighties, Agni radiates a strong aura of pride, respect, humility, and completeness. Her impressive physical appearance and charismatic, impeccable character is truly inspiring. It has been fifteen years since our last meeting, yet she did not age a bit. I was invited to her home and greeted with the same friendliness, respect, modesty, and elegance as our first time. Agni never stops being active—a joint retrospective exhibition *Incontri* (Michalis's and her work) at the Tellogleio Foundation in Thessaloniki was held in October 2023. Her advice to young graphic designers, girls and boys, is "Knowledge. Knowledge is very important, I didn't achieve it that well … to see, to observe to have an interest, this is the most important!"

© **Dr. Marina Emmanouil**

NOTES

1. Kairofilas, Y., *Athens since the War (II)*. Athens: Filippoti, 1988, pgs. 16–17.
2. Rizopoulos, A., "A Woman in Advertising," *Dimosiotis ke Provoli*, 116–117 (July 1972), pgs. 32–3. Among the sixty-seven advertisers indexed, only eight were women.
3. The author had two interviews with Agni Katzouraki: the first on March 22, 2008 (jointly with her husband, Michalis Katzourakis) and the second on July 8, 2023, both at their home at Palaio Psychiko in Athens. The quotes in this paper are drawn from the latter occasion unless otherwise stated. Other sources that refer to Agni's work include Emmanouil, Marina (2012). *Graphic Design and Modernisation in Greece, 1945–1970*. Royal College of Art (United Kingdom); Emmanouil, Marina (2014). "Modern Graphic Design in Greece after World War II." *Design Issues*, 30 (4), pgs. 33–51; Arvanitis, Dimitris, ed. (2008). *Design Routes* (ELIA & Benaki Museum: Athens); Bozoni, A. (2023). "Agni Katzouraki: At Work, We Were All … A Little Crazy," *Lifo* March 28, 2023; Eptakili, Yiouli, "Michalis and Agni Katzouraki discuss with Yiouli Eptakili," online video: https://www.youtube.com/watch?v=1UpfSHl7ukE; Rigopoulos, D., "The Birth of Greek Style in the 1960s," *Kathimerini*, Sunday, November 4, 2007, pg. 1; Bistika, E., "Freddie Carabott, Michalis Katzourakis, Agni Katzouraki: The Exemplars of Graphic Design as Art at the "Design Routes" Exhibition" in *Kathimerini*, September 2, 2009; Anon., "Social History Written … by Design" in *Ta Nea*, September 2, 2009.
4. Studied at the School of Fine Arts around 1932–35 under the tutelage of painter Konstantinos Parthenis (1878–1967).
5. Most likely at the Technische Universitat Berlin.
6. Her mother originated from the Peloponnese (Southern Greece), and her father's family roots were from the Greek island of Andros and the Peloponnese. She has one sister, Avgi, a medical doctor and

mother of three sons, who spent most of her life abroad (in the UK in her childhood and teenage years, and now in the USA with her Norwegian-American husband).
7. During the 1960s and 1970s, he taught at the Illinois Institute of Technology, USA.
8. Interview on 07/08/2023.
9. Bozoni, "Agni Katzouraki," 2023.
10. Freddie Carabott studied design at Chelsea and St. Martin's Schools in 1950–53 in London, a center of Swiss influence under the teaching of modernist designers, such as Anthony Froshaug (1920–1984), Edward Wright (1912–1988), and Herbert Spencer (1924–2002).
11. K+K was the abbreviation of the first (Greek) letters of the surnames of Freddie Carabott (Κάραμποτ) and Michalis Katzourakis. In 1957, Michalis Katzourakis met Freddie Carabott through a common friend (Panos Moliotis) and they embarked on several design commissions together—one notably for the Greek National Tourism Organization in 1958.
12. GNTO was reconstituted by the Greek government shortly after the end of the Greek Civil War in 1949.
13. Their work in the early 1960s was featured in *Modern Publicity* and *Graphis*, primarily for their work in the GNTO between 1958 and 1967. Their "modern" profile is noted in Perrakis, A., ed., *K&K: The Greek Profile of Modernism*. Athens: Perrakis, 2005; Anon., *Design Routes: Freddie Carabott, Michalis & Agni Katzouraki*. Athens: E.L.I.A.–Benaki Museum, 2008.
14. Michalis received second prize in the International Poster Exhibition in Livorno, Italy, in 1961. The following year, Michalis and Freddie won the first and second prizes among the 300 shortlisted submissions of 1,300 posters from forty countries.
15. Emmanouil, "Modern Graphic Design in Greece," 2012.
16. Zannias, "One and a Half … ," pg. 240.
17. For instance, her husband's name was included in the design credits for the illustrations she did for a series of three children's books. She recalled: "This was my only personal commission outside of K+K, but the person who commissioned me to do the job wanted to put the name of Michalis there, too. Maybe he wanted to have Michalis be mentioned in this work." Interview on March 22, 2008.
18. Rigopoulos, "The Birth of Greek Style."
19. Interview with Freddie Carabott on September 4, 2004.
20. Interview with Michalis and Agni Katzouraki on March 22, 2008.
21. Interview with Freddie Carabott on September 4, 2004.
22. Hollis, Richard (2006). *Swiss Graphic Design: The Origins and Growth of an International Style, 1920–1965*. London: Laurence King.
23. Interview with Michael Katzourakis on February 6, 2004.
24. Interview with Freddie Carabott on September 4, 2004.
25. Interview with Agni Katzouraki on March 22, 2008.
26. Interview with Agni Katzouraki on March 22, 2008.
27. Bozoni, "Agni Katzouraki."
28. Ibid.
29. Ibid.
30. Zannias, "One and a Half … ," pgs. 239–41. Zannias worked briefly in K+K and claimed that "they were the professional archetypes I watched […]. [K+K] was a hub of genuine creativity, in a pleasant and above all civilized atmosphere full of humor. […] In Greece, at any, rate, there never was another K+K."
31. Interview with Michalis and Agni Katzouraki on March 22, 2008.

2.17

Bonnie MacLean: Pioneering Psychedelic Poster Artist

Elizabeth Resnick

The 1967 Summer of Love was a momentous event within the youth-led counterculture movement of 1960s America. Between 75,000 and 100,000 young people, hippies, and beatniks streamed into San Francisco's Haight-Ashbury neighborhood, which served as its epicenter.[1] Hippies—sometimes called flower children—became synonymous with visions of a utopian society. They advocated for free love and communal living, challenging traditional American notions of personal relationships and family structures. They opposed the Vietnam War, were suspicious of the government, and rejected consumerist values.

The San Francisco Bay area was the birthplace of psychedelia.[2] The term "psychedelia" refers to a cultural and artistic movement distinguished by its fascination with psychedelic drugs such as LSD and marijuana to alter states of consciousness. It encompassed various aspects of music, art, literature, and fashion as a means to reject societal norms and embrace individuality, freedom, and exploration of the mind.[3]

Figure 2.17.1 Bonnie MacLean signing posters for the Hall & Oates concert at the opening of the Philadelphia Fillmore in 2015. Her son, David Graham, is standing behind her. Photo: © Michael Morsch. Image courtesy of Michael Morsch.

Surfacing in 1966, psychedelic[4] rock—featuring surreal lyrics, unconventional song structures, and mind-expanding musical effects—incorporated experimental electronic sounds and recording techniques influenced by cultural exploration centering on perception-altering hallucinogenic drugs.[5] "If psychedelic rock was the soundtrack to the countercultural revolution, psychedelic posters provided the sight track—the eye-cons of a cultural movement (and moment). With its bold colors and mellifluous lines, its surreal and pop imagery, and its challenging, often inscrutable type, the psychedelic poster was central in formulating and propagating a distinct aesthetic language that expressed the visual identity of the emergent counterculture."[6]

From 1966 to 1971, an unprecedented quantity of extraordinary graphic art was produced in the Bay Area, resulting from the demand for posters, handbills, and flyers advertising rock concerts in San Francisco. The two prominent patrons of this proliferation of posters were Bill Graham (1931–1991), who promoted concerts at the Fillmore Auditorium, and Chet Helms (1942–2005), leader of an organization called the Family Dog, which produced concerts at the Avalon Ballroom. "Psychedelic posters gave visual focus to new ways of seeing. An inherently populist medium, the poster brought this to the street, resonating with both political flyers and commercial advertising. But even when announcing a concert, a psychedelic poster offered a new vision—both in terms of a new visual poetics and in a new repertory of imagery—all aligned to new utopian dreams of a better society."[7]

The concerts "were intense perceptual experiences of loud music and light shows that dissolved the environment into throbbing fields of projected color and bursting strobes. This experience was paralleled graphically in posters using swirling forms and lettering warped and bent to the edge of illegibility, frequently printed in close-valued complementary colors. Younger audiences deciphered, rather than read, the message."[8]

Most rock poster artists were primarily self-taught male enthusiasts intent on giving visual form to the community they were immersed in. "The Big Five"[9] were Wes Wilson (1937–2020), Victor Moscoso (1936),[10] Alton Kelley (1940–2008), Rick Griffin (1944–1991), and Stanley Mouse (1940). A sixth artist, Bonnie MacLean (1939–2020), was the only woman to produce a significant body of work.[11] "MacLean's story is a fascinating microcosm of the roles women typically played at that time. As enlightened as hippies aspired to be, misogyny still ran rampant in the counterculture, and women often remained relegated to the background."[12]

Bonnie MacLean

Bonnie MacLean was born in Philadelphia, Pennsylvania, on December 28, 1939, to Russell MacLean (n.d.) and Beatrice (White) MacLean (1921–1996), who was just eighteen at the time. The family lived in the Trenton, New Jersey area. Her father, whose

nickname was Mac, served in the armed services and was employed as an insurance salesman. He was a handsome but complicated man, which led to an early divorce. Her mother then married Francis J. Lipinski (1920–1984) and gave birth to another daughter, Valerie, in 1947. "My mother married my father, who was willing and indeed wanting to marry and take on Bonnie as one of his own. And he raised her that way."[13]

The family lived in a duplex in Yardley, Pennsylvania, then moved into a new house in Levittown in 1952. According to her half-sister, Bonnie thrived. She was interested in art and actively involved in Pennsbury High School's theater club. "She was a very good actress and funny, and she delivered good lines, so I know she had a rather rich upbringing in those regards … she was able to do what she wanted. My mother favored her."[14] Valerie remembers Bonnie as a caring older sister—occasionally helping her with her homework. Valerie also recalls having many dolls and doll clothes messily strewn about her room. One day, she came home from school and found that Bonnie had sorted everything out for her.

Bonnie's mother and stepfather separated in the mid-1950s. Valerie was in middle school and continued to live with her father when her mother left the home. Bonnie went to live with her father in East Orange, New Jersey. She didn't have a close relationship with her father, making it difficult for them to bond.[15] Bonnie graduated high school and returned to Pennsylvania in 1957 to attend Penn State University, graduating with a degree in French in 1961. The following year, Bonnie moved to New York. "After I got out of school and realized that I didn't want to do anything with my major, I thought I'd move to New York … and the best I could do was get a job at Pratt Institute working for the head of the Department of Interior Design. There was nothing else closer to actual art I could get a job in … they allowed me to take free classes because I was an employee. So, I did take some figure drawing classes there."[16]

Bonnie became disillusioned with living in New York City and commuting to the Pratt campus in Brooklyn. In 1963, she moved to San Francisco to room with a college friend. There, Bonnie met Bill Graham (1931–1991),[17] a regional office manager for Allis-Chalmers, an international company that made hydraulic equipment, trucks, and conveyor belts. As Graham recalls in his book *Bill Graham Presents*, "One of my jobs at Allis-Chalmers was to hire and fire secretaries. An employment agency sent over a young lady named Bonnie MacLean that I interviewed. They called me up afterward and said, 'What do you think?' I said, 'No, no, she won't do.' A few days later, Bonnie MacLean herself called me and said, 'You told the agency you couldn't use my services. Could you tell me why? What qualifications *didn't* I have?' I said, 'I'm sorry. I have to tell you the truth. You were wearing the ugliest chartreuse coat I ever saw in my whole life.' She laughed. I said, 'Would you mind coming in again?' She did, and I hired her. Then we started dating, which was taboo."[18]

Graham left the company in 1964 to work as the business manager of the San Francisco Mime Troupe, a radical theater group that performed free in various local parks. After Mime Troupe leader R.G. Davis was arrested on obscenity charges during an outdoor performance in 1965, Graham organized a benefit concert to cover the troupe's legal

fees. The concert's success was a transformative experience for Graham, and he saw a business opportunity as a rock concert promoter for the Fillmore Auditorium. Bonnie joined him on the Fillmore staff,[19] serving in whatever capacity was needed—collecting tickets, scheduling and obtaining permits, passing out handbills, and counting receipts.[20] Unlike many in their community, Bonnie and Bill didn't "turn on, tune in, or drop out." She was the only poster artist content to remain drug-free.[21] "We were a pair of straitlaced,

Figure 2.17.2 Bill Graham standing in front of the Fillmore announcement board for the Blues Project, Mothers and Canned Heat Blues Band, February 17–19, 1967, painted by Bonnie MacLean. Photo: © Jim Marshall Photography LLC.

backward people when it came to drugs," Bonnie revealed. "That didn't appeal to me. I didn't want my brain diddled with."[22]

Bonnie was predominately an unseen presence as she worked behind the scenes at concerts, preferring to remain on the fringes of the emerging psychedelic culture. "I don't think I ever felt like I quite fit in, but it didn't really bother me."[23] Bonnie was also responsible for painting the in-house blackboards—announcing the current and upcoming concerts that needed to be repainted weekly—which helped her develop her lettering style. Impressed with her skill, Graham promoted her as the in-house poster artist[24] in May 1967 after his acrimonious split with Wes Wilson over money matters.

> The blackboards gave me the idea she could do posters for the Fillmore, and when Wes left, Bonnie took over. They say her style is derivative of Wes, but I think she evolved a style of her own pretty quickly. She was never anybody but her own person, with her own creative expression, and she was the person who kept the posters coming.[25]

Essentially untrained in the graphic arts, Bonnie's first poster (that she became known for)[26] was for three consecutive concerts featuring the Jefferson Airplane with The Paupers, May 12–14. For the image, Bonnie employed Medieval Gothic architectural decoration in a circular frame encompassing Herb Greene's photograph of a band member dressed as a priest—illustrations of carved figures complete the composition. She hand-drew the stylized red lettering detailing the event. Bonnie's dream of becoming an artist inspired her to explore and experiment within the 14-by-21-inch poster frame. In a 2015 interview, she said the posters "… were made to catch people's eye, but the great thing about Bill is that he didn't have an agenda … He let me have free rein. I could do what I wanted, but the object was for people to notice the poster and hopefully come out."[27]

Bonnie and Bill were married on June 11, 1967, at their home on Sacramento Street. The following weekend, they attended the Monterey International Pop Festival in place of a honeymoon. Bill recalled in his book *Bill Graham Presents*, "That summer (1967), we were working all the time. I had my work, and I was living with Bonnie, and that was my whole life. We were at the Fillmore or Winterland six days and nights a week. One day, there was a break in the schedule, and Bonnie suggested, 'Good, we can get married.' And I said, 'All right.' I think it was that simple."[28]

Shortly afterward, Bonnie created her most celebrated poster, widely considered one of the best of the psychedelic era. The Yardbirds split the billing with The Doors (opening acts were the James Cotton Blues Band and Richie Havens) for six consecutive concerts July 25–30, 1967. The poster featured brightly contrasting colored peacock feathers (a Yardbird reference) drawn with Art Nouveau-inspired flowing curves and sinuous lettering framing the woman's serene face. Bonnie's posters were distinguished for her use of faces and expressions. "What I was most interested in was the human face … I captured certain emotions that related to the era in those expressions."[29]

Figure 2.17.3 Bonnie MacLean, concert poster for The Yardbirds, The Doors, James Cotton Blues Band, Richie Havens, July 25–30, 1967 (BG75). © Bill Graham Archives LLC.

Figure 2.17.4 Bonnie MacLean, concert poster for Eric Burdon and The Animals, Mother Earth, Hour Glass, October 19–21, 1967 (BG89). © Bill Graham Archives LLC.

A few months later, Bonnie created an exquisite poster for a three-night concert, October 19–21, 1967, promoting Eric Burdon and The Animals, with opening acts Mother Earth and Hour Glass and a light show by Holy See. Bonnie drew a woman's face, displaying a Mona Lisa smile. The lettering of the band names ripples through the woman's headdress, echoing Wes Wilson's lettering style, influenced by the Secessionist lettering style from 1902.[30]

In early 1968, Bill started traveling between San Francisco and New York in preparation for opening a second venue, the Fillmore East, located on Second Avenue near East 6th Street. This area is now known as the East Village. The venue opened on March 8, 1968, and featured some of the biggest acts in rock music. Bill's constant absences constrained his relationship with Bonnie—she was lonely and pregnant. Bill confessed, "We had difficulties at home because I was not there much. The friction was created by my obsession with running both Fillmores correctly. There was no question that Bonnie had to share me with too much."[31]

Bonnie gave birth to their son David on September 19, 1968, while Bill was in New York. One of Bill's staff members airmailed the baby's picture to New York, and it was shown on screen at Fillmore East. It was the first time Bill saw his son. "Around Christmastime," Bonnie recalls, "I learned he was having this affair. Right after that, David and I moved to another place in San Francisco … I certainly had my faults in the matter, too. I don't mean to put all the blame on him."[32]

Both Bill and Bonnie had extramarital affairs before they officially separated in 1971. Once her poster work for the Fillmore ended in February 1970, Bonnie took classes at the San Francisco Art Institute, the San Francisco Academy of Art, and the California College of Arts and Crafts, where she met the artist/educator Jacques Fabert (1925–2013).[33] "They were living together, and then we moved to Mexico for nine months," David Graham recalled.[34] "After that, in 1972, we moved to Pennsylvania because my mother is from there."[35] Interviewed in 2015, Bonnie reminisced, "We both wanted to leave San Francisco and our exes. He was French and English and didn't have any idea where else to go in America, but I grew up here [Bucks County]. He really enjoyed it here."[36]

In early 1973, Bill sued to gain full custody of his then-four-year-old son, David. The judge decreed that the child spend the school year with his mother in Pennsylvania and would live with Bill for two weeks at Christmas and during the summer months. Bonnie's divorce from Bill Graham became final in 1975, but they remained friends.[37]

Bonnie and Jacques, who would become her second husband in 1981, bought a house in Buckingham, Pennsylvania, and shared a studio.[38] Living her dream of becoming an artist, Bonnie became an accomplished painter of nudes, still lives, and landscapes. Her work has been exhibited at prominent East Coast galleries and institutions.

> A person is an amazing thing. I paint people because it's the subject matter most fraught with the mystery of life. The eyes looking at nature and absorbing a sense of the immensity of something … it provokes, like poetry does. When

a portrait is done well, such as one by Velasquez, you know you're looking at a real human being.[39]

In 1990, Bonnie and David spent Christmas with Bill at his home in Northern California. "That Christmas before Bill died,"[40] Bonnie recalled, "He gave me a gift. He always had a sense of ritual, so I was made to sit down while he presented me with this big black portfolio. I opened it, and there they were—all of my original black-and-white Fillmore poster drawings. I was so touched because I hadn't seen them in twenty years."

Bonnie's health declined as she aged. "She had a stroke in 2007, and she spent 12 years trying to overcome the results of it," Valerie recalls, "Jacques would come to the hospital every day while she was recuperating. I'd get lunch there with them, and we'd go outside to eat. It was around May, and it was nice of him … he was really constant. When they finally brought her home, David had built a bathroom on the first floor. She had trouble with the stairs, and she had a bed downstairs. Jacques cooked every night. He was a good cook and would make sure there was a meal every night."[41] David adds, "She had a severe left side deficit for the rest of her life. She had trouble walking. But, her brain, her intellect, was mostly intact."

After a long decline, Jacques died in 2013 at the age of eighty-eight.

In mid-2015, Bonnie was commissioned to create a commemorative poster in the style of the 1960s San Francisco rock posters to commemorate the opening of the Fillmore Philadelphia concert hall on October 1, 2015, with the inaugural concert by Daryl Hall & John Oates. When interviewed about the poster commission, she gushed, "It's fun to be back in the poster business again."

In 2018, Bonnie developed dementia. David cared for her at home until the end of 2019, when she entered the Buckingham Valley Rehabilitation and Nursing Center, passing on February 4, 2020. "I designed a total of thirty-two posters; I was off the scene by 1971, though, so it was a short time doing it. All the success of the posters … surprised me. I knew people were collecting in those days, but I did not know that it would reach the heights it has. My posters are in museums all over the world now—it's amazing."[42]

© **Elizabeth Resnick**

NOTES

1. Before the Summer of Love, the Haight-Ashbury neighborhood was home to a small community of "hip" residents interested in art, music, theater, and literature. Afterward, it was known worldwide as the center of countercultural activities. https://daily.jstor.org/the-summer-of-love-wasnt-all-peace-and-hippies/ (accessed online April 26, 2024).

2. "The art, music, style of living, etc., that is associated with psychedelic drugs and especially with the time in the 1960s when many people were using psychedelic drugs" (Britannica.com).

3. San Francisco had an emerging music scene of folk clubs, coffee houses, and independent radio stations that catered to the population of students at nearby Berkeley and the free thinkers who had gravitated to the city (Wikipedia).
4. The term "psychedelic" (from the Greek for "mind-manifesting") was coined by Humphry Osmond, a British psychiatrist working in Canada in the 1950s. When the recreational use of LSD took off in the 1960s, psychedelics became the label for a whole subculture that built up around the drug. https://www.newscientist.com/definition/psychedelic/ (accessed online April 26, 2024).
5. The Beatles, The Doors, Pink Floyd, Grateful Dead, and Jefferson Airplane were all influential bands in this movement.
6. Montgomery, Scott B. (2020). "San Francisco's Psychedelic Poster Movement," in *Titus O'Brien's Dreams Unreal: The Genesis of the Psychedelic Rock Poster*. Albuquerque: University of New Mexico Press, pg. x.
7. Montgomery, Scott B. (2019). "Radical Trips: Exploring the Political Dimension and Context of the 1960s Psychedelic Poster," *Journal for the Study of Radicalism*, Vol. 13, No. 1, pgs. 121–54.
8. Meggs, Philip B., Purvis, Alston W. (2016). *Megg's History of Graphic Design*, 6th Edition. Hoboken, NJ: Wiley Publishing, pg. 479.
9. Opening in July 1967 in San Francisco's Walter Moore Gallery, *The Joint Show* was the first significant exhibition of counterculture poster art. At that time, the prominent psychedelic poster artists became known as the "Big Five."
10. Victor Moscoso was the only one of the "Big Five" educated in the graphic arts. He attended Cooper Union, Yale University (studying with Joseph Albers), and San Francisco Art Institute (Wikipedia).
11. This male-dominated artistic community was a boy's club. Had Bonnie MacLean been a man, perhaps the group would have been called the "Big Six." Nonetheless, she pioneered as one of the few women to produce psychedelic posters. https://www.pastemagazine.com/music/bonnie-maclean/poster-artist-bonnie-maclean-dead (accessed online May 9, 2024).
12. Montgomery, Scott (2020). "San Francisco's Psychedelic Poster Movement," pg. 233.
13. "My mother was a difficult woman. She was pretty much a narcissist. It was a terrible upbringing for us both …that was our common thread." Interview with Valerie Sands, April 5, 2024.
14. "My mother wanted my sister to be her friend because she had my sister when she was very young." Interview with Valerie Sands, April 5, 2024.
15. "He died of heart disease in his late forties. In that day and age, there was not a lot of attention paid to personal health the way we do now. My mom was closer to her dad than she was to her mother. Beatrice was not a very kind person." Interview with David Graham, February 26, 2024.
16. Victoria Binder interviewed Bonnie MacLean on November 9, 2016.
17. Born Wolfgang Wolodia Grajonca in Berlin in 1931, Graham emigrated to New York in 1941 as part of a Red Cross effort to help Jewish children fleeing the Nazis. He lived with a foster family in the Bronx, and by age eighteen, he was drafted into the army to fight in the Korean War. In the early 1960s, he relocated to San Francisco.
18. Graham, Bill and Robert Greenfield (2004). *Bill Graham Presents: My Life inside Rock and Out*. Cambridge, MA: DaCapo Press, pg. 114.
19. "It was a family operation for the first two years." Interview with David Graham, February 26, 2024.
20. "Bonnie did all the books. I had … a checking account at the local bank. The staff was very small. It was Bonnie, me, Johnny Walker, Jim Haynie, and Marushka Greene (Herbie Greene's wife)." Bill Graham, *Bill Graham Presents*, pg. 160.
21. "She did not set off an inviting glow. She stayed in the background. She certainly wasn't like the other artists in appearance

or manner," interview with Herbie Green, March 28, 2024; "I did meet Bonnie and found her likable but I really never got to know her at all, alas," email from poster artist Lee Conklin, March 23, 2024; "Wes Wilson was a hard act to follow. I think Bonnie did a great job," email from poster artist Victor Moscoso, April 1, 2024.

22. "It's Still Rock 'n' Roll to Her," by Ed Condran, *Bucks County Courier Times*, September 27, 2015. https://www.phillyburbs.com/story/entertainment/local/2015/09/27/it-s-still-rock-n/18082997007/ (accessed online May 11, 2024).

23. Lemke, Gayle, Jacaeber Kastor (1997). *The Art of the Fillmore: The Poster Series 1966–1971*. Petaluma, CA: Acid Test Productions, pg. 71.

24. "She was interested in art and she was interested in performance and acting. But she was not an artist at that point … that started her career as an artist. And the fact that she was so adept at it was incredible." Interview with David Graham, February 26, 2024.

25. Bill Graham quoted in Paul Grushkin's *The Art of Rock: Posters from Presley to Punk*, New York: Abbeville, 1987.

26. Before May 1967, Bonnie designed four small handbills and one poster for Fillmore Auditorium concerts during 1966.

27. Ed Condran, "It's Still Rock 'n' Roll to Her."

28. Bonnie recounts, "I think things between us had already changed *before* we got married. We got married because we had come to a crisis … we had come close to parting ways … there was a resentment about difficulties between us." *Bill Graham Presents*, pg. 198.

29. *The Art of the Fillmore*, pg. 72. The poster was printed offset on white index stock. It measures 13.9 × 21.25 inches. The offset printing credit is Neal, Stratford, and Kerr.

30. The poster was printed offset on white index stock. It measures 14 × 21 inches. The offset printing credit is Tea Lautrec. https://www.wolfgangs.com/posters/eric-burdon-and-the-animals/poster/BG089.html (accessed online May 16, 2024).

31. *Bill Graham Presents*, pg. 250.

32. *Bill Graham Presents*, pg. 251.

33. Jacques Fabert was born in Paris, France, and studied at the École Nationale Supérieure des Beaux-Arts, also in Paris. He was featured in many one-person and group shows. As a result of his life accomplishments, Fabert's works are part of private and corporate collections worldwide. He has taught in diverse American art institutions on the East and West Coasts of the United States.

34. Jacques Fabert taught at California College of Arts and Crafts, a Mexican extension program during this time.

35. Interview with David Graham, February 26, 2024.

36. Ed Condran, "It's Still Rock 'n' Roll to Her."

37. "It amazes me to this day how they were ever attracted to each other. They are just polar opposites in so many ways. My mother is mellow and slow. My dad goes a mile a minute. There must have been … some kind of mystic attraction that brought them together." David Graham, *Bill Graham Presents*, pg. 252.

38. "She and I were very close. When Bonnie and Jacques got together, they bought a house in Buckingham that needed some upgrades, which became a family project. Our cousin Richie worked with Jacques, my husband worked with Jacques, and I helped paint and make curtains." Interview with Valerie Sands, April 5, 2024.

39. "Ellarslie exhibits are black and white and red all over," by Ilene Dube, February 12, 2015. https://whyy.org/articles/ellarslie-exhibits-are-black-and-white-and-red-all-over/ (accessed online May 17, 2024).

40. Bill Graham, his girlfriend Melissa Gold, and the pilot Steve "Killer" Kahn

were killed in a helicopter crash west of Vallejo, California, on October 25, 1991 (Wikipedia).

41. "After she had her stroke, none of her friends kept up with her. Nobody called her, and David was really, really angry with those people." Interview with Valerie Sands, April 5, 2024.

42. "A Conversation with Bucks County's Bonnie MacLean, Fillmore poster artist past and present," by John Vettese, September 28, 2015. https://xpn.org/2015/09/28/bonnie-maclean-fillmore-poster/ (accessed online May 16, 2024).

SECTION THREE

Postmodern Innovators (1940–1970)

For female design practitioners in the early 21st century, the opening two decades have brought attention—and, with attention, visibility. This renewed interest in the role of women helps to counter design history's systematic erasure of their presence. While there is reason to cheer, why stop there? This is an important moment, charged with possibilities to bring about overdue change, with consequences that will benefit not only women but all those who fight for equality.

As women step into the spotlight, myths and long-standing beliefs within design can be shattered. The lone genius, the heroic creator, the idea (and object) that arrives fully formed—all of these can be challenged, and the discipline can finally re-evaluate all its messy complexity, its collaborative nature, and non-linear processes."[1]

— Quote from "Dear Gatekeepers,"
initially published in *Icon* 190, April 2019.

3.0

Introduction

Elizabeth Resnick

The sixteen women included in this section were born during and after the Second World War and came of age during the postmodern era. Postmodernism is a late twentieth-century approach in art, architecture, and literature that typically mixes styles, ideas, and references to modern society, often in an ironic way.[2] It can be seen as a reaction against the ideas and values of Modernism—shattering established ideas about art and design—and a description of the period that followed Modernism's dominance in cultural theory and practice in the decades following the Second World War.[3]

As societal norms and expectations evolved, postmodernism, with its emphasis on fracturing the traditional and celebrating the unconventional, provided a platform for women graphic designers to challenge stereotypes and push against the boundaries of traditional graphic design practices. "There are definitely more women in the workforce, in all sorts of jobs and positions … increased opportunities for women in design have mirrored the opportunities that all working women have experienced in the past 40 years. Specific to our profession, there are many more vehicles for one's work to be acclaimed and noticed today than 40 years ago."[4]

With the rise of postmodernism, collaborative and interdisciplinary approaches enabled women graphic designers to form networks and collaborate across disciplines. "Technology is great for everyone and levels the playing field for women," US art director Jackie Merri Meyer states. "Almost anyone can start a business from their kitchen table. That is especially helpful for women who are serious about their careers but may want to or need

to be at home for the family or to be an independent contractor or entrepreneur and not rely on male supervisors for that raise or promotion. In other words, it breaks down the old boy network."[5]

Although postmodernism provided a more inclusive environment for women working in graphic design, obstacles allied with gender bias and inequality persist. When considering the experience of multicultural women, it is essential to recognize a broader sociocultural and historical context. Like other marginalized groups, multicultural women have faced challenges and under-representation in the design industry.[6] US designer/design educator Sylvia Harris (1953–2012) advocated broadening entry points into the profession.

> Black designers are working at a disadvantage when they do not feel a kinship with existing design traditions and also have no evidence of an alternative African or African-American design tradition upon which to base their work … by "Black tradition," I do not mean Black subject matter or imagery, but the styling and expressions common to people of African descent. I believe this tradition does exist, but Black contributions to America's rich graphic design history have been overlooked, so far, by design historians who have focused either on European influences or on the current phenomenon of cultural hybridity.[7]

"It was hard in Delhi as a woman to set up a business," affirmed Indian graphic designer Sujata Keshavan (1961) as she reflected on her experience setting up her design firm Ray + Keshavan. Especially challenging was supervising her clients' print jobs, which required her to spend long hours in industrial print facilities. She recalled, "No woman had ever entered the press. It was a very male environment. There was sniggering and comments. I was eyed up and down. They always delayed my job and would make me wait for hours, sometimes till midnight … the whole ecosystem was very unprofessional and hostile to women."

"I have encountered and experienced numerous instances of discrimination throughout my life and career," states Iranian illustrator, designer, and publisher of children's books Farideh Shahbazi (1952). "As I've grown older, I have gradually found the courage to stand up more easily and express my opposition. I set boundaries for men. You see, in patriarchal societies (which, to me, is the entire world), men have been raised so that it appears perfectly normal to them to behave in certain ways. Sometimes, they don't even realize that they are perpetuating patriarchal structures, even those who claim to be progressive and educated."

The captivating stories in this section feature sixteen determined and resilient female graphic designers who defied stereotypical paths and societal gender norms. Their amplified, diverse voices helped create more inclusive spaces, address systematic obstacles, and foster a more equitable and representative design community through their grit and tenacity. Almost all the women were in personal relationships or married, but only ten chose motherhood.

3.1 Eulindra Lim

Eulindra Lim (1940–n.d.) was born in Singapore and departed in the 1950s to study graphic art at St. Martin's School and the Central School of Art before finishing a diploma at the London School of Printing. She traveled to Switzerland to complete her studies before returning to Singapore to begin her practice. She stood out as the rare female graphic designer in a creative industry dominated by expatriates and men, winning many awards for her work. In 1966, she was named the Best Asian Designer by the Creative Circle in Singapore. In the 1970s, she established a design firm known for branding hotels in Singapore and overseas. Her clients included the Dynasty Hotel and Ming Court Hotel in Singapore and the Bali Beach Hotel and Hotel Indonesia in Jakarta.

3.2 Elizabeth Fitz-Simon

Elizabeth Fitz-Simon (1943) was born in London. She began her career with the Derek Forsyth Partnership on accounts including Pirelli Tires. She moved to Ireland in 1971, taking up a position at the state-sponsored Kilkenny Design Workshops (1963–88) and becoming one of few female graphic designers working in Ireland. In 1975, she became an independent design consultant. Her work is typographically led, and she specializes in identity systems and publications.

3.3 Anna Monika Jost

Anna Monika Jost (1944) was born in Klosters, Switzerland. After completing the foundation year at the Kunstgewerbeschule Zürich, she moved to Milan in 1965 to work at Olivetti under Walter Ballmer. From 1969, she worked in Basel and Milan for international clients through the advertising agency Reiwald AG. She moved to Paris in 1972 and designed for well-known institutions such as the International Council of Museums, the French Ministry of Culture, Unesco, and the Louvre.

3.4 Anya Eymont, Myriam Kin-Yee, and Alison Hulett

Anya Eymont (1948), Myriam Kin-Yee (1950), and Alison Hulett (1953) founded EKH Design in 1987, an all-women partnership based in Sydney, Australia. EKH Design was regarded as one of Australia's leading design companies in the areas of corporate branding and marketing solutions. Their high-profile clients and successful business model were unique in this male-dominated field, as were their individual career trajectories and multicultural backgrounds in the Australian context. EKH was strategic in its approach to graphic design and notably worked on the successful launch of the telecommunications brand Optus, serving the Australian market.

3.5 Patricia (Trish) de Villiers

Trish de Villiers (1950) was born in Cape Town, South Africa. She was active as a cultural worker, theater and graphic designer, contributing to the "alternative" theater movement, especially Broadside Mobile Workers' Theatre in the United Kingdom during the 1970s and the Community Arts Project (CAP) in the 1980s in Cape Town. As a founding member of the CAP Poster Workshop, where she served as a coordinator, she facilitated, designed, and made posters, T-shirts, banners, and murals for various organizations opposed to apartheid. During the 1990s, she freelanced and focused on designing informal educational materials and illustrating children's books. From 1997 to 2012, she was the Deputy Director of Health Promotion for the Western Cape Health Department in Cape Town.

3.6 Mahnoosh Moshiri

Mahnoosh Moshiri (1950) was born into a well-known Kurdish family. She is a graphic designer and illustrator based in Tehran, Iran. When she began her career as a graphic artist, it was rare for a woman to work in design, in contrast to the illustration field, which recognized many female illustrators. She is also successful as an illustrator, creating hundreds of poster designs for different cultural events and many original book cover designs, making it difficult to define the border between her work as a designer, illustrator, author, and even poet. She has completed many multifaceted projects using her talents in these many different roles. In a patriarchal society such as Iran, she has been a role model for all girls pursuing their agency through art and design.

3.7 Arlette Haddad

Arlette Haddad (1951) was born in Ghazzir, Lebanon, and works as a type designer in London, UK. After fleeing the civil war in Lebanon, she began practicing type design and founded Boutros Fonts with her husband, Mourad Boutros. For the past five decades, she has developed Arabic fonts for TV stations, corporations, and independent entities. Her work is underrepresented and deserves to be studied by younger designers, especially those developing Arabic-type design solutions.

3.8 Farideh Shahbazi

Farideh Shahbazi (1952) was born in Rasht, Northern Iran, and is an illustrator, graphic designer, and publisher of children's books. She began her professional career designing logos for many famous Iranian companies in 1973. She has served as a member of the

Iranian Illustrators Association (2003–2005 and 2005–2006) and as the chairman of the Board of Directors for the Iranian Illustrators Association (2007–2009). She has served as a jury member for national and international exhibitions and has focused on teaching students design and illustration for the past few years. She continues to live and work in Tehran, Iran.

3.9 Polly Bertram

Polly Bertram (1953) was born in Hamburg, Germany, and grew up in Lucerne, Switzerland. She studied graphic design at the Zurich School of Design. She founded a studio with Daniel Volkart in 1981, and in 1992, she took over the studio and hired freelancers. She taught at Hochschule Luzern and SUPSI in Lugano and has worked for cultural institutions such as the Schauspielhaus in Basel, Switzerland.

3.10 Sylvia Harris

Sylvia Harris (1953–2011) was born in Richmond, Virginia. She was the founder and principal of Citizen Research & Design and co-founder of the Public Policy Lab, a nonprofit working to develop human-centered design strategies for government agencies and their respective communities. She is remembered for her approach to improving the usability of public spaces and using design to solve problems for civic agencies, universities, and hospitals, pioneering the concept of public information design. She was the creative director for the United States Census Bureau's 2000 census, which focused on encouraging more Americans, particularly underrepresented groups, to participate. Sylvia Harris was awarded the prestigious American Institute of Graphic Arts medal posthumously in 2014.

3.11 Kyungja Keum

Kyungja Keum (1954) was born in South Korea and worked as a magazine editor and creative director for about 20 years. After graduating from Hanyang University, her first job was as a reporter and layout designer for *Monthly Job Placement* magazine. After leaving the *Monthly Job Placement*, she worked for several more magazine publishers before being hired at Kyemongsa, a well-known periodical publisher in South Korea. As an editing and creative director at the publisher, she founded *Hometopia* magazine, the leading Korean lifestyle magazine during the 1980s–1990s. South Korean social expectations did not allow her to continue working after she gave birth to her youngest child. Even though she had to leave her position, her heart remained in the publishing industry.

3.12 Winnie Wai-kan Kwan

Winnie Wai-kan Kwan (1956) was born in Hong Kong. Her career as a designer has taken her from the junior to the managerial level at the Hong Kong Museum of Art. In the over four decades since she joined the Museum in 1977, she has acted as a conduit between various stakeholders to connect the world of high art and the public. She is also an innovator in two-dimensional and spatial exhibit design, bilingual typography, and evolving design production technology as a designer and manager. She is not only a key witness to the development of Hong Kong graphic design but has trained generations of designers in cultural design for museums.

3.13 Elisabetta Ognibene

Elisabetta Ognibene (1957) was born in Modena, a northern Italian city with a high per-capita income. She graduated in 1976 from the Istituto d'Arte in Modena, and her first job was in the graphics department of the Modena municipality, managed by renowned art director Massimo Dolcini. Dolcini founded the Grafica di Pubblica Utilità movement, an Italian approach to graphic design for public communication. In 1983, Ognibene moved to Milan to work on a two-year contract in the Olivetti Corporate Image Office, primarily designing environmental signage for trade shows. After this experience, she returned to Modena to establish Avenida Studio, specializing in political and social communication. She creates message graphics, hard-hitting and direct presentations of social and political ideas. Her large volume of work conveys vitality and focuses directly on its content, and Avenida has become an influential force in Italian communications design.

3.14 Mara de Oliveira

Mara de Oliveira (1957) was born in Artigas, Uruguay. She graduated from the National School of Fine Arts in Montevideo, Uruguay, and also trained as an architect's assistant at UTU (University of Labor of Uruguay). Her career has been in editorial design as a staff member at the weekly newspaper *El Popular* and the *La Hora Popular, Últimas Noticias*, and *El Observador* newspapers. She has also worked as an independent designer for the publishers *Santillana* and *Random House* and the publications of the Rodney Arismendi Foundation. She has taught in the Bachelor of Design program at BIOS University Institute, in the Diploma of Edition of the CLAEH, in the Visual Communication Program, Faculty of Architecture, Udelar, and in the Visual Communication Program at the School of Social Communication, UTU.

3.15 Marjaana Virta

Marjaana Virta (1958) was born in Lahti, Finland. She is a graphic designer nationally known for her award-winning book design and typography work. Her book designs in the 1990s, especially in collaboration with philosopher Esa Saarinen, were groundbreaking and culminated in a collection of printed products and textiles for Marimekko and Routledge. The resulting concept and collection of *Mediatext* is an exceptional example—in Finland in its time—of mixing typography and lettering, postmodern media theory, and textile print as equal domains of knowledge. However, the significance of her contributions to Finnish graphic design and typography has yet to be discovered.

3.16 Sujata Keshavan

Sujata Keshavan (1961) was born in the southern city of Bangalore, India. She studied visual communication design at the National Institute of Design, Ahmedabad, and graphic design at Yale University, USA. She worked in advertising and co-founded her branding and design agency Ray+Keshavan in 1989, designing corporate identities, logo design, and branding for several well-known Indian companies. Her idea of purposeful design, shaped by the influence of her teacher, Paul Rand, brought her success in promoting a design culture during economic liberalization in India.

NOTES

1. Quote from the article, "Dear Gatekeepers," originally published in *Icon* 190, April 2019. Accessed online: http://www.foreign-legion.global/#dear-gatekeepers.
2. "They frequently borrowed historical forms and embraced pluralism, irony, and fragmentation. They questioned notions of good taste and used linguistic and social theories to inform their practices. This was the influence of postmodernism." Toppins, Aggie, "Good Nostalgia/Bad Nostalgia," *Design and Culture*, 2021, pgs. 1–25.
3. Definitions are from: Collins English Dictionary-Collins COBUILD Advanced Learner's Dictionary, © HarperCollins Publishers, and The Tate website: https://www.tate.org.uk/art/art-terms/p/postmodernism.
4. Piscopo, Maria, "Women in Design," *Communication Arts* Magazine 287, March/April 1999, pgs. 42–4.
5. Ibid., pg. 44.
6. "I went to RISD. I went to Pratt. I went to MICA. What art history did I learn? *Your* art history. What design did I learn? *Your* design. You learned nothing of mine." Korsunskiy, Eugene. "Dismantling White Supremacy in Design Classrooms: My conversation with Cheryl D. Miller." *Medium*, September 1, 2020. Available at: https://medium.com/future-of-design-in-higher-education/dismantling-white-supremacy-in-design-classrooms-my-conversation-with-design-guru-cheryl-d-miller-5dc9c48b15e4.
7. Harris, Sylvia. "Searching for a Black Aesthetic in American Graphic Design," in *The Education of a Graphic Designer*, edited by Steven Heller, pgs. 269–73. 2nd ed. New York: Allworth Press, 2005.

3.1

Eulindra Lim: The Rise of Women in Singapore Design

Justin Zhuang

In 1966, the advertising industry in Singapore and Malaysia recognized the "Best Asian Designer" for the first time—the prize given by the Creative Circle, an annual award show organized by the advertising agencies in the two neighboring countries. This honor was presented to Miss Eulindra Lim. An art director at S.H. Benson—a British advertising agency that was one of the largest in the two former colonies—Eulindra was recognized to have distinguished herself among the local advertising workforce of primarily Chinese, Malays, and Indians.[1] They worked in agencies traditionally owned and led by white expatriates from Australia and the United Kingdom, a legacy of how the advertising industry in Singapore and Malaysia had developed with colonial industrialization.

However, both colonies had become independent nations by 1966. The Creative Circle was established four years earlier to elevate local creative standards and ultimately nurture "top creative people to originate and lead in this field—in their own country."[2] Although the award initially recognized only the best work in various categories each year,

Figure 3.1.1 Eulindra Lim, photograph, circa 1972. Photographer unknown.

the addition of the "Best Asian Designer" prize from its fourth edition sought to spotlight local talents and attract more of them into the industry.

Mr. Peter Morgan-Harry, the managing director of S.H. Benson, said about Eulindra's achievement: "As a career, any serious-minded young man or woman joining the business at the moment can look forward to a very bright and successful career. There is every prospect of the expenditure on advertising rising rapidly during the next ten years."[3]

Besides an effort to localize, Eulindra's win could also be seen as the rise of women in Singapore's advertising industry. In 1966, barely a quarter of the country's economically active population of over 576,600 was female, and the majority were employed in the community, social and personal services.[4] The advertising industry was no exception, having long been "exclusively a man's world" where women were thought not to be as capable as men.[5] This began changing by the 1960s when an estimated 100 females "held coveted executive positions."[6] In the 1970s, Eulindra joined their ranks when she opened her design studio, Eulindra Designs, working on several significant projects that supported Singapore's modernization into a global city-state. The studio's success encouraged the rise of other female-led creative agencies that have become a part of Singapore's creative community today.

The "Flower of the East"

Born circa 1940, Eulindra was the eldest among four siblings, including a brother and two other sisters. Her father was Lim Yew Hock (1914–1984), a trade unionist turned politician, and her mother, Chia Kim Neo (1914–1982), was a housewife. In 1955, Eulindra's father was successfully elected to Singapore's first legislative assembly as part of a new constitution that gave the British colony partial internal self-government. The following year, he took over as the chief minister and successfully negotiated with Britain the final arrangements for Singapore to become a fully self-governing state in 1959.

During these years, when her father was head of state, the teenage Eulindra first came into the public spotlight. Then known as Pansy, she was often spotted by the media accompanying her parents to events, including dinner parties and show openings.[7] Her "model-sized" features captivated the media, particularly on a trip to London in 1958.[8] Eulindra had accompanied her father, who was meeting with the colonial government to finalize Singapore's new constitution, and her appearance in a "form-fitting Chinese-styled gown"—reportedly one of 100 that she designed herself—made the news in the British tabloids.[9] *News of the World* printed a picture of her on the cover, while *The Sunday Express* dubbed her "a flower from the east."[10]

The attention reportedly made Eulindra uncomfortable to "walk around the London streets."[11] Her mother added that they "almost needed a police guard" when they visited Naples and Rome. Nonetheless, Eulindra did not want to simply blend into the crowd.

Even when her mother told the media she was more than happy to let her daughter "wear Western-styled clothes, including sacks" (a loose, unwaisted dress then popular in the West), Eulindra wanted it styled to her vision. "It will have short sleeves and be cut straight across the front. And it must be made of soft material like silk so that it hugs the body and shows curves," she said.[12]

It was an early indication of Eulindra's belief in individual expression and her ability to tailor the latest design trends to her needs. Both would emerge as she embarked on a career in graphic design after the London trip. She soon returned to the city to attend a graphic art program at St. Martin's School and the Central School of Art.[13] During her time overseas, Eulindra also earned a diploma at the London School of Printing, finished her studies in Switzerland, and reportedly worked in both countries as a visualizer and freelance designer.[14]

Disrupting Singapore's Advertising Industry

Eulindra eventually returned to Singapore around 1963, becoming one of the few locals formally trained in design. Most locals working in the advertising industry then received their training on the job. A few would have attended ad-hoc commercial art courses conducted by Singapore's only fine arts school, the Nanyang Academy of Fine Arts, and training workshops run by the Adult Education Board established by the government in 1968. Going overseas for design training was accessible only to privileged families, and a national applied arts school with a proper design curriculum would only emerge in 1968.[15] Besides the lack of local design education, the advertising industry was not regarded as one offering good job prospects, and most parents would have discouraged their children from pursuing it.

The overseas training gave Eulindra an advantage, as seen in her early work upon her return. In the second and third Creative Circle annual advertising awards, Eulindra received multiple nominations for her work, including an advertisement for Shell, which came in third in the category, and a leaflet for Hotel Singapura, which won a merit award. Her name stood out in a field filled with male and expatriate names. It is no wonder the Creative Circle named her the Best Asian Designer in its fourth edition.

Close to two years after clinching the title, Eulindra achieved another milestone at the Sixth Asian Advertising Congress in 1968. It was the first time this gathering of regional advertisers, agencies, and media met in Singapore and Kuala Lumpur, and Eulindra designed the event's official symbol. She rendered "sixth" in the Malay script of Jawi into a circular form, which snagged the third prize in the symbols and emblems category for the awards competition held in conjunction with the congress. Eulindra received two other prizes for other designs, including a counter showcard for Fidgi Perfume and a poster promoting the congress.

Figure 3.1.2 Eulindra Lim, page from a brochure with the Fidgi Perfume counter showcard (above) and the logo for the Sixth Asian Advertising Congress (below). Image courtesy of Singapore Graphic Archives.

Pioneering Her Own Design Studio

These wins probably encouraged Eulindra to leave S.H. Benson after the congress to join International Design and Scripts—a new ad agency founded by Australian creative director John Nicol, who was also her husband. The couple were married in June 1968, and Nicol incorporated the agency in Singapore three months later. One of their early clients was Mr. M.K. Zephyr Amir, who sold Persian carpets in the region. The agency created a buyer's guide for handmade carpets, which was subsequently expanded into other editions. The guide also featured Zephyr's shop logo—Oriental Carpet Palace—which was probably designed by Eulindra too. Similar to the advertising congress's symbol, the design

Figure 3.1.3 Cover for *A Concise Guide to Hand-Made Oriental Carpets* featuring the logo for Oriental Carpets. Eulindra Lim likely designed both the logo and the cover. Image courtesy of Singapore Graphic Archives.

Figure 3.1.4 *Left:* A luggage tag for Hotel Bali Beach circa 1970s, likely designed by Eulindra Lim. Image courtesy of Singapore Graphic Archives. *Right:* PUB logo designed by Eulindra Lim, 1977. Image courtesy of PUB, Singapore's National Water Agency.

appropriated cultural references by featuring the word "Oriental" in the shape of an onion dome that is popular in the imagination of Persia and the Orient.

International Design and Scripts, however, did not last; nor did Eulindra's marriage. By 1970, two years after its establishment, the agency was S$33,000 in debt.[16] The couple divorced, and this was just one of several tragic events Eulindra experienced during this period. Her father—who stepped down as chief minister in 1959 and gradually lost his political influence—had a very public disappearance in 1966 while serving as Malaysia's High Commissioner in Australia. He eventually divorced Eulindra's mother. A few months after her own marriage to Nicol in 1968, Eulindra learned that her ex-fiancé had committed suicide, and she was required to recount their relationship in court.[17]

These personal troubles, however, did not distract Eulindra from her design work. In a 1968 interview, she said that work was everything to her and she would sacrifice family life if the two ever clashed.[18] After her divorce, she started her own design studio, Eulindra

Designs, to serve the steady stream of clients—oil firms, banks, and food manufacturers—commissioning her with work. There were also projects for various new hotels being built in the region during the 1970s, including the Mandarin Hotel in Singapore, The Bali Beach Hotel, and Hotel Indonesia in Jakarta. Eulindra was so successful that she was described in a 1972 newspaper article as living in a "tastefully furnished studio (her own work) in one of Singapore's better residential areas" and owning a "chauffeur-driven Jaguar."[19]

Eulindra Designs was part of the first wave of independent design studios that emerged in Singapore during the 1970s. They sought to step out of the shadows of large advertising agencies, which traditionally earned significant commissions from media owners. This led to agencies often offering free graphic design services to secure a lucrative advertising account, which devalued the profession.[20] There was also a growing market for design beyond media advertising, such as brochures and packaging, with the government encouraging local manufacturers to export their goods and services. Athough many of the new design studios were led by men, the owner and creative director of Eulindra Designs was a female, and Eulindra believed this brought something different to the table. "Women can contribute more," she once said in an interview.[21] "We pick up fashion trends all the time. We are more susceptible to new ideas, more conscious of the nice things around us."

By starting her own studio, Eulindra joined several other prominent women executives in Singapore's creative scene during the 1970s: Joan Pillay, a creative director at Henry Chia Associates, and Fung Chui Lin, who was general manager of the Kuala Lumpur office of Marklin Advertising.[22] There was also Lucy Goodwin, who was the general manager of Advertising Consultants.[23]

Blending Progressive Design and Tradition

At Eulindra Designs, Eulindra was joined by a team of three artists, an accounts clerk, and a receptionist. She kept the office small to give her clients the "personal touch" they liked.[24] Despite its size, the studio completed significant works that contributed to the modernization of Singapore, particularly designs for logos and related graphics, which Eulindra acknowledged was her forte.[25]

One prominent example was the 1977 logo Eulindra and her team designed for the Public Utilities Board (PUB), the national agency that managed Singapore's supply of power, gas, and water. Since its founding, PUB's logo literally depicted its functions with a power station, gas holder, and flowing water enclosed within a circle. When PUB moved into a new Brutalist headquarters, Lim and her team created a logo that abstracted the agency's functions into three elements that formed a circle—an upper semi-circle outlined in light blue to depict gas joined by a lower dark blue semi-circle to represent water, while a red jagged line ran through them both to illustrate the flow of electricity.

Eulindra Designs also supported efforts to turn Singapore into a tourism destination. During the 1970s, the country experienced a hotel development boom, and many

Figure 3.1.5 Eulindra Lim, brochure for The Ming Court Hotel, circa 1970. Image courtesy of Singapore Graphic Archives.

followed the American model of being designed in the idiom of modernist architecture.[26] They were also localized by blending cultural motifs and symbols in their architecture and interior design. For instance, the modern towers of The Ming Court Hotel (1970) and The Dynasty Hotel (1979) were topped with roofs inspired by the Chinese pagoda. They had logos designed by Eulindra and her team that adopted a similar design approach. The Ming Court Hotel was a stylized "M" and "C" assembled in the shape of a Chinese emperor crown, and the logo was paired with the hotel name spelled out in "chop suey" typeface. The logo for The Dynasty Hotel was two Ds arranged to resemble an ancient Chinese coin.

These simple and geometric logos by Eulindra Designs were forerunners of the modernist designs many government agencies and corporations adopted through the decade. By helping Singapore adopt this visual language that had become recognized worldwide as the "International Style" by the 1970s, Eulindra helped the young nation project its aspirations to become a "modern" and even "global" city-state. This drive to become modern peaked in 1986 when it was reported that over fifteen large organizations in the country were adopting new logos.[27]

For Eulindra, pursuing modernist design for her client reflected her beliefs in challenging conventions. "If you stick to tradition, you will never change, never make any progress," she once said.[28] This echoes the spirit of Modernism, which sought to break with the past to search for new forms and expressions that spoke of the values of modern life. Even as Eulindra's designs bore the marks of her training in the West, they also feature local cultural motifs and references that are blended and updated. This was especially so in her work for hotels, which one could argue were exotic portrayals of Western notions of Asia and Singapore. But this was the 1970s when Singapore's own tourism agency was positioning the country as "Instant Asia."

A Creative Who Never Conformed

Eulindra "disappeared" from the creative scene after the 1970s for reasons yet to be discovered. There were no longer extended newspaper profiles of her as a successful career woman or mentions of her company working on a new logo design. In 1980, the PUB logo she designed won a prize when the Creative Circle award was revived after being discontinued in the 1960s. It was the first and last time the studio and Eulindra participated in the event. In 1986, a mention of Eulindra emerged in her father's posthumous autobiography. He had died in 1984 and singled out his elder daughter as "doing very well running her own commercial art designing establishment."[29] According to official business records, Eulindra Designs was closed in 2013, but there is no trace of the work produced by the studio or whether Eulindra ran the firm till she was in her seventies.

Nonetheless, the role of women in Singapore and the creative scene took flight by the 1980s. By then, the population of working women more than doubled from the decade before to power Singapore's industrialization efforts.[30] Many more women also

took up roles in the advertising and design industry or even started their own studios.[31] The latter included Viscom Design Associates, started by Sylvia Tan in 1980, which became known for publication design. Another was Su Yeang Design, a packaging and branding agency started by Su Yeang in 1983, which is most well known for rebranding Singapore's iconic Tiger Beer and designing the official emblem of the World Trade Organization. Many other women have followed in their footsteps. Although there is no official census of Singapore's advertising and graphic design industry, women are believed to make up the majority, be it as students, freelancers, or employees.[32] The exception is business owners.

What might Eulindra have to say about all this? She said little about gender per se, but one thing she felt strongly about was the individuality of human beings. Eulindra did not shy from her femininity in an advertising industry famous for objectifying women. Her stylish dressing was "a far cry from the bespectacled, rather masculine looking businesswoman often depicted in cartoons," as one profile noted.[33] Lim also won the respect of her peers with her distinctive modernist designs that were progressive for their times.

"One must preserve one's integrity as an individual at all costs," she once said. "To conform blindly is not to exist as a person."[34] By staying true to her beliefs and charting her own career, Eulindra paved the way for other women to enter and excel in Singapore's design scene.

© **Justin Zhuang**

NOTES

1. The population of Malaysia and Singapore has historically been made up of natives referred to as "Malays" and immigrants from China and India, as well as other parts of the world. Both countries have long been seen as a single geographical entity.
2. *Annual Advertising Award 1963*. Singapore Creative Circle Singapore, 1964.
3. Subashini Ratnam, "Wonder Girl … and How Your Daughter Can Also Become One …" *The Strait Times*, August 14, 1966.
4. Siok Hwa Cheng, "Recent Trends in Female Labour Force Participation in Singapore," *Southeast Asian Journal of Social Science* 8, no. 1/2 (1980), pgs. 20–39.
5. Judith Yong, "Glamour … Behind All That Glitter and Gloss." *The Strait Times*, June 23, 1968.
6. Ibid.
7. "Laryngitis—But the Show Went on Last Night," *The Singapore Free Press*, May 21, 1956; "Adelaide Easterly, Singapore Spotlight," *The Singapore Free Press*, August 21, 1957.
8. "Cheongsam Poses Problem for Pansy," *Singapore Standard*, May 16, 1958.
9. "Pansy Makes a Hit in London," *Singapore Standard*, May 14, 1958; "Newspapers Dub Pansy as 'Flower of the East,'" *Singapore Standard*, May 14, 1958; "Cheongsam Poses Problem for Pansy," *Singapore Standard*, May 16, 1958; "Never Was so Much Poured into so Little," *Singapore Standard*, June 13, 1958; "Pansy May Have to Swap Her Slits for the Sack Line," *The Straits Times*, May 16, 1958.
10. "Newspapers Dub Pansy as 'Flower of the East.'"

11. "Cheongsam Poses Problem for Pansy."
12. Ibid.
13. Subashini Ratnam, "Wonder Girl … and How Your Daughter Can Also Become One …"
14. Yong, "Glamour … Behind All That Glitter and Gloss."
15. Justin Zhuang, "Becoming Modern by Design," *BiblioAsia* 16, no. 4, March 2021, pgs. 54–9.
16. "Firm Winds up with $33,000 in Red after Two Years," *The Strait Times*, November 26, 1970.
17. "Coroner Told of the Two Moods of Ad Executive," *The Strait Times*, October 30, 1968.
18. "Ad Girl Eulindra Has Designs on a Winning Career," *Singapore Herald*, August 10, 1970.
19. Su San Lee, "Women in Business …," *The Strait Times*, May 21, 1972.
20. Justin Zhuang, *Independence: The History of Graphic Design in Singapore since the 1960s*. Singapore: The Design Society, 2015, pg. 15.
21. Yong, "Glamour … Behind All That Glitter and Gloss."
22. Marianne Pereira, "Girls in Advertising," *Female*, June 1974.
23. Judith Yong, "I Feel so Big Tonight Says Jubilant Lucy," *The Straits Times*, July 5, 1968.
24. Lee, "Women in Business …"
25. Ibid.
26. Jiat-Hwee Chang, Justin Zhuang, and Darren Soh, "Hotels: Singapore as a Tropical Asian Paradise," in *Everyday Modernism: Architecture & Society in Singapore*. Singapore: Ridge Press, 2022, pgs. 128–33.
27. Kin Sang Chan, "New Logos for 15 Big Organisations in '86," *The Straits Times*, January 26, 1987.
28. "Ad Girl Eulindra Has Designs on a Winning Career."
29. Yew Hock Lim, *Reflections*. Kuala Lumpur: Pustaka Antara, 1986, pg. 11.
30. Chian Kim Khoo, "Census of Population 1980, Singapore. Release No. 4, Economic Characteristics." Singapore: Singapore Department of Statistics, 1981.
31. Peta Meyer, "Ad Women Are an Emerging Force," *The Sunday Times*, June 1, 1986, sec. Sunday Plus.
32. "*Don't Mind If I Ask*," Singapore: Don't Mind If, 2021.
33. Lee, "Women in Business …"
34. "Ad Girl Eulindra Has Designs on a Winning Career."

3.2

Elizabeth Fitz-Simon: Professionalizing Graphic Design in Ireland

Dr. Linda King

Elizabeth Fitz-Simon (1943) is a British-born graphic designer who lives in Dublin. She began her career in London but moved to the Republic of Ireland[1] in 1971, taking up a position at the government-sponsored design initiative Kilkenny Design Workshops (KDW). In so doing, Elizabeth was one of the few professionally trained graphic designers working in Ireland at the time.

Ireland, in the 1970s, had a very complex sociopolitical landscape. It provided a marked cultural contrast to London and an environment where design had difficulty flourishing organically.[2] After decades of economic and cultural stagnation, Irish society was moving from being insular and largely agrarian to accepting that future prosperity lay within the European Economic Community (or EEC, now the European Union). Ireland applied for membership in 1961 and was eventually admitted in 1973. Part of this shift towards

Figure 3.2.1 Elizabeth Fitz-Simon, photographed in 1977. Image courtesy of Elizabeth Fitz-Simon.

Continental Europe included the political realization that the design professions could become substantial economic drivers, particularly in exports and service provision. There was one huge hurdle, however: except for fashion and textiles, Ireland had little by way of indigenous design industries or design infrastructure. Where such deficits needed to be addressed in the past, "foreign" expertise had been imported into crucial areas. This had been the case in the 1950s with a number of Dutch graphic designers hired from the publicity department of KLM to work on the advertising campaigns for Aer Lingus, the Irish national airline.[3] Some women worked in advertising, primarily as secretaries, although a few were employed as illustrators, including Terri O'Sullivan, who also designed for Aer Lingus.

The reasons for such an absence of design growth and expertise are intrinsically linked to Ireland's history as a colony of the British Empire until its independence in 1922. In this climate, wide-scale industrial manufacturing had not developed on the island outside Ulster, the six counties comprising Northern Ireland, of which Britain retained governance post-independence. Industrial production in the twenty-six counties of the new Free State, or Saorstát Éireann (1922–49), largely comprised alcohol and confectionary. As a newly sovereign country, a succession of governments focused on creating a basic social infrastructure, including the provision of electricity, schools, roads, and hospitals, but a strong consumer culture was decades away. In the pursuit of stressing cultural distinction, there was also an educational emphasis on the Irish language to the detriment of teaching visual arts. In 1949, the Free State—which had been a dominion of the British Empire—became fully independent and known as the Republic of Ireland. However, the circumstances for Irish design to grow as a by-product and in support of mass manufacturing had not occurred organically and was now the subject of much political debate.[4]

Despite Ireland's embrace of European paradigms, life for Irish women in the 1970s was difficult. It was almost impossible to work outside the home professionally once married, and indeed, those in the public and civil service were obliged to resign from their jobs, succumbing to a Marriage Ban that was not lifted until 1973. The stranglehold of the Catholic Church ensured that contraception was available to married women only, and those who did not fit the accepted societal "norms" were often incarcerated in religious-run institutions. The island was also politically unstable, and Anglo-Irish relations were fraught. In Northern Ireland, the civil rights marches of the 1960s that demanded equal rights for its Catholic population ceded to widespread sectarian violence in the wake of the deployment of British troops in 1969. In 1972, for example, British soldiers shot twenty-six unarmed civilians during a protest march in Derry. The incident became known as Bloody Sunday, and it inflamed tensions on the island, leading to the expansion of IRA membership and the burning down of the British Embassy in Dublin in 1972. Although much of the violence was contained within Northern Ireland, loyalist bombings also occurred in the Republic, specifically in Dublin and Monaghan in 1974, claiming the lives of thirty-three civilians, and the IRA began a campaign of violence on mainland

Britain. Anglo-Irish relations were at a particularly low point in the early 1970s and would worsen in the years ahead.

In this complex sociopolitical climate, Elizabeth's career choice in coming to Ireland is somewhat unusual. In addition, the number of professional women in Ireland at the time was small, the number of female design professionals even smaller, and the number of female graphic designers could have been counted on one hand. However, her design output during her time in Ireland reflected the general and specific opportunities provided by this complex and changing sociopolitical landscape.

Early Life, Education, and Career

Elizabeth Fitz-Simon was born in Oxfordshire in 1943 and grew up in Esher, Surrey, the younger of two children.[5] Her father, Vincent, was an engineer who had served in the RAF during the Second World War; her mother, Gertrude, was the daughter of the painter Charles Trevor Prescott (1872–1947). Charles had attended the Liverpool School of Art and the Académie Julian in Paris in the late nineteenth century. He was known for capturing Liverpool streetscapes, some of which can be seen in the Walker Gallery, Liverpool. He also worked as an illustrator for the advertising industry, where notable clients included Bird's Custard and Quality Street chocolates. Elizabeth's paternal grandfather, Charles Fitz-Simon, was a Dubliner; and his family owned a wood importing and coopering company in the city center for over a century. This provided materials and skills to support the distilling and brewing industries clustered in the Liberties area of the city, of which Guinness's and Power's would have been among the largest. Charles's business collapsed in 1909, and he subsequently died, at which point Elizabeth's grandmother sent her two younger children—Elizabeth's father and his sister—to schools in England. She went to live in Nice, where she met some Russians "wintering" there, and traveled back with them to St. Petersburg. She stayed there until 1917, fleeing the Russian Revolution before moving to London.

Gertrude recognized Elizabeth's talent in drawing and lettering from a young age—similar to her father's creative strengths—and encouraged Elizabeth to study graphic design. Elizabeth's elder brother, Stephen (1937–1997), worked in advertising, although his career path changed after marrying the Polish fashion designer Barbara Hulanicki (1936). The couple started a mail-order business in 1963 to sell her designs; this became the hugely successful fashion house, Biba, and the very embodiment of "swinging London."

Elizabeth completed a foundation course at Guilford Art School in 1963. She then enrolled in a BA course at the London College of Printing (LCP) in 1966, where she secured one of 35 places available to about 200 applicants. The course had been established by the poster designer Tom Eckersley (1914–1997) and offered the first degrees in graphic design in England. Tom ran the program for twenty years and was famous for designing myriad posters, including for the Royal Mail and Aer Lingus. Two of Elizabeth's

Figure 3.2.2 Elizabeth Fitz-Simon, *Drink Metric* poster for the *Think Metric* campaign, 1967. Credit: the Construction Industry Training Board. Image courtesy of Elizabeth Fitz-Simon.

classmates were Tom's son, Richard Eckersley (1941–2006), and his Swedish partner, Dika Lagercrantz (1939–2015). They later married, and, like Elizabeth, he also went to work at KDW, overlapping with her time there. Due to its emphasis on print technologies, the curriculum at LCP was strong in typographic layout. Elizabeth developed a distinctly modernist aesthetic of clean lines, sans-serif type, and clear grid structures in this climate, which defined her professional output.

Elizabeth subsequently completed her MA studies at the Royal College of Art in 1969 as one of just three women in her class. Jock Kinnear (1917–1944)—who had designed Britain's road signage system—was Head of the Graphic Design Department and her principal typography tutor. Other influential tutors included Douglas Coyne (1930–2008), Margaret Calvert (1936)—who had also worked on the road signage system—and Bob Gill (1931–2021), co-founder of the London design studio Fletcher/Forbes/Gill. The Swedish-born photographer Eric Boman (1946–2022) was a classmate and collaborator, and he and Elizabeth studied photography together under John Hedgecoe (1932–2010).[6] She describes the experience at the RCA as more "graphic design focused," although her work continued to have a robust typographic leaning. One example was her win in a student poster competition organized by Kinnear for the British Construction Industry. The brief was to provide a public information campaign on the introduction of the metric system, and her posters, with the slogan "Think metric," were hung on walls of public spaces all over England.[7] While at the RCA, Elizabeth undertook professional commissions, including a summer working at *Vogue*, and she designed a travel brochure for the American Grand Circle (1970), a company specializing in European tours for US tourists. The brochure's layout continued along the modernist lines she had developed at LCP, defined by a strong and confident aesthetic of grid structures, clear hierarchies of sans-serif type, and bold photography.

After graduation, Elizabeth began working for the newly formed Derek Forsyth Partnership. Its clients included Pirelli, the Italian tire company for which Forsyth had launched its famous calendar in 1963.[8] At the time, it was typical of the motor industry to gift their clients calendars of semi-naked women, but Forsyth saw an opportunity to provide something similar but "more tasteful." The first calendar was photographed by Terence Donovan (1936–1996), who embodied the zeitgeist of 1960s London, and the second was photographed by Robert Freeman (1936–2019), who had worked extensively with The Beatles. Elizabeth worked in a team designing ads for tires, producing the calendar, providing stands for trade fairs, and publicity material for other items the company manufactured, including footwear. Elizabeth enjoyed working for Forsyth, but the pace of working in London was demanding and she had little personal time. In 1971, she saw an ad in *Design* magazine for a new initiative in Ireland actively recruiting designers from other parts of Europe. Elizabeth thought that Ireland might offer her a different pace of life and "an adventure." She already had friends in Waterford and Dublin and thought she

would try living there for six months. This led to her taking up a position as a temporary "break" from London, which led to her staying in Ireland for the next seven years.

Professionalizing Design in Ireland

The Kilkenny Design Workshops (KDW, 1963–1988), to which Elizabeth arrived, was an ambitious project conceived by William H. Walsh, the General Manager of the Irish Export Board (Córas Tráchtála Teo).[9] KDW was a subsidiary of this state-run organization. It was established in the wake of a controversial and broadly negative appraisal of Irish design provisions and standards in 1961 by an invited group of Nordic design experts. The findings from their visit were published as *Design in Ireland* in 1962 (more commonly known and misrepresented as the *Scandinavian Report*). Walsh was a charismatic and visionary individual who had the ear of the government on the economic potential arising from raising Irish design standards and had personal penchant for Scandinavian design. KDW took its name from its location, Kilkenny, a small city in Ireland's southeast. The organization occupied the converted coach-houses of the city's fourteenth-century Ormond Castle, and Elizabeth described these surroundings as "stunning and beguiling." Kilkenny was quite rural in the 1970s: the community was close-knit, and a lack of traffic lights showed how few people owned cars.

KDW was conceived as an interdisciplinary, collaborative design consultancy comprising a series of workshops dedicated to prototyping, designing, retailing, and promoting Irish goods and services. It focused on creating sustainable links with local manufacturers and adapting traditional Irish practices to mass production. Workshops were dedicated to ceramics, glass, metalwork, textiles, and graphic design, with industrial design—which became more clearly defined as design linked to engineering—added at a later point. As KDW matured, its services, including the prototyping of objects and their branding and packaging, were utilized by international companies, including Rosenthal Ceramics in Germany and Bell and Howell projectors in Chicago. The legacy of KDW was huge: from filling seismic gaps in Irish design professionalization and education to becoming a benchmark for national standards, it provided inspiration and expertise to other countries, including the Philippines, India, Sri Lanka, Barbados, and Lesotho in developing similar initiatives to hothouse design activities where organic growth had been limited.

Ireland's limited professional design capabilities required that a significant number of European designers be employed by KDW, principally drawn from Britain, the Netherlands, Finland, Denmark, and Germany. Although controversial, this reflected an established practice of filling gaps in Irish design expertise. KDW did not promote a single aesthetic, but Modernist and vernacular forms were often fused to create a visual language combining Irish vernacularism with European contemporaneity. This was particularly evident

Figure 3.2.3 Elizabeth Fitz-Simon, *Eirebus* bus, and identity, photographed outside Kilkenny Design Workshops, 1973. Credit: Eirebus. Image courtesy of Elizabeth Fitz-Simon.

in the Graphic Design Workshop, which Elizabeth joined. It was established in 1968 by Damien Harrington (1943–2020), who, although Irish, had studied at the Royal Academy in the Hague. Damien's Office of Public Works (OPW) logo embodies this synthesis: re-framing markings from Neolithic tombs within clean Modernist lines. When Elizabeth arrived in 1971, she was the workshop's only employee apart from Damien. Her first job was working with his OPW logo to create bilingual signage and way-finding for national monuments, a challenging task as she did not speak the Irish language. She found greater surety in the packaging of company products, many destined for existing or emergent consumer markets as Ireland moved closer to EEC membership. Amongst these were designs for Cavan Crystal glassware, Wade Pottery, and Beleek Pottery. Some of this work was in partnership with the Danish industrial designer Holger Strøm, who, in addition to designing one of KDW's most iconic objects, the IQ light (1973), became a specialist in innovative cardboard construction. Damien left KDW in 1973, and Richard Eckersley, Elizabeth's classmate at LCP, arrived at the Graphic Design Workshop in 1974, remaining until 1980.

Elizabeth had arrived into a country of massive contradictions. Although there was a considerable push to link Ireland to spheres of European influence and modernization, most Irish women could not work professionally due to the Marriage Ban; the nascent graphic design industry—as an off-shoot of printing and advertising—was almost exclusively run by men; and criticism of the importation of "foreign" design expertise to fill gaps where local "talent" did not exist was commonplace. Elizabeth was also taken aback by the slowness and the limited quality of photographic and printing services in Ireland compared to London. Yet, amid these many challenges, there were also opportunities, and many of the jobs she worked on during her time at KDW directly reflected Ireland's movement closer to European paradigms and the modernization of Irish society more broadly.

Branding, Packaging, and Promoting Ireland

One such example is Eirebus, a brand name that amalgamates "Eire," the official name of the twenty-six counties of the Republic, with public transportation. Eirebus was established in 1971 as a consortium of thirteen private bus companies wishing to capitalize on Ireland's growing tourism industry by offering bus tours. With this brief, Elizabeth visually amalgamated these companies, giving this collective a coherent, singular identity with a distinctive typographic mark and logo based on a bounding hare, clearly referencing America's Greyhound Bus company. Design applications were clearly articulated in a brand guidelines manual and the company was launched with the slogan: "Eirebus—thirteen times better." The company is still operational today; although the design has changed in the interim, the hare has remained a constant.

Once Ireland joined the EEC in 1973, Elizabeth found herself designing myriad projects—mostly magazines, booklets, books, and posters—that might be described as having a diplomatic agenda. This included work for the European Parliament, the European Commission, and the Irish Department of Foreign Affairs (DFA). Through such work, she eventually found suitable printers and established a working relationship with a young diplomat from Carlow, Paul Murray. One of the most notable of these projects is *Ireland Today*, for which Paul was the commissioning editor for the DFA. This eight-page, bi-monthly bulletin highlighted Irish achievements in the arts, sports, politics, and culture more widely. It was sent to Irish embassies worldwide, becoming a significant means of communicating Irish achievements to a broader world. In 1975, Senator Ted Kennedy, for example, wrote to Paul stating that he had enjoyed the issue on the Abbey Theatre so much that he had placed it in the Congressional Record. The publication was previously called *Eire/Ireland*; the text was typewritten and crudely printed on cheap paper. Under Elizabeth's design direction, *Ireland Today*, by comparison, was laid out with a bold photographic cover and a masthead in Gill Sans and the inside pages displayed a strict three-column grid of sans-serif type and photography.

Figure 3.2.4 Elizabeth Fitz-Simon, cover of *Ireland Today*, May 1977. Credit: The National Film Studios of Ireland (photograph) and reproduced with permission of the Irish Department of Foreign Affairs. Image courtesy of Elizabeth Fitz-Simon.

Figure 3.2.5 Elizabeth Fitz-Simon, *ROSC '77* poster, 1977. Credit: collage by Patrick Scott. Image courtesy of Elizabeth Fitz-Simon.

One of the most striking covers featured Charlotte Rampling (1946) and her son Barnaby (1972) sitting in the rocky landscape of Connemara, County Galway. The cover and some of the pages are dramatically reversed out of black, a technique that Elizabeth used on several occasions and is similar to the strategy used by the German graphic designer Willy Fleckhaus (1925–1983) for *Twen* magazine. Rampling was in Ireland filming *Purple Taxi* at the time, and the edition used the opportunity to promote the fledgling Irish film industry, which has now become one of the country's most significant areas of employment. Elizabeth and Paul found an easy synchronicity working together: he sourced and or wrote the content, and she visually interpreted it.

In 1975, Elizabeth left KDW but continued to work freelance with the organization while retaining the DFA and the EEC Commission as clients. One of her more publicly recognizable projects from this time was her catalog and publicity materials for *Rosc '77*, an exhibition of historical and contemporary Irish art displayed alongside international art, held every four years between 1967 and 1988. This initiative eventually led to the establishment of the Irish Museum of Modern Art in 1990. 1977 was also a turning point for Elizabeth: she married Paul, and while they had discussed marriage, his imminent posting to Tokyo as Deputy Head of Mission brought forward the decision. Diplomatic life, with all its challenges of frequent moves, cultural adjustments, and endless entertaining, is well known for being difficult. Elizabeth attempted to keep her graphic design practice going, working for English-speaking publications, but the remuneration was poor and often clashed with diplomatic duties. Another major obstacle was that legal restrictions required the spouses of diplomats to have work permits. However, as Elizabeth discovered, outside of the EEC, the United States was the only other country to have such an agreement with Ireland at the time. So, for pragmatic reasons, it was impossible to keep her graphic design practice going. Elizabeth has said that the decision to park her career was easy for her initially as Tokyo was a "great adventure," and she was confident she could resume her graphic design career later. In the interim, she was determined to have a measure of independence and the means to continue professional collaborations with Paul, so she enrolled in Sophia University and studied Japanese politics.

The couple were subsequently posted to Ottawa, Canada, in 1980, with Paul as Deputy Head of Mission. Elizabeth couldn't secure a work permit in this jurisdiction either, although the EEC Commission in Ottawa asked her to design for its publications. This posting included extended periods in New York when Paul was working at the UN General Assembly. By this time, he was planning to write a biography of the Greek-born, Dublin-raised author Lafcadio Hearn (1850–1904), who is credited with bringing Japanese culture to the attention of the West. Elizabeth found a new interest in researching primary source material for the book and designed its cover for publication.[10] Their first son, Daniel, was born in Canada in 1984, at which point they moved back to Dublin, and their second son, Stephen, arrived four years later in 1988. Paul was posted to London in 1989, and Seoul, South Korea, followed in 1999, at which

point Paul had been appointed Irish Ambassador. This posting was a particularly happy one for them both as they created and supported several initiatives that strengthened Irish–Korean relations, including initiating Bloomsday—the annual celebration of James Joyce's *Ulysses*—and the St. Patrick's Day parade. Paul became the first Irish Ambassador accredited to Pyongyang, North Korea, in 2004, before they both returned briefly to Dublin. Their final posting was with Paul as Irish Ambassador to the OECD and UNESCO in Paris in 2006, and after six years, he retired from the diplomatic service, and he and Elizabeth returned to live in Dublin.

Impact and Legacy

Elizabeth has said that she certainly missed working as a graphic designer, but it was impossible to sustain a career with the uncertainty of diplomatic life. In 1999, she was interviewed for *Image* magazine, where the author suggested that "Marry a diplomat and the first casualty is likely to be your career" for several interconnected reasons, including the uncertainty of where you will be, for how long, and the restrictions on gaining work permits.[11] These restrictions limited her career, but while she was in Ireland, Elizabeth made significant contributions to the country's design development: by being part of the extraordinary experiment that was KDW, helping to professionalize Irish design standards, and producing innovative and culturally significant work. She also experienced a country undergoing huge societal changes, particularly for women, and her presence in Ireland helped normalize the graphic design profession for younger generations. The first Irish degrees in graphic design were awarded in the 1980s, and the number of women studying this subject today far outweighs the number of men.

© **Dr. Linda King**

NOTES

1. Hereafter referred to as "Ireland."
2. For the history of Irish graphic design, see Linda King, "Culture is Ordinary: An (Incomplete) History of Irish Graphic Design, 1950–2020" in Catherine Marshall and Yvonne Scott (eds.), *Irish Art 1920–2020: Perspectives on Change*, Dublin: Royal Irish Academy (RIA), 2023, pgs. 224–51; for the history of Irish design more broadly, see Linda King and Lisa Godson, "Design & Material Culture" in Catherine Marshall, Peter Murray (eds.), *20th Century*, volume V of *Art and Architecture of Ireland*, Yale/RIA, 2014, pgs. 120–34.
3. For more see Linda King, "(De) Constructing the Tourist's Gaze: Dutch Influences on Aer Lingus Tourism Posters, 1951–61," in Linda King and Elaine Sisson (eds.), *Ireland, Design and Visual Culture: Negotiating Modernity 1922–1992*, Cork: Cork University Press, 2011, pgs. 165–87.
4. Thomas Bodkin, *Report on the Arts in Ireland,* Dublin: The Stationery Office, 1949.

5. Linda King, interview with Elizabeth Fitz-Simon in Dublin on August 10, 2022; much of the personal details in this essay are from this interview.
6. Eric made his name in the United States working with *Vogue*, *Harpers & Queen*, and *Marie Claire*, amongst many other publications.
7. One appeared in the background of an ad for the popular Polytan polypropylene stacking chairs by the Birmingham-based Tan-Sad furniture company.
8. Richard Tomkins, "Pirelli Calendar Comes Home," *Financial Times*, October 31, 2008.
9. For more see Linda King, "Reform and Advocacy: The Legacy of the Kilkenny Design Workshops (1963–1988)," in *Vernacular*, Kilkenny: Design and Crafts Council of Ireland, 2013; Nick Marchant and Jeremy Addis, *Kilkenny Design: Twenty-One Years of Design in Ireland*, London: Lund Humphries, 1985; Designing Ireland; Ruth Thorpe (ed.) *Designing Ireland: A Retrospective Exhibition of Kilkenny Design Workshops 1963–1988*, Kilkenny: Crafts Council of Ireland, 2005; Anna Moran, "Tradition in the Service of Modernity: Kilkenny Design Workshops and Selling Irish Design at American Department Store Promotions, 1967–76," in King and Sisson (eds.), *Ireland, Design and Visual Culture: Negotiating Modernity*, pgs. 191–211.
10. Paul Murray, *A Fantastic Journey: The Life and Literature of Lafcadio Hearn*, Abingdon: Routledge, 1993.
11. Ros Drinkwater, "Mission Impossible," *Image*, September 1999, pgs. 50–2.

3.3

Anna Monika Jost: A Nomadic Practitioner

Dr. Chiara Barbieri and Dr. Davide Fornari

The career of Anna Monika Jost is exemplary of the many Swiss nomadic practitioners who moved abroad and adapted to different work settings, clients, briefs, and cultural environments thanks to their training, multilingual skills, and the good international reputation of Swiss Graphic Design and designers.[1] In particular, she is one of the few, and possibly the only woman, who played an active role in both of the two main communities of Swiss graphic designers abroad, namely that of the so-called "Scuola milanese" (Milan School) and the "Suisses des Paris" (Swiss in Paris).[2] In both cities, the historical narrative reiterates the same stereotypical national design discourse of local designers lagging behind and benefiting from the arrival of better-trained Swiss graphic designers. Anna Monika Jost was one of the Swiss graphic designers who initiated and fostered design exchange and contributed to and benefited from a network of practitioners, clients, and institutions that shared a similar understanding of Swiss graphic design as a historically shaped vision of national design.

Figure 3.3.1 Anna Monika Jost photographed in her Paris home, 2023. Photo by Rudi Meyer.
© Rudi Meyer.

Born on August 19, 1944, in Klosters-Serneus, then a small village of about 3,000 inhabitants in the canton of Grisons, Anna Monika grew up in a family speaking German, Swiss-German, and Wallis German dialect—a variant language similar to Middle High German, similar to the language spoken between 1050 and 1350. Her father, Michael Jost (1909–1989), was a teacher at the local secondary school, where he taught classes in math, physics, geography, singing, and woodwork. He was also the director of the local band and choir. Her mother, Elisabeth Jost née Lier (1914–2005), was a housewife in charge of a large orchard cultivated with organic standards (since 1936) and caring for six children. She was an expert weaver and taught courses on fiber dying. She made clothes for her sons, daughters, nieces and nephews. Later on, some of the paintings made by Anna Monika as color tests for her graphic work were transformed into vividly colored tapestries by her mother.

Anna Monika grew up with five siblings: Michael Jost (1937) is talented at drawing and a very good violinist and photographer. He moved to the USA after obtaining a PhD in Biochemistry at the ETH in Zurich. Johan Friederich Jost (1938–1944) died of sepsis three weeks after Anna Monika's birth. Luzia Elisabeth Jost (1942) lives in Chur and is a language teacher (German, French, and Italian), a talented piano player, and an expert potter who trained in Japan, Italy, and Switzerland. Margreth Serena Pedersen-Jost (1946–2017) completed her business studies and worked as an executive secretary, an architectural model maker, and, finally, in support of disabled people. Johann Benedikt Jost (1950) is a photographer and worked first as a school teacher and then as a documentalist.

After six years of primary school and three years of secondary school in Klosters, Anna Monika relocated to Zurich in 1960 to attend the preparatory year of the Kunstgewerbeschule (School of Applied Arts) under the supervision of Swiss artist, illustrator, and graphic designer, Karl Schmid (1914–1998). Following her mother's example, she enrolled in the textile design course but soon discovered she was better suited for the drawing course. At the suggestion of Swiss artist and graphic designer Gottfried Honegger (1917–2016), Anna Monika specialized in scientific drawing. While working as an apprentice at the Zoological Museum of the Zurich University, she attended the evening course at the Kunstgewerbeschule, where she studied calligraphy with Swiss typographer and type designer Hans Eduard Meier (1922–2014) and color theory with Swiss visual artist Emil Josef Mehr (1909–1988).

The Honegger family played a vital role at the beginning of Anna Monika's career. She described herself as an "experiment" of Gottfried Honegger, who prompted and supported her decision to leave the textile design course to enroll in the drawing course he led at the Zoological Museum of the University of Zurich. The relationship with the Honegger family also extended beyond the professional sphere and affected her private life. Indeed, not only did Anna Monika consider Gottfried Honegger as her mentor and professional godfather, but she also studied and shared a flat with his two daughters, Cornelia (1944) and Bettina (1943). Cornelia would become an accomplished painter and

scientific illustrator with twenty-five years of experience at the Zoological Institute of the University of Zurich. Bettina would become a painter and art therapist. Honegger had married Warja Lavater (1913–2007) in 1940, a graphic designer who had studied under Ernst Keller at the Kunstgewerbeschule in Zurich (1931–35). After setting up a studio with her husband in 1937, Lavater started designing logotypes, including the one for the Swiss Bank Corporation, still used by the investment bank UBS (1937).

After completing her studies, Anna Monika decided to use the savings her father had set aside for his children to finance a sabbatical year abroad, traveling and learning a new language. At the time, Milan and Paris were the "places to be" for a postwar generation of Swiss graphic designers willing to seek their fortune abroad.[3] Following the example set by many fellow citizens and graphic designers—such as Max Huber (1919–1992), Lora Lamm (1928–2025), and Walter Ballmer (1923–2011)—Anna Monika left Switzerland in 1965, crossed the Alps and settled in Milan.[4] She had down-to-earth expectations: if her plans to intern at one of the many graphic design studios in town were to fail, at least she would have learned some Italian. For sure, reality exceeded by far her most optimistic predictions as she landed a job at Olivetti. At the time, the typewriter manufacturer was a much sought-after working environment for designers thanks to remarkable budgets, international visibility, and creative freedom.[5] Anna Monika's portfolio attracted the attention of Ballmer, one of the four art directors, who asked her to join his team.[6] One of the few women, besides secretaries, working in the Olivetti Advertising Office, Anna Monika was Ballmer's graphic design assistant for two years. Between 1965 and 1967, she designed posters and identities for exhibitions that have, in the meantime, become iconic examples of the International Typographic Style.[7]

The two posters accompanying the traveling exhibition *Olivetti Innovates* (1966) exemplify the International Typographic Style with their asymmetric layout, sans-serif typefaces, and abstract composition of geometric forms and plain colors reminiscent of Concrete Art. The exhibition was first installed in Nairobi Charter Hall (July 5–8, 1966) and then moved to Hong Kong City Hall (October 19–25, 1966). On the occasion of its installation in Hong Kong, the poster had to be redesigned as its colors conveyed a feeling of mourning to the local public. A warmer color palette of reds, oranges, and yellows was selected to adapt to the local culture. The poster redesign allowed Anna Monika to make further and more meaningful changes. The selection of typographic characters—letters and numbers—that appear in the new version of the poster was anything but fortuitous. It is a clever stratagem put into place by Anna Monika to reclaim her authorship. Indeed, she managed to hide her initials by strategically placing the capital letters A, M, and J in three circles along a slightly off-center vertical line that adds to the asymmetry of the overall composition. The stratagem was a subtle call for public recognition of her contribution to the design of the Olivetti identity, and it provides, more in general, evidence of the assistants' frustration towards the lack thereof. At the time, graphic assistants were usually not allowed to sign their work. Even art directors did not sign most of their designs

Figure 3.3.2 Anna Monika Jost, poster for the *Olivetti Innovates* exhibition held in Hong Kong, City Hall, October 19–25, 1966. Courtesy of Associazione Archivio Storico Olivetti, Ivrea.

at Olivetti. Despite being common, the practice created discontent and fueled tension within the office, especially among assistants. To get around the rule, and similarly to Anna Monika, the Swiss graphic designer and Olivetti assistant, Urs Glaser (1944), included a letter addressed to him—and thus featuring his name and address—in a 1970 advertising brochure for the Copia 2 photocopier.

Returning to Switzerland in 1967, Anna Monika Jost worked for the Heinrich Lorch and René Egger advertising agency in Zurich. There, she designed a poster for the local beauty salon Kaiser—which was included in the 30 best Swiss posters of 1967[8]—as well as for Jean Reiwald AG in Basel. For the advertising agency Reiwald AG Werbeagentur, she took care of the Italian-speaking clients. Eventually, she moved back to Milan in 1970 to work for the agency's branch office in town, whose art director was Swiss graphic designer Gerhard Forster (1937–1986). The car manufacturer FIAT was one of Reiwald's Italian-speaking clients for whom Anna Monika conceived posters, advertisements, and different promotional gadgets. FIAT had adopted other communication policies and generally hired different graphic designers than Olivetti, partly due to an aversion to the Ivrea-based company for political reasons. While the relationship between management and workers was highly contentious at FIAT, Olivetti had tried to ally all the company's stakeholders. Like Olivetti, FIAT was no stranger to Swiss Graphic Design's methods, visual vocabulary, and connotative added values. Indeed, its logo—with the letters FIAT in italics inscribed in rhombuses—and visual communication had been designed in 1967 by the Swiss graphic designer Armin Vogt (1938). Felix Humm (1945) moved to Milan at the age of twenty-one to supervise FIAT Italy's visual communication for Reiwald after being in charge of communication at FIAT Suisse. Anna Monika Jost joined Humm at FIAT Italy in 1970. Her hiring at FIAT after Olivetti was noteworthy because very few designers had worked for two companies in mutual competition, of which even fewer were women.

The poster *Con Fiat verso gli anni 70* (*With Fiat Towards the 1970s*) is an interesting case of adaptation of the Swiss Style to different clients and briefs. This poster was commissioned by Reiwald's Basel office by FIAT Suisse to advertise the company's dealerships based in Canton Ticino, which is the Italian-speaking part of Switzerland. The visual language deployed by Anna Monika in this poster is reminiscent of those she had previously employed at Olivetti. In comparing the FIAT poster with the printed matter for the exhibition *Olivetti Innovates*, one can spot both the differences and similarities. On the one hand, the two posters have different purposes and formats. Whereas the poster for Olivetti is a medium format used chiefly for wayfinding at the various exhibition venues, the FIAT poster is a weltformat[9] poster designed for street posting, requiring immediate communication by a mass audience.

On the other hand, in both cases, Anna Monika favored an abstract language of geometrical shapes and harmonic or contrasting ranges of plain colors over images picturing the advertised products. Anna Monika also worked for the car manufacturer on special projects, such as a new year's gadget featuring the plastic model of a car packaged like

Figure 3.3.3 Anna Monika Jost, poster designed for the advertising agency Reiwald, *Con Fiat verso gli anni 70* (*With Fiat Towards the 1970s*) for a Swiss Fiat dealership based in Ticino, 1970. Courtesy of Anna Monika Jost.

a piece of confectionery or a trophy for the first FIAT Italian Rally, which took place between March 3 and 6, 1970. The Italian Rally edition of 1970 was critical because it marked the merging of two existing rallies (the Sanremo rally, established in 1928, and the Sestrières rally, 1950–1987). It was the national competition for accessing the manufacturers' international championship. Thus, the visual communication designed for the rally, including the trophy, had particular relevance for the company. The trophy—made of satinized silver metal—was shaped like a three-dimensional arrow reminiscent of the Concrete Art experimentations dear to Swiss-German graphic designers ever since Max Bill (1908–1994) organized the first Concrete Art exhibition in 1944.

Paris, France, was the other destination for many Swiss nomadic practitioners.[10] During and after the Second World War, the French context had remained adamantly distant from changes in the field of graphic design set in motion by modernist debates. The local scene was dominated by poster artists, working in the wake of Belarus-born Alexey Brodovitch (1898–1971), active in Paris from 1918 to the 1930s, and Ukraine-born A.M. Cassandre (1901–1968). Paris had become an epicenter of the artistic avant-garde after the First World War and attracted Swiss designers thanks to both a sense of artistic freedom and the presence of well-established and renowned art institutions such as the Academy of Fine Arts.

Anna Monika Jost left Milan again in 1972 and moved to Paris to work for the store chain Prisunic, applying the new retail concept designed by Tomás Maldonado (1922–2018).[11] At the beginning of the 1970s, he had been recommended by the management of the Italian department store La Rinascente to the Maus Frères Group, which owned the French chain. The recommendation was based on the Argentine designer and design theorist's expertise in accurately applying the modern principles of corporate identity to the design of interior settings and facades.[12] For the Prisunic project, Anna Monika supervised the application of Maldonado's concept for the new visual identity to be implemented nationwide, a task which made her travel across France to document the high number of stores and report back to the design team in Milan. Tired of this rather uncreative task, in 1973, she began working for the French industrial designer Roger Tallon (1929–2011) as head of the visual communication service at his newly established design studio, Design Programmes SA. There, Anna Monika worked for clients such as Laboratoires Goupil, a French pharmaceutical company founded in 1945, for which she designed packaging and visual material, and SNCF, the French national railway company. For the latter, she participated in the design team for a new visual identity that included Tallon and Swiss graphic designers Rudi Meyer (1943) and Peter Keller (1944–2010).[13]

In 1978, Anna Monika opened her practice and worked freelance until her retirement in 2012. She generally worked alone and relied on the cooperation of peers trained to use desktop publishing software to transform her layouts into digital files at the onset of the digital turn. She also collaborated with a graphic studio based on the mutual exchange of professional skills and knowledge: their technician took care of her computer, and in

exchange, she trained them in page layout. Specializing in visual identities and editorial design, she was commissioned by many prestigious cultural and institutional clients, national and international, such as the French Ministry of Culture, the Réunion des Musées Nationaux (National Museums Association), the Louvre, UNESCO (United Nations Educational, Scientific and Cultural Organization) and ICOM (International Council of Museums). These cultural and institutional briefs better suited her personality, for she felt that graphic design for advertising was a commercial, competitive, and male-dominated sector. As she put it, she did not want to "sell toothpaste any longer."

The poster *AIDS. It's Time for Schools to Act* shows, on the one hand, that international organizations stepped in to find a solution to a global disease and, on the other hand, that graphic design played a role in the battle against AIDS. Since the outbreak of the AIDS pandemic in the mid-1980s, graphic designers have used their work—posters above all—as a vehicle to address and correct general misinformation, raise donations, influence public debate, promote prevention, and foster a sense of empathy that was expected to overcome the stigma attached to the disease.[14] One way graphic designers could participate in defiance of the AIDS epidemic was by producing educational material that addressed taboo and touchy subjects while dealing with issues of prejudice and denial. Often using the language of advertising and fashion photography, graphic works communicated directly with the communities at most risk. Anna Monika's poster falls into this category. Commissioned by UNESCO in 1992 on World AIDS Day, the poster—which also appeared in French and Spanish—was part of an educational campaign promoting AIDS awareness among children of the Global South. The poster exists in two versions printed by UNESCO, as the World Health Organization had selected Jost's slogan for two following years: the first one was printed in blue in 1992, and the second one, in pink and yellow, was printed in 1993.[15] The writing in the foreground is arranged in the shape of a clock face with yellow marks in between the letters A, I, D, and S, and two clock hands that metaphorically illustrate the catchy slogan of the poster: the clock is ticking and "It's Time for Schools to Act." The images in the background portray four children from different parts of the Global South: while two are carefully listening, the other two are raising their hands, showing that education can turn listeners into activists.

For the C2RMF, the Centre de recherche et de restauration des musées de France (Centre for Research and Restoration of Museums of France) affiliated with the Louvre Museum in Paris, Anna Monika took care of the graphic design for the bi-annual scientific journal *Tèchnè*, dedicated to disciplinary debates on restoration and conservation for the arts and the cultural heritage, established in 1994. The editorial project shows Anna Monika's ability to adapt to the industry's technological changes. The 1980s heralded desktop publishing software into an already innovative landscape of "cold" composition. Thus, inheriting from the latter the metaphor of the photo composition workshop, layout software often brought an impoverishment in the language of graphic designers. Instead, the covers of *Tèchnè* maintained a clever approach over the years, with gestural interventions

Figure 3.3.4 *AIDS. It's Time for Schools to Act* poster designed by Anna Monika Jost and Jean Francis Chériez for the UNESCO campaign on World AIDS Day, December 1, 1993. © Zurich University of the Arts/Museum of Design Zurich/poster collection.

Figure 3.3.5 Anna Monika Jost, cover and frontispiece of the monographic issue no. 9–10 of the scientific journal *Techně*, dedicated to color and perception, for C2RMF, the Centre for Research and Restoration of Museums of France, 1999. Photo by Niccolò Quaresima. Courtesy of Anna Monika Jost.

by the designer that play with the topic of the monographic issues, such as in the square cut out in the cover of double issue 9–10, dedicated to color and perception, which allows to appreciate the detail of an eye from a painting by French cubist painter Fernand Léger (1881–1955) onto two different rainbow-colored patterns.

Anna Monika Jost also worked for the small French municipality of Mouans-Sartoux in the department of Alpes-Maritimes, which has about 10,000 inhabitants. Between 1988 and 1992, she was tasked with redesigning the city's coat of arms (a lion and a tower) and its derivative corporate identity (corporate paper, envelopes, standard posters): a public utility commission that is typical of France and manifests a particular engagement of public institutions in visual communication, signage and wayfinding during the 1990s.[16] She received this commission to establish the Espace de l'Art Concret, (Space for Concrete Art), a center for contemporary arts installed in the Castle of Mouans-Sartoux. The museum hosted Gottfried Honegger's art collection (including his own work) that he had donated to the French government. Honegger had referred Anna Monika to extend and expand the visual quality of the city's image in the newly established Espace. Thus, she simplified the figures in the city's aristocratic devices, employing a five-column grid and choosing the typeface Times New Roman for ease of application. This small project for a visual identity connects multiple aspects of her experience: the use of grids typical of the Swiss Style, the geometric abstraction of Concrete Art, and her personal point of view aimed at practical beauty.

In 1989, Anna Monika met Christian Chauliac (1947), a contractor for refurbishing apartments, on the island of Belle-Île-en-Mer in Brittany, and they married in 1992 in Klosters. Having always worked under her maiden name, she decided not to change it to "Jost Chauliac." They currently live between Paris, Belle-Île-en-Mer during summer, and Klosters-Serneus during winter.

Anna Monika Jost's career—spanning the 1960s to the 2010s—empowers us to appreciate industry shifts across three different cultures: Switzerland, Italy, and France. She is an "exception" in the system: one of the few women working in a male-dominated work environment such as Milan in the 1960s, with other exceptions being Lora Lamm and Anita Klinz (1923–2013); one of the few designers active both in Milan and Paris (together with her fellow Urs Glaser); a flexible practitioner capable of moving through different technological systems (from letterpress to photo composition, through desktop publishing software) as well as diverse visual languages and clients, commercial and not for profit. Although Anna Monika Jost worked consistently with highly visible clients, on par with her male peers, she has been relegated to a marginal position and only recently rediscovered due to a donation to the Museum für Gestaltung in Zürich graphics collection of part of her archive.

In 2025, the Federal Office of Culture attributed to Anna Monika Jost the Swiss Grand Award for Design, in recognition of her contribution to the renown of Swiss design internationally.

© **Dr. Chiara Barbieri and Dr. Davide Fornari**

NOTES

1. This chapter is based on email exchanges and the unpublished transcripts of two conversations between Anna Monika Jost and Davide Fornari held in Paris on December 7, 2015, and April 29, 2023, as well as on the designer's curriculum vitæ (unpublished typescript document, 4 pgs., n.d., post–2012). The authors are most thankful to Anna Monika Jost and Rudi Meyer for their cooperation.
2. Barbieri, Chiara (2021). "Gender," in Chiara Barbieri, Jonas Berthod, Constance Delamadeleine, Davide Fornari, Sarah Owens, eds., *Swiss Graphic Design Histories— Multiple Voices*. Zurich: Scheidegger & Spiess, pgs. 83–95. Gendre, Vanessa (2016). "Anna Monika Jost," in Barbara Junod and Roxane Jubert, eds., *Les Suisses de Paris. Graphisme et typographie*. Zürich: Museum für Gestaltung Zürich, pgs. 86–7.
3. Fornari, Davide (2016). "Swiss Style Made in Italy: Graphic Design across the Border," in Robert Lzicar, Davide Fornari, eds., *Mapping Graphic Design History in Switzerland*. Zurich: Triest Verlag, pgs. 152–80.
4. Barbieri, Chiara and Davide Fornari (2021). "Hotspot Milan: The Perks of Working on the Other Side of the Alps," in Ueli Kaufmann, Peter J. Schneemann, Sara Zeller, eds., *Swiss Graphic Design Histories— Tempting Terms*, pgs. 38–48, Zurich: Scheidegger & Spiess. Barbieri, Chiara and Davide Fornari (2021), "Speaking Italian with a Swiss-German Accent: Walter Ballmer and Swiss Graphic Design in Milan," in *Design Issues*, vol. 37, no. 1, Winter, pgs. 26–41.
5. Fornari, Davide and Davide Turrini, eds. (2022). *Olivetti Identities: Spaces and Languages. 1933–1983*. Zurich: Triest Verlag.
6. Barbieri, Chiara and Davide Fornari (2022), "Walter Ballmer, One of the Bs in Olivetti," in Davide Fornari, Davide Turrini, eds., *Olivetti Identities: Spaces and Languages. 1933– 1983*, pgs. 206–17, Zurich: Triest Verlag. Trincherini, Elisabetta (2022), "Egidio Bonfante's Displays in Olivetti Exhibitions, from Moscow 1966 to Madrid 1972," in Davide Fornari, Davide Turrini, eds., *Olivetti Identities: Spaces and Languages. 1933–1983*, pgs. 144–55, Zurich: Triest Verlag.
7. Barbieri, Chiara and Davide Fornari (2021c). "Corporate Printed Matter," in Sandra Bischler, Sarah Klein, Jonas Niedermann, Michael Renner, eds., *Swiss Graphic Design Histories—Visual Arguments*. Zurich: Scheidegger & Spiess, pgs. 38–44.
8. Billeter, Erika (1967). *Die besten Plakate des Jahres 1967*, exh. cat., Basel: Dickmann.
9. Weltformat (World format) is a system of paper format preexisting the DIN series, proposed by the German chemist, philosopher and Nobel laureate Friedrich Wilhelm Ostwald (1853–1932) in 1911. This format was adopted in 1913 by the advertisement committee of the Swiss National Expo of 1914 for all printed artifacts. Thus, the format prevailed in Switzerland and it is still used for street posters. It corresponds to 90.5 × 128 cm or 35.5 × 50.5 inches.
10. Junod, Barbara and Roxane Jubert, eds. (2016). *Les Suisses de Paris. Graphisme et typographie*. Zurich: Museum für Gestaltung Zürich.
11. Junod, Barbara, "Prisunic," in Junod, Barbara and Roxane Jubert, eds. (2016). *Les Suisses de Paris. Graphisme et typographie*. Zurich: Museum für Gestaltung Zürich, pgs. 54–9.
12. Fornari, Davide (2022). "Non temere le soluzioni innovatrici." Industria italiana: Olivetti e la Rinascente-UPIM, in *Tomás Maldonado e la sfida della trasversalità*. Milano: Fondazione Giangiacomo Feltrinelli, pgs. 39–61.

13. Forest, Dominique and Françoise Jollant Kneebone, eds. (2016), *Roger Tallon: Le Design en mouvement*, exh. cat., Paris: Musée des Arts décoratifs.
14. Jobling, Paul, and David Crowley (1996). *Graphic Design: Reproduction and Representation since 1800*. Manchester: Manchester University Press, pgs. 281–2. Resnick, Elizabeth, and Javier Cortés (2010). *Graphic Intervention: 25 Years of International AIDS Awareness Posters 1985–2010*. Boston, MA: Massachusetts College of Art and Design.
15. For the complete set of variants, see: "Anna Monika Jost" in *eMuseum*, emuseum.ch/en/people/57161/anna-monika-jost/objects (accessed July 20, 2023).
16. Maréchal, Caroll (2019). "Le Château, le Lion et la Tour. Anna Monika Jost, une graphiste suisse à Mouans-Sartoux," in *Centre national des arts plastiques—Graphisme en France*. cnap.graphismeenfrance.fr/article/chateau-lion-tour-anna-monika-jost-graphiste-suisse-a-mouans-sartoux (accessed on July 20, 2023).

3.4

Anna Eymont, Myriam Kin-Yee, and Alison Hulett: EKH, the Quiet Australians

Dr. Jane Connory

Women lack visibility in the history of Australian graphic design. Sadly, this is not an isolated story, as this book highlights. When surveyed in 2017, the Australian industry struggled to name women who had made significant contributions to the field.[1] As in most Westernized countries, the award platforms, Hall of Fames, podcasts, and conferences all fall short of offering equitable levels of visibility and voice to women and non-binary designers.[2] Still, women continue to dominate the number of students graduating with communication design degrees.[3] These inequities extend into the classroom environment as students are not offered profiles and case studies that reflect their identities. This lack of representation leads to a lack

Figure 3.4.1 EKH Partners, group portrait, 1993. *Left to right:* Myriam Kin-Yee, Alison Hulett, and Anna Eymont. Courtesy of Myriam Kin-Yee on behalf of EKH.

of self-efficacy—among other complex societal and political issues—that contributes to women's exclusion from senior positions in the industry and effectively erases the importance of their work from history.[4]

Culturally, the history of graphic design in Australia is also heavily influenced by European technology, practices, and aesthetics but lacks an informed impact from its Indigenous culture. Australia was colonized by the British beginning in 1788 when the First Fleet carried convicts, soldiers, crew, and their families from England to Sydney, and by the 1850s, commercial art was practiced by the non-indigenous population in capital cities on the East Coast and in the goldfields. In the early 1900s, Australia's states and territories were federated, and the last wave of Art Nouveau and the Arts and Crafts Movement became evident in the nationalistic commercial art practice of the time. Motifs of native flora and fauna are featured in this work, like wattle and waratah flowers alongside kangaroos, koalas, and emus. Much of this was visible in national newspapers like *The Bulletin*—a publication that reflected public sentiments of the day, which we would now label racist and misogynistic. However, the rich legacy of Indigenous Australia's visual storytelling and craft was almost completely abolished during this time.

The loss of life in Aboriginal and Torres Strait Islander communities through colonization was devastating, as was the possession of their lands and their ability to connect to the country that had continuously sustained them for over 60,000 years. Most history books documenting the birth of graphic design look to the Lascaux cave paintings in southern France as their prehistoric origins.[5] However, archaeologists are still discovering caves with paintings that pre-date these throughout Western Australia's Kimberly region, demonstrating the visual legacy of Indigenous Australians.[6] Hand stencils in some indigenous traditions included those of women and their younger female children.[7] The white Australian policy led to removing Indigenous children from their homes and continuing the eugenics-based ideas of "breeding out the color."[8] As a result, the visual cultural legacy of Australia's first nations people is limited—some are lost forever.

Although overshadowed and underrepresented, if you scratch the surface, women have impacted Australian graphic design. In the early 1900s, Ruby Lindsay (1887–1919) had a career as an applied artist. Her work can be seen in the newspapers of that era, like *Punch*, on posters she designed for the Sydney Society of Artists, and on the design of the First-Class Diploma for the first Australian Exhibition of Women's Work.[9] Later, in 1935, Dahl Collings (1909–1988) worked as a commercial artist for László Moholy-Nagy (1895–1946) in London—where he had gone after the Nazis drove him from Germany—and, on returning to Australia, became its direct link to the Bauhaus. Alison Forbes (1933) was a highly awarded book designer with a five-decade career. It was claimed by the newspaper *The Sydney Morning Herald* in 2018 that she was the "first full-time independent book designer in Australia." She designed covers for the first editions of some classic Australian literature, including *Picnic at Hanging Rock*. Women also contributed to the political landscape through graphic design in Australia. In the 1980s, poster collectives

embraced new technologies and traditional printing techniques to amplify their social advocacy messages. Dianna Wells (1961) was a part of this movement at the Another Planet Posters collective.

Australia's history of women in graphic design is long and diverse but still resides at the fringes of the established design canon. Many of these narratives have become the foundation for the thriving industry, whose revenue is projected to be $5.1bn (AUD) in 2023.[10] Rather than seeking external validation and a global platform for fame, these women have kept their heads down. They have often focused on intrinsic values like a work–life balance and gaining personal satisfaction from keeping their clients happy. Some of these quiet yet important stories are those of Anna Eymont (1948), Myriam Kin-Yee (1950), and Alison Hulett (1953)—three women from diverse backgrounds who built (and then sold) EKH, their prestigious design studio, during the 1980s and 1990s—becoming trailblazers for women in the industry for decades to come.

Anna Eymont's Story

In her words, the "E" in EKH, Anna Eymont, had a "fabulous" childhood in Poland. Born in 1948 to parents John and Halina, she grew up there with her younger brother Voytek (1951). Her mother, Halina, was a high school principal, and her father, John, worked in importing and exporting Polish poultry to the UK. Anna remained in Poland for her entire education and graduated from the Warsaw Academy of Fine Arts in 1973. During her six-year degree, Anna did a lot of socializing in jazz bars, coffee shops, and discotheques and enjoyed the cultural scene of the late 1960s in Poland during its communist era.[11] This time, also known as poster design's golden era, greatly influenced Anna. Henryk Tomaszewski (1914–2005), a professor from her academy, was famous for creating highly conceptual poster designs through simple line illustrations.

Equipped with her master's degree in fine arts with a specialization in graphic design, Anna followed her brother and father to Australia as soon as she graduated. A master's degree was a rare qualification in Australia then, becoming a source of pride and frustration for her. Australia was slow to introduce such degrees at the university level, and studying commercial art at a technical college was more common. As such, the corporate landscape in Australia lacked acknowledgment and acceptance of graphic design as a legitimate career path. Anna found that people thought graphic designers had a simple ability to scribble ideas down on serviettes and not much more.[12] Businesses had yet to learn the financial value that graphic design could offer, and she was often asked to do work for free or at reduced rates. Intellectual property rights were ignored, and work was published without proper remuneration. She found doctors, lawyers, and accountants were accepted as "good professions," but graphic design was perceived as a "non-profession."

This situation did not quelch her enthusiasm to establish herself as an expert in graphic design in her new country. She became involved in the inception of the Australian Graphic

Design Association (AGDA), as well as a representative for Icograda (the International Council of Graphic Design Associations), now known as the International Council of Design (ICoD). She witnessed Australian design grow to be showcased on global print platforms like *Communication Arts* magazine and the Swiss-published *Graphis* magazine, and she participated in regular workshops to improve her artistic skills.

Anna's first job in Australia was with Horman Design at Wilson's Point in Sydney. Within three years, she went from being a studio manager to a senior designer producing corporate graphics and annual reports. By 1980, she had resigned to become one of the first female lecturers at Sydney College of the Arts—hired because of her rare qualification and industry experience in Australia. She taught for six years under the leadership of Arthur Leydin (1932–2010) and supported his push to teach concept-based graphic design. When she was ready to return to the industry, Anna was in her mid-thirties and was considered either too old to employ or a threat who might steal clients. Then, John Spatchurst (1938), who ran his successful studio, passed on some small clients like the NSW Housing Trust to assist Anna in starting her practice, Eymont Design.

With one employee, Debbie Kelton, she rented a vast studio on Bellevue Road in Surry Hills, Sydney, and began searching for people to share the space. A local typesetter introduced her to Myriam Kin-Yi, who moved in with her studio, Sky Visuals. By the early 1980s, Myriam had been commissioned to do an illustration for the Maritime Museum in Sydney and asked Anna to design the poster. This project was their first collaboration and iteration of what would become EKH, running out of Boronia Street in Sydney, Australia.

Figure 3.4.2 EKH, logo designed for Optus, the second-largest telecommunications company in Australia, 1993. Courtesy of Myriam Kin-Yee on behalf of EKH.

Myriam Kin-Yee's Story

Myriam Kin-Yi was born in 1950 in the New Hebrides, now known as Vanuatu. Her mother, Marie, was Vietnamese and a homemaker, and her birth father, Wu, was Chinese, but her French stepfather, Pierre, raised her with her mother. This multicultural background and her parents' creative pastimes profoundly influenced her. Her father practiced traditional Chinese painting and calligraphy on scrolls, and her mother exhibited paintings influenced by European tradition.

Myriam's creative career began in 1972 as a frantic crisscross of studying, teaching, and working as a designer. She first studied to become an art teacher at Sydney University, after which she completed a diploma in graphic design at Randwick Tech. After graduating, Myriam worked for the education department as a graphic designer but soon returned to study for a degree at Sydney's College of the Arts in the early 1980s. There, she realized that the portfolio of work she developed in her degree course was more important than the actual "piece of paper" itself—and so she never completed the qualification. Instead, Myriam decided to spend a year studying at the School of Visual Arts in New York City in 1985. She later described this experience as the "best year of her career that changed everything." Her attitude toward the value of hard work matured. Exposure to the infallible belief that she sensed Americans had in themselves was infectious and contrary to the laid-back, self-deprecating Aussie trope. When she returned to Australia, Myriam jumped back into teaching, working at her old haunts in Randwick Tech and the University of Wollongong.

Bubbly and vivacious, Myriam was enthusiastic about sharing her recollections of EKH. However, she quickly pointed out that this sense of friendship, loyalty, and respect for the female founders was unique. During her design career in the 1980s and 1990s, she had experienced male studios suing each other and imploding over their egos. Yet, twenty years after EKH was successfully sold, the female founders and many past employees still enjoy keeping in touch. The culture of togetherness was important to Myriam as it helped make coming to work a pleasure and "battling" with clients easier. There was never a day that Myriam did not want to go to work. She enjoyed the international travel that hotel branding jobs afforded her but was also happy to do branding for smaller, more local businesses like restaurants. She stood firmly in defending her staff against bullying clients and was known to release the clients of their obligations if they did so. Myriam wanted to create a happy and productive studio culture where the partners worked to their strengths. Together, their intuition and common sense aligned toward building a team of people that fostered their philosophy that "good design is common sense, but not so common."

Apart from illustration and design, Myriam's passion resides in education. Both she and Anna would take six to seven months off to teach overseas. Myriam taught at an American university in Switzerland, and Anna returned to Poland to teach at both the EAS (European Academy of Arts) and the WIT (Warsaw School of Information Technology),

which both offered degrees in design. Through her friends Imre Molnar (1941–2012) and Felicia Eisenberg (from the ArtCenter College of Design in Pasadena), Myriam was hired and paid incredibly well, teaching one day a week, allowing her to "galivant" around Europe for the rest of the time. She considered herself very lucky to work in an industry she loved, with good people, where she could create an environment conducive to encouraging Australian creativity. To her, design was either good or bad, and it didn't have a gender assigned to it. She found doing so disconcerting; although she empathized that some women were victimized in the industry and that the glass ceiling did exist, she felt privileged to have bypassed these issues with the establishment of EKH.

Alison Hulett's story

Alison Hulett's early life was peppered with politically incorrect experiences. She was born in 1953 and raised in Paisley, Scotland, a mill town on the border of Glasgow, where the Paisley pattern was made popular after some inappropriate appropriation from traditional hand-woven Indian Kashmir shawls. Her father, Harry, was an aircraft engineer, and her mother, Annie, was a homemaker and a model for a department store furrier—a job no longer as glamorous as it once was. When she was fourteen, she and her older brother Alister (1951–2010) were uprooted from a very progressive high school and relocated to New Zealand. She was enrolled in a more draconian institution in Christchurch. The bookend siblings, Alison and Alister, were originally going to be called Alison and Michael until a meddling and staunchly conservative grandfather refused to have a grandchild named after a Pope.

She remained in New Zealand until the age of twenty-one, completing a bachelor of arts degree at Canterbury University and Teachers College in Auckland. She trained to become a high school teacher, but after a brief foray into teaching, she followed her brother to Australia and, from that moment, called Sydney her home. On the ideologically unsound side of society, once again, Alison joined a friend to work as a "trolley dolly" in an illegal casino. She made good money before finding a job at the Sebel Townhouse Hotel, where she was asked to try her hand at design by handcrafting calligraphy for their menus and Elton John's wedding invitations. She was hooked. In 1981, she returned to Sydney College of the Arts to study graphic design. There she found herself being taught by Anna Eymont and was soon offered an internship position during the summer holidays for $5 (AUD) an hour. She realized she was learning more working for Anna than in the classroom.

However, her husband's film production work took them to Los Angeles, and she was away from graphic design work for two years. She loved her lifestyle in America, but her marriage did not last. She returned to Sydney with her son James to continue working with Myriam and Anna part-time, balancing this job with freelance clients so she could work at night when her toddler was asleep. Some of these projects included the corporate identity and packaging for Porters Paints, print work for Annabelle James' fashion PR

Figure 3.4.3 EKH, poster for the Australian National Maritime Museum commemorating two centuries of maritime contact between the United States and Australia, 1991. Courtesy of Myriam Kin-Yee on behalf of EKH.

agency, and catalogs for Dymocks book stores. At this point, Alison secured work with a new and second-only telecommunications giant in the Australian corporate landscape—Optus, through a highly competitive 700-page pitch document, which Alison could not handle alone. This opportunity and the idea that Myriam and Anna were scared of losing her talent to another studio brought the three women permanently together as partners in Eymont, Kin-Yi, Hulett Design, as they embarked on the most significant work they ever produced. The Optus logo they designed to bring the pitch document together was chosen to become their corporate identity and was launched with much fanfare on a national scale.

However, the studio name proved too long and evolved through several naming iterations, including EKH Design, EKH, and then finally to EKH Branding. The initial name, although fair for all the partners, proved confusing. They often received mail addressed to Almond, Kin-Yi, Harlot but found an acronym that employees could identify with and not just a reflection of themselves.

It's Only the Beginning

EKH did not last forever. In 1998, Alison initiated a collaborative pairing with business advisor Ralph Rogers to help the studio become a viable commodity that could be sold. As well as being an award-winning creative studio, the processes and technology used in the company made it profitable. It placed it in a unique position in the Australian landscape. The "Ralph Factor" resulted in the introduction of timesheets, monthly financial spreadsheets, and their own product line to extend their brand commercially. The "Coral Coast" featured their designs on photo albums, stationery, and wrapping paper. Before Ralph, two or three other companies looked into buying out the partners, but after his influence, the business was successfully sold to the Singleton Group in 2004. Myriam left the company, which had now grown to twenty-three people. Anna left a year and a half later, and by the time Alison moved on in 2006, it had grown to seventy-five employees. The sale left the women financially comfortable in early retirement, and the circumstance became a fiscal model for the industry to aspire to.

Today, Anna still speaks her native tongue and enjoys returning to Poland to socialize with her friends from university. It is a familiar and reassuring place that reminds her of her success in her career. The creative streak running through her life continues, and she sometimes exhibits her work alongside Myriam's. Her photography has been showcased at an International Film and Art Festival in Poland, and she has self-published eight books of her paintings. After her retirement in 1995, Myriam took up painting, replacing her passion for illustration. She returned to art school overseas at the New York Studio School (NYSS) to refine her techniques and began exhibiting her work, proving her self-deprecating joke that good designers turn into bad artists. Myriam remains in Sydney but regularly

Figure 3.4.4 EKH, *Sex Discrimination Book*, 1990, *Insurance and the Sex Discrimination Act 1984*, book cover for the Human Rights Commission. Courtesy of Myriam Kin-Yee on behalf of EKH.

returns to Melbourne to paint with a group of friends who travel to find inspirational landscapes. Alison's life in retirement has revolved around gardening, cooking, reading, and actively participating in social activism. Her natural ability to lead has moved seamlessly into running a memorial for her singer and songwriter brother, Alistair Hulett.[13]

The legacy of EKH is multipronged, but one powerful narrative is the multicultural nature of the founders and the way it existed in the context of Australia's wider and burgeoning multicultural society of the 1980s. Myriam commented that this was not something evident to her back in the day, but on reflection became an obvious factor in sparking the innovative ideas and collaborative nature of their creativity. The founders' disparate voices and areas of expertise created a perfect environment so that staff could explore and experiment. Their originality was awarded by institutions like AGDA, but the women did not care about such trophies. They were more interested in giving back to the young industry. At one stage, Anna was part of SOCOG (Sydney Organizing Committee for the Olympic Games) and was involved in the 2000 Sydney Olympics logo selection committee. The decision to be a judge rather than submit a design was made collectively and cemented EKH as respected experts in their community of practice.

Another unique legacy is their studio model, in which everyone was considered essential and could act as a designer. There was an unofficial flat hierarchy at EKH—which was more a matter of necessity than planning in the beginning—one that revealed the progressive nature of these three women. Everyone was prepared to take on every role, including answering the phone, yet everyone had the opportunity to indulge their interests, capabilities, and passions. Their creative process involved everyone contributing to the initial concepts; however, final jobs were funneled to those who specialized in the areas specific to each job. EKH's focus on individually addressing each problem kept their clients satisfied and their portfolio diverse. Although other studios pinned their reputation on their ability to follow trends or to create cutting-edge designs, EKH was focused on designing solutions that best served the client. EKH is an Australian success story that deserves to be included within a globally inclusive canon of women in the history of graphic design.

© **Dr. Jane Connory**

NOTES

1. Read more about this survey online in the online EYE Magazine blog titled "Invisible Women in Australian Graphic Design." https://www.eyemagazine.com/blog/post/invisible-women-in-australian-graphic-design.
2. This research is all collated and analyzed in my 2019 PhD exegesis titled "The View from Here: Exploring the Causes of Invisibility for Women in Australian Graphic Design and Advocating for Their Equity and Autonomy," Monash University, pgs. 3–4.
3. Ibid., pg. 16.
4. This was elaborated on in my conference presentation published in the proceedings of DRS 2020 International Conference, Vol. 2 "Impacts," titled "Processes That Cause

Invisibility for Women in Australian Graphic Design," pgs. 494–512.

5. Think Drucker's 2013 *Graphic Design History: A Critical Guide*, Jubert's 2006 *Typography and Graphic Design: From Antiquity to the Present* and Meggs's famous 1992 *A History of Graphic Design*. In fact, this American influence on Australia, beyond the realms of graphic design, has not extended to our written language. We insist on the obviously correct letter "s" instead of the letter "z" in many words—noting that Australia is not known for its own individual style of graphic design like the Swiss, but our self-deprecating, often sarcastic and larikkin (i.e., mischievous) sense of humor is pervasive.

6. Evidence of these paintings is reported on in Finch et al.'s 2021 paper "Ages for Australia's Oldest Rock Paintings." *Nature Human Behaviour*, Vol. 5, 2021, pgs. 310–318.

7. These can be viewed via the YouTube video, accessed September 20, 2022: https://www.youtube.com/watch?v=QACpWLpLmLk, titled "Through our Eyes—Interpreting hand stencils at Muatwintji with Mark Sutton."

8. McGregor, Russell (2002), "Breed Out the Colour or the Importance of Being White," *Australian Historical Studies*, 33:120, pgs. 286–302. Also note the correct Australian spelling of color is colour, which I've insisted on highlighting in these footnotes with my tongue firmly in my cheek.

9. Read more about Ruby and this event in my online article for *The Conversation* in 2019, titled "Hidden Women of History: Ruby Lindsay, One of Australia's First Female Graphic Designers." https://theconversation.com/hidden-women-of-history-ruby-lindsay-one-of-australias-first-female-graphic-designers-109184.

10. As outlined in a 2022 Reilly industry report titled, "M6924. Specialised Design Services in Australia," pg. 18. Just saying that dollars (D) is a currency we also have in Australia (AU), although it has a whole different value to the USD.

11. Here's another one of those pesky instances where this "z" in socialising makes no sense to an Australian.

12. For our American readers, the official translation for the Aussie word "serviettes" is "napkins." We also call "trash cans" "bins," and "lemonade" "cordial." Maybe the British have had a bigger influence on us in some ways after all?

13. The online memorial "Remembering the life and legacy of Alistair Hulett" can be found here: https://www.alistairhulett.co.uk/alistair-hulett/

3.5

Making a Difference: The Graphic Design Work of Trish de Villiers

Dr. Deirdre Pretorius

In 1988, Patricia (Trish) de Villiers created a striking poster for the Congress of South African Trade Unions (COSATU) at the Community Arts Project (CAP) Poster Workshop[1] at their premises based in Community House in Cape Town. The poster shows a domestic worker hanging up washing to dry in a stiff breeze, which whips up her dress and flaps the washing on the line, a baby tied to her back with a blanket. She is leaning into the breeze with outstretched arms to peg down the laundry, thereby creating a diagonal line that, in combination with the washing line, creates a dynamic figure pointing upwards and forwards in a pose reminiscent of the heroic workers of revolutionary posters. The dynamism of the composition is reinforced by the angular yellow color plane in the background and the loud call in bold uppercase sans-serif lettering: WOMEN WORKERS!

Figure 3.5.1 Trish de Villiers, photographed in Cape Town, South Africa, circa 1985. Photographer unknown. Image courtesy of Trish de Villiers.

UNITE & FIGHT FOR YOUR RIGHTS, positioned to reinforce the direction of the yellow shape. The strong red, black, and yellow color scheme and the pointed red shapes in the corners of the poster further enhance the energy of the composition.

The red shapes act as frames for, in the upper left corner, the COSATU logo and the words "LIVING WAGE CAMPAIGN," and in the bottom right for a silhouette comprising industrial structures, including mining headgear, factories, and smokestacks, underlined by the demand "6 MONTHS PAID MATERNITY LEAVE" followed by three identical shapes. On closer inspection, each shape reveals the same elements: the organization's name on a banner with a raised clenched fist below.

The COSATU logo consists of three workers pushing a wheel forward under a banner held aloft by a woman who, like the poster's subject, has a baby tied to her back. This female worker replaced one of the males in an earlier version of the logo after the organization received complaints about the absence of women.[2] De Villiers reinforces the logo's inclusive rhetoric by linking domestic and industrial work through an ingenious visual device: the washing that is being pegged onto the line in the foreground transforms, first into a banner shape and then into smoke rising from the smokestack in the background.

The imagery in the poster draws on what is identified in the literature on South African resistance posters as an "international visual vocabulary of struggle"[3] or "international revolutionary graphics."[4] Likewise, Trish describes the Poster Workshop aesthetic as being inspired "by the long international tradition of political poster-making, traceable to the futurists and constructivists in the early Soviet Union, through May '68, Cuba, Mozambique, and Angola." Therefore, she continues, "most of the posters produced were essentially agitprop in nature, sharply defined edges, flat blocks of color and dominated by the familiar symbols: clenched fists, blindfolds and gags, chains being broken and heroic figures enduring poverty and confronting military might."[5]

Although the COSATU poster includes a number of these symbols, it combines the tradition of resistance posters with a more personal expression. The artist's hand is very much evident in the self-assured linework with which the figure is sketched, which ranges from thin, delicate lines to energetic, bold strokes. Trish explains that she tried combining the text with the drawing in this poster, thereby creating a "richer kind of imagery." This renders the representation of the woman as human and individualized, as well as heroic and strong.

The poster draws together many of the concerns that had been present in her graphic designs since her early working days: feminism, labor issues, women's rights, social justice, and politics, but also technical issues of print production, experimentation with medium and style, and integration of image and text. This poster exemplifies the impactful posters de Villiers created or co-created at CAP during the turbulent and volatile 1980s in South Africa. Its focus on the invisible, hard, and underappreciated work that women do aptly also reflects the lack of attention de Villiers has received to date as a graphic designer.

Figure 3.5.2 Trish de Villiers, CAP, poster design for COSATU, Cape Town, South Africa, 1988. Image courtesy of Trish de Villiers, ASAI, and UWC RIM Mayibuye Archives.

The key text on resistance posters in South Africa, *Images of Defiance*,[6] does not refer to poster makers by name. Hence, the reproduction of the COSATU poster in *Images of Defiance* is credited to "Gardens Media Group/CAP for COSATU." The posters that were produced at CAP were credited to organizations and not to individuals, in line with the community arts ethos, which emphasized collective, not individual creativity.[7] In 2007, Trish[8] reflected that within the context of a collective process, "the concept of intellectual property is suppressed, the 'auteur' is the organization … it does mean, for me and others, that there is no evidence that we did anything at all for 10 years. To say this is not a bewildered cry for recognition …"

Publications that do acknowledge her by name include *Inheriting the Flame: New Writing on Community Arts in South Africa*,[9] *Red on Black: The Story of the South African Poster Movement*,[10] and *From Weapon to Ornament: the CAP Media Project (1982–1994)*.[11] Such references are, however, cursory and always in the context of her contribution to CAP.

This essay seeks to expand on this literature by providing a fuller picture of the graphic design career of Patricia de Villiers than has been previously available. Whereas the emphasis is on the CAP decade, it will include references to the decade preceding and following this time frame to show the continuities in her work and her feminist position. The focus also moves from the collectively created political posters at CAP, which have been widely reproduced and written on,[12] to the posters she created individually for theater productions during the 1980s. These have not received attention and do differ considerably in style from the political posters. The theater posters allowed her more creative freedom, room for experimentation, and the development of her own voice. For her, there was a clear distinction between the work she executed individually and that which resulted from assisting others. The theater posters also constitute most of the posters included on the Africa South Art Initiative (ASAI) website,[13] which features digital archives on the careers of selected African artists to enhance their visibility.[14]

The 1970s: Broadside Mobile Workers' Theatre Company & Spiderweb Print Cooperative

Trish joined CAP as a volunteer in 1982 while working at the People's Space—an alternative theater in Long Street, Cape Town—as a stage manager and costume designer from 1981 to 1983. She had joined this theater company after struggling to find employment as an offset lithographic printer in Cape Town's male-dominated, unionized printing trade, despite carrying a British National Graphical Association card and having obtained a Certificate in Reprographics from the London College of Printing in 1981. She returned to South Africa in 1981 after living in the United Kingdom since 1972, a country to which she had "fled [from] the miseries of apartheid" to study Theatre and Costume Design at Sadler's Wells Design School in London. Three years earlier, she had graduated, with distinction, from the Johannesburg School of Art with a National Diploma in Fine Arts in 1969.

Trish loved living in London, she felt very much at home as she had been schooled there from the age of eight to sixteen after her family had relocated in 1957 from South Africa due to her father's employment. Her father, Izak Frederick (Derick) Albertus de Villiers (1918–1992), worked for the South African Department of Foreign Affairs from 1945 to 1964 and would later move into opposition politics in South Africa.[15] He married Phyllida Compton in 1945, and Trish was born on February 23, 1949, the second-born daughter and middle child after her brother was born. Her mother came from a liberal English background, and Trish's grandfather, Professor R.H. Compton (1886–1979), was one of the "foremost botanists in South Africa."[16] Trish remembers her mother as being a talented artist who had studied under renowned South African artist Maud Sumner but who "opted for marriage and children rather than to pursue her career." Her mother was an early artistic influence, and she nurtured the young Trish's artistic talents with art materials and encouragement.

Returning to London in 1972 from South Africa felt like "complete freedom" to Trish. Here, she developed an interest in Marxism and Feminism due to her exposure to left-wing thought and having experienced "some painful personal experiences" that she made sense of by reading Marxist feminists. Exhilarated by a performance she saw of Red Ladder Theatre, she joined the Broadside Mobile Workers' Theatre Company, a new political touring theater company that "aimed to give a voice to workers" by creating "thought-provoking, innovative, entertaining and accessible theatre."[17] Broadside worked collectively, aiming for group consensus on all aspects of play-making and management, so although being appointed as stage, costume, and graphic designer, she was in fact, involved with "everything." She therefore gained valuable experience in a range of skills, including producing printed material using affordable, accessible technologies such as duplicating machines and hand lettering and working with typesetters and printers. She developed a lifelong love for the work of John Heartfield (1891–1968), particularly his photomontage technique, which he created with "rudimentary technology," the influence of which is visible in the poster for *The Working Women's Charter Show* created for Broadside. She increasingly became captivated by the printmaking process as well as the poster collectives working in London and was impressed by the work of the feminist See Red Women's Workshop who collectively silk-screened posters to challenge the media's negative depictions of women and promoted women's liberation.[18]

Following the shocking events of June 16, 1976, when South African police killed hundreds of protesting school students in Soweto, she vowed to return to South Africa, deciding that "my most practical contribution to the anti-apartheid struggle would be through print media." In preparation, she joined Spiderweb Print Cooperative as the only female printer and took advantage of the opportunity for further upskilling by obtaining a Certificate in Reprographics. Her decision to join the male-dominated Spiderweb was criticized by those who felt that she should have opted to become part of an all-women's printing group. She explains the differing opinions as follows:

> Printing was traditionally a male job, and I was proud of myself for acquiring that skill. I suppose I saw myself as opening up a space in a male arena—but the all-women groups ... saw a need to organize separately ... to create that space ... I remember becoming quite upset because they were kind of going well; you know you're a sell-out working with men.

Trish arrived in Cape Town in 1981 to be joined later by Peter Lewis, her future husband, whom she had first met when she interviewed him for a position as a musician at Broadside. Despite having nearly a decade of graphic design experience behind her and having union recognition as a small offset lithographic printer, she found she was effectively excluded from working in the printing industry due to her gender and race. She had to wait for a while before she could use her knowledge and skills—with a printing technology she had minimal experience with—silk-screen printing—at CAP.

The 1980s: CAP

CAP was established as a community arts center in 1977 to serve the needs of the black population of Cape Town.[19] Pissara[20] describes CAP as "a multi-faceted and multidisciplinary initiative that over time came to focus on the visual and performing arts, as well as on what it termed 'media.'" The silk-screen workshop was initially founded in 1978 by artists and art students, which included Jon Berndt (1950–2010), Clive Helfet, Emile Maurice (1955–2016), and Kevin Humphrey.[21] The workshop initiative stalled over a dispute about funding sources but was revived in 1982 following the Culture and Resistance Symposium and Festival by artists and activists inspired by the silk-screened political posters produced by the Gaborone-based Medu Art Ensemble.[22] According to Seidman[23] it was Jon Berndt and Lionel Davis (1936) who returned from Botswana with the intent to create a poster-making unit, and they were joined by about eight others, including Trish.

Trish did not attend the festival, but she participated in the meeting held shortly after the attendees returned from Gaborone, remembering "basically people broke into small groups and they said OK, so what are we going to do? There was a writer's group, a theater group … and a silkscreen poster-making group, which is where I decided to move in!" Initially, she volunteered, recalling that "I was delighted to find myself in a space like that. And even more so when I began actually receiving an income from it and was able to work there all the time."

As proposed by MEDU, anti-apartheid artists redefined themselves as "cultural workers" who used art as a weapon to collectively struggle against apartheid and bring about social change. The right to speak for oneself was considered a key principle and led to the Silkscreen Workshop's purposeful training of activists to design and print their own media.[24] Trish acknowledges that although they tried to enable the organizations to make the posters entirely themselves, they ended up doing "quite a lot of the actual typography and the putting together of the screen and all the rest of it."

Lionel Davis[25] remembers being "inundated with requests for posters and T-shirts to be printed, and banners to be painted. Day and night, we slogged, not only designing artwork for the posters and T-shirts but also printing and cleaning the screens." Organizations required media for a range of concerns, including business boycotts, forced removals, rent and bus boycotts, detentions without trial, freeing of detainees and political prisoners, and the withdrawal of soldiers from the townships.[26]

The Poster Workshop's services were used by various grassroots organizations such as the civics, youth, sporting, women's, faith-based, and cultural organizations. In 1983, The United Democratic Front (UDF) was launched as an umbrella organization uniting many such anti-apartheid organizations, and it was primarily these UDF affiliates that came to the Poster Workshop for assistance.[27] However, "CAP was non-partisan, and … activists from all anti-apartheid organizations were welcome."[28]

The COSATU poster indicates the organization's acknowledgment of the need to "pay special attention to the organizing of women workers,"[29] and Trish purposefully aimed at creating a representation of a strong woman on this poster. Another example of a strong female figure by her is found on the right-hand side of the mural in Community House, created in 1987 by a loose collective nicknamed "The Muriels"! The statuesque figure of a woman balancing a bundle of wood on her head while holding a child is reminiscent of the murals of Diego Rivera. To her left, various workers representing a range of genders and occupations appear, showing CAP's strong adherence to inclusivity and egalitarianism. Trish remembers arguments about gender representation taking place during the mural's creation,[30] an issue that she had been conscious of since her time in London during the 1970s.

Back in South Africa, Trish joined the UWO, which was founded in 1981 and later became the United Women's Congress (UWCO) when it merged in 1986 with The Women's Front.[31] She recalls that there was "some hostility" between feminists and women who argued that "we have to fight shoulder to shoulder with our men." Trish had joined the ANC before leaving London, however, as the ANC was banned in South Africa until 1992, she did not openly disclose her affiliation.

Berndt[32] identifies two political poster types: "those that were produced by untrained political activists, and the second, those made by trained 'cultural workers' or 'media activists' who worked alongside the grassroots political activists." Although Trish worked in the latter capacity as a facilitator, technician, and educator to enable activists to create media, she and Lionel would later start making their own posters whenever the opportunity arose, allowing for more experimentation and creativity in their design and execution.

The Theater Posters

Trish recalls that she and Lionel were both "very excited" by the silk-screening process and the possibilities it offered; and because there was minimal photographic capacity at the time, it was all handmade. When no workshops were taking place, they would be experimenting and "playing around with the screens and trying out various techniques with crayon and wax and stencils," a process which she enjoyed immensely.

Although Trish found it very rewarding to teach and work with groups of activists to create political posters, she found it to be "more constrained." She felt there were expectations about what was considered "acceptable imagery" and what she describes as "an element of correctness." Therefore, she seized opportunities that allowed her more creative freedom, which usually arrived in the form of poster designs for theater productions. The Poster Workshop was frequently approached by CAP's drama group, other community theater groups, and the UCT (University of Cape Town) Drama School to produce posters.[33] Thirteen of the twenty posters that appear on the ASAI website as representative

of her work at CAP are for theater productions. Of these, nine posters show links to Mavis Taylor (1924–1997), either as a director, being involved with the conception of the play, or as being presented in venues affiliated with UCT.

Professor Mavis Taylor, a staff member at the UCT Drama Department since 1952 and Head of the Department from 1988 until her retirement in 1992,[34] was involved in the development of "innovative community-based drama work at the Space Theatre, CAPAB [Cape Performing Arts Board], CAP and the New Africa Theatre Association."[35] She was considered a "legendary teacher of improvisation" who championed this method in the UCT Drama Department.[36] She was also the chairperson of the CAP board of trustees and instituted a full-time two-year drama training course at CAP in 1984 with funding from the Ford Foundation.[37]

Trish developed a good working relationship with Mavis, designing one production and several exceptional theater posters for plays that she directed. According to Trish, these required an "amount of work that … was actually quite ridiculous, but it was such a pleasure." Mavis did not prescribe to her at all, and she had "complete artistic freedom,"

Figure 3.5.3 *Left:* Trish de Villiers, *The Madwoman of Chaillot*, theater poster design for UCT Little Theatre, Cape Town, South Africa, 1985. *Right:* Trish de Villiers, *The Great South African Circus*, theater poster design for CAP Theatre Group, Cape Town, South Africa, 1985. Images courtesy of Trish de Villiers, ASAI, and UWC RIM Mayibuye Archives.

which is why she found making the posters so enjoyable and a "great release." De Villiers approached the theater posters as "an area of exploration … an opportunity to play … with images and with type."

Although stylistically diverse, the theater posters are similar in their playful approach to type and the preference for images created through line drawing and photographic montage, and the use of flat color shapes that contrast with areas of texture achieved with techniques such as splattering, stippling, and scratching. The text on almost all of the posters is hand-lettered, using a variety of media, and crafted to match the style of the image, with careful attention paid to the integration of text and image into a cohesive whole. Color palettes are limited to three colors or fewer. Also notable is the sense of humor that is conveyed in some posters, particularly by using caricature.

Examples of this approach can be seen in three posters created by Trish for plays directed by Mavis Taylor in 1984 and 1985. *The Great South African Circus* was a satirical

Figure 3.5.4 Trish de Villiers, *Your Own Thing*, theater poster design for UCT Little Theatre, Cape Town, South Africa, 1984. Image courtesy of Trish de Villiers, ASAI, and UWC RIM Mayibuye Archives.

play workshopped and performed by the CAP Theatre Company, which uses the circus as a metaphor for South Africa.[38] A satire written by the French dramatist Jean Giraudoux, *The Mad Woman of Chaillot* was produced by UCT Drama Department students (ESAT 2021), and *Your Own Thing*, also by UCT, was billed as "a 60s musical in terrible taste." Considering her working relationship with Mavis and her delight in experimenting with silk-screen techniques, I would describe the theater posters as a type of "graphic improvisation" that enabled her to freely give expression to her imagination.

Change is Inevitable

As South Africa started transitioning to democracy, media requirements changed, anti-apartheid donor funding started drying up, and change became inevitable for Trish as well. After the birth of her daughter in 1989, she moved back into a volunteer position at CAP, remaining involved until 1994. From 1989 until 1997, she worked from home for non-governmental organizations (NGOs), activist groups, and the Constitutional Assembly, creating illustrations, posters, and cartoon strips and producing a "vast quantity" of work for children's publishers, including thirteen illustrated story books. In 1990, she obtained an Advanced Diploma in Adult Education at the University of the Western Cape.

However, feeling somewhat isolated and looking for a closer connection to social reconstruction, namely through state service provision, she opted for a position as Deputy Director of Health Promotion for the Western Cape Health Department in Cape Town in 1997, where she acquired skills, among many other things, in the "nuts and bolts" of computer-generated design, which she put to use after her retirement in 2012. In addition to design work, Trish returned to book illustration and has embraced writing and ceramics as a further means of self-expression. Having now relocated to a rural area, she is converting a small barn into a usable workspace to further pursue printmaking and clay work.

© **Dr. Deirdre Pretorius**

NOTES

1. The workshop was known under different names, including the Silkscreen Workshop, Poster Workshop, and CAP Media Project.
2. COSATU, "Ten Years of Workers' Unity and Struggle; Special COSATU Tenth Anniversary Edition," *The Shopsteward* 4, no. 6 (1995), pg. 10.
3. The Posterbook Collective. 2004. *Images of Defiance: South African Resistance Posters of the 1980s*. Second edition, first printed 1991 by Ravan Press. Parktown: STE Publishers, pg. 8.
4. Seidman, J. (2007). *Red on Black: The Story of the South African Poster Movement*. Parktown: STE Publishers, pg. 27.
5. De Villiers, P. (2017). "Culture is a Weapon of Struggle: Lionel Davis and the CAP Poster Work," in *Awakenings: The Art of Lionel Davis*. Edited by Mario Pissarra. Cape Town: ASAI, pg. 90.

6. The Posterbook Collective 2004.
7. Van Robbroeck, L. (2004). "Community Arts in South Africa: A Brief History," in *Inheriting the Flame: New Writing on Community Arts in South Africa*. Edited by Graham Falken. Cape Town: Arts and Media Access Centre (AMAC), pg. 48.
8. In Berndt, J. 2007. *From Weapon to Ornament: The CAP Media Project Posters (1982–1994)*. Cape Town: Arts and Media Access Centre (AMAC), pg. 55.
9. Falken, G. (ed). (2004). *Inheriting the Flame: New Writing on Community Arts in South Africa*. Cape Town: Arts and Media Access Centre (AMAC).
10. Seidman 2007.
11. Berndt 2007.
12. Since the demise of the apartheid regime in 1994, the resistance posters, including those printed at CAP, have been featured in numerous publications and have become publicly accessible through online archives such as The South African History Archive (SAHA) and UWC RIM Mayibuye Archives.
13. https://asai.co.za/artist/patricia-de-villiers/
14. I interviewed Trish three times in mid-2022, and I am grateful to her for sharing her time and memories so generously with me. I have also drawn information and images from the entry on her on the ASAI website.
15. https://atom.lib.uct.ac.za/index.php/de-villiers-izak-frederick-albertus.
16. Rycroft, H.B. (1979). "Professor R.H. Compton," *Veld & Flora* 65 (3), pgs. 74–5.
17. https://www.unfinishedhistories.com/history/companies/broadside-mobile-workers-theatre/
18. https://seeredwomensworkshop.wordpress.com/
19. Davis, L. (2004). "Posters for Liberation: A Personal Perspective," in *Inheriting the Flame: New Writing on Community Arts in South Africa*. Edited by Graham Falken. Cape Town: Arts and Media Access Centre (AMAC), pg. 23.
20. Pissarra, M. (2020). *The Community Arts Project: Legacies and Limitations of an Arts Centre*. Third Text Africa, 12 (August), pg. 33.
21. Berndt 2007, pg. 2.
22. Ibid., pgs. 2–3.
23. Seidman 2007, pg. 111.
24. Berndt 2007, pgs. 6–7.
25. In Berndt 2007, pg. 47.
26. Davis 2004, pg. 23.
27. De Villiers 2017, pg. 88.
28. Davis 2004, pg. 26.
29. The Poster Book Collective 2004, pg. 61.
30. De Villiers, P. (2018). Mural at Community House, Salt River, Cape Town, 1987, in Angela Ferreira African Unity Mural. Lisbon: MAAT, pg. 41.
31. Anonymous. (1988). Our Branch History—A Personal Account. UWCO Obs/Claremont Newsletter. October: 8.
32. Berndt 2007, pg. 14.
33. Davis 2004, pg. 27.
34. Calburn, C. (1994). *A Critical Documentation of Mavis Taylor's Teaching of Improvisation*. MA thesis submitted to the University of Cape Town, Cape Town, pg. 10.
35. Falken 2004, pg. 21.
36. Calburn 1994, pg. 1.
37. Pissarra 2020, pg. 40.
38. Falken 2004, pg. 20.

3.6

Mahnoosh Moshiri: Designs as a Poet, Writes as an Illustrator, and Lives as an Artist

Parisa Tashakori

Mahnoosh Moshiri is an Iranian graphic designer and illustrator living in Tehran, Iran. She began her career in 1968 as a graphic artist at a time when women's names were known in the illustration field but not in design. She has successfully created hundreds of book covers and posters for cultural events. Discerning a border between her professional work as a designer, illustrator, author, and poet is always challenging. She has engaged her talent with multi-tasking projects in different areas. Working within Iran's patriarchal society, Mahnoosh Moshiri is a role model for girls and young women seeking their own agency through art and design. We talked about her life and career in her lovely house in Tehran in August 2022.

Figure 3.6.1 Mahnoosh Moshiri photographed in 2020. Photo by Alireza Fani. Image courtesy of Mahnoosh Moshiri.

Parisa Tashakori To begin, please talk about yourself, whatever you think is interesting to know about you.

Mahnoosh Moshiri I was born in 1951, and due to my unique family situation, I am who I am today. I do not believe I am anything and never thought I was an artist. Many people believe that my Sufi lifestyle demands this humility, but it comes from my existence. I am a tiny particle of cells in the infinite sea of longtime Iranian art.

PT What a profound and poetic interpretation. Would you like to tell us about your family and their influence on you?

MM I was born into a well-known Kurdish family. All the women in my father's family were educated—primarily as teachers—and were considered at the highest level of society. Some family members were even candidates for parliamentary elections. My mother, Parvin Rezai, earned a diploma, and even my father's mother, Hamideh Sadr, was educated. My aunt, Fakhr al-Sadat Moshiri, in Kurdistan, founded the first kindergarten in Iran. Being of Kurdish ethnicity with a strong matriarchial foundation resulted in us being more than just typical women.

With that said, the most direct influence my four siblings and I received was from my father, Mir Jamal Moshiri, who was educated in theology and the Arabic language. He was the chief editor of *Shahnameh Rooz* newspaper. He was a government employee, and due to the nature of his job, he would criticize government policies. In those days, in the 1960s, it was not the case that if someone opposed the government, they were executed; my father was always exiled to very remote places while maintaining his high-level position. For example, during my childhood, we lived in the town of Borazjan,[1] which was very impoverished at that time. Even though Borazjan was considered exile in those days, we had a good government life there. My father was the head of finance at the Iran Tobacco Company in Borazjan.

We also lived in Bushehr, Nahavand, Kashan, and Yazd. In Yazd, I studied at the Markar school, which is for Zoroastrians.[2] In this place, I became an authentic person. I did not attend Zoroastrian religious courses because I was a Muslim, although I had never studied my own religion. I lived and grew up free from any organized religion! During our time in Borazjan—which had the most significant impact on my life—there was absolutely no public assistance outside our home. In 1958, when I was seven years old, I fondly remember how much I was interested in drawing, although we had no access to colored pencils.

And yet, with all these limitations, my father always encouraged us to read books. My three sisters and little brother read *Golestan* and *Bustan* by

Saadi and *Four Discourses* of Nizami Aruzi Samarqand during our teenage years.[3] In addition, we had access to *Keyhan Bacheha*,[4] *Tehran Mosavvar*,[5] and *Ettelaat-e Bacheha*,[6] three children's magazines that reflected the rich culture of our childhood. The radio also had a unique program for children, and we listened to that as a component of our lessons.

PT It sounds like your environment was culturally inspiring.

MM Absolutely, and those three magazines were not the only ones available to us. My mother had a monthly subscription to *Ettelaat-e Banuvan*,[7] and my father would receive *Sepid-o-Siah*[8] magazine. We were surrounded by an atmosphere that nourished our minds. Also, my uncle[9] and my mother's uncles were well-known poets.

PT When did you discover you were interested in painting and illustration?

MM I remember drawing an image of a dog but had no material to color it. So, my father's driver and I searched through the whole bazaar for colored pencils and found none. Afterward, I took refuge in our garden and colored the drawing using petals and wild leaves. My father sent the picture to a competition in Japan and then another copy to *Keyhan Bacheha*. Later, I received a muslin package with "Mahnoosh Moshiri" sewn on it! My name was written in such an artistic/typographic way that I continue to use the same format in my signatures. The twenty-four-piece colored pencil set that arrived in the muslin package became a game-changer in my life and my family's.

Later, we moved to Tehran during my teenage years, and I studied the natural sciences in high school. I wanted to attend art school, but my father would not let me go. Ultimately, I agreed with him, not because I didn't like art schools but because, in my opinion, I firmly believed that mathematics is the mother of art and philosophy, and art is the older brother of philosophy.

PT How fascinating! This is an interesting topic for another discussion. Based on what we have experienced recently from the time design was synthesized with engineering, its results have become more influential on human life.

MM Exactly, and I experienced this with all the cells of my body.

PT Why did you change your direction from the natural sciences to art?

MM I was a very lazy student in high school. I read Sartre at age thirteen and became an existentialist. When my father came home from work, I would hold a textbook in my hand with Sartre tucked inside. At school, I was the worst student in the eyes of others because they knew I read novels that were considered dishonorable for families. I failed for several years, and as a result, I became my younger sister's classmate. I was trying to finish high school while working as a magazine

Figure 3.6.2 Mahnoosh Moshiri, illustration for a *Tamasha* magazine cover on Artour Maimane, 1974. Image courtesy of Mahnoosh Moshiri.

Figure 3.6.3 Mahnoosh Moshiri, poster design for Shakespeare's play, *Hamlet*, 1977. Image courtesy of Mahnoosh Moshiri.

	illustrator, even though I was only seventeen. After high school, I passed the entrance exam for Tehran University and studied painting at the College of Fine Arts.
PT	In your professional life, you have sometimes been involved in illustration and painting and other times engaged with graphic design work. How did this happen?
MM	In the College of Fine Arts, my painting professor, Mohsen Vaziri-Moghaddam (1924–2018),[10] wanted me to stay in the painting program, and my graphic design professor, Morteza Momayez (1936–2005),[11] insisted that I should train in the graphic design program. Later, I chose graphic design as my major and studied philosophy and Eastern religions as my minor. Perhaps the main reason for my becoming a graphic artist was the influence of my dearest master, Morteza Momayez, who also supervised my dissertation. Later, I became his assistant and managed his atelier when he traveled. Above all, I had access to excellent inspirational sources, like his magazines, books, and original graphic artworks. When Momayez was in charge of the graphic design classes at Kanoon,[12] I worked with his students in his absence. I also worked in the studio of *Tamasha* magazine,[13] which Ghobad Shiva[14] managed. Initially, I had a hard time there because I was a mischievous kid, but as I was a fast learner and could process complex information, the studio let me illustrate the magazine's serial. I grew up with graphic design.

There is an interesting story about my entering the professional world of graphic design. During the Shiraz Festival of Arts,[15] a foreign troupe of Shakespearean actors visited *Tamasha* magazine. The theater group organized a competition to design a poster for *Hamlet*. I participated in that call as a young junior designer, along with many professional graphic designers. My poster was accepted, and I felt like an ignorant child in that wise crowd. |
| PT | You started your career at a time when graphic design was primarily a man's domain. I also grew up in this culture—although in a different era—and worked professionally. I know you must have experienced many problems along the way. Are there any stories you wish to share? |
| MM | You are asking this question to someone for whom the issue of women was vital within their family. This question should be asked of others who look at women differently in their families. I never felt I was a woman because of my upbringing, as we were never raised in the framework of a "woman." I always joke that I was the most beautiful woman—in my whole life—because I was the only woman in all my |

Figure 3.6.4 Mahnoosh Moshiri, two pages from the 1980 illustrated love story, *Khosrow and Shirin*. Images courtesy of Mahnoosh Moshiri.

	meetings. When I was between eighteen and twenty-two years old, I attended meetings where no women were present!
PT	Your point about your family upbringing is fascinating. It would seem that in those years, a family would regard their children as human beings, not through a sexist lens. Weren't you shocked that your family saw you differently when you entered a society with sexist attitudes?
MM	I didn't notice anything like that because of our family's equal education and non-gendered attitude; none of us—the three sisters—were ever harmed by the patriarchal society. For example, I clearly remember that when I was eighteen years old, and our car broke down, my father asked me to go to the repair shop—a very masculine atmosphere—and I stood there for hours to have the car fixed.
PT	In addition to your professional career, you were also engaged in teaching. While following you on Instagram, I noticed that your classes had an exciting atmosphere. Would you describe your learning environment?
MM	After the revolution, I started teaching at the University of Tehran in 1985 as an adjunct. I was an employee of National Iranian Radio and Television (NIRT),[16] and the university asked me to teach after my retirement. I teach just for the presence of students, and I don't get paid.

My teaching method may seem special based on what others say, but I don't know about that. I tell students how an artist must be a tourist in this world before anything else. Thinking in this way, you can be different every day, and when you walk in the streets, your eyes will discover new things that you have not noticed before. With this thinking, you can be born every moment.

PT What classes do you usually teach at the university?

MM Composition in photography, types of illustrations—such as children's and advertising illustrations. Interestingly, the University of Tehran asked me to teach children's illustration in a class titled Art in the World of Children! I assume that because I am an illustrator, they would have assigned me to teach the children's illustration class. But art for a child is more than just illustration. Drama, music, and writing are inseparable aspects of art in the children's world, as is the child's cognition. As a result, I made changes in the syllabus, and now, as an example, one of their assignments is writing a story. During class, I talk about children's games and teach a little about child psychology. I try to open a window to another world by speaking about *Emile* by Jean-Jacques Rousseau (1712–1778).[17] I don't seek techniques from students; I am looking for ideas.

I have also supervised many theses about autistic children and children with intellectual disabilities.

PT We need such research to accelerate solving social issues.

MM Essentially, one must verify that art and design should be used as problem-solving tools. In retrospect, you had asked me if I see a border between graphic design and illustration. For me, graphic design is an engineering of composition and color theory. But a designer who understands illustration, painting, or drama has a different view of the design. Graphic design is a multifaceted geometric art. But art itself is not pure geometry; it is a combination of music and geometry, or in other words, the synthesis of the infinite and absolute. These two together can make art bear fruit.

PT Can you describe the gender ratio in your classes and what factors this depends on?

MM In past years, the number of men was more, but over time, women have outnumbered men—there are only a few boys in my classes now. This might be because art, for no reason, is considered feminine, especially in our society. From an ordinary person's view, art is used just for decorative and household purposes, which is incorrect thinking. Also, the market for women's art in Iran is restricted. As storytelling is considered

a maternal activity in our ancient culture and literature, we have more female illustrators. But in management roles, the gender ratio is unfairly different. Still, in the Iranian Illustrators Society board meetings, the majority, if not all, are men. So, our society is still male-dominated! In the graphic design community, the situation is quite similar. Today, when you enter a design studio, most designers are women because men should bring home the bread by finding jobs with higher incomes. Before the Islamic Revolution,[18] graphic design was a primary career for many men. In the studio of *Tamasha* magazine, we were only two female designers.

PT You have recently started a self-promotion project about Iranian female musicians before and after the Islamic Revolution. Why is this topic interesting to you, and what is your ultimate goal with this project?

MM This project is critical to me. As an illustrator, I have always received work orders from others. You can find hundreds of design/illustration projects in my portfolio. But painting is in my blood and comes from my inner nature. So, I am my own client! The difference between painting and illustration is that although you are the creator of both, the illustration ultimately invites you to look at "it," while the painting says look at "me!"

PT So, this project represents your authentic self who wanted to work on this topic and dedicated this work of art to the women of Iran?

MM I am not a feminist because I don't care about gender. But I can't bear injustice. Female artists have always been oppressed in every historical period from the Sassanid Empire[19] until now—especially female musicians. Of course, the situation is the same worldwide, but it happens much more to Iranian women. I like Edith Piaf (1915–1963) very much. The Virginia Woolf picture has always been on my wall, and I am aware of the severe discrimination they both experienced. Although I wasn't one of those women who have been ignored, I observed that they don't play a role because that's how masculine society works. Georges Sand (1804–1876) was a famous French novelist, a woman who entered the professional writing community with a man-like name and outfit. She pretended to be a man when she was a woman!

I have researched this topic over the years, and it has only been about five years since I have focused on the painting project of female singers. We saw a contemporary female singer like Mahasti[20] from the era of Mohammad Reza Shah (1919–1980), who freely performed on stage in a skimpy dress. Her memoir talked about her barriers when

Figure 3.6.5 Mahnoosh Moshiri, portrait of Qamar-ol-Moluk Vaziri from *Daughters of Cyrus* project, 2022. Image courtesy of Mahnoosh Moshiri.

her brother threatened to behead her if she continued to sing. This is a manifestation of a patriarchal society where guardians like fathers, uncles, and brothers rule over women, which really bothers me.

Among these singers, Qamar-ol-Moluk Vaziri (1905–1959)[21] is one of my favorite women; I have painted her many times. Interestingly, when Qamar performed on stage without a hijab, she was punished by the King, Reza Shah, a so-called open-minded leader who forbade women from wearing hijabs in Iran. Moluk Zarrabi (1910–2000),[22] an innovative Iranian singer, described how her father threatened her. If he heard her voice coming from vinyl records, he would disown and deprive her of her inheritance. When Mahvash (1920–1961),[23] another popular singer, passed away, the newspapers reported: "One less bitch!" Women who captured men's hearts within Iranian society seemed to have no place in their families as their sisters, mothers, and daughters. I

Section 3 Postmodern Innovators (1940–1970)

	have no idea where these contradictions originated.
PT	This observation is spot on. Here another question arises, why women musicians and not women painters? We all know this discrimination has also existed in other fields.
MM	It is obvious that all men from both the civilized and uncivilized world are delighted with women on the stage and behind the microphone. From my point of view, female painters could handle themselves, but female singers seemed defenseless and somehow vulnerable. In addition, the discrimination and challenges to women in the music industry are not a problem of the past or just for traditional societies as it has been and still exist in all countries. Even Catholic organizations tried to ban Madonna's performances in Italy as they believed her act overflowed with vulgarity and blasphemy. Women are caged nightingales whose voices are enjoyed, but not your sister's or mother's voice.
PT	Can you talk about this project's beautiful and legendary title?
MM	I found an old song titled "Daughters of Cyrus,"[24] a famous poem from Iran's Constitutional period,[25] and named the project "Daughters of Cyrus." I remember hearing my mother address us using this name—"Hey, Daughters of Cyrus, come for breakfast," but I did not know who those girls were. Later, when I heard this song referring to the limitations of Iranian women, I was inspired by its modern message.
PT	Given the prevailing atmosphere, will this project ever be able to be exhibited in Iran?
MM	It will never be displayed. Just like the girl who took off her hijab in Enghelab Square and the punishment she was subjected to, our women continue to be oppressed.[26] Unless you take these paintings abroad, they will remain here and might be exhibited after my death. My women's paintings are incarcerated here in prison.
PT	What excites you about starting a new project, and what is your process?
MM	Honestly, I don't know. I meditate sometimes, and I have tendencies to go beyond this world. My motivations are sometimes my dreams.
PT	I read a book by Abbas Kiarostami (1940–2016)[27] titled *Lessons with Kiarostami*, which has helped me in my teaching practice. Kiarostami continuously mentions the power of dreaming when he works with young filmmakers in his workshops.
MM	Undoubtedly, art is thought, and our mind is its cradle. Socrates said, "My job is like a midwife, and, just as my mother who took children from their mother's womb, I take the ideas from your brain." In the mind, there is something that has life; it gives birth, grows, and dies.

PT Have mentors helped guide you, whether directly or indirectly?

MM Plenty. Modern philosophers have always fascinated me. Once, I liked Sartre very much, but later, when I became an existentialist, I left him, too. I have a collection of male and female mentors. Some of my favorites may be very ordinary people. But some are also special, like Cleopatra, one of my favorite characters. In the field of illustration, Nizami Ganjavi[28] is a unique master. At a symposium titled "Nizami as Painter," I spoke about Nizami to signify that he was a painter and colorist before becoming a poet. In the academic environment, I am indebted to all my professors, especially Mohsen Vaziri Moghaddam (1924–2018)[29] and Mahmoud Javadipour (1920–2012),[30] who were particularly influential.

PT My last question: how does Mahnoosh Moshiri spend most of her time? What does she enjoy most?

MM My main focus continues to be the women musician's project. When I put a drop of color in the corner of the canvas, I get incredibly excited, as if that drop, like a tear, is coming out of the corner of my eye. My only concern now is the execution of *Daughters of Cyrus*, which I hope to finish soon. Sometimes my sister says the path is important, not the goal. In the end, this project may never be completed!

© **Parisa Tashakori**

NOTES

1. Borazjan is a city in the central district of Dashtestan county, Bushehr province, Iran.
2. Zoroastrianism is one of the world's oldest monotheistic religions, having originated in ancient Persia.
3. These books were assigned reading in a college-level literature course.
4. *Keyhan Bacheha* is the oldest children's magazine, and has been published in Iran since 1956.
5. *Tehran Mosavvar* was a magazine with various social, political, economic, and artistic content published between 1930 and 1982.
6. *Ettelaat-e Bacheha* was a children's magazine affiliated with *Ettelaat* newspaper published in 1957.
7. *Ettelaat-e Banuvan* was a women's magazine established by Ettelaat Publishing Group in 1957.
8. *Sepid-o-Siah* was an entertaining family magazine established in 1954.
9. Iraj Rezaei was known as Anvar (which means brighter).

10. Mohsen Vaziri-Moghaddam (1924–2018) was an Iranian avant-garde designer, painter, and sculptor.
11. Morteza Momayez (1936–2005) was an Iranian graphic designer and founder of the graphic design major at the University of Tehran in 1970.
12. Kanoon, the Institute for the Intellectual Development of Children and Young Adults, is an Iranian cultural/educational institution founded by Farah Diba and Leyli Amir Arjmand in 1965.
13. *Tamasha* was the weekly magazine of National Iranian Radio and Television published between 1971 and 1979.
14. Ghobad Shiva (1940) is an Iranian maestro of graphic design.
15. The Shiraz Festival of Arts (1967–1977) was an annual international summer arts festival, held in Iran, Shiraz, bringing about the encounter between the East and the West.
16. NIRT was the first Iranian state broadcaster, established in 1971.
17. *Emile, or On Education* is a treatise on the nature of education written by Jean-Jacques Rousseau, published in 1763.
18. The Islamic Revolution refers to a series of events that culminated in the overthrow of the Pahlavi dynasty in 1979.
19. Sassanid Empire (AD 224–651) was the last Persian Empire before the early Muslim conquests.
20. Mahasti (1946–2007) was an Iranian classical, folk, and pop singer.
21. Qamar (1905–1959) was the first celebrated Iranian singer who sang in public in Iran without wearing a veil.
22. Moluk Zarrabi (1910–2000) was a pioneer Iranian singer and actress.
23. Mahvash (1920–1961) was an Iranian singer, dancer, and actress who was lauded as a singer of the people in the 1950s.
24. "Daughters of Cyrus" is a song against women's hijab and was published for the first time in 1927. The possible singer of this song is Muhammad Ali Amir Jahid, and the composer was probably Morteza Neydavoud (1900–1990). Due to the fear of the possible reactions of religious fanatics to this song, musicians preferred to keep their names hidden. Qamar and Molouk Zarrabi sang this ballad at different times.
25. The Constitutional Revolution of Iran (1905–1911) which led to the establishment of a parliament in Iran during the Qajar dynasty.
26. Vida Movahed (1985) was the first Iranian activist who stood on a utility box in Enghelab (Revolution) Square with a scarf tied to a stick in protest of mandatory hijab. She was arrested after a few minutes on December 27, 2017.
27. Abbas Kiarostami (1940–2016) was an award-winning Iranian film director, screenwriter and photographer.
28. Nizami Ganjavi was one of the greatest twelfth-century Persian romantic epic poets.
29. Mohsen Vaziri Moghaddam (1924–2018) was an Iranian designer, painter, sculpture, and professor of contemporary art.
30. Mahmoud Javadipour (1920–2012) was an pioneer of Iranian art in painting, printing and graphic design.

3.7

Arlette Haddad: An Arabic Type Design Hermit

Dr. Bahia Shehab

Situated on the eastern edge of the Mediterranean, Lebanon is a small country that gained independence from the British mandate in 1943. This diverse, multi-ethnic country, famous for its mountainous landscape and seashores, was once a beacon of creativity and innovation in the region before the shadows of war cast their long, haunting embrace in the 1970s. The Lebanese Civil War (1975–90) was a multifaceted armed conflict involving various religious minorities that forced many of its citizens to flee overseas. Amidst this tumultuous history emerges a tale of artistic ingenuity and tenacity—that of the Lebanese type designer Arlette Haddad.[1]

Before the ravages of conflict, Lebanon was a flourishing cradle of culture, and the written word held a cherished place in society as Beirut became the publishing capital of the Arab world. From the bustling streets of Beirut to the tranquil villages nestled in the Lebanese mountains, diverse traditions and languages came together. The Lebanese diaspora—spread across the globe—was driven by economic aspirations and the desire for

Figure 3.7.1 Arlette Haddad photographed in London. Image courtesy of Arlette Haddad.

stability and bringing with them the essence of their homeland. In this context, the story of Arlette Haddad embodies the enduring spirit of a nation determined to preserve its identity, even in the face of adversity.

Arlette Haddad was born with a twin sister in Ghazzir, Lebanon, in 1952, into a family of four girls and two boys.[2] Her family was neutral to her drawing talents as a child. Still, Sami AbiKhair, a Lebanese painter who taught art at her school, encouraged her to consider a career in the arts after recognizing her talent. At the time, Lebanon was known for its rich tapestry of languages, religions, traditions, and diverse cultural backgrounds. In 1970, Arlette enrolled at the Lebanese University to pursue a degree in interior architecture. After graduation, she worked in different architecture offices and also as a furniture designer but discovered she was more interested in advertising; even though her salary as an interior designer was significantly higher than an ad woman's, she decided to pursue her passion.[3]

Within a short period, Arlette worked at various advertising companies in Beirut, beginning with SNIP, then Publirizk in Hamra, moving to Promoseven, followed by Intermarket, Impact BBDO, and finally Johnson International in the Strand area in Beirut. She was promoted to art director in her last post and eventually moved with the company to London in the 1970s when the war started.[4] If all these job shifts suggest anything, they allude to a vibrant economy where markets were dynamic, creating a high demand for good talent—Arlette's desire to learn and grow in a field where she found that her skills were flourishing. While in Beirut, she briefly met her lifelong partner Mourad Boutros (1951), who, at the time, was moving from Lebanon to Saudi Arabia. They would meet again in London, where he moved after his post in Saudi Arabia.

It was considered quite revolutionary for an unmarried woman to leave her country and move to another country for work. But these were challenging times, and the whole social fabric of Lebanon was changing due to the war. Arlette would travel back to Lebanon yearly to see her family and friends. In the mid-1970s, Mourad moved from Saudi Arabia to London to work as a calligrapher at Letraset. On one of her trips to Lebanon, Mourad Boutros's family sent him a letter she delivered. Arlette had met his brother John in one of the agencies she worked for in Beirut and had developed a working relationship with him. It was customary for families to send their children letters, gifts, and recorded tapes with friends and relatives during the war. The mail and other essential communication infrastructures were damaged, and people delivering things to each other was common.

Arlette and Mourad married in 1977, and their first child, Daniel, was born in 1979. During this same year, they formed the Boutros group,[5] a collective specialized in designing Arabic fonts. By starting a family, Arlette had to abandon her job as an ad woman by replacing it with freelancing from home. Her second child, Mark, was born in 1982. Her marriage kickstarted her career as a type designer. The quiet and convenience of working from home benefited the new mother as Arlette designed her life around the needs of

Figure 3.7.2 *Left:* Arlette Haddad, Arabic Borders, Letraset instant lettering, London, 1981. *Right:* Decorative Kufic No. 2, Letraset instant lettering, London, 1982. Images courtesy of Arlette Haddad.

her children. Once they were older, she would drop them off at school, join her husband in their office to work if needed, and then pick them up to tend to their needs. At the time, the Boutros group started getting commissions from clients worldwide. In an interview on AUC's Typelab, Arlette confessed, "We did not face many challenges because we were pioneers in the market; we collaborated with big companies who reached out to us."

One of these companies was Letraset. Founded in London in 1959, Letraset was an innovator in the dry-transfer lettering sheets technology. Designers and design-related companies used their lettering sheets in different fields due to their ease of use and relative affordability. Within three decades, Letraset was the leader in the lettering dry-transfer technology until the arrival of desktop publishing, which eventually made their product obsolete. Mourad Boutros stated that in 1976, Letraset began work on several Arabic typefaces and eventually developed around fifty.[6] They commissioned many Arab designers and calligraphers for this project—the first commercial project in the history of Arab typography to bring together Arab and international talent. Arab designers and calligraphers were commissioned in London—like Arlette and Mourad and later others, such as the Sudanese

Figure 3.7.3 *Left:* Arlette Haddad, Antarat, Letraset instant lettering, London, 1984. *Right:* Arlette Haddad, Marco Polo, Letraset instant lettering, London, 1984. Images courtesy of Arlette Haddad.

calligrapher and designer Taj al-Sir Hassan (1954), who was studying at Central St. Martins in the late 1970s. Letraset then contacted designers from different parts of the Arab world, like Hani al-Masry from Egypt, Mahmoud al-Hawary from Syria, Ismet Chanbour from Lebanon, and Ahmad Shaath from Palestine, to name a few. Not all the designers who designed Arabic fonts for Letraset were of Arab origins, such as Margret Tan (1965) and Walter Tracy (1914–1995). Tracy was a prominent name in the industry and had set up the Department for Typographic Development for Linotype. Linotype's involvement with Arabic typesetting started in 1911 when they shipped the first machines with matrices for Arabic fonts to Cairo.[7] Letraset was targeting the same markets as Linotype, expanding into the Arab world where there was a need for their new technology for designers and different publishers. Letraset probably followed the module of Linotype in their expansion. Lintoype employed the assistance of their Middle East Liaison Office (MELO in Beirut) for linguistic input and customer feedback.[8] Fiona Ross from Linotype speaks of her experience at the company in the 1970s when consultants such as Walter Tracy and Tim Holloway, both designers of Arabic typefaces, were employed. Tracy collaborated with both teams at Letraset and Lintoype. Due to market demand and the scarcity of Arabic font

designers, both companies had to reach out to Arabic calligraphers and designers whose already existing fonts were used and repurposed to work in the new mediums, or they were commissioned to design new fonts for the UK-based companies.

Despite practicing type design for the past fifty years, Arlette is not well known within the Arab world, even though her fonts are used and viewed by millions worldwide. However, this does not bother Arlette, who, besides working as a type designer and graphic designer, also accepted freelance jobs in interior and furniture design and fashion. One of her passion projects was the cookbook *Enjoy: Lebanese Healthy Recipes*, in which she cooked recipes, authored the text, art directed the layout, and produced herself in 2007. She has also created a range of high-quality shawls throughout her career, collaborating with different fashion design houses in London.

That Arlette Haddad is unknown to my students makes me wonder why she did not get the recognition she deserves. Many scenarios come to mind. First, mechanisms and systems for finding and disseminating knowledge on regional designers still need development. Even though design jobs are as old as the printing machine, documentation about the designers is different. Design was considered a craft less worthy of documentation, and thus, several designers in the Arab world have also practiced as artists in parallel to their careers in design. Designers like Dia Azzawi (1939) from Iraq and Kamal Boullata (1942–2019) from Palestine both practiced as artists while practicing as designers.

There are several reasons why design in and from the Arab world is under-documented, starting with the setup of colonial higher educational institutions whose curriculums were predominantly Western and Eurocentric. Also, regional academic institutions focused on producing practitioners rather than reflectors on the field; thus, only recently did scholarship on design and designers come to fruition. Additionally, there were no museums of design in the Arab world, and there was only one publishing house based in the Netherlands that specialized in producing books about Arab design and designers. In the past twenty years, there has been a shift in awareness of the need for documentation. Thus, knowledge sharing on design in the Arab world has improved, but not to the extent that the layperson on the street knows it is a career path for their children. Without relevant school curriculums, publishers, reflective scholarship, museums, and governmental support for design, knowledge about the field will remain with its practitioners.

The second reason why Arlette is not known to younger designers and educators in the Arab world, despite her accomplishments, is due to the Lebanese diaspora. Wars and invasions destroy the social fabric of society. Links to relatives, schoolmates, work colleagues, and other members of the community break, and people are forced to form new connections in the new community they have moved to. Arlette's move from Lebanon due to the war could be considered a blessing and a curse.

On the one hand, the Arab world lost their expertise and skills to the companies of the West, but on the other hand, the Boutros group would not have had this number and kind of commissions if they stayed in war-torn Lebanon. Their work reached and

impacted the Arab world despite their physical absence from it. They were not the only Arab designers to flee their country and set up successful practices in the West. The colonization of Palestine, the war in Lebanon, the 1952 regime change in Egypt, the US invasion of Iraq, the war in Syria, and many other regional political events have sent waves of talented people from different sectors into a diaspora reality. But just like the Boutros group, several have been quite successful in their artistic and design practice endeavors to the extent that we couldn't write the history of the Arab world without including the diaspora designers. A parallel of this condition would be that of Gibran Khalil Gibran (1883–1931) and the Mahjar (Arab diaspora) writers—Arabic-speaking writers who had emigrated to America from Lebanon, Syria, and Palestine during the Ottoman rule and started Mahjar as the literary movement, of which Gibran was a founding and influential figure. Their work impacted the Arab world even though they lived elsewhere.

When Arlette started collaborating with Letraset in the late 1970s, she developed customized Arabic borders and some of her most creative and innovative fonts. Letraset borders were created for magazine ads and layouts and used for different design needs.

Figure 3.7.4 *Left:* Arlette Haddad, Daniel Chrome, Letraset instant lettering, London, 1986. *Right:* Kufic Display, Letraset instant lettering, London, 1986. Images courtesy of Arlette Haddad.

The borders found new life as digital clip arts with the advent of computers. Arlette states that most typefaces she was commissioned to design were headlines or display types, but only a few for body text.

I found five Letraset sheets with Arlette's name on them in an old store in downtown Cairo, and there are several more that I have not been able to find. The earliest was Arabic Borders from 1981, followed by Decorative Kufic No. 2 in 1982; Antarat and Marco Polo were released in 1984, whereas Daniel Chrome and Kufic Display came out in 1986. The borders and the decorative Kufic were what the company felt they needed or what would be in demand in the region. Antarat and Kufic display were reinterpretations of classical scripts. Her most creative fonts were Daniel and Marco Polo. The fonts were named after her two sons. She confirms that no Latin fonts inspired her during her Letraset period, even though some look Latin-inspired. During the Letraset experiment, the Boutros group also collaborated with the world's top brands. Advertising was their most sold font—the go-to Arabic font in most Arab advertising agencies in the late 1980s and 1990s.

For her process, Arlette starts her ideas by sketching on paper. With every font[9] she designs, she follows a brief. Is it a headline or a text font? Is it for print or the screen? Is it traditional or modern? And she takes it from there. She can start with one or two letters, like the letter qaf, then yeh, and then try to see how they work next to each other. To her, the secret to a good font is patience and passion. The first type design tool she used was the Ikarus, developed by URW type foundry in 1975. She later migrated to Fontographer in the late 1980s, and now she uses Glyphs, the latest font design software with more options for designing Arabic letters.[10]

Regarding the work dynamics with her partner and husband, Arlette shared that she never meets with clients or handles the business side of their operations. Her husband is in charge of those activities. When they receive a brief, they decide if it is typographic or calligraphic. Accordingly, they choose who will be handling the design. Her partner is the calligrapher, so most of their calligraphic scripts are scribed by him. She then takes his work and converts it into a font. If the job requires a typographic approach, she handles it from start to finish.

Al-Arabiyya TV station approached Boutros group to design a font in 2004, and then sixteen years later, they commissioned Arlette to design a new font that came with a list of demands. Due to the nature of the screen medium, it took a lot of time for her to fit the diacritic marks. She designed the font in five weights. She started with the light, medium, and heavy weights and then created the extra bold and regular weights. The client needed the bold weight, so she added the masters and created the in-between weights. Redrawing every weight was like designing a new font. The British motor manufacturer Mini Cooper approached her to design a bold and regular font, but she created the light because she felt it was very delicate. She often collaborates with her husband, Mourad Boutros, and sometimes with Latin designers, like when she designed Tanseeq Modern; Lebanese architect and designer Nasri Khatter (1911–1998) gave her guidance for her work on Boutros Basic

Arabic. It was a font designed for children, and legibility was vital; it had fewer variations and was easier to read.

Arlette speaks of her fonts as if she is speaking of friends. She states that she designed Angham in ten weights and especially enjoys creating challenging fonts. Jameel is a sharp but round font, Basic Arabic saves spaces more than other fonts, and Green was the first font she created with Glyphs in six weights. Farasha is a soft font for women's magazines; it is light and gentle. She doesn't like the font Arlette, as she thinks it is wide and short, but she had to adapt it to the Latin version. She can see mistakes in her old fonts even thirty years later.

Arlette Haddad is multitalented in different fields; she practices as an interior designer, type designer, fashion and publication designer. She has transitioned through various technologies, adapting to each change by being at the forefront of adopting and using every new technology related to font design since the 1970s. In a career that has spanned fifty years, Arlette has designed over sixty fonts used and viewed by millions of people today. She has dedicated her career to modernizing the Arabic script, leaving an indelible mark on the design landscape. She designed the unnoticed scripts that represent the identity of a nation. Her ability to adapt to different mediums speaks of her skill and passion. A remarkable synthesis of tradition and innovation characterizes her work on Arabic type design. She understands the inherent beauty of the Arabic script's calligraphic origins but recognizes the need to adapt it to contemporary design contexts. Her designs bridge the gap between the classical and modern, making them accessible to various applications, from print to digital media. Her early experiments with Letraset still stand out in character and form; maybe it is the medium. However, they had charm in a pre-digital era that was playful and experimental. Part of that magic was lost when some of these fonts were digitized.

Arlette is a designer's treasure, and her valuable knowledge should be passed on to the next generations to ensure that the learning is preserved and that her legacy survives. For over five decades, Arlette designed Arabic fonts quietly out of her studio in London, like a font hermit.

© **Dr. Bahia Shehab**

NOTES

1. Haddad was her maiden name. She is now known as Arlette Haddad Boutros.
2. She was born on July 2, 1951, but her birth was registered on March 5, 1952.
3. In the early 1970s, she was paid 700 Lebanese Lira while working in architecture. When she switched to advertising, she was paid 125 Lebanese Lira. Within one year, her salary jumped to 975 Lebanese Lira when her employers recognized her value, passion, and skill.
4. Historians mark the war in Lebanon as starting in April 1975 and ending in October 1990, but events of bombing and shooting started as early as 1973 and continued well into the mid-1990s.

5. www.boutrosfonts.com.
6. Zaidi, Raisa. "Looking Cool in Arabic," *Language Magazine*, August 16, 2012. https://www.languagemagazine.com/looking-cool-in-arabic/.
7. Ross, Fiona. "Non-Latin Type Design at Linotype." *TN Typography*, February 9, 2017. https://tntypography.eu/resources-list/non-latin-type-design-linotype-fiona-ross/.
8. Ibid.
9. The terms *typeface* and *font* are often used interchangeably, but they refer to different aspects of text design in the world of typography. The critical distinction between them is a *font* is a specific instance or variant of a typeface. It represents a particular size, style, and weight within a typeface family. You install fonts on your computer or use them in design software to render text. A *typeface* is a specific design of a set of characters, including letters, numbers, punctuation, and symbols. It defines these characters' visual appearance and style, such as their shape, weight, slant, and decorative elements. Typeface refers to the overall design or style of the characters, encompassing variations like bold, italic, regular, or light within that design.
10. Ikarus was a pioneering type design software known for its early digital font creation capabilities. Fontographer, developed in 1986, is a versatile and influential font editing tool that played a significant role in the digital typography revolution. Glyphs, developed in 2009, is a modern, user-friendly font design software that provides a streamlined and contemporary approach to creating and editing typefaces.

3.8

Farideh Shahbazi: Illustrator, Graphic Designer, and Publisher of Children's Books

Mehrdokht Darabi

I have heard it said—both in my culture and other cultures—that certain jobs were exclusively designated for men. I beg to differ. It wasn't just a few jobs. The idea of women having any job was considered unacceptable. Women were not expected to earn money and were confined to tasks that, although they may have had some financial benefits, were initially intended to be performed without compensation, such as painting. Women had to fight for the opportunity to have a job that encompassed genuine professional characteristics, such as having clients and meeting deadlines.

Graphic design was just one of the numerous professions that women struggled to be included in, and Farideh Shahbazi was among the first courageous women who had the determination to pursue it. Farideh Shahbazi, an Iranian graphic designer and illustrator,

Figure 3.8.1 Farideh Shahbazi photographed in her office in Tehran, Iran, 2023. Photo: Mehrdokht Darabi. Image courtesy of Mehrdokht Darabi.

was born on December 7, 1951, in Rasht, Northern Iran.[1] Her first student job, at eighteen, was in a primary school as a painting teacher. She worked for various organizations and advertising agencies until 1973, when she was hired at *Soroush*.[2]

Farideh witnessed significant social and political changes in Iran. In the 1950s, a central conflict existed between a minority of liberal aristocrats and traditional pro-monarchists within a feudal society. In the 1960s and 1970s, the liberal aristocrats were replaced by radical left-wing movements, particularly in Farideh's hometown of Rasht. However, the opposition remained the same—supporting the monarchy. This ongoing conflict weakened both sides, leading to the religious fundamentalist's unexpected victory in the 1979 revolution.

Today, Farideh Shahbazi owns "Rooster" children's books and has produced illustrations and graphic design for over 100 books. She has also created logos and designed other advertising items for various clients. In collaboration with her husband, Masoud Tazhibi (1947), she authored *Persian Motifs in Art*,[3] which is used as a reference book for art students attending university. The couple spent a significant amount of time during the blackout periods of the 1980s (due to the war between Iran and Iraq)[4] searching for and collecting various Persian motifs. Years later, having duplicated and simplified the most repetitive motifs found in Iran, such as textiles, stones, and silverware from historical sites, they were able to publish the book. To date, *Persian Motifs* has been reprinted over sixteen times.

Figure 3.8.2 Farideh Shahbazi, *Persian Motifs* books: Vol. 1, 1996 and Vol. 2, 2015. Image courtesy of Farideh Shahbazi.

Section 3 Postmodern Innovators (1940–1970) **436**

Figure 3.8.3 Farideh Shahbazi designed city-themed notebooks stacked (*left*) and one notebook spread (*right*). Cities: Tehran, Shiraz, Tabriz, Isfahan, Yazd, and Gilan. Photo: Mehrdokht Darabi. Images courtesy of Mehrdokht Darabi.

As a former student of Farideh Shahbazi, I remember her as a tall, beautiful, and impeccably dressed teacher who carried an air of seriousness, at times appearing slightly grumpy—she never met her student's eyes; her gaze always seemed fixed just above our heads. Years later, I encountered the two notebooks—themed after the cities Esfahan and Tabriz—which mesmerized me. I felt compelled to purchase these uniquely beautiful notebooks without knowing who had created them because they were perfect for my daily use as someone who always carries a notebook to jot down ideas and sketches. It was through these notebooks that I reconnected with Farideh Shahbazi after all these years, and our conversation began with the notebooks (and the Tehran notebook she kindly gifted me) as we sat in her small yet beautifully designed office, savoring coffee and the delicious cookies she had freshly baked for Persian New Year.

Mehrdokht Darabi How did you conceive of creating notebooks featuring cities in Iran? Did you anticipate their popularity?

Farideh Shahbazi Producing notebooks with illustrations has always been a component of my work in my business. As an illustrator, I often assign illustrators to projects to provide them with opportunities for growth and development. I'm constantly looking for intriguing subjects to incorporate into the notebooks. The idea of creating notebooks for cities in Iran came to me when I stumbled upon a small notebook from Paris, although it differed from the ones I envisioned. That sparked the thought of producing notebooks showcasing various cities in Iran. I approached my niece, Aylar, who is

a painter, and she readily agreed to be a part of this project. She would travel to different cities and return with sixty to seventy drawings.

We would then pass the illustrations to my graphic design colleague, who created the layouts. As you can see, Tehran is entirely black, and interestingly, my husband was one of the people who doubted its success. He believed that no one would want an all-black notebook. However, contrary to his expectations, people loved it, and we had to quickly reprint it to meet the demand.

MD Can you talk about the business you own?

FSh I have always been working for others. At some point, I thought having my own publication would be a good idea. I went through the process of obtaining the necessary licenses several times throughout the years, but I became frustrated with the complicated bureaucracy involved with government offices. So, I gave up. However, one day, I discussed the idea with Mr. Bahmanpour, who already owned an art publication and with whom I had previously collaborated. He loved the idea, and everything fell into place in just one session. During that session, we even devised the name "Rooster" for a children's book publication.

MD How interesting! All these decisions were made in just one session. What luck!

FSh I wonder if it's luck or not. I already knew him, and we had collaborated in the past, so I went to the right person at the right time. But the main problem I faced was something more extensive than individuals—it may have been societal, legal, or governmental. That has always been my greatest obstacle. In the business, I only focus on the parts that I know best. I have no knowledge of marketing, pricing, or other aspects. So, I don't involve myself in those areas. We have mutual trust, and each person focuses on their specialty.

MD How do you identify yourself? You are a woman, a mother, an artist, a teacher, a manager in this office, and in other contexts, you're a daughter, a sister, and more. Which of these roles defines you the most?

FSh All of these roles form a collection many women have, and I am one of them. I've tried to fulfill each role to the best of my talents and abilities. Therefore, being a mother doesn't stand out more than my job or social presence. I like to think that my social image is a comprehensive blend of all these roles. I have put equal effort into each of these identities. For instance, I remember whenever one of my children was sick,

and I had to stay awake in the middle of the night, I would have my computer on the dining table and work simultaneously. I always wanted to pursue whatever I enjoyed doing. I never had a grand goal like becoming number one in mind. I have never been inclined to compete with others to win. For me, creation matters more than competition. Competing feels like a waste of time.

MD Have you ever felt that being a woman has made your life more difficult?

FSh I want to say that being a woman may be the most significant aspect for me personally, not necessarily for others. Let's be realistic here, like any part of the world, being a woman has always been synonymous with abuse and discrimination.

I, too, have encountered and experienced numerous instances of discrimination throughout my life and career. As I've grown older, I have gradually found the courage to stand up more easily and express my opposition. I set boundaries for men. You see, in patriarchal societies (which, to me, is the entire world), men have been raised so that it appears perfectly normal to them to behave in certain ways. Sometimes, they don't even realize that they are perpetuating patriarchal structures, even those who claim to be progressive and educated.

I have consistently reminded men that if they believe they are educated and modern, they should prove their claims and not make life harder than it already is for women. As a woman, I am doing my best to exert tremendous effort in overcoming this social injustice. This effort is significant for me and holds a certain sense of sacredness.

Allow me to share a childhood story: In the past, it was considered normal for a girl or her mother to iron a boy's shirt. Ironing was viewed as a woman's task. When I was a teenager, I was playing with a friend when my brother approached and asked me to iron one of his shirts so he could go out with his friends. I naturally agreed, but as I was engrossed in play, I simply forgot to do it. Later, he approached me angrily, shouting about his shirt. Being much younger than him, I replied, "You don't have to shout at me. Why do I have to do the ironing for you in the first place?"

Years later, when we were both adults, his wife confided in me that my brother had shared this story with many people, expressing his deep embarrassment because I had opened his eyes when he was a young man. The irony is that my brother was a very progressive individual with an up-to-date mindset, yet he failed to recognize this inequality in his own actions.

Long before the "women, life, freedom" movement, I believed that the majority of Iranian men I have encountered (excluding intellectuals,

Figure 3.8.4 Farideh Shahbazi, two *Soroush* magazine covers. *Left:* July 1991; *Right:* October 1992. Images courtesy of Farideh Shahbazi.

who are always a small percentage in any society) had no issues with the laws that restricted women in every aspect of their lives, such as compulsory hijab and other limitations. Men were okay with keeping women inferior. Many Iranian men withheld the rights women naturally deserved, such as "permission to travel abroad," simply because the law gave them that power over their wives. They believed they had the authority to decide whether their wives could travel abroad or not.

Let me share an experience from about twenty years ago when I worked at the *Soroush* publication. At that time, I was one of the best and most experienced graphic designers on staff. However, when it came to selecting the atelier manager, the managerial team told me directly that even though they acknowledged that I deserved the position, they couldn't give it to me because there was a man present who would feel offended if I became the manager. So, they asked me to act "lady-like" and leave the position to him but work as hard as if I were the manager! Interestingly, even that man, who was a friend of mine, didn't think that way and didn't expect such a decision. It was simply a case of them being unable to tolerate a woman in charge of other men.

MD It would appear that the moral of this story is that although it was acceptable for a woman to feel offended and hurt, the management

	couldn't bear to put a man in a situation where he might feel offended simply because they believed a man's pride was more valuable than a woman's pride.
FSh	Exactly. Let me share another story: Years ago, I was tasked with designing a book cover for a collection of Palestinian poems translated into Farsi. The book was selling successfully in the market with my design for quite some time. However, one day, the translator approached my manager and requested a redesign, stating that the cover looked too feminine. My manager responded, "Well, it's completely fitting because the cover designer is a woman, not imitating men." It's amusing how the translator, without any design knowledge, requested a redesign, perhaps believing that if a man designed the cover, it would somehow help the Palestinians win the war [both laugh].
MD	What made you feel comfortable with your gender and brought your attention to the fact that some men engage in what you describe as irreverent saber-rattling?
FSh	Initially, I thought I could answer this question by referring to my family upbringing. However, despite growing up in the same family, my sisters and I developed three distinct mindsets toward life. So, it's not solely a result of our family environment. I believe that each person has something deeply personal and individual within them that influences their mindset.

My father was an ordinary, incredibly hardworking man striving to provide a good life for our large family (we were seven children: four brothers and three sisters). He placed a high value on education for all his children and consistently emphasized that both his sons and daughters must graduate from university. Furthermore, he made it clear that no one could propose marriage to any of us (daughters) before we finished university. During that time, arranged marriages were common, and relatives often approached a girl's family to seek a potential match. However, my father never allowed such proposals until graduation. Pursuing a university education meant we would have to work afterward, not simply obtain a degree and keep it tucked away like a precious jewel [laughs]. It ultimately made us independent women with our own jobs and salaries. Interestingly, the outcome of our education was not meant to be spent on the family but to manage our own lives independently. However, despite our shared upbringing, each of my sisters and I chose to lead very different lives. So, it largely depends on our individual personalities and choices.

MD You had strong personal boundaries and were unwilling to accept bias. Can you talk about your early childhood experience where you grew up?

FSh Right after the 1953 coup against the legitimate government of Dr. Mossadegh (then prime minister),[5] my father, along with many socialist or liberal activists of that time, was imprisoned. Lots of people were executed at that time because of their dissent. My father was lucky to be sent to jail and not be killed because he thought differently. He spent some time in jail, most of it in solitary confinement without any visitors allowed except for me, the youngest child at that time.

Oddly enough, I don't remember those visits as terrifying or horrible experiences. On the contrary, I felt a sense of pride and honor that my father was imprisoned. I had heard somewhere that he was a brave man fighting for his beliefs and risking his life, and that made me proud of him. Visiting my father in his solitary confinement cell was a blessing to me. I vividly remember the cell, which was empty except for a small stone bench (nowadays, there's a bed there) and a tiny window near the ceiling. Each time my father would playfully throw me up in the air, I tried to reach that window. Later, my father lost his job once he was released from jail. There were no opportunities left for him in Rasht, so he decided to go to Tehran to find work.

While playing with me one day, he asked if I would like to join him in Tehran. I immediately agreed, and that thought never left my mind. I clearly remember the day he was set to travel to Tehran. Early in the morning, while my mother and father were having breakfast, I overheard my mother saying, "Shush! Don't wake her up. She's just a kid and will soon forget about all this." At that moment, I loudly replied that I was fully awake and ready to go with him.

I traveled to Tehran at the age of three with my father, probably thinking I would protect him in case they wanted to arrest him again. I spent the last three months of the school term with my father at my uncle's house until the rest of our family joined us. I believe that time spent alone with my father significantly impacted my personality.

Traveling has always been challenging for me because I easily get motion sickness. The journey to Tehran was long and arduous. I had a small bag filled with sour candies, lemons, and other things to help me feel better during the trip. Despite feeling sick the whole time, I refused to eat any food, determined not to give up. As a child, I have sad memories of that time without my mother, but I never talked about it with my family until I grew up. Years later, when I finally shared my feelings

Figure 3.8.5 Farideh Shahbazi, logo design for various companies. Image courtesy of Farideh Shahbazi.

with them, they were shocked as to why I had kept it a secret.

For instance, when I arrived at my uncle's house, his wife, probably trying to entertain me, took me to a barbershop across from their home and asked them to give me an "a la garcon" haircut. If that wasn't enough, a second cousin was in their house, around my age, wearing shorts. They dressed me in his shorts and made me pose for a photo in front of a camera. It was a nightmare at that age because I felt like they were trying to turn me into a boy. Looking back, I don't believe they had any ill intentions. Taking photos of children seventy years ago was not as common, so she must have tried her best to make me enjoy my time there. However, I was furious simply because I felt my gender was being questioned. During those years, social evolution was evident, especially in the northern cities of Iran. My parents came from northern cities but still held onto certain traditional beliefs. For example, my mother once had an opportunity to become a teacher, but my father didn't allow her, and she carried that regret throughout her life.

MD It's interesting how parenting mistakes can shape a person's life. Even with careful parenting preparation and education, we all make mistakes. It's possible that painful childhood memories of your parents while growing up, combined with their unique characteristics, played a role in forming your personality.

FSh Absolutely! Maybe the combination of all these factors shaped who I am. My father had certain dictator-like qualities (like most fathers back

then), even in his voice. But at the same time, he was a dictator who only wanted happiness for his children. I believe everything he went through made him persistent in certain aspects of life.

MD The concept of persistence holds great value for you. You mentioned earlier how you were persistent in pursuing what you loved.

FSh I have always strived to continue doing what I love. As a woman, I know I must go the extra mile to achieve what I want. When I got married, my husband and I were a modern couple, and we didn't want a routine life. We didn't want to have children right away, and when we eventually decided to, we thought about the consequences.

My parents moved to a new building at one point, and we bought an apartment next to theirs. My mother told me that if I wanted to have kids someday, it would be the best time while she was so close to me. So, we made up our minds and decided to have children. However, right after my daughter Mahni was born (1982), my mother suffered a severe stroke and became a patient with significant damage, unable to help me at all. But that's life—it's always difficult.

Since it was after the 1979 revolution, the country was in an unstable situation, and there weren't enough jobs, especially for freelancers like my husband, Masoud, who was self-employed. So, we decided to take shifts taking care of the baby. I would go to the office until 2:30 p.m. to work, and then my husband would go to his office until 8 p.m. But as you know from experience, most household chores fall on the woman's shoulders, and you have to do all the extra work for everything. Although my husband participated fully in everything, I had to ensure everything was prepared in advance: the baby's food and clothing, lunch for the next day, and everything else.

Well, it was undoubtedly difficult, but now I have mostly forgotten about the hardships and only remember the good parts of always being active and productive. We raised our children to be independent. They know that parents don't own them, and they don't have to support us in our old age. We always did our best to encourage them to pursue what they love, and both made their decisions based on their own personalities. My daughter never wanted to leave the country, but my son Rouzbeh, born in 1988, did. We didn't interfere in their life choices; we simply supported them in every way until they both graduated and no longer needed our support.

MD: Do you have any grandchildren?

FSh: I don't, although I adore little kids. But both of my children have decided not to have kids, and we respect their choice. Instead, I enjoy

the presence of other people's little kids [laughs]. My children believe that humans are destroying Mother Earth, and if just one generation decides not to reproduce, it would significantly help fix things.

MD: On the other hand, each child, if raised correctly, has the potential to make a significant difference on Earth.

© **Mehrdokht Darabi**

NOTES

1. Rasht is the largest city on Iran's Caspian Sea coast in Northern Iran and has historically served as a source for new freedom movements by virtue of its location.
2. *Soroush* was a weekly magazine of the National TV & Radio publication department. First titled *Tamasha*, it was later renamed *Soroush*.
3. Masoud Tazhibi and Farideh Shahbazi, *Persian Designs and Motifs for Artists and Craftsmen*, Tehran: Soroush Press, 2013.
4. The Iran–Iraq War was a war between the armed forces of Iraq and Iran, lasting from September 1980 to August 1988. It began when Iraq invaded Iran on September 22, 1980, after a long history of border disputes and after Iran demanded the overthrow of Saddam Hussein's regime (Wikipedia).
5. The 1953 Iranian coup d'état, known in Iran as the 28 Mordad coup d'état, was the US- and UK-instigated, Iranian army-led overthrow of the democratically elected Prime Minister Mohammad Mosaddegh in favor of strengthening the monarchical rule of the shah, Mohammad Reza Pahlavi, on August 19, 1953 (Wikipedia).

5.–28.
APRIL

AUSLANDE
STIPEND
AN
STA

ICH

3.9

Polly Bertram: From New Wave to AGI

Dr. Chiara Barbieri and Dr. Davide Fornari

Polly Bertram's work shows how expressions of the counterculture movements in early-1980s Switzerland have been eventually incorporated into mainstream graphic design discourses. Indeed, her career has evolved from subculture activist to inclusion in the institutional discourse of design at the highest levels of the profession: membership in AGI, jury member for the Most Beautiful Swiss Books, and contribution to the Swiss design education system.[1]

Polly Bertram was born in Hamburg, Germany, on March 15, 1953. Her family soon relocated to Lucerne, Switzerland, where her father, Ferdinand Bertram (1926–2017), worked as a set designer for the city theater, and her mother, Martha Widmer (1928–2011),[2]

Figure 3.9.1 Polly Bertram, photographic portrait. In the background is a poster designed by Polly Bertram for the exhibition *Auslandateliers Stipendien Ankäufe Stadt Zürich* (*Acquisitions of the City of Zurich from the foreign artist's grant program*), held in Zurich, Helmhaus, April 5–28, 1991. Photo by Jul Keyser. © Jul Keyser.

was an internationally renowned jewelry designer employed by Gübelin, the Swiss jewelry and watchmaking company established in Lucerne in 1854. When Polly was three, her parents divorced, and her half-sister Laura Widmer was born in 1957. As their mother worked Monday to Saturday, they were placed with a foster family during weekdays. Polly completed her primary and secondary cycles of studies in Lucerne. After obtaining her high school diploma in 1974—from a curriculum that included Latin—she worked as a teaching assistant in a primary school in the city of Dietikon, Canton Zurich. Although this work experience lasted only one year, it was Polly's first encounter with teaching, an activity she was to devote herself to later in her career when she taught in various design schools across Switzerland from 1986 until her retirement in 2010.

Between 1975 and 1980, Polly studied and then graduated from the Schule für Gestaltung (School of Design and Applied Arts) in Zurich.[3] She had initially selected the school in Lucerne. Still, she switched to Zurich as her half-sister Laura Widmer (1957) was already applying to study visual arts there, and their mother wanted to avoid competition in the family. Her half-sisters, Christiane Bertram (1956) and Erna Luise Bertram (1987), were born during her father Ferdinand's second and third marriages.

Polly's final-year project—focused on the life of a fictive member of an extreme right-wing movement—is an early example of her lasting enthusiasm for politics and the use of graphic design as a means to deliver a sociopolitical message. During her studies, she met her life partner—and husband since 1999—the photographer Jul Keyser (1940), who had studied at the Staatlichen Schule für Kunst und Handwerk (State School for Arts and Crafts) in Saarbrücken and the Kunstgewerbeschule (State School for Arts and Crafts) in in Zurich and was employed, by the time they met, as a photography teacher at the Schule für Gestaltung.[4]

Polly Bertram's first work experience was at the graphic design studio of Ernst and Ursula Hiestand (E+U Hiestand), where she interned between 1980 and 1981 together with her two classmates Christoph Müller (1958)[5] and Daniel Volkart (1959).[6] Polly left E+U Hiestand, establishing her studio with Volkart. The studio worked for both institutional and commercial clients in corporate design and book design, specializing in poster and magazine design until 1992. The two partners worked in symbiosis, making it difficult to pinpoint their individual contributions within their collaborative design.

Among their first clients were several left political parties and associations—demonstrating the designers' interest in current politics and social concerns and their activist approach to the practice. The Progressive Organisationen der Schweiz POCH (Progressive Organizations of Switzerland) was established as an evolution of the 1968 student protests, whereas the Partei der Arbeit der Schweiz PdA (Swiss Party of Labour) originated in 1944 after the Swiss Communist Party had been banned. The two parties commissioned Bertram and Volkart to design propaganda posters for the many referendums that the Swiss political system entails as a direct democracy. The Schweizerische Energie-Stiftung SES (Swiss Energy Foundation) was another studio client. This public utility organization was

Figure 3.9.2 Polly Bertram and Daniel Volkart (with photographs by Cristina Zilioli), poster for the Swiss premiere of the play *Die Oper vom großen Hohngelächter* (from *The Beggar's Opera* by John Gay), by Dario Fo, Theater am Neumarkt, Zurich, on April 27, 1984. © Zürcher Hochschule der Künste/Museum für Gestaltung Zürich/Plakatsammlung.

established in 1976 to foster an innovative, environmentally friendly, and considerate energy supply for the country. SES commissioned Bertram and Volkart to design its corporate identity and house organ *Energie & Umwelt* (*Energy and Environment*),[7] a quarterly magazine launched in 1982. Bertram and Volkart conceived a visual language based on rigorous layouts produced in photo composition featuring black-and-white photography, with a spot color changing yearly. The design turned the house organ into an efficient, visually rich, and provocatory medium for communicating the foundation's agenda and activities.

The poster series for the Theater am Neumarkt in Zürich is one of the best-known design projects by Polly Bertram and Daniel Volkart, and it represents their shift toward clients in the cultural domain. Founded in 1966, the Theater am Neumarkt was a place for experimental director-driven theater between alternative and institutional scenes.[8]

Polly and Daniel were responsible for the theater's corporate design and visual communication for six consecutive seasons—thirty-six productions with numerous side events from 1983 to 1989—coinciding with the direction of Peter Schweiger (1939). The design of the theater's printed matter mirrored the director's experimental program.

The series of posters exemplify Polly and Daniel's systemic approach to design based on a layering process that provides consistency and variation simultaneously. Each season exhibited a different design concept, yet each series was based on the same principle consisting of an iconographic program that changed with the gradual addition of overlapping and hermetic images and transparencies. The first series was based on black-and-white image collages, the second on duotone illustrations made of typographic materials, and the third on photomontages of black-and-white photography with graphical elements in color gradients. The fourth and fifth series were based on one poster for the whole season, with additional smaller posters for each production. During the last theatrical season, the posters got increasingly crowded, complex, and densely nested, from the first to the last monthly poster.

These posters incorporated photography—often by Polly's life partner Jul Keyser—and graphic design with typography woven into complex graphic compositions. Their experimental typographic approach often pushed the limits of legibility, particularly for the small posters for the one-off productions. The overlapping cutouts and the cut-and-paste technique evoke the DIY aesthetics of counterculture graphics, producing mysterious yet seductive aesthetics. It resulted from a traditional process, with the recurrent use of a repro camera, and without relying on desktop publishing software.

The Swiss premiere of the play *L'Opera dello sghignazzo* (1981), translated as *Die Oper vom großen Hohngelächter (Opera Guffaw)* was staged in Zürich at the Theater am Neumarkt, on April 27, 1984. Dario Fo (1926–2016) was a highly engaged Italian playwright—in a polarized political context, such as in 1980s Italy—who received the Nobel Prize in Literature in 1997. In his theater, he embraced satire and improvisation in the manner of Middle Ages jesters. *L'Opera dello sghignazzo* is a musical inspired by *The Beggar's Opera* by John Gay (1685–1732) and by *The Threepenny Opera* (1928) by Bertolt Brecht (1898–1956). In Italy, the play was forbidden to minors. The black-and-white weltformat[9] poster designed by Bertram and Volkart belongs to the first series of posters for the Theater am Neumarkt. The poster merges typography and images by cutting three photographs—commissioned to the photographer Cristina Zilioli (1954)—in the shape of glyphs that form the surname "Fo." One can only see portions of a face: the eyes are covered with coins, the gun barrel is stuck into the nose, and a dildo is clenched between the teeth. The three images' figurative content and the graphic composition's experimental language mirror Fo's play's provocative subject matter while effectively and evocatively forming the playwright's surname.

The Museum für Gestaltung (Museum of Design) Zurich was another cultural client for Polly Bertram and Daniel Volkart. The commission was concurrent with their teaching

Figure 3.9.3 Polly Bertram and Daniel Volkart, exhibition poster for *Wissenschaftliches Zeichnen* (*Scientific Drawings*), Museum für Gestaltung Zürich, August 29–October 14, 1990. © Zürcher Hochschule der Künste/Museum für Gestaltung Zürich/Plakatsammlung.

positions at the school annexed to the museum. The Museum für Gestaltung was founded in 1875 as part of the local Kunstgewerbeschule, and in 1933, was relocated to a building on Ausstellungstrasse—designed by architects Adolf Steger (1888–1939) and Karl Egender (1897–1969)—which is an example of Swiss architecture from the Modern Movement. Over time, the museum has developed into the leading authority on design in Switzerland for the depth of its collections of posters, graphics, design, and applied arts and for the ambition of its curatorial agenda. The visual design supporting these exhibitions has usually been entrusted to alumni or faculty members of the design school. Bertram and Volkart conceived the graphic design for the following museum installations: a monographic exhibition of posters by Otto Baumberger (1889–1961), held May 26–June 17, 1988; *Wissenschaftliches Zeichnen* (*Scientific Drawings*), held August 29–October 14, 1990; and

Schweizerwelt. Plakate aus der Sammlung (*Swiss World: Posters from the Collection*), held July 10–August 25, 1991. Designing these posters, they employed some of their signature traits: the use of transparencies and given or found images or the creation of variants that reinforce the visual message by repetition, as in an allegory. Although the communication of an exhibition had different goals than those of the identity for a theater, the designers maintained a similar layered approach as in their previous posters for the Theater am Neumarkt.[10]

As a result of her political engagement and activist approach to the practice, Polly played an active role in the Swiss design community and contributed to discourses on graphic design. Between 1993 and 2003, she served as the vice president of the Stiftung für engagierte Visuelle Kommunikation (Foundation for Engaged Visual Communication), established in Biel in 1991 and was active until 2011.

Figure 3.9.4 Polly Bertram and Daniel Volkart, exhibition poster for *Schweizerwelt: Plakate aus der Sammlung* (*Swiss World: Posters from the Collection*), Museum für Gestaltung Zürich, July 10–August 25, 1991. © Zürcher Hochschule der Künste/Museum für Gestaltung Zürich/Plakatsammlung.

Polly Bertram was one of the three women included in *Emigre* magazine (1990) issue no. 14.[11] *Emigre* was published quarterly between 1984 and 2005 in Berkeley, California, and produced by Dutch designer and art director Rudy VanderLans (1955) and his Slovak-born, American type designer and typesetter wife, Zuzana Licko (1961), who met in San Francisco. The magazine was self-funded through the commercial work of the editors and was known for its pioneering digital technology in layout and typeface design. The focus was on the discourse around émigré artists, with monographic issues on geographical boundaries, international culture, or alienation. The magazine soon attracted the attention of international designers and institutions.

Issue 14, titled *Heritage*, explored the legacy left by the "apostles of the grid,"[12] i.e., Emil Ruder (1914–1970), Josef Müller-Brockmann (1914–1996), and Armin Hofmann (1920–2020), in a younger generation of Swiss graphic designers through a series of interviews conducted by Rudi VanderLans and a selection of graphic compositions conceived on purpose for the issue. In his introduction, VanderLans expressed his interest in researching the impact of the digital shift on the "orderly and functional approach" of Swiss designers. He was instead surprised by how his prejudice did not correspond to the reality of the work by Richard Feurer, who had visited the offices of *Emigre* in the summer of 1989, and other representatives of the so-called New Wave of Swiss graphic design. In his interview with VanderLans published in the issue, Wolfgang Weingart (1941–2021) was very skeptical about the status of Swiss graphic design and dismissive of the younger generation of Swiss graphic designers: "You don't have to come to Switzerland to see imitators."[13] VanderLans visited Switzerland in November and December 1989 to interview some of these designers in Basel and Zurich, including Richard Feurer (1954), Hans-Rudolf Lutz (1939–1998), Peter Bäder (1957), Polly Bertram and Daniel Volkart, as well as Wolfgang Weingart, who also wrote an introductory text. VanderLans also interviewed Hamish Muir (1962) and April Greiman (1948), Basel School of Design alumni. The issue included a "special 24-page insert written, designed and produced in Zurich, Switzerland"[14] by the abovementioned Feurer, Bäder, and Bertram and Volkart, with the addition of Roland Fischbacher (1956), Margit Kastl-Lustenberger (1960), who recorded the conversation, and Daniel Zehntner (1955), who led the discussion and edited the text. Titled "Against Conventions," the visual essay is a crucial primary source on the status quo of the Zurich design scene after a decade marked by the youth riots and counterculture incursions in the 1980s.

In their interview with VanderLans, Polly and Daniel talked about their design approach, collaborative work, the poster series for the Theater am Neumarkt, their clients, and their audience. Taking a stand on the current graphic design discourses and the legacy of Swiss Style, they declared their rebuff of rigid formal rules, clean, rational, functional graphics, and commercialization. Moreover, they openly criticized the work and methods of Wolfgang Weingart, the "father" of the so-called Swiss Punk typography, who also expressed bold statements about the young Swiss graphic designers in his interview. For Bertram and

Figure 3.9.5 *Emigre* magazine, no. 14 (1990), cover and double pages featuring a twenty-four-page visual essay by Richard Feurer, Peter Bäder, Polly Bertram & Daniel Volkart, Roland Fischbacher, Margit Kastl-Lustenberger, and Daniel Zehntner. Photo by Niccolò Quaresima. Courtesy of Polly Bertram.

Volkart, the goal of graphic design was not to believe in dogmas and adjust composition rules to them, as Weingart was doing, in their opinion. Instead, the goal was to produce a new visual order that reflected the current chaotic historical situation, which did not allow for simple representations and ease of readability.

When their work was featured in *Mehrwerte*, their contribution to the Swiss graphic design scene was officially recognized. *Mehrwerte: Schweiz und Design: die 80er (Added Value. Switzerland and Design: the 1980s)* was an anthological exhibition that critically viewed the previous decade, and was held at the Museum für Gestaltung in Zurich in 1991.[15]

After more than ten years of working together, the partnership with Volkart ended in 1992, as Polly and Daniel developed in different directions and collaboration was no longer fruitful. Polly began working with different collaborators, often former students

from the Schule für Gestaltung Zürich—such as Alberto Vieceli (1965) and Tania Prill (1969)—where she started teaching in 1991.

Polly's experimental graphic work secured her entry into one of the most exclusive international graphic design associations, Alliance Graphique Internationale (AGI).[16] The membership is granted by invitation only; prospective members are invited by an internal sponsor and can be vetted by current members. Graphic designer and publisher Lars Müller (1955) was Polly's sponsor. He had been admitted himself in 1993, and like Polly, he had studied in Zurich, and her husband Jul Keyser had been one of his teachers.

When she joined AGI in 1997, women were in the minority, with only fifteen members. Among her predecessors, one could count Ursula Hiestand (1936), at whose studio Polly had worked at the very beginning of her career. Ursula established the graphic design studio E+U Hiestand with her husband Ernst (1935–2021) in 1960. The couple worked together until the early 1990s, when they distanced themselves from each other in their professional and private lives. The partnership with Ernst might have eased Ursula's inclusion into AGI as the first Swiss female member of an association that has been criticized over the years for being an elite club for white, middle-aged men, preceded only by BBC production designer Natasha Kroll (1914–2004), who was admitted to AGI one year before Ursula in 1967.[17] In the case of E+U Hiestand, both Ursula and Ernst were AGI members admitted in 1968.[18] The other Swiss woman admitted to AGI before Bertram was Rosmarie Tissi (1937) in 1974.[19] Polly Bertram was admitted in the same year as Dutch graphic designer Irma Boom (1960).

Between 1997 and 2001, Polly Bertram was invited by the Swiss Federal Office of Culture to serve as a jury member in several competitions organized within the framework of the State's institutional activities in support of design. From 1997 to 2000, she participated in the jury for the Schweizer Plakat des Jahres (Best Swiss Poster, established in 1942 and discontinued in 2021). In 1999 and 2000, Polly served as a jury member for the Most Beautiful Swiss Books, a competition initiated by Jan Tschichold (1902–1974) in 1943.[20] Both appointments are evidence of the public recognition of her work.

In parallel with her professional activity, Polly Bertram devoted herself to teaching, an activity she increasingly focused on in the latter part of her career. From 1991 to 1999, she taught graphic design at the Schule für Gestaltung Zürich. Working together as faculty colleagues with her partner Jul made it hard to differentiate between private and professional life. In 1998, the couple moved to Meride, a small, historical, peaceful village with about 300 inhabitants in Ticino, the southern and Italian-speaking part of Switzerland. Its location enabled Polly to continue teaching after Jul's retirement at sixty. As the daughter of a designer practitioner mother, Polly seldom experienced difficulties in her professional affirmation. Yet, the reform of vocational schools in Switzerland was seen as a potential menace to the precarious positions of women in education.

The 1999 Bologna Process for the harmonization of European education brought a profound restructuring of the Swiss educational system: the intensive four-year unique

cycle was to be extended and restructured into bachelor (three-year) and master (two-year) programs. The efforts needed to make these adjustments often fell to the female faculty members. As a result, Polly found herself leading the redesign of the visual communication course curriculum at the Hochschüle für Gestaltung und Kunst Luzern (Lucerne School of Art and Design) between 1999 and 2002. She concluded her teaching career at the newly established Laboratory of Visual Culture at the University of Applied Sciences and Arts of Southern Switzerland (SUPSI) in Lugano, where she worked from 2002 until her retirement in 2010. At SUPSI, Polly was active as both a teacher and a researcher, working on research projects such as "Coloreonline," an interactive platform for teaching color theory online,[21] and serving as a member of the board of Swiss Design Network (2003–2010), the Swiss competence network for design research. In November 2009, she was the co-convenor of the Swiss Design Network Symposium titled "Multiple Ways to Design Research," held in Lugano.[22]

From political posters to design education, through commissions for cultural clients and AGI membership, Polly Bertram has made her mark on the Swiss graphic design scene. In the *Emigre* interview, she unapologetically stated, "For Switzerland, but especially for Zürich, I think we do very important work."[23] Her work with Daniel Volkart challenged the viewing habits of passers-by in Zurich and continues pushing viewers out of their comfort zone. Alone, she was granted the honor of being included in the institutional discourse of design. As a teacher, she passed on her ideas to generations of graphic design students in Zurich, Lucerne, and Lugano, and she initiated design research as a practice once the Federal government entrusted Swiss universities of applied arts to fulfill a mission of research to comply with the Bologna Process.

© **Dr. Chiara Barbieri and Dr. Davide Fornari**

NOTES

1. This chapter is based on email exchanges and the unpublished transcript of a conversation between Polly Bertram and Davide Fornari held in Meride on May 5, 2023, as well as on the designer's curriculum vitæ (unpublished typescript document, 9 pgs., n.d., post-2010). The authors are most thankful to Polly Bertram and Jul Keyser for their cooperation.
2. NEA Service (1951), *Youngest Watch Designer Possess a Midas Touch*, a press release published in various US local newspapers, January.
3. Sikart (n.d.), "Polly Bertram," in *SIKART Lexikon zur Kunst in der Schweiz*, recherche. sik-isea.ch/sik:person-12361162/in/sikart/ (accessed July 20, 2023).
4. For a selection of works by Jul Keyser, see emuseum.ch/people/35625/jul-keyser/objects (accessed July 20, 2023).
5. Sikart (n.d.), "Christoph Müller Columbus," in *SIKART Lexikon zur Kunst in der Schweiz*, recherche.sik-isea.ch/sik:person-4003231/in/sikart/ (accessed July 20, 2023).
6. Sikart (n.d.), "Daniel Volkart," in *SIKART Lexikon zur Kunst in der Schweiz*, recherche. sik-isea.ch/sik:person-12361365/in/sikart/ (accessed July 20, 2023).
7. The digital version of the magazine is available at e-periodica.ch/digbib/

volumes?UID=eum-002 (accessed July 20, 2023).

8. Jaeggi, Martin, and Peter Schweiger (2007). *Breaking the Rules. Plakate der bewegten 1980er Jahre in der Schweiz. Posters from the Turbulent 1980s in Switzerland*. Baden: Lars Müller Publishers. Bella, Félix ed. (2008). *Romper las reglas: tipografía suiza de los turbulentos años ochenta*. Valencia: Campgrafic Editores. Jaeggi, Martin (2014). "How the Theater Took to the Streets," in Christian Brändle, Karin Gimmi, Barbara Junod, Christina Reble, Bettina Richter, eds., *100 Years of Swiss Graphic Design*. Zurich: Lars Müller Publishers, pgs. 258–63.

9. Weltformat (World format) is a system of paper format preexisting the DIN series, proposed by the German chemist, philosopher, and Nobel laureate Friedrich Wilhelm Ostwald (1853–1932) in 1911. This format was adopted in 1913 by the advertisement committee of the Swiss National Expo of 1914 for all printed artifacts. Thus, the format prevailed in Switzerland and it is still used for street posters. It corresponds to 90.5 × 128 cm or 35.5 × 50.5 inches.

10. Studinka, Felix, ed. (2001). *Posters for Exhibitions: 1980–2000*. Baden: Lars Müller Publishers. Fornari, Davide (2012). "TDM 5. Grafica italiana vs 100 Years of Swiss Graphic Design," in *Progetto grafico*, vol. 10, no. 21, Summer, pgs. 58–65. Richter, Bettina (2014). "Catching the Eye in Public Space: Snapshots from the History of the Swiss Poster," in Brändle et al., eds., *100 Years of Swiss Graphic Design*, pgs. 36–9. Rotzler, Willy (1990). *Das Plakat in der Schweiz: mit 376 Kurzbiographien von Plakatgestalterinnen und Plakatgestaltern*. Schaffhausen: Stemmle. Heller, Martin, ed. (1994). *Who's Who in Graphic Design*. Zurich: Benteli-Werd Verlag.

11. VanderLans, Rudy, ed. (1990). *Heritage*, monographic issue of *Emigre*, 14.

12. Ibid., pg. 1.

13. Wolfgang Weingart, cited in VanderLans, *Heritage*, pg. 24.

14. VanderLans, *Heritage*, pg. 1.

15. Gantenbein, Köbi ed. (1991). *Mehrwerte: Schweiz und Design: die 80er*, exh. cat. Zurich: Curti Medien.

16. Bos, Ben and Eli Bos (2007), "Polly Bertram, Switzerland," in Ben Bos and Eli Bos, eds., *AGI: Graphic Design since 1950*. London: Thames & Hudson, pg. 404.

17. Lodge, Bernard (2004). "Natasha Kroll. Brilliant Designer who Brought About a Style Revolution at BBC Television," in *The Guardian*, April 7, 2004. theguardian.com/media/2004/apr/07/broadcasting.guardianobituaries (accessed July 20, 2023).

18. Bos, Ben and Eli Bos (2007), "Ernst Hiestand, Switzerland," and "Ursula Hiestand, Switzerland," in Bos and Bos, eds., *AGI: Graphic Design since 1950*, pgs. 184–5.

19. Bos, Ben and Eli Bos (2007), "Rosmarie Tissi, Switzerland," in Bos and Bos, eds., *AGI: Graphic Design since 1950*, pg. 243.

20. Fischer, Mirjam, ed. (2000). *The Most Beautiful Swiss Books 2000*. Bern: Federal Office of Culture.
Fischer, Mirjam, ed. (2004). *Beauty and the Book. 60 Jahre Die schönsten Schweizer Bücher / 60 Years of The Most Beautiful Swiss Books*. Sulgen: Niggli.

21. "Coloreonline" was a joint research project of three Universities of Applied Arts (Scuola universitaria professionale della Svizzera italiana, Hochschule der Künste Bern, and Hochschüle für Gestaltung und Kunst Luzern), led by Polly Bertram (2004–2007): supsi.ch/home_en/ricerca/progetti/dettaglio.5187.html (accessed July 20, 2023).

22. Botta, Massimo, ed. (2009). *Multiple Ways to Design Research. Research Cases that Reshape the Design Discipline*. Milan: swissdesignnetwork et al./edizioni.

23. Polly Bertram, cited in VanderLans, *Heritage*, pg. 19.

3.10

Sylvia Harris: The Enduring Influence of a Resolutely Black and Worldly Citizen Designer

Anne H. Berry

What influence have African Americans had on contemporary graphic design? Is there such a thing as an African-American design aesthetic? These are questions that I have been asking designers and art historians for the last ten years. The answer I am usually given is, "I don't know."

The questions that designer, strategist, and educator Sylvia Harris posed in her formative essay "Searching for a Black Aesthetic in American Graphic Design"[1] reflected the chronic challenges black designers faced—namely, each generation's lack of knowledge of and access to information about the industry's black design forerunners. The ongoing efforts to understand

Figure 3.10.1 Sylvia Harris, photographic portrait. Photo: George Larkins. Image Courtesy of George Larkins.

our history have been systematically disrupted due to, at least in part, historic discrimination against black designers and lack of recognition for our achievements.

Change has been slow, but the number of books published on black designers' work and the introduction of newer, more inclusive teaching approaches serve as markers of progress. And although this measure of success is the result of many designers over the course of many years, Sylvia Harris was an essential leader in this effort. One of the relatively few black design practitioners who came to prominence in the 1990s, Sylvia is remembered for, among other achievements, co-founding the public information design firm Two Twelve and serving as creative director for the 2000 US Census. Some of her most significant contributions to the profession, however, are the less-visible and less-public efforts she made throughout her successful, decades-long career: opening doors and mentoring and supporting newer generations of black and brown designers.

Identity and Creative Formation

Sylvia Elizabeth Harris was born in Richmond, Virginia, in 1953 to parents Thomas (Tom) Harris (1908–1982) and Olive (Lollie) Layton Harris (1920–1985), whose September 21 birthday she shared. Her only sibling, Juliette Harris, was born in 1944. Tom and Lollie came from vastly different worlds—Tom grew up in remote, rural southwest Arkansas, whereas Lollie grew up in the North, the daughter of a physician—yet they shared a common appreciation for the value of education, which they instilled in their daughters.[2]

The Harris's were both educators who created a harmonious family life for themselves. Residing on the campus of Virginia Union University, an historically black college and university (HBCU) where Tom was the athletic director, Juliette recalls that the girls found it "a great place to play!" Lollie taught art in the Richmond Public School system.[3]

At home, Sylvia was exposed to print media through publications that Lollie bought, including *Show* magazine, *House Beautiful*, *Vogue*, the *Diners Club* (credit card) magazine, *Gourmet*, and special issues of *Life* magazine. Sylvia's mother also bought issues of the first black-published literary magazine, *Urbanite*, and, beginning in the late 1960s, collected first-edition books and other vintage items by and about black people. Trips to museums, art galleries, and bookstores were common during travel and, when possible, in Richmond. Juliette credits their mother for nurturing both daughters' passion for art and design. As adults, the sisters were close friends who enjoyed spirited conversations on subjects related to design and material culture.[4]

Still, legally mandated segregation between black and white people was part of their daily lives. Sylvia recalled encounters with hostile teachers when she first attended an integrated middle school and knew what it was like to be "other."[5] By contrast, she had a positive high school experience with close friends who were both white and black. "[She] had a heightened sense of racial identity and knowledge of how to get along with all kinds of people in all kinds of situations," Juliette explains.[6] Growing up amid racial segregation

and transitioning into an increasingly desegregated society deeply shaped Sylvia, who was determined to succeed despite the limitations imposed on her.

Early Professional Career

According to Sylvia, becoming a graphic designer "was never calculated."[7] After one year of undergraduate foundations at Virginia Commonwealth University (VCU), the graphic design teacher approached Sylvia, telling her she belonged in design, and she followed his lead. She was also heavily influenced by prominent design historian Philip B. Meggs (1942–2002), who taught her about design theory and philosophy. She earned a degree in communication arts and then applied for positions at television stations due to her interest in motion and animation. She eventually got the call from WGBH in Boston, a public television station responsible for a significant percentage of nationally televised programming.

At WGBH, Sylvia worked with the vice president of design, Chris Pullman (1941), who also taught in the design program at Yale University. In an interview with AIGA, Sylvia noted that although he demonstrated an interest in her career trajectory, she was likewise impressed by his work, "not for the private sector but in this other whole world of design for the public good. It made a big impression."[8] Yet, she remained aware of the lack of diverse representation in design, noting that "There were few women, no people of color, few people close to me in age" providing support and mentorship.

Sylvia was undoubtedly talented and had "a sense of the visual" although, by her own admission, she knew little about typography because she hadn't studied the subject.[9] Subsequent positions at The Architects Collaborative (TAC) and Skidmore, Owings, and Merrill (SOM), where she was introduced to environmental graphics and urban planning, rounded out her visual communication design-specific training. Then, with encouragement from Chris, she applied and was accepted to a program for Graduate Graphic Design Studies at the Yale University School of Art, receiving an MFA degree in 1980.

A Graduate Education

At Yale, Sylvia became good friends with Juanita Dugdale (1953), who recalls, "Her warmth was infectious. We hung out together as friends, but I was soon wowed by her visual talent (and her singing!). Her work always had a nice touch, a sense of style recognizably hers."[10]

For Sylvia and Juanita, Yale was "an educational playground! We felt privileged to be there, and the sense of camaraderie in class was very strong." Sylvia and her classmates studied a range of topics from a rotation of prominent designers such as Armin Hofmann (1920–2020), Dorothea Hofmann (1929–2023), Paul Rand (1914–1996), Alan Fletcher (1931–2006), Rudolph de Harak (1924–2002), Andre Gurtler (1936–2021), and Bradbury Thompson (1911–1995). In 1979, Juanita and Sylvia were selected to represent Yale at

the International Design Conference in Aspen, where they rubbed shoulders with international and American designers like April Greiman and Japanese-American artist Isamu Noguchi (1904–1988). "We were young, inquisitive and having fun."

Design was her principal course of study, but Sylvia sought inspiration from classes that allowed her to explore black art and culture. She studied African and African diaspora cultures with Robert Farris Thompson (1932–2021) and came to admire the work of art historian Sylvia Ardyn Boone (1942–1993). She also researched racial stereotypes in print media and advertising, which she wrote about for her non-design courses. When she proposed a thesis project on this research, however, she was told by her design advisors that it was "an inappropriate topic" and did not pursue the idea.

Reflecting on the experience years later, Sylvia conceded that seeing other designers pursue similar themes presented "a great sadness" for her—she was upset for not having the perseverance to continue investigating a subject that was of such great interest to her. She was mentored by the most prominent designers in the field, was shaped by European traditions, and had access to resources that reflected her elite education. Yet, she remained firmly rooted in her identity as a black woman working in spaces where she was typically one of a few and never lost sight of black influences or the inspiration she gained from her travels.

Figure 3.10.2 Sylvia Harris, 2000 US Census materials. Image courtesy of Gary Singer.

Building a Business

"She was elegant, she was warm—she did have a very special quality. I think that's what drew people to her," says David Gibson, who also came to know Sylvia at Yale. And when Sylvia was asked what her post-graduation plans were, she announced, "I'm going into business with Juanita and David!" They named their firm Two Twelve after their building's address, 212 York Street, which was also NYC's phone area code.[11]

According to David, "Two Twelve was rarely about selling things. It was more about providing information, access, and support for citizens early on." Additionally, being a two-thirds female-owned company qualified Two Twelve for Women Business Enterprise (WBE) certification, which kept them competitive.

Regarding the connections she formed with her Yale classmates who became her business partners, Sylvia noted that they were all "somewhat outsiders in the design community, in one way or another." She was a black woman going into business with a gay man and one of the relatively few women practicing in the industry at the time. Not being part of the mainstream in 1980 brought a different energy to their practice. "We started with a rather egalitarian approach to design … instead of being hierarchical, it was more of a collaborative where everybody got input [and it was] very democratic."[12]

Each co-founder brought valuable skill sets to their collaboration, including prior professional experience working for government agencies. Additionally, Sylvia's instincts about how to run a small business—managing staff, juggling finances, marketing, presenting, writing proposals, and nurturing client relationships—served them well. Juanita describes their working relationship as "based largely on trust, tact, and mutual admiration despite our differences," adding that "Sylvia's inherent empathy made her both a great information designer and a great friend."

The process of defining themselves as a firm evolved organically. "We came up with the idea of public information design as the kind of focus of what we were doing and that's something that Two Twelve still talks about."[13] This specialized area would also define the rest of Sylvia's career. Two Twelve clients included New York's Central Park Zoo, Asia Society, the University of Pennsylvania, the Municipal Art Society, and the New York State Council on the Arts.

Curiosity Genes

Sylvia's inherent interest in the world around her manifested through travel abroad. Trips to India, China, Ghana, Thailand, Italy, and Turkey, including hikes in the Himalayas and summer meditation retreats, would come to significantly affect the course of her life.

In The International Year of Tibet, 1991, Gary Singer[14] went to a dinner party in Manhattan to hear a monk talk about the political situation in the region. Afterward, Gary encountered Sylvia, surrounded by a group of white people arguing about American

imperialism. She was pushing back on some of the group's preconceptions and holding herself in a "very Zen-like" way. "All the other people were contending with her, but she was just incredibly calm."[15] He had just come from his first trek through Nepal and had personally witnessed Western businesses cropping up. Within less than a minute, Sylvia's arguments had persuaded him of the inevitability of change. "By our traveling there, we are all agents of this transition, and there's no way to deny that. So, I'm thinking, this woman is absolutely right."

Sylvia and Gary developed a friendship that, over time, deepened into romance. Gary was preparing for a two-year international trip at the time, however, so Sylvia encouraged him to go but gave him a reading list that included books by black writers from Africa, the Caribbean, and the United States, including Frantz Fanon (1925–1961), Chinua Achebe (1930–2013), James Baldwin (1924–1987), and Maya Angelou (1928–2014). "She said, 'Listen. If I'm going to start a life with a white man, then you have a lot of education to [do].' I said, 'Great!'" The curiosity gene they shared—an openness to learn and understand—profoundly affected the way they related to each other and moved through the world. "We've always had a very, very open and transparent series of ongoing conversations, including about race … I could challenge her. She could challenge me … I saw her for who she was, and I celebrated her."

Gary left, and Sylvia stayed at Two Twelve, but they continued to connect across the globe: "We would meet in China. Then, we spent two months in China, and then Tibet and Nepal. Then she flew back [to the States]. Then, she met me in Africa. So we traveled the world together. It was a hyper-romantic courtship." After a year and a half, Gary returned early. "I said to myself, I'm clearly in love with this woman. Why am I waiting?" They moved in together in Brooklyn and married in December 1995.

Excerpts about Sylvia's solo travel, which shed light on what she learned, were included in Elaine Lee's *Go Girl: The Black Woman's Book of Travel and Adventure*. In one entry, Sylvia writes:" The roots of the modernist movement are right here in Africa. Complex communication reduced to the essence of symbol and form. When the modernists imported the primitive into their work, they left behind the one thing that could not be exported. The soul. Soul arrived in the West in the minds and bones of African people and was reintroduced to the modern world through African American music. It is fascinating to imagine that African people travel thousands of miles to America to meet up with their own cultural "stuff" in the form of modern art!"[16]

Connections

In 1993, Sylvia left Two Twelve to create her own business, Sylvia Harris, LLC, to focus more exclusively on systems planning and strategy. She would go on to work with "some of the nation's largest hospitals, universities and civic agencies through systems planning, policy development, and innovation management."[17] She was simultaneously

Figure 3.10.3 Sylvia Harris presenting work. Image courtesy of Gary Singer.

brainstorming with design colleagues and close friends Michele Y. Washington and Folayemi Wilson about ways to bring black designers together. Folayemi recalls, "I don't care if it's 25 of us in a hotel room, just showing our portfolios. I wanna know people, and I want a sense of community around the country." The trio reached out to David Rice, chairman and founder of the Organization of Black Designers (OBD), and pitched the idea of a design conference in Chicago, Illinois. David agreed, and planning moved forward.

Sylvia, Michele, and Folayemi, who spearheaded the effort, worked with David, OBD executive director Shauna Stallworth, and a team of volunteers to bring the idea to fruition. OBD's first national conference, *Dogon to Digital: Design Force 2000*, was held in October 1994 and featured an interdisciplinary group of designers from fashion, film, interior design, academia, graphic design, and related fields to "expand the idea of what design is and what black design is." Greg Tate and Arthur Jafa were keynote speakers at the gathering, which included over 300 designers from across the country.[18] Sylvia also arranged for the special issue of the *International Review of African American Art* on black designers, published in 1996. Her sister Juliette was the managing editor of the issue.[19]

As an extension of the communities she built professionally, Sylvia was equally intent on fostering community in her personal life. When Saundra Thomas met Sylvia in the mid-1990s, Gary was convincing Sylvia to move to Brooklyn where Saundra and her

Figure 3.10.4 Sylvia Harris, "Who Owns Cultural Imagery?" The Property Issue, *AIGA Journal of Graphic Design*, Vol. 14, No. 1, 1996, edited by Sylvia Harris and Steven Heller. Image courtesy of Michele Y. Washington.

wife Susan Siegel lived. The two couples became part of "The Village," a dynamic, inclusive, multiracial community of families and friends. "We [still] refer to ourselves as The Village. 'How are The Village kids doing? What is The Village doing for the holidays?' Sylvia created that."[20]

When Sylvia was rushed to the hospital on New Year's Eve (1996) and gave birth prematurely to her daughter Thai, the experience cemented their friendship. Describing Sylvia as the big sister she never had, Thomas adds, "Her energy was that of someone who's interested in helping you *become*."

A Damn Good Designer

Sylvia began moving into new, groundbreaking areas while still part of Two Twelve.[21] She had an early interest in "interactive media and the user-centered design process that came with that exploration"[22] before the terminology was part of the design lexicon and worked with Citibank to develop the user interface for the first ATM. "I learned everything I know about user testing, product design, and strategic planning from that experience. It was like going to graduate school in usability, and I made contacts that have lasted to this day."[23]

Figure 3.10.5 Sylvia Harris, *Voting By Design* poster 2003. Client: University of Minnesota Design Institute. Image courtesy of Gary Singer.

As both a friend and design peer, Folayemi was attuned to the characteristics that set Sylvia apart, particularly her skills as a design strategist. Sylvia was a critical thinker who understood problems from various viewpoints and knew how to work with complex institutions and entities, analyzing and developing methods that were foundational for a given design project.

Consequently, when the ACLU approached Folayemi about designing an identity system, she reached out to Sylvia to collaborate. A complex project for a complex organization, Sylvia's civic design expertise was "instrumental in designing a process that would help us do the work." Forty-eight of 50 chapters adopted the ACLU's first branded system.[24]

In 1992, the Bill Clinton–Al Gore transition team held policy development meetings with experts from various fields. As one of the designers recruited by Chee Pearlman, editor of *I.D.* magazine, to participate in a national roundtable focused on design, Sylvia co-authored a white paper response that "challenged the administration to demonstrate their commitment to improving citizens' access to government by developing 'design standards that remove barriers to participation.'" Areas of particular concern included voting, tax forms, and census questionnaires.[25, 26]

Inspired by the roundtable, Sylvia created a simplified version of the census project brief for her Yale graduate students. The research-based ideas they generated impressed the members of the Census 2000 team. As a result, Sylvia consulted and was then hired as the creative director. She brought Two Twelve on board to lend additional expertise.[27] The design process and outcomes posed essential questions about the design of government documents and communications and the ongoing challenges involved.[28]

Citizen Research and Design

Sylvia continually grew and adapted, just as her expertise and interests evolved. Years after establishing herself professionally through Two Twelve and Sylvia Harris, LLC, she embarked on yet another career transition that reflected future projects she wanted to pursue.

Chelsea Mauldin was deputy director of the Design Trust for Public Space when she and Sylvia met. She had come across Sylvia's bio and cold-called her, recruiting her to provide user experience expertise for a project focused on New York City's Yellow Cab taxis. The project team published a book titled *Taxi 07: Roads Forward* which was "deeply informed and influenced by—and I would say guided by—Sylvia saying, 'think of all the different ways to tell this story,'" Chelsea explains. As one example of Sylvia's progressive thinking, she adds, "It was the early 2000s, so nobody said 'there's a thing called the service journey,'" but they created a diagram showing the journey of the rider and the driver, and how the two experiences converged and diverged.[29]

A few years later, Sylvia met Chelsea for lunch and told her, "Barack Obama is going to get elected and there's going to be this opening for the design community to reengage with the federal government, and no one's getting ready." They began meeting in a small

group, which included David Gibson, and published an op-ed, "Healthy Credit" for the *New York Times*, advocating for the relationship between good design and policy implementation. An official from the Centers for Medicare & Medicaid Services (CMS) reached out in response, ultimately resulting in the designers joining a research team working to reimagine how Medicare communicated to beneficiaries.

Throughout 2010, Sylvia, David, and Chelsea discussed the work they had embarked on. They recognized the disconnect between the expertise they were able to provide and social services/agencies' awareness of their existence. To bridge the gap, they formed Public Policy Lab, one of the first—if not *the* first—nonprofit organizations in the United States to develop human-centered service and policy design for domestic government entities. Their mission is to "design policy and services that help the American public build better lives."[30]

While developing Public Policy Lab, Sylvia was also working with Folayemi on strategic plans for their respective businesses. They were both in professional transitions, leaning on each other for practical help and support. Folayemi assisted Sylvia in the shift to a full-time consultancy, which she named Citizen Research and Design.[31] Sylvia was launching the new brand and serving on the US Postal Service's Citizens Stamp Advisory Committee when she passed away suddenly from heart failure on July 24, 2011, at the age of fifty-seven.

Steve Jones was in graduate school at Rhode Island School of Design in the late 1990s when he and Sylvia met. His MFA thesis project, "BLACK—A Thesis Fo'Yo' Ass …" on the topic of Black icons and their representation in printed mass media, provides evidence of Sylvia's influential role in his life. A poignant bookend to her own graduate school experience, she offers a cautionary tale while advising him to push forward, which he captured on a page titled "Black Mail": "I proposed a similar thesis topic in grad school many years ago, and it got shot down. Looking back, I needed to make a better argument about why this is relevant to the field of graphic design."

This anecdote encapsulates the challenges Sylvia faced with indefatigable optimism, her consciousness of identity as part and parcel of her work, and the responsibility she felt to "raise the visibility of black designers and the visibility of black culture as much as she could."[32]

The recognition Sylvia received for her work and the impact of her contributions is significant. She was posthumously awarded an AIGA Medal in 2014[33] and recognized as a Society for Experiential Graphic Design (SEGD) Fellow in 2021,[34] and the Sylvia Harris Citizen Design Award[35] and SEGD Sylvia Harris Award[36] were established in her honor. Yet it was the path she chose, eschewing the trappings of commercial work to support and improve the lives of others, that best defined her.

She has been gone for over a decade, but her work and approach to design embody what we value most in the present. Even for those who never had the privilege of meeting her or working with her, we still feel her influence via her words, the civic design space,

and through her work in user experience design/user interface design. She was the living, breathing embodiment of what many of us aspire to be—creative, curious, and driven by a commitment to doing meaningful work in the world.

© **Anne H. Berry**

NOTES

1. Sylvia Harris, "Searching for a Black Aesthetic in American Graphic Design" in *The Education of a Graphic Designer*, 2nd ed., ed. Steven Heller. New York: Allworth Press, 2005, pg. 269.
2. Juliette Harris is an independent writer, editor, and former editor in chief and writer for *The International Review of African American Art*. Personal communications and written interview by author, May–July 2023.
3. Historically Black Colleges and Universities were "founded and developed in an environment of legal segregation and, by providing access to higher education, they contributed substantially to the progress Black Americans made in improving their status (source)." https://nces.ed.gov/fastfacts/display.asp?id=667.
4. Juliette Harris, interview by author, May–July 2023.
5. Gary Singer, interviewed by author, Zoom, May 16, 2023.
6. Juliette notes, "The educational approaches of the times did not reward creativity. But those were the mores of a segregated society. Syl thrived in the integrated circumstance of her adolescence and young adulthood."
7. Sylvia Harris, interviewed by Michele Y. Washington, New York City, NY, 1993.
8. Laura House, "Sylvia Harris: Biography," aiga.org, October 4, 2011. https://web.archive.org/web/20111004035114/http://www.aiga.org:80/design-journeys-sylvia-harris/.
9. Sylvia Harris, interviewed by Michele Y. Washington, New York City, NY, 1993.
10. Juanita Dugdale, interviewed by author, Zoom, May 10, 2023.
11. Ibid.
12. Sylvia Harris, interviewed by Michele Y. Washington, New York City, NY, 1993.
13. David Gibson, interview by author, Zoom, April 13, 2023.
14. Sylvia's husband, a psychotherapist and teacher of Buddhism.
15. Gary Singer, interviewed by author, Zoom, May 16, 2023.
16. Elaine Lee, *Go Girl: The Black Woman's Book of Travel and Adventure*. Portland, OR: The Eighth Mountain Press, 1997, pg. 22.
17. Laura House, "Sylvia Harris: Biography," aiga.org.
18. Michele Washington, interviewed by author, Zoom, May 19, 2023.
19. Juliette Bowles (Harris) (ed.), "Design Force 2000: African American Designers Anticipate the New Millennium," *The International Review of African American Art* 13, no. 1, 1996.
20. Saundra Thomas, interviewed by author, Zoom, May 1, 2023.
21. Folayemi Wilson, interviewed by author, Zoom, April 8, 2023.
22. https://www.archpaper.com/2011/08/sylvia-harris-1953-2011/.
23. Laura House, "Sylvia Harris: Biography," aiga.org.
24. Folayemi Wilson, interviewed by author, Zoom, April 8, 2023.

25. Chris Pullman, "Sense & Census," *Critique*, Summer 2000, pgs. 54–61.
26. Chee Pearlman, Michael Sorkin, and Sylvia Harris Woodard, "Designing America," *I.D.*, March/April 1993, pgs. 54–61.
27. Sylvia's former mentor, Chris Pullman, wrote a detailed article about overhauling the US Census, published in the Summer 2000 issue of *Critique* magazine.
28. Chris Pullman, interviewed by author, Zoom, May 3, 2023.
29. Chelsea Mauldin, interviewed by author, Zoom, May 8, 2023.
30. "Our Mission," Public Policy Lab. https://www.publicpolicylab.org/.
31. Folayemi Wilson, interviewed by author, Zoom, April 8, 2023.
32. Gary Singer, interviewed by author, Zoom, May 16, 2023.
33. David Gibson, "2014 AIGA Medalist: Sylvia Harris," 2014. https://www.aiga.org/membership-community/aiga-awards/2014-aiga-medalist-sylvia-harris.
34. "2021 SEGD Fellow: Sylvia Harris," 2021. https://segd.org/resources/2021-segd-fellow-sylvia-harris/.
35. "Sylvia Harris Citizen Design Award," 2017. http://designigniteschange.org/.
36. "Prep Your Projects for the 2023 SEGD Global Design Awards!" 2022. https://segd.org/resources/prep-your-projects-2023-segd-global-design-awards/#:~:text=The%20Sylvia%20Harris%20Award%20is,honor%20and%20continue%20Harris'%20legacy.

3.11

Kyungja Keum: Golden Days

Dr. Yoonkyung Myung

In Korea, when we hear the word "woman," we naturally think of "mother." Being a mother is a representative identity of women, both in the past and still in the present.

Since the Korean War ended in 1953,[1] South Korea has achieved phenomenal economic and technological development. More women have been educated, earning university degrees, and taking their place in an essential workforce. As a result, women assumed more responsibility, but the reality was that they were also mothers and homemakers, and this responsibility in the home remained the same.

It was common for many Korean women in the mid to late twentieth century to leave their jobs when they married or had children. Even if they continued to pursue jobs after marriage and childbirth, it was challenging to maintain their positions for many reasons, including the existence of glass ceilings. Also, there is a term, "hyunmoyangcheo,"[2] which describes what Korean society in the past expected from women. Therefore, when I was a little girl, I thought I would have to quit my job when I married. Many women were pictured in such a way on television.[3] My mother also quit her job as soon as she married

Figure 3.11.1 Kyungja Keum photographed working at her desk. Image courtesy of Kyungja Keum.

my father. She said my paternal grandparents (her in-laws) expected her to do so to concentrate on being a good wife and a wise mother.

In my generation, commonly called the millennials, born between 1981 and 1996, society's expectations for women differ from the past. Many women today do not think quitting their jobs is necessary after they marry. However, as soon as we give birth, we assume the responsibility of becoming mothers. If there is no one to help with childcare besides our husbands, we find ourselves at a crossroads of resigning from work. One of my high school friends, who holds a master's degree from a respected university, recently had to leave her job when she gave birth to her second daughter. She confessed that she could not handle her work and the parenting of two children simultaneously.

Although balancing work and household responsibilities in today's society remains challenging for both men and women, compared to the past, there is a more supportive institutional environment and a keener social awareness. But even in our parent's generation—working under more difficult conditions—there were career women who were also mothers. Although their names may not be as widely recognized as those found in Google searches, they diligently performed their duties as working professionals and family members. The design industry, indeed, has many hidden figures like Kyungja Keum, who balanced a career as an editor/designer and a parent in the 1970s and 1990s when achieving both was an enormous challenge.

Kyungja Keum

Kyungja was born in 1955. Her father was a soldier, and her mother was a housewife. Her father always put much effort into raising her and her two younger brothers to behave and follow the rules. But he was a cheerful person who always uplifted the family. On the other hand, Kyungja's mother was strict—not only to Kyungja and her brothers but also to herself, as she always maintained a neat and elegant appearance. Kyungja's parents were very respectful to each other.

At that time in Korea, sons were preferred to daughters, but Kyungja's parents were different. They gave her love and support; she never felt she was being neglected (compared to her younger brothers) because she was a daughter. Her parents were incredibly attentive because she was the only daughter. They were not wealthy, yet they raised their children optimistically. Kyungja remembers a happy childhood filled with good memories.

When Kyungja turned sixteen, her father passed away unexpectedly. Her mother was left alone to raise three children, and Kyungja thought she would need to help her mother run the house. Fortunately, her mother swiftly pulled herself together and started a new job at an insurance company. Losing her father was a challenging experience for Kyungja, but witnessing her mother become a strong woman inspired her. She assured herself that she would become a strong woman like her mother.

Figure 3.11.2 Kyungja Keum, cover, and table of contents, *Monthly Job Placement*, Vol. 7, No. 12, December 1979. Image courtesy of Kyungja Keum.

Choosing Her Path

Kyungja's mother always emphasized the importance of education in her children's life. Despite the deficient percentage[4] of women pursuing higher education, her mother still wanted her to attend college despite the economic burden. Kyungja's mother firmly believed that Kyungja should attend college to aspire to a better life.

Kyungja had so many dreams and desires inspired by her parents. She considered becoming a writer and possibly a judge to uphold justice according to her father's wishes. Observing her always stylish mother wearing clothes she designed, Kyungja developed an enthusiastic interest in fashion and even dreamt of becoming a designer. All her dreams seemed unrelated and somewhat random, as she had yet to establish a clear career path and was going through a period of confusion where there were either too many things she wanted to pursue or her desired pathways had yet to be determined.

She first applied to college to study law but was rejected. Then, in 1973, she applied to Hanyang University's Clothing and Textiles Department[5] and pursued her studies there. The curriculum in the Clothing and Textiles Department included theoretical aspects, such as the properties and uses of textiles and various art subjects—including drawing, color, and composition—which are fundamental to the study of fashion design. She found herself intrigued by the different art activities she encountered for the first time. In the 1970s, the Clothing and Textiles Department was part of the College of Education at Hanyang University. Upon graduation, she obtained a secondary school level 2 teaching certificate,[6] opening a career path in teaching. After graduating from Hanyang University in 1976—while considering a career path—she married a supportive and loving husband. They had two sons, Minho and Minsoo, and a daughter, Minjae.

Working Professionally at Ario Publisher

After her college graduation and marriage, Kyungja faced a dilemma—should she become a fashion designer or a teacher? Then fate intervened, and her life took an unexpected turn due to an acquaintance's urgent request. The publishing company Ario[7] was looking for a temporary reporter to help the editorial team on their magazine, *Monthly Job Placement*—a publication that provides information to job seekers—to cover an important story, as the regular Ario reporter suddenly went absent. She thought the temporary position would fill and support her gap year before being hired as a fashion designer or a teacher, so she decided to join them in 1977. She did not see herself staying in the publishing industry for long.

In her position, Kyungja had to interact with many people she did not know. Meeting unfamiliar people and engaging in the unfamiliar task of collecting necessary information felt strangely natural, like water flowing fluidly. She turned her field notes into an article when she returned to the office. When conversing with new people, Kyungja's introverted and shy demeanor seemed to vanish. She transformed into a lively and vibrant version of herself.

Realizing Kyungja's potential after observing her for a few days, her supervisor at Ario urged her to join the magazine editing team and offered a probationary period to become a journalist. Although she had some lingering feelings about the teaching profession and being a fashion designer, she was drawn to the allure of working as a journalist, where skills were valued above gender, and the work was dynamic and proactive—being a female journalist for a magazine was an admirable profession.

However, the reality was less glamorous than she had hoped. Ario published the *Monthly Job Placement*,[8] a magazine targeting high school students seeking jobs after graduation. At that time, except for a few large media companies, most magazines were operated by small publishing houses like Ario, where the work was not divided into specialized tasks. Journalists had to handle everything from planning, interviewing, writing articles, editing, proofreading, and layout to prepress. She had to manage all aspects of her reporting, from

Figure 3.11.3 Kyungja Keum, spreads from the article "Pass or Fail: The Glory and Defeat in Interviews! From the Basics of Interviews to Model Answers—Part 2," *Monthly Job Placement*, Vol. 7, No. 12, December 1979. Image courtesy of Kyungja Keum.

start to finish, leaving her feeling rushed and often working overtime, spending more time at the office than at home.

Being a wife and a mother would have been an enormous burden for her, but her husband was very supportive of her having a job, and he was helpful with housework. When their two sons, Minho and Minsoo, were born, his parents cared for them so she could focus on her job. Even though she had enough support from her family, she always felt guilty and sorry that she could not support her family like other "normal" wives.

Another challenge Kyungja faced was her lack of training as a graphic designer, as layout design and prepress works were challenging. However, the design-related courses she took while attending Hanyang University were helpful in this case. For the *Monthly Job Placement* issue published in December 1979, Kyungja also worked on the layout design and wrote a few articles. The magazine cover's title was written in Chinese characters, suggesting the nostalgic mood of the 1970s.[9] The magazine utilized text, photos, illustrations, and diagrams printed in black and white, except for the cover, printed in full color. Various fonts were used for the table of contents, with different sizes of Korean sans-serif and serif typefaces mixed horizontally. This method serves as a device to indicate the importance of the article.

Kyungja included photos, texts, and charts in one article in the December 1979 issue. The article "Pass or Fail: The Glory and Defeat in Interviews! From the Basics of Interviews to Model Answers—Part 2" analyzes the procedures before and after a job interview. Kyungja used typographic hierarchy to highlight how essential the interviews are in job placement. At the beginning of the article, the serif words "Pass or Fail" are prominently placed in a box decorated with geometrical glyphs at the top of the page; below that line, the rest of the title follows. A photo in a box shows the scene of the interview room, taking up an area equivalent to one-third of the page—a visual device designed to lure the job seeker's attention. Under the photo, there is a tagline that reminds the title of this article, "Pass or fail depends on the interview," and a summary of the article follows in smaller sans-serif type. To use the space wisely and draw attention effectively, she borrowed the graphic method from the Diminuendo style,[10] which originated from the Celtic Illuminated manuscripts of early Christianity.[11] She employed large fonts and graphics to remind readers of the content's importance and to gradually fill the space without wasting it by reducing the font size. From the back page,[12] Kyungja designed a two-column Swiss-style grid, showing the job interview procedures at different companies through diagrams and related text content. Photos of interview rooms are inserted as supporting material throughout the article, along with a typical Korean serif typeface[13] widely used in newspapers, magazines, and textbooks at that time.

Aside from the limitations imposed by the texture of the paper and the typesetting and printing technology of the time, the magazine displayed outstanding readability. The column width of the text was suitable for quick reading, and the line spacing was neither too narrow nor too wide, allowing for good concentration. The improved layout design,

Figure 3.11.4 Kyungja Keum, *Hometopia* cover and a spread from the article, "Barbecue Lunch in Summer," Vol. 2, No. 6, June 1989. Image courtesy of Kyungja Keum.

which included photographs, illustrations, and various sizes of text mixed in with dense typesetting, was enough to pique readers' interest. Kyungja's efforts to improve the readability of the *Monthly Job Placement* led to increased circulation.

In a society where women were marginalized, Kyungja found great satisfaction, dignity, and fulfillment in her profession. Although her work environment was challenging, Kyungja formed close relationships with her fellow journalists, sharing joys and sorrows like a family and helping her alleviate some of the work stress. Most importantly, each time she held the freshly printed *Monthly Job Placement* in her hands, she felt satisfied that her life's moments were not scattered but preserved as a clear trajectory.

New Start at *Hometopia*

Ario's *Monthly Job Placement* magazine flourished daily with the employees' efforts. As Ario gained a solid foothold, the publishing industry experienced a boom in magazine launches, with new monthly magazines springing up one after another. One of the biggest challenges for newly established magazines was recruiting personnel, especially experienced journalists with proven capabilities. This presented an excellent opportunity for journalists and editors seeking new work environments. With the increased interaction and camaraderie among journalists in the magazine industry, they formed networks, exchanging diverse information and freely moving between companies to find the best fit for themselves. Kyungja Keum also received several offers from different publishers.

First, after leaving Ario Publishers in 1986, Kyungja worked at *Monthly Parenting and Education* magazine for two years. In 1988, she left *Monthly Parenting and Education* and joined Kyemong-sa,[14] where her position expanded. Kyemong-sa was a big publishing company, unlike her previous employers, and she joined the company as one of the founding members of *Hometopia*[15] magazine, becoming the editing department's directing manager. Unlike the black-and-white print of *Monthly Job Placement*, *Hometopia* was a full-color magazine with a photo-centric editing approach employing large-format photos that filled the entire page. Because Kyemong-sa was a big company, she was teamed up with the best photographers, prepress specialists, and more from the publishing industry.

The targeted demographic for *Hometopia* was married Korean women—housewives and working mothers. With the catchphrase "Happy Women, Harmonious Families," *Hometopia* was a magazine born from the publisher's belief in the power of women's influence, asserting that as women's consciousness level rises, it can also bring about changes in families and society. *Hometopia* aimed to rekindle women's sense of value and preciousness, even when engaged in homemaking and childcare. The publisher instructed the editorial team to move away from the sensational and stimulating content that other women's magazines mainly focused on, and instead focus solely on content that could elevate women's culture and consciousness, such as literature, arts, and child education. Furthermore, they even insisted on censoring advertisements—vital for the magazine's production to maintain the highest quality—leaving the staff astonished and bewildered. The magazine was closely observant and made rational judgments on the current social issues of the day.

Kyungja always ensured the integration of photography and typography for the layout. For the cover of the June 1989 issue, the color of the type matched the colors in the image. As a magazine printed in full color, *Hometopia* emphasized its visual design. The magazine's distinguishing feature was its neat letter arrangement, delicate lines, and large, high-quality color photographic images. In the article "Barbecue Lunch in Summer" from the June 1989 issue, a large image takes up about 7/8 of the entire spread. The related text is arranged in a narrow column in one corner, making the image far more dominant than the text. The format remains consistent throughout the entire article until the last spread, where changes are made. Unlike the other spreads that cover a single menu recipe, the final spread of the article presents two menu recipes, and the photographs take up about 3/4 of the page at the bottom, with three columns of text on the top. This article is particularly noteworthy for its generous use of photographs, even though other articles have more text than photographs in the same issue. Most articles, like the barbecue article, have a clean layout, clear separation of pictures and text into columns and plenty of white space, and bright pages to help readers understand the content rationally.

One of the features in the June 1989 issue of *Hometopia* is the attempt to connect photos and text to create a single scene. The "Oh! It's Raining" article introduces children's clothing made of waterproof materials suitable for the Korean monsoon summer season.[16] The silhouetted photos of the child models wearing featured outfits are arranged on an

Figure 3.11.5 Kyungja Keum, spread from the article, "Oh! It's Raining," *Hometopia*, Vol. 2, No. 6, June 1989. Image courtesy of Kyungja Keum.

empty white background. Blue crayon-like raindrops are placed in the open white space and bounce off the umbrellas, creating a natural harmony between the photo, illustration, and white space on the page. The content and sponsorship information are arranged in one area of the spread, and the necessary text information about the clothing is neatly placed beside the related photos.

Kyungja and her team pioneered the design of the photo-centered layout in Korean periodicals—inspiring Korean magazines to transition from primarily "reading" material to becoming mostly "seeing" material. As a result, Korean magazines began offering more visually appealing content and adopted a style of conveying information visually.

Hometopia encouraged its readers to objectively reflect on their lives while revisiting traditional women's roles that were often overlooked. As a working mom, Kyungja realized she had been living her life chasing after work and family and thought about whether she had burdened her family with too much responsibility for her achievements. She also wondered whether both she and her family were truly happy. She found that she could reflect on the trajectory of her own life and reconnect to what she wanted in the future.

Leaving the Company

Kyungja left Kyemong-sa in 1990 and started freelancing as a journalist/editor, continuing her career but with few opportunities to work in design-related positions. With her father-in-law's health declining—while she gave birth to her third child, a daughter named Minjae—she could not ask her in-laws for further help. Like other Korean mothers, Kyungja reduced her work hours and mainly stayed home. With the advent of digital technology in the early 1990s, design and layout editing techniques rapidly changed. As a freelance editor, she did not have the opportunity or support from her employer to continue developing her layout design tools and methods skillsets. She had to stop working as a designer, but still did a little writing and editing work.

Becoming a full-time housewife was more challenging than she had thought. There were hidden issues in the seemingly trivial aspects of daily life. As an inexperienced novice housewife, Kyungja needed a considerable period of adaptation that was no less demanding than her previous work life. Nevertheless, even while focusing on household chores, her eyes and ears remained attuned to the industry she had been involved in. She continued communicating with relevant people and couldn't relinquish her intense interest and ties to the publishing world. Most publishing companies needed more hands, so they turned to Kyungja, who was not tied to any specific workplace and asked her to take on various tasks.

All in all, she devoted about twenty years to editing publications. As a talented journalist and a design director, she led Korea's photographic magazine culture, although she is not widely known. She demonstrated her perseverance that women could overcome difficulties and be successful even in the challenging times for women in the workforce. Even at an older age, she is still a very passionate working woman living her golden days.

© **Dr. Yoonkyung Myung**

NOTES

1. The Korean War took place on the Korean Peninsula, beginning with North Korean Army's illegal invasion across the 38th Parallel on June 25, 1950. It was a clash between communism and capitalism; China and the Soviet Union supported North Korea, whereas South Korea was supported by the United States and allied countries. The war ended with an armistice on July 27, 1953. Available at: https://encykorea.aks.ac.kr/Article/E0042143.

2. Hyunmoyangcheo (현모양처) is a term that refers to "a wise mother and a good wife."

3. Mothers in the Korean dramas of the 1990s were often portrayed as stereotypical housewives who sacrificed themselves for their family's happiness. They stayed home and took care of all the house chores. Television advertisements in the 1990s for refrigerators or washing machines primarily showcased women as spokespersons showing the convenience of technology to perform household chores.

4. According to Kyungja's recollection, the percentage of women attending college in her first year was only about 3.7 percent.
5. Hanyang University is a highly ranked university in Seoul. Available at: https://www.hanyang.ac.kr/.
6. This certification allows one to teach in middle schools.
7. Ario was a publishing company where Kyungja was employed as an editor from 1977 to 1986. The company published job market periodical magazines, such as *Monthly Job Placement* and *AM*.
8. *Monthly Job Placement* was published from June 1977 to December 1979.
9. *Hangul*, formerly called *Hunminjungeum*, was created by the King Sejong of the Chosun Dynasty in 1443. Even after its creation, Chinese characters were still heavily used to write Korean. Hangul became the official writing system of the Korean language in 1894 and has been replacing the usage of Chinese characters since then. The name Hangul started being used in the 1910s. Even though Hangul became the official writing system, Chinese characters were often used for semantic reasons and to avoid confusion between homonyms. Since the 1990s, Chinese characters are only used when needed. Available in *Great Cultural Heritage*: https://terms.naver.com/entry.naver?docId=3569386&cid=58840&categoryId=58856.
10. Diminuendo is a graphic style that starts a book or a chapter with a giant decorative initial character and gradually reduces the size of the other characters on the same page. *The Book of Durrow* is the best example of the diminuendo style. *Available in British Library*: https://www.bl.uk/collection-items/book-of-durrow.
11. Celtic illuminated manuscripts are known as some of the best-illuminated manuscripts of early Christianity. Illustrations in the manuscripts show the beautiful mixture of Irish folk art and Christianity that was introduced to Ireland. Phillip B. Meggs and Alston W. Purvis (2016). *Megg's History of Graphic Design*, 6th ed. Hoboken, NJ: John Wiley & Sons, pgs. 52–4.
12. Just like English, modern Korean is written and read horizontally from left to write, and the binding is on the left side.
13. Korean serif typeface is called Buri-che (부리체), or Myeongjo-che (명조체).
14. Kyemong-sa, established in 1946 as the first specialized children's publishing company in South Korea, had been a leading player in children's literature for half a century. Their launch of *Hometopia* monthly magazine garnered attention from the periodical publishing industry. Available at Namuwiki: https://namu.wiki/w/%EA%B3%84%EB%AA%BD%EC%82%AC.
15. *Hometopia* was launched in May 1988 by Kyemong-sa, and discontinued in December 1989.
16. I am one of the child models in the article. My mother had worked at Ario as a reporter, and Kyungja Keum was her supervisor. When I was six, I visited Kyemong-sa, Kyungja's workplace with my mother. Back then, Kyungja was the managing director of the *Hometopia* editorial department. Kyungja had recommended me as a child model, and I did a photoshoot for this particular issue. I still remember her welcoming smile and how she energetically directed the photoshoot. It was a rare scene for me to experience as she worked outside her home, unlike most mothers I knew who stayed home.

3.12

Winnie Wai-kan Kwan: The Nurturer of Museum Design, Public Engagement, and Life Balance

Dr. Wendy S. Wong

In 1988, Matthew Turner, who taught at the Hong Kong Polytechnic University between 1982 and 1995, curated an exhibition titled *Made in Hong Kong: A History of Export Design in Hong Kong, 1900–1960*. The exhibition brought to light the design history of early twentieth-century Hong Kong. In a subsequent journal article, Turner argued that design history was exclusionary, reflecting neo-imperialism and chauvinism by neglecting Hong Kong as an example. He provided three reasons for this

Figure 3.12.1 Winnie Wai-kan Kwan, 2014. Photo: Kam Lan Chow. Image courtesy of Winnie Wai-kan Kwan and The Hong Kong Museum of Art.

exclusion: the need for more exploration in design history beyond modern capitalist nations, limited availability of evidence, and Western definitions that prevented a comprehensive understanding of design history beyond the First World.[1]

Despite over thirty years since Turner's critique, academic research on Hong Kong's design history remains limited. The handover of Hong Kong to China in 1997 marked a shift, with the Hong Kong Special Administrative Region striving to shed its "cultural desert" image, especially in the past two decades.[2] This increased interest in local cultural identities and preserving local designs as a specialized study field, including visual cultural history.[3] However, individual women designers in this context remain largely unexplored.

To contest neo-imperialism and chauvinism in design history, this essay explores the significance of Winnie Wai-kan Kwan, a woman designer who has made substantial contributions to the museum design scene in Hong Kong for over four decades. Winnie's work reflects the unique challenges faced by Hong Kong as a British colony, a gateway to mainland China, and a global capitalist hub. Her designs skillfully blend Eastern and Western influences, showcasing Hong Kong's rich cultural heritage and challenging Western design paradigms.

The East Meets West Milieu in Hong Kong

In the aftermath of the Second World War, Hong Kong, where East meets West, underwent significant changes. The British resumed control over Hong Kong from Japan, and the Korean War (1950–53) led to trade bans on China by Western countries, prompting Hong Kong to seek alternative economic survival strategies in the 1950s. The influx of refugees and migrants from mainland China laid the groundwork for industrialization in Hong Kong.

The film *The World of Suzie Wong* (1960), filmed in Hong Kong, appealed to Western audiences and reinforced the binary "East meets West" relationship within Hong Kong's cultural identity across all sectors. This concept and economic growth following the Second World War shaped the baby boomer generation in Hong Kong. Wai-kan was born in Hong Kong on January 8, 1956. Her parents gave her a name that embodied their wishes for her to be filled with wisdom, luck, and happiness. Like many others in her baby boomer generation, she experienced a unique set of educational, social, cultural, and economic circumstances that shaped her life.

Winnie attended St. Mary's Canossian College, a Catholic girls' grade school founded in 1900. In this institution, all students were required to adopt an English name. Wai-kan chose "Winnie" as her English name for school correspondence and continued to use it throughout her career. Being the youngest in the family with two elder brothers and caring parents living in a humble public housing dwelling, Winnie had the privilege to pursue her own life.

Despite having little idea what design is, she applied and was accepted into the three-year Higher Diploma in Design program at Hong Kong Polytechnic University, and she

graduated in 1976. Winnie was one of the youngest students of her cohort in the program and, for the first time, studied in a co-ed education environment. There, she met her future husband, a senior student, Max Fuk-fan Cheung (1955), whom she married in 1981. Max later established himself as a renowned industrial designer. He became Winnie's soulmate, supporting her success in completing the program and becoming a partner in her family and career.

In the 1970s and 1980s, the contemporary art and design scene was still in the early stages of being shaped by key pioneers like Henry Steiner (1934) and Wucius Wong (1936), gradually emerging toward the Western standard of "good" modern Chinese design. With an initial foundation laid by critical figures like Steiner and Wong, among others, Winnie gained valuable training in both two-dimensional commercial design and spatial design at the Hong Kong Polytechnic. This equipped her with the skills and expertise for various creative opportunities in museum design.

After graduating, Winnie followed her love for illustration and took a job as a graphic designer at Macmillan Publishers. A year later, she began working at the City Museum and Art Gallery—which later became the Hong Kong Museum of Art (HKMoA)—in the role of Technical Officer of Design, marking the beginning of her successful lifelong career path. As a woman in a male-dominated industry, she had a unique perspective on the connection between high art and public engagement in museum design. This distinctive viewpoint established her as a role model and mentor for younger designers. Winnie was a pioneer in her field, defining museum design standards for public appreciation and upholding a professional ethos among her colleagues. Society in Hong Kong at that time accepted women pursuing careers, reflecting Western values rather than traditional expectations of women primarily as homemakers.

The Hong Kong Museum of Art and Early Career

The museum in Hong Kong has a long history, with the first opening in 1869. Over the years, it received significant donations of historical paintings and Chinese artworks, establishing its East/West identity. In 1969, it was renamed the City Museum and Art Gallery and, in 1975, was split into two distinct entities: the Hong Kong Museum of Art and the Hong Kong Museum of History, marking its evolution into a custodian of fine art. In 1991, the Hong Kong Museum of Art had its premises in Tsim Sha Tsui, continuing to captivate and nurture Hong Kong's cultural legacy.[4]

When Winnie first joined the museum, it was situated on the top three floors of City Hall High Block in the Central district of Hong Kong Island. This iconic building of the city's modernity featured an international style with clean lines and simple geometric forms. It was where Winnie embarked on her career in museum design in 1977. She was among the few female staff members and the youngest among her co-workers. She considered herself fortunate to have their support and guidance.

Figure 3.12.2 Winnie Wai-kan Kwan, poster design for *Cheung Yee: Sculptures, Prints, Drawings*, The Hong Kong Museum of Art, Hong Kong, 1978. Image courtesy of Winnie Wai-kan Kwan and The Hong Kong Museum of Art.

Figure 3.12.3 Winnie Wai-kan Kwan, poster design for the exhibition catalog, *Hong Kong Design Exhibition 1984*, The Hong Kong Museum of Art, the Urban Council, and the Hong Kong Designers Association, Hong Kong, 1984. Image courtesy of Winnie Wai-kan Kwan and The Hong Kong Museum of Art.

Figure 3.12.4 Winnie Wai-kan Kwan, catalog design for *The Art of Xie Zhiliu and Chen Peiqiu*, The Hong Kong Museum of Art, Hong Kong, 1998. Image courtesy of Winnie Wai-kan Kwan and The Hong Kong Museum of Art.

There was a female colleague in the design team, Irene Kho, who was senior to Winnie and struck her as a contemporary woman with a posh style. Irene didn't shy away from expressing herself with her male co-workers. However, she retired in the mid-1980s, and Winnie regretted not being able to spend enough time learning from her. During her early period with the museum, Winnie found having her creative freedom without much support with technical supplies and the physical restriction of the studio setting at work.

Among her early projects, she particularly liked her poster design for the *Cheung Yee: Sculptures, Prints, Drawings* exhibition in 1978. In this poster, she used a symmetrical composition to showcase the details of the sculpture. Following the official bilingual requirement of English and Chinese, she placed the artist's Chinese name, Cheung Yee, in a larger font size, with his English name smaller below, and the exhibit's subtitle in smaller print in both languages.

One of the most frequently exhibited artifacts that Winnie handled was sculptures. The museum's mission was not only to promote local fine art and culture but also to introduce art from outside Hong Kong, including the UK. As the city had a reputation as a cultural desert, the museum aimed to engage the public and educate them about art. To associate the world-famous artist Henry Moore with the city, Winnie designed a poster and exhibition publication that featured one of his sculptures against the iconic Hong Kong harbor skyline at night as the focal point. This effectively conveyed the message of Henry Moore's work in Hong Kong. Her design earned her an award in the poster category, setting a "good" modern design standard in the museum design sector. Winnie's award-winning work educated the museum's management about design's critical role and value. She established her work ethic, influencing her co-workers to pursue high-quality work.

While Winnie was advancing in her career in museum design and establishing a strong professional work ethic, she and her husband started their family, which included three children: two boys born in 1983 and 1985 and a girl born in 1990. She credits her mother for assisting with babysitting and caring for her young children. However, Winnie was firm about supervising their schoolwork and not bringing work home with her. She and her husband, Max, worked together, with Max as a supportive father who allowed their children to negotiate if their mother was being too strict. Winnie would also dedicate herself to preparing dinner for the family as their children grew—she enjoyed cooking and believed it created a homely atmosphere. She made special festive Chinese cakes, especially before Chinese New Year, to keep the tradition alive.

Seize The Experimental Opportunities!

Despite juggling a demanding job and raising three young children, Winnie found joy in her creative work. She particularly enjoyed designing for group exhibitions, adding her conceptual touch to promotional materials. For example, she created two intriguing posters for the Hong Kong 1985 International Youth Year Poster Design Exhibition.

The first poster, a call for entries, featured a blank poster with a question mark, sparking curiosity about the event. The second poster, announcing the winners, cleverly tore off the right-hand corner of the first design to reveal a glimpse of the winning posters. These conceptual pieces showcased Winnie's creativity and ability to think beyond traditional fine art exhibitions.

Winnie's work consistently showcased her defiance of traditional design norms. Her role as an assistant curator for the 1984 Hong Kong Design Exhibition was a prime example. This event, a collaborative effort between the HKMoA, Urban Council, and the Hong Kong Designers Association (HKDA), featured award-winning designs. She was responsible for designing the printed materials for this show. Her innovative approach was evident in the poster's cover, which boasted digital effects that formed three-dimensional geometric shapes in vibrant neon colors. It also featured a line-drawn image of a humanoid robot head and a radiant sphere set against a backdrop of stars. This futuristic design was considered groundbreaking and ahead of its time within the Hong Kong design scene.

In 1986, Winnie creatively pushed boundaries for a seventy-two-page, two-color exhibition catalog, *Poetry through Material, Light and Movement*, featuring modern German sculptures that visualized the notion of motion through geometrically textured, asymmetrical patterns, gradated straight lines, and vertical bars. The cover highlighted the Chinese title set against a vertically wavy patterned background. The booklet also featured a pocket with a transparent vinyl square window, creating a sense of motion as the booklet slid in and out. This interactive reading experience encouraged active participation from viewers, making it an innovative design for its time.

In the 1970s and 1980s, the design industry in Hong Kong was largely male-dominated. Despite this, Winnie served on the executive committee of the HKDA, a rarity for women at the time. She later withdrew from the HKDA due to potential conflicts of interest with her work at the HKMoA, a government-funded organization. However, she continued to support the HKDA by submitting her graphic and exhibition design works for their awards, aiming to elevate the museum's design profile. Winnie's involvement in the industry made her a role model for younger women designers, demonstrating their potential for creativity and leadership in a predominantly male field.

In the 1990s, as the HKMoA expanded, Winnie was promoted to a management position. Despite the demanding work culture in Hong Kong's design industry, she empathized with the challenge of balancing work and family. She sought additional budget to hire contract designers to lighten her team's workload. As a woman and a mother, Winnie understood the challenges her female co-workers faced, juggling responsibilities at work and home. She introduced a practice that allowed co-workers to bring their young children to the office on weekends when necessary. This practice fostered a familial atmosphere at work, with colleagues and their children forming an extended family.

Despite Winnie's encouragement for her female co-workers to maintain a work–life balance, these hardworking individuals often found it difficult to leave unfinished work and

go home. The office phone would frequently ring after hours, with calls from co-workers' children inquiring when their mothers would be home for dinner. On one occasion, Winnie received a phone call from a co-worker's young son, who had accidentally been transferred to her extension. Knowing she was his mother's boss, the little boy politely asked, "Could you please not give my mother so much work?"

This question spurred Winnie's determination to foster work–life balance for herself and her colleagues. She strove to serve as a role model for her co-workers while negotiating for more resources and budget from management. No longer the youngest staff member at the museum as she was when she first started, Winnie saw her role evolving. She transitioned from being the youngest designer constantly seeking creative opportunities to becoming a caring and empathetic senior colleague with a multi-level perspective. She willingly took on the role of mentor to the young designers, offering guidance on maintaining their work ethics and professionalism. Winnie advised them to consistently present design proposals and create work that met high standards, as this reflected their own identities. She believed this was the key to earning respect and recognition from colleagues across various disciplines and the public in the field of museum design.

Maneuvering and Visualizing Cultures

In the 1980s and 1990s, Winnie showcased her design expertise in traditional Chinese painting exhibitions despite their limited creative freedom. In 1981, she excelled in designing *The Art of Gao Qifeng* exhibition, skillfully harmonizing calligraphy with an asymmetrical composition, revealing her profound understanding of Chinese painting aesthetics alongside Western typographic principles within the overall event design identity. In 1998, Winnie designed works for *The Art of Xie Zhiliu and Chen Peiqiu* show, where she crafted a catalog that merged Chinese bookbinding techniques with a structured grid system for illustrations and text organization, earning her numerous awards.

Winnie often adopted an "East meets West" approach, a perspective highlighted by art historian Frank Vigneron. He noted that Hong Kong designers frequently grapple with clichés and stereotypes.[5] When the museum relocated to a new site in Tsim Sha Tsui in 1991, Winnie led the team in designing the new emblem for HKMoA, exemplifying this approach. The museum's new logomark pays tribute to Lui Shou-kwan (1919–1975), a founder of the Hong Kong New Ink Painting Movement. It combines three Chinese strokes to form the gray letters "M" and "A," with a red dot between the second and third strokes. The museum's name is written as "香HONG 港KONG 藝MUSEUM 術 OF ART 館." This Chinese–English typographic arrangement and the logomark symbolize Hong Kong's continuous international progress, representing a blend of cultures and effectively communicating its cultural identity for the museum,[6] albeit in a conventional manner. Despite being closed for renovation from August 2015 until its reopening on November 30, 2019, the museum continued to use the same logo.

As Hong Kong's global connections grew, Winnie worked on numerous international exhibition projects, showcasing diverse cultures and heritages. She oversaw the design team for significant international exhibitions, including *Egyptian Treasures from the British Museum* in 1998 and *Classical Italian Painting—Guercino and His School* in 2000. With increased government investment in promoting art, the design of exhibits has evolved to become more complex. Instead of merely hanging artworks, the focus has shifted towards creating themed site installations that resonate with the exhibition's subject matter. Winnie's high professional standards in museum design have earned her recognition and respect from international collaborators.

In shaping Hong Kong's cultural identity within the museum sphere, the 2011 exhibition *From Common to Uncommon: The Legend of Ha Bik-chuen* celebrated the life and work of Ha Bik-chuen (1925–2009), a local artist known for sculpture and printmaking. Born in Guangdong, China, he lived in Hong Kong from 1957 until his death. Working collaboratively with her curatorial team, Winnie led the exhibition design to recreate the artist's humble neighborhood, offering a glimpse into his legendary journey. It showcased a diverse collection of his work, including a replica of his studio, honoring indigenous visual cultures and connecting with the local identity of younger generations.

This design direction, as observed by Wing-sang Law, a professor of cultural studies, aligns with his examination of the development of local consciousness in Hong Kong over three distinct postwar waves. These waves encompassed the baby boomer generation, the city's emergence on the global stage during the 1990s, and the cultural awakening of the post-1980s generation. Law's goal is to comprehend the emergence of local consciousness and ethnicity as products of historical factors, rather than a mere collection of traits.[7] In light of this perspective, we can link Winnie's lifelong museum design work to a broader context of culture and identity in Hong Kong.

Over the span of four decades, Winnie has grappled with the East/West binary concept at different points in her career. During the British colonial period, she initially worked as a civil servant within the museum public service system. This continued until late into her career when a new sense of local consciousness emerged in society after China regained sovereignty over Hong Kong. Her extensive and unique experience in both graphics and spatial design provided her with opportunities to transition into the commercial world, offering higher pay and social status, as proposed by a prominent company. However, Winnie didn't consider this path because her family took top priority. Spending time with her family was invaluable to her, something she wouldn't trade for a higher income and career advancement.

She is proud that all her children are now mature adults with successfully established careers in their chosen fields. Her daughter has followed in her parent's footsteps, working as a graphic designer and illustrator. She is the creator of a popular cartoon character in Hong Kong, Bac Bac, which has its own product line and is available for brand endorsements.

Figure 3.12.5 Winnie Wai-kan Kwan, exhibition design for Tsz Shan Monastery Buddhist Art Museum, Li Ka Shing Foundation, Hong Kong, 2019. Image courtesy of Winnie Wai-kan Kwan and The Hong Kong Museum of Art.

Reflecting on her life before retirement, Winnie recognizes that she devoted "zero" time to herself, prioritizing her family and work over her personal needs. Nevertheless, she harbors no regrets.

After retiring in 2016, she received numerous invitations to work as a design consultant and advisor for various educational institutions, museums, and galleries, including the Hong Kong Palace Museum. Notably, she takes pride in her work at the Tsz Shan Monastery Buddhist Art Museum, which she led in planning, designing, and setting up. This private museum is under the Li Ka Shing Foundation, a charitable organization established by a Hong Kong business magnate. Unfortunately, she had to pause her design work after being diagnosed with breast cancer following the project's completion. She underwent successful treatment with a positive and strong mindset, although she still requires monitoring. Now, she enjoys dining with friends, and cherishing moments with her young grandson.

Acknowledging the Unsung Heroine of Nurturing

During the transition from the colonial period to the new HKSAR era, the government focused on developing art and culture to enhance the city's image as a "cultural desert." Both the public and private sectors made efforts in this direction. From the 1990s to 2020,

Hong Kong witnessed the opening of several notable museums and art institutions that have contributed to its vibrant cultural scene. These include the Hong Kong Arts Development Council (1995), Hong Kong Heritage Museum (2000), Hong Kong Visual Arts Centre (2000), The Hong Kong Design Centre (HKDC) (2001), Xiqu Centre (2019) with M+ (2021) in West Kowloon Cultural District, and Tai Kwun: Centre for Heritage and Arts (2018). Private initiatives such as Hanart TZ Gallery (1994), Para Site (1996), and Art Basel in Hong Kong (officially started in 2013, formerly Art HK launched in 2007) have also contributed significantly to the city's art and cultural landscape.

The art scene in Hong Kong has undergone significant changes since the 1980s. However, there needs to be more research and writing on the history of Hong Kong design compared to the work done on Hong Kong art history. Institutions like the Hong Kong Heritage Museum are actively collecting works from key designers and organizing retrospective shows, but the representation of women designers remains absent. In the 2010s, efforts to preserve Hong Kong's graphic design heritage have increased, with more artifacts becoming available in digital online collections such as the M+ Collection and the Hong Kong Graphic Archive at the Hong Kong Design Institute. However, the work of women designers has been consistently overlooked or even absent from these collections. Furthermore, their personal lives and their pursuit of work–life balance are not subjects of research interest.

Winnie is one of many unsung heroines in Hong Kong Design and beyond whose contributions from the twentieth century have yet to be fully recognized. Devoting all her time to work and family, she is a pioneering woman designer who shaped the professional museum design scene in Hong Kong, working within a cultural patriarchy. Simultaneously, she managed to maintain a work–life balance with a loving family. Her remarkable work, particularly in museum exhibit design, poses a unique challenge for traditional photographic documentation due to its transient nature. Recognizing and preserving the legacy of women designers like Winnie, irrespective of their global location, is paramount. By highlighting their invaluable contributions collectively, we honor their enduring influence on design and affirm their place in design history. The future generations of women designers, perhaps those like Winnie's daughter, will see themselves reflected in this historical landscape and be encouraged to assert their presence in the foreseeable future.

© **Dr. Wendy S. Wong**

NOTES

1. Turner, Matthew (1989). "Early Modern Design in Hong Kong." *Design Issues* 6 (1), pgs. 79–91.

2. Cartier, Carolyn (2008). "Culture and the City: Hong Kong, 1997–2007." *China Review* 8 (1), pgs. 59–83.

3. Kwok, Brian Sze-Hang (2021). "Vernacular Design: A History of Hong Kong Neon Signs." *Journal of Design History* 34 (4), pgs. 349–66.
4. Hong Kong Museum of Art (2022). *Hong Kong Museum of Art. HKMoA Booklet.* https://hk.art.museum/documents/About-Us/HKMoA_Booklet_2023_ENG.pdf.
5. Vigneron, Frank (2010). *I Like Hong Kong: Art and Deterritorialization*. Hong Kong: The Chinese University of Hong Kong Press.
6. Tang, Hoi-chiu (2008). "Eye on Hong Kong Museum of Art: Birth of the Logo." *Hong Kong Museum of Art: Education Resources.* https://hk.art.museum/en/web/ma/resources/archive/education-resources/resources/eye-on-hk-museum-of-art-birth-of-the-logo.html.
7. Law, Wing-sang (2018). "Decolonization Deferred: Hong Kong Identity in Historical Perspective," in W.-m. Lam & L. Cooper (Eds.), *Citizenship, Identity and Social Movements in the New Hong Kong: Localism after the Umbrella Movement*. Abingdon: Routledge, pgs. 13–33.

3.13

Elisabetta Ognibene: A Militant Feminist Designer

Dr. Monica Pastore

The landscape of Italian graphic design in the twentieth century is internationally renowned primarily for being constellated with the many male figures who are considered to be largely responsible for developing the communication of the most important Italian companies between the 1950s and the 1970s.[1] Although these designers are famous worldwide, there are countless stories within the Italian "creative" panorama that have yet to be explored and deserve to be told, especially those that concern women. Except for Lora Lamm (1928–2025) and Anita Klinz (1925–2013)[2]—both of whom were active during the golden age of Italian design[3] and have been the subject of recent studies—the contribution of Italian women designers to the graphic design pantheon remains unknown. And it is precisely among these semi-unknown stories that the work of Elisabetta Ognibene may be situated.

Figure 3.13.1 Elisabetta Ognibene, self-portrait, Modena 2023. © Elisabetta Ognibene. Image courtesy of Elisabetta Ognibene.

Elisabetta Ognibene is an Italian graphic designer, nationally recognized as one of the few women who participated in the Public Service graphic design movement[4] that flourished in Italy from north to south between the late 1970s and 1980s. But Elisabetta's importance as a graphic designer reaches far beyond her unintentional participation in this phenomenon in that her design career boasts a series of collaborations that are worthy of further investigation, not only for the third sector and cultural institutions in Modena and Italy but first and foremost for the Italian Communist Party (PCI).

Her collaboration with the party gave rise to most of the projects that spanned the first twenty years of her career, highlighting the vision of graphic design that Elisabetta has held since 1976, the year she was introduced to visual communication. She believed that the profession bore an intrinsic ethical and social responsibility and that graphic design must serve the "citizen," understood as both the final user and the client for her work. Elisabetta's preference for working primarily for clients committed to both the sociopolitical and cultural spheres was strongly influenced by the context of the city she lived in. The cultural scene in Modena was heavily permeated (through 1994) by the presence of the PCI and the many citizen associations orbiting around the local political scene, that is, the political and social environment that constituted a large segment of the designer's client base.

In 1979, Modena was ranked first among Italian cities in terms of income per capita, distinguished by a highly developed industrial sector and "the construction of an effective and comprehensive system of social services and, above all, by a conception of economic planning based on the centrality of the social function and on participatory municipalism."[5]

Hence, in the early 1980s, the city fully represented what has been defined by some Italian sociologists and economists as the "Emilian model,"[6] a city shaped around a set of consistent values and ideologies and characterized by three cooperating subjects: a system of independent local government, an active and participatory citizenry, and a hegemonic political party. This was the sociopolitical and cultural context in which Elisabetta took her first steps as a graphic designer—a maturing personality deeply rooted in the territory—and a propensity toward being a militant designer.

Early Life and the Road to Political Militancy

Elisabetta Ognibene was born on July 6, 1957, in Castelfranco Emilia, in the province of Modena, one of the wealthiest cities in northwestern Italy. The second child in a family of modest origins, her childhood was marked by the loss of her mother, Maria Simoni—who worked at home as a seamstress—at age eight, an event that disrupted Elisabetta's family life. Her father, Umberto, sought comfort in drink, forcing the young Elisabetta to take on responsibilities prematurely. During her pre-adolescent and adolescent years, the role of father figure—her father died in 1975—was filled by her brother Andrea (1947), who was ten years older than she was. He supported her consistently in developing her independence and was her ally as she made critical life choices.

Thanks to her brother's support, Elisabetta enrolled in the Istituto d'Arte "Adolfo Venturi" in Modena (1970–75), motivated in part by her desire to follow in her brother's footsteps and undertake a career as an architect when she completed her studies. But she soon reconsidered this direction in light of her growing interest in drawing and graphic design. Her high school years were formative for various reasons, first and foremost for three meaningful encounters that would be critical to her future as a designer and activist. Two teachers influenced her education. The first was Elsa Martinelli—a young teacher of geometric drawing—who taught her a working methodology based on extreme rigor, especially concerning the quality and precision required to draft lines. Despite her extreme seriousness, Elisabetta was able to establish a trusting relationship with Elsa that enabled Elisabetta to reveal her delicate family situation, making her feel welcome and less alone. The second was her sociology[7] teacher, who, during his one-hour weekly class, introduced his students to an analysis of comic art through the lens of semiotics, following Umberto Eco's (1932–2016) teachings, and to several other fields of study that were highly contemporary in those years.

The third encounter introduced Elisabetta to political activism when she met her classmate, Leda Sighinolfi. Leda was the daughter of two important partisan leaders from Modena, Marcello Sighinolfi (1923–2009)[8] and Ernestina Solieri (1924–2004),[9] who, upon learning of Elisabetta's family situation, welcomed her into their home, often inviting her to lunch and to spend the afternoon. Listening to the Sighinolfi family's stories of political activism and their notion of society, Elisabetta began to embrace political issues; she recognized that her "adoptive" family would become a cornerstone in her development. Through them, during her high school years, and because she needed to work, she became active in the PCI. Shortly after, they became her first client, aligned with her vision of graphic design.

Two major reasons shifted Elisabetta toward the graphic design profession. The first dates back to 1976, when she volunteered for the Provincial Federation of the PCI. She helped create the wall displays for the stands at the Festa de l'Unità in Modena. The second reason may be ascribed to her working experience in 1978 with Eros Bollani,[10] an industrial designer in Modena whose firm was right next door to that of Bollani's brother-in-law Lauro Giovanetti, a graphic designer who had long been at the service of the Party's communication. In the year she spent working with Bollani, Elisabetta "shadowed"[11] the design work in Giovanetti's workspace, which greatly impressed her and awakened her growing interest in graphic design.

This early job experience taught her a few tricks of the trade for working on small-scale artifacts. But, for the Festa de l'Unità panels, she took on communication at a large scale: a surface one hundred meters long by six meters high, which contained visual stories illustrating the major political and social themes advanced by the Party. For the 1976 edition, for example, in support of an end to the war in Vietnam, Elisabetta drew the portrait of commander Ho Chi Minh entirely by hand, working primarily with line drawing, a

technique that could be used to outline extensive color fields, and relying on a time-tested process she inherited which she prepared meticulously and followed step by step.

Today, Elisabetta defines this and the process of creating the typography/lettering as an "artisanal system,"[12] which she learned through the teachings of Gaetano Pancaldi,[13] a poster artist from Modena, and her predecessor at the Provincial Federation of the PCI. Pancaldi and Elisabetta were both self-taught in reproducing lettering at a large scale. From Pancaldi, Elisabetta learned the basic optical concepts of typography, using terms that were perhaps inappropriate but crystal clear. For example, the adjective "panciute"[14]—potbellied—describes the overshoot of certain letters such as O or a practical *in situ* demonstration of the phases necessary to determine the spacing between the letters of each word or sentence.

This early design experience would profoundly influence Elisabetta, opening her eyes to the communicative potential of the *word* on public display and her growing passion for graphic design. Her collaboration with the PCI would continue over time and, as a consequence, transform Elisabetta in 1980 from a mere volunteer and Pancaldi's poster art apprentice to head of the graphic design center of the Modena Federation and, later, in the 1990s, to the artistic director of the Federation of Young Italian Communists (FGCI) with Avenida, her first communication firm.

Massimo Dolcini and the Graphic Design Department of the City of Modena

Following her appointment as the director of the graphic design center of the Modena Provincial Federation of the PCI, Elisabetta began to design smaller artifacts such as posters and flyers. She abandoned this job after less than a year due to a series of misunderstandings with the party leaders. She was hired as a designer in the Graphic Design Office of the City of Modena, a visual communication service established by the City Council in November 1973. At the time, the City of Modena relied on a Press and Information Service, which was responsible for printed material, audio-visual content, and posters, to foster participation and involve the citizens and territorial institutions in the political and cultural life of the city, giving a voice to the protagonists of this era of thriving cultural and social initiatives which expressed the political aims of Italian local governments from that time forward. Within this context, the role of graphic design became to interpret the political and social transformations underway. As a result, the figure of the graphic designer became essential to the City's information policy—thanks in part to the work carried out in those years by Massimo Dolcini (1945–2005)[15] for the city of Pesaro—which relied on this office to promote new services and activities in the fields of culture and social welfare. Unlike most Italian cities that worked with independent graphic design consultants, Modena chose to hire a stable group of graphic designers to create a solid team.

In the 1980s, during a highly dynamic time for the City of Modena, this office responsible for communication expanded to include a cohort of young graphic designers to address the exponential growth of communication in every sector and the proliferation of information channels and new media. An actual editorial staff was established within the Graphic Design Office, and the foundations were laid for a renewed concept of communication that recognized the need for additional specific skills—graphic designer, photographer, and copywriter—to provide a complete communication service. Furthermore, the process of updating the Graphic Design Office included the institution of a new role, designated as the "communication expert" and corresponding to the creative director, who would be able to select, as needed, the most appropriate communication medium or artifact to directly engage the citizenry based on the goal to be achieved.

During this phase of expansion and reorganization, Massimo Dolcini was hired in 1980 as an independent consultant to fill the role of art director for several specific projects. He was to be assisted by two young designers working directly with him: Elisabetta Ognibene and Filippo Partesotti, who had worked in the Office since 1979. Elisabetta acknowledges Massimo Dolcini as one of her most influential mentors, from whom she learned a methodological approach and an ethical concept of the profession—the search for a balance between social and political commitment and design—and the use of specific visual languages. Concerning the latter in particular, Elisabetta re-elaborated Dolcini's design method based on the observation of the real object through a mindful use of photography, which led to the production of a graphic mark reinterpreted by illustration and defined by the designer herself as "an almost artisanal, instinctive mark."[16]

Elisabetta worked in the Office from 1980 to 1982, developing as a designer because she had the opportunity to work on various graphic artifacts and public commissions and interact and work directly with other young colleagues and a wide range of professional figures. Critical to her professional future was her encounter, at the Office, with Partesotti and with Oscar Goldoni, an artist and photographer and the driving force behind the city's Galleria Civica, the hub of cultural life in Modena and a protagonist in the national artistic scene. With Filippo Partesotti and Oscar Goldoni, she founded the graphic design firm Kennedy's Studios in October 1982.

Returning to her work at the Office, Elisabetta designed, from the start, posters, leaflets, and publications primarily for the department of the City Administration dedicated to the cinema and other cultural events in the city. Within that context, her preference emerged for graphic design projects in the cultural field because they allowed her to experiment more freely with visual languages and a range of printing techniques. One example is the poster she designed for the exhibition *Stardust Memories: Immagini, parole, musiche dei divi di ogni tempo* in 1981, in which she used only two colors and chose Pantone silver as the primary color—a rather unusual chromatic choice for this typology of work—and mixed photography and calligraphy. The latter is a distinctive feature of many of her works and, in time, has become her hallmark style, along with an almost exclusive use of typography rather than images.

Figure 3.13.2 Elisabetta Ognibene, poster *Stardust Memories: Immagini, parole, musiche dei divi di ogni tempo*, The Graphic Design Office of the Municipality of Modena, 1981. © Elisabetta Ognibene. Image courtesy of Elisabetta Ognibene.

Another critical project she created for the City of Modena was *Autobus* magazine, where she worked closely with Dolcini—the magazine's art director—and directly with the editorial staff. *Autobus* was an innovative editorial project, published as a monthly periodical of cultural information, technically conceived in the tabloid format, and consisting of sixteen to twenty-four pages, which alternately feature illustrations, photographs, and texts. Her collaboration with the Office ended in 1982, when she founded the Kennedy's Studios (1982–87) with Partesotti and Goldoni. This was her first freelance work experience—consistent with the era of Public Service graphics—specializing in design for cultural events and political institutions, such as the Province of Modena and the FGCI, among many others, and initiating a radical change in visual language ideation for political propaganda.

Figure 3.13.3 Elisabetta Ognibene, *Olivetti SMAU exhibition stand*, Olivetti Image Office, Milano, 1985. © Elisabetta Ognibene. Image courtesy of Elisabetta Ognibene.

Concurrently with her responsibilities for the new firm, Elisabetta began to work at the Olivetti Image Office (1984–87) in Milan under the direction of Roberto Pieraccini (1942–2018).[17] During those three years, she was responsible for designing the wayfinding for Olivetti stands used in trade fairs, such as SMAU[18] in Milan in 1985. The experience in Milan was significant for her because she worked in a setting with no budgetary constraints and within an eminently qualified cosmopolitan team. Despite the professional opportunities and the design context surrounding Olivetti, when her contract expired, Elisabetta chose to return to Modena, where there was a continuing sense of vitality and openness to civil and social commitment, an environment that suited her better than the international atmosphere in Milan.

The Years of Consolidation of a New Language for Political and Social Communication

With the founding of the Kennedy's Studios first and the Avenida communication agency later (1988–2015), Elisabetta consolidated not only her relationship with her political

clientele but also her innate capacity to conceive original and immediate visual codes. These codes upended traditional party propaganda languages. She did so by introducing visual and thematic elements from the youth culture experience, the new social movements, and the mass culture that emerged then. This approach transformed Elisabetta's professional persona from a "manipulator of images" to a "cultural operator," capable of hearing the messages received from the social context in which she was immersed and interpreting them as required, based not only on the needs of the client but above all on those of the final user. The outcome is often the result of her breaking the established rules of visual grammar in search of a greater hybridization between different languages, in which photography could coexist with calligraphy or comic art and the visual codes of the music counterculture.

She used hybrid forms of expression and explored new channels of communication, first and foremost for the communication of cultural events conceived for the FGCI and later, given the success of her projects for the youth section of the party, for the campaigns of the PCI for the 1986 administrative elections.

The first instances in renewing these languages were the artifacts she designed for the *Rap&Show* events in 1983, a temporary three-night disco where music alternated with

Figure 3.13.4 Elisabetta Ognibene/Kennedy's Studios, flyer *Rap&Show!*, FGCI, Modena, 1983. © Elisabetta Ognibene/Kennedy's Studios. Image courtesy of Elisabetta Ognibene.

culture, from performance art to comic art, from graffiti to theater, from music to video production. The guest artists included famous names from the "new Italian comic art scene,"[19] including Andrea Pazienza (1956–1988) and the newly formed Valvoline collective.

On this occasion, Elisabetta removed the party symbol from the communication as a clear statement of the organization's intent to modernize by reaching people who had little connection to the political left and to spark the imagination of young people on many fronts. The front of the flyer featured a kinetic black-and-white photograph of a very young Alessandro Manfredini—one of the graphic designers from Modena who animated the Italian scene in the 1990s—which highlights a can of spray paint with a fluorescent marker to underscore the direct connection between the event and street art, and the hybridization of the different cultural fields involved. On the back are the portraits of the featured guests, most of the images taken from different angles and ironic personal representations that had fallen into disuse at the time.

Further evidence of the change underway in political communication, again promoted by the FCGI in Modena and designed by Elisabetta's firm, was the "space" entrusted to the young party militants at the Festa de l'Unità, which from 1984 to 1990 Elisabetta conceived as an outdoor club that would also serve as a container for politics, entertainment, music, and graphic art. After defining a different theme for each event, she would design the space in a way unusual in the political field. For example, for the 1984 edition titled *Ritmoatletico*, she involved Wolfgang Sattler, a German designer she had worked with in the Olivetti Image Office, to interpret the theme of sports by reproducing in part the settings of sporting competitions in ancient Rome, given that the program of events also included Greco-Roman wrestling matches and theater–dance events. Four Myron discus-throwers seem to protect the dance floor, giant silhouettes guard the threshold between the indoor and outdoor sections, there is even a fake garden, and finally, a diving board built over the dance floor to be the DJ section.

Her capacity to weave together different areas and aspects of graphic design, from space design to promotional artifacts, from the manipulation of photography to the ideation of the texts, distinguishes Elisabetta as a designer-director, a professional who developed a well-articulated and differentiated expertise in the management of visual communication, skilled at offering a complex vision of graphic design.

Remaining within the field of sociopolitical commissions, in the late 1990s, Elisabetta became involved in designing the communication for the major left-wing and center-left parties—from the Partito Democratico della Sinistra to L'Ulivo—at both the local and national levels, and later for ARCI,[20] another major Italian organization that gravitated within the same cultural orbit. For the latter, she designed several campaigns from 1997 to 2015, a significant span of time that, through the evolution of the graphical languages and tools available to the profession, illustrates the designer's process of maturation, her capacity over the years to combine visual signs and codes from different cultural environments into one essential message. Indeed, in 1994, Elisabetta began to use the computer, seeking a

Figure 3.13.5 Elisabetta Ognibene/Avenida, corporate identity for Libera, 1994–2015. © Elisabetta Ognibene/Avenida. Image courtesy of Elisabetta Ognibene.

compromise between analogical drawing by hand and producing a drawing with digital tools. An early example is the poster created entirely on the computer for Libera[21] by scanning a woodcut drawing and digitally coloring in its fields.

In a career spanning fifty years that boasted many other important clients—including social associations such as the Fondazione Interesse Uomo and cultural institutions such as Festivalfilosofia and the Teatro Comunale di Modena—Elisabetta stands out for her complete dedication to her work and her consistent civic and political commitment, a choice reflected in her approach to graphic design which is always a shared collective act.

© **Dr. Monica Pastore**

NOTES

1. Hollis, R. (2002). *Graphic Design: A Concise History*. London: Thames & Hudson.
2. Lamm, L., Ossana Cavadini, N., eds. (2013). *Lora Lamm: Grafica a Milano 1953–1963*. Cinisello Balsamo, Milan: Silvana Editore;

 Pitoni, L. (2023). *Ostinata bellezza: Anita Klinz, la prima art director italiana*. Milan: Fondazione Mondadori.
3. The golden age of Italian graphic design is concurrent with the economic boom in

the early 1950s. Historians and critics often designated it with the term "design made in Italy."
4. On Public Service graphic design see: Anceschi, G., ed. (1984). *Prima Biennale della Grafica. Propaganda e cultura: indagine sul manifesto di pubblica utilità dagli anni Settanta ad oggi*. Milan: Arnaldo Mondadori Editore.
5. Cappelli, C. (2018). *Propaganda addio. La FGCI a Modena negli anni Ottanta*. Rome: Bradypus Editore, pg. 76.
6. Magagnoli, S. (2003). "Scuola, cultura e società: un modello integrato di welfare culturale," in Magagnoli, S., Sigman, N.L., Trionfini, P., eds. *Democrazia, cittadinanza e sviluppo economico. La costruzione del welfare state a Modena negli anni della Repubblica*. Rome: Carocci, pg. 126.
7. It was not possible to track down the name of the teacher.
8. Marcello Sighinolfi, code name Mirko, was the commander of the Achille battalion in Nonantola and the "Walter Tabacchi" Patriotic Action Group brigade, one of the key players in the battle to liberate Modena on April 22, 1945. During the partisan war, he joined the PCI and filled various executive roles at the end of the war. Among his many roles in the 1970s, he served Marcello as the secretary of the CGIL union in the Emilia Romagna region.
9. Ernestina Solieri, code name Diva, was a partisan runner in Modena.
10. Eros Bollani is an industrial designer in Modena, one of the major independent designers for Beghelli, a manufacturer in the field of electronics and security.
11. From the author's conversations with Elisabetta Ognibene, Modena, February 2, 2023.
12. Ibid.
13. Gaetano Pancaldi (1922–2014) was a painter and expert in letterpress printing from Modena. After the Second World War, he worked in the paper factory in Castelfranco Emilia, where he learned the trade of poster artist, given his skills as a painter. In the 1970s, he became the graphic designer and poster artist for the PCI Provincial Federation of Modena.
14. From the author's conversations with Elisabetta Ognibene, Modena, February 2, 2023.
15. Piazza, M., ed. (2015). *Massimo Dolcini: La grafica per una cittadinanza consapevole*. Verona: Grafiche Aurora.
16. From the author's conversations with Elisabetta Ognibene, Modena, February 2, 2023.
17. Pieraccini, R. (1989). *Progetto d'immagine: uno studio grafico all'interno dell'Olivetti*. Rome: La Nuova Italia Scientifica.
18. SMAU (Salone Macchine e Attrezzature per l'Ufficio) is one of the major Italian trade fairs dedicated to innovation for manufacturers, start-ups, and public agencies. The first one was held in 1964 and began as a trade fair specializing primarily in office furniture, a sector that had expanded spontaneously into office equipment and computers in the 1980s.
19. Tondelli, P.V. (2016). "Nuovo fumetto italiano," in Tondelli, P.V., *Un weekend postmoderno. Cronache dagli anni Ottanta*. Milan: Bompiani, pgs. 204–08.
20. ARCI (Associazione Ricreativa Culturale Italiana) is an organization founded in 1956 to promote workers' leisure time. In the 1960s, the organization did not work solely for workers on the left, but opened up to all young people, de facto becoming one of the major public cultural promoters in Italy.
21. Libera is a social anti-mafia association founded in 1994 by Don Luigi Ciotti to provide a new role for the properties confiscated from Mafia families, often used as farming cooperatives.

3.14

Mara de Oliveira: A Woman Designer from Northern Uruguay

Luis Blau

What defines a woman as a designer? Her university education? Her technical training? Her professional work? Experience in art workshops or teaching activities? Since the nineteenth century, the printing houses in our region have produced most of the activity known now as graphic design.[1] Although many women worked successfully in the printing industry, few have been formally acknowledged. A historical review of Uruguay's print publishing industry would be instrumental in meeting the challenge of writing about our women designers.

Producing books, brochures, or newspapers encompasses various activities and necessitates collegial relationships between multiple participants. Some people want to publish, estimate material and production costs, read and correct manuscripts, and search for topics

Figure 3.14.1 Mara de Oliveira, photographed in her home studio, 2022. Photo: Myriam Esteves (MEI). Image courtesy of Myriam Esteves.

and authors to realize a publication. People who would choose what typeface was to be used, people who thought about style, and people who would provide illustrations or other types of images that determined the aesthetic and embellishment of each page. Others were in charge of binding and finishing the final publication itself. The booksellers and bookstores[2] entered the process by handling distribution and detecting topics of interest within a community.[3] Often, many of these activities were carried out by the same person.

An individual's progress in this industry depends on skill-based learning acquired in various existing jobs. Before the establishment of formal design education, knowledge was obtained through participation and collaboration in printing workshops—a trial and error method, at best, which often meant the number of correct guesses would determine the outcome. In 1878, the School of Arts and Crafts[4] (Escuela de Artes y Oficios) was established, and these factors served as the foundation for course syllabuses in the educational institution. Typography, Engraving, and Lithography classes were offered exclusively for men.[5] The weekly newspapers *El Aprendiz* (1885–87) and *El Bromista*[6] (1884–86) were designed and published, among others. The instructors recruited to teach these courses had considerable professional experience in the field[7] and training in the arts.

At the beginning of the twentieth century, courses were opened to women thanks to Pedro Figari Solari, who, in 1916, promoted the restructuring of the School of Arts and Crafts (Escuela de Artes y Oficios), transforming it into the National School of Arts and Crafts (Escuela Nacional de Artes y Oficios). In 1942, the name was changed to Labor University of Uruguay (UTU, Universidad del Trabajo del Uruguay). In 1923, the Community Vocational School of Saint Lucy (Colonia Escuela Profesional de Santa Lucia) was created in the Department of San José's National Public Assistance (APN)[8] program to train orphans between the ages of thirteen and seventeen who were finishing school. The eight courses offered included Bookselling and Bookbinding, subjects taught together, and Typography; each class had a quota of ten students. The synchronization between the profession and formalized training, whether it be technical or university, continues to this day with the inclusion of digital media.[9] Within the large cohort that passed through this technological whirlwind, we take note of Mara de Oliveira, a woman who directly benefited from that experience. Her training encompassed the mutual exchange of information in her daily editorial practice, continual postgraduate training, professional development courses, and as a professor in Visual Communication Design, the new degree program at the University of the Republic.

Early Beginnings

Mara de Oliveira was born on November 18, 1957, in Artigas, the northernmost city in Uruguay. She was the second of four children. Her father abandoned the family when she was seven years old, prompting her mother, Sonia Grieco, and her siblings Marta, Gustavo, and Sandra to move into her maternal grandparent's home. Juan Grieco, a public official,

and Oraides Bitancourt, a retiree, were primarily responsible for raising their grandchildren and instilling in them the importance of studying. Their "children of old age" (as they used to say) might have lacked toys but never the books and materials that teachers or professors requested, even if they had to make sacrifices to buy them.

Mara attended primary and secondary school in her hometown. She developed a great passion for reading as a child, and during her adolescence, she was drawn to disciplines related to history, art, and science. She became interested in political issues during a troubled time in Uruguay and the world. Like many young people from the country's interior, she moved to Montevideo after she finished high school to study at the university—accompanied by her older sister Marta—resulting in a great financial sacrifice for her family. In 1977, Mara began her technical training as an Assistant Architect at UTU, particularly interested in sculpture and plastic arts. She received an employment scholarship in 1978 based on the quality of her student performance. That same year, Mara and Pablo Escobar—who was also studying at UTU—became a couple. They rented an apartment to live and work in with Mara's sister Marta and other friends who were all training as Architect Assistants. In 1979, they founded "El Taller," a design studio specializing in architecture and engineering.

A recession in 1981 shattered the economy and, consequently, the construction industry. "El Taller" gradually progressed to taking in graphic and advertising work. During this period, Mara worked in a construction company, a ceramics factory, and in the packaging design area of two factories: one for industrial cardboard boxes and another for corrugated plastic products. Also that year, Mara began her studies at the School of Architecture of the University of the Republic (Facultad de Arquitectura, Universidad de la República). She began to engage in militant activity through the student union and at the political level in the Union of Communist Youth of Uruguay, joining the fight against the military dictatorship that was in power in Uruguay. In 1983, the military government imprisoned twenty-five university students from her political group. Mara had to abandon her home and her studies to live clandestinely until the end of the dictatorship in 1984.[10]

The National School of Fine Arts Institute (IENBA), which had been closed by the military, reopened in 1985. Mara continued her studies there, graduating as a Graphic Artist after a few years. At the same time, she began to teach, first with children in workshops and then with young people as a teacher of visual communication in various state and private institutions. By this time, she had given birth to her daughter, Mariana, in 1984 and later her son, Manuel, in 1989.

A Working Mother

Mara began her editorial work doing traditional prepress in the second phase of the weekly newspaper *El Popular*[11] (1985–89). In the 1990s, she worked briefly as a designer at *Últimas Noticias*,[12] marking a significant technological shift to desktop publishing. She had separated from her partner and began to live alone with her two young children. Facing

the challenge of improving her education to access better job offers, she completed various training courses in new technologies. In addition, in the absence of specific training centers for editorial design and with the aim of delving into design and communication issues, she devised a course at home that she tailored to her needs by preparing a bibliography of books that examined theoretical and practical issues of design, composition, color, typography and technical development in the disciplines of editorial design. She also created proposals for practical exercises. Because she had a night shift at the newspaper, she took advantage of the mornings to study and work on the exercises she had formulated while her children were still asleep.

In 1993, she began work at *El Observador*,[13] a newspaper founded in 1991. (The newspaper was printed at Impresora Sudamericana until its printing facility opened in 2000.) The newspaper's founding team—forty-four people,[14] including eight women—supported a visionary media organization that aspired to do journalism independent of party politics and incorporating state-of-the-art technology. The multidisciplinary team committed to the visual as a standard bearer for a distinctive identity. Like other newspapers of the time, it quickly incorporated digital media as an essential tool for design. When the first Macintosh computers arrived in Uruguay,[15] no formal training was available, and everything had to be learned in-house through trial and error.

At *El Observador*, as the Coordinator of the Design Department, Mara worked with a team of illustrators, photographers, and graphic designers. She did the layout and desktop publishing, working with various computer programs that supported editorial design.

Figure 3.14.2 Mara de Oliveira, complete set of *Materia Sensible* magazines designed for the Foto Club Uruguayo. Photo: Myriam Esteves (MEI). Image courtesy of Mara de Oliveira.

For a long time, she worked in newspaper design, where work began and ended on the same day. "The day starts with a blank page, and you have the newspaper ready to print by night. You don't leave work pending for the next day," Mara recalled. "The advantage here is that you can disconnect from work when you get home."

In 1997, she worked on the design of *Culturas*, a magazine supplement for *El Observador*. She and designer Lucio Ornstein were awarded a Gold Medal in the Society of Newspaper Design's 19th Annual Creative Competition. Mara worked at *El Observador* for twenty-four years until January 2018. Recalling this time, Mara stated:

> In editorial design, the job is to present the news in such a way that the reader can find the cues to move easily through the information and to develop a plan in which signposting, as in a city, indicates priorities and paths through which the reader can travel allowing her to decide the speed with which she does so. Design, combined with journalism, breaks information into different parts and puts them back together appropriately to facilitate that journey. It is always challenging to achieve a page that can fully inform—telling a story through that intersection of disciplines. Shape, direction, movement, contrast, texture, and color are active elements, from the photo to the typography, so it is not only the text that speaks.

Figure 3.14.3 Mara de Oliveira, *Culturas*, *El Observador*'s weekly supplement designed with Lucio Ornstein. Photo: Myriam Esteves (MEI). Image courtesy of Mara de Oliveira.

A Love of Books and Magazines

In addition to her work in print journalism, Mara designed many books and magazines. Among her favorites are the magazine *Materia Sensible*, a publication of the Foto Club Uruguayo,[16] and two books designed for the Uruguayan Classics collection.

In this last project, to establish the client's identity, the covers are unified by two font colors printed on the same color background, all in upper case, and differentiated only by the title's name. The richness of the design resides in the treatment of the content. The relationship of the text block in paleographic transcription, with its signs, marginal notes, and crossed-out or underlined texts, is a true challenge of composition and synchronization of line spacing and spaces between characters. The image and text block articulate the page space to accompany the narrative meaning, providing a balanced composition that generates a remarkably comfortable reading experience. The magic of a well-designed page is that the reader can perceive the message with the least possible effort—without seeing design as a separate element—fulfilling one of the main objectives of a good editorial design. That said, it takes significant time to attain such a critical level of visual acuity. In this regard, Mara comments that she is rarely satisfied with the final result when she finishes a book and reviews its pages. She typically imagines better results, which she always applies in her future work.

Figure 3.14.4 *Left:* Mara de Oliveira reviewing a copy of the Collection of Uruguayan Classics. *Right:* title page whose cover is purely typographical with hierarchical color on a white background. Photo: Myriam Esteves (MEI). Image courtesy of Mara de Oliveira.

Another project Mara launched with the support of some colleagues from *El Observador* was the magazine *Cultura en Plantas*. The magazine had a well-defined target audience dedicated to plant lovers, homemakers, men, and women with a taste for gardening. It contained technical and scientific information and articles on gourmet cooking with vegetables and was published every three months. Unfortunately, the 2002 crisis cut off the release of a printed fourth issue, as an embargo on the distributor blocked its distribution.

Mara was elected as a member of the delegation of the *El Observador* workers' union in 2002 and became a member of the leadership of the Press Association (the national union of media workers) in 2004, where she served as the secretary for social affairs and later, general secretary of the union.

The technological revolution triggered a definitive separation of specific design practices, creating independent paths in public education. The printed and digital worlds reconfigured interdisciplinary interaction between graphic designers, artists, and visual communication designers, generating new opportunities for multi-career complementarity in the academic field. Between 2000 and 2001, the School of Architecture organized seminars for communication and graphic design professionals as the genesis for developing the curriculum for the new visual communication degree. In 2010, Mara began teaching as a second-year instructor in the new degree program. The program started in 2009 at the

Figure 3.14.5 Mara de Oliveira, *Cultura en Plantas* magazine, designed with the support of her colleagues from the newspaper, collaborating on the writing, photography, illustration, and part of the distribution. Photo: Myriam Esteves (MEI). Image courtesy of Mara de Oliveira

School of Architecture.[17] It was co-directed with the Instituto Escuela Nacional de Bellas Artes (National School of Fine Arts Institute), both from the University of the Republic (Universidad de la República). She joined the degree program in Visual Communication Design[18] (LDCV) as an adjunct professor level three (G3) in the Design Workshop 1 team. With her extensive professional experience and long productive career in the publishing industry, Mara began sharing her knowledge with the first generation of students[19] at the public university. Mara resigned from her position in response to changes in the program's management team. For ethical reasons, Mara decided to accompany the first group in the program, leaving the program due to differences with the dean.

Interview with Mara de Oliveira[20]

Luis Blau Can you tell me about your training?

Mara Oliveira I really liked drawing, Mathematics, Physics, History, and art history in high school. Also, Sculpture and Photography. I then decided on preparatory courses in Architecture, which combined everything that interested me, but I did it without a clear vision of whether or not I wanted to be an architect. When I arrived in Montevideo, I took the Architect Assistant technical course at the School of Construction at the UTU for three years. Then, I entered the School of Architecture. In between, for a few years, I interspersed studying ceramics and consumed information in areas that I liked. I did some coursework in the School of Sociology, taking Anthropology and Super 8 film classes.

Historical circumstances and my personal options in that regard—we were in a period of dictatorship in Uruguay—led me to discontinue my studies. With the return of democracy and my return to the classroom, new options arose, among them the National School of Fine Arts, which reopened its doors in 1985. I spent three years trying to complete courses at the School of Architecture and was clearly advancing in fine arts, so I opted for the latter and finished my studies there.

In the National School of Fine Arts, I took workshops with Tola Invernizzi (1918–2001) and Anhelo Hernández (1922–2010). The school gave me another way of seeing, an approach to color and expression, thanks to great teachers who possessed immense warmth and experience and often transmitted it in small details with minimal gestures. The subject of color was difficult for me as my interest was in volume, in sculpture.

At that time, I decided to work with children in the 3D area, and I went on to train at the Malvín Workshop. Also, I began to design jewelry in my fine arts courses, delving further into the subject. I studied metalsmithing for two years at the Pedro Figari School.

In 2006, in addition to editorial design, I worked as a teacher, and I had to put aside projects I had started in jewelry making. The need for further training in theoretical development for the courses I taught led me to enter the School of Humanities. I chose a history degree, which combined my lifelong interest in the discipline. My rationale was to research the evolution of writing and writing surfaces, a topic I consider important for training in the editorial design field.

L.B. When and where did you start working?

M.O. My first job was in UTE as an apprentice in 1977. I did technical drawing in Hydraulic Generation Management, an activity more linked to mechanical drawing. I learned a lot by drawing measuring devices and replacement parts for hydroelectric power plants that were accountable to management. For a while, I thought of concentrating exclusively on mechanical drawing, as machinery design seemed like a powerful thing to me. Later, I worked as a draftsperson in a construction company that was frantically designing for Punta del Este (a coastal city in Uruguay), and I worked in a ceramics factory for some time. In addition to these jobs, I ran a design studio with my partner and my sister, all draftspeople who had graduated from UTU, and also, for a while, a ceramics workshop with other friends. It was a moment of ferment, with many things to say and do, and I studied and worked on different things simultaneously.

In the early 1980s, I was a draftsperson in two flexographic printing companies: preparing the rubber plates in a cardboard box factory and in a factory that printed on plastic. In addition to drawing the plates, I did some design work for containers.

When I started at the National School of Fine Arts, in 1985, I began working for the weekly *El Popular* doing traditional prepress, a short-lived role in graphic arts. Lead type was leaving, and paper galleys were arriving. It was a period of transition in the profession; the design of the pictorial space was materially embodied in the mechanical. I performed both functions and then, with the introduction of the computer in the newsroom, combined them into one.

I worked briefly at *La Hora Popular* newspaper and for a few months in an advertising agency. With the introduction of computers in newspaper design, I became a designer at *Ultimas Noticias* and then at *El Observador*, the last place I worked.

I also ventured into teaching from 2006 to 2016, in the BIOS (Basic Input/Output System) Visual Communication degree, the Claeh Editorial Diploma, in the Visual Communication major in the School of Architecture at the University of the Republic, and as a teacher at the Visual Communication Workshop in the School of Communication at UTU.

L.B. What was it like to be a designer in the twentieth century?

M.O. I started as a graphic designer in 1985. At that time, there was no facility to train you as such. I spent about four or five years doing mechanicals for the weekly *El Popular* and then layout. In 1993, I started working at *Ultimas Noticias* as a designer who used computers, and that same year, I worked at *El Observador*, which had been founded a year and a half before. Working at *El Observador* was challenging because it was a time of many technological shifts and a different perspective on graphic communication. It helped a lot to work on an editorial project that was just beginning and not afraid to make changes. The editorial department had a rich knowledge exchange with people from diverse training backgrounds that encouraged me to adopt new technologies, perfecting the new tool while delving further into the specific discipline of editorial design.

My training came from various perspectives: engineering design and the constant application of geometry in products that had to be precise and perfect; the architecture and design of experiential spaces; ceramics with its mixture of the gestural, the art of fire, the chemistry of color, and ornament. During my training as a workshop leader, my passage through the School of Fine Arts and the Malvín Workshop provided additional insights into promoting creativity and understanding moments of expression. It was then that I began synthesizing all that I had studied.

My progression through the School of Construction and Architecture, with its rigor in methodological aspects, enabled me to put together a program—an in-depth course on topics such as shape, color, structure, composition, and harmony. Beginning at seven in the morning, while my children were sleeping, I studied the modules I had programmed based on the writing of diverse authors Rudolf Arnheim (1904–2007), Wassily Kandinsky (1866–1944), Roman Gubern (1934), and many more. I made it tangible with Mario García (1947),[21] typography books, printing systems, and the history of writing.

> The bibliographies of each of these books served to expand my library. My book orders were sent to my bookseller or to those who traveled to Buenos Aires or Europe. I started doing what I call cluster reading. A piece of information in one book was a hyperlink to another.

L.B. What was your experience with the evolution from print to digital graphic design?

M.O. It was a very rapid transition, a period of acceleration. At first, there needed to be more consistency; methods from technologies were used that were unnecessary in the new forms of media. However, introducing programs that enabled education in design in visual communication helped a lot. Naming the discipline, the stages of the work, and systematizing all generated a concentration of knowledge that created the illusion that more years had passed than actually happened.

L.B. Which of the different visual communication practices do you feel most comfortable?

M.O. I worked for thirty-five years in editorial design.[22] That is where I feel most comfortable. Books and newspapers are products that are dear to me. I like to read and seek good content and an enjoyable format. I want reading to be a different experience depending on what I'm reading; that the design is so good that it is not noticeable and that it does not take away the pleasure of meeting the author one-on-one in a good book or that the design provokes through the graphics when the subject warrants it. I like to work from that perspective, considering my experience as a reader. I don't know if I will totally succeed as a designer. But that is what I aspire to and would like to encounter in those who do editorial design.

© Luis Blau

Note: The interview and essay were written in Spanish and translated into English.

NOTES

1. *Letterforms, Icons, and Adornment,* a history of the Montevideo Charity Printing House 1822–1855 with a study and facsimile edition of sample lettering from 1838.
2. Sosa, Michelena, Linardi (2021). *History of Montevidean Bookstores, 1830–1990.* Montevideo: Planeta.
3. Darnton, Robert (2007). "What is the History of Books?" *Modern Intellectual History,* Vol. 4 (3), pgs. 495–508.
4. History of the UTU. Available at: https://es.wikipedia.org/wiki/Universidad_del_Trabajo_del_Uruguay. Suggested reading by Prof. Dayana Alonzo. Available at: http://profdayanaalonzo.blogspot.com/2010/03/utu-sintesis-historica.html.
5. Lithographic printing in the School of Arts and Crafts 1884.
6. Available at: https://anaforas.fic.edu.uy/jspui/handle/123456789/43514.
7. It is worth mentioning that the first association of skilled people in trade was the Montevideo Typographic Society, whose statutes date back to 1870. I quote the article by Cintia Demarco, "Typographers and Public Sphere in Montevideo, 1885–1902." Between 1991 and 2006, the Center for Latin American Interdisciplinary Studies (CEIL) and the Center for Uruguayan Interdisciplinary Studies (CEIU) co-published the journal *Encuentros.* Since 2007, the Center has continued publishing its digital version, renamed *Encuentros Latinoamericanos.*
8. Report of the National Public Assistance, 1916–1922, Graphic Workshops of Barreiro and Ramos, Montevideo 1923.
9. For the arrival of the first Macintosh in the second half of the 1980s, see: Fuentes, Rodolfo (2020). *From Pixel to Lead: A History of Uruguayan Graphic Design,* pgs. 38–40 (Competitive Funds/La Nao).
10. Many people had to postpone the advancement or start of their careers due to the civic–military intervention (1973–1985).
11. *El Popular* SRL Av. Daniel Fernández Crespo 1966. Director: Eduardo Viera. Secretarios de redacción: Raul Legnani, Hugo Carreras. Administrador: Ariel Hernández.
12. Founded in 1981, the newspaper began as an evening newspaper and then as a morning newspaper. Julián Safi was the director.
13. Independent party newspaper promoted by Ricardo Peirano.
14. Data obtained from the 30-Year Anniversary edition of *El Observador.*
15. Fuentes, *From Pixel to Lead,* pg. 39.
16. The Uruguayan Photo Club is a photography school founded in 1940.
17. At the end of 2015, the Faculty of Architecture changed its name to the Faculty of Architecture, Design, and Urbanism, due to the expansion of its academic offerings from one to five majors.
18. Access to the approval records for the study plan of the degree in visual communication design. (LDCV-UdelaR)
19. The program started in 2009 with the first group of freshmen/first-year students in a four-year degree. Mara taught that group in 2010 in their second year of the degree program but resigned the same year 2010. The author, Luis Blau, was part of that initial group. Mara was his teacher in design workshop 1 in 2010.
20. The first interview occured in March 2021 and the second and third interviews were conducted in January 2023.

21. Mario García worked as an editorial design consultant in 120 countries. His projects included work for *The Wall Street Journal* (American, European, and Asian editions), *The Washington Post* (USA), *South China Morning Post* (Hong Kong), *New Straits Times* (Malaysia), and *Aftenposten* (Norway), among others. Mario is a journalist and specialist in mobile storytelling and newsroom transformation for the digital world.
22. Mara retired in 2019 at the age of sixty.

3.15

Marjaana Virta: Designer for Text and Textile

Dr. Arja Karhumaa

In her own words, prize-winning Finnish Graphic Designer Marjaana Virta may have a mind equipped with something like a "hyperactive word center." Letters and words have always been her true conviction within design, along with one color: black. During her design education, she knew she wanted to work with books and publications; that is the space she has inhabited for her entire career.

Marjaana Virta was born on November 8, 1958, in Lahti, a small city in southern Finland known for its furniture industry and winter sports venues. She describes her family as working class and her childhood as not entirely carefree. Both parents came from austere backgrounds and struggled to some extent to maintain stability for the children in their household. Marjaana describes herself as a shy child, somewhat timid,

Figure 3.15.1 Marjaana Virta, photographed in 1993 with fabric from her textile line "Mediatext" for Marimekko. Photo: Markku Niskanen/Journalistinen kuva-arkisto (Press Photo Archive). Image courtesy of Markku Niskanen.

often most comfortable when immersed in solitary play. Her father was a third-generation bricklayer, and Marjaana's only brother, older by three years, eventually trained in building and construction. Marjaana, however, started searching for alternative routes very early on.

Little culture was consumed within the Virta household, although Marjaana's mother did take singing classes, and the then three-year-old followed suit. It was during this time that Marjaana became aware of her creative ambitions. She decided she wanted to learn the violin. Her determination led to violin classes in the local music conservatory from the age of nine until other interests took over in high school. Today, Marjaana considers her early musical interests and her later typographic ones a continuum: all include expression, rhythm, and, indeed, the alphabet.

After starting school, Marjaana found her art classes the most enjoyable and where she discovered an entirely new medium for expressing her inner world. Although not the most skilled in drawing, she had a powerful sense of form and a certain "ugly aesthetic" (as she herself calls it) accentuated by the prolific use of black crayon—earning the attention of her art teacher, Pirkko Niskala. Validated by Niskala's support, Marjaana gained faith in her abilities, and upon finishing high school, she set her goal: she was determined to become the best book designer on the European continent. As extravagant as she describes this objective at the time, the career choice was crystal clear and one she fully committed to. Throughout her long career, she has immersed herself in her creative expression and the work in publishing. She never sought out a family life of her own.

In the late 1970s, Marjaana studied graphic design at the renowned Lahti Institute of Design in her hometown. Initially, she felt slightly out of place, as she was not as skilled in drawing as most students. Typography classes had a mathematical approach she was not interested in either—calculating surface areas for fitting text into layouts seemed reductive. However, Marjaana was confident enough to search for unique approaches to school assignments. Over time, she developed a very distinct manner of expressing visual ideas using typography instead of images and clever ways of using tactile materials, unlike any other Finnish graphic designer before.

Almost immediately after graduating in 1982, Marjaana Virta was hired by the prominent Finnish publishing house Werner Söderström Ltd (WSOY). There, she remained working as the Head of the Design Studio until 2013. Having achieved her dream career very early on, Marjaana describes her tenure at WSOY as a significant part of her "advanced studies."[1] With characteristic irony, she describes her choice of profession as misinformed: she knew she never wanted to work in a service profession and was instead looking forward to a creative life out of sight and in a solitary studio. She found out too late that a critical part of a book designer's work is verbally convincing other people about your work, making the caliber of one's communication skills vital. This is what she considers a significant part of her schooling. And after her extensive career at WSOY, Marjaana continues to create design work under her name, Graphic Design Marjaana Virta Ltd.

Figure 3.15.2 Marjaana Virta, two book covers for Finnish author Leena Krohn: *Matemaattisia olioita ja jaettuja unia* (WSOY 1992), and *Kynä ja kone* (WSOY 1996). Photo: Maarit Bau Mustonen. Image courtesy of Marjaana Virta.

Book Covers for Leena Krohn

While overseeing the creative work for WSOY publications, one of Marjaana Virta's most significant and long-standing design collaborations has been with the prize-winning Finnish writer Leena Krohn (1947). Leena is known for her prose examining the relationship of humans, technology, and morality and for writing on artificial intelligence as early as the 1980s. Their collaboration began in 1985 with the sci-fi fantasy novel *Tainaron*, for which Marjaana designed the cover, and their latest collaboration was on a picture book by Krohn in 2022.

In an early newspaper interview in 1999, Marjaana describes her working process for Leena's book covers. She considers herself lucky to be able to read the author's full manuscript beforehand: "I wasn't familiar with the nature of Leena Krohn's work in advance, and neither is literary judgment what I even aim for. Instead, I read the book as a graphic designer. I investigate its landscape to be able to do my own work."[2] Indeed, Leena Krohn gave Marjaana complete creative freedom in her designs. Also, a certain amount of independence was always typical of this long-standing collaboration from the publisher. Leena Krohn's high status meant fewer demands from the marketing department than in other cases. However, Marjaana was never ignorant of the realities of the market, stating that "we do, nevertheless, breathe the same air."[3]

A certain playfulness with tactile materials and printing technologies has always been a hallmark of Marjaana Virta's design work, and the freedom given with Leena Krohn's books gave additional space for experimentation. For example, the cover jacket for the 1992 essay collection *Matemaattisia olioita ja jaettuja unia* (*Mathematical Creatures, or Shared*

Dreams) was printed on a shiny silver foil, a leftover material from the publishing house printer's storage. The mirroring effect in the book is striking, reflecting a broken image of its reader's face. Later, for Leena's 1998 book *Pereat Mundus*, she designed what she called an "interactive" cover jacket with thirty-six printed stickers, from which the reader could compile their own individual jacket.

Despite her realism concerning commercial publishing, Marjaana Virta's primary commitments are equally to language and literature and her confidence in her skill and vision. These are discernible in how she further describes her work for Leena Krohn: "Dare I say, my design assignment is not for the publisher, the marketing, or the editor, but the text itself. My only task has been to express something about it in an honest manner, in my own words."[4] These convictions were not missed by Leena Krohn herself, who in another interview said: "Marjaana Virta has understood something crucial of the way I express my experience of the world, and she has been able to transmit her insight into the designs of my books in a manner I never imagined was possible."[5]

Over the decades, Marjaana has designed hundreds of books and book covers and supervised and managed all the design work for WSOY general literature. A few of her other awarded projects have been the young poet Annukka Peura's (1968) 1989 debut collection *Kaaoksen matkustaja*, and in 2009, her contemporary pocket-book version of *Kalevala*—a collection of folk poetry first published in 1849 and widely regarded as the national epic of Finland.

To this day, Marjaana is eager to explore new things, for example, opportunities to design poetry in a different way. She wonders if she could find a writer interested in making a more "journalistic" poem, one offered to the reader in a visually unconventional way, using graphic devices that share a genealogy perhaps more with magazine journalism than with poetry.

Recognition

In 1994, Marjaana Virta was awarded "Graphic Designer of the Year." This annual award was established in 1985 by Grafia, the professional organization of graphic designers in Finland, and she was the first woman to receive it. Later that same year, her award led to an invitation to the annual Independence Day Ball hosted by the president of Finland—a local tradition and an acknowledgment offered to people having gained different kinds of merit over the past year. The major newspaper published a playful causerie text that mentions the "young female designer" presenting as a "happy guest" at the party and aptly described her award as having "broken a long chain of sixty-something-year-old males handing awards to one another."[6] Even more to the point, Marjaana Virta was the first "Graphic Designer of the Year" ever to be invited to this annual celebration—a fact she remembers caused some quiet outrage in older male colleagues deprived of this distinction. At the time, the Finnish design scene was primarily driven by corporate design and

advertising, and it may have been a surprise for some to find a woman book designer awarded this valuable merit.

To celebrate Marjaana Virta's award, the Design Forum Gallery in Helsinki organized an exhibition of her book designs. Two years later, in 1995, the Lahti Art Museum exhibited her books and textiles in a solo show, an opportunity still rarely available to graphic designers in Finland. During the exhibition, she reunited with her former art teacher, Pirkko Niskala, who was there to celebrate her former student's success.

In 2000, Marjaana received a Distinctive Merit award in New York for the design of the book *Symposium* by Esa Saarinen (1953). This award marked Marjaana's most well-known collaborations with the Finnish philosopher, public figure, and media star. Two early projects with Esa Saarinen are particularly noteworthy: transatlantic teamwork with philosopher Mark C. Taylor (1945) in *Imagologies: A Media Philosophy* (1994) for Routledge and *Filosofia* (1994), a philosophy textbook distributed nationwide to high schools in Finland, which the English version *Symposium* was based on. These books offered Marjaana an arena to put her linguistic and typographic sensibilities to full use: she was very much involved with the arrangement and sequence of the textual content in all of them, respectively.

Imagologies: Designing Postmodern Philosophy

The book *Imagologies* is based on the 1992 transatlantic "satellite seminar" lecture series by two philosophers and academics, Esa Saarinen and Mark C. Taylor. Taking place between Williamsburg and Helsinki, these seminars were relatively early experiments in digital correspondence and online lecturing. The "electronic twitches" and glitchy connections between two continents inspired Marjaana to design an "un-book" that would aim to be equally "multimedia." Instead of conveying meanings linearly, *Imagologies* was designed to offer insight and ideas in a non-linear mode: it was meant to be read in fragments here and there.[7]

With this book, the philosophers Saarinen and Taylor insisted on a new, radically contemporary media culture, where outdated views such as ideas about content, "one-dimensional book culture," and a "separation between surface and depth" were dismantled.[8]

This was the heyday of postmodern media theory linked to the rapid beginning of digital and online communication. The book *Imagologies* demonstrates Marjaana's free rein in interpreting the same in print. Fragmented, language-sensitive typography becomes vital for expressing conversations in visual form. Despite the concept of "un-book" and channeling hypertext in her design, the book's design relies heavily on Marjaana's knowledge of the codex format. The liberal use of page space grants a sense of choreography to the reading sequences. Disjointed typography and page layout parallel the authors' aim of "taking risks and throwing oneself in the medium," in the words of Esa Saarinen, describing the writers' ethos.[9]

Figure 3.15.3 Marjaana Virta, two layout spreads for *Imagologies* by Esa Saarinen and Mark C. Taylor, Routledge 1994. Photo: Maarit Bau Mustonen. Image courtesy of Marjaana Virta.

In *Imagologies*, Marjaana has transmitted her vision of the philosophers' ideas in layout and print in a previously unprecedented way in Finnish book design. The way she worked can only be seen as a further development of the insight that the author Leena Krohn had already recognized in their respective collaboration—only this time, Marjaana's vision was

extended from mere cover design to the organization and typographic treatment of the textual content.

Imagologies also led to an entirely new pathway in Marjaana Virta's career: textile design. The typographic world she built for *Imagologies* was striking, and this powerful black-and-white design and the expressive lettering could extend even outside the book object itself. Together, Esa Saarinen and Marjaana Virta approached the iconic Finnish textile company Marimekko to explore the possibility of collaboration. As a result, in 1993, Marimekko

Figure 3.15.4 Marjaana Virta, two layout spreads for *Filosofia* by Esa Saarinen (WSOY 1994). Photo: Maarit Bau Mustonen. Image courtesy of Marjaana Virta.

launched "Mediatext," four different fabric prints based on her layout and typography for *Imagologies* (see the photograph of Marjaana Virta). The company produced the fabrics into a clothing line, home textiles, and textile-covered notebooks. Eventually, the "Mediatext" clothing became quite trendy in the 1990s: Marjaana was told the denim jacket printed with her hand-lettered pattern was the most frequently stolen product in Marimekko stores. She takes this strictly as a compliment.

Filosofia: Book Design as Reading Comprehension

Immediately after *Imagologies*, Marjaana continued her collaboration with philosopher Esa Saarinen, who, in his own words, had found his ultimate form of bookmaking with Marjaana Virta.[10] Together, they started working on the book *Filosofia*, a high school textbook for introductory courses on Philosophy. *Filosofia*, published in 1994 by WSOY, is a groundbreaking achievement as a book on philosophy aimed at high school students. It's rare to have a schoolbook described as a "mind-blowing reading experience" by the nation's leading newspaper; however, this happened with this book.[11]

The visual world of *Filosofia* is a continuation of *Imagologies*: stern black-and-white color scheme, dramatic use of white space, fragmented layout, and typography. In this book, typography and lettering also play a double role as both the conveyor of the semantic content and illustration. If *Filosofia*'s layout and reception were out of the ordinary, the reasons might be in the working process, which Marjaana recollects today as similarly exceptional. Perhaps even more than in *Imagologies*, *Filosofia*'s design was an insightful response to the material at hand for the designer. According to Marjaana, the manuscript handed to her by Saarinen consisted of only linear text with no headings or structure whatsoever. Furthermore, the publisher expected her to illustrate the book with images of classical art, which she confesses she was not impressed with. However, ignoring these shortcomings and making full use of the autonomy given to her, Marjaana ended up creating a book design unprecedented in Finland.

For Marjaana Virta, designing a book is effectively "reading comprehension," which explains her working method. Saarinen's peculiar manuscript, with no conventional structure given by headlines and subheadings, led her to do her own editing work and provide structure to the reader's experience using page sequence and typography. Conventional imagery is replaced by using type as an image, and any potential disarray is avoided by removing color.

A Virtuoso in Text and Textile

The significance of *Filosofia* might not have been achieved without the "advanced studies" Marjaana had obtained early on in her career: her acquired skill in articulating her ideas and design choices to others. Talking through her design choices with Saarinen, she

remembers striving to find a common language, as the philosopher was unfamiliar with design terminology. Eventually, she found a vocabulary suitable for discussing time and sequence in the book: she turned to her experience in playing the violin and began using musical concepts. As in musical composition, one may find rhythms, cadences, or something "largo" (played slowly) in the performance of a book. These terms helped the writer recognize what Marjaana aimed for in her design.

Our conventional reading habits rely on chronology, the sense of having a beginning and an end. Marjaana describes her ideal page of text as being "relaxed"—one that has enough space and will make even complex content welcoming for the reader to approach and engage in. For her, designing a book is about slowing down the chronological habit, creating pauses and interruptions along the way. Marjaana's musical metaphors help us understand her approach to book design and reading as ambient, performative phenomena.

Undoubtedly, Marjaana Virta holds a prominent position in the Finnish graphic design scene. However, it has yet to be documented and recognized to its fullest extent. Over the years, she has been awarded and appreciated; however, she has been equally criticized for her progressive styling of typographic text. Many designers who were active in the 1990s and experimented with the deconstruction of form made possible by digital tools are familiar with this disapproval. Marjaana is continually drawn to testing the limits of her tools and materials. Never one to toot her own horn, she has always remained quietly confident in her skill and vision. Today, she continues to work on various projects, from detailed book typography to large-scale graphic patterns for textiles. Her work, with its exceptional affinity to both discursive and material aspects of graphic design and typography, will unquestionably inspire future generations.

© **Dr. Arja Karhumaa**

NOTES

1. "Graafikko on melkein aina toinen." *Helsingin Sanomat* September 8, 1995. Translated from Finnish by the author.
2. "Kirjan ulkoasusta päättävät kustantaja, markkinointiosasto, kirjakauppias, kirjakerho ja joskus myös kirjailija." *Helsingin Sanomat* May 9, 1999. Translated from Finnish by the author.
3. Ibid.
4. Ibid.
5. Ibid.
6. "Rennot pirskeet." *Helsingin Sanomat* December 8, 1994.
7. "Graafikko on melkein aina toinen." *Helsingin Sanomat* September 8, 1995. Translated from Finnish by the author.
8. "Filosofit palaavat markkinatoreille." *Helsingin Sanomat* March 24, 1994. Translated from Finnish by the author.
9. Ibid.
10. Ibid.
11. Ibid.

3.16

Sujata Keshavan: Indian Graphic Design Pioneer

Tanishka Kachru

During the twentieth century in India, there was a sea change regarding women's education and their entrance into the professional world. First, women had to overcome barriers at many levels—from patriarchal norms of a woman's place in the home to stereotypes of what would be considered appropriate jobs for women who worked outside the home. Although educational opportunities for women did progress over the century, the expectations for them to be employed and part of the workforce were still relatively low, and this was no different in art and design education. At best, young women were expected to take up jobs as teachers until they had children, when they would be expected to leave the workforce.

As a graphic designer and businesswoman, Sujata Keshavan utilized her unique skills to drive creative and professional change. Her story illuminates the histories of women's struggles within professional domains and still resonates today. At a time in India when there was no option to climb the "studio ladder" (the default path in the West), Sujata Keshavan forged her own path. By demonstrating a different way of working as a graphic designer, she helped shape, shift, and model the professional sphere for women in design.

Figure 3.16.1 Sujata Keshavan, portrait, 2023. Image courtesy of Sujata Keshavan.

Early Family Life and Childhood Training

Sujata Keshavan was born on February 2, 1961, in the southern city of Bangalore, India. Sujata recounts that her parents were instrumental in shaping her choice of profession. Although trained as a mechanical engineer, her father, N. Keshavan (1927–1998), had a designerly way of approaching problems. Sujata credits him with the design of her childhood home in Bangalore, where she continues to live today. He not only designed the house but also the interiors and all the furniture in it. This was how he approached his day job at Burmah Shell, taking on the additional work of designing their petrol pumps. He also experimented with designing sound systems and baking his own bricks and floor tiles with ceramic coating. Her mother, Shanta Keshavan (1932–1999), was more than an equal match for her polymath father. She trained as a visual artist and was an intellectual who wrote for magazines on art, philosophy, literature, and other subjects reflecting her diverse interests. Sujata and her sister, Saumya Keshavan (1958), grew up as avid readers surrounded by books and looking at modern art with their mother, who painted abstracts.

With her exposure to the creative world through her parent's interests and the art classes she attended throughout her adolescence at the Bangalore Art Club, Sujata considered studying architecture as a career path. She applied to Ahmedabad's Centre for Environmental Planning and Technology (CEPT) but could not register as the school did not offer on-campus housing to female students then, which worried her parents. Her father also believed that as a woman architect, she wouldn't get good commissions as it is not a level playing field. Sujata was a bright student. She had many choices but eventually enrolled at the National Institute of Design (NID) in Ahmedabad. Sujata recalls the entrance test—for which she traveled to Madras (now Chennai)—as unconventional and exciting, but she could not judge her performance. When asked to attend the admission interview in Ahmedabad, she had to undertake a journey that involved traveling on three different trains.

Visiting the campus for the first time, Sujata recalls being struck by the ensemble of the modernist building set among the exotic trees on campus and the monument—a seventeenth-century sarai, rest house for travelers—and thought it was a "paradise." Fortunately, the institute had recently set up a women's hostel, which reassured her parents, and she began her design education in 1978. Sujata recalls that NID had an unusual admissions policy that balanced the ratio of men and women to fifty–fifty.[1]

Studying at the National Institute of Design

The NID was set up in 1961 by the Indian government to further its industrial policy. The experimental institute for design, research, and training emerged through a consultation process involving many international design figures, including the American designers Charles Eames (1907–1978) and Ray Kaiser Eames (1912–1988).[2] Later, consultants tasked

with establishing the curriculum included significant figures in graphic design like Armin Hofmann (1920–2020) from the Schule für Gestaltung Basel (Basel School of Design) and Adrian Frutiger (1928–2015) from Kunstgewerbeschule Zürich (Zurich School of Design), Switzerland.[3] The institute's experimental pedagogy was drawn from both the Bauhaus and Ulm models and the influence of the education philosopher J. Krishnamurti by the visionary duo of Gautam and Gira Sarabhai, who established it in Ahmedabad.[4] When Sujata joined NID in the summer of 1978, the design program for school leavers (10+2 years of school education), or SLPEP as it was known then, was still less than a decade old.

Sujata characterizes education at NID as a revelation for her. The institute's "learning by doing" pedagogy starkly contrasted with the rote learning system of Indian schools. In the Foundation courses, her class of eighteen students worked together on exercises of form, color, and materials influenced by the Bauhaus and Ulm curriculum. Reflecting, Sujata thought the faculty had adapted these exercises well to the Indian context. A newly developed course, Environmental Perception, engaged the group with ethnographic methods of observing and documenting the city over a period of time. After three semesters of Foundation studies, Sujata was among a group of five students who chose to specialize in graphic design—Bharati Malani, Angeli Sharma, Alaknanda Dutta, Jyoti Thapa, and Nalin Pandya (aka Pan Nalin, an award-winning filmmaker). Sujata stated she was drawn to study graphic design as it would require her to push her boundaries in conceptual work.

In recalling some of the teachers who left an impression on her during the five and a half years at NID, Sujata refers to qualities that informed her own sensibilities and attitudes. She recalls the former director Ashoke Chatterjee as being extremely sensitive to the fact that the designers were being trained to work in an Indian environment; graphic design faculty and typographer Mahendra Patel (1943) as a demanding teacher who instilled rigor; graphic design faculty Vikas Satwalekar (1939–2020) as someone who encouraged exploration of more significant ideas; and general studies faculty Christopher Cornford (1917–1993) as someone who broadened minds by introducing literature, poetry, aesthetics, theory, and text. Her love of books led her to spend many hours in the library, where she remembers discovering the works of American graphic designer Paul Rand (1914–1996; later her teacher at Yale). Reflecting on her student years at NID, Sujata found that the rigor of the foundation studies at NID combined with an environment that facilitated cross-learning from disciplines like textile and exhibition design gave her a more rounded understanding of design than most of her contemporaries at Yale later.

The diploma project—the culmination of the program at NID—required Sujata to work on a project in industry. She took up a project to design an exhibition for Bharat Electronics Limited (BEL) at the Pragati Maidan exhibition grounds in New Delhi, working for the advertising agency J. Walter Thompson (JWT). Sujata recalls that the contractor for the exhibition thought of her as "a chit of a girl" and hijacked her designs by installing decorative pink panels recycled from a previous project. The project was a challenging test

of her ability to work within the industry and its contractors, leaving her feeling she had no agency. Objecting to the changes made to her designs, the contractor characterized her as a "funny, hysterical female." The exhibition, nevertheless, was awarded the first prize, and Sujata was offered a job at JWT, which she promptly declined.

The Path to Professional Experience

Instead, Sujata began working for a newly established news magazine, *The Herald Review* (later *Deccan Herald*), after receiving her diploma from NID and moving back to Bangalore. She spent three months as an assistant designer for the magazine's overall design before marrying and relocating to Calcutta (now Kolkata), where her husband Ramachandra Guha (1958)[5] had accepted his first research job after completing his PhD studies. There, she reconnected with Ram Ray (1943–2019), who had recently returned after a year abroad heading JWT's San Francisco office. They had first met during her internship at JWT. Ray had founded his own agency, Response, in Kolkata, and he offered Sujata a job. Sujata's experience in advertising had left her feeling discouraged by the lack of opportunity for conceptual and experimental work. When she expressed her concern to Ram Ray, he agreed she could handle the few other jobs in the agency, like packaging and logo design. Ray had brought an IBM computer (loaded with early design software) back from San Francisco that Sujata had experimented with. She describes Ray as a data junkie who would dive deep into the background of any subject he was researching.

Meanwhile, Sujata applied to the MFA program in graphic design at Yale University and received a Yale Merit Scholarship. Sujata's husband—whose ideological leanings opposed American politics at the time—was nevertheless very supportive of her ambitions and desire to study at Yale. Within a few months, he joined her in New Haven, having been invited by William R. Burch (1933–2024) to teach at the Yale School of Environment. Sujata matriculated into the MFA program in 1985 as one of only two international students to join the program that year. She recalls being awed by the caliber and reputation of the faculty who taught in the department, the star being Paul Rand, who drove up from his home/studio in Weston, Connecticut, to conduct a masterclass two days a week. Sujata characterizes Rand as an accomplished and challenging teacher who was treated like a god in the program. There were always donuts for everyone on the days he was there. In comparing the Swiss designer Armin Hofmann (1920–2020)—who would visit from Basel with his wife Dorothea Hofmann (1929–2023) to teach every semester—Sujata said, "Paul and Armin had different points of view. Paul Rand's designs were very idea-based and came out fully formed on paper. He resolved everything in his head. Armin Hofmann, on the other hand, said that the process of design is a process of discovery."[6]

Armin Hofmann had contributed to setting up the graphic design curriculum at NID, visiting Ahmedabad in 1964 to train the faculty. Sujata's perspective on design, shaped by

the holistic design education at NID, enabled her to challenge the worlds of her contemporaries at Yale that seemed, in comparison to her, like living in a "tiny bubble." She appreciated American liberal education and remembers learning how to look at her work critically through the group crits. Having developed close relationships with many of her teachers, Sujata remembers a project where she did sixty-five versions of a leaf photogram for a music poster exercise with Hofmann. When she shared some of this work with Paul Rand, he appreciated it, and soon Sujata received the Schickle-Collingwood Prize at Yale after completing her first year of studies. After graduation, she was offered a job at the Yale University Press, but chose to move back to India.

Comparing gender attitudes between NID and Yale, Sujata considers both institutions progressive with liberal attitudes in their effort to maintain a fifty–fifty gender ratio for student intake. At Yale, she also recalls being aware of the non-binary gender identities of many of her fellow students. At the same time, she recalls encountering very few female teachers in both institutions, and the few female faculty at Yale were not counted among the luminaries, reflecting the gender imbalance in the professional design world in the 1980s. Soon after Sujata graduated from Yale, change swept through the program. The new director, Sheila Levrant de Bretteville (1940), was a determined feminist who changed the department's remit in the 1990s.

Sujata and her husband returned to Bangalore in 1987, and she engaged in freelance work for a time. She brought back what she believes to be India's first Apple Macintosh computer. The Yale students were already involved in testing these machines with the first generation of graphic design software: Pagemaker, QuarkXPress, Fontographer (a font design program), and Adobe Freehand. Recalling her experience with getting the machine through Indian customs—which took over three months—she believes it took longer than usual as the customs department had never seen anything like it.[7]

The Partnership of Ray+Keshavan

Sujata was determined not to return to advertising agency work as print media was considered "below the line" (less critical than TV advertising, which could charge more money). In 1989, when she was only 28, she moved to New Delhi with her husband, and there she founded Ray+Keshavan in partnership with her former colleague and employer, Ram Ray. She charted new paths, establishing professional design practices and processes recognized by the industry and followed by designers who came after her. Ray+Keshavan's approaches were well-timed in responding to the emerging opportunities for designers in the newly liberalized economic landscape of 1990s India. For the next seventeen years, the company garnered an impressive reputation for its branding work, after which Sujata decided to move on, and the agency was sold to WPP Plc., a public relations company, in 2006.

Figure 3.16.2 Sujata Keshavan, poster for the Center for Contemporary Art, Ray+Keshavan, 1990. Image courtesy of Sujata Keshavan.

The decision to open Ray+Keshavan in New Delhi was predicated by her husband's job, which took them to the capital city of India. Sujata's memory of the city was colored by the difficulties of the exhibition project she had worked on during her student years. The office was set up in an elite neighborhood in a leafy corner of South Delhi. Sujata fondly remembers her first job for an art gallery founded by a young woman gallerist, Sadhvi Khullar, in the heart of New Delhi's colonial commercial hub, Connaught Place. Sujata designed a brand identity for the gallery, Center for Contemporary Art (CCA), and posters and catalogs for the art shows held every two to three weeks. This project allowed her to produce designs she considers some of her best and radical work. She produced a series of screen-printed posters with asymmetric typography for well-recognized modern artists like Ram Kumar (1924–2018), Jagdish Swaminathan (1928–1994), Krishen Khanna (1925), etc., using their signature as a graphic element. She recalls printing the posters with

a group of older Bengali men who ran a screenprinting workshop and were excellent craftspeople and, importantly, "nice and easy to work with." The visibility of this work helped Ray+Keshavan get noticed, and they were offered more projects as a result.

While setting up the office and design studio, Sujata did not have any model in India to follow, but her exposure at Yale encouraged her to look outward for inspiration. She invested 12,000 rupees of her own money in setting up the studio, and Ram Ray contributed slightly more than double that amount. Recounting the experiences, she states, "It was hard in Delhi as a woman to set up a business." She was referring to the existing stereotypes about the possible roles for women in the professional and corporate world and the day-to-day challenges of dealing with men for work and services. As a graphic designer, it was essential for her to be able to supervise print jobs to get the results she wanted personally, and this required her to spend long hours in printing presses overseeing everything from ink mixing to checking proofs.

Sujata recalls one such experience: "No woman had ever entered the press. It was a very male environment. There was sniggering and comments. I was eyed up and down. They always delayed my job and would make me wait for hours, sometimes till midnight."[8] The advertising agencies had production managers—men on backslapping terms with the press workers—and she was seen as an intruder. She also experienced a constant underestimation of her knowledge, as the printers would try to cheat on the specifications she gave, like changing the paper quality. She says, "The whole ecosystem was very unprofessional and hostile to women." Comparing the experience of working in the male-dominated space of the industrial press with the craft-based screenprinting workshop where she made her CCA posters brings out an interesting contrast of attitudes faced by women in a craft setup versus an industrial setup. Later, she discovered a press in the industrial area of Okhla, closer to her studio, which was run by Sunita Paul, a woman and the owner of Paul's Press.

One of the first brand identity projects accepted by Ray+Keshavan was for Escorts, an industrial manufacturing company. In the early days, Sujata constantly had to explain to

Figure 3.16.3 Sujata Keshavan, identity for J&K Bank (Jammu and Kashmir Bank), Ray+Keshavan, 2006. Image courtesy of Sujata Keshavan.

Figure 3.16.4 Sujata Keshavan, identity for Kotak Mahindra Finance Bank, Ray+Keshavan, 2010. Image courtesy of Sujata Keshavan.

people the difference between design and advertising. Reflecting on her client experience, Sujata remembers, "Because of my education, perhaps, I never felt scared of the bosses and put my point across to them firmly." She found the work culture in Delhi somewhat feudal with a strong enforced hierarchy. She would, however, persist and demand to work directly with the decision-makers. Her process involved asking for one or two interviews with the person in charge to understand their outlook. While in Delhi, she also worked on small but fulfilling assignments with the Swiss Embassy and artists like Vivan Sundaram.[9]

One of the significant business challenges she faced was the fact that advertising agencies did not charge a design fee but charged for the cost of artwork and would take a 15 percent commission on the cost of the print run—the problem was there was no acknowledgment of creativity and intellectual property. Drawing on her experience at Yale, Sujata knew that designers charged for their time in the West and that every designer maintained time sheets. She was unhappy with both systems and developed her idea of charging a design fee, which Ray+Keshavan adopted in their billing practices. Her mantra was, "We should be able to stand on a table and say—We did this!" She asked her clients to let the company put their name on the work, probably the first time designers received a byline in India.

The Delicate Balance of Motherhood and Work

Three years into establishing Ray+Keshavan in Delhi, Sujata had her first child, Mukul, in 1990 and decided to work from home for a while. Her mother came from Bangalore for three months to help support her with childcare. Her second child, Ira, was born in 1993; this time, her mother-in-law came to help her for six months. Sujata continued her practice through both pregnancies, taking a break only after the children were born. Ray+Keshavan had built a small but loyal team to run their offices, and almost everyone hired then was trained at NID. However, the first employee she hired was Jagadev Gajare, whom she first met when he worked as a mechanical artist at the advertising agency O&M.

Sujata recalls two reasons she decided to move cities just when she established her practice. The first reason was her dislike for Delhi's status- and money-conscious culture, which she considered a poor environment for raising her children. The second was the lack of a professional work environment and the bureaucracy in Delhi—some of the best large-scale impact government projects always eluded her. Bangalore, in contrast, was a very different story, a garden city for retirees that was being transformed by the revolution in India's IT industry. She found people in Bangalore taking advantage of this new economy, which made it an exciting place for her as it gave her access to a more educated clientele.

A somewhat experienced design and branding studio like Ray+Keshavan was uniquely positioned to help the new businesses that were cresting the post-liberalization wave in India. They were looking outwards to the global market to sell their IT products and

Figure 3.16.5 Sujata Keshavan, identity for Vistara Airlines, Ray+Keshavan, 2014. Image courtesy of Sujata Keshavan.

services. At the same time, multinational companies worldwide were now bringing their products to India and had to face the challenges of adapting to a different kind of market. While uniquely positioned to help the companies entering both the Indian and global markets, Sujata speaks of her struggle to dispel the notion of design being connected to "designer" stuff, which could only be applied to high-end products. Her approach was to show clients the power of design in being relevant to every aspect of business and how it can be used to differentiate from the competition. Ray+Keshavan became well known for its research-based processes that could produce unique insights for its clients through "strategic design." Sujata recalls that after the company used this term on its website, it quickly became a buzzword in the industry. They set up a brand consulting division that helped link design back to business. Working for the MTR food brand, Sujata was told that being a woman would give her particular insights to help understand its female customers. Although her gender seemed advantageous, Sujata emphasizes that clients came to her despite being a woman designer. These stereotypical gender attitudes constantly pushed her to be very aware and demonstrate how good and intelligent she was at her work.

Ray+Keshavan hired many women over the years. Sujata characterizes it as a "university"—the mentoring process involves training people in the basics. Sujata has advocated for design and designers by using her voice on diverse design, business, and advertising

platforms. She had been involved with international platforms like the women's forum at Davos, as a jury member at D&AD and Design Indaba, and on the boards of CII and World Economic Forum's Design and Innovation group. Sujata recognizes that sometimes it was a token representation. She also acknowledges that there were always more women in professional design in India, as men were supposed to do more serious work. Despite this, she was constantly approached by parents of young women, wondering if this would be the right choice, implying that mere presence was not enough and the urgent need for more visibility of designers in the overall landscape of professions, especially women designers.

Sujata always exuded a sense of power in dealing with people and situations. She is an exceptional communicator who would find multiple ways to explain her point until she ensured it was clear to everyone. She is a multidimensional person who, while working for the most prominent corporate brands, also spent some of her time designing book covers for the feminist publisher Kali for Women, including Rani Jethmalani's (1959–2011) Warlaw (Women's Action Research & Legal Action for Women). Her belief in the credo of "Good design is good business" propelled her to bring visibility and credibility to the work of professional graphic designers in India.

© **Tanishka Kachru**

NOTES

1. Interview conducted by the author with Sujata Keshavan, July 18, 2023.
2. Charles and Ray Eames produced a vision document called *The India Report*, 1958, in which they recommended establishing an institute for design service, research, and training by the Indian government.
3. National Institute of Design (2013). *50 Years of the National Institute of Design, 1961–2011*. Ahmedabad: Research and Publications, National Institute of Design, pg. 41.
4. Gautam Sarabhai (1917–1995) and Gira Sarabhai (1923–2021) were the youngest of eight children of the wealthy industrialist Ambalal Sarabhai (1890–1967), founder of The Sarabhai Group of companies and the Calico Textile Mills. Gautam was appointed the first chairperson of NID's Governing Council and held the post for thirteen years. Gira had trained with Frank Lloyd Wright in his Taliesin West studio in Scottsdale, Arizona, from 1947 to 1951 and is recognized as the creative force behind the modernist architecture of NID.
5. Ramachandra Guha (1958) is an Indian historian and environmentalist who has published widely and won many awards for his writing.
6. Interview conducted by the author with Sujata Keshavan, July 25, 2023.
7. Ibid.
8. Interview conducted by the author with Sujata Keshavan, August 1, 2023.
9. Vivan Sundaram (1943–2023) was an Indian contemporary artist who produced politically conscious work in many different media. His well-known work, *Re-take of "Amrita,"* is produced from the archive of his maternal aunt, Amrita Sher-Gil (1913–1941), a pioneering early modernist painter.

NOTES ON CONTRIBUTORS

Ginger van den Akker studied Media, Art, Design, and Architecture with a specialization in design at V.U. University and the University of Amsterdam. She served as the Curator-in-Training in the Design Department at the Stedelijk Museum Amsterdam. She also worked on the publication and exhibition dedicated to Fré Cohen, the twentieth-century graphic designer at Museum Het Schip.

Dr. Chiara Barbieri is a researcher in design history at ECAL/University of Art and Design Lausanne (HES-SO). She holds a PhD in History of Design from the Royal College of Art, London, with a thesis on the professionalization of graphic design in Italy from the interwar period to the mid-1960s. Her research interests include visual and material culture in fascist Italy, national design discourses, transnational networks of design exchange, and everyday design practice.

Anne H. Berry is a writer, designer, Professor, and currently the Director of the School of Design, University of Illinois, Chicago. Her published writing includes "The Black Designer's Identity" for the inaugural issue of the *Recognize* anthology and "The Intersection of Electoral Politics and Design Education" for the international design research journal *Message*. She is also co-creator of the exhibition project *Ongoing Matter: Democracy, Design, and the Mueller Report* (2020) and managing editor of *The Black Experience in Design: Identity, Expression, and Reflection* (Allworth Publishing, 2022).

Sandra Bischler-Hartmann holds a BA in Visual Communication and an MA in Art and Design Science. As a doctoral student, she contributed to the SNSF-Sinergia research project "Swiss Graphic Design and Typography Revisited" (2016–20). In her PhD dissertation, she analyzes graphic design education in Switzerland during the mid-twentieth century, examining educational principles and design philosophies concerning their integration and migration across national borders. She is a research associate at the Basel Academy of Art and Design and works as a design history lecturer at universities in Switzerland and Germany.

Luis Blau is a design educator in the Visual Communication program in the Department of History and Design Studies, Institute of History, Faculty of Architecture, Design, and Urbanism, University of the Republic, Montevideo, Uruguay.

Dr. Raquel Castedo is a Brazilian graphic designer, educator, and researcher based in Baltimore, Maryland. She holds a PhD in Communication and Information from the Universidade Federal do Rio Grande do Sul (UFRGS), Brazil. Her research interests include book design and Latin American design histories. In 2022, Raquel joined BmoreArt as Creative Director, focusing on branding and special publications. Since 2023, she has shared her expertise by teaching book design at the Maryland Institute College of Art (MICA).

Dr. Jane Connory has twenty-seven years of experience working in the design and advertising industry and eighteen years of experience teaching university-level design education. Her research focuses on exploring the visibility of women in Australian graphic design and using communication design as a tool to advocate for a more inclusive world.

Mehrdokht Darabi is a creative director, graphic designer and public speaker. She has spoken at universities in Portland, USA, on the role of women in Iran's advertising industry in 2017. During the pandemic, she launched a series of live international talks featuring renowned design experts. Now based in Singapore, she is the founder of Picograph, an advertising agency.

Dr. Maria Cecilia Loschiavo dos Santos, PhD, is a Professor of Design at the University of São Paulo. Her areas of research interest and expertise are sustainability, Brazilian design, Brazilian modern furniture design, social design, sociospatial exclusion, and Design philosophy.

Luciene Ribeiro dos Santos, MSc, has a Bachelor of Arts with double qualifications (Portuguese and French) from FFLCH-USP. She is a researcher in Design and Architecture and has carried out translation work since 1999.

Ömer Durmaz is a visual communication designer, writer, and Senior Lecturer at Dokuz Eylül University, in the Faculty of Fine Arts Graphic Arts Department, Izmir, Turkey. Along with writing articles and making presentations on Turkey's visual communication history, Durmaz published a research book, *100 Graphic Designers and Illustrators of Istanbul* (Istanbul Buyuksehir Belediyesi, 2011). Durmaz is an energetic organizer and participant in many national and international design activities and is active as a freelance designer.

Dr. Marina Emmanouil holds a PhD, an MA in the History of Design (RCA), and a BA (Hons) in Graphic Design. Since 2017, she has been a faculty member at Ghent University and a co-founder of the design.nexus research group, leading the design education pillar. Other management duties include that of the "T-CREPE" Erasmus+ KA2 project on design education and co-creation (2019–23). She currently serves as Associate Professor and Chair of the Department of Arts & Creative Industries, overseeing programs in Graphic Design, Visual Arts, and Cinema Studies at Deree, the American College of Greece.

Rose Epple, aka Rose Apple, was born in Hamburg, and lives and works in Berlin. She studied illustration and graphic design in Lyon, Hamburg, Paris, and Central Saint Martins College in London. Her practice comprises exhibition design, curation, education, and design writing for children and adults.

Dr. Murat Ertürk is an Associate Professor at Sakarya University (SAU), Turkey, teaching typography and visual communication design. He writes articles, translates, and publishes a monthly newsletter for the Turkish Typography Society. He is also a visual communication designer who designs sociopolitical posters. His award-winning posters have been included in the Moscow International Biennial of Graphic Design Golden Bee, Trnava Poster Triennial, Ecuador Poster Biennial, Warsaw Poster Biennial, and MadridGráfica.

Dr. Cinzia Ferrara is an Associate Professor at the University of Palermo, where she teaches visual communication design. She was president of the Italian Association of Design for Visual Communication (2015–18) and vice president (2009–15). She has published many articles and books such as *Marc Newson, design tra organicità e fantascienza* (Lupetti, 2005), and *La comunicazione dei beni culturali* (Lupetti, 2007).

Dr. Davide Fornari is a full Professor at ECAL/University of Art and Design Lausanne (HES-SO), where he has led the applied research and development sector since 2016. He holds a PhD in Design Sciences from University Iuav of Venice. Besides ECAL, he teaches at SUPSI in Mendrisio, Switzerland, and Design Academy Eindhoven, the Netherlands. Among his publications are *Carlo Scarpa. Casa Zentner a Zurigo: una villa italiana in Svizzera*, with Giacinta Jean and Roberta Martinis (Electa, 2020) and *Olivetti Identities: Spaces and Languages. 1933–1983*, with Davide Turrini (Triest Verlag, 2022).

Dr. Sara Miriam Goldchmit, PhD, is an Assistant Professor of Design at the University of São Paulo. Her research interests and expertise are information design, design for health, human-centered design, communication design, and image-making.

Dr. Francesco E. Guida is an Associate Professor in the Department of Design at Politecnico di Milano, where he teaches visual communication design. He has been the Secretary of the Communication Design Courses (2020–2024), holds a PhD in Design and Technologies for the Enhancement of Cultural Heritage, and has been involved with visual communication since the early 1990s. He is a former board member of AIAP (Italian Association of Visual Communication Design) and is the scientific coordinator of the Graphic Design Documentation Centre (AIAP CDPG).

Margo Halverson is a Professor Emerita, Graphic Design, Maine College of Art and Design, where she taught for over 30 years. She earned her BFA and MFA degrees in photography from Arizona State University, and then, as a post-grad, she studied with graphic designer Rob Roy Kelly, also at ASU. She is a co-founder of DesignInquiry, a nonprofit design educational organization. Margo and her designer/design educator husband, Charles Melcher, operate Alice Design, an award-winning graphic design studio in Portland, Maine.

Tanishka Kachru holds an MA in Design and Decorative Arts History from the Parsons School of Design, The New School, New York. She is currently a senior communication design faculty member at the National Institute of Design, Ahmedabad. Her research focuses on feminist design histories and histories of museums and representation. She is a co-author of *Nakashima at NID* (NID Press, 2017) and *The Routledge Handbook of Craft and Sustainability in India* (Routledge, 2023) and has been directing the *Women in Design at NID* project for the archives at NID since 2021.

Dr. Arja Karhumaa is a graphic designer and text artist, or text designer and graphic artist, and Assistant Professor in Visual Communication Design at Aalto University, Finland. Their work spans design, experimental writing, typography, poetry, and publishing. Karhumaa is the author/designer of the artistic research *Epä/igenesis* (2021), featuring the book *Epägenesis: Katalogi X*, a catalog of conceptual writing, and co-editor of *Experimental Book Object: Materiality, Media, Design* (Routledge 2023). Karhumaa is co-founder of the independent publishing platform Multipöly.

Dr. Linda King is a design historian, curator, broadcaster, and former graphic designer who analyzes graphic design as social and cultural history. She is a Senior Lecturer/Associate Professor at the Institute of Art, Design and Technology (IADT), Dublin. She sat on the Board of the National Museum of Ireland (2018–23) and remains as an expert advisor to the organization.

Ian Lynam works at the intersection of graphic design, design education, and design research. He writes for *IDEA* (Japan), *Modes of Criticism* (Portugal/UK), and *Slanted*

(Germany), and has published several books about design, including *Fracture: Japanese Graphic Design 1875–1975*.

Faride Mereb is a Venezuelan book designer, educator, and researcher based in New York City. She studied Graphic Design and holds a Bachelor of Arts degree earned in Latin America. She learned bookmaking with experienced printer Javier Aizpurua at ExLibris Press in Caracas. Mereb was a visiting scholar at Columbia University, (2021–2022), and a guest professor at Yale University (Fall 2024).

Dr. Yoonkyung Myung is a Seoul-based graphic designer and Assistant Professor in Kookmin University's Visual Communication Design Department. She earned her BFA at Massachusetts College of Art and Design, Boston, an MA at London College of Communication, UK, and a Doctor of Design degree from Seoul National University, South Korea. Bridging academia and practice, her work combines creative innovation with cultural insight to advance visual communication design.

Laura Ottina is a graphic designer specializing in publishing. Florence-based since 1995, where she has been involved in the design, editorial coordination, iconographic research, and art direction for book packagers and publishing houses. Since 2009, she has been a Professor of Graphic Design and the History of Visual Communication at IED Firenze and the Florence Institute of Design International.

Dr. Monica Pastore is a PhD researcher in the Science of Design at the Iuav University of Venice. Her research is in the history and criticism of graphic design, identifying topics of interest such as political graphics, the role of the underground Italian magazines of the 1970s in the diffusion of the visual project, and the reconstruction of the period of public utility graphics in Italy and the digital turn in Italian graphic design between the 1980s and the 1990s.

Vanina Pinter teaches the history and theory of graphic design at the Le Havre School of Art and Design (ESADHaR). Each year, she participates in *Une Saison Graphique*—the annual graphic design festival—as co-organizer and co-curator. Pinter is the former co-editor in chief of *Étapes* magazine, and currently, she continues to publish numerous texts on contemporary graphic creation in magazines, monographs, and exhibition catalogs, as well as contributing to the online journal http://www.tombolo.eu/ and *Neshan*, the international design journal.

Dr. Deirdre Pretorius is a Professor in the Graphic Design department at the University of Johannesburg. She currently lectures in Design Studies at the undergraduate level and supervises postgraduate students in the Honors design, MA design, and PhD (Art and

Design) programs. As a design historian, her research focuses on contemporary and historical graphic design and visual culture in South(ern) Africa. She has published in academic journals, presented at conferences, and contributed book chapters on topics that include South African Communist Party graphics, Second World War posters, political party logos, and overviews of visual communication history.

Dr. Paula Ramos is an art historian, art critic, and curator. She is a Professor at the Institute of Arts at Universidade Federal do Rio Grande do Sul (UFRGS) and director of the Pinacoteca Barão de Santo Ângelo, one of Brazil's most important university art collections. Her research covers modernity and the relationship between art, graphic and visual culture, as well as aspects related to memory and artistic and cultural heritage, all focused on the South of Brazil.

Elizabeth Resnick is Professor Emerita, Massachusetts College of Art and Design, Boston. She is a designer, design educator, curator of design exhibitions, and the editor of *Women Graphic Designers* (Bloomsbury Visual Arts, 2025), as well as *The Social Design Reader* (Bloomsbury Visual Arts, 2019), *Developing Citizen Designers* (Bloomsbury Academic, 2016), and *Design for Communication: Conceptual Graphic Design Basics* (Wiley, 2003).

Alice Roegholt is the founder and emerita director of the Museum Het Schip in Amsterdam, which focuses on the architecture, art, and public housing of the Amsterdam School. The museum is located in a building by architect Michel de Klerk, the great inspirer of the Amsterdam School. She has published several books on the art and architecture movement about the Amsterdam School.

Stephan Rosger is a Canadian designer, artist, and independent design researcher focused on critical inquiry through experimental making and writing.

Dr. Olga Severina is a Ukrainian-born designer, educator, and exhibition curator from Los Angeles, California. After obtaining her PhD in Visual Art, Olga founded *PosterTerritory*—a multimedia platform where she launches graphic design campaigns and socially conscious poster exhibits in the USA and abroad. A passionate promoter of contemporary poster design, Olga writes books and articles exploring the latest graphic design trends. In 2022, Olga co-founded Rukh Art Hub—a Ukrainian creative initiative committed to promoting contemporary Ukrainian art and design through cultural diplomacy.

Dr. Bahia Shehab is an artist, author, Professor of Design, and founder of the graphic design program at The American University in Cairo. Her work has been exhibited internationally and has received several international awards, including the BBC's 100 Women's

List, a TED Senior Fellowship, a Prince Claus Award, and the UNESCO-Sharjah Prize for Arab Culture. She is the founding director of TypeLab@AUC. Her latest publications include *You Can Crush the Flowers: A Visual Memoir of the Egyptian Revolution* (Gingko, 2021) and the co-authored *A History of Arab Graphic Design* (The American University in Cairo Press, 2020).

Dr. Maria Helena Souto holds a PhD in Art Sciences and an MA in Art History from the Nova University of Lisbon and is currently an Associate Professor at IADE–Universidade Europeia. As a researcher, she participated in a project co-funded by Creative Europe titled *MoMoWo—Women's Creativity since the Modern Movement 2014–2018*. She has published several articles on Portuguese Art and Design History related to gender issues. She has curated exhibitions at the National Tiles Museum (MNAz) and the Design Museum, Lisboa (MUDE).

Tasheka Arceneaux Sutton is a graphic designer, educator, image-maker, and writer. She is an Associate Professor of Design at The University of Texas at Austin and a faculty member in the MFA program in graphic design at Vermont College of Fine Art. Tasheka is also the principal of Blacvoice Design, a studio specializing in branding, electronic media, identity, illustration, and publication design for educational institutions, nonprofit organizations, and small businesses.

Ruth Sykes is a College Admissions Tutor at Central Saint Martins, London. Her research interests include the history of women in graphic design. In 2004, she co-founded the graphic design practice REG with Emily Wood.

Dr. Yasmine Nachabe Taan holds a PhD in Art History and Communication Studies from McGill University and is currently an Associate Professor of Art and Design History at the Lebanese American University, Beirut, Lebanon. Her research focuses on gender representation, design, photography, and visual culture in the Middle East. She received the Design History Society Grant for her research published in *Mouna Bassili Sehnaoui: The First Lebanese Graphic Designer to Brand her Nation* (2023). She is the author of *Reading Marie al-Khazen's Photographs* (Bloomsbury Visual Arts, 2020); *Saloua Raouda Choucair: Modern Arab Design* (Khatt Books, 2019); *Abdulkader Arnaout: Designing as Visual Poetry* (Khatt Books, 2017); and *Hilmi el-Tuni, Evoking Popular Arab Culture* (Khatt Books, 2014).

Parisa Tashakori is an Iranian visual artist and graphic designer focused on social, environmental, and cultural communication. She has been a jury member for numerous design competitions and art festivals. She has organized and carried out various cultural projects and workshops, individually or jointly, with her friends. She is currently the director of

the Master of Strategic Communication Design program at the University of Colorado Boulder.

Rukminee Guha Thakurta is an independent graphic designer, teacher, and writer. She works with museums, artists, publishers, and collectors worldwide and has received the Deutscher Fotobuchpreis.

Dr. Carlo Vinti is an Associate Professor at the Università degli Studi di Camerino (UNICAM), affiliated with the Scuola di Architettura & Design "E. Vittoria." His teaching and research focus on culture and the history of design, and he has published extensively on the history of Italian graphic design.

Dr. Wendy S. Wong is a Professor in the Department of Design at York University, Toronto, Canada. She has established an international reputation as an expert in Chinese graphic design history and comic art history. Two of her books, *The Disappearance of Hong Kong in Comics, Advertising and Graphic Design* (Palgrave Macmillan, 2018) and *Hong Kong Comics: A History of Manhua* (Princeton Architectural Press, 2002), serve as key references in the field. She is a regional editor of the Greater China Region for the *Encyclopedia of East Asian Design* (Bloomsbury Academic, 2020).

Justin Zhuang is an observer of the designed world and its impact on everyday life. Over the last decade, the journalism graduate has researched and written essays and books on Singapore's design histories. They include *Independence: The History of Graphic Design in Singapore since the 1960s* (The Design Society, 2012), *Fifty Years of Singapore Design* (Design Singapore Council, 2016), and *Everyday Modernism: Architecture and Society in Singapore* (Ridge Books, 2022). He is the founder of the Singapore Graphic Archives, a digital resource for research into local design, and runs the writing studio and publishing imprint, In Plain Words, with his partner Sheere Ng.

INDEX

Italic page numbers indicate figures.

A

abstract art, Choucair and 88, *89*
Académie Julian 20
Adams, George 146
Adnan, Etel 88
advertisements
 Keil's for Pompadour 73, *74*
 see also branding; posters
Agrarische Afdeeling (Agricultural Department) Jaarbeurs conference poster (Zeijst) 59, *60*, 62
AIDS. It's Time for Schools to Act poster (Jost) 380, *381*
Akalp, Ayhan 220
Alliance Graphique Internationale (AGI), Bertram's membership of 455
Amsterdam
 Amsterdam School 44–5, 47
 Jewish community in 44
 see also the Netherlands
Anand, Mulk Raj 255
Andersen's Tales illustrations (Bitterlich) *116*, 116–17
Antonelli, Paola 121
Antwerp, Jewish community in 44
Arab Cultural Club, Lebanon 84

Arabic typesetting 427, *427*–9, *428*, *430*, 430–2
Arab world, under-documentation of design in 429
Araújo, Matilde Rosa, collaboration with Keil 80
architecture
 Great Architecture in Chicago poster (Miho) 234
 Omniplan Architects, Miho's work for *236*, 237
 signage, Miho and 238
Ario publishing company, Keum at 475, *476*–9, *477*
Arredate la vostra casa d'estate (Lamm) *159*
Art Nouveau 22–3
The Art of Xie Zhiliu and Chen Peiqiu catalog (Kwan) *489*, 493
Arvanitis, Dimitris 316–17
Association of Visual Artists, East Germany 245
Atché, Jane 4–5
 Belle capricieuse: valse par Gabriel Allier (cover illustration) *26*, 27
 early life and family 19–20
 Gaz Benoit, poster for 22

 gigolette (flapper) drawings 21
 Japanese prints, influence of 21
 La Célestine poster *24*, 25
 Le Gui et le Houx (decorative panel) *24*
 lettering 27
 medieval/folklore inspiration 25
 Mucha as teacher 23–4
 Paris, influence of 20–1
 retreat from public life 25
 Self-portrait with a green hat 16, 19
 shadow of authority over work 25–6
 Smoker 17, *18*, 18–19
 social origins, impact of 25
 support, absence of 27
 women, presentation of 21–2
Australia
 growth of graphic design in 389–90
 National Maritime Museum poster (EKH Design) 393, *393*
 non-profession, graphic design seen as 389
 visibility of women in graphic design 387–8
 visual legacy of indigenous culture 388

women in graphic design 388–9
see also EKH Design
Autobus magazine, Ognibene and 504
awards
 Emori, Eiko 293
 Lim, "Best Asian Designer" award 347, 348
 Shōen, Order of Culture Award 14
 Virta, "Graphic Designer of the Year" award 528–9

B

Bâb-ı Âli, Üretmen at 217
Bashkirtseff, Marie 20
Beardsley, Aubrey 23
Beckman, Ronald 233
Beginning of Film Art poster (Hofmann) *196*
Belle capricieuse: valse par Gabriel Allier (cover illustration) (Atché) *26*, 27
Berndt, J. 405
Bertram, Polly 343
 Alliance Graphique Internationale (AGI) membership 455
 early life and family 447–8
 education and training 448
 in *Emigre* magazine 453–4, *454*
 E+U Hiestand, work at 448
 first work experience 448
 as jury member for competitions 455
 Mehrwerte: Schweiz und Design: die 80er, work in 454
 Museum für Gestaltung Zürich, work for 450–2, *451, 452*
 photo *446*
 sociopolitical messages, graphic design and 448
 studio with Volkart 448
 teaching 448, 455–6
 Theater am Neumarkt posters *449*, 449–50

"Best Asian Designer" award 347–8
bijinga style of painting, Shōen and 11
Bilimoria, Behroze 259, 261, 263
Bitterlich, Roswitha 6–7
 Andersen's Tales illustrations *116*, 116–17
 in Brazil 115–18
 duality in work 110, 111
 early life and family 111
 Eulenspiegel 113, 114
 exhibitions 110, 114, 118
 first exhibitions 111
 Grimm's Fairy Tales illustrations 117
 Hirt on 109
 illustrations *116*, 116–18, *117*
 Mit Roswitha ins Märchenland (With Roswitha in to the Fairyland) 111–12
 photo *108*
 as prodigy 111–14, *112, 113*
 reception of work post Second World War 115
 Schwarz-Weiss-Kunst 112, 112–14
 Thumbelina illustration *116*
Black Americans
 graphic design and 303–4, 459–60
 see also Harris, Sylvia; Hayes, Dorothy E.
Black Artists in Graphic Communication exhibition, Hayes and 308–9
"The Black Experience in Graphic Design" (Jackson) 308
Blues Project announcement board (MacLean) *328*
Body Language poster (Casey) 147–8, *149*
Bondinho, Toscano's work on 270, *271*
book and magazine covers
 Choucair, Saloua Raouda *85, 86,* 86–7

Cohen, Fré 52–3
Começa uma Vida (A Life Begins) (Lisboa) (Keil) 75
Jovens do Mundo Todo (Youth of the World) collection, Toscano's work on *269*, 270
Keshavan, Sujata 545
Klinz, Anita *135*, 135–8, *136, 138*
Krohn, Keena, Virta's book covers for *527*, 527–8
book design
 Iwanami Shoten publishing house, Emori at *292*, 292–3
 Oliveira, Mara de *516*, 516–18
 Sahiar and 259, 261, *262*
 Teaching an Algonkian Language as a Second Language, Emori's design of 297–8
bookplates, Cohen and 53
Boutros group 426, 429–30
branding
 Eirebus, Fitz-Simon and 365
 Keshavan, Sujata 540–1, *541, 542,* 543–4, *544*
 personal, Dekk and 98
Brink, Mechthild Maria 111, 115
Brink, Michael 115
Broadside Mobile Workers' Theatre Company, De Villiers and 403
Brun, Donald 186
Burgess, Deborah 297

C

Caland, Huguette 87–8
Canada
 Emori, lack of recognition given to 290
 exclusionary narratives of design 289–90
 see also Emori, Eiko
Cantor, Eli 309
Carabott, Freddie 317, 318
Casey, Jacqueline S. 125
 Body Language poster 147–8, *149*

early life and family 143–4
education and training 144
Faculty-Student Exchange Program poster 147, *148*
fashion design and illustration 144
Intimate Architecture: Contemporary Clothing Design poster *151*
at Media Lab, MIT 153
MIT Office of Publications 145–54, *148, 149, 150,* 152
Moll, Thérèse, and 146–7, 284
pay scales at MIT 152
photo *142*
RUSSIA/USA Peace 1985 poster 148, *150*
typography 147, *148, 149, 150*
Winkler on 153–4
Catholic designer, Zeijst as 64–6, *65*
Catholic Labor Movement in the Netherlands 62–4, *63*
Center for Advanced Research in Design (CARD), Miho at 234
Center for Contemporary Art poster (Keshavan) 540–1
Ceramiques Sanitaire poster (Morgagni) *177*
Charles J. Dorkins, logotype for by Hayes *309*
Chéret, Jules 22
Cheung Yee: Sculptures, Prints, Drawings poster (Kwan) *488*, 491
Chinese painting exhibitions, Kwan and 493
Choucair, Saloua Raouda 6
abstract art 88, *89*
aesthetics and utility combined 91–2
Arab Cultural Club, Lebanon 84
art and design, crossroad of 89, 91
book covers *85, 86,* 86–7
feminism and 84–5, 87–8

Islamic art, Western perspective on 83–4
other Arab women and 87–8
photo *82*
Point VI project 91
social activities, dislike of 84–5
traditional crafts, revival of *90*, 91
Chowdhury, Dilip 257
CIBA Pharmaceuticals cover (Morgagni) *178*
Cirque de Reims exhibition, 1896 19
Citizen Research and Design, Harris and 469
Classical Dance Painting (Shōen) *13*
clothing design
Stepanova, Varvara Fyodorovna *35,* 36–8
Virta, Marjaana 531–2
Coburn, Ralph 146
Cohen, Fré 5
Amsterdam School, influence of 44–5, 47, 51
Antisemitica bookplate *52*
book and magazine covers 52–3
bookplates 53
calendar *50,* 51
death 54
early life and family 44
education and training 45
feminism 49
flag for Social Democratic Women's Clubs 49
German invasion 54
holidays at Ascona 53
Hoogty, Tag der Freude, cover for *47*
importance of work 43
labor/socialist movement and 46–7, *47, 48*
lectures in England 51–2
paintings 53
photo *42*
printing office of the City of Amsterdam 49–52, *50*

renewed interest in 54
September 14 Rotterdam poster *48*
social life 46
successful career in graphic design 49
support for Jewish refugees *52,* 52–3
teaching 54
versatility of 53
collective work, lack of recognition and 401
color, use of by Katzouraki 317–19
Começa uma Vida (A Life Begins) (Lisboa) 75
Community Arts Project (CAP) Poster Workshop, South Africa 399–402, *401,* 404–5
A Concise Guide to Hand-Made Oriental Carpets (Lim) 350, *351,* 352
Concrete Art movement 190
Con Fiat verso gli anni 70 (With Fiat Towards the 1970s) poster (Jost) 377, *378*
Congress of South African Trade Unions (COSATU) poster (De Villiers) 399–400, *401,* 404
constructivism, Stepanova and 34, 39
Cooper, Muriel R. 144, 145, 152
corporate identity
Eirebus, Fitz-Simon and *365,* 366
Lamm at La Rinascente 160–4, *161*
Mouans-Sartoux municipality, Jost's work for 383
Prisunic department store, Jost and 379
costume design
Stepanova, Varvara Fyodorovna 34
see also fashion design
Cultura en Plantas magazine, Oliveira and 517, *517*

Culturas magazine supplement, Oliveira and 515, *515*
Culture and Resistance Symposium and Festival, South Africa 404
cutlery and tableware design by Zeijst 58
Cynar aperitivo poster (Lamm) *166*

D

dance performance by Martha Graham, poster for (Katzouraki) 317, *318*
Dan Flavin catalog by Emori 295
Daughters of Cyrus project (Moshiri) 419–21, *420,* 422
Daver, Abidin 220
Davis, Lionel 404
Dekk, Dorrit 6
 early life and family 96
 eyewear entitled "Dorrit Dekk" 104
 first years in London 96
 gender (in)equality/bias/discrimination 98
 glamorous contexts for work 96
 illustrations for Tender Co. 103–4, *104*
 Land Traveller Exhibition 102
 move to London 96
 origin and use of name 95, 99, 102
 personality portraits 103
 photo *94*
 professional identity 98, *100,* 102
 sexist attitudes, dealing with 102
 variety and extent of work 95–6
 visual language, changing 103
 wartime role 96, 98
 We Londoners poster *101*
De Logu, Giuseppe 110
Denizcilik Bankası (Maritime Bank), Üretmen at 219–20
Denizyolları (Maritime Lines), Üretmen at *219,* 220, *221*

Derek Forsyth Partners, Fitz-Simon at 363
DeRespinis, Lucia 238
Design journal, Sahiar's work on 257
Design Programmes SA, Jost at 379
De Villiers, Patricia (Trish) 341
 anti-apartheid artists 404–5
 Broadside Mobile Workers' Theatre Company 403
 collective work, lack of recognition and 401
 Community Arts Project (CAP) Poster Workshop, South Africa 399–402, *401,* 404–5
 Congress of South African Trade Unions (COSATU) poster 399–400, *401*
 Culture and Resistance Symposium and Festival 404
 early life and family 402
 education and training 402, 403
 The Great South African Circus poster *406,* 407–8
 The Madwoman of Chaillot theater poster *406,* 408
 photo *398*
 post-apartheid work 408
 South Africa, return to 403
 at Spiderweb Print Cooperative 403
 Taylor, Mavis, work with 406
 theater posters 405–8, *406, 407*
 women, presentation of 399–400, *401,* 405
 Your Own Thing poster *407,* 408
Dhotel-Velliet, Claudine 24
diaspora designers 429–30
Die Geburt eines Stils (The Birth of a Style) (Hofmann) 199–200
diversity of work
 Keil, Maria 73
 Zeijst 64, 67
Dogon to Digital: Design Force 2000 conference, Harris and 465
Dolcini, Massimo 502, 503

Donald Judd catalog by Emori 296
Dorothy's Door studio 306, 306–7, *307*
Doshi, Saryu 263
drawing
 gigolette (flapper) drawings by Atché 21
 Hofmann, Dorothea 198, *199,* 200, *201*
 Keil, Maria 75–6
 Sahiar's style 263
Drink Metric poster (Fitz-Simon) *362,* 363
Druckrey, Inge 198, 200
Duepiù magazine, Klinz and 139
Dufau, Clémentine-Hélène 23

E

early life and family
 Atché, Jane 19–20
 Bertram, Polly 447–8
 Bitterlich, Roswitha 111
 Casey, Jacqueline S. 143–4
 Cohen, Fré 44
 Dekk, Dorrit 96
 De Villiers, Patricia (Trish) 402
 Emori, Eiko 290
 Ernst, Anneliese 244
 Eymont, Anya 389
 Fitz-Simon, Elizabeth 361
 Haddad, Arlette 426
 Harris, Sylvia 460–1
 Hayes, Dorothy E. 304
 Hofmann, Dorothea 194–5, 199
 Hulett, Alison 392
 Jost, Anna Monika 374
 Katzouraki, Agni 314
 Keil, Maria 72
 Keshavan, Sujata 536
 Keum, Kyungja 474, 476
 Kin-Yee, Myriam 391
 Kwan, Winnie Wai-Kan 486
 Lamm, Lora 158
 Leizaola, Karmele 206, 209
 Lim, Eulindra 348–9
 MacLean, Bonnie 326–7

Miho, Tomoko 227–8
Morgagni, Claudia, 173
Moshiri, Mahnoosh 412–13
Ognibene, Elisabetta 500
Oliveira, Mara de 512–13
Rudin, Nelly 185
Sahiar, Dolly 256
Shahbazi, Farideh 439, 441, 442–5
Shōen, Uemura 9–10
Stepanova, Varvara Fyodorovna 30
Toscano, Odiléa Helena Setti 268
Üretmen, Gülümser Aral 217
Virta, Marjaana 525–6
Zeijst, Ans van 57–8
East Germany
 Association of Visual Artists 245
 film posters 248
 freelance work in 245
 lack of recognition for female graphic designers 252
 women graphic designers in 243–4
 see also Ernst, Anneliese
education and training
 Atché, Jane 19–20
 Bertram, Polly 448
 Cohen, Fré 45
 De Villiers, Patricia (Trish) 402, 403
 Emori, Eiko 290–1, 293–4, *294*
 Ernst, Anneliese 244
 Eymont, Anya 389
 Fitz-Simon, Elizabeth 361, 363
 Haddad, Arlette 426
 Harris, Sylvia 461–2
 Hayes, Dorothy E. 304–5
 Hofmann, Dorothea 195–7, *196*
 Hulett, Alison 392
 Jost, Anna Monika 374–5
 Katzouraki, Agni 314–15
 Keil, Maria 72, 73
 Keshavan, Sujata 536–9
 Keum, Kyungja 476

Kin-Yee, Myriam 391
Kwan, Winnie Wai-Kan 486–7
Lamm, Lora 158
Leizaola, Karmele 206
Lim, Eulindra 349
MacLean, Bonnie 327, 332
Miho, Tomoko 228–9
Moll, Thérèse 277, 279
Morgagni, Claudia, 173
Moshiri, Mahnoosh 412, 413, 416
Ognibene, Elisabetta 501
Oliveira, Mara de 513–14, 518–19, 521
racism in 305
Rudin, Nelly 185–7
Shōen, Uemura 10–11
in Singapore 349
Stepanova, Varvara Fyodorovna 30
Toscano, Odiléa Helena Setti 268, 271, *272*, 273
Üretmen, Gülümser Aral 218–19
Uruguay 512
Virta, Marjaana 525, 526
Zeijst, Ans van 58
Eirebus, Fitz-Simon and *365,* 366
EKH Design 341
 Australian National Maritime Museum poster 393, *393*
 evolution of name 394
 Eymont's story 389–90
 first collaboration, Eymont/Kin-Yee 390
 Hulett's story 392, 394
 Kin-Yee's story 390, 391–2
 legacy of 396
 multicultural environment of 396
 Optus, work for *390,* 394
 photo *386*
 sale of 394
 studio model 396
 togetherness, culture of at 391
El Greco Toys packaging (Katzouraki) 315

El-Khal, Helen 88
El Observador, Oliveira at 514–15, *515,* 520
El Popular, Oliveira at 519
"El Taller" design studio, Oliveira and 513
Emigre magazine, Bertram in *454*
"Emilia" syllabic font, Emori and 298
Emori, Eiko 128–9
 awards 293
 Dan Flavin catalog 295
 Donald Judd catalog 295, *296*
 early life and family 290
 education and training 290–1, 293–4, *294*
 "Emilia" syllabic font 298
 glass-making 298–300
 government organisations, work for 296
 I. M. Pei & Associates, summer job at 293
 Inuktitut magazine 298, *299*
 at Iwanami Shoten publishing house *292,* 292–3
 lack of recognition in Canada 290
 National Gallery of Canada (NGC), work for 295, *296*
 Ottawa's chapter of GDC, organization of 296–7
 Perspecta: The Yale Architectural Journal 293, *294*
 photo *288*
 Teaching an Algonkian Language as a Second Language, design of 297–8
 Tokyo, freelancing in 291–3, *292*
Enciclopedia dei Ragazzi, Klinz and *138*
Epoca photojournalism magazine, Klinz and 134
"Era of the Discoveries" stamp (Keil) 75

Eric Burdon and The Animals concert poster (MacLean) *331*, 332
Ernst, Anneliese 127
 Association of Visual Artists membership 245
 early life and family 244
 education and training 244
 film posters *247*, 248
 first jobs 244–5
 freelance work in East Germany 245
 GDR Television, work for 245–6, *246*
 on gender bias 124
 logos for national parks 251, *251*
 photo *242*
 reunification of Germany, impact of 249, 251
 updating of skills 251
 VEB Berlin Cosmetics, work for 245
 West German Protestant Church Day, poster for 248–9, *250*
 working at home with husband 245
eroticization of the female body
 Atché, and absence of 21–2
 see also women, presentation of
Esso Extra Motor Oil poster (Morgagni) *175*, 176–7
Estúdio Técnico de Publicidade (ETP) 73
E+U Hiestand 448, 455
Eulenspiegel (Bitterlich) *113*, 114
Eulindra Designs 348
Ev-İş magazine, Üretmen's fashion illustrations for 217
Eymont, Anya 341
 creativity, continued 394
 early life and family 389
 education and training 389
 Eymont Design 390
 first collaboration with Kin-Yee 390
 growth of Australian graphic design 389–90
 at Horman Design 390
 as lecturer at Sydney College of the Arts 390
 photo *386*
 teaching 391
 see also EKH Design

F

Faculty-Student Exchange Program poster (Casey) 147, *148*
Fagone, Vittorio 177
family see early life and family
fashion design
 Casey, Jacqueline S. 144
 Virta, Marjaana 531–2
female body, eroticization of
 Atché, and absence of 21–2
 see also women, presentation of
feminism
 Choucair, Saloua Raouda 84–5, 87–8
 Cohen, Fré 49
 Dufau, Clémentine-Hélène 23
 historiography and 217, 224
 Keil, Maria 77
 Shōen, Uemura 14
 see also De Villiers, Patricia (Trish)
Festa de l'Unità, Ognibene and 501–2, 507
FIAT, Jost's work for 377, *378*, 379
film posters (Ernst) *247*, 248
Filosofia, Virta's work on *531*, 532
Finland see Virta, Marjaana
Firefly painting (Shōen) 12
First World War
 beliefs following 123
 employment of women during 3–4
Fitz-Simon, Elizabeth 341
 in Canada 369
 at Derek Forsyth Partners 363
 Drink Metric poster *362*, 363
 early life and family 361
 education and training 361, 363
 Eirebus *365*, 366
 impact and legacy 370
 Ireland, move to 359, 361, 363–4
 Ireland Today 366, *367*, 369
 Kilkenny Design Workshops (KDW), Ireland 359, 364–9
 in Korea 369–70
 packaging 365
 photo *358*
 Pirelli, work for 363
 Rosc '77, work for *368*, 369
 Tokyo, move to 369
flag for Social Democratic Women's Clubs (Cohen) 49
Flame painting (Shōen) 12
Flavin, Dan 295
folding envelopes for Jack Lenor Larsen (Miho) 235
Forbes, Colin 291
France
 Paris during and after Second World War 379
 poster art in 22
 see also Atché, Jane
"Francesca" typographic design by Hayes *310*
Friend? Or Foe? poster (Miho) 237
From Common to Uncommon: The Legend of Ha Bik-chuen exhibition (Kwan) 494

G

Garimella, Annapurna 257
GDR Television, Ernst's work for 245–6, *246*
gender, attitudes towards
 blindness to 71
 Daughters of Cyrus project (Moshiri) 419–21, *420*, 422
 Dekk, Dorrit 98
 expectations for women 435
 hippie culture 326
 historiography, undervaluation of women in 215–17

historiography of design 123
Iran, graphic design classes and 418–19
Keshavan, Sujata 537–8, 541, 544–5
lack of credit given to women 211
lack of information about women designers 66
Miho on 237
Moshiri, Mahnoosh 416–17
multicultural women 340
the Netherlands 59
NID/Yale comparison, Keshavan on 539
obstacles for female designers, Üretmen on 124
othering of women 1
pay scales at MIT 152
postmodernism, women graphic designers and 339–40
recognition of women, lack of 215–17
Russian Revolution and 31
1950s and 1960s 124
Shahbazi, Farideh 340, 439–41
Genghis-Khan book cover, Klinz and *136*
Gerçin, Ruzin 224
Gerritsen, Albert 58
Gerstner, Karl 281, 282–3
gigolette (flapper) drawings by Atché 21
glass-making, Emori and 298–300
Gogel, Peter 137, 138
Goldoni, Oscar 503
Gompers, Joseph 46, 53
Graas, Tim 63–4
Graham, Bill 326, 327–9, *328*, 332
"Graphic Colorgraphy" (Stepanova) 32–3
Graphic Design Manual: Principles and Practice (Hofmann) 279–80
Graphic Design Office of the City of Modena, Ognibene at 502–5, *504*

Grasset, Eugène 19
Great Architecture in Chicago poster (Miho) 234
The Great South African Circus poster (De Villiers) *406*, 407–8
Greece
women in graphic design 313
see also Katzouraki, Agni
Grimm's Fairy Tales illustrations (Bitterlich) 117

H

Hadad, Marie Chiha 87
Haddad, Arlette 341
 Al-Arabiyya TV station, work for 431
 Boutros group 426, 429–30
 early life and family 426
 education and training 426
 freelancing work 426–7
 Letraset, work for *427*, 427–9, *428*, *430*, 430–1
 marriage and husband 426–7
 organization of work with husband 431
 photo *424*
 recognition, reasons for lack of 429–30
 as type designer 426–9, *427*, *428*, *430*, 430–2
 variety of work 429
Hamlet poster (Moshiri) *415*, 416
handmade paper 257
Harley Earl Associates, Miho at 230
Harris, Sylvia 343
 ATM user interface 466
 Black identity 462
 Citizen Research and Design 469
 complex institutions, work with 468
 on disadvantages for Black designers 340
 Dogon to Digital: Design Force 2000 conference 465
 early life and family 460–1

education and training 461–2
husband Singer 463–4
impact and recognition of 460–1
personal community and 465–6
photo *458*
Public Policy Lab 469
Sylvia Harris, LLC 464–5, *465*
travel abroad 463, *464*
Two Twelve business 463
Voting by Design poster *467*
at WGBH 461
Hayes, Dorothy E. 129
 black and white, use of *306*, 307
 Black Artists in Graphic Communication exhibition 308–9
 Charles J. Dorkins, logotype for *309*
 at Crowell-Collier Publishing Company 305
 Dorothy's Door studio *306*, 306–7, *307*
 early life and family 304
 education and training 304–5
 "Francesca" typographic design *310*
 photo *302*
 plastics, use of 310–11
 professional, presentation of self as 305
 at Robert N. McLeod, Inc. 05
 as role model for Black graphic designers 305
 teaching 307–8
Heartfield, John 403
Helmbold, Detlef 248
The Herald Review, Keshavan at 538
Herdeg, Walter 279
Herman Miller, Miho's work for *231*, 232–3, *233*
Hiestand, Ursula 455
hippie culture, misogyny in 326
Hirt, Karl Emmerich 109
Histórias da Minha Rua (Stories from My Street) (Correia), Keil and *76*, 76–7

historiography
 feminist perspective, need for 217, 224
 gender bias 123
 neglect of women in 222, 224
 undervaluation of women in 215–17
Hofmann, Armin 186, 195, 196, 197, 279–80, 281, 537, 538
Hofmann, Dorothea 126
 Beginning of Film Art poster *196*
 as classmate of Moll 279
 Die Geburt eines Stils (The Birth of a Style) 199–200
 drawing, growing importance of 198, *199*
 drawings 200, *201*
 early life and family 199
 education and training 195–7, *196*
 India, drawings made in 198, *199*
 interview letters from 193, *194*
 photo *192*
 Swiss youth music community poster *196*
 teaching 193–4, 200
 typography 196
 work after graduation 197–8
Hometopia magazine, Keum's work on *479*, 479–1, *481*
Honegger, Gottfried 374
Hong Kong
 arts and culture, development of 495–6
 design history of 485–6, 496
 East meets West identity 486
 see also Kwan, Winnie Wai-Kan
Hong Kong Designers Association (HKDA), Kwan and 492
Hong Kong Design Exhibition 1984 (Kwan) *489*, 492
Hong Kong Museum of Art (HKMoA), Kwan at 487–95, *488, 489, 490*
Hoogty, Tag der Freude, cover for (Cohen) *47*

Horii, Kenneth 232
Hulett, Alison 341
 early life and family 392
 photo *386*
 retirement 396
 see also EKH Design
Humm, Felix 377
Hunter, Lorraine 295

I
I. M. Pei & Associates, Emori's summer job at 293
identity, Russian avant-gardists 36
illustration
 Araújo, Keil's collaboration with 80
 Atché, Jane 25, *26*
 Bitterlich, Roswitha *116*, 116–18, *118*
 Ev-İş magazine, Üretmen's fashion illustrations for 217
 fashion design and illustration 144
 Histórias da Minha Rua (Stories from My Street) (Correia), Keil and *76*, 76–7
 Jovens do Mundo Todo (Youth of the World) collection, Toscano's work on *269*, *270*
 Keil, Maria *76*, 76–7
 Lamm at La Rinascente 160–4, *161*
 Mit Roswitha ins Märchenland (With Roswitha in to the Fairyland) (Bitterlich) 111–12
 notebooks, city-themed, by Shahbazi *437*, 437–8
 O Estado de S. Paulo, Toscano's work on 268–9
 O Pau-de-Fileira (Keil) 79–80
 school books (Keil) 79
 Schwarz-Weiss-Kunst (Bitterlich) *112*, 112–14
 Shōen, Uemura 13
 Tamasha magazine illustration (Moshiri) *414*, 416

for Tender Co. by Dekk 103–4, *104*
 third way between Swiss/Italian graphic art 164–7, *166*
 Üretmen, Gülümser Aral *219*, 219–20
Il Saggiatore, Klinz at *135*, 137–8
I Maestri dell'Architettura Contemporanea (Masters of Contemporary Architecture), Klinz and *135*
Imagologies, Virta's work on 529–32
India
 National Institute of Design 536–7
 patriarchal norms regarding women 535
 see also Keshavan, Sujata
indigenous culture and identity
 racism in Australia 388
 typography and 297–8, *299*
 visual legacy of 388
industrialization in Russia 33–4
International Design and Scripts, Lim and 350, 352
International Typographic Style 375
International Women's Year stamp study (Keil) 76
International Youth Year Poster Design Exhibition, Kwan and 491–2
Intimate Architecture: Contemporary Clothing Design (Casey) 151
Inuktitut magazine, Emori and 298, *299*
Iran
 gender and graphic design classes 418–19
 patriarchal society 411
 social and political changes in 436
 see also Moshiri, Mahnoosh; Shahbazi, Farideh
Ireland
 absence of design expertise 360
 sociopolitical landscape 359–60

women, life in 1970s for 360–1
 see also Fitz-Simon, Elizabeth
Ireland Today, Fitz-Simon and 366, *367,* 369
Islamic art
 Sufism, book covers by Choucair 85, *86,* 86–7
 Western perspective on 83–4
Italian Association of Advertising Artists (AIAP) 172
Italian Communist Party (PCI), Ognibene's collaboration with 500
Italy
 golden age of design 133
 Milan 157–8
 Modena 500
 women active in graphic design 172–3, 499
 see also Klinz, Anita; Morgagni, Claudia; Ognibene, Elisabetta
ItamCo, Morgagni at 176–7
Iwanami Shoten publishing house, Emori at *292,* 292–3

J

J. R. Geigy A. G., Moll at 281–2, *282*
Jackson, Dorothy 308
Japan
 Atché, Jane, influence of Japanese prints on 21
 see also Shōen, Uemura
Jones, Steve 469
Jost, Anna Monika 341
 AIDS. It's Time for Schools to Act poster 380, *381*
 Con Fiat verso gli anni 70 (With Fiat Towards the 1970s) poster 377, *378*
 corporate identity for Prisunic department store 379
 at Design Programmes SA 379
 early life and family 374
 education and training 374–5

FIAT, work for 377, *378,* 379
freelance work 379–80, *381, 382,* 383
at Heinrich Lorch and René Egger advertising agency 377
International Typographic Style 375
Mouans-Sartoux municipality, work for 383
Olivetti, work for in Milan 375, *376,* 377
in Paris 379
photo *372*
recognition, lack of 375, 377
at Reiwald AG Werbeagentur 377, *378,* 379
Swiss Graphic Design and 373, 377
Tèchnè cover and frontspiece 380, *382,* 383
Jovens do Mundo Todo (Youth of the World) collection, Toscano's work on *269, 270*

K

Katinsky, Julio 269
Katzouraki, Agni 129
 color, use of 317–19
 dance performance by Martha Graham, poster for 317, *318*
 early life and family 314
 education and training 314–15
 Greece, work in 315–17
 at K+K Athens Publicity Centre 315–19
 lack of recognition of 316
 Mobil oil poster *315*
 package design for El Greco Toys 315
 photo *312*
 social and technical limitations on 318–19
 women, presentation of 319, *320*
 as a working mother 321

Keil, Maria 6
 Araújo, collaboration with 80
 arrest and imprisonment 77
 collaboration with husband 72–3
 Começa uma Vida (A Life Begins) (Lisboa) 75
 early life and family 72
 education and training 72, 73
 "Era of the Discoveries" stamp 75
 Histórias da Minha Rua (Stories from My Street) (Correia) 76, 76–7
 historic/folk themes, distancing from 73–4
 International Women's Year stamp study 76
 magazine covers 75–6
 O Pau-de-Fileira, illustrations in 79–80
 Pavillon de la Publicité, visit to 73
 photo *70*
 polygraphic body of work 73
 Pompadour advertisements 73, 74
 range of art forms 72
 school book illustrations 79
 Seara Nova magazine. vignettes for 74
 set and costume design 75
 social design 75–6
 stamps, working women on 79
 Stars of the Paris Opera program 78
 tile art 77, *77,* 79
 travel, enjoyment of 80
 Ver e Crer (See and Believe) magazine 75–6
Kennedy's Studios, Ognibene and 503, *504*
Kepes, György 145
Keshavan, Sujata 345
 book covers 545
 brand identity projects *540,* 540–1, *541, 542,* 543–4, *544*

Index **562**

business, running as a woman 541
Center for Contemporary Art poster *540*, 540–1
challenges faced as a woman 340
Delhi, move from 543
different way of working, demonstration of 535
early life and family 536
education and training 536–9
gender, attitudes towards 537–8, 544–5
gender (in)equality/bias/discrimination 340
at *The Herald Review* 538
J&K Bank identity *541*
Kotak Mahindra Finance Bank identity *542*
NID/Yale comparison of gender attitudes 539
photo *535*
power of design, explaining to clients 544
Ray + Keshavan partnership 539–45, *540*, *541*, *542*, *544*
at Response agency 538
Vistara Airlines identity *544*
Keum, Kyungja 343
at Ario publishing company 476–9
early life and family 474, 476
education and training 476
as freelance journalist/editor 482
Hometopia magazine, work on 481
at Kyemong-Sa publishing company *479*, 480–2, *481*
Monthly Job Placement magazine *475*, 476–9, *477*
photo *472*
typography, use of 478, 480
Kilkenny Design Workshops (KDW), Ireland, Fitz-Simon at 364–9, *365*, *367*

Kin-Yee, Myriam 341
early life and family 391
education and training 391
first collaboration with Eymont 390, *390*
painting 394–5
photo *386*
teaching 391–2
togetherness, culture of at EKH Design 391
see also EKH Design
K+K Athens Publicity Centre, Katzouraki at 315–19
Klatzow, Dorrit Karoline Fuhrmann see Dekk, Dorrit
Klinz, Anita 125
book covers *135*, 135–8, *136*, *138*
Duepiù magazine 139
early life and family 133–4
Epoca photojournalism magazine 134
Genghis-Khan book cover *136*
at Il Saggiatore *135*, 137–8
I Maestri dell'Architettura Contemporanea (Masters of Contemporary Architecture) 135
L'Impero Americano (The American Empire) 139
Milan, early work in 134
at Mondadori publishing house 134–7, *136*, *138*, 139–40
newspaper design 140
Ostinata Bellezza, Anita Klinz, la prima art director italiana (Pitoni) 140
photo *132*
renewed interest in 140
Koefoed, Jean 279
koppenserie (Series of Heads) (Zeijst) 62–3, *63*
Korea, South
expectations of women 473–4
see also Lim, Eulindra
Kothari, Sunil 259

Krekel-Aalberse, Annelies 58
Krohn, Keena, Virta's book covers for *527*, 527–8
Kwan, Winnie Wai-Kan 344
The Art of Xie Zhiliu and Chen Peiqiu catalog *489*, 493
Cheung Yee: Sculptures, Prints, Drawings poster *488*, 491
Chinese painting exhibitions 493
From Common to Uncommon: The Legend of Ha Bik-chuen exhibition 494
cultures, visualization of 493–5, *495*
early life and family 486
East meets West approach 493, 494
education and training 486–7
history of design and 496
Hong Kong Designers Association (HKDA) 492
Hong Kong Design Exhibition 1984 *489*, 492
at Hong Kong Museum of Art (HKMoA) 487–95, *488*, *489*, *490*
International Youth Year Poster Design Exhibition 491–2
logo for museum 493
as mentor to young designers 493
photo *484*
Poetry through Material, Light and Movement catalog 492
sculpture exhibitions 491, 492
Tsz Shan Monastery Buddhist Art Museum, work at 495, *495*
work–life balance 492–3
Kyemong-Sa publishing company, Keum at *479*, 480–2, *481*
Kyoto Prefectural School of Painting 10

Index **563**

L

labor movement
 Cohen, Fré 46–7, *47, 48*
 see also Ognibene, Elisabetta
La Célestine poster (Atché) *24,* 25
La Hora Popular, Oliveira at 519
Lamm, Lora 125
 Arredate la vostra casa d'estate poster *159*
 Cynar aperitivo poster *166*
 early life and family 158
 education and training 158
 freelance work while at La Rinascente *163,* 163–4
 on gender bias 124
 at La Rinascente 160–4, *161*
 Milan, work in 157–8
 Motta confectionery 159–60
 photo *156*
 Pirelli posters *163,* 164
 Studio Boggeri 159
 Thiessing, Frank, and 158
 third way between Swiss/Italian graphic art 164–7, *166*
 typography 162
Lampadariou, Fani 316
Land Traveller Exhibition, Dekk and 102
Late Autumn painting (Shōen) 14
Law, Wing-sang 494
L+C, Rudin's advertisements for *186,* 188
Lebanon
 Arab Cultural Club 84
 creativity and conflict 425–6
 diaspora 425–6, 429
 see also Haddad, Arlette
Lee, Elaine 464
Le Gui et le Houx (decorative panel) (Atché) *24,* 25
Leizaola, Karmele 126
 archives of work 205–6
 early life and family 206, 209
 education and training 206
 father, influence of 210
 at Gráficas Valverde in San Sebastián 208–9
 magazine work 206–8, *207, 208, 209,* 210, *211*
 newspaper work 209–10
 photo 204
 photomontage 210
 political/social influences on work 207
Les ambassadeurs (Toulouse-Lautrec) 20
Letraset, Haddad's work for 427, 427–9, *428,* 430, 430–1
lettering
 Atché, Jane 27
 see also typography
Libera corporate identity, Ognibene and 508, *508*
Lim, Eulindra 341
 A Concise Guide to Hand-Made Oriental Carpets 350, *351,* 352
 "Best Asian Designer" award 347, 348
 Creative Circle nominations for work 349
 early life and family 348–9
 education and training 349
 Eulindra Designs 348, 352–3
 individuality of human beings 356
 International Design and Scripts 350, 352
 luggage tag for Hotel Bali Beach *352*
 Ming Court hotel brochure *354*
 modernism 355
 personal troubles 352
 photo *436*
 Public Utilities Board (PUB) logo *352,* 353
 at S.H. Benson 347, 348
 Sixth Asian Advertising Congress 349, *350*
L'Impero Americano (The American Empire) (Klinz) *139*
Linotype 428–9
 see also typography

M

Machado, Lourival Gomes 268
MacLean, Bonnie 129
 at Allis-Chalmers 327
 Bill Graham and 327–9, 332
 Blues Project announcement board *328*
 commemorative poster 2015 333
 early life and family 326–7
 education and training 327, 332
 Eric Burdon and The Animals poster *331,* 332
 first poster 329
 health issues 333
 painting 332–3
 photo *324*
 Yardbirds/Doors concert poster 329, *330*
The Madwoman of Chaillot theater poster (De Villiers) *406,* 408
magazine design
 Cohen, Fré 52–3
 Keil, Maria 75–6
 Oliveira, Mara de 516–18, *517*
 Stepanova, Varvara Fyodorovna *39,* 39–40
Malaysia
 Creative Circle 347–8
 see also Lim, Eulindra
male domination
 struggle against 1
 see also gender, attitudes towards
Malhas, Thuraya 85, *86,* 86–7, 88
Marg art review quarterly
 aims of 255–6
 Dolly Sahiar as designer for 256–9, *258, 260, 261, 263*
Marimekko, Virta's work for 531–2
Martin, Noel 283
Marx, Enid 98, *99*

Massey, John 234, 236
Mattill, John I. 145, 146, 282
Mayakovsky, Vladimir 31
Metcalf, Celia 152
Methodik der Form und Bildgestaltung, Aufbau, Synthese, Anwendung (Hofmann) 279–80
Meyerhold, Vsevolod 34
Miho, Tomoko 127
 architectural signage 238
 at Center for Advanced Research in Design (CARD) 234
 design methodology 227
 early life and family 227–8
 education and training 228–9
 European trip, impact on work 230–1
 folding envelopes for Jack Lenor Larsen *235*
 on gender issues 124, 237
 at George Nelson Associates 232–3
 Great Architecture in Chicago poster 234
 at Harley Earl Associates 230
 Herman Miller, work for *231, 232–3, 233*
 husband James Miho 229–30, 234, 238
 internment during Second World War 228
 National Air and Space Museum, work for 237–8
 in Newark, NJ 232
 New York City posters 234, 236
 Noguchi and Sadao, work with 238–9
 Omniplan Architects, work for *236*, 237
 package design 229, 230
 partnership with husband 236–7
 photo *226*
 recognition given to 239
 return to New York City 236
 "shakkei," influence of 232, 238

Tomoko Miho Co. 238–9
MIT Office of Publications
 Casey at 145–54, *148, 149, 150*
 Moll at 146–7, 282–4, *283*
Mit Roswitha ins Märchenland (With Roswitha in to the Fairyland) (Bitterlich) 111–12
Mobil oil poster by Katzouraki *315*
Modena, Italy 500
modernism 165
 beliefs after First World War 123
 Choucair, Saloua Raouda 88, *89*
 gender bias of historiography of design 123
 Keil and 72
 Lim, Eulindra 355
 Moscow 30–1
 patriarchy of design profession 124
 Portugal 71–2
Moll, Thérèse 128
 early life and family 277
 education and training 277, 279
 Graphic Design Manual: Principles and Practice (Hofmann) 279–80
 at J. R. Geigy A. G. 281–2, *282*
 at MIT Office of Publications 146–7, 282–4, *283*
 package design for Broxi 280
 photo *276*, 277
 at Studio Boggeri 280–1
 typography 146–7, 284
Momayez, Morteza 416
Mondadori publishing house, Klinz at 134–7, *136, 138*
Monthly Job Placement magazine, Keum's work on *475*, 476–9, *477*
Morgagni, Claudia 125–6
 Calza che non molla (Never-giving-up stockings) 175
 Ceramiques Sanitaire poster *177*
 CIBA Pharmaceuticals cover *178*
 early life and family 173
 education and training 173
 as emblematic and unique 171–2
 Esso Extra Motor Oil poster *175*, 176–7
 exhibitions of figurative arts 173–4
 French Syndicate of Ceramic Sanitaryware Manufacturers, winning poster for 178
 health problems 174
 investment in graphic design 176
 at ItamCo 176–7
 Lanerossi house organ covers 176
 multiplicity of roles 180
 Pellizzari, work for *177*, 178–9
 photo *170*
 professional autonomy 180
 recognition of 179
 at Santagostino 175, *175*, 176
 singles covers 179
 teaching 179
 Vetrine in Vetrina (Showcases in the Window) 175
Morgan-Harry, Peter 348
Moshiri, Mahnoosh 341
 on art and graphic design 418
 Daughters of Cyrus project 419–21, *420*, 422
 early life and family 412–13
 education and training 412, 413, 416
 as graphic designer, reason for 416
 Hamlet poster *415*, 416
 inspiration, sources of 421–2
 mentors 422
 Momayez as mentor 416
 photo *410*
 Tamasha magazine illustration *414*, 416
 teaching 417–19
 as woman in graphic design 416–17

Mother and Child painting (Shōen) 14
Mouans-Sartoux municipality, Jost's work for 383
Mucha, Alphonse 4, 18, 19, 21, 23–4
multicultural women, challenges and under-representation 340
Museum für Gestaltung Zürich, Bertram's work for 450–2, *451, 452*

N

Nassar, Saloua 88
National Air and Space Museum, Miho's work for 237–8
National Gallery of Canada (NGC), Emori's work for 295, *296*
national identity *see* individual countries
National Institute of Design, India 536–7
the Netherlands
 Amsterdam, Jewish community in 44
 Amsterdam School 47
 Amsterdam School, influence of 44–5
 Catholic Labor Movement 62–4, *63*
 Cohen, Fré *42*, 43–54, *47, 48, 50, 52*
 gender equality 59
 German invasion 54
 printing office of the City of Amsterdam 49–52, *50*
 reconstruction after Second World War 62–4
 see also Zeijst, Ans van
New Graphic Design magazine, Rudin at 189–90
newspaper design, Klinz and 140
Noguchi, Isamu 238–9
nudes, ban on painting (France) 21–2
Nusko, Karin 110

O

objectification of women's bodies
 Art Nouveau 22–3
 France, poster art in 22
 see also women, presentation of
O Estado de S. Paulo, Toscano's illustrations for 268–9
Ognibene, Elisabetta 344, *506*
 Autobus magazine 504
 early life and family 500
 education and training 501
 Festa de l'Unità 501–2, 507
 at Graphic Design Office of the City of Modena 502–5, *504*
 importance of as graphic designer 500
 Italian Communist Party (PCI), collaboration with 500, 501–2
 Kennedy's Studios 503, 504
 Libera corporate identity 508, *508*
 motivation for graphic design profession 501, 502
 at Olivetti Image Office 505, *505*
 photo *498*
 political activism 501
 political communication, changes in 505–8, *506, 508*
 political parties, work for 507
 Rap&Show events *506*, 506–7
 sociopolitical/cultural context for 500
 Stardust Memories: Immagini, parole, musiche dei divi di ogni tempo poster 503, *504*
 typography 502, 503
 visual codes, original *506*, 506–7
Oliveira, Mara de 344
 book and magazine design *516*, 516–18, *517*
 Cultura en Plantas magazine 517, *517*
 Culturas magazine supplement 515, *515*
 digital graphic design, transition to 521
 early life and family 512–13
 education and training 513–14, 518–19, 520
 at *El Observador* 514–15, *515*, 520
 at *El Popular* 519
 "El Taller" design studio 513
 first work experience 513, 519–20
 at *La Hora Popular* 519
 photo *509*
 teaching 517–18, 520
 union membership 517
 Uruguayan Classics book collection 516, *516*
 at UTE 519
Olivetti, Jost's work for in Milan 375, *376*, 377
Olivetti Image Office, Ognibene at 505, *505*
Omniplan Architects, Miho's work for *236*, 237
O Pau-de-Fileira, illustrations in 79–80
Optus, EKH Design's work for *393*, 394
Ostinata Bellezza, Anita Klinz, la prima art director italiana (Pitoni) 140
othering of women 1

P

packaging
 Broxi design by Moll *280*
 El Greco Toys (Katzouraki) 315
 Fitz-Simon, Elizabeth 365
 folding envelopes for Jack Lenor Larsen (Miho) *235*
 Miho, Tomoko 229, 230
 Mit Roswitha ins Märchenland (With Roswitha in to the Fairyland) (Bitterlich) 112
 Rudin, Nelly *186*, 188

painting
bijinga style 11
Chinese painting exhibitions, Kwan and 493
Classical Dance painting (Shōen) 13
Cohen, Fré 53
Daughters of Cyrus project (Moshiri) 419–21, *420*, 422
dedication to painting, Shōen's 10–11
Firefly painting (Shōen) 12
Flame painting (Shōen) 12
MacLean, Bonnie 332–3
Mother and Child painting (Shōen) 14
nudes, ban on painting (France) 21–2
Self-portrait with a green hat (Atché) *16*, 19
Women of the Four Seasons painting (Shōen) 10
Young Woman Miyuki painting (Shōen) 14
paper, handmade 257
Paris, influence of on Atché 20–1
Partesotti, Filippo 503
patriarchy
Daughters of Cyrus project (Moshiri) 419–21, *420*, 422
design as 121
Iran 411
Italy 133
Moshiri as woman in graphic design 416–17
resisting, Shahbazi and 340
1950s and 1960s 124
Shahbazi, Farideh 439–41
struggle against 1
Pavillon de la Publicité, Keil's visit to 73
Pellizzari cover (Morgagni) 177
Persian Motifs in Art (Shahbazi) 436, *436*
Perspecta: The Yale Architectural Journal, Emori's design of 293, *294*

Peura, Annukka, Virta's book design for 528
pharmaceutical industry, Rudin's designs for 188
photography, Sahiar and 263
photomontage, Leizaola and 210
Pinter, Ferenc 137
Pioneers of Fight poster (Miho) 237–8
Pirelli
Fitz-Simon's work for 363
posters (Lamm) *163*, 164
Pissarra, M. 404
Place, Alison 1
plastics, Hayes' use of 310–11
Poetry through Material, Light and Movement catalog (Kwan) 492
political communication, changes in, Ognibene and 505–8, *506*, *508*
political/resistance posters 399–401, *401*, 404–5
Pompadour advertisements (Keil) 73, *74*
popular culture
Eulenspiegel (Bitterlich) 114
First World War 4
see also posters
Portugal
independence commemorations 74–5
late development of design in 71–2
Women's Democratic Movement 79
see also Keil, Maria
postcolonial perspective on visual art 84
posters
Agrarische Afdeeling (Agricultural Department) Jaarbeurs conference poster (Zeijst) 0, 59, *60*, 62
AIDS. It's Time for Schools to Act (Jost) 380, *381*

Arredate la vostra casa d'estate (Lamm) *159*
Australian National Maritime Museum poster (EKH Design) 393, *393*
Beginning of Film Art (Hofmann) 196
Board of Tourist Industry poster (Shōen) 13
Body Language (Casey) 147–8, *149*
Catholic Labor Movement, posters for (Zeijst) 62–4
Center for Contemporary Art (Keshavan) 540–1
Ceramiques Sanitaire (Morgagni) 177
Cheung Yee: Sculptures, Prints, Drawings (Kwan) 488, 491
Con Fiat verso gli anni 70 (With Fiat Towards the 1970s) poster (Jost) 377, *378*
Congress of South African Trade Unions (COSATU) (De Villiers) 399–400, *401*, 405
Cynar aperitivo (Lamm) *166*
dance performance by Martha Graham (Katzouraki) 317, *318*
Drink Metric (Fitz-Simon) 362, 363
Eric Burdon and The Animals concerts (MacLean) *331*, 332
Esso Extra Motor Oil (Morgagni) *175*, 176–7
Faculty-Student Exchange Program poster (Casey) 147, *148*
film posters (Ernst) 247, *248*
France 22
Gaz Benoit, poster for (Atché) 22
The Great South African Circus (De Villiers) 406, 407–8
Hamlet (Moshiri) *415*, 416
Hong Kong Design Exhibition 1984 (Kwan) 492

Intimate Architecture: Contemporary Clothing Design (Casey) 151
La Célestine poster (Atché) 24
The Madwoman of Chaillot (De Villiers) *406*, 408
Mobil oil poster by Katzouraki *315*
Museum für Gestaltung Zürich, Bertram's work for 450–2, *451, 452*
National Air and Space Museum, Miho's work for 237–8
Philips, posters for (Zeijst) *61*, 62
Pirelli posters (Lamm) *163*, 164
Poland, 1960s 389
political/resistance 399–401, *401*, 405
RUSSIA/USA Peace 1985 (Casey) 148, *150*
SAFFA (Swiss Exhibition for Women's Work) (Rudin) *184*, 184–5, 187
September 14 Rotterdam poster (Cohen) *48*
Smoker poster (Atché) *18*, 18–19
Swiss youth music community (Hofmann) *196*
Theater am Neumarkt posters by Bertram *449*, 449–50
Voting by Design (Harris) *467*
We Londoners poster (Dekk) *101*
West German Protestant Church Day, Ernst's poster for 248–9, *250*
Yardbirds/Doors concerts (MacLean) 329, *330*
Your Own Thing (De Villiers) *407*, 408
postmodernism, women graphic designers and 339–40
Prisunic department store, Jost and 379
Proctor, Nancy 172

professional identity
 Dekk, Dorrit 98, *100*, 102
 Hayes, Dorothy E. 305
 Morgagni, Claudia 180
prozodezhda (industry garments) 36–8
psychedelia
 defined 325
 posters 326
 rock music and 326
Public Policy Lab, Harris and 469
Public Utilities Board (PUB) logo (Lim) *352*, 353
publishing
 Belle capricieuse: valse par Gabriel Allier (cover illustration) (Atché) *26*, 27
 bookplates (Cohen) 53
 Cohen, Fré 46, 54
 Il Saggiatore, Klinz at *135*, 137–8
 Mondadori publishing house, Klinz at 134–7, *136, 138*
 see also book and magazine covers; book design; magazine design

Q
Quraishi, Humra 264

R
racism
 Australia, indigenous culture and 388
 Black Americans, graphic design and 303–4, 459–60
 graphic design and 303–4, 305
 Harris, Sylvia 460–1
 multicultural women, challenges and under-representation 340
 segregation 460–1
 see also Hayes, Dorothy E.
Rahman, Ram 257
Rap&Show events, Ognibene and *506*, 506–7

Rawsthorn, Alice 121
Ray + Keshavan partnership 539–43, *540, 541, 542, 544*
Reiwald AG Werbeagentur, Jost at 377, *378*
religious commissions by Zeijst 64–6, *65*
resistance posters 399–401, *401*, 404–5
Response agency, Keshavan at 538
Rice, David 465
Robaudi, Mario 174
Robert N. McLeod, Inc., Hayes at 05
"Rooster" children's books, Shahbazi and 436, *438*
Rosc '77, Fitz-Simon's work for *368*, 369
Ross, Fiona 428
Ruder, Emil 279, 281
Rudin, Nelly 126
 Concrete Art movement 190
 early life and family 185
 education and training 185–7
 at J.R. Geigy *187*, 187–8
 L+C, advertisements for *186*, 188
 New Graphic Design magazine 189–90
 packaging *186*, 188
 pharmaceutical industry, designs for 188
 photo *182*
 photo reportage of 183–4
 poster for solo exhibition *189*
 SAFFA (Swiss Exhibition for Women's Work) poster *184*, 184–5, 187
 Swiss style 186–8, *187*
 Zurich studio 188
Russia
 Avant-Garde 31–2, *32*, 34, 40
 constructivism 34, 39, 40
 factories after the Revolution 38
 Futurism 30, 31

industrialization 33–4
modernists in Moscow 30–1
prozodezhda (industry garments) 36–8
Revolution of 1917 31–2
Stepanova, Varvara Fyodorovna 28, 29–40, *32, 35, 37, 39*
RUSSIA/USA Peace 1985 poster (Casey) 148, *150*

S

Saarinen, Esa, projects with Virta 529–33, *530, 531*
Sadao, Shoji 238–9
SAFFA (Swiss Exhibition for Women's Work) poster (Rudin) *184*, 184–5, 187
Sahiar, Dolly 127–8
 book designs 259, 261, *262*
 Design journal, work on 257
 drawing style 263
 early life and family 256
 equal credits with book editors 259
 Marg art review quarterly, design for 256–9, *258, 260,* 261, 263
 photo *254*
 photography 263
 travels with Anand 263
Samen denken samen praten over het religieuze leven (Thinking Together Talking Together about Religious Life) (Zeijst) 65, *66*
Santagostino, Morgagni at 175, *175,* 176
Santagostino advertisement (Morgagni) *175*
Schleger, Hans 291
Schmid, Max 281
Schoener, Allon 283
Schwarz-Weiss-Kunst (Bitterlich) *112,* 112–14
sculpture
 exhibitions, Kwan and 491
 plastics, Hayes' use of 310–11

Second World War
 Cohen, Fré 54
 Dekk, Dorrit 96, 98
 German invasion of the Netherlands 54
 Katzouraki, Agni 314
 Miho, Tomoko 228
 reconstruction in the Netherlands after 62–4
 Shōen, Uemura 14
 Zeijst, Ans van 59–62, *60, 61*
Seidman, J. 404
Self-portrait with a green hat (Atché) *16,* 19
Sellers, Libby 123
September 14 Rotterdam poster (Cohen) 48
set and costume design by Keil 75
sexist attitudes, dealing with
 Daughters of Cyrus project (Moshiri) 419–21, *420,* 422
 Dekk, Dorrit 98–9, 102
 Moshiri as woman in graphic design 416–17
 Shahbazi, Farideh 439–41
 see also gender, attitudes towards
Shahbazi, Farideh 341–2
 blend of roles 438–9
 collaboration with Bahmanpour 438
 early life and family 439, 441, 442–5
 first jobs 436
 gender (in)equality/bias/discrimination 340, 439–41
 notebooks, city-themed *437,* 437–8
 Persian Motifs in Art 436, *436*
 photo *434*
 "Rooster" children's books 436, 438
 at *Soroush* publication 440, *440*
 teaching 437
Sheikh, Gulammohammed 256
Shepard, Jacqueline P. *see* Casey, Jacqueline S.

Shōen, Uemura 4
 artist name, Shōen as 10
 bijinga style of painting 11
 Board of Tourist Industry poster *13*
 Classical Dance painting *13*
 dedication to painting 10–11
 early life and family *9*–10
 education and training 10–11
 feminism and 14
 Firefly painting *12*
 Flame painting *12*
 Late Autumn painting 14
 legacy 14–15
 Mother and Child painting *14*
 Order of Culture Award 14
 photo of *8*
 Second World War 14
 success of 11–12, *13*
 teaching 11
 as unmarried mother 11
 women, presentation of 11, *12, 13, 13,* 14, *14*
 Women of the Four Seasons painting 10
 Young Woman Miyuki painting *14*
Shōnen, Suzuki 10
signage, architectural, by Miho 238
silverware design by Zeijst 58
Singapore
 Creative Circle 347–8
 education and training in 349
 independent design studios 353
 tourism development *354,* 354–5
 women in the advertising industry 348, 355–6
 see also Lim, Eulindra
Singer, Gary 463–4
Singh, Patwant 257
singles covers (Morgagni) 179
Sixth Asian Advertising Congress, Lim and 349, *350*
Smoker poster (Atché) 17, *18,* 18–19

socialist movement
 Cohen, Fré 46–7, *47, 48*
 see also Ognibene, Elisabetta
Soroush publication, Shahbazi at 440, *440*
South Africa
 anti-apartheid artists 404–5
 Culture and Resistance Symposium and Festival 404
 political/resistance posters 399–401, *401*, 404–5
 United Democratic Front (UDF) 404
South Korea
 expectations of women 473–4
 see also Lim, Eulindra
Spiderweb Print Cooperative, De Villiers at 403
sportswear design by Stepanova *35,* 38
stage and theater design
 Keil, Maria 75
 Stepanova, Varvara Fyodorovna 34, 36
stamps
 "Era of the Discoveries" (Keil) 75
 International Women's Year stamp study (Keil) *76*
 Keil, working women on 79
Stardust Memories: Immagini, parole, musiche dei divi di ogni tempo poster (Ognibene) 503, *504*
Stars of the Paris Opera program (Keil) *78*
Stepanova, Varvara Fyodorovna 5
 clothing design *35,* 36–8
 constructivism 34, 39
 costume design 34
 early life and family 30
 education and training 30
 "Graphic Colorgraphy" 32–3
 industrialization in Russia 33–4
 magazine designs *39,* 39–40
 modernists in Moscow 30–1
 photo *28*
 Russia in early 20th century 29–30
 Russian Avant-Garde 31–2, *32,* 34
 Russian Futurism 30, 31
 Russian Revolution of 1917 31–2
 sportswear design *35,* 38
 stage and theater design 34, 36
 textile design *37,* 38–9
 typewriters, use of 33
 "Zaum" (visual poetry) 32–3
Stratigakos, Despina 215
Studio Boggeri
 Lamm at 159
 Moll at 280–1
Studio Morgagni *177,* 177–9, *178*
Sufism, book covers by Choucair 85, *86,* 86–7
Summer of Love 1967 325
Swiss Graphic Design
 Emigre magazine, Bertram in 453–4
 Jost and 373
 Rudin, Nelly *187,* 187–8
Swiss youth music community poster (Hofmann) *196*
Switzerland
 counterculture, incorporation of 447
 education system, restructuring of 455–6
 see also Bertram, Polly; Lamm, Lora; Rudin, Nelly

T

tableware design, Zeijst and 58
Tamasha magazine illustration (Moshiri) *414,* 416
Taylor, Mavis 406
teaching
 Bertram, Polly 448, 455–6
 Cohen, Fré 54
 Eymont, Anya 390, 391
 Hayes, Dorothy E. 307–8
 Hofmann, Armin 279–80
 Hofmann, Dorothea 193–4, 200
 Kin-Yee, Myriam 391–2
 Morgagni, Claudia 179
 Moshiri, Mahnoosh 417–19
 Oliveira, Mara de 517–18, 521
 Ruder, Emil 279
 Shahbazi, Farideh 437
 Shōen, Uemura 11
 Toscano, Odiléa Helena Setti 274
Teaching an Algonkian Language as a Second Language, design of 297–8
Technè cover and frontpiece (Jost) 380, *382,* 383
textile design
 Stepanova, Varvara Fyodorovna *37,* 38–9
 Virta, Marjaana 531–2
Theater am Neumarkt posters by Bertram *449,* 449–50
theater design
 Keil, Maria 75
 Stepanova, Varvara Fyodorovna 34, 36
Theofoor, Sister
 baby book for Catholic families 58
 development of work 58
 photo *56*
 religious commissions 64, *65,* 66
 see also Zeijst, Ans van
Thiessing, Frank 158
Thole, Karel 137
Thumbelina illustration (Bitterlich) *116*
tile art, Keil and 77, 79
Toscano, Odiléa Helena Setti 128
 Bondinho, work on 270, *271*
 early life and family 268
 education and training 268, 271, *272,* 273
 Jovens do Mundo Todo (Youth of the World) collection *269,* 270

Largo 13 de Maio station 273–4
O Estado de S. Paulo, illustrations for 268–9
photo *266*
public spaces, work in 273–4
subway stations of São Paulo 273
teaching 274
travel and study in France and Portugal 270
urban spaces, representation of 271, *272,* 273
women, portrayal of 268–9
Toulouse-Lautrec, Henri de 19, 20
tourism development in Singapore *354,* 354–5
Tracy, Walter 428
training *see* education and training
Tscherny, George 237, 238
Tsz Shan Monastery Buddhist Art Museum, Kwan's work at 495, *495*
Turkey
graphic design and 215–16
see also Üretmen, Gülümser Aral
Turner, Matthew 485–6
Two Twelve, Harris and 463
type design, Haddad and 426–9, *427, 428, 430,* 430–2
typography 165
Arabic typesetting *427,* 427–9, *428, 430,* 430–2
Atché, Jane 27
Atché and 20–1
Casey, Jacqueline S. 147–8, *148, 149, 150*
Charles J. Dorkins, logotype for by Hayes *309*
Cohen on 51
"Emilia" syllabic font, Emori and 298
"Francesca" design by Hayes *310*
grid 147
Hofmann, Dorothea 196
indigenous identity and 297–8, *299*

integration with photography, Keum and 480
International Typographic Style 375
Keum, Kyungja 478
Lamm, Lora 162
Mattill on 145
Moll, Thérèse 146–7, 284
Ognibene, Elisabetta 502, 503
SAFFA (Swiss Exhibition for Women's Work) poster (Rudin) *184*
Virta, Marjaana 526, 529, 532, 533
Wendingen magazine 44–5

U

United Democratic Front (UDF), South Africa 404
urban spaces, representation of, Toscano and 271, *272,* 273
Üretmen, Gülümser Aral 127
at Bâb-ı Âli 217
companies worked for 220
at Denizcilik Bankası (Maritime Bank) *219,* 219–20
Denizyolları (Maritime Lines) *219,* 220, *221*
early life and family 217, 221–2
education and training 218–19
Ev-İş magazine, fashion illustrations for 217
on obstacles for female designers 124
photo *214*
recognition of, lack of 222, 224
Uruguay
education and training 512
print publishing industry 511–12
see also Oliveira, Mara de
Uruguayan Classics book collection, Oliveira and 516, *516*

V

VanderLans, Rudy 453
VEB Berlin Cosmetics, Ernst's work for 245
Ver e Crer (See and Believe) magazine 75–6
Vierkens, Lenie 59, 62
Vigneron, Frank 493
Villani, Dino 172, 177–8
Virta, Marjaana 345
book covers for Keena Krohn *527,* 527–8
early life and family 525–6
education and training 525, 526
exhibitions of book designs 529
Filosofia 531, 532
"Graphic Designer of the Year" award 528–9
Graphic Design Marjaana Virta Ltd 526
Imagologies 529–32, *530*
musical concepts, use of 533
Peura, Annukka, book design for 528
photo *524*
reading comprehension, book design as 532
recognition of 528–9
Saarinen, Esa, projects with 529–33, *530, 531*
textile design 531–2
typography 526, 529, 532, 533
at Werner Söderström Ltd (WSOY) 526
visual poetry by Stepanova 32–3
Vorrink, Koos 46
Voting by Design poster (Harris) *467*

W

Weingart, Wolfgang 453
We Londoners poster (Dekk) *101*
Wendingen magazine 44–5
Werner Söderström Ltd (WSOY), Virta at 526

West German Protestant Church Day, Ernst's poster for 248–9, *250*
WGBH, Harris at 461
Wilson, Folayemi 465, 468
Winkler, Dietmar 151–2, 153–4
Wolff, Katharine 198, 200
women
 employment during First World War 3–4
 restricted lives in 19th and 20th centuries 3
 see also gender, attitudes towards
women, presentation of
 Art Nouveau 22–3
 Atché, Jane 21–2
 Daughters of Cyrus project (Moshiri) 419–21, *420*, 422
 De Villiers, Patricia (Trish) 399–400, *401*, 405
 Dufau, Clémentine-Hélène 23
 France, poster art in 22
 Katzouraki, Agni 319
 Shōen, Uemura 11, *12*, 13, *13*, 14, *14*

Toscano, Odiléa Helena Setti 268–9
Women of the Four Seasons painting (Shōen) 10
workers' clothing 36–8
work–life balance, Kwan and 492–3
Wunderlich, Sylke 243–4

Y
Yardbirds/Doors concerts poster (MacLean) 329, *330*
Young Woman Miyuki painting (Shōen) *14*
Your Own Thing poster (De Villiers) *407*, 408

Z
"Zaum" (visual poetry) by Stepanova 32–3
Zeijst, Ans van 5
 Agrarische Afdeeling (Agricultural Department) Jaarbeurs conference poster 59, *60*, 62
 archives and collections of work 67
 in Augustinian convent 64–6, *65*
 as Benedictine nun 58
 as Catholic designer 64–6, *65*
 Catholic Labor Movement, posters for 62–4, *63*
 early life and family 57–8
 education and training 58
 koppenserie (Series of Heads) 62–3, *63*
 map for *Holland Fair* in Philadelphia 64
 "Mon.Aug" signature 64, 66
 Philips, posters for *61*, 62
 photo *56*
 reception of work 66–7
 religious commissions 64–6, *65*
 Samen denken samen praten over het religieuze leven (Thinking Together Talking Together about Religious Life) *65*, 66
 Second World War 59–62, *60*, *61*
 silverware design 58
 see also Theofoor, Sister
Zeusl, Erich 110